BOOKS BY MICHAEL MACDONALD MOONEY

THE MINISTRY OF CULTURE/

Connections Among Art, Money and Politics

by Michael Macdonald Mooney

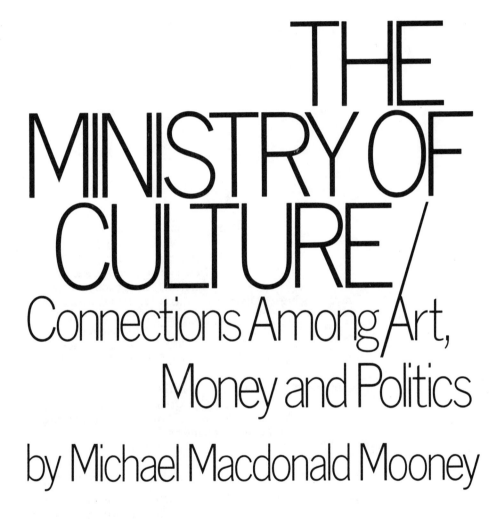 Wyndham Books NEW YORK

For Hervey McNair Johnson
constitutionalist & companion

Copyright © 1980 by Michael M. Mooney
All rights reserved
including the right of reproduction
in whole or in part in any form
Published by Wyndham Books
A Simon & Schuster Division of Gulf & Western Corporation
Simon & Schuster Building
Rockefeller Center
1230 Avenue of the Americas
New York, New York 10020

WYNDHAM and colophon are trademarks of Simon & Schuster
Designed by Jeanne Joudry
Manufactured in the United States of America
Printed and bound by Fairfield Graphics, Inc.
10 9 8 7 6 5 4 3 2 1

Library of Congress Cataloging in Publication Data

Mooney, Michael Macdonald, date.
The ministry of culture.

Includes index.
1. Art patronage—United States. 2. Politics in
art—United States. 3. Art and state—United States.
I. Title.
NX730.M66 353.0085'4 80-20660
ISBN 0-671-61021-X

Acknowledgments

Originally I thought I would just write an article—no more than 2,500 words—for *Harper's* magazine. I was curious about what the National Endowment for the Arts might be doing. I certainly had no intention of spending three years wandering through the vast labyrinth of national cultural programs. I soon was required to learn how each program connected to many others; that national cultural objectives had been syndicated and incorporated; that budgets could not even be estimated until combined with state, municipal, regional, county, foundation, university, and corporate funds—all of which were commingled; that the Federal Council on the Arts and the Humanities was coordinating more than 300 national programs.

To make my way through the corridors of politics in the arts I needed many guides. I am grateful to those who served as Ariadnes, to those who tutored, to those who supplied materials I used, to those who provided materials I could not use. I am grateful to the few singled out here for particular contributions; but also to many more I could not list because the catalogue of those who helped and encouraged would go on page after page. My thanks to all.

At the outset I decided to work from official documents—insofar as possible. I would interview only after I had studied the published records; but there was no bibliography as a bench mark from which to begin a survey; moreover, the central difficulty was that there were too many documents. There were no sources to trace the historical growth of the multiplying art programs; there was no index of materials; there were no summaries of national arts activities except the *Cultural Directory*, but no officer of national culture could identify to Congress what the agencies in the *Cultural Directory* did or spent, and no one in Congress knew. No one could supply an estimate of total federal expenditures, much less state or local amounts. Besides, almost all agencies of national culture conduct the significant portions of their meetings in secret, and when the minutes are not declared secret, they may not exist at all. In sum, I had

to start at the beginning; throughout I needed tutors to comment upon which materials were significant and to explain the nuances of what I'd read.

My basic materials consisted of the annual appropriations hearing reports of the Congress, as well as the enabling and subsequent authorization debates; the testimony of witnesses before the House and Senate subcommittees; the investigative reports of the House Committee on Appropriations and the answers to the House reports by NEA and NEH; and finally, the annual reports and promotional materials of the major agencies with programs in the arts and humanities. For the Congressional materials I am particularly grateful to Mary Bain, Mike Dorf, and Sandy Crary. With high good humor they always provided whatever materials I requested.

In addition, I am grateful to each and every public information specialist at more than two dozen agencies, and another two dozen state agencies or trade associations, not only for copies of their reports, newsletters, studies and what not, but also for providing follow-up documents, and then for spending patient hours explaining what the documents meant —in some cases answering more than twenty call-backs. I am also grateful to an unknown number of "whistle-blowers" inside the agencies of education, arts and humanities who sent documents as if on cue in answer to questions that had not yet even occurred to me. For nearly three years the mail delivered to my door included internal memoranda and studies postmarked from four states as well as Washington, D.C. Whoever you are, wherever you are, thank you.

Before a major housecleaning, I had collected some sixteen boxes, or approximately 90,000 pages, of official materials. The problem was to make sense of it, if I could. A partial list of those to whom I am indebted for instruction includes: Shana Alexander, Jim Backas, Mathew Bruccoli, Harold Cannon, Myron M. Cherry, Jerry Colbert, Robert Dash, Joan K. Davidson, Joseph D. Duffey, Bruce Duff Hooten, William Jovanovich, Virginia Kassel, Erwin Knoll, Sally Ann Kriegsman, Joan Kufrin, Peter Kyros, John Leonard, Mary Ann Liebert, Florence Lowe, Mary MacArthur, Frances McCullough, Patricia McFate, Geoffrey Marshall, Howard Morland, Jacob Neusner, Brian O'Doherty, Gerald O'Grady, Donn Alan Pennebaker, Claiborne Pell, Ron Plesser, George Plimpton, Coates Redmon, Rose Slivka, Jack Skuce, Mary Anne Tighe, Dick and Joan Whalen, David Wilk, Galen Williams, Douglas Wood, and Sidney R. Yates.

For my accounts of the Erica Jong and H.L. Mencken censorship cases I am grateful to the American Civil Liberties Union for the background materials, and particularly to Jack Taurman and Ralph Temple. When I depended upon the reporting of others, the reporters and their newspapers or magazines are cited in the text along with the materials in my account, but I would particularly like to express my debts to: Donald P. Baker, Ron

Kessler, Donnie Radcliffe and Lon Tuck, Tom Shales and Jacqueline Trescott of the *Washington Post;* Howard Blum and Paul Montgomery, John S. Friedman and Hilton Kramer of the *New York Times;* Philip Nobile and Chris Welles of *New York* magazine; Paul Harris of *Variety;* Nat Hentoff of the *Village Voice;* Karl Grossman of the *East Hampton Star;* Mary Lynn Kotz of *Art News;* and, Miss Ruth Dean of the *Washington Star*—my friend and companion on the beat, whose tape recorder always worked.

When Susan Wagner of *Publishers Weekly* left Washington for Paris, she generously turned over her entire file on the patronage wars in NEA's literature program. I am particularly grateful to Susan Wagner because by then NEA had declared her materials secret, but I could begin with ten years of accumulated NEA history. For my accounts of the NEA literature patronage wars I am also indebted to the published materials of Geoffrey Cook, Richard Kostelanetz, Peter Marin, Richard Peabody, Charles Plymell, Zack Rogow, Felix Stefanile, A.D. Winans, and the indefatigable Eric Baizer—both for his published materials and for his private files.

As I explored the maze built within temples upon Washington's Great Mall, I discovered that I was, in effect, retracing passages about the connections between art, money, and politics that I had covered in my summary of nineteenth-century American attitudes in *Evelyn Nesbit and Stanford White,* William Morrow & Co., N.Y., 1976. There is no point in relisting my sources from that work. Instead, I am indebted to an added list of sources for bringing the story forward into the twentieth century. I hope the text of *Ministry of Culture* makes my intellectual debt to George Orwell abundantly clear: for *1984,* The New American Library, N.Y., 1961 edition; but particularly *The Collected Essays, Journalism and Letters,* edited by Sonia Orwell and Ian Angus, Harcourt Brace Jovanovich, Inc., N.Y., 1968. It was Orwell who directed my attention to *It Can't Happen Here* by Sinclair Lewis, The Sun Dial Press, Inc., Garden City, N.Y., 1935, and to *The Iron Heel* by Jack London, Grayson Publishing Corp., N.Y., 1948. To deal with the difficulties of the transcendental faith of humanism I used: *The Essential Comte,* edited and with an introduction by Stanislav Andreski, Barnes and Noble Books, N.Y., 1974; *A General View of Positivism,* Auguste Comte, Robert Speller & Sons, N.Y., 1957; and *Auguste Comte and Positivism* by John Stuart Mill, University of Michigan Press, Ann Arbor, 1961.

Mill's critique of the religion without a God is still the final word. All the rest is a matter of bringing the details up to date. I depended upon: *Mass Culture,* edited by Bernard Rosenburg and David Manning White, The Free Press, N.Y., 1957; *Culture and the Crowd,* Deric Regin, Chilton Book Company, Philadelphia, 1968; *Darwin, Marx, Wagner,* Jacques Barzun, revised second edition, Doubleday Anchor Books, Garden City, 1958; *Inside The Third Reich,* Albert Speer, The Macmillan Company,

N.Y., 1970; *Unacceptable Risk*, McKinley C. Olsen, Bantam Books, Inc., N.Y., 1976; *A Public Trust*, The Report of the Carnegie Commission on the Future of Public Broadcasting, Bantam Books, Inc., N.Y., 1979; *Public Support for the Arts in the United States*, Dick Netzer, Cambridge University Press, N.Y., 1978; *The Art Museum*, Karl E. Meyer, William Morrow and Company, Inc., N.Y., 1979; *The Power Lovers*, Myra MacPherson, G.P. Putnam, N.Y., 1975; *The Corporate Lobbies: Political Profiles of the Business Roundtable & The Chamber of Commerce* by Mark Green and Andrew Buchsbaum, Public Citizen, Washington, 1980; *Twigs For An Eagle's Nest*, Michael Straight, Devon Press, New York, Berkeley, 1979.

I owe certain special debts. First, to Julie Motz, as an example of moral impatience with hypocrisy. She continues to track leads to their bitter ends as a volunteer for many who are equally outraged, but lack Julie Motz's determination. I owe special thanks to Amanda G. Birrell and Michael Tigar, who worked as volunteer lawyers. I am grateful to Elizabeth Bartelme and Sophie Sorkin for exhaustive copyediting; to Sheila Nealon of Wyndham Books and to my editor and publisher, Larry Freundlich, who was not at all afraid to be "too big a target" if he published *Ministry of Culture*. Finally, as always, I thank Roberta Pryor for her wit and wisdom; Anne Sears Mooney not only for her patience through three years of instant replays, but for her editorial falcon's eye; and, Hervey McNair Johnson, companion in work and at play, careless golfer but great story teller, teacher of the First Amendment, to whom this book is dedicated.

Michael Macdonald Mooney
Washington, D.C., June 1980

Contents

PART III / THE NEW ORDER

PART I / The New Foundation

1

SKETCHBOOK / GROUND ZERO . . .

. . . and they have hewn out for themselves cisterns, cracked cisterns that can hold no water.

—JEREMIAH, *2:13*

Like many other tourists, I went to see the official national bench mark, Ground Zero, located at the north edge of the Ellipse, just across the macadam road from the iron picket fence guarding the south lawn of the White House grounds. On maps of Washington, D.C., the radii of power emanating from the capital of the United States of America—and seat of empire for the trembling West—were measured from the rock designated as Ground Zero.

Quarried from a single cutting of gray granite, the national bench mark was a somewhat stunted obelisk about four feet high, about two feet square at its base, slightly tapered to a flat top. Although the National Park Service—its appointed guardian—claimed that shades of pink colored the granite, I couldn't see any pinks in the polished grain of the stone. A bronzed compass card was fixed upon the monument's flat top. Although its cardinal points were worn smooth from uncounted rubbings by other tourists, the compass was still distinct enough for me to make the traditional sightings. By placing the fingertips of both my hands on the opposing edges of the flat top to steady a partial crouch, I could sight dead north, and see the center door of the south portico of tne White House. When I sighted the reciprocal, I was looking dead south across the Ellipse, then over the Great Mall and across the stilled waters of the Tidal Basin. I could see the shadowed statue of Thomas Jefferson standing there between the columns of his memorial. Across a bronze compass card, I could fix the monuments of a glorious past in their permanent places. Because centuries were required to compress crystalline rock, the national bench mark must have been creating its granite densities long before the Pyramids were sweated up. Now the stone would surely lie heavy with its own gravities somewhere near its present location for millennia yet to come.

For all its apparent permanence, however, Ground Zero was histori-
cally uncertain. To begin with, like any other stone carefully placed in a
sacred grove, Ground Zero could just as well have been located thirty feet
east of its calculated position at the north edge of the Ellipse, or sixty feet
west, or a mile away at the foot of the Washington Monument, or up on
Capitol Hill, where it was said the United States Congress made laws.
The national bench mark could have been put in some other exact spot
—after having been approved by the vote of the appropriate committee
one fine day—but its meaning would continue to change. Although fixed
by precise geography, Ground Zero marked a place at which startling
changes had constantly occurred in the nation's high purposes or good-
will.

Goodwill—as expressed in customs, manners and traditions—paved
the roads by which Promised Lands were reached. When Henry Clay's
nationalists began a system of national roads and canals from Washing-
ton, Clay's men expressed their understanding of continental geography
and political necessity. Although the Promised Land was then only
vaguely located on the Pacific somewhere near Oregon, the expansive
faith in Henry Clay's day was to push the frontier west. The wagons
creaked toward Manifest Destiny loaded with hymnals, Bibles, Consti-
tutional law, Kentucky whiskey, Bridgeport brass screws, Lowell cottons,
Pennsylvania iron pots, New York notions, Boston tea, Hartford rifles—
and along with all that baggage an indispensable faith in adventure,
change, invention. The pioneers sang as they traveled the national road:
"Where are the Holy Christians? Where are the Holy Christians? Safe in
the Promised Land!"

By 1832 the National Road, as it was then called, could be measured
out from Washington as far west as Vandalia, Illinois. Constructed to
handle the cargo of wagons, Clay's continental political system was soon
overtaken by a network of railroads, also emanating from Washington,
but remarkably different in how its good works were to be blessed. To
build the continental railroads, the nation adopted as its theology the
economic necessities of whacking amounts of capital, and the peculiar
goodwill extended to huge profits and cutthroat competition was justifi-
able, because it could be shown, beyond a reasonable doubt, that heaven
would be financially secure—an entirely different faith from, "When
we've wood and prairie land, won by our toil, We'll reign like kings in
fairy-land, Lords of the soil."

By 1900 the Lords of Capital spent their summers in Newport, Rhode
Island, a Promised Land occupied in August each year before the very
rich returned to New York or Boston to attend to their investments, be
seen at the opening of the opera, and review the paintings they might
contribute to the Metropolitan Museum of Art. But these magnificoes
were soon replaced by a quite different group of lords, representing a
schismatic dissent to old capital, known as the New Capitalism—also

emanating from Washington and also expressing goodwill—but advertising an entirely different Promised Land. To commemorate the Good News of the New Capitalism, the national bench mark was quarried and established in its permanent site by special Act of Congress in 1920 and designated Ground Zero.

At the time, the great majority of legislators agreed with the sermons preached by the United States Chamber of Commerce: Ground Zero marked the exact spot from which another system of roads was to be measured out, a system for automobiles beginning at the White House, running past Abraham Lincoln's memorial, then over the Potomac River upon the new Memorial Bridge into Virginia, and then west. When Ground Zero was dedicated, a fine band played, of course, and great speeches were made. The orators of the New Capitalism said they were creating a system of paved roads because their hopes, their ambitions, their plans were to link city and town and hamlet in one great national market. The New Capitalists were men of many goodworks with the distributive interests of the entire nation always first in their hearts: "free enterprise," they called it. After the speeches in 1920, a pistol was fired to start the first transcontinental auto race for San Francisco. Even on unpaved roads, some of the starters made it all the way to the Pacific coast: "Won't you come with me Lucille, in my merry Oldsmobile?"

The Promised Land reached by Oldsmobile was a little nest, where roses bloomed, for Molly and me and the baby who made three. Access to the shopping centers which supplied my blue heaven was considerably improved in the 1950s by the proconsuls of empire who served in the cabinet of President Dwight D. Eisenhower. They were men equal in goodwill to Henry Clay's continental men of Manifest Destiny, to the financiers of 100 million miles of railroad track, to the Chamber of Commerce men of the New Capitalism. Eisenhower's men made treaties by the dozen and always put the empire's defense first upon their list of national highpurposes. They promoted their new system of roads from Ground Zero by demonstrating the interstates were necessary for defense. From the bungalow built for two or three or more, the Promised Land had apparently moved again, this time to the E ring of the Pentagon where a Q clearance was required for entry into the more prestigious suites. Any quibbles by the Congress about the military necessity for the interstates were easily hushed by increasing the dollars spent in particular home districts, for national security. Thereafter the legislators also stood at attention whenever the Marine Corps band played "Hail to the Chief."

By 1980 Eisenhower's "interstates" were in bad repair and no new roads were proposed to radiate out from Ground Zero; on the contrary, all roads apparently led to Washington as they once did to Rome; and it was being said that the Promised Land now had something to do with the Arts.

2

PROFILE / JOAN OF ARTS . . .

*"From the age of uniformity, from the age of solitude, from the age of Big
Brother, from the age of doublethink—greetings!"*

—George Orwell
1984

Mrs. Joan Adams Mondale, wife of the vice-president, was a woman of
goodwill. The laws of the United States forbade her to hold any office:
that's why Joan Mondale was listed as no more than honorary chairper-
son of the Federal Council on the Arts and the Humanities; but the
"honorary" in her title was said to be in name only.

The Federal Council on the Arts and the Humanities was authorized
by Congress in 1965 to coordinate the vast and complex national cultural
efforts, but no one knew how many different national programs there
were—perhaps as many as 300; nor did anyone know how much these
programs actually spent—perhaps more than $20 billion each year; nor
had there ever been any assessment of what these efforts or monies may
have accomplished. Although authorized by Congress, the Federal Coun-
cil on the Arts and the Humanities not only did not coordinate the na-
tional policy on the arts, it was dormant until it was revived by Joan
Mondale in the spring of 1978.

By then Joan Mondale had conducted a two-year political campaign
with what was described as evangelistic fervor "to support the arts." She
saw herself as President Jimmy Carter's chief emissary for the arts, and
she explained that there was "an incredible constituency of people who
love the arts, and we want to encourage them, and to show our concern
that the federal government does indeed care."

The headquarters for her campaign was a small study in Admiral's
House, the vice-president's official residence on Observatory Circle, but
her busy staff operated in the Old Executive Office Building next door to
the White House. Each week her staff fielded about 300 requests for

speeches, appearances, meetings. In her campaign, it was said, she had covered more than 300,000 miles by air. Trip expenses were always paid by the sponsoring organizations, it was said, and the wife of the vice-president never flew anything but coach.

When her husband was elected in 1976, Joan Mondale thought the arts was "an area where I might make a real contribution." Before the inauguration, at the first cabinet meeting held in Sea Island, Georgia, she was reported to have cornered Interior Secretary-designate Cecil Andrus and made him promise to sell crafted work instead of plastic souvenirs at the hundreds of National Park Service concessions stores. Crafts was an "area" special to Joan Mondale's heart, she said, and the National Park Service concessions was an "area" that could be improved. Jimmy Carter apparently agreed.

After he took office, President Carter provided Mrs. Mondale with a written letter, a *passeporte*, to the federal bureaucracy. As she wandered through the labyrinth of national cultural programs, she soon learned that no one knew what the government was already doing in the arts, much less what they planned to do or hoped to do; some coordination of policy would certainly make better sense. When she learned that the Carter administration domestic staff planned to spell out in position papers what the policy would be on each major issue—energy, taxes, cities, health, welfare, and so forth—she did not see why there could not be a policy for culture. "Art is not the icing on the cake," she argued. "It is the essence of our lives."

Art was also a fine "peg" for that section of a newspaper usually headed "Style, Arts, Entertainment, TV, Comics," and Joan Mondale's campaign for art soon earned her the admiring sobriquet, "Joan of Arts." Feature writers turned to with gusto, and Mrs. Mondale was characterized as the government's "chief lobbyist" for artists, writers, craftsmen, theater, opera, dance, museums, and even women who sewed their own clothes. She was credited with "wielding a steadily increasing influence over national cultural policy." At the seat of empire, an admiring *Washington Post* concluded, "Joan Mondale is not just mouth, she's muscle."

Despite heaping praises, "Joan of Arts" maintained her habitual modesty, always giving credit where credit was due. She told Ruth Dean of the *Washington Star:* ". . . to me it's been just an incredible success story." Joan Mondale pointed out that the twin endowments of Arts and Humanities had been the real leaders, ". . . and guiding lights and dispensers of grants, and they have done it so well, and so carefully, and so sensitively, that they never had any trouble getting their money from Congress. They've never had any trouble with their budget. The Senate last year voted with just three people opposing. It was just astounding!"

To the ear untutored in the language and manners of official Washington, it might have sounded as if Joan Mondale was talking in italics and exclamation marks; as if she gushed enthusiasms like a political variety

of the *Cosmopolitan* cover girl. There were even those who had nominated her for the vanilla cream puff award: "Is that all an act? I find her unbelievable."

But if Joan Mondale gushed, it was always discreet, disciplined, timed exactly to fit the pragmatic necessities. She never said anything that wouldn't be, you know, "appropriate." She insisted that her campaign to support the arts was really only a matter of doing what obviously needed to be done anyway. If there seemed to be italics in the way she spoke, it was all said modestly—a demonstration of a consistent style. She wore the kind of simply cut clothes once described as "understated," just short of high-fashion chic, but perfectly tailored to hang straight from her taller than average, angular frame; and what she chose to wear was always perfectly acceptable for the occasion. Perhaps she would add a scarf at the neck of her shirtwaist dress for just the right accent of dashing color— the exclamation mark; but her brunette hair was kept medium short, practical. It probably only took her a moment to brush it out before her next appearance.

She was as clean-scrubbed, as open and straightforward as any good-thinking-active-American-woman ought to be. She was involved. She was doing her best. She was committed, she said, to social justice. She wanted to show that government could care. She wanted to make a contribution. She was an experienced campaigner. She had handled five, even ten, tea parties in a single day; smiled at a hostess she didn't know; picked up a name from a fumbled introduction; said just the right thing by reading a name-tag, gave the two-minute thirty-second speech about helping, about caring; moved on, shook hands, moved on, shook hands, moved on, shook hands. The smile was almost real, and its firing pin was set permanently on semiautomatic.

When she had to wait through the interminable reports of highpurpose, goodworks, committee findings—all that palaver for which the minutes would be waived next time, Joan Mondale provided the very model of that infallible advice to goodwomen: "just act naturally, be yourself, and sit up straight." It was exactly that combination of posture, American attitude, and goodmanners—poise, ten million mothers had said, don't fidget, they had said—that displayed the reasons why her goodintentions were never to be questioned. And so it was difficult to imagine Joan Mondale padding across the wine-stained floor of an artist's loft, or nested down in a studio where the dope smoke hung like a light fog up near the ceiling. She had never been the girl to run away for a life upon the wicked stage.

She was at home in the marbled corridors of air-conditioned museums. She was an experienced docent. When Mary Lynn Kotz of *Art News* took a tour with her, Joan Mondale could express the extravagant enthusiasms of a schoolmarm, with a giggle at just the right moment, for the very best in painting: "Oh, it's gorgeous, just gorgeous—I can't believe it!" And

always mindful of her responsibilities, she never forgot to maintain her poise, be a good listener, enunciate clearly when she had something to say, and to speak deliberately in her very best alto voice to get done what ought to be accomplished. Faced with controversy over the politicization of the national arts, she searched for consensus, then accented the positive: "If being an elitist means being for quality, then yes, I am for quality. If being a populist means accessibility, then yes, I am a populist. I want the arts to be accessible."

If Joan Mondale's sentences seemed to be cantilevered, or sounded as if they were being read from a teleprompter, she was only talking that way for the very best of reasons: "I'm sure by now we're all familiar with the statistics which show more people are attending cultural than sports events. So the audiences are there and they're asking for more. But the question is, how can we give them more?"

It was the schoolmarm's question, posed to the class with self-evident goodwill; and if the boys in the last row looked as if they were getting restless, getting near spitball time, for the purposes of class participation she was ready to follow up: "How can the federal government encourage the orchestras and the museums and the dance companies to give the audiences what they want?"

If at first giving-the-audience-what-it-wants appeared to be a curious objective for the inherent powers of the Constitution of the United States, Joan Mondale was only expressing in her own way one of the central themes of the Carter-Mondale administration, a theme that had been expressed again and again, and sometimes tagged "The Caring Community." As a matter of fact, "The Caring Community" was only scrubbed out of Jimmy Carter's 1979 State of the Union address at the very last minute. The substitute at four in the afternoon on the day of the address was "The New Foundation." Whichever slogan turned out to be appropriate, the notion the administration was attempting to express, and Joan Mondale was saying in her own way, had been, once upon a time, one of the central revelations of the American theology: that if the community learned to work together, if we just cooperated toward common ends, miracles could be accomplished—in the here and now and on this earth. Brothers and sisters, we have come to this Promised Land, thank the Lord, thank Him for our good fortune, and love one another!

When Joan Mondale improvised variations on traditional themes in order to support the arts, she combined the promised-land-here-and-now with other evergreen optimisms from the catechism of the fundamentalist American faith: that salvation could be won by goodworks; that conscience and taste were reliable guides to gooddoings; that by working together we were to see a better day tomorrow; that of course there must be leadership to accomplish national ends, just as the goodministers had served generation after generation to accomplish local ends; and that of course the parsonage door always stood open.

If Joan Mondale's assurances seemed to have in them something of the earnest cadences of the parsonage, that was not strange at all. Joan Adams was born the daughter of a Presbyterian minister in 1930, and grew up in parsonages in Columbus, Ohio, and Wallingford, Pennsylvania, not far from Philadelphia's Main Line. As a matter of fact, she made the connection herself between the style of ministerial duties and political responsibilities. She had accepted the loneliness, the absences, the peculiarities of being a political wife, she said, because she was trained to them. Her father was never home. He traveled six months out of every year. She was never accustomed to having a man around the house. She had never expected anything, she said. "I was very lucky."

When her father was named chaplain at Macalester College, her family moved on again to Minnesota. In her sophomore year at Macalester she took the train down to Cincinnati to visit her uncle, Philip Adams, director of the Cincinnati Art Museum. "Uncle Phil," she said, "shaped my career in art."

She studied history at Macalester, minored in art, got a part-time job cataloguing at the Minneapolis Institute of Arts. After graduation she worked as an assistant slide librarian for the Boston Museum of Fine Arts, then returned to the Minnesota Institute to work in the Museum's education department. She guided tours and taught children how artists could show us to see in new ways. "That was in 1953," she said, "and art has been part of me ever since."

She met Walter Frederick Mondale on a blind date in 1955. He, too, was the child of a minister. They married six months later—in December. Fritz graduated from the University of Minnesota Law School the next year, practiced law until appointed Minnesota attorney general in 1960. In Myra MacPherson's book on politicians and their marriages, *The Power Lovers,* Joan Mondale confessed that the year Fritz was appointed attorney general was the worst time in her life. Nobody *knew* him! Her eyes widened at the horror of it. "I mean, *nobody knew him!*"

For six months Joan and Fritz campaigned. They had to make themselves *known.* They had to go and say they needed help. *Oh! It was so terrible!* But Fritz was finally elected, was then appointed to the United States Senate in 1964 to fill the unexpired term of Hubert Humphrey; won election in his own right to the Senate in 1966 and again in 1972; and was then elected vice-president on the 1976 Carter ticket. For each of Fritz's appointments and elections, Joan Mondale campaigned. She also raised three children—Teddy, Eleanor Jane, and William. By 1970 she could renew her old interest in art, and began serving as a tour guide in Washington's National Gallery. In 1972 she wrote a book which was published by Lerner Publications in Minneapolis as one of a series of "Fine Art Books for Young People."

Politics in Art explained in straightforward, simple prose that politics was everybody's business, but Joan Mondale believed that we often

needed to be reminded of our duties as citizens. She thought that artists could look at our politicians, our institutions, and our problems "to help us understand them better." Artists, she wrote, could reveal the truth about ourselves in powerful and compelling ways. "And when they do this, they can spur us into action."

In the text which accompanied thirty-nine illustrations of compelling art, Joan Mondale earnestly recommended the pragmatic utility of art to the sovereignty of politics. "When paintings and other works show unhappy aspects of the human condition, a politician may see such works as comments on problems he may be able to help solve. Thus, even if an artist did not originally create his work to have a political interpretation, a politically minded viewer may find that the art points out a relevant political issue."

If it seemed difficult to distinguish which art was relevant and which was not, in the end that would not be a problem—if we worked together to find a consensus for the good of the community. Art could help us understand; Art could help us care. *Politics in Art* reproduced a Thomas Nast cartoon from *Harper's,* and Joan Mondale pointed out how a caricature could be "a respected and powerful form of social comment." Thomas Nast was useful, respected, relevant. Joan Mondale said a Norman Rockwell portrait from the cover of the *Saturday Evening Post* seemed to agree with the 1952 campaign slogan "I Like Ike": that was how Norman Rockwell helped us understand President Eisenhower. *The Lone Tenement,* painted by George Bellows, "asks a question of political and social significance: what happens to the lives of people in the city when 'progress' intrudes on their homes?" If Mrs. Mondale's question remained unanswered, that would surely reveal the truth about ourselves in a powerful and compelling way, would it not? Ben Shahn's painting *The Passion of Sacco and Vanzetti* served "as a reminder that America's freedoms must be carefully protected from abuse."

Surely Mrs. Mondale must have been correct: our freedoms ought to be protected; therefore Sacco and Vanzetti were *useful.* Her book was divided into *relevant* sections, each appropriately illustrated: *Campaigns* and *Elections*—every citizen should participate; *Political Figures*—the nation looked to the president for leadership and relied heavily on him to solve its problems; *Issues*—including Human Needs, War, Freedom, and the Quality of Life; *Progress and Reform*—great national problems have been accompanied by widespread public efforts to find solutions. Although perhaps it was never intended as anything more than a study guide for children, in *Politics in Art* Joan Mondale recited the essential catechism of the "Great Society"—the theology of a government that "cared," and the sovereignty of national politics over every activity.

There were agnostics who insisted that the Great Society, when reduced to its essentials, was never anything more than the ambition of President Lyndon Baines Johnson to put every man, woman, and child

over the age of twelve on the federal payroll, but there always had been more to it than that. The new expanded gospel of the Great Society could be understood by accepting that Love stood as its first principle. It was not only the kind of Love expressed from the rear platform of campaign trains by LBJ himself—for the land he loved and his reiterated love for every American boy and girl—but a Love of first principle encompassing all humanity. Once that kind of love was accepted—a continuous altruism, infinite and indivisible—the logic of the new and eternal covenant was thereafter indisputable: there was but one Earth, shared mutually by all Mankind—past, present, and future. To preserve and to improve upon this magnificent gift—to make Progress—all men were to accept their brotherhood. Hence the positive goal of life itself, the greatest Hope of Man's Love for-his-fellow-man, had to be everlasting and universal Peace. Amen. The Spirit be with You. Let us Pray.

Meanwhile, Happiness was to be found by the exercise of the affections: by caring for others, by sharing the gifts of this Earth, by sacrifice on behalf of communal ends. This was why artists helped us to understand. This was how art was useful, particularly when art celebrated man's sturdy achievements, when art sang for the community of man's humanity to man. It was a hymn in which the community should participate. As frequently as possible, therefore, poets were commissioned to read upon the great malls, dancers rehearsed to pirouette in sacred halls, the vivid colors of artists and the massive shapes of sculptors set into templed galleries, actors engaged to play again the great human dramas, and orchestras struck up for every momentous state occasion. The inspirations of art were to be celebrated, and made accessible to the people, because art illuminated the Great Society's positive political goals.

These goals, these incorporated hopes of Progress founded upon universal altruism, were identified by the leadership of the Good State not merely by the activities usually identified with boisterous democratic politics—because sometimes the People were ill-informed as to their own rational interests—but were rightly understood by an interpretation of the nation's sociological processes. It was sometimes necessary to make historic integrations of all the People's organic desires before determining what was the best, as well as the pragmatic, course to take to insure the People's future. These choices, these options, were studied with great care by the best minds—including many university scholars —and "interpreted" as was the Talmud to discover in each particular case the applicable law.

It had happened, of course, that some governments had faltered in meeting the People's expectations because some political leaders lacked sufficient understanding. Those leaders were judged as having lacked "vision." Yet there was no pragmatic alternative to the highly organized technical national state for giving-the-people-what-they-want, or for achieving universal peace for the brotherhood of man. There was no

pragmatic alternative except those efforts made by technologically developed nations to secure History itself for our posterity.

Hence, the Great Society's positive goals when understood correctly—because there was no alternative—made science, art and even history subsidiary divisions not only of government but of the state itself—the incorporation of the People's organic desires, including all those institutions incorporated to serve the People's needs. Those nations which incorporated the Will of the People in their programs, those states in which the effects of science and art and the interpretation of history were taken together as politics-correctly-understood, were necessarily benevolent—at least in the long run.

It was obvious therefore that no nation could secure Peace—that universal hope of the Brotherhood of Man—unless all nations were equally secure. In effect, the state apparat could not wither away until that happy day when altruism—the Love of Everyman for all Mankind—had come to be universally established. In the meantime, some nations in the Brotherhood of Mankind inevitably chose systems different from others to achieve their special versions of Progress, their happiness by participatory activities, their systems of organization to effect their state's positive goals. Obviously, what constituted public order to achieve these ends in each state was differently defined, but while the Brotherhood of Man continued to insist upon Human Rights, everyone was to understand each other's needs. Against the overriding benefits to be secured by the Great Society, against the hope of all Mankind for Peace, against the overwhelming Truths of what-the-People-really-wanted, criticism would be accepted, of course, because the Great Society was open to all opinions, just as the parsonage door had always been open, but criticism ought to be useful. It had to be moderate and constructive. Independent thought, after all, had never served the Community's ends, only selfish ambition; and *that would be inappropriate!*

This Great Society was not only an ideal, but also a pragmatic political system. It was founded in Love, pursued Peace, guaranteed Happiness by activity, applied the benefits of Science through highly organized institutions, celebrated Art, and modestly gave over to history any final judgments. To say that the Great Society was nothing more than a vast system of patronage was to slander its ideals. To say that its philosophy was gibberish was to deny the pragmatic necessities—surely.

Mrs. Mondale served as a model spokesperson for the Great Society and its positive variations—The Caring Community and The New Foundation. Her goodwill in all that she said and did could not be doubted, and if the expressions she used to assert her faith were at times banal, they were nonetheless "appropriate." In *Politics in Art*, Joan Mondale analyzed a painting by Grace Hartigan called *Billboard*. She explained that the painting was about the hustle and bustle of the fast-moving lives we live today; that Grace Hartigan had taken images of advertisements

she had seen on billboards "while driving quickly by"; and if the painting was a little confusing to us because it was both realistic and abstract at the same time, yet it was still "highly organized, happy and optimistic in feeling. Perhaps Grace Hartigan believes there can be order and happiness within the hectic pace of modern life." *Order and Happiness! Love and Understanding!*

"Joan of Arts" had these reflections about the last painting illustrating *Politics in Art*—Robert Indiana's *Yield Brother:* "The peace sign has the same meaning to people all over the world. . . . The artist used four peace signs to create a design, but *Yield Brother* is more than a simple decoration. With the message printed along the bottom of the poster, it becomes a strong plea for peace. Indiana's use of the word *yield* comes from the road sign. Brother suggests world-wide friendship. In other words, he is saying that if we are ever to stop war and have peace, we must learn to understand each other."

3

SKETCHBOOK / LEARNING TO UNDERSTAND: "SWEET GEORGIA BROWN" . . .

At this moment, for example, in 1984 (if it was 1984), Oceania was at war with Eurasia and in alliance with Eastasia. In no public or private utterance was it ever admitted that the three powers had at any time been grouped along different lines. Actually, as Winston well knew, it was only four years since Oceania had been at war with Eastasia and in alliance with Eurasia.
—GEORGE ORWELL
1984

The National Cultural Center was authorized by Congress during the presidency of Eisenhower, but when it was dedicated in 1971 it was memorialized as the John F. Kennedy Center for the Performing Arts. Designed by architect Edward Durrell Stone, it was one of three massive landmarks along the eastern bank of the Potomac between the Arlington Memorial Bridge and the Key Bridge to Georgetown: the most northerly of these was the Watergate complex; the most loved was the Lincoln Memorial; and between them sat the Kennedy Center. Each of these architectural statements expressed some significant element in the history of the positive national faith, even if there were particulars about each one that may have seemed absurd.

From the Virginia side of the Potomac, the Watergate complex was a curved candy-box facade, steel and glass, in modern gingerbread tiers. It was not only a Whitman's Sampler in design: it was a complex of rental apartments, offices, hotel and convention facilities, shops and services, underground parking concessions—all the variety, all the nougats, chocolate-covered almonds, sweet cherry stuffings made possible by the endless possibilities for subdivision profits, for write-offs, deductions,

buy-and-lease back, and who-knew-what-else. *Buy-a-share in America!*
Real Estate Boosters Make Good on Early Promise!(Incorporated in Del-
aware.) Managing Partners profit-sharing plan. (General Partners Rights)
Four Hundred and Fifty Units at four fifty two per month plus the carry-
ing charges, less chargeable earned income not carried over . . . Great
Opportunity! Bound to Go! If the big boys had only given him the chance
to syndicate the deal, Sinclair Lewis's hero, George F. Babbitt, would
have believed he'd died and gone to Heaven.

It had been a certainty of the American experience that each hero who
reached the Promised Land, whether it was in fabled Oregon or golden
California, had thanked the Lord for His mercy, then subdivided. In the
same sense, any fair-minded reading of the *Washington Post*—according
to the column inches devoted to meditation upon the subject—showed
the principal devotions celebrated on the Lord's Day in Washington D.C.,
had to do with the blessings of real estate. The Watergate complex upon
the banks of the national river only accidentally became the symbol for
a third-rate burglary; it was in the beginning significant to the fundamen-
tal preoccupation of the leisure class, who had abandoned every other
Promised Land for real estate in the environs of Ground Zero.

The Lincoln Memorial had an even stranger double history. The archi-
tect for what appeared to be a Roman temple—but one completed in
1922—was listed as Henry Bacon. As a matter of fact, the original plan
for the Lincoln Memorial and the Arlington Memorial Bridge and the
restored White House and the entire axis of the nation's sacred Mall,
were designs of Charles Follen McKim. On January 15, 1902, Charlie
McKim and his friend, sculptor Augustus Saint-Gaudens, lined up the
dome of the Capitol with the point at which they wanted the Arlington
Bridge to cross the Potomac, then drove a stake to mark the place where
they wanted Lincoln to sit.

What McKim and Saint-Gaudens had in mind at the turn of the cen-
tury, what they told everyone who would listen—and almost every artist
alive in those days listened carefully to what those two classicists had to
say—was that the empire of America was greater than Rome's and that
Washington should be built upon Rome's classical model. When the na-
tion's great hero sat in his memorial, he was simple, dignified, classical
in white marble purity, and gigantic. There was nothing to indicate that
Abe Lincoln had ever been rough, often uncouth; that he had told smutty
stories; that what the nation loved was his earthiness. A Roman temple
as a memorial to a folk hero was a very strange thing in itself, particularly
since Honest Abe claimed he had spent every day of his youth with an ax
handle in his hands hewing farmland out of the forest.

By the time architect Edward Durrell Stone began his drawings for the
National Cultural Center, McKim's grand plan for Rome upon the Poto-
mac had already been completed. Stone may have had few practical alter-
natives except to deliver a semiclassical modern version of a Temple for

the Performing Arts. The result, the Kennedy Center, was a gargantuan carton, a mammoth statement of the package in which the State's culture was to be delivered. Flat, blank, white concrete walls—ponderous, pretentious—housed something or other: what was in there might have been a giant telephone exchange; maybe it was a warehouse; maybe it was a hangar for repairing the space shuttle or testing DC10s. Certainly there was nothing about the building to suggest that within its space the muses were summoned, or the sweet mysteries of life explored, or that anyone would giggle—much less laugh—in The Kennedy Center for The Performing Arts.

The gigantic hall was not a place for art at all, except to the extent that art served as a division of politics. It could only become useful at night, when lights played against its blinded walls and flags flew in rows out front. The Kennedy Center was useful for the pageants and processions of an Imperial State: it was surrounded by Italianate piazzas and roadways for official comings and goings, for caravans of long black caddies with flags snapping from their bumpers, and with motorcycles out front, their sirens wailing. That's what the Kennedy Center waited there to do. When China sent its peace delegation to the United States in January 1979, the official entertainments in the Kennedy Center were the climax of the diplomatic exchange. The arts played their part to help us understand each other, to make all men brothers in the search for Peace.

Vice-Premier Teng Hsiao-ping and his wife, Madame Cho Lin, heading a delegation of twenty-four from the People's Republic of China, arrived by helicopter on the White House south lawn early on a Monday morning. Immediately after being greeted by the President of the United States, the Chinese delegation and their new American friends broke up into working groups for the required whirlwind political appearances. Working groups placed wreaths at the Lincoln Memorial. Working groups met to effect *appropriate* cultural exchanges. Until the Chinese left, the days and nights would be long for Mrs. Joan Mondale and every other member of the Washington establishment, organized, it was said, in working groups.

A troupe of American women drove away from the White House arrival ceremonies Monday morning with Madame Cho. The column of limousines made a twenty-minute stop at the National Archives—scholarship of great nations was always to be admired; then on to Children's Hospital because, Madame Cho said, one of her grandchildren had been born very small and was in an incubator for three months—children always were a common bond. *Washington Post* reporter Jacqueline Trescott described Madame Cho as a small woman of ample build, with delicate facial features and pierced ears, although Madame Cho was not that day wearing any earrings.

After the working group visit to Children's Hospital, the formal lunch at the State Department was hosted by Mrs. Cyrus Vance. During the

many toasts, Mrs. Helen Dudman, Director of Public Affairs of the Public Broadcasting Service, thought that Madame Cho looked at her husband just the way Nancy Reagan looked at Ronald Reagan during his speeches: "a respectful, warm glance." The *Post*'s Ms. Trescott, however, thought it should be noted that at age sixty-two, Madame Cho was no mere shadow of her Premier husband, but a "forceful advisor on military affairs."

Although Madame Cho gave no indication at the State Department lunch that China had gone to war that day, six months later it was revealed that CIA had informed President Carter before the official State Dinner Monday night.

After a brief rest for the visiting delegation, the black-tie official State Dinner began at 6:15 sharp in the East Room of the White House: B. V. Chardonnay, Robert Mondavi white wine, and fruit juice cocktails. The receiving line formed just before seven, because all guests were to be seated by seven twenty to get through a four-course meal in one hour, twenty minutes. Extra butlers were hired and put through security checks at the last minute. Otherwise the plates and silver would never have gone down and been picked up in time: *timbale* of seafood—lobster, shrimp and scallops in a sauce Americaine; *plume de veau*—a roast loin stuffed with a mixture of ground veal, mushrooms, sherry, cream, shallots, bread crumbs and accompanied by fresh broccoli and saffron rice; *endive and watercress salad* and Kentucky Trappist cheese; *chestnut mousse*—made with marron puree, flavored with kirsch lightened with whipped cream, bound with egg yolks and filled with glazed chestnuts; finally, there were chocolate boxes with flower-decorated lids filled with milk-chocolate *truffles* and surrounded by *tuiles*. With the seafood—a Paul Masson chardonnay, 1976; with the veal—a Simi Rose or Cabernet Sauvignon, 1976; for the toasts—Hans Kornell Extra Dry Champagne.

Seats at the dinner were said to cost about $1,000 per plate—part of the expense attributable to the extra butlers hired at the last moment. Many international corporations were solicited to buy "tables of five or ten" just as they usually did at any other political benefit. The extra seats purchased by generous corporations covered the cost of those government officials whose meager salaries—and devoted public service—could not, of course, cover the expense of so momentous an occasion. Checks were made out directly to the United States Treasury and were tax-deductible, without a doubt. The White House Inflation staff placed the telephone calls to those given the opportunity to contribute. There were a few minor difficulties about refusals to sit at the same table with former President Nixon; Mrs. Henry Kissinger sent regrets because of the recent death of her close friend, former Vice-President Nelson Rockefeller; there were comments (surely founded in jealousy) about what Ms. Shirley MacLaine, who was often escorted by Mr. Kissinger during his bachelor days, was doing there; but, on the whole, it was the most coveted invita-

tion in President Jimmy Carter's term of office. The major corporations responded handsomely.

And so, in addition to those who were required to attend from Washington's automatic list of protocol, the heads of a dozen United States corporations came to dinner: Thomas A. Murphy, Chairman, General Motors Corporation, and Mrs. Murphy; A. Robert Abboud, chairman, The First National Bank of Chicago, and Mrs. Abboud; John C. Brizendine, President, Douglas Aircraft Co., and Mrs. Brizendine; William A. Hewitt, Chairman, John Deere, Inc., and Mrs. Hewitt; William T. Seawell, Chairman, Pan American World Airways, Inc., and Mrs. Seawell; J. Paul Austin of Coca-Cola whose firm would be building a bottling plant on the Mainland soon; and Robert O. Anderson, Chairman, Atlantic Richfield Company, whose firm would explore for oil in the China Sea and had underwritten the $500,000-plus production costs of televising and transmitting by satellite to China the gala reception at the National Cultural Center.

Immediately following the White House dinner, a battalion of limousines pulled away to arrive at the Italianate piazzas in front of the Kennedy Center. The after-dinner entertainment, "America Entertains Vice Premier Teng," was produced as a live TV special and broadcast on the Public Broadcasting Service. Dick Cavett played host, and he had to fill time with his patented monologue until Vice-Premier Teng and President Carter arrived at 9:30, took their seats in the presidential box, and the Chinese national anthem got under way. Then, Gregory and Maurice Hines tap-danced their duet from the musical *Eubie*. Shirley MacLaine introduced *Rodeo*, choreographed by Agnes DeMille and performed by the Joffrey Ballet. John Denver, dressed in embroidered black satin, blew his lines in Chinese but sang sweetly. Eighty members of the National Children's Choir closed the show by singing in Chinese, "I Love Tien-An-Men Square." Yet, the hit of "The Teng Show" was the Harlem Globetrotters doing their magic with basketballs upon the main stage of the Kennedy Center Opera House: tap, tap, tapping to the tune of "Sweet Georgia Brown." Premier Teng loved it. The Harlem Globetrotters loved Premier Teng. They wanted to give him an official Globetrotter T-shirt. He surely would have accepted, but a Kennedy Center production official said the gesture would be "inappropriate" because the other acts on the program would feel bad if Teng couldn't have their T-shirts, too. President Carter thanked all the performers, saying "There could be no better way to demonstrate the diversity of our catalytic culture."

Perhaps the President had meant to characterize our culture in some other way but after the gala 1,500 guests repaired to the atrium of the Kennedy Center for *babas au rhum* and bourbon on the rocks with branch water—if that's how they felt about it. Corporate executives mingled with White House staffers, senators, congressmen and cabinet officers. Many of the corporate executives already had business cards printed

Kennedy Center Program

in both English and Chinese. Stanley Young, vice-president of the National Council for U.S.-China Trade, which picked up the tab for the reception, said: "There's so much euphoria floating around that it's horrible."

There were perhaps one or two afterthoughts. At the end of the week, Tom Shales, *Washington Post* TV critic, raised awkward questions about Dick Cavett pointing out on the PBS network exactly where the chairman of Atlantic Richfield was seated in the audience, and in case there was anyone who did not understand how generous an oil company chairman could be, PBS had spelled out Mr. Anderson's name in a caption subtitle when the PBS cameras picked up their sponsor's smiling face. Critic Shales was bothered by the way PBS had handled the event, including PBS's editing out the protests of the dissenters who had appeared, and who were waved into oblivion by Dick Cavett as "one or two inevitable hecklers who were escorted away." The hecklers had apparently tried to say something about a Chinese invasion of Vietnam. The sponsorship of oil companies and the evaporation of dissent by editing gave the whole project a political tone, Tom Shales thought, "a distressingly propagandistic tinge."

4

PROFILE / THE MINISTRY OF CULTURE—"THINGS GO BETTER WITH COKE." . . .

The past was dead, the future unimaginable. . . . Like an answer, the three
slogans on the white face of the Ministry of Truth came back at him:
WAR IS PEACE
FREEDOM IS SLAVERY
IGNORANCE IS STRENGTH
—GEORGE ORWELL
1984

The Federal Council on the Arts and the Humanities, chaired by Joan Mondale, was scheduled to meet at ten o'clock in the Museum of History and Technology of the Smithsonian Institution at 14th Street upon the Great Mall. But on Wednesday morning the Chinese cultural peace delegation was still in town; access to Constitution Avenue was blocked off after passing the Kennedy Center; and police were clearing a path for still another column of limousines with Chinese flags flying on their way to the Lincoln Memorial. To get to the meeting, I had to arrive by a zig-zag course, driving around by way of Independence Avenue.

At the museum's door I was directed by uniformed police past the McGraw Hill bookstore and beyond a bank of elevators to the reception suite. While hanging my overcoat on the pipe rack set in the reception suite foyer, I could identify the plainclothes Secret Service men by the cords running down from their earplugs to the radio receivers somewhere beneath the jackets of their three-button suits. The customs of a city of empire had their curiosities. Armed janissaries, dressed to look like real estate salesmen, stood guard at every door. They were polite, but firm. They wanted identification. When I first arrived in Washington, my re-

action had been a restless outrage. Why should I be required to produce passports at every door? By the time the Chinese were in town, I had resigned myself to the local customs: as everyone else did, I would have to obey the ordinances of what, in effect, was the regime of a barricaded city.

Beyond the inner doors, the museum's reception suite turned out to be a long narrow room without windows—say ninety feet or so by thirty. The whole effect of its proportions—high ceilings, walls of walnut panels in vertical rectangles, a high center chandelier, niches cut into the walls at the narrow ends set with sconces, entrances at either end of the room's long axis—exaggerated the room's length. It was a modern adaptation of a reception suite, compressed in design from the wider, handsomer, grander meeting rooms of another era—like those designed perhaps by McKim, Mead and White for the members of clubs such as the Metropolitan, the Cosmopolitan, or maybe the Century in New York, where McKim had presented the plans for Washington's Great Mall. Although the Smithsonian's reception suite had about it some traces of a glorious past, there were now no windows. Form followed function—the modern aesthetic: less was more, which meant that meeting rooms did not need windows.

To add to the effects gone awry, a long table covered with a white cloth was set so that its twenty occupants would take their places with their seats backed against one long wall. Behind their heads, in the long wall's center niche, stood one lone vase of stale yellow flowers. Facing this odd seating plan were two rows of about sixty steel folding chairs backed against the opposite wall. The entire arrangement was that of a Norman court's High Table prepared to hold the morning's audience to hear petitions from the estates. Yet, as the room filled for the meeting, there was a sense that great plans and high adventures were only lingering ghosts: in a room without windows no one would suggest laying tracks across a continent or sending ships 'round to China or even give sailing orders for the New York Yacht Club cruise. Near my chair against the wall facing the High White Table of National Culture, there was a speaker for a sound system. According to its legend, the speaker was the "property of Smithsonian Associates." The High Table was set with microphones at intervals, and I had to expect that the words from on high were going to be amplified to the minor orders then taking their places.

As expected, what was said was amplified. The meeting was called to order at 10:15. Joan Mondale, as Honorary Chairperson of the Federal Council on the Arts and the Humanities, sat at the High Table's center. The stale yellow flowers were exactly behind her head. She wore a shirt-waist dress—small beige and white checks, with a gathered sleeve and a beige tie at the neck. Just right. She sipped coffee from a paper cup, waiting, and said nothing as reports were read. She looked exhausted. Dark circles under her eyes. Too many Chinese. At the break, she told

me that she and Fritz were going to get away for two weeks, ski Vail, as soon as the Chinese left.

Seated at Joan Mondale's left was Joseph D. Duffey, Chairman of the National Endowment for the Humanities and also listed as Chairman of the Federal Council on the Arts and the Humanities—the intergovernmental coordinating committee revived by Mrs. Mondale. Seated at Joan Mondale's right was Livingston L. Biddle, Jr., Chairman of the National Endowment for the Arts. As chairmen of the twin national endowments —Arts and Humanities—Liv Biddle and Joe Duffey were the two guiding lights, as Joan Mondale had characterized them, of her evangelistic campaign to support the arts. It was Biddle and Duffey who were the best known dispensers of grants. They were the ones Joan Mondale said had done so well, had been so careful, so sensitive, that they never had any trouble getting their money from Congress. None of the other 300 federal cultural programs had much trouble getting money from Congress either, but those activities were what Joan Mondale's Federal Council was going to coordinate. The winter meeting to effect coordination was conducted with dispatch by Joe Duffey. Reports were being made, although it was not clear to whom these findings were being amplified. Each report took about ten minutes.

Peter Kyros, listed as Deputy Director of the Federal Council, led off with a report of the "Working Group on Federal Museums Policy." The agenda item was identified as (TAB A) in a large green briefing book. When I asked if I could see a copy of the briefing materials in the green three-ring binder, I was told that "unfortunately copies were not available to members of the public at that time." But I gathered from Peter Kyros's oral summary that whoever the "working group" may have been, it had met December 14 past to discuss something called "a draft interim report on Federal Museum assistance prepared by the staff of the Federal Council." What was described as "the revised draft" would include the comments of a dozen museum associations expressed to "the working group" at a meeting held January 20.

Nods of approval at the High Table. Peter Kyros went on to explain that the "working group agencies" had completed arrangements to have applicants for museum assistance indicate whether they were applying to more than one federal museum program on any given project. He concluded that the "working group" would present its "revised interim report" at the next meeting of the Federal Council, and he asked the council to discuss the report's findings "in executive session." The backup materials, Kyros said, were in the briefing book at (TAB A). Nods of approval. Executive session: coordination in action. Peter Kyros, age thirty-one, lawyer, very bright young man; had been on Mondale's staff; now running Carter administration "cultural policy" apparat from offices in Old Executive Office Building. "Thank you, Peter, for a fine report."

Next at bat was Dr. Ernest L. Boyer, Commissioner, United States

Office of Education. Back-up materials in green briefing book at (TAB B). For a moment, I had a stray copy in my hands, but I had to give it back: "Inappropriate." It seemed, however, from what Dr. Boyer was saying that he had also been heading a "working group." Apparently in (TAB B) members of the council could see that Dr. Boyer's "working group" report No. 2 explained that *A Guide for the Arts in Education* was in progress. The "working" title of the directory would be "School-Community Collaboration for the Arts in Education: A Guide to Federal Resources."

Dr. Boyer assured the members of the Federal Council present that consultation would continue with the staff preparing the *Cultural Directory,* another guide that would list and index all federal programs in the arts. It would be published by The Smithsonian. He was also pleased to report that the Office of Education would effect new regulations on school-community ties "to strengthen education in the arts." Nods of approval from the High Table. New regulations: committees in action. Dr. Boyer cited as a pertinent example how collaborative funding had been worked out between the New York City Board of Education, the New York State Council on the Arts, and forty "cooperating" museums. He also explained that the United States Office of Education was preparing "technical assistance" for those in Arts Education to show them how to get together to write proposals for grants, and how to coordinate education grants on the regional, state, and national levels with the National Endowments for the Arts and the Humanities.

Commissioner Boyer assured all those present that the United States Office of Education would set minimum requirements for projects cooperatively funded; that cost-sharing provisions by the states would be included; and that all projects so funded would be referred each year to the Federal Council for formal review. Nods of approval, thoughtful understanding from whole length of High Table. Technical assistance. Minimum requirements. Cooperatively. Cost-sharing. Formal Review: Coordination at the highest levels.

Obviously, under the direction of Mrs. Mondale, the once moribund Federal Council seemed well on its way to coordinating all the nation's cultural activities—starting with the first day of school. It would turn out, for example, that at the direction of the White House, the International Communications Agency (ICA) had signed a joint "Memorandum of Understanding" in October, 1978, with the National Endowments for the Arts and the Humanities. The October Memorandum specified that review panels at the endowments who passed upon applications for grants—"peer-review panels" composed of representatives of "the American artistic and scholarly communities"—would, in the future, "screen" the cultural "activities" to be presented overseas in the best interests of the United States. The twin Endowments for the Arts and the Humanities would form "working groups" with ICA—the agency created by the

Carter administration by merging the United States Information Agency (USIA) and its Voice of America division (VOA) with what was once the Cultural Affairs Division of the Department of State. The new ICA spent about $260 million a year for exhibitions, events, speakers, and "other types of cultural activities" to express America's neighborly goodwill to all the peoples of the world.

But the Chinese were at that very moment in town! As part of the rituals of diplomacy, the morning after the Teng Show at Kennedy Center President Carter and Vice-Premier Teng had signed an agreement to effect cultural exchanges! The Federal Council, therefore, turned its immediate attention to coordinating the problem of what "activity" was to be sent to China. John E. Reinhardt, director of ICA, said he had not yet seen the signed protocols. Joe Duffey remarked he thought they were printed in the morning's *New York Times.* Liv Biddle allowed as how he thought he would be sending the Boston Symphony to Peking.

Perfect! Fine Choice. General approval. But Liv Biddle said there were many problems yet to be resolved. Program arrangements had not yet been worked out. A great deal of money had to be raised because the Chinese said they could only cover local costs, not transportation, and so forth. Besides, the symphony's Boston audience faced cancellations. General amusement from the High Table at problems Biddle would have to solve. Boston could be very difficult. Did he have a source yet for the money? He hoped his endowment might raise the required sums from "private sources." Could he say who they were? No, he could not reveal yet who these major contributors might be. Secret backers? Well, for the moment, yes.

Then, at 11:15 A.M. Chairman Duffey declared the remainder of the agenda of the January 31, 1979, meeting of the Federal Council on the Arts and the Humanities would be "closed to the public." The next item on the agenda was to be considered in "executive session." The council would be considering the "Arts & Artifacts Indemnity Program—Review of Policy Issues and Applications," identified in the green briefing book prepared for council members under (TAB C). The program to be considered in secret was one directly administered by the Federal Council itself, as opposed to mere coordination. The program provided insurance of up to $50 million for each traveling exhibit imported from a foreign country—indemnification to Egypt, for example, against loss or damage to the King Tut show. A nation-to-nation insurance policy, in effect. Very sensitive matter. Any other business that might come before the Federal Council was also "closed to the public." It was clear that the "Luncheon" listed would be for "Federal Council Members Only."

All right, time for visitors to go. I estimated that altogether there were about eighty men and women at the council's meeting in the reception suite. Since officially listed members of the council accounted for twenty of those who had been in attendance, I expected the other sixty—those

who had been seated in the double row of chairs facing the High Table of Culture—to exit and head for the pipe racks where coats were hung. But in the foyer, as I picked my coat from those jammed on the rack, I found myself in the company of Jim Backas, director of a lobby group known as the American Arts Alliance. I realized we were the only ones to exit— apparently the only casual visitors who had to be excused from the secret sessions. We said bye-bye to the patient Secret Service man guarding the inner doors, then headed for the museum's cafeteria.

Surely the pageant we had attended was not staged solely for the sake of the coordinating agencies assembled. Surely we had not been the only members of the "public" present. Surely those other sixty people—were they all agency staff? And the elaborate goodwill expressed up and down the table for each amplified report and to each agency chief, surely it must have been intended for some wider audience than an assembly of their own assistants and deputies. Surely what we had just seen and heard must have been a pageant more significant than a college of cardinals calling together for their own amusement their curates, rectors, vicars, and men-at-arms.

And Liv Biddle's coy reticence on the money to get the Boston Symphony to China, wouldn't those be precisely the monies funded for propaganda by ICA? Yet John Reinhardt seemed to know nothing about it. And how come the National Endowment for the Arts was now operating *foreign* cultural exchanges? That kind of "activity" used to be the sole province of USIA—even when USIA had been used as a cover for CIA.

All the hocus-pocus about executive session and sources of funding which Liv Biddle could not reveal at that time, was immediately printed in *Variety* the following Wednesday. Liv Biddle had, as a matter of fact, already raised the money the Boston Symphony needed to play Peking. Under a classic *Variety* headline, U.S. TO SELL SHOW BIZ TO THE WORLD, Paul Harris reported that the cultural exchange agreement signed in Washington between President Carter and Chinese Vice-Premier Teng Hsiao-ping signaled the start of an elaborate effort by the United States to "export" a great variety of artistic skills. The pact was described as hurriedly written, but Liv Biddle allowed that the talent swap with China was still in its formative stages, and it would be too soon to say what "areas" would be among the first to be stressed. The Federal Council on the Arts and the Humanities would develop the guidelines soon. In all "areas," Biddle stressed, there would be "heavy dependence on the private sector."

Major corporations were putting up the money: the Boston Symphony's nine-day trip to China would cost approximately $650,000. It would be backed by the National Endowment for the Arts; and with $100,000 from the Gillette Corporation; and with $300,000 from the Coca-Cola Corporation of Atlanta, Georgia. One reason Biddle's NEA was the federal instrument used to put the Boston Symphony on the road

was that the State Department and ICA were limited in their operations by congressional budget authorities; whereas the twin National Endowments for the Arts and the Humanities had at their disposal not only budgeted federal funds, but another category of monies known as "Treasury Funds." These national cultural "trust funds" were authorized, but not appropriated. Instead they were "matched" by the government when tax-deductible "contributions" had been made from the "private sector" —individuals, foundations, or corporations. Any expenditures of these "cultural" Treasury Funds was, for all practical purposes, at the whim of each endowment chairman.

Within six weeks the Boston Symphony held its first concert in Peking in the Red Tower Theater. Conducted by Seiji Ozawa, the program consisted of Tchaikowsky's *Pathetique,* the Liszt Piano Concerto no. 1 in E—flat, and Ravel's *Daphnis and Chloe* Suite no. 2. The high point of the evening was the Liszt as played by Liu Shikun, China's leading pianist. He had been arrested in 1967 during the Cultural Revolution, imprisoned for six years, and was once rumored to have had his hands cut off by the radicals. Chinese spokesmen made a joke for western reporters of the beatings Mr. Liu had undergone, saying that he played very well for a man with no hands, did he not? During the Boston Symphony's tour, China was at war with Vietnam, but that couldn't be helped either.

Coincidentally, in an entirely unrelated development, the Coca-Cola Corporation announced that it soon expected to be bottling America's favorite beverage in China. Perhaps the Cultural Revolution would go better with Coke! *Order and Happiness! Love and Understanding! Peace!* Those were the hopes of all Humanity, were they not? Mrs. Mondale's Federal Council on the Arts and the Humanities was engaged in attempting a modest coordination of national cultural activities—something that obviously needed to be done, was it not? After all, the Arts were not the icing on the cake, as Mrs. Mondale had so aptly put it, they were the very essence of our lives, were they not? And if the working groups of the Great Society pursued such worthy objectives with undoubted goodwill, surely no one should have any objection. Criticism which was not constructive would be inappropriate.

Litany / Great Society Working Group—(TAB A) Green Book

Section 9 (20 USC 958) establishes within the Foundation on the Arts and the Humanities a Federal Council on the Arts and Humanities:(c) The Council shall (3) coordinate, by advice and consultation, so far as practicable, the policies and operations includingjointsupportof activitiesasappropriate;
(4) promotecoordination
betweenthe programsofthe Foundation

andtheInstituteofMuseumServicesandrelatedprogramsandactivities
of other Federal Agencies; and
(5) planandcoordinate appropriate participation
(includingproductionsandprojects)inmajorandhistoricnational
events.
Amen.

 Welcome by Joseph D. Duffey, Chairman,
FederalCouncilontheArtsandHumanities, Agenda and Meeting procedure by
Peter Kyros, Deputy Chairman, Museum Working Group
Meeting, January 20, 1979, 10:20 Presentations by Museum Organizations
AmericanAssociationofMuseums, AmericanAssociationforStateandLocal
History, AssociationofArtMuseumDirectors, AssociationofScienceTechnology
Centers, African-AmericanMuseumAssociation, NationalConservation-
Council,
AmericanInstituteforConservationofHistoricandArtisticWorks,
AssociationofMuseumDirectors,AssociationofSystematicsCollections,
AmericanAssociationofBotanicalGardensandArboreta,AmericanAssociation
ofYouthMuseums. Oramus.
Petition: What Needs Warrant Assistance?

Response: eachfunctioninterrelatedwithand dependent uponallothers
serve the public today
resourcesadequately develop programs interpretationand
education
basicfunctionspreservingandtransmittingprograms
satisfytotalobligationsto
the public
Petition: Do programs meet those needs?

Response: Additionalsupportpressingneedsnotnowaddressed
grave concern
currentevolvingdefinitionsdramaticgrowthfullrange
as trustees
ofthenation's patrimony
commitment
manytimesthe amounts nowavailable
Petition: Are Resources applied equitably?

Response: Evolutionarystageofdevelopmentinthiscontextwecommend
the federal council
thoseresponsibleconscientious concerned
community
communicationonlyifmuseumprofessionalsunderstand maximized
Petition: Are there ways to streamline?

Response: In general attentionshouldbegivenincludingtechnical
Adopted. Plenum gratiae et veritas.

Adoption: (TAB A) Federal Council's Working Group. Green Spiral Binder. Efforts at clarifying programresponsibilities should neither destroy the pluralisticmultiagencystructureof Federalmuseumassistance nor impair the Government'sflexibilityinrespondingtothediversenature and needs of Americanmuseums.Deo Gratias.

5

PROFILE / MINISTRY OF CULTURE:
THE POLITICAL ARTS ...

*A new cabinet position, that of Secretary of Education and Public Relations,
was created. Not for months would Congress investigate the legality of such a
creation, but meantime the new post was brilliantly held by Hector Macgoblin,
M.D., Ph.D., Hon. Litt. D.*

—SINCLAIR LEWIS
It Can't Happen Here

The Federal Council on the Arts and the Humanities, it seemed, was an
extraordinary institution. Seated in a long row behind their microphones
at the High White Table of National Culture, the designated members of
the Federal Council represented something more than was being admit-
ted. Except when their presence was cited as evidence of Mrs. Mondale's
campaign to support the arts, the comings and goings of these high com-
missioners were unattended, apparently unknown, unexamined by any
social analysts. Here sat commissioners, who said they were coordinating
all national cultural policy, but there were few records of their achieve-
ments, nor any annotation of their purposes.

Although the council had been vested with authority for a national
cultural policy, no observers of either the political or cultural scene had
measured the council's jurisdiction. There had been debates, to be sure,
about "the politicization of art." There had been displays of pique be-
tween those who identified themselves as "elitists" and those who ar-
gued for "populism," but these squabbles at best came down to
complaints about who should hold the privileges of power. Although
authorized by law, the council was unfunded by the Congress who had
created its powers; nor was there any oversight of its operations; nor any
investigation of its performance. Although the council had a small staff,
paid by appropriations apparently borrowed from the budgets of the twin

National Endowments, the council's proceedings were met among itself. It held hearings, took minutes, issued reports to itself, allocated funds, reviewed programs, raised money from corporations, chose its own priorities, and sent the Boston Symphony to play Liszt in Peking for Peace.

Although it did all these things, it seemed to me there was about the Federal Council an almost otherworldly quality. The Deputy Director, Peter Kyros—author of (TAB A) on museum policies—pointed out that the council's activities raised "serious First Amendment problems," but when asked, he would not specify what constitutional issues Mrs. Mondale's campaign for the arts had apparently raised. The Federal Council on the Arts had never raided a student newspaper without a subpoena, as the Justice Department had argued to be necessary to insure domestic tranquility; nor had the Federal Council gagged by prior restraint either speech or publication, as the Department of Energy had affirmed to the courts to be obligatory for world peace. If Peter Kyros was referring to that portion of the First Amendment which begins, *Congress shall make no law respecting an establishment of religion,* I thought there would be scant evidence—few relevant materials—to support a claim that mere *coordination* of programs to support national culture constituted a *de facto* establishment of a state religion.

Besides, the positive hopes of the Federal Council on the Arts and the Humanities, and the goals expressed for a Great Society were not the substance of any religion at all—not in any ordinary sense. They were merely statements of goodwill. They might be nonsense, and I supposed there might be a few ecstatics who misunderstood banalities preached from the stump, took them to heart, and then obeyed Party without question, but surely there could never be many such Party loyalists. Only a few. They would be no more than placeholders, mercenaries, *condottiere*—the sort of crusaders whose hopes for the Promised Land would be to arrive, then sack it. No matter how pragmatic humanism was expressed—as promises from the hustings for a Great Society, or as the anchorite humanism of universities, or as the smiling positivism, the Babbitry in the annual reports of great corporations for living-better-electrically-tomorrow, or having things-go-better-with-soda-pop—I could not accept humanism as anything like an ordinary religion. Humanism would be a religion without God: at best humanism was a mere philosophy; at worst, the didactic ideology of petty tyranny.

A variation in Babbitry writ large: it seemed to me that pragmatic humanism not only bore no resemblance to any religion, it had never even been a coherent philosophy. As a system for politics, *civitas civi,* it had as much sweep as a book of postal regulations. It was about as cogent as something like a schedule to get the-trains-to-run-on-time. As a system of thought, even its original proponents had admitted that any learning, any joy in discovery—poetic or mathematical—would be dangerous to humanism's continuance. And the system of thought which denied

independent thought hardly recommended itself to philosophers. John Stuart Mill had identified humanism as nothing but the regimen of a barricaded city. As a system of spirit, *civitas dei,* pragmatic humanism reduced to its essentials sounded something like the good advice given by schoolmarms just before the senior prom about "The Meaning of Life."

Goody-goody goodthink: no song, no poetry, no magnificent dash of color, no gorgeous mathematical curve, no disturbing intuition had ever emanated from the futile, banal, otherworldly schedule of regulations posted by pragmatic humanism. If, therefore, the Ministry of Arts and Humanities should ever attempt to claim jurisdiction for the Great Society as the state religion, or even as the national philosophy, not only would there be no evidence of its establishment—nothing relevant—I was sure that the community of common sense would yawn at its proclamations and ignore all its works as well. When Deputy Director Peter Kyros told me about infringing the First Amendment, surely he was dreaming of glories that could never come to pass. Only fraud, and eventually force, by determined men of Party could ever get Americans to render to Caesar more than his due.

Yet by the time Jimmy Carter was elected president, I sensed in Washington a palpable looniness. Whether the mysterious language of a secret (TAB A), or of treasury funds, matching grants, interrelated functions, total obligations, commitments and what-nots were merely silly, or were in fact crazed, was moot. The significance of the Federal Council on the Arts and the Humanities and its curious meetings could only be discovered by listing, to begin with, who sat in its honored places, what institutions they represented, what they did, and why they said they did it. The difficulty was, as Mrs. Mondale had accurately pointed out, so many programs had been consecrated to the national culture that their activities constituted a labyrinth unending. Each program I examined was connected by secret passages to every other: the National Park Service operated theaters, such as those in the Kennedy Center, from which the Public Broadcasting Service aired shows sponsored by corporations with tax-deductible funds routed through the National Endowment for the Arts, which in turn financed still other constituencies, such as the Boston Symphony which went to Peking. But the symphony was in turn supported by state, municipal, community or still other organizations, connected again by still other tunnels to tax-exempt foundations, nonprofit corporations and universities. In sum, to enter the labyrinth of national culture I needed to unravel from a cat's cradle some string with which to make the passage.

Any thread looked as good as every other to make a start: President Carter had made a "statement on the arts." He expressed, as usual, his goodwill: "Our government needs to develop a rational, well-coordinated policy directed to the advancement and dissemination of the arts."

Surely, this was just another example of speechifying. For at least a century, the United States had enjoyed a vivacious, sparkling, and admired artistic life—in architecture, painting, sculpture, literature, theater, music. The coordination of these energies would be a considerable ambition, but what could be meant by "dissemination"? I thought the phrase ambiguous, if taken literally.Then the president made clear what he apparently wanted: ". . . a government that is prepared to make active use of the arts."

Art as utilitarian? To what end? "To advance our cultural life," the president said, an objective something like the propagation of the national faith. Lest there be any misunderstanding, the president pointed out: "More effectively than weapons, more effectively than diplomacy, the arts can communicate, people to people, the spirit of America." He was defining art as a means, art as a division of politics, art as propaganda. The president apparently believed art was a moral equivalent of some kind: How many divisions does the Pope have? None, but he has many artists.

After dealing with these matters of the spirit, President Carter came to the heart of the matter: "But most important of all, we need to place greater emphasis on educating young Americans to be sensitive to the arts and humanities so that there will be a hard, long-term base of support and appreciation." He was describing art as catechism; art as communion; art as confirmation. As a goodthinking American I was supposed to appreciate the arts because they were not the icing on the cake, but the very essence of our lives. "I want to assure you," the president said, "that I will not approve any actions as president which would impair the autonomy of the arts or the proper priority they deserve." Well, of course not. As far as I knew no one had ever impaired the autonomy of art, not even the popes, although some had tried.

Shortly after the president had made his assurances, a White House Conference was announced in 1978 to be in the planning stage—a grand council, it would seem, not unlike those once called at Nicea or Basel or Trent, or the one called by John at the Vatican. The procedures, as announced, were familiar. First there would be municipal and community assemblies. Simultaneously, conventions were to be called by the guilds and hallowed orders—those with hegemonies in dance, literature, music, stage, museums, and so forth. All would participate. Letters were to be exchanged, and nuncios to travel. Then the fifty State Councils were to be called to assembly: their task would be to hear confessions, rectify differences, then arrange the several claims upon the national interest by priority. Finally, there would be a grand and magnificent convocation, entitled The White House Conference on the Arts and Humanities, originally scheduled for 1980. Agendas could be approved. Heresies condemned. And plans drawn—with five-year authorizations—for a future without end.

Reasons for fed arts funding

The White House Conference would be gathered upon the Great Mall. Yellow-and-white striped tents would be swayed up from the grass, and from beneath the canvas the view would include the nation's museums and memorials to Jefferson and Lincoln and Washington, and to Space, Aeronautics, History, Technology, Art, and Peace. Unfortunately, Congress refused to appropriate the synod's expense, pointing out that the conference had been awkwardly scheduled in the middle of the 1980 primaries. Besides, the expense—which was estimated to be $4–6 million—ought to be postponed until after the 1980 elections. Until the voters had their say, Congress wanted budgets to stay tight. Proposition 13 had been a bit unsettling.

Never mind: the proposed grand convocation to support the arts was to have been called, provisioned, and coordinated by The *Federal Council on the Arts and the Humanities*, an instrument of administration dormant until 1978, but authorized by Congress in 1965 (Public Law 89-209) as part of something called The *National Foundation on the Arts and the Humanities*, another institution with no directorate, no officers, no staff, and no substance except for the magic folderol of enabling legislation and byzantine establishment under the United States Codes—(20 USC 958) —as an "independent agency." I found traces of the original National Foundation lingering as fictional legal devices: it still had a franking privilege for free mail, used by its twin operating divisions The *National Endowment for the Arts* (NEA), and The *National Endowment for the Humanities* (NEH).

Beginning in the Eisenhower era, at about the time the National Cultural Center was commissioned, Senators Jacob Javits (R-N.Y.) and Claiborne Pell (D-R.I.) started proposing legislation for federal subsidies of the arts. Upon his election in 1958, John Brademas (D-Ind.) took up their cause in the House, but there were difficulties. Some members pointed out that if the federal government entered into the activities of art, there would some day be First Amendment difficulties. The most imposing difficulty for the proponents of the various bills was that the Congress understood "support for the arts" as a subsidy useful to New York City first of all, then maybe Boston, Philadelphia, Chicago, and San Francisco; and, yes, an argument could be made for Cleveland; but where did it go after that? The First Amendment was always a problem to national ambitions, but Congress had already brushed aside hesitation to create the federal education system: funding to support science and public libraries and high school encyclopedia and teacher's colleges and ag schools, well that was one thing: subsidies to support high culture for the rich snobs from the ivy-league-eastern-liberal gang, why hell's bells—opera, symphony, museums? Long-haired poets saying dirty words? God-only-knows they weren't no part of what Americans just had to spend hard-earned dollars for. Ballet? Sheet—that was jes baseball for fairies!

Against such objections, Senators Javits and Pell made little progress

with their bills. A Rockefeller-sponsored study was commissioned to prove there would be a "short-fall" in the economics of the arts, but who cared? August Heckscher, special consultant to President Kennedy, made a report on the arts in 1963: there were in fact government policies which affected the arts willy-nilly, particularly inequitable application of the tax laws, and something should be done, but nothing much happened until 1965.

Then the impetus for the creation of a National Foundation for culture was renewed, but with obscure historic urgencies. It was said that the new impetus came from Lyndon Johnson's frustrations as his war in Vietnam escalated. Furious at opposition to a war the president believed it was his duty to prosecute, he supposedly said, "Buy me a coupla hundred of those goddamn perfessers. An' git me another hundred of those smart-ass poets and artistes." The difficulty with LBJ stories is that he exaggerated. He wanted history to remember him, but as much larger-than-life than he really was. And his loyalists exaggerated his apocrypha: if LBJ's natural instinct was to nationalize every American activity, even if for the most exuberant reasons, he rarely failed to supply some low-down mean reason for what he demanded. Whether LBJ really wanted a national opera company, as he claimed, or something else, a marvelous deal was struck: "a shotgun wedding" between the constituencies of the performing arts and the university humanists.

Not until 1965 did the university humanists realize that a golden opportunity might be at hand. For years they had been jealous of the National Science Foundation, and of a hundred other Office of Education and Pentagon programs which were pouring billions of R&D monies into university corporations. Meanwhile, history, psychology, sociology and philosophy—"those aspects of the social sciences which have humanistic content and employ humanistic methods"—had stood by unnoticed without anyone offering to fill in their dance cards. What complicated the problem was that until 1965 the academic humanists had sniffed at any involvement with performing artists. The manners of academies required limiting scholarly interest to distant criticism with footnotes, and perhaps a reading once each term by some wandering poet, if sponsored by the Literature Society and provided the fee did not exceed $150.

In 1965, the social sciences finally understood what they had to do: a study was quickly put together which showed that "The Humanities" had been neglected upon the university campus. Appropriate slogans were pieced together—after all, if the nation spent X on the technology of war, it ought to expend less than one-half of one percent of X "to preserve our heritage, to expand our knowledge and understanding of other peoples and bring our People together." With the backing of university corporations—and the muscle those corporations could summon from their trustees, their political regents, and the political swat located in the great land-grant colleges—the humanists backed an LBJ bill to

support the arts *and* the humanities. The combined forces of ivy-covered little Princeton and mammoth educational factories such as Minnesota wiggled an odd piece of legislation through a reluctant Congress, but at last the humanists had a piece of the national pie. LBJ signed the bill in the White House Rose Garden on September 29, 1965. With his habitual grandiloquence, LBJ called for a National Theater Company, a National Opera Company, a National Ballet Company, and for Great Artists and Authors to serve residencies in our Great Universities, funded by the national government for their time upon the campus.

In contrast to the grandiose purposes of LBJ, none of that stuff was what either of the two supporting constituencies had ever had in mind. Fourteen years later, there were still no national performing companies. What the arts muscle wanted was subsidy for the companies upon whose boards they already sat; any silly expectation that either artists or writers were going to get a break from the new foundation's largesse had to be innocence abroad. Despite all the fine speeches, the arts had always operated upon the trickle-down theory. Fourteen years after LBJ's Rose Garden hopes, Edward Villela told Congress how he continued to dance for the New York City Ballet Company for the same old performance fee of $100 per night. Living artists and living writers continued to be the bane of the campus. Not only did they tend to be a scruffy and opinionated lot, they were awkward to the maintenance of the delicate hierarchies of academic senates and tenure. Especially tenure. As an invited lecturer, I was once told, I was actually nothing but a scab. My personal experience was typical, because living artists and working writers were positively dangerous. Their criticisms were hardly "constructive." They were always liable to say something "inappropriate." They talked about politics and sex. They were likely to say the first thing to pop into their heads, without realizing how much might be at stake—a whole program! When you came right down to it, if you really thought it through, government certainly could not afford to deal with working artists and writers, and so much depended on government these days, including so many university programs. Immediately after LBJ signed the National Foundation into law, he booked Vice-President Hubert Humphrey as the speaker for the annual dinner of the American Council of Learned Societies, the college of national organizations concerned with the humanities—languages and literatures, philosophies and religions, histories and art criticism, and the social sciences. Hubert Humphrey expressed in his fulsome prose how grateful LBJ was for ACLS's leading role in winning an enactment for a National Foundation at last. Since the night of Humphrey's speech it has been not only meet, but proper that NEH has supported handsomely the scholarly activities of ACLS. And since 1965, the bargain with the performing arts has also been scrupulously kept.

A shorthand distinction was frequently made: that if they did it, it was *art*; and if they talked about it, it was *humanities*. Whatever the differ-

ences have been, under the aegis of the legal fiction of the National Foundation, the twin endowments—NEA and NEH—have grown from small agencies, each with federal budgets of about $2.5 million, to agencies now spending about $150 million each to support their respective fields. Their growth has always been side by side, keeping the old political bargain by silent consent. Their total expenditures of $300 million were said to be matched by equal sums from state, regional, community, foundation, or corporate monies, but except for the dollars appropriated by Congress, how-much-money-was-spent-for-what turned a bit fuzzy upon investigation. In any event, the Federal Council originally charged under the National Foundation Act with coordinating the activities of NEA and NEH, and *all* other national cultural activities of the government, was never funded or active until February, 1978.

Then the Federal Council reconstituted itself at Joan Mondale's insistence to give effect to what the White House described as an "Issues Definition Memorandum in the Area of Cultural Affairs," prepared by a "working group" called the "President's National Policy Staff," Mr. Stuart "Stu" Eizenstat, director. When the proposed White House synod on the arts had to be abandoned, the Federal Council took up at last the coordination of "all Federal Agencies in the Arts." The members of the council were directed by the president to undertake "a major review of the arts and cultural policy of the United States." Despite the clear language of the president's directive, when both NEA and NEH operations were later investigated and criticized by a congressional committee report, the twins replied angrily that their mission had been misunderstood: they were never, never, never to develop and promote a national policy for the arts or the humanities; that would be "authoritarian!" They were restricted by legislative mandate to a "broadly conceived national policy of *support for* the Arts and the Humanities." The distinction, they claimed, must not be misunderstood. Otherwise, the Federal Council on the Arts and the Humanities might be viewed as a Ministry of Culture! Never, never, they promised.

Well, hardly ever. President Carter appointed Mrs. Mondale as honorary chairperson and Joseph D. Duffey, Chairman of NEH, as Chairman of the council as well. The first meeting of the Federal Council was called for the Treaty Room in the Old Executive Office Building at 11 o'clock, Thursday, June 15, 1978. When the members of the White House Ministry of Culture took their seats around the Treaty Room table, they represented, if not all, many of the major national ministries with active cultural constituencies.

• Joan Mondale, Honorary Chairperson, 300,000-mile campaigner to support the arts, which were "not the icing on the cake, but the very essence of our lives."

• Joseph D. Duffey, chairperson, also chairman, NEH. Budget about $150 million, university humanistic studies and fellowships.

• Peter Kyros, Deputy Director, author of policy studies to effect the president's ambitions: "a rational, well-coordinated policy . . . a government prepared to make active use of the arts . . . more effectively than weapons."

• Livingston L. Biddle, Jr., Chairman, NEA. Budget about $150 million, symphonies, ballet, opera, stage, museum, literature—the performing arts tied to state arts councils, and cities. Activities also listed, for example, under the publicity and promotion budget of the City of San Francisco for tourism.

• Charles Blitzer, Assistant Secretary for History and Art of the Smithsonian Institution, and Paul N. Perrot, Assistant Secretary of the Smithsonian's museum programs, representing together the *gris eminence*— S. Dillon Ripley, Secretary, The Smithsonian Institution: a national "organic" corporation and world's largest system of museums, exhibitions, technical, scholarly, and art research. Federal appropriations listed at about $100 million, but the national sums barely hinted at the totals wielded by The Smithsonian Institution.

• Joshua Taylor, Director, National Collection of Fine Arts, one of the many Smithsonian museums.

• J. Carter Brown, Chairman, National Commission of Fine Arts, and Director, National Gallery of Art, one of the many Smithsonian temples upon the Great Mall.

• Dr. Ernest L. Boyer, Commissioner, United States Office of Education. Budget about $14 billion, or maybe $20 billion, and in 1978 still a division of the Department of Health, Education, and Welfare, with a total annual budget approximating $200 billion, but with interconnecting lines to almost every other national or local social activity.

• Ms. Lee Kimche, Director, and George Seybolt, Chairman, the Museum Services Institute, Department of HEW. The newest and smallest federal arts agency—in 1979. IMS spent about $13 million—but "coordinated" with The Smithsonian's National Museum Act Program, the "Arts and Artifacts Indemnity Act" administered by the Federal Council, and the NEA and NEH exhibition programs.

• John Reinhardt, Director, International Communication Agency. Budget about $280 million. Total of about 9,000 employees, most of them overseas. ICA, the merged combination of USIA and the Cultural Affairs Division of the Department of State, but still interconnecting for operations with State, CIA, Department of Defense, National Security Council, etc.

• John Slaughter, Assistant Director, National Science Foundation, representing its Director, Richard C. Atkinson. Budget about $1 billion. Largely spent for basic research at universities; but reconnecting with the National Academy of Sciences, National Academy of Engineering, and the R&D budgets of the Pentagon for hardware on one hand, or various university think-tanks for programs on the other.

• Jay Solomon, Administrator, the General Services Administration. Budget about $5 billion for the government's building, contracting, housekeeping agency. Particularly involved with the arts of architecture and contract bids. Solomon, although present at the first Federal Council meeting in June, 1978, was later forced to resign when he attempted to clean up the GSA scandals, thereby offending the Speaker of the House, Mr. "Tip" O'Neill, Democrat of Massachusetts.

• William G. Whalen, Director, National Park Service, Department of the Interior. Operating Budget about $600 million, but additional millions for acquisitions. Operator of theaters, museums, historic districts, as well as the great parks in which Smokey Bear helped to stop forest fires.

• Daniel J. Boorstin, librarian of Congress, the largest research facility in the world and the registrar of copyrights. Budget about $150 million from all sources.

• James B. Rhoads, Archivist of the United States, and Director of the National Archives and Records Service. Budget about $78 million. Publisher of record of the *Acts of Congress*, the *Federal Register*, and the *Public Papers of the Presidents*.

• J. S. (Stan) Kimmit, Secretary of the U.S. Senate, and Executive Secretary of the Senate Commission on Arts and Antiquities.

• Fortney H. (Pete) Stark, Member, United States House of Representatives.

A billion here and a billion there, the late Senator Everett McKinley Dirksen once pointed out, soon added up to money. Despite repeated assurances that no coordinated national policy on culture would ever be appropriate, its ministers met in the Treaty Room. From the first day, the White House Ministry of Culture went about its business confidently. Four working groups were appointed. The first of these busied itself with the Ministry's own procedures and operations, drawing up of memoranda on coordinated policy, and plans such as the White House synod on the arts. The second working group would see to the needs of the nation's museums, and soon had called conferences, heard testimony, and recommended procedures. The third working group concluded the Memorandum of Understanding upon the programs necessary to improve art education, and the concordat was solemnly witnessed by NEA, NEH, and the United States Office of Education. The fourth working group also concluded a Memorandum of Understanding signed by NEA, NEH, and ICA on coordinated procedures for international cultural presentations, exhibits, performances, and scholarly exchange. Whether any of these initiatives were consistent with enabling legislation from Congress was immaterial. They were just practical steps taken because it was obvious they needed to be done.

At the first meeting of the Federal Council in June, 1978, President Carter's Memorandum on Cultural Policy was read out to the ministers assembled. What the President wanted seemed to be clear enough: ". . . a rational, well-coordinated policy." In response, the White House Ministry of Culture commissioned the investigation necessary to publish a *Cultural Directory,* something approximating a classified telephone book for a small city, listing insofar as possible all the federal agencies funding or operating cultural activities. A similar *Cultural Directory* listing 299 programs in 340 pages had been commissioned by Ms. Nancy Hanks when she was Chairman of NEA, and published by the Associated Councils of the Arts in 1975. Because of the spectacular growth in federal, state, and local budgets, the new ministry agreed that by June, 1978, the old *Cultural Directory* was "hopelessly out-of-date." A new listing was necessary, and it would be published in 1980 by the Smithsonian Press.

The final report at the first meeting of the White House Ministry of Culture was made by Dr. Joshua Taylor, Director of the National Collection of Fine Arts. He reviewed the Arts and Artifacts Indemnity Act insurance for the traveling exhibitions currently on the road. These were cosponsored by NEA, NEH, ICA, major United States museums, book publishers, public-spirited corporations, and in part by P.L. 480 blocked overseas funds administered by the Department of Agriculture. Dr. Taylor could report with pleasure that huge crowds were flocking to "The Splendors of Dresden," "Pompeii A.D. 79," and "The Treasures of Tutankhamen." The first meeting of the Ministry of Culture concluded by lunchtime, but discussion could continue, it was announced, during lunch in "executive session." Lunch in the Smithsonian's private dining rooms was for administrators on the inside track.

Litany / The Language of a National Culture—Nancy Hanks, 1973 . . .

> Giventhe Endowment's
> current level of funding
> thepolicyofprogram/projectsupportratherthanoperatingcostsupport
> is appropriate at the present time
> Unquestionably
> thisisamatterthatneeds constant evaluation and in-depth study
> Further,
> manylocalcountystategovernmentsbelieveittobe
> their responsibility
> Approximately 37.1 percent
> ofhistorymuseumsiscoveredfromthosesources;
> 28.9 percent of science museums;and
> 16.5 percent oftheexpenditures of artmuseums.

I think itwouldbeamistakefortheFederalgovernmenttotakeany
action thatwouldinanywayhavetheeffectofdecreasingordiscouraging
maintenance funding
fromlocalandstatesources—both governmentandprivate

6

SKETCHBOOK / TREASURY FUNDS, HOW NEH MADE FRIENDS . . .

The guys on the inside track . . . they set each other up to banquets in rooms where everything's velvet an' soft an' sit there eatin' pheasants an' french peas an' Philadelphia poultry, an' beautiful actresses come up out o' pies like blackbirds an' dance all naked 'round the table.

—JOHN DOS PASSOS
The Garbageman

Not long after the first meeting of the Ministry of Culture in 1978, near the end of July in fact, the *Washington Post* took a swipe at Joseph ("Joe") D. Duffey, chairman of NEH. *Post* reporters Lon Tuck and Donnie Radcliffe had dug up a list of some forty parties given by the Humanities Endowment "to make new friends."

Chairman Duffey explained: President Carter had expressed his concern about NEH's reputation as an exclusive preserve of the academic establishment. The president suggested that it would be appropriate for the NEH to shed its "elitist image." Duffey explained that the parties were organized to boost the public image of NEH: to raise its public visibility.

According to the *Post* story the parties were paid from monies contributed by individuals, hospitals, museums, art trade associations, and "discretionary funds" available to the chairman of the endowment. Some expenses were even paid from Joe Duffey's own pocket. Nearly a year later a congressional investigation team found "all expenditure documents reviewed of this type of activity were charged against 'regular unrestricted gift' (private) fund accounts. . . . The General Counsel of each Endowment has offered an opinion that such expenditures are within the purposes and authorities for the funds."

Surely. The NEH parties were organized by the endowment's press

officer, Ms. Kay Elliott. When five summer interns and a public affairs consultant to NEH were suspected of having leaked news of the "authorized" parties to the press, they were fired. Their actions had been inappropriate. Meanwhile, other groups of more favored members of the press had attended small luncheons at which orchids floated in brandy snifters filled with Perrier water. Tastefully done.

To shed its elitist image, NEH invited fifty guests to a lunch on February 24, 1978, in a dining room at the Capitol. The guests heard Majority Whip John Brademas and Mr. Speaker, Thomas P. O'Neill, express their devotion to the arts at a seated luncheon set with the silver and crystal of Congress. Five round tables were decorated with large baskets of white tulips and violets. After sherry, guests were served cold artichoke, marinated beef, zucchini, and poached pears. Very informative.

April 19, 1978, thirty guests attended a luncheon in Chairman Duffey's NEH office to brief Mrs. Mondale, then newly named chairperson of the Federal Council, on the subject of the humanities. Endowment staff members were joined by "several figures from the academic community." Apparently Mrs. Mondale was impressed. After thinking things over, her campaign speech for the arts included a new declaration: "We must reject the imperialist aristocracies of academia." A caterer was said to have donated both the food and her services for Mrs. Mondale's briefing. There were $150 worth of flowers. The menu consisted of mixed cold vegetables, cold pork, and fresh fruit. Reject those imperialists! Divest the old-time universities of their traditional snobbishness!

The large reception May 3, 1978, at the Library of Congress following the endowment's annual Jefferson Lecture was attended by approximately 1,200 guests. To coordinate such a large affair, Ms. Phoebe Franklin, described as a private consultant, was hired at a cost of $8,000. She was reported to have raised "in excess of $25,000" in contributions for "the discretionary fund," described as a traditional money-raising function in connection with the Jefferson Lectures. The reception itself, it was said, cost only $15,000. Jefferson always made for a good fund raiser. Traditional.

The formal luncheon for about 100 guests on May 12, 1978, was held under a yellow-and-white striped tent upon the grasses of the Great Mall. A baroque ensemble serenaded present and former members of the councils of both endowments—Arts and Humanities. The year's appropriation hearings were over, hard questions had been met on "how to build a culture," how to get "a national culture to take hold," how to answer questions on the national agenda of ethical choices. "Curiosity in the Humanities is a free person's humility," Chairman Duffey had told Congress, "and a humble person's freedom." The bill for wine and Perrier came to $411. Washington area artist Lou Stovall provided silkscreened menus at a cost of $12.96 each. The menus listed cole slaw, tuna fish salad garni, cherry tomatoes, and angel food cake. Council members,

staff, and representatives from the invited media could take home special souvenir mugs and yellow tote bags inscribed: "Humanities: Civilization's Study of Itself."

Chairman Duffey said the function of the parties, large and small, was primarily promotional. "I don't see my job here to be so much to change the Endowment's image as to let people know it's here. And one way to do that is to get the staff and other members of the government in contact with each other. . . . When I arrived here there was almost a feeling of secrecy."

Litany / Cultural Directory, 1975, Associated Councils of the Arts . . .

Taken from page 149; Funds and Services #145
National Audiovisual Center
National Archives and Records Service (NARS)
General Services Administration (GSA)
Washington, DC 20409
lends, rents, or sells copies of all
unclassified
audiovisualmaterials produced byorforFederalagenciesforinteragencyor
public use
About90percentofall
audiovisual materials
offeredforsalebytheFederalGovernmentarehandledbytheCenter
Available
motionpictures,filmstrips,slidesets,soundrecordings,videotapes
Catalogues
art,aviationhistory,civicsandgovernment,drugaddictionandnarcotics,
environmentalhealth,music,andspaceprograms.
Films: Project Slush-Makeup From the Neck Down-Handel's Messiah at the Naval Academy-What Now Skipper-Days of a Tree-Stamp Out Hog Cholera-One Bug is Too Many-We Tiptoed Around Whispering-Solving A Problem With Sedation-Speaking of Explosions-The Wet Look-Working Mother-Sex Life of the Norway Rat-Great Balls of Fire—

7

PROFILE / HOSTILE TREASURY: JAMIE WYETH'S PHANTOM SWISS CHALET . . .

"You are a slow learner, Winston," said O'Brien gently.
"How can I help it!" he blubbered. "How can I help seeing what is in front of my eyes! Two and two are four."
"Sometimes, Winston. Sometimes they are five. Sometimes they are three. Sometimes they are all of them at once. You must try harder. It is not easy to become sane."

—George Orwell
1984

Sometimes it was not easy to see what yellow-and-white pavilions upon a tended lawn signified. A tent such as the NEH celebration to promote civilization's study of itself rarely appeared except at the zenith of an empire's history—whether that narrative was written upon the banks of the Seine, the Tiber, the Potomac, or any other river. The etiquette of such ceremonies, however, was invariable: lunch was always set on tables with crystal and silver; places were appointed by cards; chamberlains and ladies-in-waiting stood ready as guides to the established hierarchies; flowers were cut and arranged according to precise instructions; music was played from strings and its melodies were soft, complex, counterpointed; when there were minstrels, there was delicate laughter; if there were dancing masters, their fingers wove wondrous patterns in stilled air; there were always words said, for the occasion demanded it, but the oratory was brief, not eloquent, and flattered those happy few whose perceptions were so sensitive they had chosen to be present; and as the women came and went, "talking of Michelangelo," no drum roll or trumpet call disturbed the moment.

When striped tents occupied a mall, it was always midday, never dawn, and there was never any urgency because there was no flooding tide to be caught, or any need to go by forced march, or reach the base of some soaring pass before dusk. When a civilization took up the study of itself, it was always High Noon, and if the sun had touched its zenith it was

only imperceptibly so, and there would be, surely, plenty of time yet. After all, the sun's course was nearly constant and any gathering momentum was only apparent as it set. High Noon was measurable on the charts of history from Ground Zero or any other meridian and could be calculated to the second: when an empire quit imitating once-upon-a-time heroes, gave up its once-upon-a-time expansion, refused the irrational intuitions of genius. All of these activities—adventure, change, invention—were insufferable to active, well-coordinated regulations. In fact, they were invariably disruptive as soon as an empire settled down behind secure frontiers to administer the surplus accumulated from the past. It was at High Noon that the great temples were completed at last, ceremonies perfected, and manners sanded smooth. Yet these were truisms, and the difficulty with truisms, as George Orwell pointed out, was that they were true. To seize upon the truth that two and two were sometimes four was to insist upon the obvious. Yet it was not easy to fix the present coordinates between art and politics.

The calculation of High Noon always had to begin by establishing where the horizon lay. When any civilization started out, its territories could not be located by any boundaries. Heroes carried frontiers across continents and oceans, willy-nilly. There were no post offices, nor any need for them. A letter addressed *Ship Rachel*, South Pacific, would be delivered in due time. There were few schools, and those were devoted to the revelations of God and to whatever Divine Purpose He apparently had in mind. The only laws were derived from custom and tradition; not only were there few cases in court, there were no regulations and no taxes, because there existed neither sovereignty for political government nor jurisdiction for governors. For fifty years all the lawyers trained in the only school for the purpose passed through the same white frame house in Litchfield, Connecticut. In Judge Tapping Reeve's house, there was no need to occupy more than the two downstairs front rooms for all his classes.

Change was not only constant, but delightful: the result of chaotic energies. Each innovation carried with it bubbling charm. Both art and politics were exuberant, exact, claimed title to fantastic myths and fictions, but were executed realistically upon small canvases. Both art and politics were conducted by a loose aristocracy who were yet to be entitled, but who had few fears of either democracy or its assemblies. There was a general uncodified consent not only to the myths accumulated from the past, but to the adaptations of those fictions to the new opportunities. Leaders were emulated and civil society was organized by internal consents.

The political system of democracy was very nearly like the unstated contract in effect when a policeman directed traffic at a busy street corner. He waved, and some proceeded while others waited. No written regulations were necessary; nor would the voluntary consents at each

street corner have operated any better if each lane was required to obtain orders to show cause, subpoenas of previous records, or judicial hearings to establish equality of access to popular left-hand turns. Democracy was that stage of history not merely dependent upon a constitution—or any other mythical contract, or upon an aggregate of imperfect political instruments, or upon the raucous campaigns, but upon a particular social realization: that the participation of many men was necessary—and not just morally correct in the abstract—because their energies, skills, and goodwill were needed to increase goods, provide transportation, create inventions, and accumulate surplus for still further expansion. Every man jack aboard a ship to China had his lay of the voyage's homecoming. Every woman who walked beside the wagon to Oregon had her say in each day's miles.

The political and social systems of democracy expanded together: happy increases in population, streets laid down that the cities would grow, deserts watered and forests cleared for seed, a startling increase in the understanding of general principles in science, fiction, and history, a quick sophistication in tools, and if there were perceptual differences about the culture of the Promised Land, those distinctions were hotly debated because change, wonder, science—all varieties of independent thought—were considered eventually to result in beneficial consequences. Finally, it was often said that in a young society its government was weak; yet it was remarkable how easily every war was won, how effectively diplomacy met each goal, and how often at the frontier daring forays by a handful of men swept unharmed across entire continents.

After High Noon, the very opposite was true. Diplomacy was confused and wars were conducted constantly at the empire's boundaries at a staggering cost with frightful casualties against handfuls of the barbarians, yet the result was usually *status quo ante bellum.* The government apparatus was described as powerful, even overwhelming of its citizens' daily occupations and private behavior, but crises recurred constantly, and the administration—*La Police,* as it was defined in French analyses, meaning the efforts of bureaucracy, ministers, and sovereign taken together—was helpless to cure even the simplest problem. There were many post offices, but no letter could ever be delivered to a ship wandering in the South Pacific. Searching for some authority, indeed any legitimacy to which perhaps the people might consent voluntarily, a claim was put forward that the empire was a system founded upon laws. Thereafter, regulations multiplied, the courts were swamped by litigation, prisons filled with criminals, every social effort for change conflicted with some other established interest and was thereafter paralyzed by legal pleadings. Nonetheless, repeated assertions were made that it was law that bound the community together for the common good; and that the laws were applied equally. The sovereignty of law was made in the teeth of justice which served the interests of only a few. The Rule of Law never

amounted to much more than a political claim by lawyers to sovereignty. Yet what was most remarkable about the Rule of Law were its deceits: Rome claimed that in the name of the emperor it brought law, as well as roads, to the barbarians. Rome also happened to bring slavery, and the empire solemnly went on codifying its laws long after the barbarians had conquered, sacked, and occupied its cities.

In Rome or anywhere else only lawyers believed in the legitimacy of their jurisdiction. The common man soon equated lawyers' contributions to society on a par with those of undertakers. Yet after High Noon in an empire's history, the search for some legitimacy—any reasonable basis for hope—always became frantic. What had been an optimistic future gave way to permanent pessimism. Adventure, change, invention—independent thought in any of its varieties—became suspect as dangerous and was believed to have potentially destructive results. To the extent that any debate occurred, it had to be limited to the topic of reform. All other conceptions were syncretic: the Promised Land, whatever its location once had been, and the Manifest Destiny, by whichever road it was to have been reached, were tacitly agreed to have been mirages. To an empire, the future was unimaginable. The sun would never set.

The dawn, which once served as the awakening from which adaptations were derived, was gone and could only be invoked as an incantation. Its lessons were still repeated in the political rhetoric of democracy, a language which continued to be spoken, but no one listened to its evocations or bothered to participate in its self-evident hypocrisies. Much of what was said in the name of what was once virtue had become cant or unintelligible: "Curiosity in the Humanities is a free person's humility." Instead of describing civic participation as a joy, a season of gaieties and parades and harmless follies, it was described as a duty; but only a few attended its wakes. Although the family once illustrated a self-evident connection to the future, it no longer served any useful function, except perhaps as a personal indulgence. Population stabilized. Cities not only ceased to grow, their streets were soon in need of repair. Bridges cracked. Ditches filled. Rats multiplied. Aqueducts were left unfinished.

Although education was made universal, understanding of general principles became scant. Instead, teaching was directed to the inculcation of certified values and employable skills. The old poets were read incessantly, and the office of censor was established. Sophisticated tools and the applications of technology had to be put in the hands of specialists whose activities were considered mysterious, even taboo, and witnessed only by those approved to their priesthood. Under such restrictions, invention came to a halt. If the received doctrine held that the sun stood at the center of the universe, any assertion that some other arrangement might be possible could not be well-received by the heretic's peers, because not only doctrine was questioned when new hypotheses were formed, their proof would always require a rearrangement in established

hierarchies. Intuitions, therefore, were not only dangerous in themselves, but to social order as well.

Adventure ceased for similar reasons. When discovery was actually new, it was impossible for every Balboa to prove in advance where his distant shore was sure to be found. As soon as invention and adventure ceased, the surplus they once supplied was no longer useful for still other escapades, consequently the surplus had no utility to the future. Soon all demanded a distribution of its benefits in the present. A refusal to provide for the future inevitably resulted in shortages. Dislocations appeared first in the most complex systems—whether they were social, intellectual, military, or economic—but then eventually in the basic supplies of fuel and food. Politics was helpless: new initiatives could not be imposed by edict. The social uses of democracy were by then considered so limited that administration of the State's affairs was considered to be managed better by appointed officials sitting as juridical committees—"working groups."

These overseers were charged with pursuing "a rational, well-coordinated policy." To effect their responsibilities, ministers had no alternative but to attempt a regulation of the chain of events to which men formerly agreed by voluntary consent. Objectives were set, programs and studies drawn up, and edicts proclaimed, but there were no practical alternatives except to function through the highly structured, established organizations already in existence—corporations already articulated, staffed, and equipped with disciplined cadres of men and women who were prepared to obey. Since the notion of law, or a government of laws, and lawyers themselves, were already in considerable disrepute, the arbitrary and capricious regulations imposed by the ministries and cooperating corporations sought some source of legitimacy: something that resembled the fictions—the mythical, royal, or constitutional patents— of the past. Without some designated legitimacy, there could be no "higher reasons" for the majority to obey. Therefore, the corporate state adopted the national "culture" as its ideology. *Pontifex maximus* was Caesar's official imperial title—pope, as well as general.

Exactly what the national "culture" meant was not open to question: it was ambiguously defined, according to circumstance, and its meaning could conveniently be shifted in case administrations—elected under the old politics—happened to change. Yet culture had none of the inconveniences of the old religions—no one actually needed to have faith; nor was culture inhibited by any of the difficulties of philosophy—contradictions in its premises could be whistled away. It was "Civilization's Study of Itself." It was the "very essence of our lives." And if its language was opaque, a collage of slogans, its indeterminacy had great advantages: what was thought to be true today need not be true tomorrow; or everything could be true at the same time, and beautiful, too. Whatever the conditions happened to be, the Corpo ministers were always seen doing

good works, helping the unfortunate, comforting the sick, visiting the aged, encouraging youth, painting the landscape of the ruined cities—all this in the name of Grace, Truth and Beauty. Corpos cared. Corpos served all Humanity. A New Foundation.

Against the coordinated, caring New Foundation to support the national culture, to support "accessibility" to the arts, there existed only one possible center of opposition, negligible in its powers, divided in its opinion, unorganized in its associations: the singular attitudes of unconverted artists and authors. Their voices would be the only ones who would ever challenge Grace, Beauty or Truth. They would be the only authorities opposed to any particular example of two plus two totaled as five. They would never speak for any constituencies but their own. They would always be a minority of one, and so need not be heard. Any doubt as to the legitimacy of national culture, either taken in its entirety or in any particular instance, need only be declared as not having come before the tribunal to which the doubt was presented, and it would then be evaporated. No need to worry about independent thought. "Appropriate criticism must be constructive."

On the other hand, there were no limits whatever to the extension of the state's ideology. Livingston Biddle, Chairman of the NEA, was asked what he estimated the federal share of total arts philanthropy might be. Biddle thought the federal share was now probably about 10 percent, and he said he wouldn't want the federal share to exceed 25 percent of all arts support. One month later Biddle was asked the same question again. His estimation of the current federal share was still 10 percent, but Biddle said he would never want it to exceed 33 percent—an 8 percent increase in ambition within one month. "The federal government has to have a certain leadership role here," Biddle explained. "The catalyst has to be more than a responder. We must initiate."

What was significant to the new initiative was that the arts were articulated political systems, not merely aggregate dollar budgets. Joseph D. Duffey's principal constituencies at the NEH were the university corporations, but NEH had incorporated many others as well. Although the NEH was relatively small as government agencies went, with only 240 full-time employees and a budget of just $150 million, the Humanities Endowment was advised by a National Council of twenty-six members appointed by the president for terms running six years. Each member of the National Council for the Humanities in turn represented other constituencies, all of whose activities in either arts or humanities were officially blessed by tax exemptions: among them, the General Motors Corporation, the Rockefeller Funds, the Museum of Modern Art, and Columbia, Stanford, and Princeton Universities. Each of these tax-exempt institutions in their turn had councils, commissions, and directorates representing corporate activities approved for other tax exemptions. NEH grants were effective not only as marginal invest-

ments, but as imprimaturs to an entire range of still other culturally "approved" activities, and their supporting councils, advisory boards, committees, "support" organizations, all of them tax-exempt because they were engaged in the goodworks necessary to the incorporated national culture.

The NEH operated its grant-making process by divisions, and these were designated as Research, Fellowships, Public Programs, Educational Programs, State Programs, and what was called "Special Programs." Not only were each of these NEH activities coordinated in their objectives, not only did each of these divisions approve grants and subsidize activities coordinated with still other federal programs—such as PBS and ICA —each NEH grant-making division also created still other constituencies of its own. A state program for the humanities, for example, created by the federal NEH, was operated as a regranting subdivision, which in turn raised "matching funds" to write state histories to be published by a commercial New York publisher, who in turn sold the authorized histories by approved professors back to each state's own Department of Education, which paid for them with state funds appropriated to match federal funds, but appropriated from budgets funded through the United States Department of Education.

Any financial analysis of such a labyrinth of goodworks failed. No calculation of sums invested for stated purposes was commensurate to any measurable result. Every expense was a portion of some other cost. Nor did study by function or by systems analysis provide any conclusions as to cost and benefit or provide categories by which it might be understood whether some end had been met. Since the objectives of incorporated national culture were indeterminate, each day's progress was but a wandering through still other shadowed corridors. No one knew how much the national ministries spent directly, indirectly, or any other way.

Treasury Department estimates of the totals deducted from taxes annually as charitable contributions ranged from $1 billion to $36 billion, but no one was entirely sure of what the exact total might be. Nor did anyone know what portion of these totals, as distributed, were attributable to inheritance, income, or corporate taxes. Nor could anyone distinguish which contributions made by corporations were tax deductible, because in many cases they were entered in ledgers as public relations, or perhaps as advertising, or as sales expense. In those ledgers where "philanthropy" might clearly be identified, no one knew how much was designated for church, hospital, educational institutions, or for "the arts." When Coca-Cola coughed up the expenses to send the Boston Symphony to Peking, there was no way to calculate whether the $300,000 should be considered "philanthropic," or "public relations," or as necessary to the corporation's conduct in securing for itself the franchise for China. When checks were made out to the United States Treasury as payee for seats at White House dinners at $1,000 per plate, the sum surely included the tip

for the extra butlers hired for the occasion, but was the "business deduction" for "educational" or "public relations" purposes, or to "support the arts"? Estimations of the total amounts contributed by corporations annually in the name of the arts varied considerably: somewhere between $300 million and $1 billion. More or less.

To extricate some meaning from such confusions, it was worth inquiring whether the administration of tax laws favored one class of persons while penalizing others for exactly the same activities, particularly in the arts. Everyone agreed that the tax policy of the United States was a "national disgrace," but laws consistently administered so as to continue inequities could be understood to have deliberate objectives and would illustrate something more than haphazard chaos.

The most obvious class of tax exemptions applied to those corporations whose ostensible purpose was to improve the national culture: universities, foundations, colleges, attendant "nonprofit" supporting organizations, museums, park systems, educational broadcasting systems, symphonies, ballets, and theater companies. As long as they claimed the comedy was played for the public's good, they were tax-exempted—even if later the production was moved to a larger Broadway house, where the tickets were deductible for a "benefit," while the week's net was then counted as "profit."

What was remarkable about this exempted class of corporations was that it differed only in minor detail from those activities which were once the singular title of the Church Triumphant. That is, if the "cultural activity" was a goodwork performed for "legitimate" higher cause, *income* was exempt. More important, the applicable tax laws of the American empire were based on a marvelous fiction, a mystery equal—to the members of its faith—to doctrines such as transubstantiation. Described differently by a variety of sects, and interpreted differently by the many oracles who prophesied in its name, the myth could be summarized more or less as follows: profits were the purpose of economic activity. In practice, this holy incantation meant that as long as any corporation declared that profits were not its objective, or alternately that no profits had appeared upon its journals or ledgers, *therefore* its activity would not be taxed. The principal variations in this doctrine were those deriving from Adam Smith, who alleged that profit was the result of capital, and Karl Marx, who claimed that profit was the result of labor. Neither of these apostles had calculated either the social or economic effects of adventure, change, or invention. As a result, the tax policy based upon their revelations, and all subsequent glosses, was studied item by item by wise men in towers at the higher institutions of learning and debated endlessly in the national legislatures, but loopholes were invented one after another to encourage investments or rectify injustices. How was the tax to be calculated upon an invention: was a stroke of genius the result of labor? What happened if a poor farmer ploughed across Captain Kidd's strongbox

and found himself the owner of a cache of gold doubloons? What if a desert sheik drilled a well at an oasis and found oil instead of water? Income earned?

To these confusions another category of complexities was added when Senator Roscoe Conkling of New York, a great patriot owned outright by a consortium of railroad corporations, changed one word in the Fourteenth Amendment to his clients' favor: ". . . nor shall any State deprive any *person* of life, liberty, or property, without due process of law." What was originally intended as equal justice for citizens was altered to create instead a class of "persons"—the corporations—no longer subject to the states in which they had been incorporated, or limited to any specified purposes. Moreover, corporations were entirely ethereal: if by any slight chance they should die, they could be resurrected within three days upon the motion of counsel and then rise up to their special heaven, which was generally located in Delaware. Although persons with all the rights of the law, corporations were not inhibited by any consequences for death, disorder, theft, perjury, or any other misdemeanor or felony. Perhaps a few unfortunate officers or directors might have to be sacrificed from time to time, as propitiations to the public's rage, but the incorporated organization itself was immune to any social penalty for any crimes, except payment of nominal fines from the corporation's administrative budget. Finally, and most important, since corporations were continuous they paid no inheritance tax; and since the dogma held that profits earned—whether the result of either capital or labor—were the basis of tax, the corporation need only state that despite all its activity there were no calculable profits, and *therefore* no tax would then be due. Significantly, if deductions from earnings to support culture could be designated as necessary to the conduct of a corporation's business, those sums were tax-exempt; and if, conversely, the same amounts were obviously not necessary to the conduct of corporate business, then they could be designated as "philanthropy" and deducted anyway—either directly or through captive foundations.

There were still further advantages legislated for the benefit of these mythical persons. Despite the announced intention of the Fourteenth Amendment for equal justice and due process under the law, there were in fact two separate but equal tax codes: one for corporations and another for all those other persons who rode in the back of the bus. The result of this miraculous differentiation was that 85 percent of the national revenues were collected from citizens; whereas the balance of the national expense was contributed by the empire's Praetorian Guard—the Corpos. Put the other way around, the leading 500 corporations were said to account for 90 percent of all the nation's business; but of these, 135 paid not a penny of tax, and the rest paid 15 percent of all national expenses. Whether registered as a university corporation dedicated to higher purposes, or a foundation of similar goodwill, or declared to be a nonprofit

corporation licensed to pursue "appropriate" activities, or even a corporation registered as devoted to the Elysian Fields of profit, without exception the Treasury Department favored these peculiar institutions. Yet when the laws of Congress and the regulations of the Treasury Department were applied to either the works or the activities of individual artists, writers, or composers, the policy of national culture was relentlessly hostile.

For example, a painter who donated his painting to a museum could deduct only the cost of the raw materials—paint, canvas, etc.—but could not deduct the cost of the finished work at its fair market value. Whereas the corporation which donated the very same painting could deduct the market value of the painting and reduce a tax which would otherwise be due, simultaneously claiming philanthropy and earning applause as a virtuous actor on the social stage. To assess deducted values claimed for tax purposes, the Treasury Department operated an Advisory Committee on Art, and the Treasury's committee met quarterly in secret. Its membership consisted of four New York City art dealers and eight museum curators or scholars. All were sworn in as government employees for the day of their deliberations. A survey of the values deducted indicated the *average* amount claimed for deductions for the donation of art was approximately one-third too high, but no known investigation by the IRS of spurious claims was in progress. Besides, IRS agents were too busy chasing waitresses who had allegedly underreported their tips.

The Treasury Department often blamed Congress, justifiably, for having passed stupid laws. Yet there was more to it than the wording of the *laws;* there was a consistent interpretation of the laws by the wording of the *regulations* based upon the laws, and further, an administration of the regulations which demonstrated determined hostility to individual initiative and independent activity of any kind. The regulations were composed, published, and interpreted by tax collectors—federal, state and municipal governments—not by legislatures. As a result, royalties paid to authors were determined by regulation to be different from royalties secured by any other inventor, and entirely different from royalties from invention accumulated by any corporation. Despite Article I, Section 8, of the Constitution prescribing the promotion of "the Progress of Science and useful Arts," the exclusive rights of authors to their respective writings were differently interpreted for authors and their publishing corporations. Similarly, the estates of artists and writers were assessed at death differently from the estates of any other heirs in the community by virtue of the Treasury regulations, not because of law. With respect to drawings and manuscripts, the corporations were not subject to any tax at all, because, of course, corporations never died. At an artist's death, however, tax collectors assessed his widow for unsold drawings or unpublished manuscripts or a composer's unfinished melody at full *retail* market value; whereas, an automobile dealer's inventory would at most be

calculated at wholesale. The product of genius, however slight, was so appalling to national cultural policy that the advice of tax lawyers to artists' widows was to destroy, rather than be pauperized by all remaining works.

Whether a widow's fevered burning of the evidence would constitute a criminal act had not yet been determined. What had been decided was that the tax could not be paid by offering the unsold works as payment in kind. Only cash was acceptable. Meanwhile, arts councils at every political level—municipal, state and federal—were funding, in cooperation with corporations, acquisition for permanent collections similar paintings, sketches, manuscripts, and sheet music as evidence of the incorporated national culture. And the reason the Ministries of Culture could not effect tax-relief for artists, authors, or composers was simple enough: independent genius had nothing whatever to do with any corpo ministry's objectives.

The city of New York, for example, boasted continually of its advantages in the arts. The national endowments and corporations joined together to fund the city's destitute library for preservation and acquisition of manuscripts and books. "New York has found a Rich Uncle," said the advertisements to announce the federal funds and to raise the local matching grants. Simultaneously, however, the city of New York continued to impose a tax of an *additional* five percent of income on artists, writers, and composers—a tax levied at five percent over and above the city's ordinary personal income tax schedule. The city's tax collectors had determined upon their own motion that artists and writers working independently were "unincorporated businesses!" The penalty determination by the city's collectors was made in direct contradiction to a specific exemption in the state's code, but with an undeniable pride, an acting director of the New York City Bureau of Tax Collection said: "Yeah, before he died, we even got John Steinbeck on that one."

While the National Endowment for the Arts funded a New York City-based organization called Volunteer Lawyers for the Arts to study such questions, the volunteer lawyers said there was little that could be done to change the city's ways—although the city's hostility was obviously unauthorized by any law. Should an individual artist or writer object to the tax authorities, he was told: "Yeah, we had a guy in here once who wanted to fight it. We kept him tied up for four, maybe five years."

But there was more to understanding the incorporated national cultural policy than the evident hostility of tax collectors or tax regulations. Under the Privacy Act the Treasury Department was required to publish annually in the *Federal Register* a list of those categories of citizens on whom the Treasury Department maintained dossiers. As a matter of fact, the dossiers were IBM printouts as well as ordinary "file folders" in a metal cabinet, but a review of the Treasury dossier list was fascinating in itself: it included *anyone* "of interest" to *any* executive department;

anyone who filed a Freedom of Information request with the Treasury Department; anyone who used the Treasury library; known criminals and fugitives from justice; suspected narcotics dealers; IRS informants —and there were said to be 4,000 or so. As part of the active, well-coordinated national policy for the arts and the humanities there was a dossier for "famous or noted artists"; and another kept current on "writers whose opinions may affect the integrity of the Internal Revenue Service."

There were, of course, many who held opinions upon the integrity of the Internal Revenue Service. Among them was the "famous or noted" artist Jamie Wyeth, who coincidentally served a term as a member of the National Council on the Arts. He was said to have convinced Mrs. Mondale of the folly of the Treasury's policy, which forbade donations by artists to museums or universities, but favored such gifts from all other persons. Thereafter, Mrs. Mondale was reported to have met with senior Treasury officials to see what could be done. Checking later for what effect Jamie Wyeth's and Mrs. Mondale's explanations might have had, Treasury answered: "Why the hell should we be concerned with Jamie Wyeth's tax problems? I believe in culture as much as the next man, but I can't feel sorry for wealthy artists like Jamie Wyeth who end up with Swiss chalets."

I asked Treasury if, as a matter of fact, Jamie Wyeth had ended up with a Swiss chalet?

Treasury's spokesman couldn't say. It didn't matter, in his opinion. It all amounted to the same thing. "These artists just work for their own purposes, as far as I'm concerned. I guess you could say I'm like one of those commissars."

To Treasury, obviously art's own purposes were antisocial; greedy; going to end up with a Swiss chalet somewhere—which would not be in the national cultural interest. Because the national *tax* policies and their practical administration were so entirely consistent, the national *cultural* policies and administration could be roughly summarized:

Now therefore, to promote the General Welfare, and to develop an active-well-coordinated-policy-of-national-culture, and to form a long-term-hard-base-of-support-more-effective-than-weapons, it was deemed right, proper, and necessary:

That henceforth the National Foundation for the Arts and the Humanities, (hereinafter referred to as the "New Foundation"), would determine programs, (hereinafter referred to collectively as "the Arts"), appropriate to the national interests;

That the Federal Council on the Arts and the Humanities (hereinafter referred to as "The White House Ministry of Culture"), would coordinate all government activities in the Arts; and further, as appropriate, the Ministry would develop programs in the Arts insofar as possible in cooperation with the private sector, particularly interested corporations along

with their designated officers, (hereinafter collectively referred to as "Corpos"), whether public or private, profit or nonprofit, foundation, trust, university or any other appropriate instrument, and irrespective of domicile, whether Delaware, Panama, Peking, or any other place;

That appropriate programs in the Arts would be defined as all those activities which contribute to the Happiness of the People, promote Domestic Tranquility, and contribute to International Peace, including but not limited to state dinners or entertainments, symphonies and all other music, exhibitions by museums of paintings and sculpture along with their interpretation, theater, literature and criticisms thereof, history, programs for radio and television or any other medium, scholarship, the exchange of views people-to-people, or any other activity of highpurpose and goodwill; provided, however, that the Arts in whatever form they were approved would never be created for selfish purposes, but always defined as a product of labor or capital, and therefore identifiable as an activity or process taxable to the creator, but exempt from any tax by its proponents or those to whom it had Utility;

That the Arts so defined would be deemed as Accessible to the People and all its proceedings would be open to the Public, and all meetings would be noticed by publication in the *Federal Register* not less than thirty days before their call, excepting only matters of National Security or other matters of privilege as identified in 5 USC 552 (b), which would be secret;

That the Organic Utility of The Arts would be advanced by coordinated programs of The Ministry as well as cooperating Corpos at every level of political action, including but not limited to The Congress, States, Regional Associations, Counties, Municipalities, and Towns, along with each and every Federal Department, Agency or Bureau, but in no event as any act of independent thought.

All the Arts defined by the foregoing were declared to be Educational or Good Public Relations, whichever was appropriate.

Litany / Cultural Directory, Cont'd, 1975, ACA, selections . . .

Invocation: Honorary Chairperson Mrs. Joan Mondale, commenting upon "wearable art," the fashion of home-made clothes, 1979:

"I like supporting small, sometimes tiny, businesses. It's nice to think about the artists working at their sewing machines all night."

Parade: A sample of federalcultural programs. . . .
ACTION, Foster Grandparent Program; Retired Senior Volunteer Program, (RSVP), SCORE/ACE, CooperativeVolunteerProgram, ProgramforLocalService, StateandLocalVolunteerMobilizationandCoordinationPrograms, University YearinACTION, VolunteersinServicetoAmerica (VISTA)

Appalachian Regional Commission
Architect of the Capitol
Atomic Energy Commission, Citizen's Workshops, Exhibits, Films,
Publications,
Used Nuclear Equipment Donations
Corporation for Public Broadcasting, CommunityServiceGrants,
CoverageExpansionGrants,MinorityTrainingGrants,ProgramProductionGrants,
NationalCenterfor AudioExperimentation, NationalCenterfor Experiments
in Television, National Public Radio, OfficeofCommunicationsResearch,
OfficeofEngineeringResearch, PublicBroadcastingService
Department of Agriculture, CommunityResourceDevelopment,4-H Youth
Program, HomeEconomics, Craft DevelopmentProgram, BusinessandIndustrial
Loans, CommunityFacilityLoans, Nonfarm EnterpriseLoans, YouthProjectLoans
Forest Service
Amphitheaters
Forest Products InterpretativeAssociations Sales Outlets
Visitor Centers and Information Bureaus Historic Preservation
Research Technical Assistance Forest Service Graduate School
Courses Rural Electrification Administration Services
Department of Commerce Business Development Loans Planning
Assistance Grants Public Works Grants and Loans Public Works
Impact Program Technical Assistance Minority Business Assistance
Arts-related Census Data
Department of Defense
Armed Forces Art Collections/Traveling Exhibits
AirForce Art Program Army Artist Program Navy Combat Art Program
Marine Corps Art Program
Armed Forces Bands and Choruses Commissioned Portraits Educational
Benefits Historical Property Donations Museums Professional Entertainment
Program Recreation Programs Libraries MilitaryHistoryCollections
Arts and Crafts Music and Theatre Scientific Exhibit Economic
Adjustment Assistance
Department of Health, Education, and Welfare
Educational ResearchandDevelopment, ResourcesInformationCenter
(ERIC), Alliance for Arts Education, Public Housing Modernization
Program, Insured Housing, UrbanResearchGrants,New CommunitiesLoan
Guarantees
Department of Interior
Economic Development Assistance, IndianBusinessGrants, Loan
Guaranty and Insurance Fund, RevolvingLoanFund, HigherEducation
Assistance, InstituteofAmerican Indian Arts, Maps, Indian Arts
and Crafts . . .

8

SKETCHBOOK / NEA AND CULTURAL RESOURCES INCORPORATED . . .

They saw arising a Corpo art, a Corpo learning, profound and real, divested of the traditional snobbishness of the old-time universities, valiant with youth, and only the more beautiful in that it was "useful."

—SINCLAIR LEWIS
It Can't Happen Here

"Picture Your Community without the Arts," the headline warned at the top of a full-page ad. What appeared to be a blank canvas already stretched upon its frame served as the illustration. "Imagine," the copy drove on, "no theater. No music. No sculpture or painting. Picture the Arts gone and you picture a lot of beauty missing."

Oh dear: if the Arts ever left town there sure would be a lot of beauty missing: it would never be the same, you can 'pend on it. "But the Arts not only create beauty," the ad pointed out, "they create jobs."

Yessir, there was no denying that: "Because the Arts attract tourists. And the dollars tourists spend in restaurants and hotels, on transportation and in stores. The Arts attract industry. Businesses prefer to locate in communities with a rich cultural life."

Now, there was practical talk: no frivolous idealism. Mind you, ideals can have their place, but when it was time to get down to brass tacks art had to earn its profits too. So let's not forget those tourists. "And the Arts are an industry in themselves. Like any other industry they employ people, buy goods and services, and generate taxes."

An industry! Labor and Capital working together! "Picture your community without the Arts and you have to imagine industry and jobs gone, too. And after that, the people. So it'd not only be pretty dull, it'd be pretty lonely."

Lonely! Phew, I guess it sure would be, especially with all that beauty

missing, and the tourists gone, and what-not. "Support the Arts," the ad concluded. "That's where the people are."

The ad pointing out where-the-people-were ran in the Washington, D.C., metro editions of magazines and newspapers as "A Public Service of the Advertising Council." Along with thirty-second TV spots and radio kits repeating the same message, the advice was prepared by the agency of Doyle, Dane, Bernbach, Inc., and signed by the advertiser: The National Endowment for the Arts.

Just because the ad ran simultaneously with Mrs. Mondale's evangelistic campaign to support the arts, there might be a few skeptics who interpreted the NEA advertisements as an effort to promote its own good-works, and even perhaps to lobby Congress for its own appropriations. Surely, nothing could be further from the truth. NEA was only suggesting support for the arts in general, as a goodthing for every community; merely calling attention to how important the arts were to the quality of life—surely that much had to be obvious. The concurrent establishment of a coordinating White House Ministry of Culture was to act as "no more than a catalyst," as Mrs. Mondale had pointed out, and "could not do it all." Subministries, such as NEA, those "guiding lights," had to be more than responders; they had to initiate, as Mr. Biddle had said. Particularly because, as Senator Claiborne Pell, faithful sponsor to the foundation's needs, had explained: the arts were not like having a good meal and then feeling full; "the need to experience the Arts could never be satiated."

Despite such reasonable explanations of where the People's interests really were, a few unenlightened citizens might lack both vision and understanding. If the NEA ads for itself still appeared to be lobbying or self-promotion, it was only because a few people in the minority obviously misunderstood the basic language, manners, and style that had now been adopted by ever so many. In the first place, the meticulous and genteel solemnities in the NEA advertisement were never meant to cause any harm. The uses of *ipse dixit* as to where the People might be located, the quiet balance between divine glory and pragmatic utility, were promises of nothing whatever. Not one defective ideal would have to be recalled to repair some spiritual amenity too dangerous to operate. And if at first the language at the center of empire seemed opaque, its rhetoric was easy to master. By following a few simple rules, and with a little practice, it was easy to get the hang of its declensions. It might seem to be Orwellian, something comparable to "Newspeak," or "Doublethink," but this was only a first impression. To straighten out any misunderstandings, perhaps it would be best to point out a few of the easiest matters of the new grammar, then cite a few examples by way of application.

The first rule, the principle from which all other nuances of the language were derived in Washington, was simplicity itself: no matter what was said, there were no possible contradictions. The decent, compassion-

ate, and reasonable foundation to this first principle could instantly be mastered as soon as the student realized the profound reasons—in a dangerous world at a dangerous time—for caution, for quietism, for compromise in the search for consensus, for demonstrations of love for all humanity, and the constant desire for peace. When put the other way around, the first rule of the empire's language was: All Things Were True at All Times. Sometimes two and two were four; sometimes three, sometimes five, sometimes all of these at once.

The practical applications could be seen immediately. It was frequently necessary to revise what was apparently true yesterday for today's purposes; or what was apparently true today for yesterday's purposes. Not the least of these permutations were related to the all-important matters of war and peace: today's enemy may have been yesterday's ally, or vice-versa. Similarly, the politics of the ideological state required crises, otherwise the authority of its leaders might be doubted. Conversely, without crises the citizens might begin to make changes on their own initiatives. Hence, as in the threat of war, so also in the matters of energy or law or the arts—or any other incorporated and institutionalized activity—no awkward fact need ever be relevant because realities might impinge upon idealism, and besides might lead to contradictions, which of course could not exist.

A corollary to All Things Were True at All Times was nearly as easy to grasp: any statement which might lead to contradictions, whether based upon irrelevant details or upon mere subjective opinion, was "inappropriate"; and therefore had not come within the jurisdiction of any established authority. Combining therefore the first principle and its corollary, the second premise of the empire's language could be derived intuitively: what was said or done gained its significance or meaning from having been said or done, and from nothing else. In short, what was not said did not exist; what was said was always true; and the meaning of what was said was significant only to the extent that it had been said, and no more. "Support the Arts, that's where the People Are," was obviously as clear as any statement could possibly be.

For example, as many as forty "fund-raisers" were held each week in Washington for the benefit of senators and congressmen. These parties were conducted after working hours by hostesses practiced in the necessary skills. Clearly, cachet was added if the happy guests at these affairs sloshed their drinks about in the bottom of their glasses, nibbled at small bits of cheese, and ate meats rolled in pastries in the company of great works of art. "Fund-raisers" were necessary because millions were required for a single politician's prospective campaign. Moreover, only a hick could fail to notice that the patrons of art, whether as individuals or as incorporated institutions, had the wherewithal to support the very best, both in art and in politics. Nor was that the end of it: often some of the finest museums and most musical of symphonies were discovered in

the home districts of the very same senators and congressmen who were seeking reelection! What honest representative would neglect to raise whatever funds were necessary from either the national treasuries or those of cooperating corporations to continue the Art and Music in his home district Where the People Are? To fail to make the Arts Accessible in his own district would condemn a representative prima facie of Poor Public Relations. And think too of the many Educational Opportunities lost by such negligence! And so, at Washington's fund-raisers, the arts and politics were both supported with goodwill by all those assembled. That none of the guests in attendance happened to be registered voters in the representative's home district, or that none of the representative's home voters attended the Washington fund-raiser was immaterial, irrelevant, and inappropriate to a well-coordinated-active-national-cultural-policy-with-a-long-term-hard-base-of-support, as President Carter had made so clear.

Suppose, for example, that the president of a major textile corporation had wished to chat for a few moments with four different chairmen of House committees and two Senate committees, but all within a quick two-day visit to the capital. The Corpo president valued his time ever so much because it was always so limited. He never had any alternative but to get right to the heart of the matter. Moreover, just as everyone else did, he had a legitimate and continuing interest in the nearly endless issuance of laws that affected not only his corporation, but also the many communities it inhabited. The appropriate legislation was spread through the jurisdictions of ten, twenty, even more subcommittees of the Congress. On the House side of Capitol Hill, each member, regardless of seniority or committee assignment, operated a staff of eighteen assistants at a cost approximating $400,000 per year, including expenses. Every morning, therefore, something on the order of 9,000 loyal staffers reported to work in their congressmen's offices. In addition, there were 152 subcommittees of the House, and each subcommittee also had its own budget. These House committee budgets started at about $500,000, including expenses, and provided for subcommittee staffs accounting for another 2,000 dedicated workers who arrived at work each morning to make laws. As a result of assiduous study and hard-working ambition, the subcommittee staffers soon became experts in whatever laws the subcommittee had defined as "the issues." Because, however, of the first principle of empire that All Things Were True at All Times, more than one hundred simultaneous congressional studies conducted on the same topic did not create any contradictions in the education necessary to government.

All of the same scholarly interests extant in the House were duplicated on the Senate's side of Capitol Hill, except of course that pay, allowances for travel, and prestige were all at much higher levels. A hundred in staff for the Senate's Committee on the Judiciary was, without doubt, reason-

able considering the complexity of the laws to be reviewed. Fortunately, the Library of Congress, National Archives, National Academy of Sciences, Office of Technology Assessment, General Accounting Office, and a host of others were prepared to aid the Congress in its responsibilities. Moreover, the combined interests of the people as represented by their Congress were incorporated with the enabled, but separated powers, in the executive departments, independent agencies, commissions, presidential task forces, advisory committees, and what-not, where thousands of additional experts added their considered opinions to each topic, and thousands more who were trained in the law drafted the intent of legislation and then the applicable regulations. There were thousands of others who were concerned with the people's right-to-know, and announced and explained the public relations of operating, coordinated policy. Those students of civics who remained confused by suggestions that there were something on the order of 300 separate programs in support of the arts need only remember the second rule of empire's language: what had not been said did not exist, and the meaning of what was said was significant because it had been said, and nothing more. "Support the Arts, that's where The People are."

Then go back three spaces and reconsider the Corpo textile president who wished to chat for a few moments with four different chairmen of House committees and two Senate committees, but all within a quick two-day visit to Washington. Corpo president was required to remember that at any given moment somewhere in the vast and incomprehensible system of the state, some scholar or some lawyer might take it into his head to cut off all the textile corporation's government contracts. The reasons given for such an extraordinary decree might be something such as an assertion, *ipse dixit*, that Terrible Textile Corporation had failed to comply with "federal antidiscrimination orders;" or worse, had failed to comply with the administration's wage guidelines; or was in the shameful posture of "probable noncompliance," and "failure to cooperate," or some such. Since these violations of the established ethic, or some others equally reprehensible, could be discovered at any moment, Mr. Corpo Textile President had to keep his fences mended, and he paid regular social calls on the Hill.

To facilitate the schedule of the Corpo, not to mention the convenience of the schedules of six busy statesmen with whom the Corpo wished to exchange views, a specialist familiar with the corridors of power was retained. Such specialists quoted "market" prices to accomplish the burdens placed upon them. In January, 1980, a "fair market price" to deliver four House chairmen and two senators in two days flat ran to approximately $35,000. No "lobbying" was involved; there were law partnerships available to draft any necessary bills or file the appropriate suit. The facilitator merely "put people together." Except in a few widely publicized instances, no paper bags were ever stuffed with $100

bills and left unattended on any politician's desk, or seen on videotape recorded by FBI sheiks. Nothing of the sort; it was never done. After the Corpo had paid his calls, however, it would be rude for the facilitator to refuse an invitation to a fund-raiser—even if the cost of cocktails came to, say, $1,000 per head. And if it should turn out that there existed a superb library, university, opera, ballet, museum, or theater in a legislator's home district, would it not deserve, in its turn, Corpo support?

For example, $10 million to support symphonies by the Bell Telephone Companies in coordination with the NEA was surely an example of good citizenship, and beyond any doubt entirely unrelated to the introduction in the same year of more than one hundred bills simultaneously suggesting revisions in the regulation of Bell's telephone monopoly. Similarly, what was now nearly a solid mile of new office buildings along K Street in downtown Washington, every one of them occupied chock-a-block with men and women devoted to the law, to education, and to public relations, served as a testimonial not only to the complexity of modern politics, but also to the willingness of corporations to participate. Surely, participation was a sign of good citizenship, and surely there were no contradictions inherent to so many goodworks.

In search of concrete examples of national goodwill for the arts, I visited one of those new handsome steel and glass office buildings just off K Street, where Cultural Resources, Inc., had offices at 1019 19th Street, on the same floor as the Association of American Water Companies. Near the elevators downstairs, the new building's lobby directory listed Cultural Resources, Inc., as occupying Room 1120. I noticed that the lobby directory listed the National Endowment for the Arts as also occupying the same Room 1120. Later, I telephoned P. David Searles, deputy chairman for policy and planning of NEA, and asked him if NEA maintained offices at 1019 19th Street. He said he knew of no NEA office either at 19th Street or in Room 1120. I explained that I'd just seen NEA so listed in the building's lobby directory. Deputy Chairman Searles said he'd never noticed that. He guessed he never looked at the directory when he went in there.

Never mind. The president of Cultural Resources, Inc., was Mr. Carl F. Stover, formerly director of the National Institute of Public Affairs, and then director of the National Commission on U.S.–China Relations. Mr. Stover promoted the Ping-Pong tour that opened the way for the establishment of normal diplomatic relations with China. Stover's board of directors at Cultural Resources, Inc., was equally distinguished: Governor Raymond P. Shafer, chairman; Frances Humphrey Howard, National Library of Medicine, National Institutes of Health; R. Heath Larry, president, National Association of Manufacturers; Clark MacGregor, vice-president, Development and Resources Corporation; Herbert E. Striner, dean, School of Business Administration, The American University;

Eddie Albert, actor; Billy Taylor, pianist-composer; and John E. ("Jack") Skuce, senior associate of CRI.

In a corporation devoted to the arts, it must have been a happy circumstance to have Eddie Albert and Billy Taylor join such distinguished corporate directors as those who served Cultural Resources, Inc. The company had eventually been established as an independent, nonprofit, tax-exempt, 501(c) (3), corporation in June, 1978. Before that date, however, Stover's group of associates had operated from offices inside NEA as an independent "contractor," rather than a corporation, under a succession of names: The Bicentennial Resources Development Project, then the Cultural Resources Development Project, and finally as Cultural Resources, Incorporated, which was the "contractor" who moved out of the NEA E Street offices to the 19th Street address in August, 1978, but apparently carried along with it some NEA activities, if the 19th Street building directory was to be believed.

There were some quibbles about Cultural Resources, Inc., between the NEA and a congressional investigative staff of the House Appropriations Committee. These contradictions, however, were easily resolved by the empire's first law of language—All Things Were True at All Times. For example, the congressional investigators charged that Cultural Resources, Inc., had been awarded approximately $1 million over four years in noncompetitive contracts as an entrepreneurial enterprise to perform various tasks that were, in fact, extensions of NEA staff duties. Among projects identified in NEA documents were the "City Spirit Program," and the "Support the Arts Program," including the arrangement of the 1977 "Support the Arts" convention, and Cultural Resources supervision of still other "independent" contractors, including a public relations firm to support a "Support the Arts Conference" at a cost of $22,500 in "consultant fees," $6,800 for lunches, and $1,900 in fees to "workshop reporters" who, curiously, were selected from the NEA staff and other Washington area cultural institutions.

Surely, supporting the arts was accomplished most parsimoniously where the workshop reporters already were—in Washington. The NEA was furious at the investigative staff's determined misunderstanding of the "vital" services provided by Cultural Resources to the arts, to cultural institutions and to arts organizations. NEA denied with vehemence that the Cultural Resources group had been responsible for the "City Spirit Program;" denied that Stover's group had been engaged in lobbying for CETA funding. No lobbying activity was done for the Metropolitan Cultural Alliance in Washington, D.C., nor the Cultural Alliance of Greater Washington, nor for a "Consortium of major Washington Cultural Institutions." Cultural Resources, said NEA, merely provided assistance to arts organizations, but any activities before Congress undertaken by such consortiums had been on their "own initiative."

Nor did Cultural Resources duplicate the efforts of the Business Committee for the Arts, in the opinion of NEA, nor those of the Associated Councils of the Arts. Recently the efforts of Cultural Resources had been refocused, said NEA, upon the private sector—independent foundations, business, nonarts unions, trade and professional associations, and individual donors. In a statement made to NEA's council, Cultural Resources had explained that although the group presently received its entire funding from NEA, it would now "seek support from corporate entities."

In Room 1120 at 1019 19th Street, Cultural Resources, Inc., senior associate Jack Skuce could run down some of the sources available to support the arts. He said that while he was at NEA he had "located" nearly $250 million in "public employment funds" under the CETA programs of the Department of Labor—monies that could be made available to arts institutions in local jurisdictions. Although the NEA itself spent only $150 million, Skuce estimated that the states spent $108 million to support the arts in 1979. Corporations spent another $245 million, in his opinion, although still more might have been spent, but disguised as advertising or public relations budgets. Foundations spent another $160 million apparently, but of some 27,000 foundations listed, only 9,000 "were involved in the Arts." Skuce estimated there were now nearly 2,000 arts councils in counties, towns, regions and cities, and perhaps 3,000 more "community" arts councils. The amounts spent by these jurisdictions to support the arts was impossible to calculate.

Chicago, for example, had a parks budget of $3.5 million, but substantial amounts of what was listed for Chicago's parks actually was spent for "theater in the parks." Los Angeles spent $10 million on parks and recreation and had its own Cultural Commission to coordinate its activities. Seattle spent about $1 million, as did San Francisco, although the San Francisco cultural budget was part of the city's publicity budget for tourism. Moreover, there were still other "independent" cultural organizations in nearly every state, such as the Saratoga Performing Arts Commission at the old spa in New York. Many of these "independent" organizations were also multimillion dollar operations. In sum, under its contract for NEA, the responsibility of Cultural Resources, Inc., was to generate "financial and other forms of support for art and culture" in coordination with NEA's "on-going grant programs." Many corporations had to be instructed in the "opportunities" available in the arts. Jack Skuce estimated that NEA's $150 million in grants represented in 1980 what was actually about $1 billion in cooperating, matching, or coordinated funds. Since the NEA five-year plan was to take the level of federal funding to approximately $500–600 million, the matching contributions from all corporate sources—city, state, profit and nonprofit—might be expected to grow proportionately: something on the order of $3 billion, let's say, to support-the-arts-where-the-people-were by 1984. What Jack

Skuce wanted me to understand was how corporations would be playing an increasing role in "matching" NEA's initiatives.

Shortly after hearing the role played by Cultural Resources Incorporated, at a reception for the Associated Councils of the Arts in the vice-president's mansion during the summer of 1979, Robert Sakowitz, of the Sakowitz chain of department stores, said, "Art is good business." Not only was Sakowitz on one of the lists of "ten best dressed men," he also served as a member of the ACA board of directors, along with Edward M. Block, vice-president of AT&T, Rodney Rood of Atlantic Richfield, Frank Saunders, vice-president of Philip Morris, and Stephan Stamas of EXXON. For the ACA reception of well-dressed men, Mrs. Mondale provided chocolate-covered strawberries.

Ed Block said AT&T invested in the arts for "purely business reasons," and that the contract between AT&T and the seven symphony orchestras jointly sponsored with about $10 million provided by AT&T and about $3 million provided by NEA for national tours specified that the playbills publicize the concerts as "Bell System American Orchestra on Tour." The Philip Morris representative sponsored the arts for slightly different reasons. He said his corporation's sponsorship of the arts meant that people perceived his corporation as "very enlightened." Philip Morris, Saunders said, sponsored the visual arts; whereas, he pointed out, "the oil companies are into public broadcasting."

Whether PBS was actually the "oil-can-network," as some critics called it, whether art was good for business, whatever the amounts appropriated by Congress for distribution by grants, or raised by matching, treasury, nonprofit, deductible, or any other kinds of funds, or for the sake of 200 or 300 or however many programs there might be, the Corpo language—that All Things Were True at All Times, that there never were any relevant contradictions, and that what had not been said did not exist—was the distinctive style of the empire. On Thursday, June 28, 1979, Mrs. Mondale hosted still another luncheon at the vice-president's mansion for the Ministry of Culture to announce still another coordinated program. With Mrs. Mondale's beaming approval, Livingston Biddle, chairman of NEA, and A. Vernon Weaver, administrator of the Small Business Administration, jointly announced the new project: funding $30,000 for three workshops for artists to be held September 13–14 in Los Angeles, and with other workshops to follow later in New York and Chicago.

The workshops had been proposed to the SBA by the NEA, but the SBA's management training division would administer the program, and SBA expected to "reach" 1000 artists. SBA would teach artists "the basics of business"—how to draw up a cash-flow plan, for example—and they would supply legal and accounting advice: "Then we'll help them market their products." Ruth Dean, reporting on the luncheon in the Washington *Star*, quoted SBA's Weaver as saying that with the new change in the tax

laws, artists would be advised to incorporate "so their taxes would be lower."

Since the Treasury Department and most tax lawyers had long since held that an artist, composer, or author who attempted to avoid tax by incorporation risked being penalized under the personal holding corporation provisions of the law—paying penalties of up to eighty percent of income—it seemed worthwhile to ask the NEA whether, in fact, there had been some change in the tax law.

Well, no. NEA had not actually researched the tax implications of the advice, as announced. As a matter of fact, NEA had only drafted, but not completed, whatever it was the 1,000 artists were going to be taught about business. If there were any contradictions to the applicable laws in what Mr. Weaver had said, according to Lee Kaplan, author of the program and special assistant to Biddle at NEA, those contradictions were the result of inaccurate reporting by the *Star's* Miss Dean: "Irresponsible Press."

But Chuck Searcy, spokesman for SBA Administrator Weaver, subsequently told me that Miss Dean had quoted Weaver accurately. SBA had advised incorporation because there were changes in the tax laws with respect to small businesses, but SBA knew nothing about personal holding corporation regulations applied by the Treasury to artists, composers, or writers. In fact, SBA knew very little about the business aspects of the arts at all—that would be the NEA's affair.

The answer of Mrs. Mondale's staff to these irreconcilable details was that regardless of what was said, or what was advised about incorporation, or whether there was, in fact, any finished agenda for the "workshops" announced to educate artists, or even whether what had been said was true or false, what was relevant was that the luncheon had taken place, the plan was announced, it was a very agreeable idea, and the sort of program so useful to support for the arts. Surely I ought to agree to that. Mrs. Mondale herself had said so: "Artists, when they're trained in schools now, are not taught survival skills."

The pageant staged at the vice-president's mansion illustrated an expression of goodwill, and in addition a demonstration of "caring" for artists with respect to their public relations and education. Moreover, the announced SBA-NEA coordinated program was no more than a minor alleyway in the magnificent labyrinth of incorporated national cultural policy—a minor administrative error, perhaps, but neither the SBA-NEA program, nor the lobbying of Cultural Resources, Inc. for the sake of NEA, nor all the memoranda of joint understandings between NEA, NEH, ICA, Office of Education, CETA, Smithsonian, Museum Services Institute, PBS, GSA, NSF, Park Service, Coca-Cola, Mobil Corporation, EXXON, AT&T, Philip Morris, or any activities undertaken by the White House Ministry of Culture were admitted to be evidence that a Ministry of Culture even existed.

No evidence whatever. George Orwell's prediction in *1984* that there would be a Ministry of Truth displaying upon its blank white walls slogans such as "Ignorance is Strength" was merely a literary conceit—a fiction. It had no standing in reality.

The arrival of such a peculiar moment in history as that predicted by Orwell, or even the similar fiction imagined by Sinclair Lewis in *It Can't Happen Here,* had always seemed to me as remote. Such a circumstance would depend upon the ability of Corpo idealists, the worshipers of pragmatic humanism, to politicize every social energy, to create a Great Society Triumphant with education and public relations constantly emanating from Ground Zero, untroubled by any contradiction—not even the most insignificant detail. Like the regime of a barricaded city, the Corpo regime would be driven to regulate by administrative codes every local instinct or initiative, governing by Power unbounded. Such ambitions might be attempted in the name of Goodwill, or disguised as an effort to coordinate the national culture, whichever seemed most "appropriate" under the applicable laws, but in the end these frauds would inevitably fail. Only naked force would achieve such ends, and so extraordinary a chain of events in the United States of America, home of the free and the brave, was unlikely, I believed.

PART II / Understanding Congress

9

SKETCHBOOK / BLACK-TIE BENEFIT AT BLOOMINGDALE'S . . .

The idea of the Corporate or Corporative State, Secretary Sarason had more or less taken from Italy. All occupations were divided into six classes: agriculture, industry, commerce, transportation and communication, banking and insurance and investment, and a grab-bag class including the arts, sciences, and teaching. . . .

—SINCLAIR LEWIS
It Can't Happen Here

The benefit on a 1978 Saturday night at Bloomingdale's, White Flint Shopping Center, Maryland, was black-tie, at $50 per seat. The goal was to raise $10,000 for the Capital Children's Museum, then located at the old Lovejoy School, 12th and D Streets, N.E., District of Columbia.

By table-hopping, guests could talk with celebrity Paris ready-to-wear designers, including Chichi and Claude Barthelemy, Jean Bousquet of Cacharel, and Elie Jacobsen and Dorothée Bis; but the big production number was going to be museum clothes danced down the runway to period music—against a backdrop of slides illustrating the years in which the costumes had been created. Originals by Paul Poiret, Chanel, and Balenciaga were on loan from the Musée du Costume in Paris, a shrine of *haut couture* run by the French fashion industry. Dancing in the dark! $100 per couple. Such fun! A marvelous evening!

From Camp David, White House Press Secretary Jody Powell drove directly to White Flint. At Bloomie's he changed into the tuxedo which his wife, Nan, had brought from their home on Lowell Street in the District. Jody's wife and Nancy Moore, wife of White House congressional liaison officer, Frank Moore, were cochairpersons of the benefit committee for the Children's Museum. Everyone who was anyone in

Jimmy Carter's administration was there. It was just stardust! They might raise the $10,000 too.

During dinner, gifts to the museum were announced by Ann White Lewin, the museum's director, including a doll with a bisque face dressed in cotton lace! And a game of colors by the artist *Vasarely!* He was ever-so-famous, and such a wonderful person, too: applause for *Vasarely!* According to the ambassador of France, a farm dollhouse made by French schoolchildren was on its way: applause for France! Ann White Lewin conducted the auction for a roast suckling pig with an apple stuffed in its mouth. The high bidder was Conrad Valanos, identified as the owner of the Monocle Restaurant: applause for the high bidder, and for the Monocle Restaurant too!

No sooner had Mr. Valanos claimed his pig, when a handsome woman was described as ready to make an important announcement. In case there was anyone who didn't know, she was introduced as Mrs. Patricia Roberts Harris, then secretary of Housing and Urban Development (HUD). Later, after the Camp David massacre, she would be the designated replacement for Joe Califano as secretary of Health, Education, and Welfare (HEW). Mrs. Harris, according to the Washington press corps, was distinguished as the first black woman ever to serve in the cabinet of a United States president. At the Bloomie's benefit, nearly everyone at the tables interrupted their chatter for a moment to hear what Mrs. Harris had to say. To everyone's surprise, she revealed that she had found an extra $2 *million* in "the Secretary's discretionary fund, and we're trying to persuade the District of Columbia to give it to the Children's Museum." Standing ovation! Cheering! If the District could be persuaded, the Bloomie benefit would exceed its goal by $1,990,000!

The District was persuaded. Soon thereafter Ann White Lewin promised the new Children's Museum would be ready in six months, but with one thing and another, the museum couldn't be ready quite that quickly. Never mind: an "opening" was staged February 14, 1979, anyway—to declare that even if the Children's Museum was not open yet, it was open "officially." Open or closed, All Things Were True at All Times; no contradictions were possible.

Therefore, Rosalynn Carter and the ambassador from Mexico and Mrs. Peter Jay, wife of the British ambassador, and a washboard-and-tambourine-senior-citizens-band from Baltimore, and some black District schoolchildren who were rounded up for the event and bused over to have their pictures taken having a good time, and Amy Carter, and Amy Carter's friend Cricket, and invited members of the press all came. Everyone agreed that when it finally opened, thanks to Mrs. Patricia Roberts Harris, the Children's Museum would certainly be a wonderful place. Such fun! Just marvelous! It showed, too, how much Jimmy's administration cared!

And who would ever object to such a wonderful place for children? Yet,

if Mrs. Harris could discover $2 million in her evening bag while attending a fashion show at Bloomingdale's, what had once been perceived as the control of the Congress over the national purse was obviously a thing of the past. Any inquiry into how such a remarkable change in political traditions had happened inevitably raised awkward questions.

During the same year, at the Senate authorization hearings for the National Endowment for the Humanities (NEH), Chairman Joseph D. Duffey proposed a minor change in the wording of the law under which NEH operated. He sought specific authority, he said, in Section 16 to "enter into inter-agency agreements" to coordinate the activities of NEH "with the cultural activities of other Federal agencies." Just a minor change in wording, mind you, nothing to fret about unless someone raised irrelevant questions about the coordination of cultural activities that had been going on since 1978 under the direction of the Federal Council on the Arts and the Humanities. If there was no authority from Congress under the law to coordinate national "arts" policy by a Ministry of Culture, although the various agencies involved had been doing just that, then obviously the thing to do was to fix up the law. No contradictions there, surely. They wouldn't matter much anyway—except perhaps to some fanatic minority devoted to irrelevant detail. Sometimes two and two were five, sometimes three, sometimes all of these at once. It was the *process* that mattered. There might be those who insisted upon the constitutional contract crafted by James Madison and Alexander Hamilton, the contract which separated powers between the branches of government, which insisted upon checks and balances, the contract which reserved to the Congress the sole authority to make law, to raise taxes for the general welfare or in the event of war, and which guaranteed to citizens a Bill of Rights *against* the ambitions of national ministers. But realistically, anyone who still maintained that any such system was actually how-things-worked was living in the distant past: that was over, finished, not up-to-date, done with. The past was dead.

Sure, there were a few congressmen and a few senators who earnestly described their love, their permanent devotion to the folks back home—particularly around election time. If by chance they happened to be defeated by some electoral misadventure, they never went back home. They stayed on the national payroll, either in Washington or in some other sinecure provided by the empire. Despite what the franked newsletters might tell the hometown folks, the main business of Congress was listed upon national or international, not local, agendas. The system might look different in a high-school civics text, but the business of politics was now power for power's sake; and the muscle of power, as opposed to its mouth, was patronage: the jobs were in Washington; the programs were in Washington; the money was in Washington; the only place to cut a deal was in Washington. It might be difficult, as Orwell's torturer explained to his sobbing victim, to become sane; but any sane observer

could see that all the incorporated interests of the biggest conglomerate of them all—the empire of the West—were centered in Washington D.C. and locatable in 1980 for the purposes of history at Ground Zero.

At the seat of empire, in August 1979, Senator William Proxmire had the wit to bestow his monthly "Golden Fleece" award to his colleagues in Congress. He noted that the combined staff of Senate and House totaled 18,400 people at an annual cost to taxpayers of $550 million per year. Yet the significance of the congressional staff, Proxmire said, was that they were now stumbling over themselves, creating additional bills, additional work, additional spending in such chaotic extravagance that Congress had difficulty coping with its traditional mandates.

The most important of these congressional duties was to control the national purse. Within a month of Proxmire's award the Congress was again considering the national budget. Once again the legislators had set for themselves tentative spending limits: by September 15 of each fiscal year, they were supposed to have set binding totals, but before their debate began they had missed their own deadline by at least a month. Each senior legislator was willing to cut the budgets of any other programs except those funded and supervised by his own subcommittee's jurisdiction. The Agriculture Department, for example, was asked to cut its budget by $100 million by reducing by five cents per meal the subsidy to middle-class schools for lunches. Senator Herman E. Talmadge, chairman of the Agriculture Committee, was outraged: "Programs that could be cut should be cut—but that's not the case here."

As he spoke, Senator Talmadge's colleagues were investigating thousands of dollars in one-hundred-dollar bills received by Talmadge from indeterminate sources and carelessly left in the pockets of his overcoat. Yet, crisp one-hundred-dollar bills did not suggest bribery and corruption, and small change was certainly irrelevant to Senator Talmadge's record of goodworks as Georgia's most admired legislator. As committee chairman for Agriculture, Senator Talmadge supervised budgets of tens of *billions.* In all fairness, it had to be said that the senator's overcoat had been stuffed with no more than a few one-hundred-dollar-misunderstandings; but a similar misunderstanding of the honored senator's motives would be to imagine that he was defending the wholesome meals necessary for schoolchildren at lunch. Not at all: as chairman of Agriculture, Senator Talmadge was outraged by an assault upon an established transfer payment: $100 million paid at five pennies per head for children's lunches to the agricultural industry. In the instance, Senator Edmund S. Muskie of Maine, chief defender of the budget's limits, asked of Senator Talmadge were there no limits to federal largesse, "no limits at all?" As a matter of fact, there were not, because money was political muscle. "Transfer payments"—money extracted from taxpayers by the Treasury Department and from state and local tax districts, and then commingled in goodwill for highpurposes to support favored national constituent in-

terests—accounted for more than half of all national spending. "Transfer payments" indexed the patronage spent by the managers of the national corporation to perpetuate themselves in the responsibilities of power. When Mrs. Harris discovered $2 million in her purse at the Bloomingdale's benefit for the Children's Museum, she was merely casting a few pearls from the purse she administered for Congress—and her purse was restocked each fiscal year with tens of *billions* to be spent in the "appropriate" districts.

Besides improbable sums of money, each national department, agency, commission, committee, council carried within its operating budget provisions for staff lawyers, researchers, scholars, scientists, economists, engineers—whoever might be necessary to see to it that "congressional liaison" was maintained. If the "appropriate" programs could not be drafted within the national agency, why then it would be practical to commission "outside" institutions such as universities, think-tanks, foundations, trade associations, or "councils," directed by the appropriate citizens, to discover how the illusion of progress might be continued, or at least the present maintained. What these hopes actually meant in practice was that the 18,400 staffers on Capitol Hill, upon whom Senator Proxmire had bestowed his "Golden Fleece," coordinated their ambitions with tens of thousands of national managers—22,000 of whom earned more than $47,500 per year—and then with agency staffers, tens of thousands more who labored for the cooperating states, municipalities, universities, foundations, councils, committees, and corporations. There were only two essential elements to these politically articulated syndicates. First, of course, the cost of ambition was always borne by the middle-class taxpayer—either directly from budgeted "line" appropriations of region, state or city corporation, or indirectly by tax-exemption for the university, foundation, trade association, or profit or nonprofit corporation involved. Secondly, since the budget for each agency or program had to be approved by Congress, all those working collectively for its adoption agreed that the first priority was the goodwill of the relevant congressional authorities, hence the benefits were to be paid into particular districts first. Social theory and constituent interest always had to be artfully combined.

Inevitably there would be anomalies in the organic behavior of the corporate state. There would be divisions between interests. There would be disagreements over spoils. To maintain the empire, for example, conservatives argued for more military monies; to maintain the social structure, liberals argued for economic redistribution. Inevitably, there would be comedies, too. The secretary of Health, Education, and Welfare, for example, might take up virtue to campaign against the evils of tobacco; but simultaneously he would be required to appear before the tobacco growers of North Carolina, subsidized for their crop by a different congressional coterie, to explain why he didn't mean a word he'd said.

The secretary of Energy could create a shortage of gasoline for the sake of what he perceived to be the national "geostrategic interests," or variously, the national "geopolitical realities," even if simultaneously the Department of Treasury, the Bureau of Customs, the Presidential Office of Management and Budget, the General Accounting Office, and the National Petroleum Institute all agreed there was no shortage of gasoline except the shortage deliberately created by the secretary of Energy himself. All these curiosities were easily swept away by the style of Corpo manners. In Corpo language, All Things Were True at All Times; no contradictions could possibly exist. Two and two were sometimes five.

In a fit of rectitude, Congress had once passed a law forbidding national agencies from propagandizing or lobbying in their own behalf. This strange law went so far as to forbid any national department, agency, commission, or committee from hiring "public relations specialists" to promote the goodworks Congress had authorized for itself and which the relevant agencies administered for their constituencies. Because no lobbying activity could be pursued under the rubric of "public relations," forty-seven national agencies and commissions carried on their payrolls 4,926 "information specialists" at a cost of $149 million to provide press releases, reports, and documents from government presses in coordination with congressional committees, but never, never, never were they engaged in any "public relations" activity.

Yet even these "information specialists" represented only a tiny fraction of the lobbying activity by the Corpo state in its own behalf. Every agency also hired "congressional liaison specialists" as well. The bill for paper, printing, and binding from the Government Printing Office ran to $1.5 billion per year. Another $600 million was spent directly each year by agencies to make movies or other audiovisual materials—an amount that did not include the amount spent by the national agencies to contract "outside" for films or television programs; nor did it include the amounts appropriated for the National Endowments for the Arts and the Humanities, or the Corporation for Public Broadcasting, or the Public Broadcasting Service, or collective adventures in public relations between the national administrators and their peers at states, municipalities, universities, foundations, or corporations. The national corporate state was itself, for its own account, one of the top twenty advertisers—right up there on the list with Procter & Gamble, American Telephone & Telegraph, General Motors, and the major oil companies—but of course the corporate state's advertisements were always "educational" efforts.

Although these "public relations" activities were forbidden by law, as long as they were called something else—"information" or "education" —they might proceed. To understand the significance of the White House Ministry of Culture, to understand why there were no limits to federal largesse—no limits at all—to sense the extent to which all social goals

were now to be syndicated from Ground Zero, it was only necessary to realize that legislators were just doing the sensible thing: funding their own or each other's national constituencies with transfer payments.

Understanding Congress was a film project proposed by Gerald E. Colbert to the National Endowment for the Humanities in January, 1976. Colbert applied to Dr. Ronald Berman, then chairman of NEH, for what was designated a "chairman's grant." He summarized his project as the first film to record the actual processes of law being made in Congress. He said cameramen would follow the "many-sided struggle" over passage of the nation's clean air laws, "capturing arguments and lobbying of environmentalists, industry and labor, and parliamentary maneuvering, influencing, and crucial votes in committees and on the House floor."

In his application to the NEH, Colbert said his purpose was to provide all citizens with a "better sense of what happens to Congressional legislation and thereby understand and be able to effectively participate." The Clean Air Bill had been designated HR 6161, and Colbert said his first film would be entitled *An Act of Congress*. In January 1976 he was awarded a chairman's grant of $17,500 "to solidify planning efforts and project team."

Within a month, Jerry Colbert's project team submitted a "supplemental proposal" requesting further support for scripting and production: $272,000 in outright grants were approved by NEH, and NEH offered another $100,000 if Colbert's project team could "match" it. By then the project team included: Jerry Colbert, executive producer; Charles Guggenheim, producer/director; and Robert Peabody, listed as "advisor." By September, 1976, Colbert's team had collected $50,000 from Westinghouse Corporation, hence his NEH grant award was increased by $50,000 to match Westinghouse's stake in the film. By September, 1976, the project total for *Understanding Congress* was $389,500.

It seemed, however, that Colbert's team had initially also been funded in part and for a small sum by the National Park Foundation (NPF). There might be those who would be surprised to discover in the labyrinth of national cultural activities that the National Park Service had been engaged in producing films, or for that matter that Smokey Bear had somehow become the trustee of a foundation, but never mind. In March, 1977, Jerry Colbert transferred his project from the NPF as his "grantee" organization to the Educational Broadcasting System station, WVIA–TV/FM, in Pittston, Pennsylvania.

The station's charter, of course, explained that as a nonprofit corporation its activities were educational in nature, and therefore not specifically related in any way to the manufacturing activities in Pennsylvania of the Westinghouse Corporation, sponsor of Colbert's project. Nor should any inference be drawn from the fact that WVIA–TV happened to be located in the tenth district of Pennsylvania, represented by the Honorable Joseph M. McDade, M.C., who also happened to be the ranking

Republican member of the House Subcommittee on Appropriations for the "Department of Interior and Related Agencies." Included among the "related agencies" were the United States Trust Territory administrations, to which the subcommittee's chairman, and ranking Democrat, the Honorable Sidney R. Yates of Illinois, had served as ambassador after an unfortunate Senate campaign.

In addition, the same House subcommittee also sat in hearings upon the appropriations for the Department of Energy—and only a small portion of the DOE budget could be connected in any way with equipment manufactured by Westinghouse Corporation, and the Smithsonian Institution—which was not connected in any way with Jerry Colbert's project, and the National Park Service—which did seem to have provided some of the impetus for *Understanding Congress*, and the National Endowment for the Arts—which would soon be involved with Jerry Colbert's vision, and oddly enough, the National Endowment for the Humanities—cosponsor of Colbert's project with Westinghouse Corporation. In any event, by March, 1977, Jerry Colbert's project and his team had both grown considerably.

His new letterhead made that much clear: *Understanding Congress— An Educational Film Project on Congress.* Six of Jerry Colbert's films were going to emphasize "the formation and historical development of the Congress as it has meaning for the citizen today." The remaining seven films were going to "focus on such contemporary working aspects of Congress as the appropriations and taxing powers, investigations, and the legislative process." As a stipulation of the NEH grant to make the first film, Colbert had been required to hire fifteen university political scientists to "advise" him on congressional procedures, but to make a series on Congress he would need, of course, not only a good deal more money—for which he began to apply to the National Endowment for the Arts (NEA) as well as the NEH—but also many more well-informed "advisors" for so complicated an educational subject.

Apparently, Executive Producer Jerry Colbert already understood Congress fairly well. The letterhead upon which he proposed his series to NEA listed public television station WVIA in Mr. McDade's district as his sponsor—right at the top. Just underneath, Colbert's "Location Office" and his telephone number were given as Room 4J, Cannon HOB, Washington D.C. 20515, which just happened to be among the offices reserved for none other than Mr. Thomas P. O'Neill, Jr., the Honorable Tip himself, Mr. Speaker of the House. By March, 1977, Colbert's "advisory board" was chock-full of political wisdom and experience. Tip O'Neill and McDade of Pennsylvania were, indeed, weighty gentlemen in the House's procedures, especially with respect to appropriations for NEA and NEH, but Colbert had enlisted many others.

Colbert's "advisory board" for *Understanding Congress* could be de-

scribed without undue exaggeration as "star-studded." Colbert had en-
listed Senators Jacob Javits and Claiborne Pell—the very same honorable
gentlemen who had sponsored the National Foundation on the Arts and
the Humanities in the first place. The Hon. John Brademas had also
joined Producer Colbert. Former members of the House included William
H. Avery, Edith Green, Jed Johnson, William S. Maillard. The advice of
Edwin J. Feulner of the Republican study group would certainly be in-
valuable; so too the experience of Dr. John Stewart of the Congressional
Joint Economic Committee; not to mention David Cohen of *Common
Cause*; or the practical suggestions available from members currently
seated, including Richard Bolling, Norman Mineta, Albert Quie, Morris
K. Udall, Guy Vander Jagt, and John J. Rhodes of Arizona, minority leader
for the Republicans.

With such good advisors, it would be difficult to imagine how Jerry
Colbert's project team could go wrong in their attempt to *Understand
Congress*. Apparently Colbert wanted to ensure the very best in develop-
ing the "concepts" in researching and preparing script treatments "to
bring to the viewer an indepth experience about the historical develop-
ment of the Congress as it has meaning for the citizen today." And so,
among his advisors he added Carl Degan of the National Park Service, his
original sponsor, and he also added respected scholars and teachers, such
as Dr. Robert O. Blanchard, The American University; Dr. Martin Cor-
coran, Advisors in Management; Dr. Richard F. Fenno, University of
Rochester; Dr. Charles O. Jones, University of Pittsburgh; Dr. Bruce Op-
penheimer, Brandeis University; Dr. Norman Ornstein, Catholic Univer-
sity; Dr. Robert L. Peabody, Johns Hopkins University; and Dr. Ralph
Hull representing the state universities and land-grant colleges.

With such a distinguished "team" assembled, and his series projected,
Executive Producer Gerald E. Colbert paid a call upon Ms. Nancy Hanks,
Chairman of NEA, in March, 1977. To get the *project* started with NEA,
as opposed to the *film* on the Clean Air Bill funded by NEH, Colbert
thought the immediate financial requirements would be satisfied by a
modest $15,000 NEA chairman's grant for two film *treatments* at $6,000
each, plus $3,000 for consultants, travel, and per diem.

But inside the National Foundation, at both NEA and NEH, Jerry Col-
bert's proposal for *Understanding Congress* was raising some awkward
questions. In considering Colbert's proposal, there was a feeling by an
NEH review panel that the integrity of the project might be questioned;
that NEH was going to be responsible for funding a series on the Congress
which provided NEH's appropriations; that such a hand-in-glove arrange-
ment might be "setting the stage for charges of a white-washed view of
the Congressional process." The NEH media-review panel was also con-
cerned that the public television station in Congressman McDade's dis-
trict was so small that it might not have the capacity to shoot, edit, and

can film. And there was a long list of other concerns. Among them was the estimation by Larry Chernikoff, assistant director of NEA's congressional liaison team, that Jerry Colbert was "slippery and resilient."

By June, 1977, it was not entirely clear whether Colbert was proposing a six-part series to NEH, or a thirteen-part series to NEA, or whether NEA was to fund $15,000 for the development of a project which was to be approved for a grant of $5 million dollars at NEH. Whatever was actually at stake, NEA Congressional Liaison AD Larry Chernikoff concluded that "this really is a problem sitting in Humanities' lap. Whatever decision we make, we should make it quickly. I think the longer we delay, the deeper the quicksand."

Whatever decision NEA made, they were being asked to fund Congress to examine *itself* with funds Congress gave NEA. But, as Chernikoff pointed out, Jerry Colbert was not only slippery and resilient, he was also a good friend of Speaker O'Neill. As opposed to any ordinary applicant for a National Foundation grant, the formal calls of Executive Producer Colbert were attended by NEA Chairperson Nancy Hanks in person, as well as by congressional liaison officers of both NEA and NEH. There were, besides, numerous "consultations" between NEA and NEH staffers and their appropriate counterparts on Capitol Hill, such as Jim Dyer of Congressman McDade's staff, upon the topic of resilient Jerry Colbert. Interoffice memoranda, alternative solutions, and suggested courses of action passed to and fro, with copies both indicated and blinded. Brian O'Doherty, director, Media Arts: Film/Radio/Television, NEA, took the position that *Understanding Congress* should be funded "because Colbert had been given to understand that we would help, and that Nancy /Hanks/ had been party to that understanding." O'Doherty pointed out that the National Council of Citizen Advisors to NEA had not rejected the proposal, only tabled it; that the project still had a "go" from NEA, "requiring only minor modification"; and the fact that the projected film series had nothing whatever to do with art was an issue that had never been raised.

But the quicksand looked too deep to NEA's congressional liaison staff. Joe Hagan was dispatched to meet quietly with Speaker Tip O'Neill and with Mr. McDade of Pennsylvania. Then in August, 1977, NEA's media director, Brian O'Doherty, wrote Producer Colbert to bring Colbert "up to date on the status of the $12,000 /sic/ grant for which you applied and which was discussed with Nancy Hanks in March." O'Doherty rephrased, for the convenience of Colbert, the bases of Colbert's request. It had been, "you will remember," to enable Colbert to commission two *scripts* on *Understanding Congress* to carry over until the $5 million, or whatever it amounted to, could be released from NEH. Colbert was told that his project was brought to the National Council on the Arts on May 13; that at that time they were informed that NEH had not approved the series; and that therefore the council "felt it would not be proper to

approve funds for a series that its sister agency, the major funder, had not supported." As time had passed, O'Doherty remarked, other questions had been raised, "one being that *Understanding Congress* could not conceivably be construed as a grant in the 'arts' unless of course, politics is considered an art—which indeed it may be."

O'Doherty remembered Colbert's eloquence "with regard to your ambitious series," and O'Doherty hoped that Colbert would find it possible "to continue it with funds from other sources." As a matter of fact, within a month, by September, 1977, Colbert raised an additional $60,000 from NEH as a "supplemental award to complete two films." The total for *Understanding Congress* was by then up to $449,500.

And Colbert was resilient. On March 22, 1978, the Hon. Joseph M. McDade, 10th District, Pennsylvania, wrote Livingston Biddle, Nancy Hanks' successor as chairman of NEA, that "many Members feel that a thoughtful, comprehensive film series on the legislative process would be an ideal educational vehicle to help interpret the meaning [and] the experience of the legislative process in this new age of television." As members of the advisory board of *Understanding Congress*, six congressmen, including Tip O'Neill and Mr. McDade, signed their names and suggested "that Jerry Colbert, producer of the legislative film on Congress for public television, call on the National Endowment for the Arts to discuss the possibility of helping with such a project."

The result of McDade's letter was that the interoffice memoranda on Jerry Colbert went to and fro once again. Brian O'Doherty brought the new chairman of NEA up-to-date, as well as Ms. Mary Ann Tighe, deputy chairman for programs, Don Moore, chief of NEA's congressional liaison staff, and Larry Chernikoff, the assistant director. By April, 1978, Jerry Colbert's team, including Charlie Guggenheim, a local Washington filmmaker, had about 100 hours of film on the passage of the "Clean Air Bill," sponsored by Congressman Paul Rogers (D.–Fla.). From the 100 hours, Charlie Guggenheim was editing a film on the passage of the bill for PBS; and, in addition, another film for the National Visitor Center on the same subject. The National Visitor Center at Union Station in Washington D.C. was operated by the National Park Service. The work on both films had been funded by NEH, supplemented with funds from Time-Life Corporation and from the Lannan Corporation of America, as well as the original "matched" funds from Westinghouse Corporation. Since Westinghouse had now promised to match any further funds raised from either of the two endowments, resilient Jerry Colbert, with his star-studded board of advisors from Congress and the universities, was calling again upon the National Endowment for the Arts.

O'Doherty's interoffice memorandum in April, 1978, summed up the NEA's problem: "What do we do?"

"1. Give the same answers as before, after discussion with the Council?

"2. Sympathize with the idea and help Mr. Colbert raise funds in the private sector?

"3. Find funds somewhere in our budget and open ourselves to criticism from a variety of sources."

It seemed to O'Doherty that the Corporation for Public Broadcasting would be "far less vulnerable" than NEA in providing funds, but O'Doherty conceded that none of his suggestions was very helpful, because he did not know "how committed Speaker O'Neill and his colleagues were to Colbert's project."

Jerry Colbert's first installment played the PBS network in April 1979: *HR 6161: An Act of Congress.* Because *An Act of Congress* had among its purposes education, it was neither relevant nor particularly significant that Colbert's above-the-line costs might be estimated as twice as expensive for the same hour of film if produced by, say, NBC News. Because PBS was an educational network, funded under entirely separate appropriations by Congress, it was irrelevant that the "feed" to syndicate the program was not included in the program's expense.

In April, 1979, Colbert's second film was characterized by NEH as "still in progress." It was neither relevant, nor significant, that the film in progress appeared to be the film being edited for the National Park Service Visitor Center, another entirely separate appropriation by Congress—although within the jurisdiction of the same House Subcommittee on Appropriations chaired by the Honorable Sidney R. Yates, and with Joseph McDade representing the 10th District, Pennsylvania. Because the annual budget for the National Visitor Center ran to about $9 million, perhaps Colbert's film could contribute to understanding Congress for tourists when they arrived at their nation's capital. Because the Visitor Center itself was only maintained for educational purposes, a film for the Visitor Center could not be contradictory to what producer Colbert first proposed, hence any funding by NEH of the National Park Foundation, or vice-versa, if that happened to be the case, contributed to the nation's educational "process," in cooperation with the "participation" of corporations such as Westinghouse, Lannan Corporation, and Time, Inc. The only curiosities to *Understanding Congress* would appear to be the two $6,000 "treatments" or "scripts" funded by NEA for PBS, NEH, NPF, Westinghouse, Congress, or whoever—which surely would be made clear by the proper authorities in due time.

On July 30, 1979, NEA Chairman Liv Biddle announced that Larry B. Chernikoff, who had served for three years as assistant director of NEA's Congressional Liaison Office, would become its new director. Biddle said, "He has the experience, knowledge and background in this field so important in carrying out our work in coordination with Congress."

The press release, issued by Information Specialist Ms. Florence Lowe, went on to explain that Chernikoff was succeeding Donald A. Moore,

who had recently been named deputy chairman of the Federal Council on the Arts and the Humanities, White House Office, headed by Mrs. Joan Mondale, "which coordinated all culturally-related government programs."

employment opportunity	National Endowment for the Arts Washington, D.C. 20506
	official business

announcement number: 79-076-A Area of Consideration: All Sources	date: 9-11-79 Closing Date: Open until filled

TITLE:
Congressional Liaison Specialist, GS-0301-12/13, ($23,087 p.a./$27,453 p.a.)
Office of the Chairman
Congressional Liaison Office

THIS POSITION HAS KNOWN PROMOTION POTENTIAL TO THE GS-14 LEVEL

DUTIES:
Writes and/or edits testimony for the Chairman regarding authorization, appropriations, and similar matters of concern to the Endowment; analyzes pertinent legislative initiatives; serves as a key resource within the Endowment on legislative matters; maintains liaison with Congressional offices and committee staffs, and other Federal agencies; maintains current knowledge and awareness of the daily working of Congress and developments in the art field.

QUALIFICATION STANDARDS:
Three years of general and three years of specialized experience are required. *General experience* is any kind of work which provided a good basic or general knowledge of the principles of organization, administration, and management. *Specialized experience* is progressively responsible operating administrative or managerial experience in a type of work or combination of duties directly related to the duties described above, or in comparable work. At least one year of the required experience must have been at a level of difficulty comparable to the next lower grade in the Federal Service. Education may be substituted for experience in accordance with O.P.M. handbook X-118. An interest in the arts is highly desirable.

TO APPLY:
Submit an updated SF-171 citingVacancyAnnouncement 79-076 atthetop to:

Carole S. McNamee
National Endowment for the Arts
Personnel Office, Room W-711
2401 E St. N.W.
Washington, D.C. 20506

For furtherinformation call (202) 632-4853

Applicants are assuredofequalconsiderationwithout regardto race, color, religion, sex, national origin, politics, maritalstatus, age, handicap, or membershipin an employee organization.

10

PROFILE / EDUCATION: THE KNOWLEDGE INDUSTRY . . .

Doctor MacGoblin pointed out that this founding of entirely new universities showed the enormous cultural superiority of the Corpo State to the Nazis, Bolsheviks, and Fascists. . . . All Corpo universities were to have the same curriculum, entirely practical and modern, free of all snobbish tradition . . .
—Sinclair Lewis
It Can't Happen Here

The White House Ministry of Culture had good reason to coordinate all culturally related educational programs and, in some ways, producer Jerry Colbert's failure to raise $5 million for *Understanding Congress* provided a poignant example. If Colbert had been able to skirt the deep quicksand at NEA, if he had successfully landed in NEH's lap, he would have discovered that his proposals duplicated an entirely different series of programs already in progress, also funded by Congress, but by the authority of entirely different congressional subcommittees on appropriations from those in which resilient Jerry Colbert had put his faith.

Despite the assertions of Tip O'Neill and Mr. McDade that Colbert's series would be "the first educational vehicle to interpret the legislative process," the Close Up Foundation of Arlington, Va., spent $7 million annually for similar highpurposes and goodwill. With $1 million from the Allen J. Ellender Fellowship—established by Congress as a tribute to the late senator from Louisiana—and with national educational funds "coordinated" with funds from state education departments, as well as local school district monies, thousands of high school students were awarded "fellowships" to travel to Washington, D.C. Upon their arrival at the seat of empire, these "fellows" were given the opportunity to observe "government in action," and to question the honorable members

99

of Congress, as well as representatives from the judiciary and other na-
tional officials, "on a variety of foreign and domestic issues."

These educational seminars with officials of the empire were video-
taped. Through arrangements with the Cable Satellite Public Affairs Net-
work, known as C-SPAN, the seminars were transmitted to more than
1,000 high schools in fifty states, then distributed by the school cable
television systems for "classroom use." The president of the Close Up
Foundation, Stephen A. Janger, observed that in his opinion the real ac-
tion was at the local level. "We try to infect them with the idea that they
ought to get involved."

Whatever infections the high school fellows brought home from Wash-
ington, D.C., it should have been apparent to producer Jerry Colbert that
in his attempt to explain the workings of Congress for educational TV,
he had persistently wandered the wrong corridors of the labyrinth of
culturally related programs. Despite the advice of dozens of academic
experts in political science, and dozens of advisors from the floor of the
legislature, Colbert had lost his way. If the programs authorized by Con-
gress were incomprehensible to Congress, and if it was demonstrable that
appropriations overlapped in their fundings of an infinite variety of good-
works, it was also a truism that congressional goodwill for anything
labeled education was unending, and therefore nothing would ever be
done to circumscribe education's activities. As Senator Muskie had
pointed out, there were to be no limits—no limits at all.

All educational activities were inherently Good—in the impeccable
logic of the Great Society's pragmatism—because education was defined
as a process, rather than a particular end in itself, or a tool of adventure,
intuition, or change. As soon as education was defined as a process, no
contradictions could be identified in any particular activity. If two or two
thousand programs overlapped, all were Good; if two specific programs
were administered to contrary ends, both were Good. All Things Were
True at All Times. The New Foundation promised love, peace, under-
standing and order, and education was the appropriate means by which
these values were to be actively inculcated to establish, as the president
had said, "a hard, long-term base of support." The president had omitted
to say support of *what*, but from the context it was clear enough that he
meant support for the Great Society which provided the education.

To clarify the New Foundation's unlimited goodwill, Mrs. Joan Adams
Mondale, acting as chairperson of the coordinating White House Ministry
of Culture, spoke in Austin, Texas, in December, 1978. She addressed an
academic conference on "Government and the Humanities" sponsored
by the Lyndon Baines Johnson School of Public Affairs at the University
of Texas. She recalled for her audience that it was LBJ who had signed
into law the national act creating the National Foundation on the Arts
and the Humanities. She cited LBJ as the man who "transformed Amer-

ica's commitment to the Arts and Humanities from a fragile matter of private belief to a permanent fixture of public policy."

Mrs. Mondale's rhetoric carried with it an unfortunate difficulty: no one could be entirely sure that she meant what she said. Yet all matters of private belief, fragile or otherwise, had once been expressly forbidden from interference of any kind by any public policy. Under the First Amendment, Congress could make *no* law respecting the establishment of any belief in any form whatever. Although children were forbidden to recite the Lord's Prayer in a public school, Mrs. Mondale seemed to be suggesting that academics in Austin could transform a fragile private belief in art or scholarship into a permanent fixture of public policy. Although the constitutionalists had deliberately rejected similar commitments offered by the theories of Thomas Hobbes for a morally effective state and had chosen instead as their model the limited social powers of John Locke, according to Mrs. Mondale that past was dead. In itself, the establishment by the national state of certified moral values to be inculcated by education in the arts and humanities as permanent establishments of public policy was astonishing; but Mrs. Mondale went on to define its circumstances. She believed, she said in Austin, that the goals of quality and equality could be balanced, "but we must stave off the twin catastrophes of arrogance and philistinism. We must reject the imperialist aristocracies of academia."

Mrs. Mondale's Austin audience was reported to have applauded these radical interpretations. Within six months another spokesperson of the New Foundation was lecturing at Harvard University. Mrs. Patricia Roberts Harris, successor to Joe Califano as secretary of HEW and patroness of the Children's Museum at the Bloomie benefit, spoke on "The Role of the American Intellectual Community in Redefining Our National Purpose." Ms. Harris thought that the public expected too much from government officials. She believed when politicians failed to achieve the "unrealistic standards set for them," public morale inevitably declined. The attitude of the people now, she estimated, was that the best government was the one which governed least. Her prescription to cure so miserable a misunderstanding, to rectify such a mistaken private belief, was to relocate the jurisdiction for public policy at the universities: "There is no escaping the conclusion that intellectuals must be the initial innovators in society."

Provided, of course, that the initiated programs were free from arrogance and philistinism. As a matter of fact, the educational establishment had long since abandoned any pretense of aristocracy, and had given up as well any political distance—once symbolized by ivy-covered towers—from the hurly-burly of national life. By a variety of standards education was the largest single complex of economic interests upon the continent, certainly the most potent social force, as well as the most

thoroughly articulated political system. Education included the only political jurisdictions in which ninety percent of all citizens still cast votes, whereas only about thirty percent bothered to express their democratic opinions in any other elections—perhaps, as Ms. Harris had pointed out, because politicians had failed to achieve the unrealistic standards set for them.

The various labor organizations affiliated with education maintained the largest lobbies in Washington, and the largest lobbies in every state, municipal, and county system besides. From kindergarten to twelfth grade the ambitions, hopes and permanent objectives of public policy were inculcated at an enormous social cost. At the apex of this economic and political effort stood the university corporations, with their own separately articulated political systems, including, but not limited to, lobbies, associations, strings of presses, and educational television networks. The university corporations were the prime contractors for information, materials, invention, and personnel for the Departments of Defense, Health, Education, Welfare, Agriculture, Treasury, Foreign Affairs, Commerce, Small Business, Big Business, Central Intelligence, Banking, Trade Regulation—and heaven knows what else. As suppliers of men and materials to the national system of industrial technology, the institutions of higher learning were without historic parallel—and there were few legislators who had failed to notice because patronage always worked both ways: from Washington, at the seat of empire, to Boston, Massachusetts, or San Jose, California, the university corporations were lavishly funded not only by their principal constituency—the United States Office of Education, but also identifiably by the National Science Foundation, the National Endowments for the Arts and the Humanities, the National Academy of Sciences, the Smithsonian Institution, the General Services Administration, the Nuclear Regulatory Commission, the Departments of Defense, State, Commerce, Agriculture—and literally tens of thousands of national systems and programs, ranging from astronomical observatories in the Andes to milk contracts for schoolchildren in Georgia.

Separating the annual budget dollars actually represented by the knowledge industry from all other budgets in which values, materials, and personnel were included would be beyond anyone's competence. Whatever the sum might be, it would be only an indication of what the Ministry of Culture meant to coordinate when asserting its authority over "all culturally related programs." Unfortunately, the budgets appropriated as "line items" in direct authorizations for national programs would give every appearance of being identifiable, but upon examination monies appropriated as "line items" in the budget of one department often supported the activities authorized in another agency. Hence, the sources of funds at any given location never represented what monies were being spent to accomplish any designated activity.

Similarly, the application of funds was rarely an accurate representation of whatever it was the congressional subcommittee had in mind with relation to the legislated purposes. Suppose, as a simple example, three professors of music met one day in a hallway of their university campus. Among them, as the entire department, they could decide to award to one of their number a summer fellowship to examine an ancient manuscript located at a monastery near Lake Como, Italy. Since the other two members of the music department would admit they had decided to take their families to the beach for the summer anyway, the bachelor would go to Italy this year, where his mistress would also be studying on a grant she had received from an entirely different university. Should the ledgers be combed, all meetings of the various departments of music would be properly logged, and the minutes of application and approval exactly correct. Moreover, the manuscript in Italy would assuredly add to the understanding of music. Professor-Gone-to-Como would, however, owe Professors-Gone-to-Beach one summer fellowship, to be paid at a later date.

The sources of funds for summer fellowships, or any other authorized activity of the educational establishment, need not be national monies. There were also federal-state programs; state education budgets unrelated to federal programs; overlapping jurisdictions between federal, state, municipalities, counties, towns—all the way down to local school boards and village libraries. To hold annual conventions, the high school principals, the school librarians, the national association of science teachers, or whoever, were so numerous in their associated populations that they were required to meet in cities with sufficient hotel-room capacity—such as Chicago, Detroit, New York, or Las Vegas: "Welcome High School Principals of America—The Las Vegas Chamber of Commerce!"

Such identifications, however, barely indicated the extent of the social and political apparatus under the command of the private and public university corporations, who were almost always the largest employers in their areas, the largest identifiable accounts of demand deposits in local banks, the sources of policy for law, management, science, or public affairs in any of their expressions—from the arts through missile deployments. In addition, the universities were the godfathers for still other systems of colleges, junior colleges, and teachers' colleges; for the apparatus of teacher-licensing and student-testing from elementary schools through doctoral dissertations; and therefore connected on the one hand to union contracts with respect to teaching, but on the other hand to "credits" earned in university courses which, in turn, earned additional raises for teaching pay-scales. Moreover, faced with declining enrollments because population growth had stopped, the university corporations were also "taking up the slack" by aggressively promoting programs of "adult education" to their local "market" populations and to other corporations.

There were no limits, no limits at all, to the establishment of university corporations in the social and political structure of the national society; but there were no systems for understanding whether in any given year any nationally designated program was fully funded for all the monies necessary to accomplish its objectives, or whether in any particular case the designated budget merely represented a fraction of what political officials had promised that its citizens would be required to pay. There were, for example, studies which concluded that if teachers' pensions were actually paid as promised, the states which had guaranteed the promises would be bankrupt. Never mind: the school bond market was in itself a fully articulated economic, social, and political system, representing in its *annual* billions of debts not only "roll-overs" and other magic financial devices, but also promises to pay obligations guaranteed by all the moral authority for which politicians were so justly famous. John Mitchell, President Nixon's attorney general, had spent his long political apprenticeship considering the legalities of bonds issued by the knowledge industry. In the city of New York, not only did Mr. Albert Shanker represent the city's teachers—one of the city's most powerful unions and most influential political forces—Mr. Shanker's teachers' pension funds were also among the principal owners of New York City bonds. When Shanker spoke, even E.F. Hutton listened, because on Wall Street, education had financial clout.

When education spoke, no matter how softly, Congress listened carefully, because education had political muscle. When education decided at last that it wanted a National Foundation for the Arts and the Humanities, the necessary bill became law, and thereafter there were to be no limits, no limits at all, to highpurpose or goodworks. Presto, the Council for Basic Education could conclude that "the arts should be part of everyone's education." Presto, a federally supported program in New York City called "Learning Through the Arts" was operating what education experts called a "total art program," including drawing, painting, film, and theater for children, in order, it was said, to improve the reading skills of children in the first to fourth grades. Presto, New York City's museums were participating in the program run by the city's Board of Education, and New York's procedures were being adopted in the rest of New York State, Arkansas, Kansas, Minnesota, New Jersey, New Mexico, and Wyoming. Presto, grants were available from the NEH to teach teachers how to write because declining scores of the Scholastic Aptitude Tests indicated that students were increasingly illiterate. In San Francisco NEH concluded that most teachers could not teach writing because they had never learned writing, and presto, fifty-six summer "institutes" were established with national funds "coordinated" with local monies as the "National Writing Project." For many teachers, the project was apparently enlightening. Mrs. Elena Bauman, sixth-grade teacher with twenty

years experience in the Middle Country School District in Brookhaven Township, New York, was quoted on her experience: "Oh, I can write official memos and things like that. But I've never *written* anything, and I've always assigned it in class." She said that when she used to get a kid who wrote a poem, she thought he was great, blessed with a gift from God. She thought she couldn't write poetry; how could anybody write? "But," she had concluded, "that's no way to teach."

Schoolchildren were not the only beneficiaries of education's goodwill. Presto, new programs were instituted for adult education, community education, programs to educate the elderly, executives, and of course, to reeducate federal, state, and local employees. Mr. Rexford Moon, Jr., managing director of the College Entrance Board's "Program of Future Directions for a Learning Society," was optimistic, despite declining school-age populations: "For the institutions that want to seriously develop programs there is probably enough business to go around." Mr. Moon's estimation of the potential market was: "The numbers are fantastic."

To estimate the social powers of education, it would be necessary to set aside for just a moment the revealed truths of economic doctrine derived from either Karl Marx or Adam Smith: if neither wages nor capital was the measure of work, then nearly half of the entire population spent its days occupied by education. Put the other way around, just because students were not paid for their work, or because no marginal return on mammoth totals of invested capital could be shown as derived from the labors of education, neither Adam Smith's doctrines or those of Karl Marx altered in any way that nearly half the national population worked at learning.

Not only was the knowledge industry the largest single category of occupations, it also collected the largest category of taxes for designated purposes—from school-tax district through state to national. Consequently, as an industry, it also dispersed more money, more jobs, and used more capital than any other single industry. Moreover, education included the most significant complex of tax-exempt institutions—ranging from private kindergartens to university corporations—but also attracting along the way associated foundations, councils, and incorporated institutes. Without exaggeration, all the hopes the people of the United States once expressed in the Preamble to the Constitution—to secure the blessings of liberty to themselves and their posterity—were now embodied in institutions devoted to education—which was why Patricia Roberts Harris had concluded that if politics had failed, then "intellectuals must be the initial innovators in society."

The shift in power from legislatures to educational institutions was also the fundamental reason why Mrs. Mondale spoke in such radical language; why she rejected what she understood to be arrogance and

philistinism opposing her high hopes for equality, for justice, for love, peace, and understanding. Education was the goodreason to coordinate under the aegis of the Ministry of Culture all national culturally related programs: presto, the NEH could fund in association with the California Bar Association a course on "Law and Society" to be taught to school children at a cost of $2 million, irrespective of the shenanigans of the California Supreme Court, which at the time was embroiled in charges and countercharges among its justices over decisions delayed for political advantage. Presto, the Nuclear Regulatory Commission in association with the Atomic Industrial Forum, an industry propaganda group, could teach high schools how safe atomic power really was, irrespective of any singular accidents at any particular generating plant. Presto, The White House Ministry of Culture could coordinate the culturally related national programs of NEA, NEH, and the United States Office of Education to achieve, as they had said, permanent fixtures of public policy, irrespective of any First Amendment constitutional proscriptions, because education's values, like all others at the seat of empire, contained no contradictions. None were possible because in education All Things Were True at All Times.

The United States Department of Education, represented by a seat on the White House coordinating ministry, was once an operating division of the Department of Health, Education, and Welfare, an articulated political and social system of such massive "coordinated" complexity—so vast, so complicated, so pervasive in its influence—that no one in Congress, or anywhere else, had the vaguest summation of what HEW had actually been doing or to what ends. According to its own pronouncements, almost all of HEW's activities involved education of some kind or another. With respect to the political results of these educational activities, much had been said by learned observers about what have appeared to be new patterns of "single issue voting": for-or-against busing, for-or-against abortion, hiring-by-quotas, affirmative action, health care, women's rights, welfare, housing, and so forth. The same commentators usually ignored that all of these singular political lobbies, both for and against, were created and were maintained somewhere in the Department of HEW, regardless of the political consequences.

At the direction of Congress, HEW had authority to administer more than 50,000 programs with budgets exceeding $200 billion annually, not counting contributory or cooperating fundings from states or other jurisdictions, and with no limits—no limits at all—on any debts simultaneously incurred. In testimony before Congress on the issue of separating the United States Office of Education from HEW, the opposition to a separate Department of Education estimated that ten percent of HEW's budget was devoted to education—an amount approximating about $20 billion annually in round figures. Proponents of the new establishment

argued that the $13 billion education budget was so small a fraction of HEW's activities that HEW could only give education fitful attention. The discrepancy of $7 billion among those most familiar with the topic was apparently not significant to the debate.

Never mind. Those who favored a separate Department of Education showed how educational programs within HEW were required to pass through twenty-six levels of bureaucratic review before being approved. The attendant delays averaged 519 days to get a program into operation. The system operated so slowly that before any program authorized by legislation could take effect, more than two years would pass. A new Congress would by then be seated to reexamine what to do about what had not yet occurred. The reason, therefore, said education's proponents for a separate department was "to have their voices heard."

The voices within HEW, or within HEW's OE, were a babel anyway, because programs designated as education appeared under one name, then disappeared under the titular reorganizations of each successive Congress or administration. What might have been the such-and-such program of highpurpose and goodwill yesterday could not be identified today, although its activities might well continue for endless tomorrows. What was designated as education or culture or arts or humanities might turn up under still other HEW operating divisions unrelated to the Office of Education, such as Housing and Urban Development, when the cultural activity so designated could be said to be "renewing a neighborhood." The identical activity might also be funded by different agencies unrelated to HEW at all, such as NEH or NEA programs for youth, or aged, or poets in schools. What might appear in a budget as a "health" program would turn out to be a loan program by which commercial banks were guaranteed the bonds they had issued to medical students for tuition at university teaching hospitals.

When an HEW inspector general was appointed to act as a watchdog against fraud and waste, there were trumpets and fanfares for the new reforms. He later testified sadly that he could only audit annually a few thousand of HEW's 50,000 programs, and he had to admit to the Senate Appropriations Committee that his task was essentially hopeless. No trumpets, no fanfares.

Although the inspector general of HEW had no way of finding out what the various commitments to education actually accomplished, education —whether separated or not from HEW—was one of the "clearly defined activities" to be coordinated by the Ministry of Culture as part of "the commitment to national culture." Within the OE, approximately ninety-four programs could be identified as spending about $13 billion annually on arts, science, the humanities, or combinations of these. OE made a distinction between two classes of expenditure in its totals: about $6 billion was spent in direct aid or loans to students; and the balance of

about $7 billion went to educational institutions. It was a nice distinction, however, because surely the amounts advanced to students eventually went to the institutions.

Thereafter, it was difficult to trace how much was spent for what by whom. For example, the National Endowment for the Humanities—not remotely an HEW agency—subsidized the authorship and editing of an *Encyclopedia of BioEthics*. The scholarship for three volumes was performed under the aegis of Georgetown University, and done by approved authors from still other universities. Then the Free Press, a division of the Macmillan Company, New York, commercial publishers-for-profit, published and sold the encyclopedia back to the market by whom it was created in the first place: university, college, school, and public libraries. The Macmillan Company had specialized for years in providing "educational" materials to the "market" of tax-supported institutions. The funds to initiate the *Encyclopedia of BioEthics* came from NEH, but the funds to buy the resulting work would have to be traced to the United States Office of Education, and through a variety of other HEW programs and budgets of changing names and authorizations. Yet all the contractors to these back-to-back arrangements could easily demonstrate that they had acted "independently."

The operating "independence" of nationally ordained programs could not be analyzed by inspectors general or anyone else using either scalar or linear estimations of function; nor by attempts to trace whether monies spent accomplished any specific objectives, because each operation was administered as a continuous "process," instead of an attempt to reach a finite goal. To the extent that education could be defined as the inculcation of values and skills, the national cultural policy could only be estimated by what was announced as true, because All Things Were True at All Times, and what was significant was what was announced, regardless of any contradictions.

Within the Office of Education, for example, there was a program called "Arts and Humanities," although it was only one of many OE programs dealing with similar educational values. Described by OE officials as "just a small program," it was said to be divided into three components. The first of these subdivisions was a program identified as "Arts in Education," and it involved eighty "coordinated" grants to state and community education agencies. The national expenditures were "not less than $750,000 per year," matched by unknown amounts from states and communities. The stated purpose of "Arts in Education" was to make the arts "an integral part of the curriculum" in education by "in-service" training of teachers at "local" colleges and universities. The program was unrelated to the "Artists-in-Schools" program administered by the Office of Education with the National Endowment for the Arts. Presumably, the teachers who benefited from "Arts in Education" had previously lacked such training.

The second subdivision of OE's "Arts and Humanities" commitment operated under the handsome title, "Alliance for Arts Education," which, it turned out, was a program spending a mere $750,000 annually at the Kennedy Center for the Performing Arts in Washington, to assist, it was said, state arts agencies "in a partnership." Children were transported to the Kennedy Center to see some shows. At one such show, Mohammad Ali performed without his boxing gloves for delighted children. Because theoretically the *children* received the money for the tickets, the Kennedy Center could claim that none of its *performances* was federally subsidized, although the Kennedy Center was maintained by the National Park Service and operated as a division of still another separate national institution, the Smithsonian. No contradictions existed, however.

The third component of OE's "Arts and Humanities" division spent $1 million annually on "The National Committee/Arts for the Handicapped" in cooperation with the Kennedy Foundation. With the help "and personal leadership" of Senator Edward M. Kennedy and his sister, Mrs. Jean Kennedy Smith, "The National Committee/Arts for the Handicapped" sponsored among its other activities a "Love-In," held in the Hall of States of the Organization of American States on Constitution Avenue for 750 handicapped children—deaf or blind or in wheelchairs or mentally retarded. The "Love-In" was described as "The National Very Special Arts Festival," and said to be part of the "Ongoing International Year of the Child." In addition to the children who were entertained and who attended "workshops" over at—of all places—the Kennedy Center, the "Love-In" at the OAS Hall of States was attended by members of the Kennedy family, Joseph Califano, then Secretary of HEW, Roger Stevens, chairman of the Kennedy Center for the Performing Arts, Mr. and Mrs. Jamie Wyeth, Andy Warhol, a singing group identified as "Up With People," Debby Boone, and Mickey Mouse. Cookies and punch were served. Mickey Mouse said he was 4 feet 8 inches tall, and went around hugging people.

The totals, therefore, of the OE active and well-coordinated "commitment" to support the arts would appear to be $2.5 *million* in national monies, not including state or cooperating foundation monies, but including, at Equity scale for a single day's performance, Mickey Mouse. In fact, under Title I of the Education Act an entirely different set of programs, but with many of the same purposes, spent $2.5 *billion* annually —a sum 1,000 times larger, but designated for educational and cultural activities for the "disadvantaged." These programs included a designated program for "handicapped children" not related to the "Arts for the Handicapped" activities for whom Mickey Mouse did his hugging. These "disadvantaged" funds when used by state or local "educational" agencies could be spent not only "to educate the young," but also to "provide cultural opportunities" for the aged, which in turn might mean buying

tickets to a theater performance anywhere in the country—as well as to the ballet, opera, symphony, museum tours, or anything else that might come to mind—provided that whatever it was could be designated "cultural."

What was "cultural" and what was "educational" was defined by the Ministry of Culture, or Office of Education, whichever was appropriate. In 1979, NEA solemnly signed a "Memorandum of Understanding" with the Office of Education, and Dr. Ernest Boyer of OE promised to coordinate OE programs with the Ministry of Culture. On the very day that these goodworks were announced, Dr. Boyer was asked whether he had made any progress in his attempt to teach English to the officials of his department. He had been holding classes once a week, he said, trying to improve the inscrutable prose of OE's official pronouncements. Dr. Boyer said he hoped he was making progress, but it was slow work. He cited a memo which had landed on his desk: "This workshop is part of an RFP issued by IOC aimed at helping SEAs better serve LEAs with reference to LEA/Prime Sponsor Agreements called for under the YETP portion of YEDPA."

The LEAs indicated might well have been law enforcement agencies; on the other hand, they might not have been. After twenty-six months of classes and serving as United States commissioner of education, Dr. Boyer resigned to join the Carnegie Endowment, the leading foundation in the study of educational values. According to Carnegie reports, education was suffering, despite the billions upon billions lavished upon its improvement for more than a generation. The Scholastic Aptitude Test scores of high school seniors continued to drop in both mathematics and English. Adult illiteracy continued to rise: 23 million American adults were considered to be functionally illiterate—unable to address a letter or read a bus schedule; another 34 million were functional, but not proficient. An estimated 56 million Americans had not completed the standard course equivalent to a high school education, but there were doubts whether it would have made any difference because a high percentage of high school teachers could not have passed the same tests as those required of their students. The Carnegie reports on higher education in the university system indicated moral deterioration on the campus as well as learning disabilities: students increasingly cheated, stole, and destroyed university property; faculties inflated grades; the system of financial aid to students and faculty was abused; academic credit was given for inadequate or insufficient work; and universities in their attempt to "sell" education, engaged in dishonest advertising. The Department of HEW, for example, in one of its rare and haphazard audits, charged Yale University with misuse of $500,000 in federal grants because HEW alleged Yale had used grant funds to pay costs not related to grant research, and Yale had paid full salaries to employees who had worked only part-time on the

items authorized for the national agenda. Yale said it would have no comment "until after the matter is resolved."

Whether Dr. Boyer as United States commissioner of education could teach English to the officials of national culture, or whether illiteracy could be cured in the national population, or whether teachers themselves were educated, or whether universities were ethically corrupt, were questions immaterial to the pragmatic necessities of the knowledge industry. Shortly after Dr. Boyer resigned, the Congress at last approved the long-debated creation of a separate Department of Education—the thirteenth cabinet department of the Executive branch. Simultaneously Congress renamed what had been HEW the Department of Health and Human Services (HHS). However a human service might be defined, Patricia Roberts Harris, secretary of HHS, promised her full support in coordinating the "transition."

The new Department of Education would start off with a budget of about $14.1 billion and employ 17,400 managers of national educational programs. Most, but not all, educational programs were stripped from what was once HEW. In addition, the new department took over Defense Department schools for overseas dependents; Agriculture Department graduate schools, but not Agriculture's continuing education programs for government employee advancements; Labor Department migrant education programs, but not Labor's various CETA programs; some science education programs formerly run by the National Science Foundation, but none of the educational programs funded by the National sister Endowments for the Arts and the Humanities; college housing loans administered by the Department of Housing and Urban Development, but not HUD core-city development educational programs that were "coordinated" with state, municipal, or local agencies. The Indian school system would continue to be administered by the Department of the Interior, and the preschool Headstart programs were continued in HHS, and not transferred to Education because presumably pre-kindergarten learning was a human, as opposed to an educational, service.

As the votes for the new department were being tallied on the floor of the House of Representatives, lobbyists from the White House and from the National Education Association applauded and cheered from the galleries. The National Education Association lobby claimed to represent 1.8 million schoolteachers and "other educators." Lobbyists for the American Federation of Teachers, which had opposed the enabling bill, were glum and silent. AFT had fought against establishing a new Department of Education, because AFT feared that its rival union would be the department's dominant political voice. During the debate the Honorable Bob Michel (R.–Ill.) had characterized the bill as the "Special Interest Memorial Prize of 1979," but a rousing speech on the benefits of education to the American people by Mr. Speaker Tip O'Neill was said to help

carry the vote 215 to 201. President Carter hailed the passage of the act as "a significant milestone in my effort to make the Federal Government more efficient."

The day after Jimmy Carter won his milestone of efficiency he was garlanded with flowers at a reception in the East Room of the White House. Several hundred teachers cheered the President and Vice-President Mondale, who said that Jimmy Carter was "the most pro-education President in American history." William H. McGuire, president of the National Education Association, responded by announcing his organization's enthusiastic support for Jimmy Carter in the 1980 Democratic primaries. The union's officials said they were prepared to commit money and volunteers to the Carter-Mondale primary campaign, although the "commitment" by the National Education Association's board of directors was subject to ratification by the union's political action committees in each state. In any event, the union and its affiliates would encourage and assist teachers to run as delegates in primary states in support of Carter and Mondale. Union officials pointed out that teachers were the largest block of delegates from any single organization at the last Democratic convention.

There might be those who imagined that party endorsements had been swapped for the creation of powers not precisely inherent in the Constitution; or, variously, there might be those who suspected that the values most favored by the Department of Education were not entirely related to learning or, for that matter, teaching. The political, social, and economic consequences of education might be incomprehensible in themselves, but when Education's programs were coordinated with every other national program of goodwill and highpurpose, the university corporations soon appeared to be the most favored establishment of national culture. Even a hasty glance at academic privileges suggested that universities compared socially to what the Church Triumphant only hoped it might obtain one day. No matter how various the denominations universities represented, and without regard to differentiations in dogma or liturgy—between, for example, Yale and Oral Roberts—university corporations were beneficiaries of national incomes without question, earned incomes for themselves without tax or inspection, operated factories, vineyards, and farms without audit, seminars in law, business, war, and diplomacy without debate, and served as the temporal repositories of truth without end. Mere schoolteachers might have to campaign in presidential primaries in exchange for a department they so earnestly desired, but university corporations would be stooping to conquer if they had engaged in any such activity.

Universities provided the answers to ethical and moral questions posed to all government departments and agencies, without exception. University corporations had a duty, they said, to set "real objectives"; to provide, they claimed, "the hard answers." The entitlements conferred upon

university corporations—exemptions and privileges without limit—derived from the absolute moral authority conferred upon academic deliberative processes. To meet the responsibilities imposed, academic certitudes on military, economic, social, political, philosophical, and moral questions had to be tempered by judicious ambiguities. Like any other vast, complex, and ambitious church, the university corporations had to abandon those who served diverse causes and promote instead syncretic values. Harmony and Order demanded Unity on divisive questions, and constant Propagation of the Faith was a necessity to its continuance.

Help Wanted. . . .

Director of Air Warfare

SYSTEM PLANNING CORPORATION is seeking a Director for its Air Warfare Division which is comprised of technical and analytical specialists in the evaluation of air weapons systems. The Director will be completely responsible for the management of all financial, recruiting and project activities of the Division and will have prime responsibility for expanding the Corporation's business in the air warfare area. The individual will report directly to the Vice President of the Tactical Systems Group.

The requirements of the position are:

—M.S. or Ph.D. in Physics or Engineering
—Demonstrated leadership and management skills
—Extensive experience in the technical evaluation of aircraft systems and air-delivered weapons
—Knowledge of Soviet air and air defense systems
—Familiarity with U.S. weapon systems acquisition process

System Planning Corporation is a private, rapidly growing organization that provides government agencies with responsive technical and analytic evaluations of complex systems. Conveniently located in Arlington, Virginia, the Corporation provides excellent opportunities for advancement, impressive facilities, and liberal benefits.

Qualified applicants should call collect (703/841-2895) or forward resumes to Mr. Donald N. Fredericksen, Vice President, Tactical Systems Group.

SYSTEM PLANNING CORPORATION
Suite 1500, 1500 Wilson Blvd.
Arlington, Va. 22209

An Equal Opportunity Employer

11

SKETCHBOOK / PBS AND ICA: AGENCIES OF PROPAGANDA . . .

*And the Records Department, after all, was itself only a single branch of the
Ministry of Truth, whose primary job was not to reconstruct the past but
supplying the citizens of Oceania with newspapers, films, textbooks, telescreen
programs, plays, novels—with every conceivable kind of information,
instruction, or entertainment . . .*

—GEORGE ORWELL
1984

The popular catechism of syncretic university values approved in the
name of education was broadcast 168 hours per week, 52 weeks per year,
on the telescreens of the Educational Broadcasting Network, also known
as ETV, a.k.a. the Public Broadcasting Service, a.k.a. PBS, a.k.a. the Cor-
poration for Public Broadcasting, a.k.a. CPB. The broadcasts were always
blessed in the name of something called "objectivity."

ETV telescreens displayed all that was favored by the officers of na-
tional culture, and they were actively coordinated, as well as funded, not
only by education's own institutions, but also by all the coordinating
agencies of the White House Ministry of Culture—including NEA, NEH,
NSF, GSA, National Park Service, the Smithsonian Institution, Depart-
ment of Interior, and Department of Education. The instruction offered
by these combined ministries was, in its turn, and for the very best of
reasons, also funded by both private and corporate foundations of all
varieties as examples of their continuing concern for the general welfare;
and in addition, sponsored by technically sophisticated corporations—
particularly those which supplied the nation's energy—as earnest assur-
ances of their devoted goodwill to the public interest. Sponsorship of
education was offered up, along with the sounding of little bells every
hour, as good public relations.

Hour after hour, on the national telescreens, education and public relations together syndicated the national culture of the corporate state to demonstrate that its ministries not only had the best interests of all citizens at heart, but in addition maintained these best interests on "public" TV against the sordid claims, the absolute evils and near occasions of sin displayed by greedy corporations advertising on the three other national monopoly corporate franchises. That the sponsors for all four broadcast monopolies happened to be nearly identical wherever they appeared was irrelevant, or insignificant in any case, to the comparisons between two systems—public and commercial TV. Virtuous announcements displayed on educational TV differed from those on the networks of the "private sector" in that commercial TV advertisements sold *Things*, whereas public TV commercials were deeply concerned with *Ideas*. If public TV was an experiment that had failed, a disaster even in the judgment of its most partisan supporters, revisions of history or diluted literature were unavoidable because education on TV was required to serve "broad audiences," and not necessarily either prosaic realities or poetic visions. If Hester's hard-earned *Scarlet Letter* turned out to be a gold A on educational TV, thirty-six academic advisors engaged by the NEH for the program were prepared to testify "objectively" that the famous scarlet A might well have been yellow after all. If the BBC described itself as the propaganda agency for what remained of the former British Empire, the syndications of England's propaganda on American educational TV by Time, Incorporated, and by Mobil Corporation were irrelevant to the beauty of the costumes in sad stories as kings died in the gloried halls of yesteryear. If "Bernice Bobs Her Hair" was a minor short story by F. Scott Fitzgerald, which avoided the dangerous questions raised by Fitzgerald in *The Great Gatsby*, what was important was how much NEH loved literature and how the facilities of educational TV could bring "the works of great American writers to public attention." Which works, objectively speaking, didn't matter. If *HR6161: An Act of Congress* did not quite explain how to understand Congress, the significant lesson was that "millions of Americans had the opportunity to see their government in action." If educational TV's brightest star, correspondent Bill Moyers, had said one day that there was "more censorship at PBS than there ever was at CBS," Bill Moyers could amend his perceptions the next day: "It isn't really censorship. It's really pluralism carried to an extreme."

Similar banalities caused George Orwell to remark upon the difference between the despotisms of the past and the authoritarian regimes of the New Order. Orwell noted how the distinction consisted in two different responses required from those subjected to dogma. In the past, when despots announced some truth to which all were to genuflect, the declared doctrine remained in force, more or less, for quite a while—probably until the tyrant died. Those who would not obey or could not

consent were persecuted, while the faithful were rewarded. Both believers and dissenters, however, obtained their punishments or rewards in the name of the same more or less consistent revelation. The new Great Society required of its subjects the very opposite: whatever doctrine happened to be celebrated today, everyone had to be prepared to praise its contrary tomorrow. All citizens of the New Order had to change their minds constantly—at least if they were to be "objective" about whatever new revelation had just been divined from new auguries. Just as Orwell's Ministry of Truth declared that Freedom was Slavery, Ignorance was Strength, War was Peace, so also Scarlet was Gold, Censorship was Pluralism—when all the facts were considered "objectively."

One of Orwell's insights in *1984* was that something terrible had happened: war and crisis had become permanent conditions, and if the legitimacy necessary to authority was to be maintained, truth, too—with its erotic irrationalities so awkward to manageable behavior—would have to be made manageable. Orwell's narrative in *1984* was acted out in a Ministry of Truth with offices not unlike those at the BBC, and the details of his black utopia were based upon his own experience as a propagandist for the BBC during war. The remarkable similarities between Orwell's *1984* and the operational details of educational television were not merely the result of Orwell's intuitions about the new authoritarian societies, but derived from the logic of "objectivity" in truth and practical experience in wartime broadcast propaganda. In his essays Orwell portrayed the BBC as a tight-lipped, earnest shop, devoted to earning the goodwill of its audiences. In *1984* he pictured similar workshops in Big Brother's Ministry of Truth devoted to the same educational virtues: constantly revising history, providing entertainments for children, earnestly discussing the wartime victories—but never defeats—and doing morning exercises to keep healthy and fit. Independent thought during war would be dangerous to established authority. Most dangerous of all to power were erotic insights, gaiety, or laughter. Comedy might make ordinary men of revered leaders. Gaiety laughed at pretense—an inconvenience to highpurpose.

Educational broadcasting calculated in 1979 that 0.3 percent of its programs were devoted to "humor," and even that whopping total may have been an exaggeration. As to any other kind of independent thought, the Public Broadcasting Service abhorred its consequences. The university corporations extended their hostility to such lengths that the Public Broadcasting Service was the only known organization in the world which refused to abide by either the International Copyright Conventions or the United States Copyright Act. Education refused to pay royalties to authors or artists for their work, but sold the results of invention on television, on campus, and at retail to the public without regard to authorship—simultaneously insisting that education had an inherent moral right to do so, regardless of the guarantees established in the Con-

stitution, by act of Congress, by any customs or traditions derived from history.

Even Soviet Russia and Vietnam had finally agreed to pay authors and artists any royalties that might be due. Whether those nations did so in fact, the United States university corporations refused in principle, saying only that education might agree to negotiate in particular instances. Although there had never been a test of whether some Aleksandr Solzhenitsyn could collect his royalties in Moscow, but not from the Corporation for Public Broadcasting in Washington, the testimony of university lobbyists to Congress upon their commitment to national culture was clear: tithes were due from all members of the faith; the tax was to be collected by the secular authorities, then given over to the educational broadcasters to determine by their sole authority what particulars of doctrine were to be explained, but no independent thought was either to be produced or rewarded except insofar as it pleased educational broadcasting to do so.

Public broadcasting consequently could be understood as the public relations campaign for the ideology of national culture, as interpreted by entitled officers of education. Conversely, the history of public broadcasting had never been associated in any way with the joys or gaieties or comedies of poetic invention, but always with the prosaic requirements of public good. A symposium of college and university broadcasting stations incorporated themselves in 1925, and in 1934 announced that they were the National Association of Educational Broadcasters (NAEB). Thereafter, acronyms multiplied. To promote its interests, the NAEB opened its first Washington headquarters in 1949 and began to lobby by publishing reports, awarding "fellowships," and engaging lawyers to argue before the FCC that licenses for TV channels and radio frequencies had to be reserved for "educational purposes." Ultimately the FCC assigned 127 VHF TV channels and 528 UHF channels, twenty-three AM radio bands and 175 FM bands. What amounted to a cultural AMTRAK was created to educate the public. The system was coincidentally a considerable capital formation.

In 1952 the Ford Foundation established an Educational Radio and Television Center to produce the programs to be distributed to the educational stations' network. The Ford Foundation production center was moved to New York City in 1959 and renamed National Educational Television (NET). Meanwhile the first educational station had gone on the air in Texas, sponsored by the University of Houston, followed by other educational stations, and finally by a hybrid type of station called "noncommercial TV station supported by community nonprofit organizations." These community hybrids would continue to have constant fund-raising difficulties. The first "auction" on the air was run off by KQED, San Francisco, and if it seemed a good idea at the time, there later would be complaints to the FCC that some "auctions" were disguises for

"commercials," complete with rate cards exactly like those for commercial TV. The number of minutes for public relations interruptions on educational TV soon exceeded those allowed by the FCC on commercial TV.

Never mind: to improve the capital equipment of public TV, in 1962 Congress passed the Educational Television Facilities Act. The first federal funding authorized a mere $32 million to be spent over five years for construction of towers, transmitters, and studio facilities; nothing yet was said about programs. Fearful that New York City had such influence that it might snatch an undue share of the appropriations, Congress limited the monies distributed to $1 million per state. As the Facilities Act was passed, a nonprofit group purchased Channel 13, New York City, from commercial owners for $5.75 million. The station's operating license was in New Jersey, but that could be cleaned up later.

In 1966, the Ford Foundation also created the Public Broadcasting Laboratory (PBL) to produce cultural and public affairs programs for distribution to the ETV stations. What was by then the Ford Foundation flagship station, WNET, Channel 13, New York, began live intercity connections in January, 1967, by broadcasting President Lyndon B. Johnson's State of the Union Address in which he articulated his hopes for a Great Society. During the same month the Carnegie Commission on the Future of Public Broadcasting issued its first report, eventually known as "Carnegie I" to distinguish it from the commission report issued in 1979 known as "Carnegie II." One result of Carnegie I was identifiable as the Corporation for Public Broadcasting (CPB), which Congress authorized and funded in 1967 to create programs and to support local "noncommercial" radio and TV stations. CPB was chartered as a "private, non-profit" corporation with a presidentially appointed board of "distinguished citizens" who would insulate its operations from political influence. By the end of 1969, CPB had received its first federal appropriation of $5 million and had made its first program grant to National Educational Television for the production of "Black Journal."

Congress, however, had prohibited CPB from operating a network of interconnected stations. So CPB set up a "study group" of CPB executives, Ford Foundation project directors, and ETV station managers who together recommended and then created still another "private" corporation, the Public Broadcasting Service (PBS), which began distributing programs to stations in the fall of 1970. Although CPB claimed final authority over what programs would be financed with federal funds, PBS represented the stations' interests and designed programming funded by still other corporate parties. The Children's Television Workshop productions of "Sesame Street," for example, were financed "at the local level" by educational interests. PBS programs such as "Civilization" were bought from the BBC and donated as "a gift from the Xerox Corporation." In 1971 Mobil Corporation underwrote the costs of "Masterpiece The-

atre" from England. More than one hundred years after the events, gorgeously costumed dramas based upon Trollope's novels examined the social consequences of the 1867 Reform Bill before Parliament. England's nineteenth-century reforms were not too "controversial," objectively speaking, for twentieth-century American audiences. Unfortunately, the Ford Foundation's favorite station, WNET, New York, misunderstood the difference between education provided by costume dramas and the public interest. The station produced and aired a program called "Banks and the Poor"—listing 133 legislators and government officials with banking connections and suggesting that a significant reason for decayed urban neighborhoods was a bank practice known as "red-lining." It was uh-oh time among the distinguished citizens who served *pro tanto publico* as trustees or directors of nonprofit community educational TV stations. A hue and cry rose up demanding "responsibility" and "objectivity."

Worse, WNET was soon engaged in controversy with the PBS stations over irreverent programs such as "Great American Dream Machine" and "The Politics of Woody Allen." Comedy threatened: WNET accused PBS of "censorship"; PBS declared WNET's charges were "irresponsible"; and soon something more serious than name-calling was on its way. Two programs had angered the Nixon White House staff: "Thirty Minutes With" and "Washington Week in Review." They were "unbalanced"; Sander Vanocur was "a notorious Kennedy sycophant"; and Elizabeth Drew, a handsome woman who never smiled, was not only too earnest a reporter, but was also "definitely not pro-administration." Something had to be done: in November, 1971, Clay T. Whitehead, then head of an operation in the White House called the Office of Telecommunications Policy, went to work. Whitehead reported to H.R. Haldeman that he'd "planted" stories in the trade press about Vanocur's salary and the salary of Robert MacNeil. Whitehead was going to put pressure on CPB, he said, to "balance their programming" or risk getting their funds cut off.

To achieve balance, President Nixon vetoed the entire public broadcasting budget in June, 1972. As a result, CPB's first president, John Macy, resigned in August, and CPB Chairman Frank Pace declined to stand for reelection. It seemed the private, nonprofit, independent corporation was not insulated from political pressures when it came right down to the bottom line of $100 million in appropriations. Despite claims to the contrary, PBS was just another government agency after all. By coincidence, President Nixon suddenly had the opportunity to appoint or reappoint, at his pleasure, eleven out of the fifteen members of the CPB board of directors. To replace Frank Pace, in September, 1972, the President named former Congressman Thomas B. Curtis as a more reliable chairman, and CPB announced its intention to take over all scheduling and programming from PBS.

As soon as the Watergate election was over, the university corporations struck back. PBS reorganized, incorporating their own station manage-

ment board with the board of the National Association of Educational Broadcasters and with the governing board chairmen of local TV stations, who then elected their own chairman, Ralph Rogers, Texas industrialist and chairman of station KERA, Dallas. The NAEB university stations had many friends in Congress, and congressmen encouraged CPB to negotiate with the PBS system. Complaining of pressure from the White House that had appointed him six months earlier, the new CPB chairman, Thomas B. Curtis, resigned. Dr. James R. Killian, Jr., chairman of the Carnegie I Commission, took Curtis's place. By May, 1973, CPB's Chairman Killian had signed accords with PBS Chairman Rogers "to provide a framework for mutual trust and industry-wide consensus."

The CPB annual reports described what happened as a "partnership agreement," although it read something like a publicity release issued simultaneously by the General Motors Corporation and the Association of Independent Chevrolet Dealers. CPB, it was said, would no longer control program content at all; only PBS would choose programs and distribute them. Instead, CPB would increase its funding of something called "Community Service Grants," which was a system to pass funds directly through to stations. In return, CPB would work diligently to increase congressional budgets, especially to secure long-term funding, and would do its best to avoid presidential vetoes. The result of the 1973 treaty was that budgets were not only restored, but increased. President Nixon signed the bills, and all was harmony again.

As if nothing had happened, by 1974 CPB began selecting and funding programs again through a new device called the Station Program Cooperative (SPC). Local PBS stations were encouraged to create the programs, but the funding came from CPB, from the Ford Foundation, and increasingly from those corporations who could understand the benefits of "education and public relations" at low network rates. Before President Nixon resigned, he apparently had been so thoroughly converted that he was even calling for five-year financing of CPB budgets from Congress.

Nixon's successor, President Gerald Ford, signed the Public Broadcasting Financing Act into law in 1975: five-year appropriations were at last in effect. They would help, it was said, to insulate CPB from political pressures. By then, another device known as the Emergency School Assistance Act (ESAA) was also contributing about $36 million to PBS stations, tax-exempt corporate contributions had grown to $14 million, and public television's total "income" was nearing $300 million. Chairman Killian could be proud of his achievements, and so could Henry Loomis, the CPB president appointed by Nixon to replace the intransigent John Macy in the dark days of White House attempts at censorship. Dr. Killian and Henry Loomis had worked together many times before.

Dr. Killian listed his occupation as "college administrator." He had earned his Bachelor of Science from M.I.T., then edited *The Technology Review*. From 1943 until 1959 he was vice-president, then president of

M.I.T., and thereafter chairman of its corporation. He was widely admired for his early and persistent advice to improve the national public education, especially in the sciences. His message was so well received that he was showered by dozens of colleges and universities with honorary doctorates in law, science, applied science, engineering, the humanities and education. In addition to chairing the commission for the Carnegie I report, he found time to be a director of AT&T, the Polaroid Corporation, the Cabot Corporation in Boston, and the General Motors Corporation. Moreover, Dr. Killian served on President Eisenhower's Science Advisory Committee, and as chairman of President Kennedy's Council on Science. For both Eisenhower and Kennedy, Dr. Killian was chairman of the Council on Foreign Intelligence Activities, and chairman of the Institute of Defense Analyses. Whatever may have been the activities of these top-secret agencies, certainly Dr. Killian's career was a visible "commitment to the national purposes."

His associate, Henry Loomis, pursued a career equally committed, but not as visible. Loomis studied at Harvard, fascinated by the intricacies of mathematics and physics. When his studies were interrupted by the oncoming threat of World War II, he served first as a cryptographer in Hawaii before Pearl Harbor, then in the Pacific as the Navy's expert in radar operations. He returned from war to the radiation laboratory at the University of California, then had the good fortune to serve as Dr. Killian's assistant in the administration at M.I.T. In 1950, Loomis moved to Washington, where he became something of a social curiosity.

The 1979 Carnegie II report would describe Loomis tersely as a "career public servant," which would be accurate as far as it went. When Loomis arrived in Washington in 1950, he calculated correctly that his longevity in public service would depend upon his anonymity. Administrations might come and go, but Loomis felt he could best accomplish his own mission by maintaining a deliberate personal modesty. It was a style that suited his tastes anyway. He had little patience for the usual babble of Washington's shoptalk. If his presence was absolutely required at a black-tie dinner in a pretty little Georgetown house held by those who considered themselves the inner circles of influence, Loomis might be convinced to attend, but in the end the only notoriety he ever earned came from the occasions when he slipped away from the chitchat of the powerful to snooze behind the nearest couch.

Loomis's habitual anonymity allowed him to accomplish much. He was listed as assistant to the chairman of the Research and Development Board of the Department of Defense in 1950–51. Thereafter, he served as a consultant to the Psychological Warfare Strategy Board, a council appointed to devise means of countering Marxist propaganda—something like fighting fire with fire. The board's reports were top secret memoranda to the National Security Council. Later there were allegations that private, nonprofit, "free" radio stations in Europe and Asia had been

suborned, and probably subsidized, and perhaps a number of magazines, quarterlies, and newspapers as well. Loomis was not necessarily expert in psychology, or in any other branch of social or mental hygiene, but familiar instead with the mathematics of high-energy transmission and reception—radio, radar, scanning systems, and the like. He served briefly on the staff of President Eisenhower's Committee on International Information in 1953, then was named chief of the Office of Research and Intelligence in the new United States Information Agency—the institution of United States propaganda that grew out of the recommendations Loomis wrote for the Psychological Warfare Strategy Board.

After Sputnik, Loomis left USIA during 1957 and 1958 to serve on Dr. Killian's staff as a special assistant to the president for Science and Technology. Then Loomis returned to USIA as director of the Voice of America from 1958 through 1965—under three successive presidents, while various appointees as director of USIA took the bows and soaked up the invitations to dinner in Georgetown that usually accompanied their appointments. During those years, even Washington insiders were often hard put to identify the director of VOA—the principal instrument of U.S. propaganda. At the height of the Vietnam controversy, Loomis moved over for a time to serve in HEW as deputy commissioner of the U.S. Office of Education under Francis Keppel, an educational executive and honorary doctor of pedagogy. Then Loomis retired from public service in 1966, until he was recalled to clean up the mess Nixon had created at CPB. When Henry Loomis resigned as president of CPB after more than six years, his place was taken by Dr. Robben W. Flemming, president from 1968 to 1979 of the University of Michigan. Dr. Flemming was justly famous for his expertise not only in university administration, but also in labor relations.

With the exception, therefore, of the breach of manners that had occurred under Nixon—a gaffe for which apologies were instantly demanded and for which bouquets were as quickly delivered from the Congress—the history of public television, its leading characters, and its declared objectives were remarkably consistent. Dr. Killian, possessing those qualities most admired by the universities, delivered the Carnegie I report in 1967 when the federal monies in public television were about $7 million. Carnegie I called for the creation of the CPB. Dr. Killian was a charter CPB board member, then returned as chairman to conclude the 1973 treaty with PBS. His associate in secret sciences and intelligence, Henry Loomis, continued as CPB's operating president. They both served as consultants to the 1979 Carnegie II report, chaired by Dr. William J. McGill, president of Columbia University. Dr. McGill, curiously, had *earned* his doctorate in psychology, as opposed to the honorary doctorates showered upon Dr. Killian and others who funded university ambitions. Dr. McGill's hopes included connecting the theories of physics to behaviorism.

When Carnegie II was issued, total incomes of the educational broadcasting system were just under $500 million. Federal funding was said to account for $135 million, or 28 percent. Nonfederal funds were about $345 million, or about 70 percent. Of the nonfederal totals, corporations and foundations contributed about $62 million, but nearly half of these "grants" made possible programs in prime evening hours—which was why PBS was characterized by some critics as the "oil-can network." Yet no clear summaries could be derived from examining statements of income and expense in educational television. Funds from universities, schools, the Departments of Education and Health and Human Services, states, cities, symphonies, operas, ballets, museums, media centers, the National Park Service, Urban Development funds, corporations, foundations, commissions, and the National Endowments for the Arts and the Humanities were all—as accountants would say—commingled. When the "Teng Show" was broadcast from the Kennedy Center there was no way to estimate either the aggregate or marginal subsidies from PBS, NEA, Coca-Cola, or the Atlantic Richfield Corporation. Chris Welles made a study of WNET, Channel 13, for *New York* magazine, and concluded that WNET's $40 million budget was larger than that of any New York commercial station; yet even that total might not represent all of WNET's costs, because the station's significant programs were co-produced with other stations, particularly WGBH-Boston and WETA-Washington. The board of trustees of Channel 21, still another New York State educational TV broadcaster, fired its general manager because he charged that J. Oliver Crom, head of Dale Carnegie Associates of Garden City, New York, and simultaneously chairman of Channel 21's board, had developed a fund-raising campaign for the station which actually promoted Dale Carnegie courses. The New York State Department of Education studied the situation, then recommended that Channel 21 be "reorganized." The manager who blew the whistle on Dale Carnegie and J. Oliver Crom was fired.

Leaving aside fund-raising costs, which at New York's Channel 13 totaled $13 million a year, and disregarding calculations of capital costs, which were raised by specific appropriations, and ignoring distribution expenses, which might be "charged" in a variety of ways for programs syndicated over the university-based educational network, there still was no accurate estimate of production costs or program expense. To begin with, national funding agencies did not allocate program costs as did commercial producers by making a distinction between "above-the-line" costs—all the expenses to get film or tape into a can—and "below-the-line" costs—all the expenses to promote and syndicate the finished program. For a given program on public TV, the costs of production, whether above or below the line, might come from so many different funding organizations—and for so many different reasons—that there never could be any journal accounts accurate to the program's expense. Worst of all,

each granting organization, whether corporate, foundation, National Endowment or otherwise, and each distributing organization, whether PBS, CPB, or WETA-Washington, required different specifications to apply for the money provided. Advisors and consultants—usually designated by the granting organization itself—had to be hired to prepare the applications for funding, and their fees had to be included in the cost of the program.

What might actually happen went something like this: in competition with many others, a nonprofit film producer applied for a "development grant" from one of the two national endowments—NEA or NEH. The endowments paid "consultants," "reviewers," and "panelists" to approve the program's "development." The amount approved for *successful* "development grants" appeared on the pages of the endowment's annual financial reports, but not the cost of the unsuccessful "development grants." Nor would the cost of any hour's development appear upon the ledgers of expense of either CPB or PBS.

As a "development grant" proceeded through script grants and production grants, reviewers and panelists would reconsider, and as "consultants," "reviewers" and "panelists" met, they would be paid. The costs of these story conferences would be in the administrative budgets of the endowments. By then the program in production would also be paying consultants for its own ends—historians, art critics, whoever was necessary to the endowment's approval—but now paid by the program's *producer* as "advisors" to the script and production, and as counterweights to the endowment's hired opinions.

Yet the costs of programs for which scripts were developed and paid, but for which no production was ever completed, disappeared from the national ledgers—simply written off. Hence, after one year's operations there could never be any ratio of expense for finished public television productions, as opposed to abandoned proposals. No losses were entered in the journal accounts of the endowments, PBS, CPB, or anywhere else.

For the few programs which did proceed toward completion, experienced public television producers used "development grants" from the National Endowments as imprimaturs to raise additional funds from foundations, which were often themselves instruments of either profitable corporations, such as the EXXON Foundation, or from university-connected systems. The value of the tax-deducted grants would be commingled in a program's production expense, locatable only upon the ledgers of the donating corporation, and not necessarily as "program expense."

Finally, the program's producer might do his editing and actual broadcasting over the PBS network, either from one of its "production centers" or at an individual station. The syndicated broadcast might carry the legend that it had been made possible by a grant from the BLANK Cor-

poration, but it would not be verifiable whether the grant made possible the broadcast or the creation of the program. The accounting procedures would be further complicated by how the PBS station or network "charged back" overhead costs to each program: overhead expenses charged back by PBS stations ranged from 15 to 40 percent of the total production budget, even if the production budget had been enabled by entirely unrelated government agencies. Throughout, various government agencies were charging each other. Those independent producers who had not entirely given up hope for public TV described the funding system as "a zoo."

Even if the funding system for programs had made any sense, Public Television's practice of requiring "independent," or what was often described as "objective," reviews by panels of university advisors would have killed off any prospect of Public TV ever broadcasting programs of dramatic impact. The best that Public TV could offer had to be imported from Great Britain's national system of propaganda, the BBC. When critics appeared in print or before Congress to point with shame at what was actually on the TV set, officials of the system claimed that the critic did not "understand" public TV's "responsibilities."

Among those responsibilities was the consistent duty of public broadcasting to eliminate any independent thought, either by refusing royalties to its creators, or by the procedures necessary to complete a program's production. Ms. Virginia Kassel, after producing "The Adams Chronicles," concluded that no dramatic program could survive public TV's procedures. Although she would continue to attempt production of documentaries for public TV, she said she would never again attempt to produce a program in which a single, consistent voice informed by an author's point of view was dramatized. She doubted that programs such as Kenneth Clark's "Civilization," or James Burke's "Connections," or any of Alistair Cooke's series could have been produced in the United States. Those programs were each informed by their narrator's unique perceptions, and a consistent point of view was anathema to public television: no comedy, no drama, no unique perceptions, no independent thought.

Ms. Kassel began work in 1970 on the "Adams Chronicles," the first dramatic series for public broadcasting based on United States history. In fact, until 1970 there had been no dramatic series of any kind on educational TV—historical or otherwise. Because Ms. Kassel proposed a series on the public and private lives of the Adams family for television, the National Endowment for Humanities (NEH) sponsored "history" for a "development grant" of $30,375 in March, 1971, to outline a series from 300,000 pages of journals, letters, official papers, and existing studies. Along with Ms. Kassel, a playwright and the editors of the Adams Papers were, at that point, the only advisors necessary on "content." In Septem-

ber, 1972, NEH awarded an outright grant of $250,000 and a matching grant of $25,000 to write and produce two programs. No advice was yet necessary on the objectivity of Ms. Kassel's "content."

The two pilot programs were screened by NEH in August, 1973. Impeccable history and compelling drama were discovered to be at odds, insofar as the family of John Adams was concerned, despite the advice of the editors of the Adams Papers. NEH required that "additional historians" be involved in the scripts to ensure "countervailing interpretations of history." The editors of the Adams Papers could not help but be offended by the implication that they lacked "objectivity." Ms. Kassel could not help but comply, if she was to complete the series. In January, 1974, NEH guaranteed to underwrite the entire series, but by then the single vision, the voice of the playwright, was lost. "Too many expectations and exercises were asked of and granted," said Ms. Kassel, "for the single vision which had begun the project."

Four playwrights, one for each generation of the Adams family, started writing the series. Everything they wrote had to be reviewed—each outline, then each draft. The story of the Adams family went first to the historians of the Adams Papers, then to those representing the "countervailing interpretations of history" appointed to the project by NEH. The time used by these various reviews, the reconciling of factions, the endless compromises, meant in the end that nine writers were credited for the thirteen programs. One wrote three episodes. Two were responsible for a pair each. Six worked on one. Two script editors left before the scripts were completed. Five others had withdrawn or been replaced because of what Ms. Kassel called "historical restraints." Budget overruns began to mount. Production was delayed.

The number of rewrites required and the amount of time between each rewrite necessary for "historical review" by university advisors finally infuriated the writers. All the playwrights were members of the Writers' Guild of America, but in contrast to commercial stations, the producing station, WNET, refused to comply with the WGA contract provisions, because education's higher moral purposes did not stoop to the principle of paying authors "scale" for their work. The Writer's Guild used the confusion created by "countervailing interpretations of history" to press WNET for a contract. First, a slowdown was started, during which the writers delivered their work no quicker than the historians. On August 15, 1974, a formal strike action was instituted against WNET. On October 10, 1974, WNET obtained a court injunction allowing work on the "Adams Chronicles" to continue. The enabling laws of Congress excepted Education from paying authors what they were due.

Twelve weeks of production were lost. The enthusiasm, confidence, and morale of the writers were destroyed. A few writers agreed to see the series to its conclusion. In January, 1975, with only half the scripts in hand, the line producers, designers, casting director, and production man-

agers went ahead anyway. Directors for segments of the series could not be recruited without the material they were to direct. Casting was risky because no one knew which characters might reappear in what episodes. Sets could not be built or locations scouted. A double schedule was put into effect—taping one program while rehearsing another. In the very best of show-business traditions, the shows went on. Between May and September, 1975, thirteen episodes of the "Adams Chronicles" were produced, although four scripts were missing when production began. Cost overruns were appalling.

Virginia Kassel's production of the "Adams Chronicles" was not only the first dramatic series on Public Television, it was rightfully hailed as the best Public TV had ever done. It was the series with Public TV's highest ratings. It was the production to which officers of the nation's culture repeatedly pointed as an example of their success. The lesson learned by its producer, however, was slightly different from the example of success the "Adams Chronicles" served for its sponsors. Although NEH officials and public television officials pointed to the "Adams Chronicles" as an example of the best that educational TV could do, Ms. Kassel contradicted their testimony before the House Appropriations Committee. She explained why she would never attempt drama again: "Drama places words in mouths . . . they are, finally, the creation of a dramatist. . . . The NEH review process as it now exists is incompatible with dramatic presentations."

At the request of the Honorable Sidney R. Yates, Ms. Kassel followed up her testimony before the Subcommittee on Interior and Related Agencies. By letter, she specified again that NEH procedures in which NEH university advisors could require modifications of the dramatist's point of view precluded any possibility of producing drama for educational TV. Because NEH and Public TV were doling out the money, producers and authors might knuckle under to get their programs on the air, but the requirements of hiring academics to include "broad issues" within each program's dramatic form was an accommodation impossible for authors. Ms. Kassel pointed out the folly of asking playwrights to rewrite seven and eight times to accommodate the indeterminate viewpoints of academic reviewers, but Congress ignored Ms. Kassel's testimony.

The funds to continue what would be described under any other historical circumstance as the procedures of propaganda were voted without opposition. Nor was any council on the arts, committee, commission, foundation, university, or corporation curious about Ms. Kassel's opinions. Hostility to independent thought meant that the most successful producer in Public Television's history had given up drama. The effects of propaganda's procedures and aesthetics were systematic. When applying for script or production monies, applicants were advised by officers of the National Foundation: "Don't be afraid to make it as dull as possible."

Aware that educational television was a spectacular failure, the 1979

Carnegie II report concluded, "stations have found that the best vehicles for fund-raising have been programs that do not threaten the audience's sense of well-being." The authors of Carnegie II avoided saying exactly what was meant by "audience," but in the context, Carnegie II clearly meant the audience who provided funds, not the audience who might watch the programs. To make clear that censorship was involved, Carnegie II went on to draw the parallel to whose "sense of well-being" might be threatened: "State colleges, for example, are often hard put to defend controversial professors."

Carnegie II authors also had a clear understanding of what had become of Public Television since the Carnegie I report. The programs that were *not made* were the programs that caused concern. The words that could not be spoken were a measure of the system's procedures. Program underwriters, said Public TV's most enthusiastic supporters, were inevitably obliged to serve only their own—not the people's—interests. "Sadly, we conclude that the invention did not work, or at least not very well. Institutional pressures became unbalanced in a dramatically short time. They remain today—despite the best efforts of the thousands within the industry and the millions who support it—out of kilter and badly in need of repair."

To repair the invention that had not worked, the 1979 Carnegie II Commission made two significant recommendations. The first could be summarized as lots more money. The second was a system of procedural reorganizations which were astonishing in their explicit hostility to political democracy. To cure the PBS stations of the corrupting necessity to raise money, Carnegie II included recommendations for five-year congressional appropriations with annual amounts reaching $1.5 billion per year. What had started at a mere $32 million per year had somehow grown in its "need" to a remarkable amount—equal to approximately half of all monies spent by the commercial networks for grubby entertainments such as sports, drama, and comedy. More surprising was that Carnegie II proposed to raise the $1.5 billion by a tax upon the commercial network channels. The monies collected would be transferred to education's network for disposal in the "public interest." To guarantee no outside interference, no inspection of revenues, no difficulties with budgets, no criticism, or complaints by the laity or by elected political representatives, Carnegie II recommended to the Congress the creation of still another new entity to be known as the "Public Telecommunications Trust." A panel composed of the librarian of Congress, the chairmen of the National Endowments for Arts and Humanities, the director of the National Science Foundation, "and two representatives from the system," would nominate a group of "distinguished citizens." From the list of nominees, the President of the United States would appoint nine trustees, each of whom would serve terms of nine years, but their terms would be staggered in such a way that once anointed no mere president

of the United States would ever again have the opportunity to choose more than three—if the Lord was willing and death took no toll. The anointed trustees would then, on their own motion, create still another statutory nonprofit corporation called the "Program Services Endowment," and the trustees would appoint to the endowment's board fifteen directors. These ordinaries, along with appropriate staff support, would choose the programs considered to be "of social benefit," and spend the $1.5 billion appropriated by the Congress.

Not only were the amounts of the funds remarkable, but the mechanics of layered "private" corporations were marvels of immunities. They were precise demonstrations of the Carnegie Commission's distaste and distrust of what was once described as democratic politics. Carnegie II wondered: "How can public broadcasting be organized so that sensitive judgments can be freely made?" Carnegie II asked how "creative activity could be freely carried out without destructive quarreling over whether the system is subservient to a variety of powerful forces including the government?"

The answer was to make of Public Television its own insulated government: thereafter, no quarrels would be possible. The Carnegie Commission concentrated, it said, upon the design of national organizations by which the system could enjoy a stable source of "funding without threat of interference with programming independence." Diversity, as Carnegie II called the results of independence, would not please some, "notably the book burners and the dogmatists among us." It would startle and anger others, "as well it should." But the Carnegie Commission concluded, "we have discovered in our own time that anger yields to understanding. America needs, perhaps even more than healing, a sense of understanding."

Surely, we must understand one another. The advocates of public broadcasting made clear how citizens were to be educated by television, and what democracy would have to understand would be determined by a self-anointed trust of "distinguished citizens." The difficulty with the language of the Report of the Carnegie Commission on the Future of Public Broadcasting was that it was impossible to know whether it really meant what it said. If the Carnegie proposals were taken literally, the procedures outlined were a parody of syndicalist institutions created in the 1920s in Italy. If, on the contrary, these examples of syndicalist theory were ignored, then what was meant by the last sentence of the report's conclusions? "Unless we grasp the means to broaden our conversation to include the diverse interests of the entire society, in ways that both illuminate our differences and distill our mutual hopes, more will be lost than the public broadcasting system."

Whatever it was that might be lost—order perhaps, or obedience—whatever differences were to be illuminated or hopes distilled, conversations upon the national culture were apparently unrelated to art, litera-

ture, music, poetry, drama, comedy. These crafts, or the consequences of their performance, had nothing to do with what was proposed for Public Television. They were not discussed. The testimony of Virginia Kassel was irrelevant. The independent authors who had quit her series were insignificant to the highpurpose at issue. On the contrary, the boards of directors of all educational corporations—universities, CPB, PBS, community ETV stations, foundations such as Ford and Carnegie—were associations of particular political and social forces. The careers of Dr. Killian, Henry Loomis, Dr. McGill, and Dr. Flemming uniformly illustrated the executive and administrative skills necessary to national orthodoxy both at universities and in government, particularly in science, but usually in the behavioral sciences, and always for organizations whose operations were conducted in the utmost secrecy. They were men who had Q clearances, who knew high energy transmission theory and propaganda. They had little or no experience in literature, theater, movies, television, music, or art. They were theorists of "utility." Their deliberations were conducted by boards of directors whose majorities consisted of other academic administrators like themselves, and bankers, cement contractors, and corporate lawyers. In many instances their boards of directors included representatives of the principal lobbyists for their board's own decisions. One scholar, one entertainer, one soprano might join their deliberations, but never more than three. Although these corporate boards were actually agencies of government's purposes, a claim was always made that the board's deliberations were "private," because a "private" corporation or university directorate would be exempt from the ordinary inquiries of legislators, journalists, or anyone else about the conduct of their affairs.

In his testimony before Congress on Freedom of Information legislation, CPB President Henry Loomis made clear that CPB did not, and would not, comply with the law applied to all other government agencies against secret deliberations. "I doubt you will find another private corporation so committed to public understanding of its works and activities," Loomis explained. Indeed, CPB's commitment to the principles of open government was a continuing one, Loomis assured Congress, "limited only by the sensitive nature of some of its functions."

Those functions of CPB that were sensitive would have to be declared secret—voluntarily, of course—by CPB itself and no one else; otherwise CPB would be subjected to political interference. Neither Congress, nor any ordinary citizen who might raise politically awkward questions, should have any reason to doubt CPB's goodwill and commitment to public understanding, but when all was said and done, CPB had been created as a private corporation, and as a *private* corporation CPB was exempt from the laws applicable to *public* works and activities. Although CPB might appear to be funded from the public treasury, CPB's opera-

tions were independent of mere "political" review—surely that much ought to be clear—and were therefore "sensitive."

The formulation of what might be sensitive about CPB's operations was remarkably similar to the explanations usually provided for what was classified as "Top Secret" about the operations of the United States Information Agency and its Voice of America division—overt agencies of propaganda which, appropriately, CPB's Dr. Killian and Henry Loomis had been instrumental in creating through their secret reports for the Psychological Warfare Strategy Board in 1950–52. USIA and VOA were founded, along with CIA, at the height of the cold war to counter by "psychological" means the propaganda of expanding Marxism. Allies could be strengthened by appeals to common traditions, it was said; enemies weakened by creating chaos in their camps; trumpets had brought down the walls of Jericho and "culture," it was argued, "could be a weapon more effective than weapons."

President Eisenhower, war hero and former president of Columbia University, supported the creation of the new institutions, but Congress was queasy at first. A few recondite orators of the old school spoke passionately to their colleagues: a nation which understood itself to be constantly at war would eventually adopt the manners and customs of a garrison state. After debate, Congress enabled the new institutions as exigencies of the cold war, but to ensure that no administration might use agencies of propaganda to domestic political advantage, the activities of USIA and its VOA broadcast division were carefully circumscribed by clause after clause in the law. There were to be no domestic operations, no domestic broadcasts—not even long-wave broadcasts, as opposed to short-wave frequencies, because long-wave might be overheard inadvertently by some idle citizen of New Jersey. There were to be no extralegal contracts or connections within the domestic territories which would have the effect of licensing otherwise forbidden domestic operations. A "private" corporation could be established in Germany, such as Radio Free Europe, to broadcast behind the Iron Curtain, and the money for the operation might be raised at a dinner held at the Foreign Policy Association at 68th Street and Park Avenue in New York City, but the broadcasts had to be carried out on foreign soil by foreign nationals in foreign languages. There were to be no interagency agreements, or interlocking arrangements with other United States agencies, or with corporations or universities by which the many proscriptions against domestic propaganda could be circumvented. Just as Congress had originally hedged about the operating charter of CIA so that CIA could never establish itself as a domestic Ministry of Intelligence, Congress similarly restricted the charter of USIA to avoid the establishment of a domestic Ministry of Culture. Having deliberated at great length and with solemn concern, Congress promptly contradicted itself by hiding the budgets for CIA

within the appropriations of other departments, including Defense, State, and USIA.

Early proponents of USIA, including CPB's Dr. Killian and Henry Loomis, cited the lessons to be learned from Great Britain's example. The Creel Committee, Britain's propagandists for United States entry into World War I, was instrumental to President Wilson's decisions. The English-Speaking Union, Britain's propagandists for United States entry into World War II, supported President Roosevelt's objectives virtually alone, harried his opponents to distraction, and won the hearts of the uncommitted. Above all, the BBC, voice of Britain's empire, was demonstrably worth fifty destroyers and perhaps launched a thousand ships. The BBC was remarkable for its consistent reliability. The BBC's propaganda was effective because the entertainment programs it provided were of the highest quality, and because its news broadcasts were unfailingly "objective." Although the BBC was the propaganda agency of Britain at war, the BBC was run as if it were a private corporation. If certain things were never mentioned among gentlemen at the Carleton Club, nevertheless the BBC carried a quality in its "voice" recognizable to other members.

The voice of Britain was moderate, genial, patient. It never shouted, as did Nazi propaganda. BBC News was always accurate, with every "i" dotted and every "t" crossed. If Welsh coal miners struck against the mean and absent operators of the mines in the midst of war, the news of the event could not be "objectively" reported until the situation was "clarified." Meanwhile, BBC entertainment emphasized those brilliant examples of high culture created and maintained by England's sturdy kings and queens against the depredations of barbarians wherever the agents of the Crown had happened to encounter them—on the riverbanks of the Ganges, along the Rhine, even from time to time along the Hudson. The BBC made it obvious to the conscience of Europe that the London Symphony's Beethoven was worth a hundred Nazi marching bands.

Because the BBC enunciated Britain's hopes in the accents of Oxford and Cambridge, it was sometimes accused of "elitism." Yet the BBC understood "elitism" to mean "excellence," and the BBC demonstrated how "excellence" was necessary to the education of the West, a civilization stricken by the horrors of still another war. The BBC never proposed, never argued for, any new day. On the contrary, the BBC applauded only victories, and kept a watchful silence when there were defeats. The political policy of its directors was always "independent," they said, of whatever party happened to be seated as the majority in Parliament. To assure the continuance of the Voice of Britain, the BBC explained its politics as just slightly to the left of the party in power: under Tory ministries, the left-wing of cosmopolitan London; under Labor ministries, the genteel left of socialism.

Similarly, BBC broadcasts were designed to reach an audience just as purposefully defined. The BBC audience was never to be measured in

mere numbers. On the contrary, the BBC defined its audience to be those few who were presently in power, both at home and abroad, or those who might come to power within the next generation. George Orwell's broadcasts to India during World War II were heard, he believed, by no more than a handful of Indian students resident by chance at Oxford and Cambridge, never by the surging population in India itself. The BBC explained it never expected anything else. The BBC was the reasonable, well-spoken, sensible voice to be heard by civil and corporate servants of empire, regardless of their actual number, or where the current war was actually being fought.

The BBC's policy for effective propaganda was a persuasive model. Later it would turn out that CPB and PBS would not broadcast Shakespeare as produced by any shoddy American company, but would only approve productions which carried the national British stage accent of the Royal Shakespeare Company: the phrasing of London was the only appropriate language for Michigan. In fact, audiences for American Public TV soon grew accustomed to gorgeous displays of the Union Jack as programs opened, although the programs were funded by what once had been a revolutionary Congress and Time, Incorporated. Inexplicably, American audiences were delivered, as part of their educational experience, leftover video tapes of week-old English soccer matches—Leeds–1; Birmingham–0.

To the extent that CPB and PBS adopted BBC policy and rebroadcast BBC programs, the Voice of America was also established in conscious imitation of BBC policies, lacking only a domestic branch to its activities, and circumscribed by a querulous Congress. From the beginning, the limitations put upon the information broadcast by USIA and the information gathered by CIA created obstacles to those agencies' accomplishment of their "sensitive" responsibilities. The restrictions were "inappropriate." In the first place, it was totally unreasonable to engage in either intelligence activities or propaganda without depending upon national cultural institutions: plain nonsense, and hypocrisy besides, to expect the designated agencies to carry out their duties without acting in cooperation—indeed, coordination—with university and private corporations already established on foreign soil. Culture knew no boundaries. Experts on the history of Nepal, or high-frequency radio transmissions, or Romanian ball-bearing production, remained experts on their subjects no matter where they happened to be. If they occupied a chair at the University of Berlin, the agencies' contracts were unrestricted by congressional authority. If they occupied a chair at Berkeley or Harvard, the limitations of congressional vision would have to be gotten around —that's all there was to it.

Of all intelligence information, 90 percent was derived from studying published works available on the open shelves of the nearest university library. The difficulty, of course, was which bibliography to search. Those

who read, digested, analyzed, and interpreted published materials were most likely to be found at the nation's own universities, as well as at the universities located on foreign soil. Every so often complaints were gotten up against the CIA, because CIA was apparently recruiting scholars upon this campus or that, but where else could CIA recruit scholars, if not upon a campus?

Despite the romantic notion that spies should look like James Bond, drive fast cars, and sneak around in Burberry trenchcoats with tiny cameras tucked into their pockets, the best source of intelligence for estimates of ball-bearing production would be what the corporate manager of one ball-bearing factory told the corporate manager of another ball-bearing factory—particularly if both factories were subsidiaries of the same Delaware corporation. Not only were minicameras, bugging devices, and other such paraphernalia inappropriate to the information exchanged, even after intelligence was gathered someone had to know what it meant. In the case of ball bearings, production estimates were best interpreted by ball bearing plant managers because not one James Bond would ever have the foggiest notion of what the plant managers were talking about.

Similarly, the single best source of information for Voice of America broadcasts had always been the Associated Press newswire, just as A.P., U.P.I., Reuters, and Dow-Jones were the prime sources for national intelligence estimates compiled by CIA for the president and the National Security Council. In sum, there never was any reasonable division by which information collection, intelligence, or information distribution —propaganda—could be separated by function into domestic and foreign networks. The left hand inevitably knew, regardless of what Congress had authorized, what the right hand was doing.

Continuing confusion by Congress and the officers of national culture over what was "sensitive" to either intelligence or propaganda resulted in astounding hypocrisies. Each morning a CIA briefing officer prepared for the president's breakfast an intelligence "estimate": a quick wrap-up of the news-of-the-day. In preparing the estimate, it was not at all unreasonable if CIA digested the front page of the *New York Times* or summarized the previous evening's "CBS Report." Perhaps the president had been scheduled to attend a reception at the Kennedy Center and had been unable to find out whether that's the way it was, Thursday, January 30, when Walter Cronkite's team said so. What was peculiar, however, was for CIA then to classify as Top Secret exactly what Cronkite had broadcast to millions the night before.

Similarly, the cable traffic of the Voice of America consisted of news gathered from thousands of available sources, then digested, reworded, and broadcast in dozens of languages. As compared to the commercial wire services, USIA cable traffic had justly earned a reputation not only for a consistent blandness, but a voice so moderate that it was difficult to

hear without falling asleep. The style of USIA was essential to its policy —credibility depended upon "objectivity," even if carried to extraordinary lengths. The corollary was that the contents of USIA dispatches were, by their intrinsic nature, impossible to classify as "sensitive matters of national security," because of how the materials came to hand and where they were going. It made no difference what secrecy stamp USIA or VOA affixed to their documents, nor how often they declared that their operations had become secret.

But the phrases "sensitive" and "national security" soon carried momentum of their own in *newspeak* as coded substitutes for the word *secret:* not because the facts at hand were actually secrets, but instead because the purposes to which the facts were put had to be kept secret from boisterous democratic opinion. As everyone knew, *secrets* were usually established in hierarchies, such as: "confidential," "secret," "top secret," and eventually even higher mysteries deep within the magic circle and whispered only by confirmed initiates to each other with mysterious letters, such as Q. Among the high priests themselves, distinctions were made about what types of knowledge deserved which order of "secret" classification. The first network of understanding usually justified was all information that could be designated as military, particularly that data connected to the ganglia of scientific invention.

Technology was sensitive to national safety because the devices of science were considered the essentials of war. Hence, the capabilities and limitations of war machines had to be guarded against enemies present and future. For many reasons, technology had acquired the same status once reserved for the never-spoken secret name of tribal gods—if any tribe's enemies ever understood, defeat inevitably followed. The taboo against discussion of technological devices continued even after the machine had been duplicated by and delivered to foreign powers. The taboo remained in force even if it subsequently turned out that the machine did not work very well, or not at all. Specifications for jet fighters remained secret regardless of how many nations had purchased them, flew them, or whether the aircraft would fly at all. The process by which uranium fuel rods were manufactured was a most holy secret regardless of how many were delivered for the operation of Romanian nuclear plants; even when, attempting to deliver such blessed devices, the Department of Energy somehow was able to lose a taboo bundle of the mysterious necessities for sacrifices of technological transubstantiation.

Understandings secret to national safety with respect to technology were taboo regardless of whether any showing could be made that technology was in fact efficient to the war in progress. Missiles ranging in size from bazookas to unimaginable showers of multiple reentry warheads were entirely taboo, regardless of whether treaties were to be based upon their display, irrespective of where they were said to be hidden, even if the same machines were to be trucked into a huge subway tunnel

beneath the deserts of Utah, and regardless of whether the missiles them-
selves were appropriate at all to the conditions of war under debate.

No matter what fantastic technology was in itself secret, the under-
standings necessary to the operations of wars actually in progress were
equally sensitive. Inadvertently, Congress had authorized CIA to engage
in acts of war even against what otherwise might be described as
"friendly powers," or allies. This second network of information and
propaganda clearly deserved the secret classifications awarded, because
the "black arts," as they were called, were being employed in "covert
operations," which included, but were not limited to: assassination plots,
guerrilla activities, the subornation of priests and ministers, sabotage,
propaganda, and what not. Domestically, of course, these activities—
even if only contemplated—were prosecuted as "criminal conspiracies."
Abroad, the same efforts were patriotic necessities. In any case, whether
heads of state ought to be murdered, or whether CIA should install a
corporal's son upon the Peacock Throne as shah of Iran, were questions
Congress judiciously avoided, because such wars were by their nature
secret anyway. From time to time some improvident journalist might
stumble across evidence of how these wars were being conducted, but
after the appropriate oversight investigation asserting traditional congres-
sional legislative authority, the entire matter would have to be forgotten.
If the journalist happened to have been correct, his discoveries would
then be declared taboo and secret. The journalist could be required to
account for his breach of the national security. If his reports were not
quite accurate, the press could then be declared "irresponsible."

After technology and war, the third type of knowledge which was clas-
sified "secret" actually did violate the oldest taboo between nations, yet
it seemed to trouble the Congress least of all. Understanding of foreign
cultural affairs was always a secret, and traditionally had been gathered
by the United States Department of State, most recently by its Cultural
Affairs division. In brief, the secrets which would determine history in
Persia would not be oil or the accession of some witless shah, but would
depend upon the coloration of Iran's social landscape by Iran's cultural
perceptions—and Iran's emotional history was Moslem. The language,
customs, traditions, manners, intellectual certainties, political institu-
tions, economic systems, army, diplomacy, and geography of Iran, taken
together, created its culture, which was a continuum of emotional reali-
ties.

Assessments of culture by reporters of the nation's department of for-
eign affairs were necessarily secret. Cultural affairs reports included gos-
sip, estimations of character not necessarily flattering, variations in bank
deposits, attendance at receptions for the great and near-great, but also
clandestine contacts with the not-so-loyal opposition. Traditionally, the
cultural affairs officer at an embassy knew not only the language, history,
and geography of the country, but gathered intelligence while simulta-

neously distributing propaganda. Suitable topics ranged from geopolitical metaphysics to a certain knowledge of whether the tyrant's present mistress danced well, or perhaps needed a size six delivered from Saks Fifth Avenue.

America's first minister to France, Benjamin Franklin, could still be cited as unequaled in his ability to understand France's desires to the benefit of United States necessities. To actually understand the nuance of an idle remark by a tipsy prince was frequently *ipso facto* to hold a valuable secret, particularly if the prince was not well loved by either his subjects or his ministers. A tyrant might be considering a vacation in Switzerland. Insofar as United States policy was concerned, his imminent departure would inherently be a secret. Yet, the difficulty with secrecy —technological, war, or diplomatic—was that it corroded initiative. Some secrets might be necessary. Too many secrets inhibited action. Ben Franklin's solution as ambassador to France was to employ knowingly the chief of Britain's intelligence service as his private secretary and simultaneously to keep an agent of France as his mistress. He believed he gained two advantages by incorporating the spies of England and France into his household during war: he would know which secrets were breached; he would also be sure that his dispatches were delivered to the Continental Congress immediately after they had been read in London. Arguments could be sustained at length over what should be secret and what should not, but those arguments were sustainable provided the reasons for secrecy were not to institutionalize power for a few, or—what was really much the same thing—to avoid initiative by disguising political failure.

On April 1, 1978, by a reorganization order of President Jimmy Carter, the Cultural Affairs division of the U.S. Department of State was severed from State and merged into the operations of USIA, creating under the reorganization a new cabinet department known thereafter as the International Communications Agency (ICA). All those materials of understanding foreign cultural affairs previously gathered by the Department of State—whether legitimately secret or not—were combined with all those materials used for the purposes of propaganda by USIA, its broadcast division VOA, and whatever connections were maintained with CIA, university, and private corporations.

Then, on October 19, 1978, under the aegis of the Federal Council on the Arts and the Humanities, to further coordinate the sprawling and haphazard efforts and to establish "an active, well-coordinated national culture" by dozens of ministries and hundreds of programs devoted to such activities, John E. Reinhardt, director of the new ICA, NEA Chairman Livingston Biddle, and NEH Chairman Joseph D. Duffey jointly signed a "Memorandum of Understanding" at the White House.

Line after line in the October White House Memorandum contradicted the repeated assurances of national officers that they were not party to

the establishment of a White House Ministry of Culture, but the State Department's Cultural Affairs division, the propaganda activities of the United States Information Service and the Voice of America, and joint operation of propaganda programs by ICA, NEA, and NEH were incorporated under ICA's jurisdiction. Since the White House Ministry of Culture was as undebated and uninspected as was the reorganization by which ICA was created, Congress said nothing at all about any of the goodworks in progress.

Never mind: the October Memorandum set clear guidelines for ICA, NEA and NEH. The guidelines would serve as the authority "to cooperate in specific activities leading to improvement of the cultural representation of the United States." Since the three agencies had complementary goals, it was said, ICA, NEA, and NEH would jointly select those overseas programs considered to be "the best choices to represent the United States." Conversely, of course, the coordinated agencies would never, never approve those cultural efforts that were not the best choices to represent the United States. Discretion would be the very heart of the matter, but joint operations would "enhance the efforts of each agency to carry out its mission." The Memorandum of Understanding quoted President Carter's definitions of ICA's responsibilities, and noted how ICA's duties were consistent with those of NEA and NEH: "To tell the world about our society and politics—in particular our commitment to cultural diversity and individual liberty."

The October Memorandum absurdly assumed that ICA's responsibility to wage war by propaganda and gather secret intelligence complemented the missions of NEA and NEH to make the arts "accessible." Under the direction of the Ministry of Culture, ICA, NEA, and NEH would jointly discuss "and establish United States international cultural policy." Should there be any misunderstanding, President Carter charged the coordinating ministries with the responsibility for making "active use of the arts," because art's utility consisted of its ability to communicate "more effectively than weapons."

The international, as opposed to domestic, activities of NEA and NEH were to be coordinated by ICA, as well as by other federal officials not specified, and by "experts as appropriate." To carry out these commitments, John E. Reinhardt, director of ICA, supervised a budget of more than $500 million and nearly 9,000 employees at 189 posts in 120 countries. About half of ICA's employees were American and the other half hired in the "target" host country after security clearances. ICA's best-known cultural activity was the Voice of America, which broadcast 803 hours of radio programs each week in thirty-six languages via short- and medium-wave broadcasts from 109 active transmitters generating more than twenty-one million watts. VOA programs, it was said, were "also made available to local stations in many countries." Some of the capabilities and limitations inherent in such a broadcasting system required Q

clearances; whereas "outgoing airgrams" to CINCMEAFSA for POLAD by cultural affairs officers summarizing what could be understood in some place such as Iran needed merely to be stamped SECRET, as President Carter put it, "to adequately understand foreign public opinion."

In addition to its radio facilities, ICA acquired and produced videotape and films. Almost 200 videotapes were produced each year in ICA's own production facilities; but about 100 films were produced and another 300 bought from "private" sources. ICA also supplied foreign TV stations with newsclips. ICA published fourteen magazines in sixteen languages, produced and toured ten major exhibitions per year—ranging from American art to a typical American all-electric kitchen—and operated the United States educational and cultural exchange programs. In coordination with university corporations, ICA ran lectures, seminars, symposia, the Fulbright scholarship program, toured foreign leaders in government, labor, science, and education through the United States, and sent American specialists to foreign countries to "participate in trans-national dialogues with fellow experts." To keep track of these various activities, ICA operated a radioteletype newswire in English, Spanish, Arabic, and French simultaneous transmissions.

The complex international operations of ICA could only be roughly summarized, but the "mission" of ICA was twofold: the manufacture of propaganda formerly carried out by USIA; and the collection and analyses of cultural developments in foreign countries formerly made by State's Bureau of Cultural Affairs. The distinction once had been that USIA explained American opinion to others, while State informed the president of foreign attitudes. Both of these activities necessarily carried with them various classifications, from merely "confidential" to the most mysterious categories in which the classification designating secrecy was itself secret. The newly established ICA was advised by President Carter, therefore, to "seek guidance" from the secretary of state because all—every single one—of ICA's activities might bear upon "the nation's foreign policy and interests."

In wishing ICA every success in the performance of its duties, President Carter reminded the agency that ". . . the Agency will undertake no activities which are covert, manipulative, or propagandistic. The agency can assume—as our founding fathers did—that a great and free society is its own best witness, and can put faith in the power of ideas." ICA Director John E. Reinhardt said he agreed with President Carter that "it is a mistake to undervalue the power of words and of the ideas that words embody."

To advance the ideas in the nation's best interest, the White House October Memorandum spelled out how ICA, NEA, and NEH would coordinate activities. Lists of grantees favored by the twin endowments of Arts and Humanities would be turned over to ICA's staff "on a regular basis." Both NEA and NEH would "work with ICA" in producing maga-

zines, VOA broadcasts, and exhibitions. Although no legislative author-
ity existed for such domestic operations, films and documentaries
produced under grants from NEA and NEH for broadcast by PBS would
be "made available" to ICA for international distribution "as appropri-
ate." Exactly which authorities decided what was appropriate was not
specified—except inferentially as those who believed in the power of
ideas.

Domestically, the two endowments would continue to assist in "brief-
ing sessions for Cultural Affairs Officers." The content of these briefing
sessions on matters sensitive to the nation's foreign policy and interests
would not be appropriate for public discussion, except at the voluntary
discretion of the agencies involved. The "appropriate" ICA staff would be
welcomed at the "closed" sessions of the two endowments' "peer-review
panels," as well as the "closed" portions of NEA and NEH National
Council meetings.

Jointly ICA, NEA, and NEH would explore "the means by which"
private foundations and corporations could be "assisted" and encouraged
to fund "arts and humanities activities." If these syndications seemed to
imply that the Ministry of Culture would be engaged in fund-raising, or
that the Joint Memorandum guidelines thereby incorporated public rela-
tions and educational efforts to the benefit of the Corporate State, such
procedural coordinations were only designed to "enlarge the scope of the
endowments' activities and the area in which they are able to serve the
arts, artists, and scholars of the United States."

Working together—under the direction of the coordinating Ministry of
Culture—ICA, NEA, NEH, foundations, and university and private Cor-
pos were to give "foreign peoples the best possible understanding of our
policies and our intentions," as President Carter explained it, "and suffi-
cient information about American society and culture, and why we have
chosen certain policies over others." Unfortunately, in putting America's
best foot forward there was now uncertainty about what was secret, or
not secret, for the national safety. What was "sensitive" might, or might
not, include technology, war, cultural affairs in foreign countries, but
also education, arts, humanities, personal histories, and cultural insights
"classified at birth," even if derived from private study or singular expe-
rience.

Author Frank Snepp described his experience as a CIA officer in Viet-
nam in *Decent Interval,* published by Random House. Mindful of the
Carter Administration's commitment to cultural diversity and human
rights, the Justice Department brought suit against Snepp on the grounds
that he had violated the terms of his contract with CIA, and therefore the
royalties he had earned as an author were due instead to CIA. The govern-
ment made no claim that Snepp had violated even a single element of
"national security." Nor did the government assert that any secret of any
kind had been divulged. On the contrary, Snepp's history was offensive

to the United States of America because, and only because, Snepp did not have his government's permission to publish his opinions—as opposed to William Colby, Henry Kissinger, Cord Meyer, Jr., and other former national officers who did have permission for their versions of history. If CIA's successful suit in the federal courts against author Snepp seemed capricious, Admiral Stansfield Turner, director of CIA, explained the reason for its prosecution succinctly: "Otherwise, the agency would have no visible means of control."

Admiral Turner admitted Snepp had been "circumspect," but visible means of control were necessary over independent initiatives. At the time of the establishment of ICA and its coordination with NEA and NEH, ICA officer Ronald Humphrey was discovered passing VOA cable materials to David Truong, including materials from the ICA radiotele-type simultaneous newswire in French. David Truong was a student in Washington, D.C., and son of Truong Dinh Dzu, a runnerup but unsuccessful candidate for president of South Vietnam. Perhaps the candidate's son was attempting to understand our policies and our intentions. Perhaps he was providing information about American society and culture to distinguish why we had chosen certain policies over others, just as President Carter had instructed ICA to do.

But how David Truong, as a resident of Washington, D.C., made his estimations was not clear. Even with all of ICA's cable traffic in hand, and supposing David Truong turned every scrap of it over to his father— instead of requiring the former candidate to listen to it on VOA—and even supposing the father had not drifted away into sleep under the weight of ICA's studious "objectivity," nothing young David Truong learned was sensitive to the national safety. But President Carter, never underestimating the power of words nor the ideas that words embody, authorized emergency national security electronic surveillance of David Truong. By bugging a student in Washington, and with the aid of another Vietnamese resident of Virginia—a paid informer of the Department of Justice—the FBI obtained clear evidence that ICA's Humphrey was passing materials which put America's best foot forward to Truong. Even if these materials carried no information of a sophisticated technological nature, or the conduct of war past or present, cultural materials could be just as effective as weapons. Therefore, agents of the FBI determined from tapped telephone conversations to a paid informer in Virginia that David Truong had committed a felony in Virginia, and therefore could be arrested in Washington, D.C., and charged along with Ronald Humphrey for "conspiracy to commit espionage."

Truong was arrested for telephone conversations to Virginia because, in the opinion of the Justice Department, the venue in the federal courthouse in Alexandria would be more likely to result in a successful espionage prosecution than a venue in the federal courts within the District of Columbia. Federal judges in the District might take a skeptical view of a

Justice Department prosecution for espionage when no war was in progress, without any enemy specified, and without any secrets for evidence. Immediately following Truong's arrest, Attorney General Griffin Bell announced to the president's cabinet, "We've caught a spy! We've finally caught a spy!"

During the pre–trial maneuvering, the attorney general of the United States was asked why he had not obtained court orders for the electronic surveillance of Truong—weren't the courts open on the day the attorney general had authorized the bugs? Mr. Bell declared that Truong presented the administration with a national emergency, and therefore time was of the essence. Although the district courthouse was less than four blocks distant from Bell's office, there was insufficient time to follow the required procedures. Besides, the attorney general conceded, he was on his way to the Kentucky Derby that afternoon, and a national security emergency consisted of whatever he declared it might be, whenever he chose to declare it, and in whatever jurisdiction he believed appropriate.

Although no showing was made during the trial that the national safety had actually been endangered—largely because the judge would not allow any argument on what was or was not national security—Ronald Humphrey and David Truong were convicted of "conspiracy to commit espionage" on the basis of Truong's possession of ICA cable traffic marked "confidential." As a result of the judge's instructions, the jury understood their duty to reach a decision on whether Humphrey and Truong had *possession* of the cables in question, not whether the cables contained any actual secrets or the national safety was in any way compromised. Setting aside the issue that no national enemy could be specified, the judge sentenced these two vicious, sneaking spies to fifteen years each in prison during peacetime. Since ideas could be, as the president had said, "more effective than weapons," the possession of unauthorized words was dangerous.

Litany/Telescreen Vidtape: Script for 1984 Convention
Fade In:

CU: Tally clerk on podium as she begins roll-call of states . . .
Tally Clerk: "Alabama, 45 votes!"

Cut To:

Medium: Alabama Delegation on Convention Floor. As Alabama delegation announces vote, roll super *National Endowment for the Humanities Challenge Grant Awards FY 77-78-79 (Annex 5):*

Andalusia Public Library (3)	$ 26,000
Huntsville Depot Museum (1) Award Declined	100,000
Huntsville Museum of Art (3)	237,500

Cut To:

CU: Alabama leader . . .
Alabama Leader: "Alabama casts 45 votes for . . ."

Cut To:

CU: Tally Clerk on Podium.
Tally Clerk: "Alaska, 12 votes!"

Cut To:

Medium: Alaska Delegation on Convention Floor. Roll Super, *NEH Challenge Grant Awards.*
University of Alaska Museum (3) 85,000

As Podium Unit pans faces on Convention Floor, FADE CONVENTION AUDIO UNDER: VO SPONSOR ANNOUNCEMENT, ROLL SUPER SPONSOR CREDITS . . .
VO: "This program has been made possible by grants from . . .

<div align="center">

The EXXON Foundation
The Ford Foundation
The Chubb Group of Insurance Companies
and
The Corporation for Public Broadcasting

</div>

END SPONSORS VO. FADE SPONSOR SUPER. PICK UP AUDIO FROM CONVENTION . . .

CU: Tally Clerk Podium.
Tally Clerk: "California, 307 votes!"

Cut To:

MEDIUM SLOW PAN: California Delegation. As California Delegation announces vote, roll super, *NEH Challenge Grant Awards . . .*

California Institute of Arts (1)	$ 70,000
Chinese Culture Center (2)	75,000
Claremont Graduate School/Institute for Antiquity and Christianity	117,500
Claremont Men's College (2)	25,000
De Anza College (2)	8,000
Exploratorium (2)	100,000
Graduate Theological Union (Berkeley) (1)	48,000

Henry E. Huntington Library and Art Gallery (1)	850,000
Judah L. Magnes Memorial Museum (Berkeley) (1)	55,000
KCET, Community Television of Southern California (3)	175,000
KQED Public Television (1)	220,000
La Jolla Museum of Contemporary Art (1)	10,000
La Verne College (2)	24,000
Los Angeles County Museum of Art (1)	312,500
Norton Simon Museum of Art (1)	200,000
San Francisco Museum of Modern Art (1)	225,000
Santa Barbara Museum of Art (1)	150,000
Scripps College (3)	150,000
Stanford University (3)	1,500,000
Stanford University Press (3)	100,000
University of California, Berkeley (3)	300,000
University of California, Los Angeles (3)	750,000
University of Redlands (2)	19,500
University of Southern California (1)	225,000

Cut To:

CU: California leader . . .
CALIFORNIA LEADER: "California casts 307 votes for . . ."

12

POTPOURRI / GOODWILL, GOODWORKS, AND CENSORSHIP . . .

There was to be only one: The American Corporate State and Patriotic Party—
no! added the President, with something of his good-humor: "there are two
parties, the Corporate and those who don't belong to any party at all, and so, to
use a common phrase, are just out of luck!"

—SINCLAIR LEWIS
It Can't Happen Here

Like guns, ideas were to be registered, and subjected to regulations for their control—a radical departure from the limits to political power imposed by the once-upon-a-time Constitution. By incorporating every social end under political authority, Congress had cast off from the moorings of the past to voyage upon an unimaginable future. All goodworks were delegated to the jurisdiction of committees active in coordinating the Great Society. The arts were declared "the essence of our lives," and therefore were to be regulated by a Ministry of Culture, which included among its powers and patrons NEA and NEH—those guiding lights, as Mrs. Mondale had described them—but also the Department of Education, PBS, CPB, and the university corporations, foundations, private corporations, the agencies of psychological warfare and foreign intelligence, the General Services Administration, the Smithsonian Institution, the National Park Service, the National Science Foundation, the Labor Department, and any other national officer or "expert, as appropriate."

By incorporating all "appropriate" goodworks under the unlimited powers of the Great Society, every social activity undertaken by any national officer was authorized by law—provided only that whatever was done could be declared, *ipse dixit,* as having been proposed in goodfaith. Conversely, any purpose determined by national officers to be "not in the

national interest" was a *prima facie* disloyalty—a heresy for which the penalties ranged from nothing more than public confession all the way through extreme measures, such as excommunication or fifteen years in prison for conspiracy to commit espionage. But as the Great Society asserted its jurisdiction over every community hope, politics discovered it had been sold, with a chain secured around its neck, to party. It was party, not elections, which defined goodfaith. "We don't feel that it is good government," said White House spokesman Rex Granum, "to have people within the Administration undermining the President's policies."

Loyalty oaths were extracted, pledging allegiance not to the flag, but to party faction. In 1979, supporters of Senator Edward M. Kennedy who lurked among the administration's political appointees were advised that they "ought to go somewhere else to work." Goodgovernment could not tolerate a variety of opinions. The White House began a survey to determine exactly who Senator Kennedy's suspected supporters might be. Goodgovernment would root out heretics. Those who lacked civil service status were to be fired. "If they are not loyal to the president," said a senior White House aide, "we don't want them on the federal payroll anymore." Hamilton Jordan, White House chief of staff, was not sure of the extent of the "political problem posed by Kennedy loyalists"—perhaps hundreds of them were "positioned somewhere" in the national agencies—but he pointed out that federal law required all government employees to give forty hours work per week to the government. Moreover, government employees were covered by the Hatch Act, according to Jordan, and the Hatch Act barred national officers from using the powers of their offices in political campaigns. "To the extent that any government officials can and do become politically active," said Jordan, "we expect them to be active in behalf of the president." The Hatch Act would be used to prosecute independent thought, but suspended for all the president's men.

President Jimmy Carter had made the matter plain. He intended, he said, "to reward his friends and punish his enemies." Some national officers were concerned they would be tagged with a "Kennedy" label merely because they supported positions or policy assessments similar to those supported by the Massachusetts senator. Even those who consented to the day's orthodoxy were not above suspicion. White House Press Secretary Jody Powell explained, "Some of them have already come to us and said that if we had any question about their loyalty, they wanted to reassure us they were loyal to the President."

The distinctions between party orthodoxy and heresy were demonstrated in October 1979 during preparations for an election of delegates to a party caucus in Florida. As far as anyone could determine, the results of the Florida caucus were entirely meaningless. The White House had announced, however, that perceptions in politics were more important than any realities. Sometimes two and two were five. Therefore, party

officials loyal to the president engaged in a contest for delegates to a meaningless party caucus with a heretical faction of the party said to be loyal to Senator Kennedy. The delegates chosen in the Florida contest then met in a state convention, where they conducted among themselves a straw poll as to their presidential preference. The results of the straw poll were duly reported in all the national newspapers and examined for auguries by objective interpreters upon the evening TV news.

The October Florida straw poll was neither binding nor relevant to the party's primary election held in March, 1980. The outcome—victory by the president's party—in the March primary in Florida was also examined at length in the columns of the national newspapers and upon the evening news, but the president's March, 1980, primary in Florida was not to be confused with the party's previous caucus election in October, 1979, when for the sake of perceptions, the party chose 877 delegates by contest, elected another 139 by party executive committees from Florida's counties, and appointed another 703 delegates because they were said to be party leaders or public officials loyal to the president. About half of the delegates were not elected by votes, but appointed by the party anyway.

To ensure that perception took precedence over reality in the early October caucus, party officials loyal to the president and officials of the National Education Association went to work on the party's affairs in Florida. The National Education Association had promised troops to the president after the president successfully lobbied in the association's interest for a separate Department of Education. Simultaneously, what had previously been known as the Federal Council on the Arts and the Humanities was redesignated for the press as the "White House Council on the Arts and the Humanities." Consequently, when Mrs. Mondale, the honorary chairperson, or Mrs. Rosalynn Carter flew to, say, Orlando aboard Air Force One, the party's ladies were no longer merely campaigning for the arts—the very essence of our lives—but performing official White House duties attendant to their offices, such as officially opening museums supported by the Museum Services Institute—an interdepartmental member of the Ministry of Culture.

Such minor adjustments to reality were coincidental, of course, to any limitations placed by law on campaign expenditures or the use of Air Force One to the advantage of either politics or the arts. Besides, neither Mrs. Mondale, Mrs. Carter, nor the president's mother, Miss Lillian, were subject to any of the provisions of the Hatch Act, because not one of these ladies was actually a government employee. Indeed, the laws forbade them any office, and therefore no contradictions to their activity could be discovered, even if they were performing official duties. Whatever their capacities may have been, they traveled to Florida exempt from conflicts. And surely the shower of goodworks which rained down upon Florida before a pointless state caucus should be understood as examples

of goodgovernment—a government that "cared." A party congressman described how much the government cared just before the contest with Senator Kennedy's faction: "I've never seen anything like it. We're getting money for highways, for housing, for hospitals. One more grant and Florida will sink under the weight of these projects."

In their attempt to excommunicate Kennedy in Florida, the president's officers announced: a $1.1 billion loan guarantee to an electric cooperative in Palatka; twenty-one community development block grants for ubran renewal, including $10.7 million in Miami, $6 million in Tampa, and $4 million each for Polk, Orange, and Hillsborough counties. In addition, Dade County received $19.9 million in grants for ten public housing projects. Another $31 million was announced for 949 housing units for the elderly across the state. The airport at Orlando received $5 million for a "people-mover." In Miami the United States Department of Labor exempted 1,000 workers from Comprehensive Employment and Training Act regulations which required termination of CETA workers after eighteen months of continuous service. Labor Department officers were studying, it was said, how to allocate a significant portion of $1 billion "unused" year-end CETA funds. Setting aside the indeterminate sums spent or allocated for CETA programs, "unused" or otherwise, the president's men rewarded loyalists at approximately $2,941,500 for *each* of approximately 400 delegates elected to the president's cause.

Surely an insignificant sum if appearances were to take precedence over reality. Besides, the party's continued ability to maintain appearances of goodfaith was contingent upon the party's ability to coordinate every political instrument of social order. Unfortunately, some skeptics —though undoubtedly loyal to the president—failed to grasp how important were the perceptions of orthodoxy. Long before Florida caucused, one poor soul, Joel W. "Jay" Solomon, represented the General Services Administration at the first meeting in 1978 of the White House Ministry of Culture. Before being appointed director of GSA in 1977, Jay Solomon had been chairman of the shopping center subsidiary Arlen Realty and Development Corporation. He had coincidentally contributed to President Carter's first campaign, but as a businessman, and as something of an idealist, he had taken the president literally when urged to clean up the mess at GSA.

Solomon took charge of GSA's budget of $5 billion per year and its 37,000 employees. As GSA's administrator, Solomon was owner of 2,500 government buildings; lessee of space in privately owned buildings for government offices from 7,500 landlords; purchasing agent of 6 million different items of goods and services for government agencies; and the operator of a motor pool including 78,000 vehicles. GSA was the government's own housekeeping organization. GSA was represented with a seat on the White House Ministry of Culture because government buildings and government grounds were ideal "areas" for arts, architecture, sculp-

ture—goodworks and goodtaste. In addition to GSA's accepted responsibilities, when Jay Solomon arrived as administrator he believed that GSA "should be used to help fulfill urban development plans, cut government spending, control inflation, give more contracts to minority groups, help in utilizing land more effectively, communicate cultural concerns, make use of historic buildings, stimulate architecture, conserve energy and improve automobile design."

In all of these activities Jay Solomon believed that "local priorities were best." He received, he said, approximately 200 letters and telephone calls each week from members of Congress identifying what these local priorities might be. In addition to obtaining contracts for constituents for new building construction in their home districts, congressmen could release to the press the good news when GSA authorized an architect's design for the building; again, when the engineering contract was let; when the ground was broken with a ceremonial spade poised in the hands of the congressman's constituents; when the building and the goodpurposes it served were dedicated; and finally when leases were signed for occupation by still other coordinated national programs in the building's offices. Obviously, goodwill, goodworks, and goodfaith were represented by every single example GSA provided to a congressional district, and as Mrs. Mondale repeatedly pointed out, gooddesign as well.

Not long after Jay Solomon took up his responsibilities to administer GSA and coordinate its efforts with the Ministry of Culture, as well as every other government agency and Congress, too, he read in the newspapers that GSA had habitually bought wholesale supplies for government use at prices much higher than those advertised by retail merchants in the Washington D.C. metropolitan area. Investigations were begun. Horror was expressed at such excess. In the end there would be more than 100 indictments; but some of the procedures followed in making the necessary audits apparently exhausted the patience of Deputy GSA Administrator Robert Griffin, who had held his office for a number of years. Griffin was recalcitrant to Solomon's efforts at reform. Solomon demanded the White House consent to firing Griffin, and President Carter backed up his GSA administrator. Press conferences were called, and the intransigent Griffin noisily fired.

It happened, however, that Robert Griffin was a longtime good and amiable friend of the Speaker of the House, Thomas P. (Tip) O'Neill, Jr., respected party leader from Massachusetts and, curiously, considered by many an ally of Senator Kennedy. Despite Griffin's doubtful connections, the president was required to learn that loyalty was due the party first; thereafter to its representatives; and lastly, if appropriate, to the mere administration of government. To begin the lessons, the party's majority leader declined to answer the telephone calls from any of the president's men, or even the president himself, upon those topics high on the priorities of the national agenda. The business of government came to a stand-

still. Happily, within a few days an enlightened President Carter discovered that Robert Griffin's long experience in government would be an asset to the White House management team—at a salary of $50,000 per year. As soon as Griffin had been hired as a presidential advisor, communications between the White House and the Capitol were cordially reestablished to conduct the party's business. Later, Griffin's experience would be found useful to the Chrysler Corporation, and he was hired by Chrysler to supervise government relations. Particularly with GSA.

There were reports in the irresponsible press that Jay Solomon's investigation of fraud at GSA was brought to a quick end. These reports were followed by other reports suggesting that Solomon was being forced to resign. Actually, Solomon did not resign until six months later and then entirely voluntarily, he said. Simultaneously, it was also somehow discovered that Solomon had sent to Congress a plan approved by GSA to buy the same condemned railroad station in Nashville, Tennessee, for $7.1 million that had been refused by the Post Office ten years earlier when offered as a gift, or for one dollar. Solomon's GSA plan proposed "downtown urban renewal of an historic district." Allegedly, former associates of Solomon were developing the district. The proposal included the one-dollar railroad station, now designated an historic federal landmark, plans for banks and shopping centers and malls, but also cultural activities of the kind approved by the Ministry of Culture and loved so well in Nashville—country music and folk arts. In the confusion over Robert Griffin's accession to a post in the White House as presidential advisor, the Nashville historic district—in contrast to districts favored in Florida at the time of the state caucus—somehow lost its way in the labyrinth.

Never mind: to replace Jay Solomon, President Carter appointed Rear Admiral Rowland G. Freeman III, a man of undoubted rectitude, once a Navy flyer and then a procurement specialist with thirty-seven years of experience. Admiral Freeman had commanded the Naval Weapons Center at China Lake, California, from 1974 to 1977. According to Ron Kessler, reporter for the Washington Post and the same journalist who had irresponsibly predicted Jay Solomon's banishment, Admiral Freeman had earned the nickname "Captain Queeg" at China Lake. Aside from the enmity of the scientists under his command, Admiral Freeman explained that what had made China Lake such an enjoyable command "was the little people—the blue collar workers, the hard-hats, the technicians—not the scientists."

Admiral Freeman announced that he planned to hold prayer breakfasts on Thursday mornings at his new GSA command, if his employees were willing. It was his experience, he explained, that the little people "put things into hardware. They'll snap to, like nothing."

GSA would snap to, like nothing, because it was something of an em-

barrassment. For more than a generation, GSA had been a permanent revolving scandal. Various audits of GSA suggested that the annual yearly losses from waste, fraud, and corruption amounted to $66 million, $100 million, $166 million, $185 million, maybe $200 million. It was difficult to determine exactly. Outside auditors guessed at even higher totals— maybe as high as a billion. GSA's chief investigator conceded: "It is almost impossible to come up with a definitive figure."

GSA had given out contracts to repaint imaginary buildings. The GSA manager in charge of HEW buildings was ordered by his superiors to spend $400,000 in the last forty-eight hours of a fiscal year, because otherwise "the money would be lost." It was a central revelation to the ethic of the Great Society that reform, if properly administered, was guaranteed to cure any temporary defects in the blessed political system. If GSA wallowed in fraud, a new administrator such as Admiral Freeman could get tough, could deliver 100 convictions to serve as suitable exam- ple, and with the aid of prayer on Thursday mornings redeem for the faith the institutions of goodworks. There were, however, structural difficul- ties to these orthodoxies. When White House designees, or those spon- sored by powerful party congressional officials, were sent over to GSA to conduct either their own or the nation's business, GSA administrators ordered their subordinates to "forget the rules . . . the rules are for little people."

Because the rules, whatever they might have been, did not apply to the guys on the inside track, the social extension of political sovereignty to every community activity could not be assessed by historic methods. In Florida, no discernible national issues were debated. No realities were at stake, only perceptions, which history had seldom confused with the facts. The GSA scandals were awkward, but were now inseparable from permanent congressional perquisites. No historian would suggest that Congress abandon its share of the loot, because if it did the political system would falter. Reform, therefore, had to be understood as New York Mayor Jimmy Walker had once characterized it: A reformer was a guy who floated down a sewer in a glass-bottom boat and got a kick out of it.

Reform would be permissible to the extent that it tinkered with the machinery of party, but structural changes would be "inappropriate." New intuitions, adventures, changes would differ so widely from ortho- doxy's requirements as to constitute "disloyalty." A well-coordinated- active-national-cultural-policy could not, by its structural exigencies, suffer either independent activity or independent thought, because skep- ticism cast doubt upon the rectitude of both goodworks and goodwill. Every nuance of heresy was by definition unpatriotic. Caesar alone deter- mined what was to be rendered.

In contrast to GSA, the Smithsonian Institution, directed by its secre- tary, S. Dillon Ripley, was a national trust of unblemished rectitude.

Tracing its origins to an "Organic Act" in 1846, the Smithsonian was the oldest of the nation's cultural institutions, and the best example of incorporation without too many fine distinctions between public and private interest, or public and private monies, devoted to agreed national cultural goals. Despite some quibbles in 1977 by Congress about the Smithsonian's "private" banking practices with "private" trust funds, the Smithsonian described itself as an "independent federal establishment" devoted to public education, basic research, and national service in the arts, science, and history. About $150 million of the Smithsonian's operating budgets were appropriated by Congress each year. Perhaps an equal amount was derived by the Smithsonian's own fund-raising efforts from tax-deductible private sources—both individual and corporate. In addition, the Smithsonian managed "trust" funds from bequests to its own purposes regardless of congressional opinion. Finally, the Smithsonian coordinated its programs with all the other agencies active in national culture and seated at the High Table of the Ministry of Culture.

The Smithsonian Institution was the world's largest museum complex. Nine Smithsonian museums were located on the Great Mall between the Washington Monument and the Capitol: Museum of History and Technology, Museum of Natural History, National Gallery of Art, the new I. M. Pei-designed National Gallery East Wing, the Freer Gallery, the original Smithsonian Institution "castle" designed by James Renwick and completed in 1855, the Arts and Industries Building, the Hirshhorn Museum, and the Air and Space Museum. Other Smithsonian operations in Washington D.C. included the Renwick Gallery on 17th Street, the National Collection of Fine Arts and National Portrait Gallery on F Street, the Anacostia Neighborhood Museum across the Potomac from the Capitol, and the National Zoological Park in the 3000 block on Connecticut Avenue, N.W.—where 2,000 animals lived, representing about 500 species. In New York, the Smithsonian operated the Cooper-Hewitt Museum of Design and Decorative Arts in the old Carnegie Mansion at 91st Street and Fifth Avenue. In coordination with the National Park Service, the Smithsonian operated the John F. Kennedy Center for the Performing Arts.

A mere listing of the Smithsonian's museums barely suggested the extent of the Smithsonian's incorporated organic activities. The Institution pursued academic and educational programs and fellowships; operated a program in American Folklife Studies; maintained archives of American art; acquired art when it saw fit to do so; worked with the United States Army on mosquito research; conducted tours of foreign study; operated an astrophysical observatory; published books and ran one of the largest local chains of bookstores in the nation; directed an Anthropological Film Center and a Center for the Study of Man; supervised the Research Institute on Immigration and Ethnic Studies; directed a Cross-Cultural Research Program; bought, funded, and operated the

Chesapeake Bay Center for Environmental Studies; operated divisions concerned with elementary and secondary education, a division of international exchange, a division of international environmental science, and a division of performing arts; endowed itself upon its own motion and from the endowment established by itself gave grants to further national Smithsonian purposes.

The Smithsonian published a national magazine for those who chose to enlist as Smithsonian Associates. The magazine carried each month Secretary Ripley's "View from the Castle," in which he might, for example, congratulate the Smithsonian's "long-time friend and colleague in research," the United States Geological Survey. *Smithsonian* delivered to its readers every month wonder upon wonder from the universe of the institution's unlimited interests, along with advertisements from Cadillac, General Electric, Glenlivet Scotch, Steuben Glass, Pan American World Airways, Campari and Soda, *Realités* and the Book-of-the-Month Club.

For its associates, the *Smithsonian* sold brightly colored kites by mail; praised NEH-funded films on PBS; described how HUD's urban renewal could be made to work in United States cities; explained the Japanese concept of time and space; operated seminars on genealogical research and the cultural history of China; explained how to get in on the tax benefits of historic house preservation; presented Sunnyland Slim singing traditional blues, and "Sons of the Pioneers," the singing cowboys of the Roy Rogers-Dale Evans westerns. There were no limits—no limits at all —to the Smithsonian's goodworks.

Although the Smithsonian Institution's projects were endlessly fascinating in themselves, far more interesting to the historian of social structure was the Smithsonian's *organic* organization. According to the Smithsonian, its activities were incorporated in an "Establishment," whose statutory members were the president of the United States, the vice-president, the chief justice of the Supreme Court, and the heads of each executive department. These authorities in turn vested the responsibility for administering what the Smithsonian described as its "trust" in another board designated the "Smithsonian Board of Regents." The regents of the institution included Chief Justice Warren E. Burger as chancellor. Vice-President Walter F. Mondale was joined by Henry M. Jackson, Barry Goldwater, Claiborne Pell from the Senate, and George H. Mahon, Elford A. Cederberg, and Corinne C. Boggs from the House of Representatives. To these distinguished national officers was added a list of names identified only as "citizen," and the state in which as ordinary citizens they presumably cast their votes. J. Paul Austin, for example, was listed as "citizen of Georgia." Any connection between Mr. Austin and the Coca-Cola Corporation would be entirely incidental to his seat as a regent of the Smithsonian Institution. Similarly, John Nicholas Brown, good citizen of Rhode Island, William A. M. Burden of New York,

Murray Gell-Mann of California, Caryl P. Haskins of the District of Columbia, A. Leon Higginbotham, Jr., of Pennsylvania, Thomas J. Watson, Jr., of Connecticut, and James E. Webb of the District of Columbia. The annual dinner of the Smithsonian Institution's regents was a distinguished incorporation of government, university, and corporate representation.

Congressional appropriations subcommittees once queried Mr. Ripley about why the Smithsonian had proceeded with a program in oceanography after the seventeen members of the Board of Regents had indicated the program ought to be postponed. Mr. Ripley pointed out that the day-to-day operations of the institution were more often approved by the regents' Executive Committee, consisting of Chief Justice Burger, Mr. Burden, Mr. Haskins, and Mr. Webb, who was the Executive Committee's chairman. Persistent congressmen pursued the question by wondering whether the regents ought to meet more frequently than three times a year. Mr. Ripley replied that the regents would consider the matter.

Yet the "Establishment," its regents, and the executive committee of the regents only hinted at the extent of the organic social structure of the Smithsonian Institution. The Smithsonian "Council" included twenty-six more distinguished citizens. These council members were distinct from the National Board of the Smithsonian Associates which included twenty-one additional distinguished citizens as well as eleven more honorary members, who were, of course, entirely different from the twenty honorary members of the Smithsonian Council. The Board of Academic Studies numbered only seven members, including two *ex officio* representatives of the Smithsonian's own directorate. The Archives of American Art had twenty-six trustees, three founding trustees and one honorary trustee. The National Museum of Man, Center for the Study of Man, and the National Anthropological Film Center Advisory Council, jointly required the advice and consent of fourteen trustees. The Cooper-Hewitt Museum had eight members on its Advisory Board and one honorary member. The Freer Visiting Committee totaled a mere nine in number. The Hirshhorn Museum and Sculpture Garden Board of Trustees totaled eleven. The Horticulture Advisory Committee came to ten, but six members of the Orchid Subcommittee really ought to be added.

The National Air and Space Museum Advisory Board listed eight *ex officio* members, of whom five were military officers and two citizen members, but six members should be added for the Visiting Committee. These were to be distinguished from the National Armed Forces Museum Advisory Board of eleven members. The Advisory Council to the administration of the National Museum Act came to eleven counselors—an entirely different program from the Museum Services Institute operated under the aegis of HEW, with an entirely separate board of advisors. The National Collection of Fine Arts Commission counted twenty-five commissioners, including its honorary members. These, of course, were dis-

tinct from the National Portrait Gallery Commission of fourteen designees.

The Offices of International Programs and Smithsonian Foreign Currency Program Advisory Councils could be broken down into: six advisors on archeology and related disciplines with one additional citizen described as an "observer"; nine members of the Council on Astrophysics and Earth Sciences; and seven members of the Council on Systematic and Environmental Biology. The Woodrow Wilson International Center for Scholars had a board of thirteen trustees. The John F. Kennedy Center for the Performing Arts was directed by forty-six members of the Board of Trustees, including Edward M. Kennedy, Mrs. Jean Kennedy Smith, and Mrs. Bob Hope. Surely so many members of a board of trustees must have seemed at times unwieldy to the Smithsonian's purposes. The Board of Trustees for the National Gallery of Art, in contrast, had four *ex officio* members, including S. Dillon Ripley, but only five general members of the board, and of these two, Mr. Paul Mellon and Mr. John Hay Whitney, were also listed respectively as chairman and president.

With so many trustees, councils, boards, regents, committees, associates, and members, every Smithsonian goal must have been carefully considered and beyond reproach. Who would object to so many assembled for such goodpurpose? The Smithsonian had the enviable freedom, as a result of "trust" funds raised from "private" sources, to grant $1 million each to four of its own museums. The Freer Gallery, the Hirshhorn, the National Collection of Fine Arts, and the National Portrait Gallery were instructed to spend the money within five years. Smaller Smithsonian grants of $500,000 each were similarly donated to the Smithsonian's museums of Natural History and History and Technology.

But before the Smithsonian's grants to its own museums passed unnoticed, something came up. Despite federal grants and local fund-raising campaigns, Boston's proud library, the Atheneum, was in financial trouble. To alleviate their difficulties the library's officers considered the sale of an asset: Gilbert Stuart's portraits of Martha and George Washington. Originally acquired from Stuart's widow and paid for in part by a public subscription raised from the citizens of Boston, the portraits had hung in Boston since 1831. When Boston's Museum of Fine Arts opened in 1876, the Atheneum had sponsored its establishment and then loaned the Stuart portraits for the museum's permanent exhibition. The Atheneum had offered to sell Martha and George Washington for $1.6 million in 1974, and for a higher sum again in 1977, but there were objections from the Museum of Fine Arts: permanent loan of works of art, in the opinion of Boston's lawyers, meant permanent.

Charles Blitzer, assistant secretary for History and Art, the Smithsonian Institution, explained to Mr. Sidney R. Yates, chairman of the House Appropriations Subcommittee on the Department of Interior and Related Agencies, that the Smithsonian had offered the Atheneum $5 million to

acquire the Stuart portraits for the National Portrait Gallery in Washington. Blitzer admitted that the Smithsonian perhaps did not have $5 million cash in hand, but it was prepared to forgo other acquisitions for years to pay for the paintings. Blitzer said: "We went out on a limb."

Yates's committee inquired politely where the money was coming from, since it was Yates's committee which provided the appropriations for the Smithsonian. Blitzer did his best, once again, to distinguish the public monies appropriated by Congress to the Smithsonian from the "trust" funds the Smithsonian generated from its operations, such as the tax-exempt incomes—but of course not profits, rightly understood—of the Smithsonian's magazine, bookstores, gifts, and bequests. Although puzzled by such fine distinctions for funds commingled for identical social ends, Yates's committee once again agreed that the two kinds of Smithsonian monies were obviously different.

Boston didn't think so. The *Boston Globe* editorialized: "The proposed deal is akin to, say, selling Faneuil Hall to the State of Arizona as a tourist attraction." Boston got itself a committee to save the Stuart portraits, with General James Gavin as its chairman, and began a fund-raising drive to match the Smithsonian's $5 million bid. Boston's lawyers filed papers in Boston's courts. Boston's wits appeared Op-Ed in the *New York Times*, pointing out that in the end Boston could never outbid the federal government, but for each treasure robbed from Boston's inheritance the citizens of Boston should receive from Washington some payment in kind, such as extracting a section from about halfway up the Washington Monument—a section constructed with Massachusetts marble: old Boston's pride died hard.

Boston's outrage over the Smithsonian's plunder of Boston's portraits of George and Martha Washington illuminated one or two troubling questions. Mr. Hilton Kramer, art critic of the *New York Times*, realized that the Smithsonian "Establishment" should be called to account. Until Boston provided an example, Kramer said, "we have all tended to look upon the burgeoning Washington museum scene with a good deal of pride, admiration and respect," but perhaps the time had come to count the cost of ambitious institutions—and not only in dollars. "The idea of a marauding federal museum establishment, armed with unlimited funds and on the lookout for valuable spoils wherever local institutions are in trouble, is pretty distasteful."

But the statutory limitations on bad taste were insufficient restraints. Kramer accurately pointed out the cruel fate of Boston's subjection: $5 million raised in Boston to ransom what Boston considered its own inevitably subtracted from the local museum's fund-raising totals for all its other activities. A $5 million subscription to keep the portraits would go to the Atheneum, while the Boston Museum of Fine Arts would be even more dependent upon the marauding federal establishment to continue its operations. The nationally established Smithsonian funds were ad-

ministered by the very same national officers who assembled at the Ministry of Culture to promote an "active, well-coordinated national cultural policy." These administrative commissioners no longer bothered to consider that the "trust" monies designated to buy art from Boston were tax monies. According to the Smithsonian's officers, a substantial portion of the Smithsonian's trust monies were derived from the advertising revenues collected by its magazine *Smithsonian*. And one quantitative result of *Smithsonian*'s tax-exempt publication was that competitive, but taxable, publications offered to much the same audience, such as the *Atlantic Monthly*, struggled to stay alive at all. The final irony to Boston's predicament was that the structural shift in social powers—not merely a change in economic powers—meant that the monies to pirate Boston's treasures were transfer payments from taxes paid by Boston and advertising pages robbed from Boston's literary pride, the *Atlantic Monthly*.

The Smithsonian's privateers raided not only Boston, but their home port of Washington, too. Any independent institution could be spoiled. To describe their ruin, Mr. O. B. Hardison, director of the Folger Shakespeare Library, Mr. Thomas Fichandler, executive director of the Arena Stage, and Mr. Peter Marzio, the Corcoran Gallery and School of Art, appeared before Mr. Yates's subcommittee on appropriations. They petitioned for 1980 funds to save their three "private" museums from collapse. They pleaded to have their maintenance expense and physical plant costs absorbed by the National Park Service. Hardison explained why three "private" institutions could not compete for the attention of corporations or foundations against the claims of Washington's other cultural institutions, particularly the Smithsonian. Hardison proposed that the National Park Service take over the expense of maintenance of Washington's remaining "independent" cultural facilities, as the Park Service already did for Ford's Theater, Wolf Trap Performing Arts Center, and the Kennedy Center. If Congress could not discover a legal device by which to fund the independent Washington cultural centers, they would be forced to close their doors. The "independents" arrived at Yates's hearings with counsel, and with a prepared memorandum of law demonstrating how the 1935 enabling act for the National Park Service could be used by Mr. Yates's committee to tap the Park Service budget.

The independents pointed out that the formerly independent Museum of African Art had already surrendered to the Smithsonian. They, too, would soon be required to strike their flags. Hardison summed up his case: the federal government provided approximately $250 million per year for the arts in the nation's capitol; these amounts were "matched" or increased by tax-exempt contributions from foundations or corporations; if the federal government would provide 2 percent of its appropriations to the independents, they might survive. The independents did not oppose fund-raising from private sources by federal institutions, but federal fund-raising from private sources had ruined the independent trade.

"Just as when an elephant walks through the forest he extinguishes a great deal of the native creatures of that forest, so the Smithsonian walking through the District is creating problems for the private institutions here."

In Washington as in Boston, each gift donated to the Smithsonian simultaneously subtracted from the funds available to smaller, less well-connected, independent institutions. To its donors, the Smithsonian offered "high visibility": certification of deeds well done among the councils of its "Establishment." When Mobil Corporation took full-page advertisements to announce that Mobil had sponsored the exhibition of the art of Edward Munch, Mobil could be proud of the company it kept. Each gift to the Smithsonian was an act of good public relations and expressed the corporation's goodwill for improvement of the national education. Boston's Museum of Fine Arts, and Hilton Kramer of the *New York Times*, and the trustees of Washington's Corcoran, Folger, and Arena Stage all began to understand at last. Suppose there was to be only one system, as Sinclair Lewis had prophesied: The American Corporate State and Patriotic Party. No! Suppose there were two parties, the Corporate, and those who didn't belong to any party at all—and so, were just out of luck. Even a small sampling from the Smithsonian's own register of gifts and bequests demonstrated what would be necessary to recognize an elephant: The Morris and Gwendolyn Cafritz Foundation, the Andrew W. Mellon Foundation, American Commercial Barge Line Company, Ashland Oil, Inc., The Brown Foundation, CBS Foundation, Inc., Crowley Maritime Corporation, Doubleday & Company, Inc., EXXON Corporation, The Ford Foundation, Janet A. Hooker Charitable Trust, International Council for Bird Preservation, The Charles E. Merrill Trust, Milliken Foundation, Mobil Corporation, New York State Council on the Arts. . . .

The difficulty to understanding by financial analyses, or anything so simple as budgetary review, the ascendancy of the White House Ministry of Culture was compounded by discovering that the New York State Council on the Arts was a donor of more than $10,000 to the Smithsonian—although the state arts councils were funded by the National Endowment for the Arts, as well as by state appropriations, and in addition by tax-exempted foundation, corporate, and private bequests. It appeared that various corporations, whether categorized as "profit," "nonprofit," "private" or "public," habitually funded each other and themselves. Except for nice distinctions apparently understood only by congressional appropriations subcommittees, there appeared to be no differences between public ends and the "private" contributions to the Smithsonian's organic "Establishment": National Geographic Society, Mr. and Mrs. S. Dillon Ripley, Rockefeller Brothers Fund, The Rockefeller Foundation, The Tobacco Institute, Inc., Thomas J. Watson, Jr., World Wildlife Fund,

American Can Company, American Institute of Marine Underwriters, American Society of Interior Design Educational Foundation, Bath Iron Works Corporation, Book-of-the-Month Club, Dow Chemical U.S.A., Michigan Council for the Arts, The National Needlework Association, American Philosophical Society, National Audubon Society, United States Postal Service. . . .

If it seemed odd for the United States Postal Service to be among the donors to the Smithsonian, or the Michigan Council for the Arts, only some of the incorporated social purposes of the Smithsonian were suggested by listing its donors. The Smithsonian was a publisher of gargantuan energies—through its own national presses, but also in cooperation with university, foundation, and commercial publishers, both national and international. The Smithsonian's annual bibliography of publications by its *own* staff—whose salaries were paid from public monies—required sixty-five pages of small print listings: for example, Bryce-Laporte, Roy S., and Stephen R. Couch, editors, *Exploratory Fieldwork on Latino Migrants and Indochinese Refugees,* Washington, D.C., Smithsonian Institution, 1976; Langley, Harold D., Francis L. Loewenheim, and Manfred Jones, editors, *Roosevelt and Churchill: Carteggi Segreto Di Guerra,* Milan, Mondadori, 1977; Klapthor, Margaret B., *The First Ladies Cookbook,* Parents' Magazine Press, New York, 1977. Margaret Klapthor's cookbook was annotated in the Smithsonian's bibliography under the "Department of National and Military History," and described as an historical text, even though published by Parents' Magazine Press.

Although the Smithsonian viewed fondly the published works of its own staff, there were certain enemies of the people whose voices the officers of the "Establishment" did not choose to hear. As an example of goodwill to the Washington D.C. community and as an element in its program of goodworks, the Smithsonian Institution sponsored readings by noted poets. Inadvertently perhaps, Ms. Erica Jong was booked to read from her poetry. She had also unfortunately earned considerable notoriety as the author of *Fear of Flying.* Apparently the Smithsonian discovered that the poet was the very same as the author of a book reputed to include an astounding scene or two of sexually related materials—particularly a scene on a train as a *wagonlit* entered a tunnel. Uh-oh.

About two weeks before the reading was scheduled, an officer from the Smithsonian telephoned Ms. Jong at her home in Connecticut. Would Ms. Jong be reading poetry that included references to sexual or political ideas, by any chance? Ms. Jong was slightly puzzled by the ever-so-polite questions. The Smithsonian's representative was not too clear about the reasons for his telephone call. Would it be possible, he queried, for Ms. Jong to send ahead copies of whatever poems she intended to read so that the Smithsonian could have a look at them? Ms. Jong began to realize what might be going on. Her poetry, she said, definitely contained both

sexual and political references, because that's what she wrote about. No, she would not send ahead copies for approval by the Smithsonian's censors. She had been booked to read her poetry, and read she would.

The Smithsonian Institution cancelled Erica Jong's poetry reading. Perhaps there had been a misunderstanding, said the Smithsonian, but the American Civil Liberties Union took up Ms. Jong's cause. The negotiations with the Smithsonian lasted for four years. The ACLU demanded "specific performance" from the Smithsonian: Erica Jong should be allowed to read her poetry in one of the Smithsonian's public rooms just as she had been booked to do. The Smithsonian—whatever it claimed about being an autonomous "organic" federal establishment—would have to consent to the language of the First Amendment to the Constitution. To avoid a suit in a federal court the Smithsonian eventually consented to hear the independent voice of Erica Jong.

On the night her reading was at last scheduled, Washington was in the grip of a blizzard. Telephone calls to the Smithsonian as to the place assigned for Ms. Jong's reading were unavailing until it was pointed out that Ms. Jong herself had no idea of where she should report to act out her victory. She was delayed by snow on Connecticut's airfields, but eventually arrived to an audience of 500 women who had waited two hours through a movie about Georgia O'Keeffe. Then Erica Jong read from her poetry of sex and politics. Neither the case of attempted censorship nor Ms. Jong's determined four-year assertion of traditional rights appeared remarkable enough to be news; and surely the event must have been beneath the notice of the chancellor of the Smithsonian's regents, Chief Justice Warren E. Burger.

During all the earnest discussions by members of the National Councils on the Arts and the Humanities at the time, the case of Erica Jong was never discussed—largely because neither committee members nor staff knew anything about it. Nor were there any congressional debates, or outraged editorials upon the dangers to democracy posed by McCarthyism. The conscience of the American Civil Liberties Union, however, was troubled. An ACLU internal memorandum for its Free Speech/Association Committee took up the difficult questions posed by government funding of the arts in a "working paper." Erica Jong's case was not the only case in which the ACLU had been involved, and if the writers of the ACLU working paper could not yet resolve what policy the ACLU should adopt, a well-coordinated-active-national-cultural-policy raised "sharp questions of government censorship."

The ACLU working paper cited those who argued that essential services such as education, health care, and street lighting should be provided by the government, and so too should the arts, because the arts were "not just a frippery of life, but one of its vital parts." Behind the argument for support of the arts, the ACLU noted, was the "somewhat

inchoate belief that the person who looks at paintings is a better and more reasonable person than the one who does not."

Exactly. The arts could help us understand each other, as Mrs. Mondale had so carefully explained: artists could reveal the truth about ourselves in powerful and compelling ways; and when they did, they could spur politics into action; which, all things considered, was perhaps why the poetry of Ms. Jong seemed to be so dangerous to the established party at the Smithsonian: poets might reveal the truth in powerful and compelling ways.

The ACLU did its very best to enumerate the reasons to support government funding of the arts: those who were deprived of great art could be considered underprivileged in the same way as city dwellers without parks; there was also a First Amendment argument that might be constructed to show that society would benefit if the government provided the wherewithal for artists to express a multiplicity of ideas. Regardless of the arguments, the ACLU noted, the arts were increasingly going public on every governmental level. Inevitably largesse was being dispensed not by disinterested angels, but by human beings whose personal tastes and political opinions "sometimes make them abusive patrons of the arts."

"Although public subsidies are a way of life in many countries, such subsidies are a debatable issue in the United States." A strong historical case could be made against public expenditures for the arts, since the roots of national cultural programs were in the royal courts of Europe. The designation of poet laureate in England, the ACLU noted, produced no advertisement for the system. His job was to produce poems on public occasions involving kings and queens. "Those who fear government pressure point to the sad and exhausted state of the arts in Soviet Russia, where the government calls the tunes."

In the Smithsonian censorship case, the ACLU board recommended a suit be instituted on behalf of Ms. Jong *and others* to enjoin S. Dillon Ripley, the Smithsonian's secretary, from: "(1) attempting to limit the content of a speech after selection of the speaker; and (2) selection and rejection of speakers on the basis of impermissible criteria." ACLU's study of documents obtained under the Freedom of Information Act procedures indicated that the Smithsonian's senior officers had been engaged in a continuing pattern of censorship. The Smithsonian's officers were preoccupied with avoiding critical or adverse publicity "which could jeopardize either the Institution's sizeable federal appropriation or its standing with private donors upon which it is also dependent."

"The Smithsonian's problems," noted ACLU advocate Ralph Temple, "are only the tip of the iceberg of the problem of government involvement in and censorship of the arts." Since the Smithsonian was eager to avoid a lawsuit, ACLU negotiated Ms. Jong's case. It was easy for ACLU

to specify fair criteria for what the Smithsonian should *not* do—for example, they should not use a "controversiality" standard to reject topics and speakers, but ACLU could not suggest to the Smithsonian what the institution—or any other national agency—should do in choosing topics, speakers, poets, literary magazines, or any other national cultural "activity."

The pragmatic result of Ms. Jong's case was that the Smithsonian would be less careless of its *recorded* procedures in the future, but do whatever it pleased nonetheless. Censorship was a political concomitant to an incorporated, coordinated Ministry of Culture. Censorship was structurally necessary to the Smithsonian's continued operations in cooperation with other government agencies, universities, foundations, corporations, and Congress.

For years the ACLU had struggled with the Department of Interior, particularly the National Park Service. The Park Service had a consistent record of arbitrary favoritism. In programming the annual "Christmas Pageant of Peace" at Ground Zero on the Ellipse, a prisoner of war display was allowed, but antiwar displays were disallowed. For the July 4th "Honor America Day" on the grounds of the Washington Monument, Reverend Billy Graham had been allowed to appear, and Bob Hope, but not those whose entertainments were deemed by the Park Service "not in the public interest."

The director of the National Park Service, William G. Whalen, occupied a seat upon the coordinating Ministry of Culture. The Park Service was most immediately identified with "Smokey Bear," the brown grizzly in a ranger's hat who wanted us all to help prevent forest fires or put litter into wire baskets. Besides being a substantial national TV advertiser, Smokey Bear's operating budget was about $500 million, and in 1980 Congress authorized an additional $146 million in capital expenditures to buy 10,635 more tracts of land totaling about 88 million more acres.

Smokey Bear's most famous park was Yellowstone. With the consent of a National Advisory Board—no national agency could be without one—and with local advisory committees for each national park—no local action without consulting local, and particularly congressional, "priorities"—the National Park Service managed: thirty-seven national parks, eighty-two national monuments, two preserves, four lakeshores, six rivers, ten seashores, fifty-three historic sites, one memorial park, twenty-two national memorials, eleven military parks, three battlefield monuments, eight battlefields, two battlefield sites, eighteen historical parks, sixteen recreation areas, one scenic trail, and ten parks designated for some reason as "other."

In addition, the Park Service operated the national parks of the Capitol, the National Visitor Center in Union Station, the White House grounds, and the Great Mall occupied by the Smithsonian's temples. In

cooperation with the Smithsonian, the National Park Service maintained the "plant facilities" and provided the funds for the Kennedy Center's operations—although the Kennedy Center insisted that it operated without national funding. Similarly, the Park Service acted as the Schubert organization for other facilities of national entertainment, including: Wolf Trap Center for Performing Arts, Ford's Theater, the Carter Baron Amphitheater, and the Shakespeare Summer Festival at the Sylvan Theater in Washington—at an annual cost of about $1.2 million—and the Chamizal National Memorial in El Paso, Texas.

None of these National Park operations should be confused with those of the Department of Interior's Bureau of Land Management—a vastly larger landholder, or with the parks maintained and operated by the United States Department of Agriculture—another entirely different system, or parks enabled under HUD programs in urban development districts. On the other hand, the Park Service's complexities included running gift shops that sold about $9 million at retail in books, educational materials, postcards, and plastic souvenirs. For these National Park Service shops, Mrs. Mondale had cornered Secretary of Interior Cecil Andrus to demand the sale of folk arts indigenous to the park areas— bead necklaces strung by Indian tribes, for example, rather than the identical souvenirs stamped "Made in Taiwan."

But to understand the extent to which there were no limits—no limits at all—to an active, well coordinated national cultural policy, some suggestion of the extent of Interior's empire was necessary. Besides the National Park Service, within the Department of Interior another division was known as the National Trust for Historic Preservation. The National Trust often coordinated its activities with those of the National Park Service, but it also was required to coordinate its activities with HUD and the IRS. The National Trust for Historic Preservation raised its annual budget of $45 million by appropriations from the subcommittee of the House of Representatives headed by the same Sidney R. Yates who also authorized the activities of the Department of Energy, the Smithsonian, and the National Endowments for the Arts and the Humanities.

The National Trust, working with the National Park Service and with state and city governments, not only designated buildings as "historic sites," thereby qualifying the developers of those buildings for special tax benefits under the 1976 law, but also entire city districts. Quibbles over just such a district in Nashville had offended the Congress in the awkward matter of Jay Solomon, former GSA administrator. Nashville's downtown plan was discovered to depend upon restoring a railroad station—an historic railroad station. Once an "Historic District" was designated by Interior, the real estate tax exemptions by local, state and IRS authorities often required a showing that the development plan improved "cultural" activities appropriate to the neighborhood. A movie house was okay, but historic folk art, or some such, would surely be better. Local

priorities had to be considered: and these were often best understood by the historic district's own congressman.

Irrespective of the total tax exemptions certified for local real estate boomers by such procedures, and in addition to the annual $45 million in National Trust appropriations, in 1978 President Carter signed a $725 million five-year "commitment"—over and above the National Park Service operating budget—for something known as the Urban Recreation Recovery Program. The authorized, but not yet appropriated, funds were designed, it was said, to help bring new life to the nation's cities by renovating "recreational facilities" in cooperation with state and local governments. Examples of "massive" urban renewal programs by the Park Service were cited for downtown Atlanta, Georgia; San Antonio, Texas; and a newly designated National Historic Park to cost $40 million in Lowell, Massachusetts.

The cultural attraction of the Lowell Historic Park District would be the conversion of the abandoned cotton mills of James Cabot Lowell into "living museums," recreating the conditions in which thousands of young girls had labored on twelve- and fourteen-hour shifts at spinning machines and water-driven looms. Although the "living museum" might conjure up memories which had appalled even the flintiest Boston conscience, the National Park Service estimated, they said, that the living museum could hope to attract as many as 750,000 visitors each year. At dedication ceremonies by the rotting water wheels stopped in the Merrimac River, despite the speeches and hoopla which promised the renewal of Lowell to its former glories, it had to be admitted that the Lowell Historic Park would not be opened for perhaps another ten years. Continued appropriations to the purpose would be necessary; but Lew Albert, designated National Park Service superintendent, was already at his post. At the not-quite-completed facility, Superintendent Albert explained: "We are here in a supportive, cooperative role and not just as a bunch of federal bureaucrats come to sprinkle money around without getting involved—we care."

With ten years of congressional appropriations still ahead, the National Park Service cared. The Department of Interior had a consistent record of "getting involved" once its appropriations were sprinkled around. Congressional liaison required it. The National Park Service, for example, was the owner of Ford's Theater in downtown Washington, and maintained in the theater's basement an historic museum in memory of Lincoln's assassination. In addition, the Park Service budgeted approximately $175,000 per year to maintain the theater, and paid another $23,000 to the theater's stage hands. The National Park Service rented the "cultural facility" to the Ford's Theater Society for one dollar per year. The Park Service provided the theater; the society, consisting of 22 national directors and headed by Ms. Frankie Hewitt, raised the money for productions and staged the plays. From the beginning there were

difficulties because the National Park Service, after sprinkling its money around, believed a national theater should stage "historical plays."

The National Park Service cared: the contract agreement between the Ford's Theater Society and its landlord, the Department of Interior, specified in paragraph 12: "No presentation or program shall be presented by the Society in the Theater without the written consent of the Secretary. If any presentation or program produced or presented by the Society in the Theater is, in the judgement of the Secretary, obscene or in poor taste or otherwise inappropriate for presentation in a facility owned by the Government, the Secretary may, by notice to the Society, require that within no more than 72 hours the obscene or otherwise offensive portion of such program be deleted from any future program or presentation by the Society in the Theater, or failing such correction the program or presentation shall be discontinued."

To ensure all rights to censor, the Department of Interior further specified in paragraph 14 of the contract that the society could not book a live theater production without the consent of the secretary. Accordingly, in August, 1971, Ms. Hewitt sent over to the Park Service the script for an historical one-actor play, *An Unpleasant Evening with H. L. Mencken.* In December, the Park Service wrote Ford's Theater, then followed up by telephone, suggesting that the playwright "soften up" Mencken's opinions.

Edwin Blacker, performing arts management coordinator, later explained, "There were a couple of passages which we thought, at the present time and in the present circumstances, might be objectionable." When queried by Tom Shales of the *Washington Post,* Blacker could not remember precisely what the passages were. He said the Park Service was not censoring, just suggesting.

Blacker attended the first preview of the show in March, and again objected to playwright Paul Shyre's adaptation of Mencken's writings. The playwright and director refused to make changes. Shyre said: "I'd close the show before I'd tamper with the script."

Despite Shyre's brave stand, before opening night the National Park Service invoked its powers to close the show if changes in the script were not forthcoming within seventy-two hours. Shyre's script was "softened." Mencken's reference to Georgia as "the home of the lynching bee" and references to lynchings in Mississippi were deleted. For the time being, Mencken's characterization of Mississippi as having earned the title of "the worst state in the American union" remained. Mencken called Mississippi a "cesspool of Baptists and a miasma of Methodism, snake charmers and syphilitic evangelists." Playwright Shyre pointed out how Mencken would have laughed over the Park Service's attempt to censor: Mencken had called all censors "fanatics and perverts."

The Park Service and Department of Interior did not consider themselves perverts at all: they were responsible for what was "in poor taste

or otherwise inappropriate" for presentation in a facility funded by congressional subcommittees. Some of those subcommittees included senior members from Mississippi, in addition to Baptists and Methodists. The slightly censored production of *An Unpleasant Evening with H. L. Mencken* came and went from Ford's Theater to delighted reviews and audiences, but Ms. Hewitt continued to have difficulties with her landlord. In 1973 the Department of Interior was unsettled because Ms. Hewitt booked the biblical rock musical *Godspell*, and it turned out to be such a success that its engagement had to be extended, week after week, from an original one-month booking to nearly a year. The Park Service "coordinators of performing arts management" were dissatisfied. The director of the Park Service sat on Ms. Hewitt's national board, and attempted to get her fired. Instead, she maneuvered to get him fired. Whereupon, Ms. Hewitt fired her general manager. Then there were resignations from the Ford's Theater Society board of directors. The success of *Godspell*, it seemed, was financially enriching not only to the theater, but by the terms of Ms. Hewitt's contract, enriching Ms. Hewitt at 1 percent of gross per week—in some weeks as much as $250! Not that *Godspell* contained anything obscene or in poor taste, of course—it just somehow did not seem appropriate to extend the run of a commercial hit in a "government-subsidized" theater. The National Park Service wanted "historical" plays.

Meanwhile, the ACLU was patiently pursuing Ms. Hewitt's case. Because Mencken had been censored and the matter reported in the press, the National Park Service found it difficult to avoid the ACLU's determined inquiries. After five months, and with Mencken long gone from Ford's Theater, the solicitor of the United States Department of Interior consented to reply to ACLU's volunteer on the case, Mr. John Taurman of Washington's distinguished law partnership Covington and Burling. Interior, said its solicitor, had made a diligent search of the files for any memorandum from Interior Secretary Morton relating "to theatrical productions on stages within the jurisdiction of the National Park Service." Interior, said its solicitor, had found no such memorandum.

However, in response to Mr. Taurman's letters to the secretary of Interior, to the assistant secretary, to the director of the National Park Service, and in response to Taurman's telephone conversations with the assistant solicitor, and reports "of a memorandum relating to this matter" in the *Washington Post*, Interior's solicitor had fortunately discovered a memorandum from Assistant Secretary Richard S. Bodman to the director, National Park Service. And so the solicitor enclosed the "Bodman Memorandum" and related documents in response to the ACLU's "informal request."

The "Bodman Memorandum" agreed to drop Interior's right of censorship from its contract with Ford's Theater. Bodman also recommended rewriting the contracts for Wolf Trap, the Shakespeare Festival in the

Sylvan Theater, and the Art Barn Exhibition space in Rock Creek Park, operated by Associates of Artists Equity. Six months later, in January and February, 1973, ACLU's Taurman wrote Interior once again to inquire whether Interior had yet revised its policy in National Park Service facilities to conform with the provisions of the First Amendment and Bodman's recommendations. In March, Ronald H. Walker, director, National Park Service, answered: "We are taking no steps to implement the policy guidelines laid down in Mr. Bodman's June 30, 1972, memorandum as they would apply to those cooperative agreements which have heretofore not been changed, until we have had an opportunity to reexamine our relationships under those agreements."

Six more months passed. Taurman wrote again, pointing out that Interior had more than ample time to evaluate its position. Taurman pointed out that public facilities under the National Park Service's jurisdiction were entitled to the full range of artistic expression protected by the Constitution. Taurman reviewed the year-old history of the case, noting that the National Park Service continued to claim by its contracts full rights to censor, and to censor even paintings: "If any work exhibited by Associates in the Barn is, in the judgment of the Director, unduly offensive for presentation in a facility owned by the Government, the Director may, by notice to the Associates, require that it be removed from the exhibition."

Another year passed. Taurman wrote again to the secretary of Interior. In November 1974, Douglas P. Wheeler, assistant secretary of Interior, replied. Although the Ford's Theater contract had been amended to conform with the "Bodman Memorandum," said Wheeler, the agreements with the National Park Service's other cultural institutions had not yet been brought up to date to "reflect this operative policy within the written agreement." Wheeler's answer was a classic of national policy prose. Although the National Park Service had been forced to abandon paragraphs granting specific powers to censor, Wheeler insisted upon the general powers of the Department of Interior, which "through the National Park System, has the responsibility to administer the areas in the National Park System for the benefit of all the American people."

"As part of these administrative duties," Wheeler asserted, "the Department has the authority and responsibility to interpret all segments of the system." The Department's legal authorities, cited under 16 U.S.C. 1 et seq., established Interior's powers to determine whether the Park Service's cooperative agreements with private organizations to present "artistic endeavors" fulfilled the Department of Interior's "interpretative responsibilities to the American people."

Wheeler claimed for the Park Service authority without limit—no limits at all—for all segments of the system; the claim was based upon administrative law; the sole interpreter of Mencken or any other "artistic endeavor" was good old Smokey Bear who helped us prevent forest fires;

and Smokey Bear's interpretation depended, as Assistant Secretary Wheeler explained, "on the overall purpose of the artistic programs to be presented." There was no doubt that only the Department of Interior could interpret what was "appropriate" to the "stated purpose" of artistic endeavor.

Despite Assistant Secretary Wheeler's astounding claims for National Park Service authority, ACLU's Taurman replied as if ignoring them, and instead congratulated the Department of Interior for putting into effect, "after some equivocation," the policies declared by the "Bodman Memorandum" at all National Park Service cultural facilities. Five more months passed.

Under the new Carter administration an acting director of the National Park Service replied to still another Taurman inquiry by assuring Taurman that "our cooperators are not unnoticed of our policy on this matter."

Since the cooperators would be all the other National Park Service "cultural facilities," Taurman asked to see copies of the amended agreements.

After a month, National Park Service Acting Associate Director Joe Brown replied. He had nothing at all to say about the revision of the Park Service contracts with its tenants. Apparently the matter had not come to his attention. Despite Taurman's requests, no copies for Wolf Trap, the Art Barn, or any other facility were enclosed. Instead Brown attached a copy of Wheeler's old 1974 letter to Taurman in which Wheeler had asserted there were no limits at all to the Park Service's authorities. Brown also enclosed the Cooperative Agreement with Ford's Theater Society amended in 1972 to conform with the "Bodman Memorandum" when the heat was on as a result of the Mencken publicity; now the heat was off—the Mencken play had gone on to other stages and other audiences. Consequently, eight years and two administrations after censoring the words of H. L. Mencken, Smokey Bear's assistants continued to claim a divine right to interpret what was morally suitable for all the People, and the National Park Service coordinated these ethical choices with the White House Ministry of Culture to promote an active national cultural policy more effective than weapons.

Although the censorship of Mencken cast doubts upon the Park Service's repeated assurances of its goodwill, the entire episode was no more than an example of farce; the censorship of Erica Jong by the Smithsonian was equally a comedy, damaging nothing more than the Smithsonian's pretense of rectitude; but the prosecutions of Truong and Humphrey for espionage during peacetime and of Frank Snepp as a "visible means of control" were different matters. Those Enemies of the People were brought to trial as examples; as warnings of what kinds of obedience national authorities now demanded from the community at large. Consequently, as the Ministers of Culture attempted to coordinate the com-

munity's efforts in science, art, or history, each approved choice to genius, inspiration, or eloquence raised doubts as to whether the programs entitled summoned up the muses or the furies.

U.S. Authors Protest Suppression of Soviet Writers . . .

NEW YORK, Aug. 12 (Combined Wire Services, Inc.)—Five American authors have sent a sharply worded protest to the head of the Soviet Writers Union, denouncing the suppression of a literary anthology that had been planned by 23 Soviet writers. The protest also scored the union's suspension of two contributors to the anthology.

Signed by the playwrights Edward Albee and Arthur Miller and the novelists William Styron, John Updike and Kurt Vonnegut, the message, a cablegram, was sent Wednesday to Feliks Kuznetsov, first secretary of the Union of Soviet Writers, according to Mr. Styron, who said there had been no immediate response.

The Americans, terming the effort last winter to publish the anthology, known as "Metropol," a courageous move that would have marked a "historicmomentinthe struggleforliteraryfreedominthe Soviet Union," expressed solidarity withthecontributorsandvoicedthe hope that they would "receivetreatmentconsonantwithstandardsofjusticeanddignity."

The message noted thatthecontributors had been subjected to official sanctions since seeking approval to publish the anthology without censorship.

"We protest these suspensions," the Americans wrote, "and we express our admiration and support for four well-known writers . . ."

No immediate response noimmediate response noimmediateresponse

13

PROFILE / NSF: THE TRANSCENDENTAL FAITH IN TECHNOLOGY . . .

Like all religious zealots, they had the blessed capacity for blindness, and they were presently convinced that (since the only newspapers they ever read certainly said nothing about it) there were no more blood-smeared cruelties in court . . . no restrictions of speech or thought. They believed they never criticized the Corpo regime not because they were censored, but because "that sort of thing was, like obscenity, such awfully bad form."

—Sinclair Lewis
It Can't Happen Here

Censors were fanatics and perverts, just as H. L. Mencken had described them. Instances of censorship required fraud, perjury, and forgery; no censor was ever honored. Censors were commonly understood to be dim-witted, wall-eyed bullies, because they interpreted liberty as the freedom to follow orders and an opportunity for their victims to obey. Freedom, censors argued, was slavery. Because they themselves were servile, censors practiced their stupidities as if they were acting on their own initiative, but they were always identifiable as flunkies for some powerful establishment. When censors asserted their authority to absolute tutelage over the community's education, they cloaked their perjuries with the state's higher moral good; but censors never were anything but political zealots. Ignorance, censors claimed, was strength. The dangers of war convenienced censors' legitimacy; but during peace censors continued their activities anyway in the name of some other absolute transcendental ethical necessity, arguing that the current conditions—social, political, economic, technical—constituted the Moral Equivalent of War. Peace, censors proved, was war. As curates of Higher Ethical Truth, cen-

sors exercised the state's powers to harry idiosyncratic behavior, icono-clastic ideas, private confession, or any other independent thought which might be heretical to the established order. Censors prosecuted heresy to justify orthodoxy's revelation. Citing applicable laws or regulations, cen-sors demonstrated forcefully the ethics and politics of the orthodox party for which they served as fanatics.

Although the fanatical claims of censors were always pursued as if they were patriotic duties, censors were perverts because they refused any obligation to keep faith with community memories—transmitted by the continuity of generation after generation as community history. In place of community's understandings, the censor substituted the positive truths by which a dominant minority—those who served Caesar's party —could maintain an appearance of legitimacy for their control of a cor-porate state's unlimited powers. Whether the dominant minority orga-nized its party along fascist lines—incorporating all educational, technological, and national cultural policy to centralized institutions of an elite, or whether the minority structured its party geographically in local soviets of people's councils, or whether Caesar's divinity was certi-fied by the arms of his own Praetorians, censorship required persistent fraud of community interests for state objectives: total power, total em-pire, and permanent order. The particular frauds of censorship were in each instance as corrupt in their detail as misleading advertisements, adulterated food, worthless medicine, shorted weights, or debased money. A script tampered to suit the party's tastes was forgery exactly as perverse as a will altered to favor one heir among many.

Yet censorship was an extension of perversity significant beyond sim-ple forgery. As soon as censorship existed in any form, every other affir-mation by authority was cloaked in possible perjuries, every identity disguised by unknown lies, and what was once the community's com-mon language was corrupted by its loss of particulars. As a consequence, censorship dissolved the boisterous voluntary consents that once bonded community action, and to the extent possible, compulsion had to be mortared into consent's place. As consent dissolved, party officials prom-ised law and order with earnest goodwill as long as they could; but then shored up barricades with brute force.

Censorship was always repugnant, but not because a National Park Service official anointed with the pretentious title "Coordinator of Per-forming Arts Management" claimed authority over H. L. Mencken's words. Censorship appalled at the Smithsonian, but not because that institution of unblemished rectitude felt its audiences would be endan-gered by the erotic poetry of Erica Jong. Censorship was abhorrent, but not because Bill Moyers attempted to explain it away at PBS as "an excess of pluralism." Censorship was outrageous, but not because ICA's cable traffic was suddenly so secret that it brought a fifteen-year sentence for espionage during peacetime. Censorship astonished because the minions

of orthodoxy were revealing how orthodoxy's incorporated powers had abandoned the voluntary community consents and substituted in place of consent the equivalent of CIA Director Stansfield Turner's Orwellian necessity: "visible means of control." Censorship shamed because when it appeared upon the stage of history, it was to play the part of cowardice. The future was unimaginable, and the New Order was soaked in terror.

But the policy discussions of the White House Ministry of Culture never centered upon the examples of censorship they could read about in the morning newspapers. Mentioning that sort of thing was, like obscenity, such awfully bad form—as Sinclair Lewis had put it in *It Can't Happen Here*. Indeed, the matter had apparently never come before the Ministry's elite council, because the ministers brought to their own attention only those matters suitable to their pleasant assemblies. Besides, orthodoxy had its duties: supervising an active-well-coordinated-national-cultural-policy-more-effective-than-weapons.

Dr. Richard C. Atkinson, director of the National Science Foundation, for example, would never sanction even the slightest occurrence of censorship—should any come to his attention. On the contrary, Dr. Atkinson would be among the first to cite as requirements of science the procedures of free inquiry. By their very nature, science and technology were exacting, depended upon an infinite variety of materials and information drawn from all latitudes and geographic regions, without respect to national boundaries or patriotic claims. Science was impersonal, dispassionate, without fear or favor of persons or party truths; an interlocking system of painstaking, collaborative effort, skeptical in its outlook, rational in its processes, conservative in its allocation of resources, and devoted to serving human needs.

Dr. Atkinson served as the National Science Foundation's delegate to the White House Ministry of Culture. He represented a magnificent system of technology to which the nation stood as a grateful material heir and from which all the peoples of the earth hoped for even better tomorrows. As part of the national effort to secure the blessings of liberty to posterity, Congress established the National Science Foundation with a small appropriation in 1950. By 1980, NSF was spending about $1 billion per year with such administrative excellence that more recent establishments of national cultural policy—such as CPB and the National Endowments for the Arts and the Humanities—hoped to emulate NSF's procedures, its reputation, and eventually its appropriations as well. NSF budgets had increased steadily without opposition from Congress, because NSF reflected, Dr. Atkinson said, "that basic research is an investment in the Nation's future . . . it develops the fundamental new knowledge needed for progress."

Just as it was hopeless to analyze the financial commitments of the Department of Education, because each program in education's labyrinth

led to still other operating or capital budgets, the $1 billion distributed as "grants" by NSF only remotely indicated the extent of NSF's prestige, influence, and leadership. White House special analyses of the national budgets indicated research and development (R&D) budgets for twenty-nine separate departments and agencies, including a dozen agencies which spent more than $100 million annually. The White House defined national R&D as: *Basic Research*—discovering fundamental knowledge; *Applied Research*—using that knowledge to meet identified needs; *Development*—design, engineering, demonstration of new technologies, systems, or methods. National R&D monies were invested for "direct national needs"—national defense, space technology, air traffic control, environmental regulation; but "public" R&D monies were also invested for "general economic and social needs" in cooperation with "private" corporations or universities for: "overriding national interests;" or to "increase the range of technological options," such as "development of energy technologies."

The Department of Energy spent $4.7 billion in 1980 for R&D; while NASA spent about $4.5 billion, and the National Institutes of Health about $2.8 billion for biomedical research. The military R&D of the Department of Defense often earned wide notoriety for its supposed extravagance; yet by the government's accounting methods, military R&D totaled a mere $391 million—which was a small fraction of the total national R&D budget of $30.6 billion, and a fraction of the R&D monies of about $3.9 billion per year directly attributable to university corporations. Just as the programs entitled by education were efficient to university ambitions, so too were all the programs allocated to research.

NSF grants were "guiding lights" to these entitlements, and closely coordinated with the operating expenses and capital requirements of university corporations. Together NSF and university researchers searched for the "fundamental knowledge" usually associated with the "hard" sciences: the marvelous curved spaces of mathematics, entirely imaginary, intuitive and often irrational; the invisible charms and ghostly energies of physics; the fantastic beauties of memory's helical chains; the positive traces of galaxies so distant in time that perhaps they never were. To these ends, NSF made grants of approximately $300 million per year for basic research in the mathematical and physical sciences and their engineering. NSF could report that new quarks had appeared; bosons apparently mediated the weak force; homotopic equivalence had at last been proved; improved oil recovery systems engineered. The NSF appropriations for astronomical, atmospheric, earth and ocean sciences totaled an additional $243 million annually. At Princeton University and Haverford College astronomers calculated dips in the intensity of cosmic microwave background in the direction of three clusters of galaxies; the new observatory in Chile was studying wave lengths in the southern

skies; the National Center for Atmospheric Research, a nonprofit consortium of forty-three United States and two Canadian universities, studied monsoons in eastern Africa and India; ocean floors were being cored.

Yet NSF and university corporations together also included among their catholic responsibilities the "soft" sciences. Biology and chemistry, for example, along with the new doctrines of earth sciences and ecology, could not be studied as if causes were unrelated to effects. What was discovered or applied affected society at large. Hence, the jurisdictions of science were necessarily broadly defined, without boundaries to curiosity or limits to discovery. The combined interests of NSF and the universities understood their responsibilities to include education, behavior, the social sciences in all their variety, and all topics of mental or social hygiene; and in addition the ethical and political consequences attendant to science's miracles. Hence, NSF support for the biological, behavioral, and social sciences had continued to expand to a level of nearly $200 million in grants each year. Approximately 7,000 proposals were received by NSF annually; then reviewed by the NSF system of 11,000 advisors, who selected something on the order of 3,000 projects as appropriate to the national interests.

About $50 million in grants were approved annually to biology: for the study of cell structure centers; the investigation of pheromones by which females attract males over great distances; and for investigations of how fertilization occurs. About $25 million in national monies went each year to the behavioral sciences, broadly defined: to study obesity, to sift the tells of archeological interest, to reconstruct the past of hunter-gatherers in the Kalahari Desert. But NSF and its cooperating universities were also engaged in studies of the ecosystem of the Okefenokee Swamp, changes in segregation patterns in metropolitan areas, and "the economic impact of the social security system."

"Divorce rates" among homosexual couples were investigated, along with "the cooperative breeding habits of the white-fronted bee-eater"—for $52,338. The development of "the sense of taste in sheep" came in at a cost of $43,800. Whereas the examination of "patterns of facial muscle activity accompanying low-intensity emotional state generated through imagery and their interaction with automatic processes" was slightly more expensive—$90,000. In cooperation with PBS, the NSF funded television programming for both children and adults. In coordination with the New Orleans Otrabanda Company, NSF supported a dramatization of medieval superstition, then sent the play touring to the nation's principal cities to illustrate the benefits of scientific progress.

Together with universities, NSF studied: the benefits of hypnosis for police interrogations; the effects of various hallucinogens upon the mental attitudes of prisoners; the delicate ethical and political problems related to the disposal of nuclear wastes. These investigations crossed the frontiers of science into university territories traditionally occupied by

the once-upon-a-time liberal arts. Consequently, NSF undertook to "co-ordinate" its scientific jurisdictions with those established by the National Endowment for the Humanities. Joint NSF and NEH grants funded university projects to study "genetic research, research on human subjects, behavior control and environmental change."

According to NEH's annual report, these joint efforts were activities to merge science, technology, and the humanities with respect to the "ethical issues." NEH's authority to merge its programs with NSF's would sustain the active-well-coordinated-national-cultural-policy established by the White House Ministry of Culture. Therefore, joint NSF and NEH grants were awarded to the Illinois Institute of Technology to conduct a summer workshop for faculty on ethical issues in engineering. Joint NSF and NEH grants funded St. Catherine College in Kentucky for a bibliography on the philosophy of technology. In Washington D.C., NSF and NEH jointly funded Georgetown University for $256,746 to develop a program in "Health and the Humanities." In New York, NSF and NEH jointly funded the Institute of Society, Ethics and the Life Sciences for $244,498 to study "the problems posed by complicated scientific disputes which have ethical and political components."

The political ramifications of technology were the occasion for an NEH and NSF coordinated grant of $155,190 to the National Academy of Sciences for scholarly exchange with the People's Republic of China. "Our national security and well-being depend upon our choices," said NSF's Dr. Atkinson. "Ideally our example will inspire the widespread creativity and hard work needed for science and technology to serve the interests of all mankind."

To make the necessary choices, the procedures at NSF were structured along the lines of Italian syndicalism, and NSF's structures had inspired those established at NEH and NEA when those endowments subsequently joined the coordinated system of national culture. Dr. Atkinson was a behavioral psychologist who depended for his decisions upon the advice of a National Science Foundation Board appointed by the president of the United States as a directorate for NSF. At last count, the National Science Foundation Board of distinguished citizens included eight deans or presidents of universities, five presidents or chairmen of corporations, and four professors. When assembled to advise NSF of the interests of all mankind, the National Science Foundation Board could be characterized by some astonishing particulars. To begin with, arguments among its directorate over private versus public contributions to national culture would probably seem as strange and distant as the inexplicable differences of ancient Christendom over the gnostic heresies. Although both public universities and private corporations were represented on the board of the National Science Foundation, the representatives from both corporate establishments were delegates from high-technology enterprises which were capital-intensive and devoted to public affairs. Such

high-technology corporations as the Upjohn Company and the Dow Chemical Corporation varied only slightly in their public interests from the Rand Corporation, or those of Southern Methodist University—irrespective of how their articles of incorporation differed. Union Carbide, M.I.T., and the University of California shared equally in the problems posed by the manipulation of genetic codes, the consequences of Temik to water tables, the requirements to carefully safeguard research into recombinant DNA, the hazards of breeder reactors. All these mysteries posed questions for the future, as Dr. Atkinson pointed out, that "must be dealt with ethically and politically."

Whatever political choices had to be made, the directors of the National Science Foundation Board had long since learned how to be discreet in those matters that might affect "national security." Aware that "progress" was sometimes a mixed blessing, NSF's board members would generally have agreed with Dr. Atkinson's summary that "advances in knowledge" were the biggest source of economic growth and productivity in the United States during the past four decades. "Any increase in knowledge—from either basic or applied research," said Dr. Atkinson, "placed a heavy responsibility on both scientists and nonscientists for setting goals."

The National Science Board approved applications for NSF grants provided that each grant was consistent with those goals approved by the directorate of distinguished citizens and consistent with their established understanding of ethics and politics. Before grants were sent up for national consideration, however, they were studied by an extraordinary system of thirty-seven advisory committees, panels, and subdirectorates established by specialized categories of interest and encompassing more than 500 other distinguished citizens drawn from the tables of organization at both universities and corporations.

These additional 500 reviewers gave their expert opinions upon what should proceed or what must be postponed, but they were advised by tens of thousands of still other university, foundation, or corporate advisors. An NSF review panel might consider grant applications under the category "Science, Ethics, and Politics" in an assembly of only six members —such as the NSF subcommittee for "Law and Social Sciences"; but NSF review panels could be as large as the sixty-eight-member "Advisory Committee for Physiology, Cellular, and Molecular Biology." By NSF's own accounts, 11,000 social scientists were solicited for their opinions on NSF grant proposals for various studies on the ethical, moral, political, and economic problems of a technological society. Yet, before proposals could even be considered for review, NSF staff studied their feasibility, consulted advisors on the likelihood of results, and only then proposed the grant to a committee of experts familiar with the topical field. When fully "prepared," the proposal was submitted to a panel composed of the

proposer's "peers," where each application for national monies was examined in absolute "confidence."

The system of "peer review" originally came from university traditions of academic departments, although it was not so very different from decentralized operating budget meetings at independent divisions of conglomerated corporate enterprise. The procedures endorsed appropriate choices between "competitive" proposals, but along with "peer review" certain problems traditionally appeared. Of these, the most awkward was that it would be difficult to demonstrate that any original mind in the history of science, arts, or manufactures had ever survived a review by peers. It would be easier to demonstrate how often the opposite was true: every intuition, every adventure, every change had so angered the peers of genius that whatever genius proposed was not only immediately denied, but forcefully so. Anyone could construct his favorite list of those whose intuitions had failed a review by peers: Galileo, Leibnitz, Descartes, Harvey, Newton, Darwin, Freud, Max Planck, Einstein. In fact, the history of stupidity at national academies of science or philosophy was equaled only by the lethargies of national academies of arts, where new perceptions were always identified with *salons des refusées:* Dante, Giotto, Molière, Voltaire, Mozart, Melville, Wagner, Joyce.

Any intuition proposed to an assembly of peers always seemed to have certifiable faults: Einstein's arithmetic was actually faulty. Although his theories were eventually accepted, sometimes his most marvelous proofs were careless. Cezanne, said his peers, drew atrociously—and they were largely right. Christopher Columbus had no proof of the continent he would discover for Spain's queen, and his sailing directions demonstrably miscalculated the earth's circumference. The queen's scholars concluded the Italian captain was unable to add and was a liar besides—and they were quite correct. Peers praised originality, but refused folly, and intuition was always irrational.

Peer review was a social convention of orthodoxy, sometimes reluctantly conceding cooption, usually refusing outright adoption—because to do so would disestablish the social arrangements which the peers represented. Frequently peer review was used for excommunication: in every drama in which some crazed prophet questioned the ethical standards of the existing social order, or preached the Good News of some new revelation against the accumulated wisdom of the priests anointed to the temple's continuity, the guardians of orthodoxy never actually had any practical alternatives: not only did the proposed changes to social order have to be condemned, but the prophet of change had to be brought to trial under the existing legal codes, and charged with corrupting revered moral values. After all, the guardians of orthodoxy were not entitled to their offices to approve heresies; therefore, every prophet was invariably guilty as charged. Peer review as established at NSF with re-

spect to the benefits of technology was no different from a college of cardinals assembled to interpret the nuances of an eternal and everlasting truth, and with an absolute duty to make ethical and moral choices, as Dr. Atkinson said, which would "serve the interests of all mankind."

Yet peer review had a strange history. No panel of peers ever announced that after careful consideration they believed their Caesar lacked the graces necessary for his claim to divinity. No Roman curia ever prepared an encyclical concluding that Rome's pope had been the cause of schism; blessed by divine inspiration, and after careful study, it was clear that Avignon had erred. No general staff ever taught their commander how he had lost his wars. No subcommittee of peers ever suggested to its board of directors that they resign because they were incompetent judges of the heavy responsibilities they had assumed. No peer-review panel ever arrived to hear choices, and then disestablished itself in gales of laughter. Instead, orthodoxy's social duties were accurately identified by NSF's Dr. Atkinson: political considerations were so important to NSF's "choices," because any increase in knowledge placed "heavy responsibilities" upon NSF's committees established to set goals. Considering the "overriding importance" of these goals, the process by which choices were made had to be conducted in "frank and open discussion" by members of the peer-review panels, and therefore the proceedings of the panel were declared secret to protect the privacy of the *panel*. If the ethical and political choices made by NSF upon the topics of technology were as critical to the future as Dr. Atkinson said they were, the clandestine procedures at NSF were demonstrations that NSF's establishment considered itself fearful of community opinion.

In addition to its political and social oddities, peer-review procedures created philosophical curiosities: when "fundamental new knowledge" was proposed for orthodox examination, applications had to be standardized as to form, and forwarded to the established reviewers according to accepted manners and customs. Proposals ought to be rational, and insofar as possible, put forward by logical arguments. New observations were expected to move forward from previously accepted scholarly work. Above all, the proposed work ought to be consistent with the philosophical reality every orthodoxy preferred—all inferences deduced from the work's conclusions should at least pretend to be mutually consistent. Put the other way around, established peer-review panels could not approve intuitions that were disorderly, irrational, inconsistent, uncertified, illogical, and which tossed overboard all the certitudes accumulated laboriously by the panel's own membership and traditions. Proposals based upon some wacky intuition, or submitted as a lark by men or women of poor reputation, if approved, would shirk the panel's established responsibilities, abandon political as well as ethical nuances to orthodoxy's authorities, and expose the peer-review panel and its enabling institution to criticism and scandal. Orthodoxy's procedures insisted upon rational

truths; that the truths pursued were knowable, if not immediately, then at least eventually; that many truths were obscured by dependence upon the senses, indeed uninformed direct observation often deceived; that, consequently, truth was established as a result of careful accumulation of data, annotated by using the tools of logic, and finally by publishing what was known along with its reasoning.

Within a small community, peer review's defects were mitigated by charitable understandings: small scholarly communities consented to intuitions over a glass of sherry at the faculty table; neighborhood agreements were made across a backyard fence. Informed by an intimate knowledge of local idiosyncracies, enthusiasms, and irrationalities, community peer review was a plausible procedure for three reasons: first, local consents forgave follies; second, local consents might improve the community's future; third, the community's future depended upon laborious efforts to effect change accumulated by successive generations. As a result, communities forgave wasted efforts. Every community could recall some nut who had attempted to build the first waterwheel, windmill, or pepper grinder. When the process of peer review was adopted by the vast administrative system of empire—in which traditions, customs, and manners counted for nothing—a peculiar social organization was established with dangerous authority over social change. National administration by peer review of science was a radical procedure which identified by its establishment exactly who were the blessed guardians of orthodoxy, and indicated the social landscape which orthodoxy claimed as its own.

Unfortunately, the inhabitants of the social landscape claimed by orthodox scientific progress were terrified by the technology promoted by NSF, its coordinating government agencies, and cooperating university and private corporations. "The explosion of knowledge" cited by Dr. Atkinson as the ethical basis for political choices was the source of community terrors: some advances in technology were beneficial; others had resulted in horrors. The perceptions science held, such as the fantastic energies of charm speeding from black holes, were realizations as morally neutral as the joys of Mozart's music, the colors of Cezanne's fields, the cadences of Shakespeare's lyrics. Perceptions might very well be emotionally rewarding for some, just as love was, but perceptions could not in themselves provide certitudes for assertions of moral authority. The sources of moral powers were located in the patient history of community consents in the public domain, but NSF, along with the other ministries of culture, was patently hostile to community opinions, as its clandestine procedures demonstrated. Besides, communities knew how science had improved some elements of social life, but disrupted others. Applications of technology made possible television broadcasts of Olympic feats, but also made possible the delivery by satellite of multiple entry atomic warheads. The machines of technology were marvelous, some of

them of nearly infinite power, and they provided leisure for many, but dispossessed millions. A transcendental faith in the powers of the dynamo made possible the cities of the earth; but the New Order had also left the cities bankrupt—with surging populations inhabiting ruins.

Government Says Letter Is Top Secret . . .

WASHINGTON (Combined News Services)—Federal officials demanded today that Sen. Charles Percy (R.-Ill.) and several newspapers surrender letters mailed to them by an amateur expert. The letters were sent by Charles Hansen, a California computer programmer whose only physics-related education consists of two years of college-level engineering. Hansen has said that, in putting together his now-classified letters, he used only "the encyclopedia, affidavits released by the government in the Progressive case, history books and pure, intuitive reasoning."

The Energy Department immediately declared Hansen's letters "Top Secret." The department contends the letters are automatically classified and the department is considering filing criminal charges. The Atomic Energy Act of 1954 bans public disclosure or discussion of ". . . all data concerning (1) design, manufacture, or utilization of atomic weapons; (2) the production of special nuclear material; or (3) the use of special nuclear material in the production of energy."

Top secret nuclear energy restricted data criminal discussion top secret productionofenergy restricteddata discussioncriminal specialmaterial
 pure intuitive reasoning top secret

14

SKETCHBOOK / CETA: DID 10,000 ARTISTS DANCE ON CETA GRANTS? . . .

He preached the comforting gospel of so redistributing wealth that every person in the country would have several thousand dollars a year (monthly Buzz changed his prediction as to how many thousand), while all the rich men were nevertheless to be allowed to get along, on a maximum of $500,000 a year. So everybody was happy in the prospect of Windrip's becoming President.

—Sinclair Lewis
It Can't Happen Here

Progress devastated the landscape through which it crusaded. Glorious advertisements about the social benefits provided by science were contradicted by evidence available from direct observation. During recent wars technology had been used to reduce honored cities to rubble. A competent physicist could ride his horse through Dresden without requiring his mount to lift a hoof. Neither Genghis Khan nor any of his imitators had razed in their entire careers what a handful of technologists could wreck in seconds. In the name of progress, studies were funded continuously by the coordinated system of national R&D to discover every nuance of death. New ways to poison crops were tested. Leaves were stripped from trees. Wells and watersheds were ruined. Land stripped and mountains moved. At the same universities which provided these useful items of technical information, the exact moral limitations of war remained undetermined. The ethical and political choices were apparently moot to the explosions provided by knowledge.

In the triumph of progress, wars were nearly continuous. During the brief periods of peace the New Order worked relentlessly to wreck the landscape of its own cities. Four successive presidents took walking tours

through the same six blocks in New York's Bronx and said that what they had seen was a disgrace. Each president compared the landscape of the nation's cities to scenes drawn from the ravages of war: bombed out, burned out, ruined, wasted, wrecked. They proposed programs. The powers of technology were cited: after all, men had landed on the moon. Congress appropriated billions upon billions of revenues taxed from the middle class for endless social schemes to restore the bankrupted cities. Programs were authorized in Housing and Urban Development, Transportation, Health and Human Services, massive programs for Education, small programs for docks, airports, bus stations. Neither the programs nor the monies spent delayed the observable social decay. The poor continued to grow in number. Murder became a commonplace of the streets. The middle class retreated from its old optimism into a sullen suburban lethargy. The rich, who had once provided the cities with entertainments —with music, art, sports, and libraries—abandoned their preeminence, turned their celebrations over to state councils of culture, took their assigned seats at the state's spectacles, wearing blue denim, and exchanged smiles with celebrities.

Although programs to improve education multiplied, the grasp of the young upon the tools of learning weakened. The aged were abandoned, shut away in nationally funded "nursing homes," with no one but fraud and death for companions. Aqueducts began to leak. Bridges rusted away. Sewers failed. Rats multiplied. Upon the fertile plains, grain was harvested in miraculous quantities, but left rotting in heaps, lacking boxcars to carry it to the hungry, while sawdust was used to give bread weight. Meanwhile, new corporate headquarters and university towers soared story after story toward heaven, sheathed in stained glasses, much like cathedrals, except that the glass was entirely uniform in modern hues— placid, bland, vacant, intended to shade light out instead of letting in the glories of color. In the teeth of such irrationalities no new social initiatives arose to circumvent the difficulties; everything continued as it was, because orthodoxy feared the consequences of change.

The land of milk and honey promised by science grew ever more distant. Millions starved. Except in the temples of technology's faithful, the effects of its theocracy were commonly understood as a nightmare in which the unchecked, all-powerful state demanded obedience from the unemployed displaced by the dynamos of progress. Worse, the New Order required fealty for its management of domestic crises and foreign wars which the state itself instigated. To the pervasive helplessness in the public domain, propagandists declared that culture was "the very essence of our lives," and education the one remaining hope to pursue the community's goals of life, liberty, and the pursuit of happiness, but exactly what the educators proposed to accomplish was never entirely clear.

The ministers of culture declared that their various coordinated programs were educational; but at the same time enabled the programs as

"processes," rather than singular efforts to achieve particular ends. Unembarrassed by any irony, the ministers spoke of "ongoing processes," as opposed to not-ongoing processes, and to distinguish whatever was ongoing from any completed work. By such definitions, all programs of national culture were simultaneously establishments and entitlements: permanent systems of their administrators and continuous usages by their beneficiaries—devices of patronage with social and political effects as well as economic objectives. Scholars in the sciences and humanities, for instance, working at universities on grants funded jointly by NEH and NSF, were commissioned to produce national studies which might reveal new lessons from history or from biology. Since any discovery they might make was part of a "process" instead of an effort to achieve a particular end, all conclusions from any particular study were equal in value to the conclusions from all other studies.

The United States Department of Labor operated a "partnership," it said, between its Comprehensive Employment Training Act (CETA) and the arts and the humanities. At first glance, direct support for artists might seem to be a system of patronage more suitably administered by the National Endowment for the Arts, but instead NEA described its "processes" as necessary to arts institutions, whereas CETA said it supported artists in the tradition of the WPA art programs. Liv Biddle, Chairman of NEA, thought CETA "employed" many more artists than NEA did, perhaps as many as 10,000! CETA believed the United States Department of Labor's programs employed about 7,500 artists, more or less. Perhaps not all of these workers were artists, but because artists were poor they qualified for training, CETA said, as part of the Great Society's continuous war against poverty.

The CETA war to reeducate the poor was an unending process necessary to alleviate the dislocations of progress. Whether there were actually two thousand artists, ten thousand, or fifty thousand hardly mattered: no one knew how many artists were being trained to do what; no one knew whether the trainees were actually artists. All the programs of CETA overlapped, and therefore were "coordinated" with still other programs of NEH, NEA, Department of Education, and all the other programs funded and authorized by Congress to the desolated national cities. No one could identify which educational programs accomplished what under any particular title. It was an "ongoing process."

The administrators of CETA could not be entirely sure of what CETA accomplished because CETA made "block grants" to approximately 444 state and local units of government. Because of changes in political fortunes, the number of units receiving grants constantly varied. The local units chose their own "priorities" and their own systems of administration to distribute about $10 billion in national funds. The local entities receiving these funds might be cities, counties, towns, or consortia of any combination of these. Either as individual units of government or as

consortia, the CETA entities reported upon their activities to regional CETA councils, but since each entity chose its own priorities and its own systems of accounting and administration, summaries of their accomplishments would be impossible. Besides, any political entity with a population of 100,000 or more could either operate its own programs directly or subcontract the operation of the programs to nonprofit CETA corporations established for the purpose. Consequently the number of artists, writers, violinists, welders, plumbers, carpenters, or ditchdiggers could never be identified at all, except as rational abstractions projected upon the walls of the Congressional committees on appropriations.

Moreover, CETA programs often supported activities that were already supported by other systems of national patronage. Suppose the wife of a mayor in a midwest city believed the city should have a first-class orchestra. The local symphony could never be improved, the conductor told Madame Mayor, unless the symphony could hire a first-rate violinist. Fortunately, an excellent first violin was available in Chicago. The only requirement necessary to conform with CETA guidelines was to move the violinist from Chicago, establishing him as a "local priority," and thereafter his honoraria could be buried in the mayor's CETA budget —over and above whatever the symphony was able to cull from the NEA program of "symphony support."

One effect of CETA's system for dispensing $10 billion in "local priorities" was to confound all analyses of all other national entitlements. Every "activity" carried forward in the name of "national cultural policy" was operated as an "ongoing process" with local and national funds commingled. CETA artists could paint the walls of HUD projects—that was "housing" for the poor. CETA sculptors could be commissioned to erect statues on the village green—that would be "urban renewal." CETA "trainees" were used to man a museum's switchboard—that was "museum services." The totals of these "processes" were not only unknown, they were unknowable. The departments of Agriculture, Education, Commerce, Transportation, the Small Business Administration, either singly or combined, encouraged the publication of books and magazines and the production of films by independent producers and publishers, by university-corporations, and by state or local corporations, both profit and nonprofit. Not only did such activities themselves qualify for subsidies from each enabling department, at national expense each group could hire CETA employees to carry forward the labor. "On-the-job-training" it was called. As a rough estimation of CETA's payroll, $10 billion divided by an annual salary of $10,000 per worker equaled one million workers. Theoretically, on-the-job training for CETA workers lasted a maximum of eighteen months, according to what the law specified, but exemptions from the law were quickly found to be necessary to meet practical political exigencies. When the president campaigned for a Florida caucus, local exemptions were continuous.

In a typical CETA "partnership," a Republican county received $66 million for one year. Of the $66 million total allotment, $27 million was earmarked for "special projects." No county official, elected or appointed, ever objected to special projects. Generally, consortia to operate CETA allotments worked handsomely when all the cooperating political entities were from the same political party, and therefore easily agreed upon priorities of what CETA described as the "prime sponsor." The typical CETA Republican county "prime sponsor" allocated a payroll of $479,537 for a small "cooperating" Republican town within the county.

Looking through the town's payrolls, the town highway superintendent employed twenty-six CETA workers on a "road beautification" project. During the year, a dispute arose over whether CETA's on-the-job-training regulations limited the trainees to the use of rakes, or also permitted them to pick up a shovel. Another seventeen CETA employees worked for the town Park Department and other town projects, including one trainee who helped at a senior citizen's nutrition program sponsored by funds from HHS. School District Number One employed thirteen CETA workers. In "coordination" with state and national education programs, three CETA workers assisted a television project which aired local interviews and carried a live broadcast over the local private cablevision system of a teenage disco dance. Four CETA workers in School District Number One worked on an "arts" project, entitled under a New York State Department of Education appropriation called "Visual Literacy," described as linking art "with such disciplines as social studies, science, mathematics, music and physical education."

CETA also delivered thirty-one workers to Boy's Harbor, a local non-profit privately operated summer camp of high reputation and considerable political influence. The town Marine Museum employed five CETA workers; the town Art Museum employed nine. Of the total 102 CETA employees allotted to the typical town in the typical county, two could be identified as having been "artists" at one time. One was said to be painting small landscapes as a hobby, but his work as an artist was not considered relevant to either his CETA employment at $7,000 per year or to the local art dealers. The other "artist" worked part-time at the town museum, but had given up painting years ago.

CETA reported to Congress that their role in public support of the arts and humanities had been a "vital one and exciting things are happening which give promise of an even greater role." CETA said they had funded an estimated 7,500 positions for artists, cultural workers, and supportive personnel "with somewhere in the neighborhood of $75 million." What was needed now, said CETA, was intensified development of the CETA partnership with the arts and the humanities. "When we consider that the monumental achievements of the WPA arts programs during the thirties cost only about $160 million, we can see the potential there is for CETA in expanding the cultural life of the nation."

In New York City, CETA workers joined the payroll of the mayor's office starting at $12,000 per year as "supportive personnel" in the city's efforts "to expand cultural life." The CETA payrolls for "cultural workers" in New York City—the showcase for American artists—exceeded in their local totals the best professional estimate of *all* monies spent at *all* galleries for *all* the work done by living artists. Whether the amounts of CETA funds were in the neighborhood of anything at all, the CETA programs were "ongoing" and "processes" unrelated to the critical standards applied to finished works of art. Keep in mind, CETA spokesmen told Congress, in the words of Atlanta Mayor Maynard Jackson, chairman of the United States Conference of Mayors Arts Task Force: "The arts reveal us to ourselves. They are an expression of community identity in its highest form."

Four years after establishing the CETA programs, Congress was appalled and attempted to sort out the chaotic labyrinth of "coordinated" and "cooperating" local priorities. Congress commissioned the General Accounting Office to investigate how one fairly typical CETA region worked: Tidewater Virginia. Forty-four different programs involving five federal departments, three independent federal agencies, one federally sponsored regional council, fifty local administering agencies and twenty-six other administrative groups, including state agencies and national organizations, were expressing Tidewater Virginia's ongoing community identities.

With the GAO report on CETA's complexities in hand, Congress did nothing, because as a matter of fact there was nothing to be done: the time for reform had passed. No one could quite remember when it went, but it was gone. The system of patronage that had worked so well in democratic experience upon a local level was irreversible when established to national constituencies; and national priorities constituted, as was so often said, "overriding national interests." The New Order was overriding with national patronage what had once been understood as community sovereignties: the public domain of accumulated customs, manners, and tradition.

In August 1978, a community magazine, *Harrisburg,* published a fictional account of a runaway nuclear reaction at Unit 2 of the Metropolitan Edison nuclear generating plant at Three Mile Island. Author Larry Arnold imagined in his story how the corporation's executives would attempt to keep a disaster hushed, if one ever occurred. Eventually, in Arnold's fiction, the news leaked and people began to evacuate Three Mile Island. "The public didn't know what to do," wrote Arnold. "Some people refused to leave, relying on past assurances that TMI posed no invisible threat." Arnold recounted the panic in Dauphin, Cumberland, and Lancaster Counties. He concluded his fictional account by remarking that the scenario he described was not as fanciful as some readers might suppose. "Repeatedly—at Chalk River, Ontario (1952 and 1958), Wind-

scale, England (1957), Enrico Fermi 1 outside Detroit (1966), Brown's Ferry 1 & 2 in Alabama (1975)—nuclear technology that was publicly characterized as fail-safe failed. Surrounding populations, faced with imminent radioactive catastrophe, learned of their plights days or months later."

Upon reading Larry Arnold's fiction in *Harrisburg* in August, 1978, Walter Creitz, President of Metropolitan Edison Corporation and operator of the Three Mile Island utility, contacted Congressman Gus Yatron, Democrat, Pennsylvania. *Harrisburg* carried community bulletin board information in a column published with grant monies supplied by the Susquehanna Employment and Training Corporation, a local subcontractor for CETA programs in a five-county area of Pennsylvania. Arnold's fiction, said President Creitz, was "sensational reading, not true, a horrible article, and blatantly distorted." In President Creitz's opinion, "if federal money supported such writing, Lord help us all."

The United States Department of Labor was advised of President Creitz's objections. The national CETA staff refused to renew funding for the bulletin board announcements in *Harrisburg*. The magazine's editors pointed out that Arnold's fiction was not paid for by federal money. The local CETA "prime sponsor," consisting of the five local county organizations, also objected to CETA's blacklisting of *Harrisburg* for a fiction —particularly upon the complaint of a congressman from Met Ed's district, which was not the district in which the magazine was published. A year later CETA officials were still reviewing the matter.

Meanwhile, a local Pennsylvania official was quoted in national news columns in an attempt to explain the attitude of Met Ed's Corpos, particularly President Creitz: "He and his staff have a theology of more and better lives by using more and more electricity. They believe it so absolutely that they find it impossible to believe there might be sensible people who don't immediately agree with them."

Transcript . . .

HEARINGS
before a
Subcommittee of the
COMMITTEE ON APPROPRIATIONS
HOUSE OF REPRESENTATIVES
Ninety-Sixth Congress
First Session

———

Subcommittee on The Department of Interior and Related Agencies
Sidney R. Yates, Illinois, Chairman

Gunn McKay, Utah
Clarence D. Long, Maryland

Joseph M. McDade, Pennsylvania
Ralph S. Regula, Ohio

Robert B. Duncan, Oregon Clair W. Burgener, California
John P. Murtha, Pennsylvania
Norman D. Dicks, Washington
Bo Ginn, Georgia

PART II

Monday, May 14, 1979

DEPARTMENT OF ENERGY

Witnesses

John F. O'Leary, Deputy Secretary
Jackson S. Gouraud, Deputy Under Secretary for Commercialization
Alvin L. Alm, Assistant Secretary for Policy and Evaluation
Mary E. Tuszka, Director, Office of Budget

MR. YATES:
This is a continuation of the appropriations hearing of the Department of
Energy for fiscal year 1980. Appearing in support of that appropriation is
its Deputy Secretary, Mr. John F. O'Leary. . . .

MR. O'LEARY:
I think the impetus is going to have to come from events external to both
the administration and the Congress.

MR. DICKS:
You are crisis-oriented?

MR. O'LEARY:
No, let me just tell you how I view this world. Our policy, as I went to
some length to explain this morning, is to import. We do not do things
that are painful. I will now talk about nuclear energy a little bit. You
know I used to license nuclear plants. I dedicated Three Mile Island.

MR. YATES:
Oh, you are responsible?

MR. O'LEARY:
Yes, indeed. I do not think I licensed Three Mile Island, but I did dedicate
it. What have I learned from Three Mile Island? That nothing happened.
It is a callous, hard, nasty thing to say, but what happened there is noth-
ing happened. . . .

15

ENEMIES OF THE PEOPLE / HOWARD MORLAND AND JANE FONDA

Winston grasped that some terrible thing, something that was beyond forgiveness and could never be remedied, had just happened.

—George Orwell
1984

Blacklisting was as loathsome as censorship, and furtive too: a slander whispered as an aside between clenched teeth. To teach the catechism of the New Order, national administrative procedures were used to bully the locally sponsored magazine: *Harrisburg* was to be punished for heresy —and the heresy consisted of technical certainties known only to Walter F. Creitz, president of Metropolitan Edison, a subsidiary of General Public Utilities Corporation. Both of these corporations were characterized as "private" organizations although they conducted no business except as public monopolies. When CETA acted in their interest, CETA illuminated by example far more than it intended. CETA was the flunkie for political powers more potent than five local district officials, their regional consortium, or the area's duly elected representative to the United States Congress. If the elected officials of what was once democratic politics had exercised their traditional powers, the United States Department of Labor should have been able to brush the zealotry of a utility Corpo off its sleeve as if he were a nuisance like a summer fly. Instead, CETA's compliance to the ethical demands of a Corpo fanatic was an example of the kind of sleazy servility that had caused H. L. Mencken to remark: "Government is the enemy of all well-disposed, decent and industrious men."

The conclusive proof of how Metropolitan Edison perverted its public trust was yet to come. The blacklisting of *Harrisburg* magazine as a result of Larry Arnold's fictional account of panic at Three Mile Island was no

anomaly; instead it was one example among many of a consistent, determined, and continuing policy of the New Order. The offending article in *Harrisburg* was soon forgotten, reduced by circumstances to a curious historical footnote—because in the early morning hours, Wednesday, March 28, 1979, an actual meltdown began in the core of Met Ed's reactor at TMI. Just as Arnold had predicted, Met Ed Corpos delayed before they told the truth to either elected or appointed public officials. Just as Arnold had imagined, there were no practical evacuation plans for the area surrounding Harrisburg—although Met Ed's license was issued upon sworn testimony that such plans had been prepared. Later, six national commissions were appointed to examine Met Ed's stewardship of its public trust. All six national commissions reported that Met Ed, along with every other public utility, all the suppliers of nuclear fuel, all the designers and manufacturers of nuclear equipment, and all the regulations of all nuclear operations were "so riddled with deficiencies" that an accident like the one that occurred at Three Mile Island had always been "eventually inevitable."

The president's commission on the accident at Three Mile Island concluded that Metropolitan Edison "did not have sufficient knowledge, expertise and personnel to operate the plant and maintain it adequately." In reply, Verner H. Condon, vice-president and chief financial officer for General Public Utilities, defended the management of GPU's subsidiary at TMI by pointing out that the same presidential commission had found that his corporation's nuclear expertise was equal to, if not slightly better than, the rest of the nuclear industry. Regardless of who pointed fingers at whom, the report of the president's commission and of every other investigation would contradict repeated assurances made by nuclear proponents: as advocates they had used every opportunity, every institution and agency of government, and every means of propaganda to assert that safeguards against nuclear accidents were adequate; that safety devices were reduplicated at great expense to provide fail-safe systems; that because so many fail-safe systems had been provided, no significant failures had ever occurred; and, moreover, that the likelihood of any nuclear accident was so remote under the mandated procedures of regulation that accidents lay beyond the calculations of reasonable probability. Clean, Safe, Dependable, said the nuclear industry's promoters.

After Three Mile Island, all six national commissions would contradict in one form or another all of the industry's claims both in their entirety and in detail—with irreconcilable technical information. The national commissions provided the technical data demonstrating that the safeguards against nuclear accidents were minimal; that regulation could be described as haphazard at best; that licenses to operate potentially fatal nuclear facilities had been issued to incompetent and unqualified corporations; that these corporations had systematically abused their public trust; that TMI was not the only significant or serious nuclear accident

that had happened; that, on the contrary, nuclear safety systems had frequently failed; that many of these failures had been kept secret, not only from the public at large, but also from other operators of nuclear utilities; that tests conducted by the Atomic Energy Commission on the designs for emergency core cooling systems had shown that every proposed design had failed; that reports on the fall-out zones in the event of an accident were based upon doubtful statistical studies, but issued to the public anyway, then used as the bases for licenses—although the issued reports were known to contradict the nuclear agency's own conclusions; that no safe storage system for nuclear wastes had been found; that no plan for any safe storage system could yet even be imagined, and therefore none could actually be designed; that Three Mile Island was not the only "clear and present danger" to community continuities. Every single nuclear installation was a similar danger because there was "no detailed blueprint for nuclear safety."

The technical information was abundantly clear. The conclusions applied to the seventy-two reactors already in operation in the United States, to nearly a hundred more for which construction permits had been issued, and to roughly thirty additional units awaiting construction. An examination of the technical tests conducted by the AEC was continued at a similar nuclear test facility in West Germany. All studies continued to indicate that the emergency core cooling systems in nuclear plants "might not work." Only after Three Mile Island did the United States Nuclear Regulatory Commission assemble an emergency meeting to consider the risks: an assembly of designers, manufacturers, and fuel suppliers—including Union Carbide, Dow Chemical Corporation, the General Electric Company, Westinghouse Corporation, Combustion Engineering, Inc., the Babcock and Wilcox Company, the EXXON Corporation, and others.

These suppliers of designs, fuels, nuclear equipment, technologically trained personnel, and sophisticated technical information operated in the United States under the jurisdiction of the Nuclear Regulatory Commission; but these same corporations were also the exporters of nuclear technology to eighteen other nations—where the probability of serious nuclear accidents was the same as it was at Three Mile Island, but entirely unregulated in any practical sense. Moreover, one byproduct of the nuclear fuel cycle was plutonium in sufficient quantities to manufacture atomic bombs—useful in themselves as awful explosive devices, but also necessary as triggers for the incredible hydrogen bomb. In sum, corporations steeped in nuclear technology had created a domestic "clear and present danger" with respect to nuclear power generating plants; in addition, they had exported the same danger to eighteen other nations where a total of 2,000 nuclear plants was planned. The export of nuclear facilities and technology with respect to generating power simultaneously exported the same "technical information" along with the fuels,

the machines, and the technologists to operate the machines by which the hydrogen bomb could be manufactured. The doomsday H-bomb device had already been tested by Russia, China, France, and Great Britain; but technically sophisticated United States corporations had exported not only nuclear power facilities, but also the materials required for H-bomb construction, *and the financing as well,* to Taiwan, South Korea, South Africa, Argentina, Brazil, Israel, India, Pakistan, and Iran.

The proliferation of doomsday machines by export was intrinsically connected by the nuclear fuel cycle to the domestic multiplication of nuclear power plants: both systems were promoted by the same corporations; both systems were regulated—"riddled with deficiencies"—by the Nuclear Regulatory Commission as a division of the Department of Energy. The technical information provided by the national commissions regarding the Department of Energy's administrative performance was appalling: instead of accidents being unlikely, there were no guarantees at all, said the national investigators, against future nuclear disasters at any nuclear power plant site. These accidents might occur on a scale of terror ranging from trifling scares to the entombment for at least 250,000 years of an area the size of Pennsylvania. After reviewing the assembled technical information, all six national commissions would recommend immediate and comprehensive change: any examination of national nuclear policy would show beyond doubt that the Department of Energy's administration of the nuclear industry constituted a threat of "direct, immediate and irreparable damage to the nation and its people."

The events at Three Mile Island resulted in recommendations for immediate and urgent "critical choices." Yet, the conclusions derived from the technical reports were limited to the clear and present *domestic* dangers, because the patents of each investigating panel did not include any consideration of the exported dangers of nuclear accidents in such stable and reasonably administered governments as those of South Korea, South Africa, Pakistan, or Iran; nor did the appointed panels consider the resulting proliferation of nuclear weapons intrinsically connected to the export of nuclear fuel and technology. Every ethical and political change recommended by the official commissions as urgent to the repair of the social fabric had long before been recommended and argued as urgent in the public domain.

Yet during the same months in 1979 that Three Mile Island illustrated why urgent changes were so necessary, officials of the New Order simultaneously asserted that all "technical information" about nuclear energy was secret, even materials that once were in the public domain; that materials in the public domain could be declared secret retroactively; that nuclear secrets included all materials, not only about nuclear weapons and nuclear fuels, but also any foreign or domestic application of nuclear energy; that nuclear secrets could include thought itself—wonder, perception, hypothesis, doubt—even if the thoughts or ideas were

known by personal intuition, by private study, or occupied a nook in an understanding mind, and without regard to whether the secret was common knowledge or could be found in an eighth-grade encyclopedia. At exactly the same moment in 1979 that the disaster at Three Mile Island illustrated the urgency of immediate change, the Department of Justice moved to stifle any discussion of how change might be effected. Moreover, the New Order asserted the extraordinary claim that any communication by either speech or writing of the "technical information" necessary to understand nuclear industry—either for weapons or for energy—subjected the participants to criminal prosecution. As these censors advanced the radical claim that they were capable of policing thought itself, they revealed the transcendental faith for which they acted as zealots. They also identified by what they declared to be heresy precisely what they believed to be orthodoxy. In the *Progressive* case, the Department of Energy and the Department of Justice demonstrated exactly that there were to be no limits—no limits at all—to the transcendental powers of technology.

On Monday afternoon, March 26, 1979, less than forty-eight hours before the disaster began on Wednesday morning at Three Mile Island, the Department of Justice obtained an injunction in the federal district court in Milwaukee, Wisconsin, to enjoin by "prior restraint" the *Progressive* magazine from publishing an article by free-lance journalist Howard Morland entitled "The H-Bomb Secret." The preliminary injunction issued March 26 was the courthouse result of a temporary restraining order issued Friday, March 9, by Judge Robert W. Warren. My curiosity about the *Progressive* case began the next morning, Saturday, March 10. Starting at ten o'clock and continuing until six that night, a "First Amendment Survival Seminar" was conducted at the National Press Club in Washington, D.C. Teams of lawyers were brought in to brief some 300 members of the press on the journalistic procedures currently necessary as a result of recent court decisions. I learned that in the end I should be prepared to go to jail; that I should routinely destroy all my notes; that I should never express my opinion in writing without consulting a lawyer first. While this nonsense about right conduct for a "free press" was in progress, news of Judge Warren's order gagging the *Progressive* arrived in the National Press Club ballroom. Television cameras were set up to hear from the distinguished members of the bar present. Not one would comment.

The television crews packed their lights and left. Until the facts of the matter could be studied and the judge's opinion read, counsel had nothing to say. They represented the American Society of Newspaper Editors, the Association of American Publishers, Scripps-Howard Newspapers, United Press International, The American Newspaper Publishers' Association, the *Washington Post*, Newhouse Newspapers, the Society of Professional Journalists—Sigma Delta Chi, the Reporters Committee for

Freedom of the Press, the *Philadelphia Inquirer,* the Radio-Television News Directors' Association, the *Washington Star,* and sixteen other sponsoring organizations. Eventually many newspapers would carry editorials supporting the *Progressive* and condemning Judge Warren's order; but many would not, because the *Progressive,* in their opinion, had not brought a "clean case." As Benjamin C. Bradlee, executive editor of the *Washington Post,* put it, he could only support the *Progressive* reluctantly, "with about as much enthusiasm as I would Larry Flynt and *Hustler,*" because he thought the passion Morland brought to the subject of atomic energy was extraneous and confused, and had blinded the editors of the *Progressive* "to the fact that there are some secrets."

What amazed me was how both editors and lawyers seemed to presume that the First Amendment protected nice clean cases, something like recipes for egg salad, but not awkward disputes; that Ben Bradlee couldn't tell the difference between a virgin and a dynamo; that lawyers would not comment on the meaning of law without studying the facts for their auguries and the judge's opinion for its reasoning. The lawyers were at a considerable disadvantage to make any defense of liberty, of course, because over a year later Judge Warren's opinion, whatever its reasoning, was still secret, according to Judge Warren.

The legalities of *The United States of America* vs. *The Progressive, Inc., Erwin Knoll, Samuel Day, Jr., and Howard Morland* were astonishing enough in themselves; the concomitant ethical, political, and cultural implications were astounding. Before March, 1979, no gag order, no prior restraint, no censorship prior to publication had ever been upheld in the history of American law, either in peace or in war, to halt publication of a single word in any instance. As a result, the *Progressive* case flickered for a while in the national news; but many accounts were inaccurate or incomplete; many columnists, commentators, newspaper editors, and TV news announcers misinterpreted the events of the case, its consequences, its conclusions, and its implications. The *Progressive* case illuminated not only the sorry conditions of the law, but the spiritual despair in the national culture. Usually history had to be tentative for its conclusions, yet certainty sometimes appeared as if by magic: when a Socrates was required to drink a cup of hemlock because of the questions he had posed, surely the glory that was Greece had died. The *Progressive* was just such a magical incident.

At the outset of the *Progressive* case, the legal arguments advanced by the Department of Justice appeared to be merely bizarre, certainly contradictory, often mendacious, and largely nonsense. Because the United States Seventh Circuit Court of Appeals would apparently decline to play the fool for the sake of Justice's extraordinary claims, Justice was forced to abandon its prosecution of the *Progressive,* declaring the issue moot. As censors always did, Justice first appeared to prosecute the *Progressive* as the red-eyed zealot of overriding national interests, then retreated from

its declarations of higher moral authority into a sullen lethargy. Whereupon Howard Morland's article about the nonexistence of any hydrogen bomb secret was published in the November, 1979, issue of the *Progressive*. By reading the article, and by an examination of the surrounding materials published at the same time, it was clear that Morland's explanations were compiled from published materials available in almost any library; that he confirmed his understandings by making a tour of nuclear weapons facilities—the tour was arranged for him by the Department of Energy; that he had discussed the H-bomb with scientists and technicians familiar with the principles of its manufacture, as well as the ethical and political choices its manufacture presented—but that every interview was "on the record"; that no discussions were conducted "off the record," nor any as "deep background," or "not for attribution," or any other variety of secret restrictions; and that, finally, Howard Morland never saw in one single instance even one "restricted" or "classified" government document. Everything Morland learned not only was in the public domain, but had been part of community understandings, community debate, community publication for at least a generation.

The substance and the details of Morland's article were, just as he said, that anyone who took the trouble could understand the technology of hydrogen bombs from the storehouse of public knowledge, *and therefore* anyone could question the national policies that required H-bomb manufacture in improbable quantities. What Morland meant to demonstrate was that there were no secrets at all to the principles of hydrogen bomb construction, but nearly total secrecy about the ministries of nuclear weapons and nuclear energy. Since there were no secrets in Morland's article, its publication by the *Progressive* left the national safety undisturbed, the proliferation of nuclear weapons undiminished, and the national defense as secure and unaffected as these overriding national interests were before the *Progressive* was gagged. None of these considerations had ever depended upon what Howard Morland knew or how he learned it. Despite what the Departments of Energy and Justice swore in federal courts, none of these concerns for national security were the proximate causes for prosecution by Justice of the *Progressive*—which explained why Justice was untroubled by any inconsistencies in its legal arguments, no matter how bizarre. What Justice meant to demonstrate was that the New Order claimed the power to quash any debate upon the topic of nuclear technology. When Justice had to quit prosecution of the *Progressive* to avoid embarrassment, Justice then announced it had only been "temporarily thwarted." Thereafter, Justice proceeded to *expand* its claims for powers to censor—regardless of law, precedent, or any other limitation.

Meanwhile, many civil libertarians were hailing the *Progressive*'s tenacity in opposition to Justice's powers as "a victory won for a free society." Editorial writers and TV commentators followed suit for a week or

two, then turned their attention to more attractive subjects. Yet the free society won no victory at all, and Justice announced that no truce was in effect, nor would any be allowed. In connection with the same *Progressive* case Justice had asked the courts to declare moot, Justice appointed special counsel to pursue investigations of criminal conspiracy on the part of anyone who had spoken out to support the *Progressive*'s case. To the extent that Three Mile Island had provided a gentle act of God from which the nation might take heart and mend its technical ways, the *Progressive* case simultaneously provided a homily of determined resistance by the New Order not only to change itself, but to all thought, speech, or writing upon the lessons of change. In the *Progressive* case, Justice resisted change in the name of a transcendental ethical and political reality never previously advanced in history: the New Order did not promise to make the trains run on time, or to restore any lost glory or tattered grandeur, or to create for the future a thousand-year Reich. The New Order did not promise any particularly attractive promised land of any kind at all. Instead, the New Order claimed the fictional landscape of George Orwell's *1984* was the present reality—a condition of permanent terror, said to be the moral equivalent of war—and, therefore, the New Order claimed the powers necessary to continue its governance undoubted. The sole objective of the exercise of power without limit would be the continuance of power without limit.

To effect such a peculiar regime, the New Order was required to control community as well as national intuitions, including all understandings previously circulated in the public domain, or by traditional systems of gregarious community activities summed up in the word "culture." Hence, if the Justice Department could not show a single precedent with which to censor or gag the *Progressive* by law, or if it turned out that there were no secrets of any kind to what Howard Morland knew about thermonuclear energy, those realities were incidental to the radical claims the Justice Department advanced. Whether two plus two equaled four, what might be true or false, which notions were secret or commonly known, could only be determined by the Corpos of the New Order. Moreover, what was decided about secrets, or why, would be determined in secret; and besides, whether or not such secrets were actually secrets could only be argued, if at all, in secret. In the *Progressive* case, Justice did not care whether the First Amendment in its guarantees of free speech, assembly, and press was intended above all to forbid prior restraint of publication; nor did Justice mind that the First Amendment's meaning and its values derived from an abhorrence of gag orders so ancient that they long preceded the enactment of the amendment itself. Justice ignored the amendment's absolute proscription: "Congress shall make *no* law. . . ." Justice disregarded that writing had been protected by case law from Cromwell's dismal day. Justice refused to concede that in the common opinion of mankind language had been sacred before the

Greeks landed from the mists at Troy's gates; and that prior restraint upon thought had apparently been beyond even God's jurisdiction in the Garden of Eden. The Lord was reported to be prodigiously angry after Adam and Eve had tasted the fruit from the tree of knowledge; but he did not presume to "classify at birth" their thought; nor did he claim jurisdiction to limit their intuitions by prior restraint, as did the Department of Justice with affidavits sworn by James R. Schlesinger, Jr., Secretary of Energy.

The sovereignties claimed by Justice in the *Progressive* case appeared at first to be merely silly: inadvertencies by inept, dim-witted, or ignorant government lawyers. Chief Justice Warren Burger had previously explained in careful and lucid language that prior restraint—gag orders—were "presumptively unconstitutional." Yet, after the incident provided by Howard Morland's article, Justice announced its continuing defiance of the Supreme Court's opinion and every other law, history, custom, and tradition. Moreover, while Justice maneuvered for six months in federal courts, demanding at the same time that the maneuvers themselves be secret, a *de facto* gag order upon the *Progressive's* presumed right to free speech was actually in effect for the first time in well over two hundred years of national history. In itself the incident was unusual, but there was more to it than that: to publish Morland's article at all, the editors of the *Progressive* had to risk continuance of the magazine itself, and they were required to raise over $200,000 for their legal fees and expenses; whereas the funds for prosecution by Justice were spent without keeping records of the time used by government lawyers by the dozen and spent from the tax monies in the public treasury. Thereafter, to make clear its radical position, Justice announced that it was prepared to prosecute any case which Justice determined—in Justice's sole opinion—might be similar, as soon as an opportunity was provided. Justice wanted all those who held independent opinions to know that anyone who expressed those ideas might be required to match public monies to defray the legal expenses attendant to private belief—regardless of precedent, law, or fact.

To these extraordinary ideological powers without limit, similar to those decrees issued from Berlin as necessities to public order after the Reichstag fire in 1933, the entire apparatus of national cultural agencies maintained a determined silence. Throughout the prosecution of the *Progressive,* and throughout the revelations provided by national authorities on Three Mile Island, the White House Ministry of Culture and its constituent subministries—the National Science Foundation, the National Endowments for the Arts and the Humanities, the Smithsonian Institution, General Services Administration, National Park Service, Department of Education, and so forth, without exception—were examples of quietism. Passive acceptance was also the rule of all the cooperating foundations and corporations, all the coordinated and cooperating advisory councils, systems of peer-review panels, experts, and consultants.

Not one peep was officially heard from a single agency devoted to the advancement of the sciences, arts, or history. A search through the contemporary records and minutes of these agencies' assemblies would show those meetings entirely blank upon the topics of Three Mile Island or the *Progressive* case; it was as if Fort Sumter and the *Dred Scott* case had occurred in the same week, but were somehow irrelevant to the social landscape. A search through thousands of pages of congressional testimony for appropriations in the name of the national culture would be equally in vain: all the records were entirely empty of any discussion in art, literature, social or local histories, scholarly interests, ethical and political necessities, "interpretative responsibilities," or even in connection with national programs grandly titled "Humanities and the Law." It was as if the urgent technical choices central to the future, the highly touted political and ethical realities to the continuance of life itself, and the censorship, gag orders, and consequent claims to radical sovereignties by the New Order had never come to the attention of any agency of the cultural establishment. Perhaps they were dumbfounded; perhaps they were indicating by their determined silence that they were nothing more than establishments of the New Order—variations of the party's governance; perhaps an active-well-coordinated-national-cultural-policy-more-effective-than-weapons did not include contradicting the Department of Justice or the secretary of Energy under any circumstances.

What was marvelous was how much the *Progressive* magazine differed from all the foundlings of whom the Ministry of Culture was so fond. To begin with, the Ministers of Culture frequently expressed their goodwill toward what they characterized as "alternate media." The *Progressive* was a magazine almost exactly the opposite of an "alternative" publication. Instead of being quick, unsure of itself, but ambitious, the *Progressive* represented an honored tradition in American letters, and was heir to a considerable history. Founded in 1909 by Robert N. LaFollette, Sr., the *Progressive* and "Fighting Bob" and his successors were unrelenting opponents for seventy years of corporate monopolies, of Big Business, Big Money, and Big Political Bossism. As a continuously published expression of LaFollette's evergreen optimism, the *Progressive* was a stalwart of popular democracy in the traditions of the Grange, the Knights of Labor, the populists in all their great variety. Always in the mainstream of community values rather than fleeting national party interests, the *Progressive* was intimately connected with achieving many of the great reforms—the hopeful tinkerings of democratic machinery now accepted as commonplaces, including: direct election of senators, voting rights for women, referendum and recall, and primary elections for direct expression of party preferences rather than secret nominations by oligarchs in smoke-filled rooms.

In 1979 the *Progressive* continued its optimism, continued to believe in independent thought, in change by tinkering for the sake of commu-

nity continuities against the claims made by national authorities; and it was precisely that independent tradition which earned the *Progressive* the enmity of the New Order. The magazine maintained its offices in Madison, Wisconsin, far from the centers of social connections and personal patronage located in either New York or Washington. For its opinions, the *Progressive* owed little to anyone except to its own editors and authors; for its influence, the magazine depended upon what it had to say rather than who said it; and for its circulation, the *Progressive* enlisted those interested in well-said, well-written, singular, idiosyncratic, and sometimes wrong-headed opinions. Yet the editors of the *Progressive*, in small matters and great, consistently argued for open debate. They defended the rights of those with whom they disagreed because they believed debate was always in the public interest. Such modesty about the power of social connections, combined with habitually independent thought, resulted in a circulation of no more than 40,000, few and infrequent advertisers, slim finances, and no government subsidies. The article by Howard Morland on the nonsecret principles underlying the construction of hydrogen bombs was begun by Morland in what the *Progressive* believed was the public interest for the magnificent sum of $500.

To the extent that the *Progressive* could be characterized as the small but influential magazine of traditional American belles lettres, the publications of the New Order's cultural agencies were radical opposites. They were published on tax monies. They were rich, not poor. Their expressions of national goodwill were expensive. The National Endowment for the Arts awarded, for example, grants for literary fellowships in amounts of $10,000 each, and to totals of $4 million, without any interest in whether there would eventually be any publishable result. In addition, NEA supported hundreds of small magazines and publications provided, of course, they rocked no boats. The National Endowment for the Humanities awarded research fellowships to academic scholars in amounts of $20,000 each, whether or not publishable results appeared; and by various devices, if there happened to be publishable results from these scholarly efforts, the amounts could be matched or exceeded by royalties from university or commercial publishers without limit. A million dollars or more spent for one scholar's views on a nineteenth-century author's work would not be out of order. The annual totals awarded through NEH fellowships for scholarly research exceeded all monies advanced for the same purposes by all university presses combined for publication of all such research.

As opposed to the questions raised habitually by the *Progressive*'s independent style, the opinions published by the Ministry of Culture were inevitably syncretic—reconciliations of differences for the sake of national goodwill, modulations of accepted themes to provide the appearance of consensus. These syncretic works were deemed right and proper to cultural objectives, because the New Order decided which national

issues were suitable for research and which researches were to be pursued, by joint approvals and cooperative understandings at the national agencies of culture with delegations sent from university and corporate establishments. To decide these questions of "interpretative responsibilities," corporate, university, and agency officers assembled around long, polished tables and approved of each other's remarks by making notes upon yellow legal notepads provided at government expense. These procedures, hushed in their style, were the exact opposite of the *Progressive's* devotion to raucous debate, disdain for modulation, grubby offices, and meetings conducted while drinking Milwaukee beer.

Among the agencies of national culture, proof of influence was adduced by producing numbers testifying how many had attended, or heard, or read whatever some project was busy doing in the name of education. "Accessibility" and "reach" were the accepted buzz words to demonstrate effectiveness. If 500,000 citizens passed through the turnstiles of a museum show advertised as "The Art of Greece," it made no difference that the art displayed was not Greek; what was important was the number—500,000. In contrast, to the extent the *Progressive* had any "reach," the magazine attained its influence by being passed from hand to hand. During the course of its opposition to the government's attempt to censor its publication, the *Progressive* lost circulation because the magazine was required to budget its funds for legal defense instead of direct mail solicitations for readers.

Every agency of the Ministry of Culture sought out the gigantic corporations to jointly fund programs of goodwill; whereas the *Progressive* was required to appear as a mendicant, hat in hand, after what the magazine had published had caused a national commotion. Not one advertisement for Cadillac, General Electric, Glenlivet Scotch, Steuben Glass, Chrysler, Pan American, Campari & Soda, The Edison Electric Institute, or Gulf Oil decorated the pages of *Progressive* magazine—as they did the pages of the government's *Smithsonian.* Never during the course of events after Three Mile Island or the *Progressive's* gag order could it be said that the "critical choices" had been studied by the *Progressive's* editors thanks to a grant from EXXON. No editor at the *Progressive* could claim tenure to his office, nor were any of the magazine's authors protected by faculty senates for their opinions in the name of academic freedom. No national cultural agencies picked up the per diem expenses when editors or authors of the *Progressive* traveled to conferences at university laboratories to assemble affidavits testifying to knowledge already available in the public domain.

Because the magazine, its editors, and its authors were well informed, they were also outspoken on CIA mind-control experiments, invasions of privacy, secret oil deals, the manufacture of neutron bombs, the implications of the SALT treaties, the dangers of breeder reactors, the proliferation of nuclear weapons by export to unstable nations, the palpable

lies in the certifications of nuclear power plants. Not one of these topics was ever funded by the incorporated interests represented by the national agencies of culture. During the course of the Justice Department prosecution of *Progressive,* Judge Warren was quoted as saying that he would not want the plans for the hydrogen bomb to fall into the hands of a madman like Idi Amin. The very essence of what the *Progressive* was attempting to publish was that there was no H-bomb secret; and as a matter of fact, the established national policy was to export not only the plans, but also the materials and money to manufacture the H-bomb to nations such as Iran, where the Ayatollah Khomeini might employ the H-bomb as a device to work the will of Allah.

For its independence, the *Progressive* would habitually flunk approval by peer-review panels, or any other similar establishments of the national agencies of culture. The magazine's editors and authors were poor prospects for the sacred Q clearances necessary to view the "technical information" contained in secret national documents. The *Progressive* never represented the interests of the New Order, only its own; by doing so, however, the *Progressive* willy-nilly represented substantial community interests with long-established patents—moral rights created by the gregarious efforts of hopeful men and women. What was at issue between the *Progressive* and the officers of the New Order were the irreconcilable differences between voluntary, traditional community understandings and the radical claims for total power advanced by Corpo ministers.

To suggest how unwelcome the *Progressive* was in the plush offices of the New Order's cultural ministers, it was useful to recount what happened in early May when Howard Morland toured Washington. He appeared before audiences in office buildings of the House of Representatives. He paid calls upon newspaper editors to explain what he believed was at issue. Despite the court's gag orders, the administration was always ahead of him. The secretaries of State, Energy, and Defense had telephoned their editorial contacts to explain how secret the materials really were that the *Progressive* intended to publish. Apparently the court's gag order applied to the *Progressive,* but not the magazine's adversaries. The *Washington Post* editorial on the case concluded: "As a press-versus-government First Amendment contest, this, as far as we can tell, is John Mitchell's dream case—the one the Nixon Administration was never lucky enough to get: a real First Amendment loser."

The *Washington Post* was privy, as far as it could tell, to matters of great national moment. As Morland made his rounds, he was interviewed by Richard Cohen, feature writer for the *Post.* As Morland talked in Cohen's glass office along the side of the *Post's* ultramodern city room, Cohen apparently concluded that what Morland was telling the *Post* was remarkably different from what the *Post* had been told by the newspaper's "highly placed administration sources." Cohen asked Morland to wait for just a moment while Cohen went to get the *Post's* executive

editor, Ben Bradlee. Within a few minutes, Bradlee stood upon the newsroom floor, staring at Morland through the glass partition of Cohen's office. After Bradlee had stared at Morland for a while, he turned and left. Cohen apologized that Bradlee was too busy to talk. Morland thought Bradlee actually did look like Jason Robards in *All the President's Men.*

As the author of an article that made him the central actor in an extraordinary historical drama, Howard Morland seemed at first to have been ill-cast for the part of an Enemy of the People. He would have made an equally poor candidate for a federal grant from the National Science Foundation or the National Endowment for the Humanities. His academic credentials would have been too skimpy. The independent research he pursued as a result of his own curiosities would be an unlikely proposal to win the necessary approvals from the appropriate consultants, advisors, peer-review panels, and national councils. Significantly, when he began his research he had a poorly defined objective for what he supposed he would find. At the same time, Howard Morland also cut a poor figure to play the role of radical: he lacked the flamboyant style; his manners reflected an ordinary, traditional, even commonplace education and upbringing. His mother would recall that he began drawing spaceships as soon as he could hold a pencil; he then made model airplanes, and Morland's glue smelled about the same as it did for everyone else. When he was an Eagle Scout he made a sailing canoe from plans he found in *Boy's Life.* When he was in junior high school, he made a three-dimensional model of an atom.

Born in 1943, he was thirty-six when he appeared on the evening TV news as the object of the New Order's fury. He grew up in Chattanooga, Tennessee, and with his parents and his Scout troop he took the bus to the nuclear research center at Oak Ridge, ninety miles upriver from home, where everyone got the guided tour, including explanations of how an atom bomb worked. After high school, Morland attended Emory University in Atlanta, Georgia. As a college freshman he was struck by the wonders in the world of pure science. Later, while he was gagged by an order of a federal court, he would recall in the *Progressive* the delights he had found in studying physics at Emory: the aesthetic appeal of Newton's laws of motion, of Einstein's extension of those laws into the relativity of phenomena. As a freshman, Morland said, he had been thrilled by the grace of James Clerk Maxwell's four equations of electromagnetism: they explained, Morland believed, electricity, magnetism, heat, and light all at once. "I was dumbfounded for a day when I discovered them."

As a freshman, Morland underlined his physics text, noting those lessons he believed were significant, those that appealed to his aesthetics, those that had dumbfounded him by their beauty, and he saved his old physics book. Eighteen years later in its prosecution of the *Progressive,* the Justice Department declared that Howard Morland's old physics book had become a national secret; that before Morland's freshman text could

be declared no longer secret, whatever it was that Morland believed to be significant, graceful, or appealing must be erased of its underlinings; that arguments about whether an old physics text actually contained any secrets were arguments that could only be conducted in secret. Whatever was secret became secret as soon as Justice said it was secret; whether secrets were actually secret was secret; and arguments over what was secret were secret not only from the community at large, but also from the editors of the *Progressive* and from Morland himself.

After graduating from Emory University, Morland joined the Air Force. He would do his tour, then he imagined he might go into commercial aviation, maybe astronautics. He said that when he was training in jets over Texas, he would sometimes imagine himself to be a point-mass, "as in classical physics, subject only to the impartial forces of kinematics, the laws of motion." Among the footnotes that Justice declared secret in the *Progressive* case and only abandoned after secret arguments over its secrecy as a portion of defendant Morland's secret brief were the words: "All electromagnetic radiation travels at the speed of light. Any particulate matter must travel at less than the speed of light." That is, whatever Morland considered about the laws of motion while flying in jet trainers over Texas could retroactively be declared secret by Justice, including the limitations placed by creation itself upon particulate motion.

Morland's tour in the Air Force lasted five years. He flew from California to Vietnam about twice a month, carrying healthy soldiers to combat aboard Air Force transports and hauling bodies back in aluminum boxes on the return trips. Morland said he surfed in his spare time. He wondered, too, why none of his friends ever considered having children. "Was it the war? Nobody seemed to know."

Discharged from the Air Force as a captain, Morland then flew as a commercial pilot for five years. His manners, his style, his speech were exactly those everyone expected from their friendly pilot up-there-in-the-cockpit: the pilot who turned on the seatbelt sign and asked his passengers to extinguish their cigarettes. Morland was lanky, tousle-haired, with a neatly trimmed dark mustache. To add to the effect, Morland spoke in the flat voice of radio traffic to the tower, slightly flecked with the accents of Tennessee, but matter-of-fact, detached and cool. After the passengers had left the aircraft for the terminal, it would be difficult to imagine Morland making his way to Operations without being accompanied by a stewardess or two, who also had just remembered some errands to complete; but his diffidence would have been a severe disability in the world of academic conferences, where earnest enthusiasms were the requirements for ambition. Except for an occasional chuckle, Morland habitually revealed less about what he understood than what might actually be so. He put his case against manufacturing hydrogen bombs as if he were talking about a Red Cross life-saving program. "I

think nuclear weapons are inherently unsafe," he said. "And I think disarmament is the equivalent of a safety program."

"Great issues" were not his style: he said he cherished the First Amendment guarantees of free speech, but his paramount interest was really disarmament. Morland's moral concerns for disarmament were exactly the same as the ethical and political choices frequently posed by popes, presidents, ministers, ambassadors, study groups, and officially approved publications almost literally without end. With respect to SALT, the neutron bomb, and proliferation treaties, Morland's questions were exactly the same as those funded at exorbitant expense for conferences initiated by every agency of the Ministry of Culture, but Morland earned the enmity of the New Order because he set off *on his own initiative* to discover who made nuclear bombs, where they were made, why they were made, and how the whole system fitted into the social fabric of American life. "I wanted to know why we are so afraid of this subject."

What was remarkable about Morland's inquiry was that the New Order was terrified by Morland's questions as much as by the answers he provided. Morland had noted that 400 hydrogen bombs would obliterate half the population of the Soviet Union in an afternoon. In any practical sense, 400 hydrogen bombs would send to certain oblivion whatever could be defined by history or by geography or by any other analysis as "Russia." What seemed odd to Morland, therefore, was why the United States had an inventory of about 30,000 hydrogen bombs—an excess of approximately 29,600—and was continuing to produce another doomsday machine every three hours of every working day. Not only did there appear to be a surplus in the manufacture of the devices, the entire procedure was shrouded in secrecy from any public debate about its reasons. Both the strange surplus and its secrecy made community discussion of national administration unintelligible with respect to SALT or any other life and death nuclear question. While attending a meeting in late 1977 of the Clamshell Alliance in Putney, Vermont, Morland looked around at what he described as the "scruffy collection of anti-nuclear activists." They were a community of interests opposed to the Seabrook, New Hampshire, nuclear power facility of New England's Public Service Company. Morland concluded that as an antinuclear activist he should be able to discover as much information in the public domain about the Pentagon's nuclear industry as the Clamshell Alliance had learned about corporate nuclear power. His New Year's resolution for 1978 was to find out where nuclear weapons were made, how many there were, and how they worked.

Almost immediately, Morland stumbled across the secret of how H-bombs worked. He had prepared a slide show of 134 slides that ran forty minutes, suitable for high school and college audiences. His topic was "Atomic Power and the Arms Race." Morland's show traced the historical connection between military technology for the nuclear indus-

try and the applications of the same technical information by domestic universities and corporations. The fuel used essentially as a means to boil water was the same fuel used to make the bombs; the cycle by which the fuel was mined, manufactured, used, and stored was operated by the same conglomerate of national and corporate organizations. According to Morland, his lecture in January, 1978, was strong on atomic power, but admittedly weak on the details of weapons proliferation. Toward the end of his slide show in a dormitory at the University of Alabama, he asked—almost casually, he would recall—whether anyone knew the secret of how the H-bomb worked. He explained to his audience that he needed to understand the industry's product in order to understand the industry. To his astonishment, a student raised his hand and gave Morland a straightforward explanation. Later, Morland would say how much he regretted that he never learned that student's name.

Despite assertions to the contrary by the Justice Department, the straightforward explanation of how an H-bomb worked was not a secret to a student in a dormitory at the University of Alabama or anywhere else either. After 1939, it had never been a secret to anyone. To manufacture an H-bomb required the industrial capacity of at least a medium-sized government, vast quantities of electricity, carloads of blueprints and computer printouts, and something on the order of a billion dollars worth of technological equipment. No one could make an H-bomb with a chemistry set in his basement; but the principles of how it worked had never been secrets and intrinsically couldn't be secrets. To begin with, an H-bomb required an atomic bomb as its trigger. There were no secrets about atomic bombs, and there never had been. Before the first atomic bomb was ever tested, Professor Henry D. Smyth of Princeton University described in the "Smyth Report" how the Manhattan Project under the command of General Leslie Groves had designed the atomic bomb, tested its possibilities in Chicago, built its factories, and then built the bomb itself. "The Smyth Report" described in detail what the atomic factories did, who ran them, and how the wartime physicists solved each problem that had confronted them. One week after Hiroshima, the United States Army published Dr. Smyth's report.

By 1948, any Princeton freshman who attended Professor Smyth's Physics 201 could not only learn from the texts Dr. Smyth provided on how atom bombs worked, but could also be hugely entertained by Dr. Smyth's imaginative lectures. Dr. Smyth's assistants prepared in advance the entire back wall of the lecture hall with about fifty vertical feet of mousetraps. For the finale of his justly famous lecture, Professor Smyth touched the electric switch to spring the first mousetrap located up near the ceiling. The first trap sprung two more; those two in turn sprung four; those fired eight, and so on, in a sequential clatter illustrating nuclear fission. Then, with courtly bows, the historian of the Manhattan Project acknowledged the whistles, cheers, and standing applause from

nearly 700 students. Those registered in Physics 201 spent their after-noon lab hours recording the half-life of twenty-five-cent pieces turned radioactive in Princeton's tiny cyclotron, but Dr. Smyth's lectures were attended not only by students of physics. Students of history, politics, and literature also audited his course. He told all who would listen what he had concluded in the official Smyth Report: "Here is a new tool for mankind, a tool of unimaginable destructive power. Its development raises many questions that must be answered in the near future. These questions are not technical questions; they are political and social ques-tions, and the answers given to them may affect all mankind for genera-tions. In a free country like ours, such questions should be debated by the people."

In 1947, another resident of the Institute for Advanced Studies at Princeton, Dr. Albert Einstein, signed an appeal for support. He wrote that the facts of atomic energy were simple; that scientists had an in-escapable responsibility to explain those facts to their fellow citizens; that atomic energy could not be fitted into outmoded perceptions of narrow nationalism: "For there is no secret and there is no defense; there is no possibility of control except through the aroused understanding of the peoples of the world."

Mindful of the responsibilities identified by Dr. Einstein, Gerard Piel, publisher of *Scientific American*, went to press in April, 1950, with an article by Dr. Hans A. Bethe, Professor of Physics at Cornell University, about how thermonuclear fusion—the energies of the H-bomb—worked. At the time, the question being debated among scientists was whether to attempt to make the H-bomb. Many scientists opposed making Faust's bargain with fusion. The energies of fusion were the same energies that emanated from the sun and the stars. They had been reproduced in the laboratory in 1932; connected by publication of Dr. Bethe's theory in 1938 to stellar energy; discussed by Austrian physicist Hans Thirring in a book published in 1946 as an argument for building an H-bomb. Because of the wartime concentration necessary to produce the atomic bomb—explosion by fission, development of the H-bomb—explosion by fusion had been postponed. Yet the materials to be used, and the use of an atomic bomb as a trigger for the H-bomb were widely known and under-stood. Only an effective design was missing.

Because the cold war was also then in progress, the new Atomic Energy Commission arrived at the offices of *Scientific American* while its April, 1950, issue was on press. The AEC ordered the presses stopped, destroyed about 3,000 copies of the magazine and the plates which included Dr. Bethe's article, and insisted that *Scientific American* delete four specific concepts from Dr. Bethe's explanation because the AEC had secretly declared them to be secret. Torn between the prospect of no information with which to form the substance for public debate about testing the H-bomb and at least some theory from the authoritative article by Dr.

Bethe, publisher Gerard Piel consented to the AEC's demanded deletions. What was most obnoxious about the AEC's censorship was that three of the deletions were materials published previously by *Scientific American* and long since in the public domain; the fourth concept was a deliberately false piece of technical information included to slow Russian development of the bomb, but the AEC also deleted what was false. Because the H-bomb had not yet been tested, Gerard Piel charged the AEC with suppressing exactly the information the American people needed in order to form intelligent judgments. Twenty-nine years later, when the AEC's successor agency, the Nuclear Regulatory Commission of the Department of Energy, moved to gag the *Progressive*'s publication, Gerard Piel wrote the *New York Times* immediately: "In the thirty years since America lost its imagined monopoly on the atomic secret, we should have learned that there never was a secret that could keep another country from making a bomb."

Piel pointed out that it was not secrets that stopped the manufacture of bombs, but the lack of industrial and technological materials, finances, and personnel—the carloads of computer printouts, the shiploads of materials, the nuclear fuel processing facilities with which to proceed. All the technical secrets needed to make atomic and hydrogen bombs "were in the public domain of the community of physics in 1939."

The Department of Justice, however, never had any concern about what was actually in the public domain. To prove its intentions and demonstrate its unlimited powers, Justice solicited an affidavit in the *Progressive* case from the same Dr. Hans A. Bethe who was the author of the censored article in *Scientific American* in 1950. Dr. Bethe had declined to comment upon the AEC's censorship in 1950, and he had continued to serve the AEC and its successor, the NRC, as a consultant. In 1979 he read Morland's manuscript after it was supplied to him by the Justice Department. Although others might not read Morland's article without a Q clearance, Dr. Bethe was cleared to keep the nation's secrets.

Dr. Bethe swore by affidavit that there were sizeable portions of Morland's text which, in his judgment, should be classified as restricted data, "because the processes described in the manuscript, despite a number of technical errors, correctly describe the essential design and operation of thermonuclear weapons." Dr. Bethe's affidavit went on to establish how expert his testimony was: he said he was familiar with the publicly available literature; that he had attended many meetings and conferences of those scientists who were knowledgeable in physics and thermonuclear design; that based upon his experience, familiarity with the subject, and his review of the Morland manuscript, "I have concluded that the design and operational concepts described in the manuscript are not expressed in the public literature nor do I believe they are known to scientists not associated with the government weapons programs."

Unfortunately, there were a number of oddities to Dr. Bethe's sworn

expert testimony as introduced by Justice Department lawyers, the least of which consisted of its positive conclusions from negative propositions. The affidavit was also fascinating in its characterizations of all those ignorant scientists not associated with the government's weapons programs. Far more significant was that Dr. Bethe was the author of a signed article in the *Merit Student's Encyclopedia*, published by the Macmillan Company, New York, and promoted by Macmillan to the school and library markets as suitable for junior high school and grade school libraries. Dr. Bethe's article in an eighth-grade encyclopedia, along with its accompanying diagram, was one of the sources in the public domain that Howard Morland used to understand the "secret" of the principles of the hydrogen bomb which Dr. Bethe subsequently swore were known only to those with Q clearances. Moreover, Dr. Bethe's article proposed that students consult "Books for Further Study," including the *Scientific American Reader*, published by Simon and Schuster in 1953, and in which the student could read Dr. Bethe's own ten-page article censored by the AEC in 1950. In addition, the *Merit Student's Encyclopedia* recommended *The Men Who Play God: The Story of the H-bomb and How the World Came to Live with It* by Norman Moss, published by Harper, 1969.

By comparing Morland's manuscript with Dr. Bethe's encyclopedia article, differences between the two articles on the H-bomb secret were readily apparent. Morland was more specific than Dr. Bethe about how the trigger mechanism worked, and the effects of radiation pressure on the shield and pencil-shaped container for the hydrogen isotopes. On the other hand, with formulae Dr. Bethe made clear even to eighth-grade students how the chemistry and physics of the reaction worked—not much of which appeared in Morland's article. What was revealing in Justice's prosecution of the *Progressive* was that Justice declared Morland's article secret, but also declared Dr. Bethe's article in an eighth-grade encyclopedia retroactively secret. When Morland introduced the Bethe encyclopedia article by affidavit, Justice also declared the affidavit showing the evidence in the public domain to be secret. Justice insisted that any arguments over whether an eighth-grade encyclopedia in the public domain was actually secret were arguments that could only be conducted in secret. These arguments about what was in the public domain were so secret that the editors of the *Progressive* who published Morland's article could not hear them, with the result that Morland's editors could not know even *after* they had published Morland's article what secrets were in either article; nor could they learn whether the secrets they had published were the same as the secrets introduced by secret affidavit and argued in secret over the Bethe article. In connection with these bizarre arguments, Justice asserted *after* the *Progressive* published Morland's article that anyone who communicated the same secret secrets, either Morland's or those in an eighth-grade encyclopedia, by

speech or by writing, would be "acting in concert" with Morland and the *Progressive* magazine, and thereby violating the *in camera* "protective orders" of the federal court, subjecting the violators to criminal prosecution. Since the affidavits were secret, and the judge's decision was secret too, there was no way to know which secrets were secret, or what secrets comprised a criminal violation of secrecy. Two bright eighth-graders, arguing over how an H-bomb actually worked and reproducing Dr. Bethe's diagram with a stick in the dirt, might be criminals. *Any* discussion of nuclear physics, according to Justice, might constitute a criminal violation. *All* "technical information," according to Justice, was exempt from the guarantees provided by the First Amendment. Any intuition either about how an H-bomb worked or how the nuclear fuel cycle for domestic energy worked were understandings "classified at birth" according to Justice—restricted data requiring a Q clearance for continuance within a knowing mind. Any communication of what the community knew within the public domain might constitute a criminal violation, in any federal district, at any time at all, retroactively or by prior restraint, whenever the Department of Justice or the Department of Energy deemed it appropriate to the New Order's "interpretative responsibilities" for peace.

For these perversions of community understandings, there never were and never would be any authority except force. Having embarked upon fraud as a national policy, the New Order would eventually have no alternatives to hypocrisy but murder. Censorship in isolated instances appalled and was disgraceful and always resisted change; but censorship as a patriotic policy eventually required violence to maintain its authority over community opinion. Censorship was the material evidence that tyranny was terrified by community speech, writing, thought, and the consequences of change. The rule was invariable: it included regimes imagined in fiction, such as those created by George Orwell in *1984*, Sinclair Lewis in *It Can't Happen Here*, Jack London in *The Iron Heel*. Without exception, it included every similar despotism remembered in history as disgraceful, including Nero's Rome, Spain's Inquisition, Mussolini's Italy, Stalin's Russia, and the regime of the Nazis tried for their collective crimes at Nuremberg.

The censors of Energy were, of course, patriots. Having ignored the community's certain knowledge that there was no H-bomb secret and never had been, the lawyers representing the Departments of Energy and Justice embarked upon a policy of fraud to prosecute the *Progressive* magazine. Having declared Howard Morland's old physics text a secret and an article in an eighth-grade encyclopedia also secret, Justice and Energy were also required to declare secret articles submitted by affidavit from an encyclopedia describing the energies of the "Sun" and the "Stars." Since those energies were the same energies as those released by an H-bomb's fusion, the logic of the Department of Energy's classifica-

tion as "restricted data" of common knowledge about the sun and the stars was an example of impeccable perversity: those heavenly bodies emitted energy, therefore the Department of Energy claimed sole jurisdiction; the moon, of course, only reflected energy and was therefore exempt from the authority vested in James R. Schlesinger, Jr. All arguments over whether the sun and the stars could be classified under the provisions of the Atomic Energy Act of 1954 were arguments, according to Justice, that must be conducted in secret; and any violation of the court's protective orders with respect to the arguments, or the affidavits upon the sun and the stars, would be a criminal violation.

Along with encyclopedia articles by Dr. Bethe on the H-bomb and those on the subject of the sun and the stars, the *Progressive's* lawyers introduced by affidavit more than thirty other articles published in the public domain by scientific and technical journals to demonstrate that there was no secret. All these articles, their affidavits, briefs relating to their introduction, and arguments over their evidence, were secrets, said Justice. Howard Morland introduced by affidavit the article from the *Encyclopedia Americana,* along with its diagram, by Dr. Edward Teller, often characterized as "the father" of the H-bomb. Both Dr. Teller's article and the accompanying diagram bore a remarkable resemblance to the article by Dr. Hans A. Bethe in the *Merit Student's Encyclopedia,* and to the article and diagram eventually published by the *Progressive.* Presumably Dr. Teller's explanation would be an authoritative one, for Dr. Teller and Dr. Stanislaw M. Ulam were generally credited with solving the mathematical design problems to build the first H-bomb. When proposed, the Teller-Ulam solution had been opposed, according to Teller, by the General Advisory Committee of the AEC, by several AEC commissioners, and by the AEC's chairman. The Advisory Committee felt that the H-bomb question had such serious implications that the question should only be decided as part of broad national policy and after public debate. To insure informed debate, the AEC Advisory Committee recommended providing the information necessary to the public, but the Advisory Committee's deliberations were never opened to the public. Moreover, no arms control advocates were admitted to its debates, because none received security clearances. Dr. Teller concluded his article in the *Encyclopedia Americana* by reviewing the history of hydrogen bomb explosions: "After the American and Russian tests, thermonuclear explosions were produced by the British (1957), the Chinese (1967), and the French (1968). It became evident that secrecy does not prevent the proliferation of thermonuclear weapons."

Justice declared that Dr. Teller's article in the *Encyclopedia Americana* was secret, the affidavits by which it was introduced were secret, arguments over whether it was secret were secret, and the court's opinion about these secrets was secret. Moreover, the restricted data declared secret in the *Encyclopedia Americana* and *The Merit Student's Encyclo-*

pedia were retroactively secret, even if those secrets were available in the public domain on the shelves of approximately 63,000 school and community library bookshelves. Although the diagrams published by the encyclopedia and the *Progressive* were remarkably similar, they were all secrets, because Justice claimed that Morland had identified in his article three concepts of hydrogen bombs never published before anywhere else. These three concepts understood by Morland were declared to be restricted data even as they resided in Morland's head, even if they were the same three concepts censored from *Scientific American* in 1950, but previously published by the same magazine. The three concepts were so secret that the editors of the *Progressive* were not allowed to hear arguments over whether the three concepts were secret without security clearances. Since the editors refused security clearances, only the Department of Energy, said Justice, could determine which secrets were secrets. The secretary of Energy, James R. Schlesinger, swore: "Based upon my review of all the affidavits submitted by the government and my review of the manuscript and information supplied to me by my advisors, I have concluded that publication, communication or disclosure of the Secret Restricted Data portions of the Morland manuscript would irreparably impair the national security of the United States by making available to foreign nations Secret Restricted Data pertaining to the design and operational characteristics of a thermonuclear weapon. Such information would materially aid foreign nations by enabling them to develop such weapons in a shorter period of time than otherwise would be possible."

Secretary Schlesinger cited the nonproliferation policy of the United States, including the Treaty on Nonproliferation of Nuclear Weapons. Secretary of State Cyrus Vance made many of the same points by sworn affidavit. If the Morland article was published, said Vance, "it would undermine our nonproliferation policy, irreparably impair the national security of the United States, and pose a grave threat to the peace and security of the world." The advice examined by these two distinguished authorities to make these conclusions was so secret that the names of the experts who provided the advice to Schlesinger and Vance continued to be secret, according to Justice, after the Morland article was published. Who reviewed secrets was secret.

All technical information or any information at all about proliferation of nuclear energy was secret. In shipping nuclear fuel rods by air from Kennedy Airport to the Soviet satellite nation of Romania, somehow the Nuclear Regulatory Commission was able to lose a bundle or two of the fuel crucial to proliferation. The NRC losses, and how they occurred, were secrets. In Erwin, Tennessee, a nuclear fuel plant operated by Nuclear Fuel Services, Inc., a division of the Getty Oil Corporation, reported in 1979 that at least nineteen pounds of 96 percent fissionable uranium was missing. Then Nuclear Fuel Services, Inc., admitted that over a pe-

riod of ten years it had lost over 246 pounds of fissionable materials, but the nineteen pounds lost in 1979 alone were enough to make at least six atomic bombs. The Getty Corporation's division losses were secret; and how they could have occurred was secret. At the same time as Justice was prosecuting the *Progressive*, using sworn affidavits by the secretaries of Energy and State based upon secret advice from secret advisors, the same national officers had secretly eased the administration's restrictions upon the export of what a secret National Security Council report described as "sensitive technology and materials that could be used to fashion nuclear weapons." Although two neighbors communicating anything declared secret by Justice were subject to criminal prosecution, the administration had simultaneously secretly eased restrictions it declared would permit "ready access to nuclear explosive materials to nonweapon states."

Within the administration, the secret revision of the regulations proposed by the Department of Energy were secretly opposed by the Department of State. State was particularly critical of Energy's suggestion that the United States link treaties for guaranteed oil supplies from nations such as Iran and Saudi Arabia to the supply of nuclear technology, including the nuclear plants with which to manufacture the fuels necessary to construct atomic bombs. In State's opinion these secret treaties proposed by Energy were "a dubious and even dangerous proposition." Unfortunately, secret criticisms of State's restrictive attitudes upon nonproliferation were voiced by the governments of West Germany and France. Thereafter, the United States secretly dropped its opposition to using plutonium in breeder reactors. Japan, which bought all its nuclear fuel from United States corporations, was secretly permitted to ship its used fuel to Britain, where the fuel was secretly reprocessed to produce plutonium. These restrictions on nonproliferation were secretly eased by Energy, even if such reshipments led inevitably to the proliferation of weapons that Secretary Schlesinger swore would result from the publication of Howard Morland's article in the *Progressive*.

"Happily," said the National Security Council secret report, "we like to think the breeder programs will be confined to the more industrial, reliable powers. However, this happy thought is deceptive. Some less developed countries, such as India, have breeder programs and a great many others believe that the breeder is the main reason for going into nuclear energy." Although Secretary of State Vance swore by affidavit that the publication by the *Progressive* of any article relevant to these issues might lead to the proliferation of sophisticated nuclear "technical" information, and therefore must be gagged, every day of the year the State Department licensed domestic corporations to export not only the "technical information," but also the fuels, designs, nuclear plants, machinery for the construction of those plants, the technologists to operate the

plants, the financing to build those plants, and the weapons-grade pluto-nium produced by those plants. After the *Progressive* had published its article sworn by the secretary of state to be a grave threat to the peace and security of the world, Secretary Cyrus Vance arrived in Seoul, Korea, to reassure the new Korean government that had taken power as a result of a bungled plot by South Korea's KCIA chief. Although the murder of Korea's president was carried through successfully, the subsequent coup d'etat failed. Secretary Vance promised the new South Korean govern-ment that the guarantees by the United States Export-Import Bank for $1.3 billion to build two nuclear plants continued. Apparently the United States secretary of state had every confidence in South Korea's new gov-ernment, and complete faith that South Korea would never use the by-products of nuclear energy for any purpose except peaceful ones. Yet any private meditations by Howard Morland or any skepticisms voiced by anyone acting in concert with Morland or the *Progressive* magazine on the same "technical information" guaranteed to the gentle, stable, and reasonable government of South Korea were intuitions "classified at birth," according to the Department of Justice, secret, and potentially criminal acts. What was guaranteed to Seoul, Korea, was forbidden to Madison, Wisconsin.

To understand the technical implications of fusion production, How-ard Morland toured the facilities of Union Carbide's Y-12 plant near Oak Ridge, Tennessee. He interviewed Union Carbide's plant manager. His tours and his interviews were arranged for him by Department of Energy officials. Although the same information might be exported to South Korea, to Britain or Brazil, although the same technical principles might be available in the public domain, whatever Morland saw or heard was retroactively declared secret by Justice to the extent that Morland under-stood it. Similarly, Morland visited libraries and museums maintained by the DOE in Los Alamos and Albuquerque, New Mexico; Livermore, California; and Washington, D.C. He collected a six-foot-high stack of unclassified brochures and books. In Washington, D.C., he saw replicas on display, or actual casings, for nuclear weapons—displayed for the ed-ucation of tourists by the NRC. All that Morland saw and all that Mor-land read was declared secret, to the extent that he understood it. Materials he read in NRC libraries were retroactively declared secret. The documents were then removed from those libraries; the card cata-logue index listing the documents was removed; and the libraries were then closed to the public. All such materials in the public domain became secrets; arguments before the courts about whether materials in the pub-lic domain were secret were secret arguments; and any discussion that the same technical information was regularly exported by the NRC was also secret. These assertions by the New Order were identical to those imagined by George Orwell in *1984:* even to understand the word

"doublethink" involved the use of doublethink; as soon as the Party could thrust its hand into the past and say of this or that event, it never happened—"that, surely, was more terrifying than mere torture and death."

"Reality Control" consisted of an unending series of victories over the community's memory, said Orwell. Precisely because there were never any H-bomb secrets at issue in the *Progressive* case, what was at stake was nothing more than the New Order's "visible means of control." On October 24, 1978, the Hon. Ronald V. Dellums, United States representative, 8th District, California, wrote a letter to the Department of Energy. Mr. Dellums was a member of the House Armed Services Committee and Chairman of the Subcommittee on Fiscal and Government Affairs. The Department of Energy had requested an increase in its budgets for hundreds of millions of dollars to rebuild the plutonium production plant at Hanford, Washington, and to refurbish and restart the standby reactor at Savannah River, South Carolina. Mr. Dellums' letter attached a list of questions to Energy asking why Energy expected a shortage of plutonium in its nuclear weapons program: Would the neutron bomb, then going into production, require more plutonium? Were the new generations of missiles using multiple warheads the reason for the new facilities? There were other possibilities as well: were Energy's budgetary requests for additional plutonium production actually disguised requests for additional production of tritium to be manufactured by the South Carolina reactors, and then used as part of the production and design development of the "Tokamak" Fusion Test Reactor secretly operated by the NRC in Princeton, N.J.? Despite all the announcements to the contrary, had the administration made a secret deal with the energy industry to proceed with the Clinch River Breeder Reactor program? The questions posed by Congressman Dellums were questions, he said, for which the American people needed answers. Each option would involve both financial costs and social risks. The answers to Mr. Dellums' questions would have raised serious issues for public debate. After three weeks, Energy replied that it would not be possible to answer, because the list of questions posed by Mr. Dellums as an enclosure to his letter contained "Secret/Restricted Data." The Department of Energy thereupon declared that Mr. Dellums' *questions* were "Secret."

In such circumstances members of Congress, such as Dellums, had the privilege of declaring a "need to know." As soon as a member did so, however, he removed whatever it was he "needed to know" from the arena of public debate—which was precisely why Energy declared Dellums' questions "secret." What was secret was not secret because it was actually secret, but secret as a measure of "reality control." Similarly, when the publicity surrounding the *Progressive* case attracted other amateur H-bomb experts in the community, Justice zealously prosecuted

some of these hobbyists, but not others. How Justice chose among possible candidates for prosecution for censorship illustrated that the New Order's legal arguments might appear to be somewhat contradictory or absurd, but its policy on dissent was consistent.

While Three Mile Island was melting down in March, 1979, and Justice was invoking the terrors of proliferation to Judge Robert W. Warren in the federal court in Milwaukee, *Fusion* magazine published an article titled "The Secret of Laser Fusion." In the March issue of *Fusion* the magazine's editors called attention to their article by noting that Energy Secretary Schlesinger might attempt legal prosecution of the magazine because the information in the article would be declared classified. "Therefore," said *Fusion*'s editors, "we want to make it clear that this article is based on information made public by the Soviet Union and readily available in Soviet and other international scientific articles. . . ."

Despite obvious similarities in the technical information provided by *Fusion* and the *Progressive*, Secretary Schlesinger did not provide any sworn affidavits as to the secrecy of the materials in *Fusion*. To the surprise of the editors of the *Progressive*, the publishers of *Fusion* then appeared with a brief *amicus curiae* before Judge Warren in Milwaukee. In the brief and affidavits the Fusion Energy Society, a pronuclear group, argued that the principles of thermonuclear weaponry were well known, as indeed they were. By repeating in substance the article it had already published, *Fusion* spread before the court essentially the same principles that the Department of Justice had declared to be continuing secrets, but no gag order issued from the court for any principles "classified at birth" by the Fusion Energy Society; nor were investigations for possible criminal violations of the Atomic Energy Act of 1954 announced by Justice; and, significantly, the *Fusion* affidavits were exempt from secrecy.

Curiously, the Fusion Energy Society and its magazine, *Fusion*, and the Fusion Energy Foundation, were largely secret organizations—as a result of Justice Department policies. To the extent that anything at all could be discovered, they appeared to be organizations founded, operated, and directed by an organization called the United States Labor Party. Headed by Lyndon H. LaRouche, Jr., the United States Labor Party had sued the Department of Justice and the FBI in a civil action for interference with the United States Labor Party's "civil rights." In connection with the party's suits, the United States Labor Party won court orders in the Southern District of New York prohibiting the Justice Department from discussing the party with news reporters; and, in addition, sealing some 5,000 pages of FBI documents obtained by the United States Labor Party under the provisions of the Freedom of Information Act. The Department of Justice filed a motion for Summary Judgment against the U.S. Labor Party's suit in March, 1978, before Judge Mary Johnson Lowe, but until Judge Lowe's opinion was final and all remedies for appeal were ex-

hausted, the effect of the U.S. Labor Party suits was to keep secret everything the U.S. Labor Party could find out about itself after rummaging through its own FBI files.

Mr. LaRouche, however, was well known. In 1976 he declared that he was a candidate for president, and he declared again for 1980, but his party had suits pending against the Federal Election Commission over matching funds. While the *Progressive* case was pending, Howard Blum and Paul L. Montgomery of the *New York Times* wrote a two-part series on the U.S. Labor Party and Mr. LaRouche. Among the *New York Times's* allegations were that members of the U.S. Labor Party had undergone intensive training in "anti-terrorist" techniques at a camp in Powder Springs, Georgia, operated by Mitchell L. WerBell III. The training-camp farm of Mitch WerBell was notorious as a base for gunrunning, assassination devices, and other "spook" insanities. WerBell counted among his clients Batista of Cuba, Somoza of Nicaragua, and the sometime Costa Rican resident, Robert Vesco. According to the *New York Times* series by Blum and Montgomery, the U.S. Labor Party was deeply involved in "counter-terrorist" propaganda; had placed its own spies within the United States Council on Foreign Relations; was violently anti-semitic; operated printing and programming corporations with revenues of $5 million and an impressive list of clients, including Mobil Corporation, Citibank, AT&T and the Ford Foundation; and had established a commercial private intelligence network. Beginning in 1976, the party voluntarily transmitted "intelligence" reports to the FBI and local police departments, including reports on the antinuclear movement. Reports on nuclear opponents were supposedly also furnished to nuclear power corporations, but by court order most of what could be learned about the U.S. Labor Party's peculiar activities was sealed, and therefore secret.

Obviously, *Fusion* magazine was ardently pronuclear. According to the *New York Times* articles, all monies gathered by the U.S. Labor Party's 1,000 or so active members through the sale of publications, and through donations raised from nuclear utilities, were transferred to party headquarters. But the Fusion Energy Foundation, publisher of *Fusion*, stated in its 1978 tax return that no part of the foundation's $103,897 income was used for "political purposes." The magazine featured articles on how antinuclear groups planned violence; called those who opposed nuclear plants "storm troopers"; and suggested that perhaps sabotage might have been the real cause of the meltdown at Three Mile Island. *Fusion* supported the breeder reactor; and published photographs of the PDX Tokamak at Princeton's Plasma Physics Laboratory. *Fusion* published diagrams and explanations for various H-bomb designs. Although Mr. LaRouche's name did not appear on *Fusion*'s masthead, *Fusion* prominently published LaRouche's theories on "the Human Condition." His characterization of John Locke's doctrines—the fundamental theory underlying the United States Constitution—was that Locke's theories cre-

ated societies of "tamed baboons." Mr. LaRouche counted himself a Platonist, but brooked no questioning of his revelations. "All previous reality is cancelled," he had said.

Regardless of what *Fusion* published or filed by affidavit with the court, neither Justice nor Energy seemed to take notice: what was secret and had to be gagged when published in the *Progressive* was apparently not secret when it appeared in *Fusion*. Samuel H. Day, Jr., managing editor of the *Progressive* and former editor of the *Bulletin of the Atomic Scientists*, was forbidden to collect affidavits from scientists as to what was known about fusion in the public domain, because Day lacked approved security clearances. *Fusion*, on the other hand, published without prior restraints. According to Day, the first reporter to understand the connection was Joe Manning of the *Milwaukee Sentinel*. Manning condensed the technical language of "The Secret of Laser Fusion" from *Fusion* magazine, spent a week reading in the local library, and published an explanation of how the hydrogen bomb worked that was remarkably similar to Morland's.

Meanwhile, the Department of Justice was censoring the *Progressive's* affidavits haphazardly. Affidavits from four physicists at the Argonne National Laboratory about what was in the public domain were censored, but other references helpful to hobbyists slipped through. The ten-year-old article by Dr. Teller in the *Encyclopedia Americana* slipped into the court's open records. An affidavit submitted by a government witness, Jack Rosengren, a nuclear weapons design specialist, indicated that Morland's explanation in the *Progressive* described the most efficient H-Bomb in the U.S. stockpile. Since Justice failed to declare its own affidavit secret, the Rosengren affidavit slipped into the open record. Examining the contradictions in the government's case against the *Progressive*, and noting that Justice had introduced into the public domain materials that the *Progressive* had not, the four Argonne physicists wrote an angry letter to Senator John Glenn of Ohio. Within a month, Energy responded by declaring the *letter* secret.

Following these astounding events by newspaper in California, another hobbyist, Charles Hansen, decided to join the fray. Hansen was a California computer programmer whose only physics-related education consisted of two years of college-level engineering. Using clues supplied by *Fusion*, others from the government's own affidavits, from the references uncensored by Energy, and clues contained in a copy of the letter sent to Senator Glenn by the four Argonne physicists, Hansen began by sponsoring an H-bomb contest: the first design to be declared secret by the Department of Energy would be the winner. He mailed copies of the Argonne physicists' letter around the country. The *Daily Californian* at Berkeley printed the letter, and six other college newspapers followed suit.

Hansen then wrote an eighteen-page, single-spaced letter to Senator Charles H. Percy, Republican, Illinois. Hansen's letter, he said, was based

upon the affidavits introduced in the *Progressive* case, particularly the brief of the Fusion Foundation, upon copies of *Fusion* magazine, articles in encyclopedia, history books on nuclear weapons available in public libraries, and "pure intuitive reasoning." The Hansen letter included a diagram drawn with the aid of a tuna fish can, and circles traced from tops of jars. Hansen explained the principles of hydrogen bomb design, saying that if anyone should be charged with revealing the H-bomb secret it was the government's own weapons experts: Dr. Edward Teller, Dr. George Rathjens of M.I.T., and Dr. Theodore Taylor of Princeton. In addition to mailing his letter to Senator Percy, Hansen mailed a copy to the Department of Energy. Thought police of the New Order appeared in Senator Percy's suite in the Dirksen Building to demand that Hansen's letter be surrendered. It had been declared secret.

Hansen also sent copies of his letter to the *Chicago Tribune*, the *Wall Street Journal*, the *Oakland Tribune*, the *Milwaukee Sentinel*, the *San José Mercury News*, the *Daily Californian*, and to his home-town paper in Palo Alto, California, the *Peninsula Times-Tribune*. As a result, the thought police were sent on a merry chase. They demanded the *Wall Street Journal* surrender Hansen's "secret" letter. The *Wall Street Journal* refused. The *Peninsula Times-Tribune* published a portion of Hansen's explanations, along with what the newspaper's editors described as a diagram so crude that it was little more than a cartoon. Justice announced that it was considering filing criminal charges against the newspaper. At the *Daily Californian*, the editors were considering whether to publish Hansen's letter or a combination of Hansen's letter with the same materials the paper had published from the Argonne physicists' letter three months earlier, when they were informed by Justice that both the Argonne letter they had already published and the Hansen letter were now "secret/restricted data," and publication would result in criminal charges. Meanwhile, the *Milwaukee Sentinel*'s Joe Manning published still another explanation of how an H-bomb worked, but this time not based upon the *Fusion* revelations. Although Justice was demanding letters be returned from senators, scientists, and newspapers, although the *Progressive* was still gagged from making any comment, *Fusion* appeared to be immune from any of the same threats Justice brought against the other dissenters.

Although declared secret, Hansen's intuitions were characterized as largely mistaken by scientists at the Livermore Laboratory in California, by others at the Argonne National Laboratory in Illinois, and by others at the Los Alamos Scientific Laboratory in New Mexico. Their published comments characterized Hansen's explanations as "a lot of misinformation or poorly understood information, a hodgepodge of material, and much of it inaccurate." Because of the "security regulations" imposed by the departments of Energy and Justice, however, the same scientists were forbidden to declare whether Hansen's "hodgepodge" was largely true or

false. The "technical information" Justice had retroactively declared secret was all inclusive: all private intuitions were secret with respect to atomic energy, including those which were mistaken. To such nonsense, and in defiance of Justice, the *Madison Press Connection* published Hansen's letter anyway, on September 16, 1979. The prestigious *Chicago Tribune* declared it planned to publish, unless taken to court. On Monday, September 17, Justice announced it was abandoning its case against the *Progressive* because the publication of the Hansen letter made the case moot, but the reasons Justice gave were not even remotely true.

Justice withdrew from the *Progressive* case after the magazine's appeal had been heard by the Seventh Circuit U.S. Court of Appeals. By withdrawing before the case could be judged upon its merits, the New Order preserved its powers to censor, as the *Chicago Tribune* explained it, "when the facts don't interfere so much with its efforts." By backing down when it did, without a court ruling that a prior restraint that stood for six months was unconstitutional, no ruling was made upon the New Order's radical claim that all "technical information" was excluded from the guarantees of the First Amendment. On the day after Justice withdrew its case, Nat Hentoff of the *Village Voice* queried the Justice Department upon what many were describing as the *Progressive*'s victory for a free society. "Everything is exactly as it was—except for this particular case," Justice answered. "The secrecy provisions of the Atomic Energy Act are intact. And I include that section of the Act which empowers us to go after prior restraint of publications that, in our judgment, violate those secrecy provisions. Nor are we inhibited in any way from engaging in criminal prosecutions after publication of those who have printed such information without our first knowing about it."

To make clear its intentions and the scope of the powers it claimed, Justice promptly began investigations of criminal violations by the Argonne physicists who had filed affidavits in behalf of the *Progressive*. Whether similar prosecutions were in progress against Energy's own witnesses who had also provided materials from the public domain was a secret. The key to understanding what the New Order meant by a secret was clearly stated: a secret was defined as information communicated without the advance approval of the Department of Energy. Hence, Energy's witness Jack Rosengren could not violate the secrecy provisions of the Atomic Energy Act, because whatever he had to say was approved even if it contained the secrets of H-bomb design. Presumably, by its remarkable exemption, whatever *Fusion* had to say was approved, but anyone who published materials based upon the same technical information in *Fusion* was subject to criminal prosecution for their understandings.

Although the customs, manners and traditions of the community could be searched in vain for any precedents, the regulations of the Atomic Energy Act of 1954 were announced to be sufficient to the New

Order's purposes. The regulations stated that anyone who possessed "restricted data," whether that person obtained the data from the government, or by their own private initiatives from nongovernment sources—including the results of study, wonder, or intuition—could not "communicate" the restricted data to anyone else by publication or by talking to his neighbor across the backyard fence. "Restricted data" included all information—whether true or false—concerning: "(1) design, manufacture, or utilization of atomic weapons; (2) the production of special nuclear material; or (3) the use of special nuclear material in the production of energy."

The New Order's radical and extraordinary powers were asserted over *all* nuclear information—weapons, fuels, and the production of energy; and the basis for these powers, according to Justice, was that *all* "technical information" was exempt from the guarantees of the First Amendment. Such claims, of course, could not be supported by either law or precedent because there were no such laws and no such precedents. Instead, these were claims for radical and extraordinary social and political powers—social and political powers to determine the character of the national cultural policy, regardless of how the meaning of the word "culture" was defined. Energy was a central question of twentieth-century politics, but the regulation of all the corporate applications and all the university theories were to be centralized within the jurisdiction of one national agency. Spokesmen for the Department of Energy explained to those who complained of its $20 billion budget that more than a third of the Energy budget was spent to produce nuclear weapons. Yet, almost without exception, every leading theoretical scientist of nuclear physics, every advisory board to the Department of Energy or to the president, had continued to argue that a policy of secrecy was damaging not only to the social and political fabric of democracy, but to the initiatives of science as well. Dr. Edward Teller argued that the habit of secrecy was a threat to national security. He pointed out that without secrecy, the United States had made spectacular advances in computer and electronic technologies, resulting in an American "lead" in those fields of "technical information" over their Russian competitors; whereas in the supersecret nuclear fusion field, the United States lagged behind Soviet developments. The technical lag, said Teller, was a direct result of America's futile policy of secrecy. Dr. Teller wrote the *New York Times* in 1973: "Unfortunately, secrecy, once accepted, becomes an addiction—it is difficult to kick the habit. A false sense of 'security' that is engendered by secrecy has misled many people. Actually I am convinced secrecy is the enemy of scientific and technical progress all over the world, and violates the best traditions of the open society for our country."

Consistently, Dr. Teller advocated abandoning all forms of scientific and technical secrecy in the enlightened self-interest of the United States. Just as consistently, the Corpos of the New Order ignored the

advice of their own star witness, because the theoretical and practical arguments made by Dr. Teller against secrecy and for the benefits of nuclear power depended for their acceptance upon immediate and urgent social and political change—the same urgencies recommended by all six national commissions appointed to investigate Three Mile Island. The New Order's transcendental authorities were consistently exercised as sovereignties against the initiatives of change—urgent or not, technical or cultural, social or political. The Argonne scientists who filed affidavits in behalf of the *Progressive* did so because they were outraged by the radical powers to censor advanced by Justice. The Argonne scientists filed their affidavits to swear what existed in the public domain, and not because they agreed with either the politics or the social objectives of the *Progressive.* After they testified to what they knew to be community understandings, the Argonne scientists were subjected to investigations for criminal violations of the Atomic Energy Act, and interrogated to determine whether they had "leaked" secret information. A security risk, by the New Order's radical definition, was anyone who "leaked" what the community had known for forty years.

Fusion magazine, on the other hand, supported the transcendental faith in nuclear development; therefore, even if it published "technical" information similar to the affidavits introduced by the Argonne physicists, *Fusion* was exempt from characterizations as a security risk or investigation for criminal conspiracy. Moreover, what *Fusion* magazine said was the "intelligence arm" of the pronuclear presidential candidacy of Lyndon H. LaRouche, Jr., collected "dossier" materials upon those who organized or contributed to antinuclear demonstrations. The Fusion Energy Foundation also published an *Executive Intelligence Report* from materials gathered from LaRouche's private "intelligence service." *Executive Intelligence Report* and its "dossier" materials were sold to officers of corporate nuclear utilities and, in addition, distributed to local police departments, the Department of Energy, the Department of Justice, and the FBI. Intelligence reports gathered by Mr. LaRouche's organization were furnished to the FBI as confidential materials, but FBI "informants" on antinuclear activities were, of course, secret. The secrets of fusion were not actually secrets; what was secret were the political and ethical choices of the New Order.

Although the New Order's claims of secrecy over "all technical information" were in themselves strange, they were particularly odd when the expenses of secret events were to be paid from public tax monies. Nuclear Fuel Services, Inc., the same subsidiary of Getty Oil Corporation that had somehow lost enough refined materials in one year to manufacture six atomic bombs—but lost the materials secretly—had previously occupied a plant site in West Valley, New York, not far from Buffalo. Between 1967 and 1968, Nuclear Fuel Services, Inc., hired approximately 1,400 men, most of them just over eighteen, as "sponges." The term

"sponges," used within the nuclear industry and accepted by the United States Occupational Safety and Health Administration, defined those temporary workers who would be subjected to such high levels of radiation that they could only be employed for short periods. If regular company employees were subjected to the same levels by entering radioactive areas within the Nuclear Fuel Services, Inc. plant, they would absorb in a few moments radiation in excess of the allowable tolerances for an entire year. Instead, the corporation hired "sponges" from the pool of unemployed, mostly black, in Buffalo. Irwin Bross, director of biostatistics for the New York State Health Department's Roswell Park Memorial Institute in Buffalo, recalled an instance in which an electric motor in a contaminated area of the plant broke down and "sponges" were sent in to repair it. "One guy would go in, turn a screw a quarter turn, then rush out," Bross said. "It was the most callous use of human beings since the slave trade."

The New York State Health Department decided to make follow-up studies of radiation effects on the workers used as "sponges," but Nuclear Fuel Services, Inc. refused the state of New York the names of those it had employed. The names of "sponges" were secret. When Nuclear Fuel Services quit its West Valley, N.Y., production site in 1976, the corporation left behind not only "sponges" who couldn't be traced, but also about 2 million cubic feet of radioactive wastes buried in fourteen trenches each 800 feet long, and in addition, about 600,000 gallons of liquid radioactive wastes in two huge storage tanks. Federal and state estimates to clean up the radioactive mess left behind by Nuclear Fuel Services, Inc. were soon as high as $1 billion. The small corporation, with only about 250 regular employees, would cost the federal and state treasuries more than the guarantees given to the Lockheed Corporation, not as much as the amounts guaranteed from tax monies to the Chrysler Corporation, but about one-third the amount guaranteed for the bonds issued by the entire city of New York. Such questions of public cost, however, entailed "technical information" about nuclear fuels declared to be secret by the Department of Justice; and besides, according to Justice, those who communicated secret information about Nuclear Fuel Services, Inc., were subject to criminal prosecution. Nuclear Fuel Services, Inc., of course, was only following regulations.

According to an Energy Department statement, released just before Three Mile Island, the high-level radioactive wastes generated by the nuclear industry would contain fission products, uranium, plutonium, and other heavy radioactive materials for *millennia*. One proposal by Energy to meet this awkward problem was to mark the radioactive dumps with signs just as permanent; but Energy admitted that even if warning signs could last as long as the radiation, someone would have to be available to "manage" the waste sites. Energy noted that agencies such as the Department of Energy could not always be expected to last a

thousand years, but with a becoming modesty, Energy also noted: "The first thousand years of the disposal period are the most critical."

According to the New Order, the critical political and ethical choices could only be decided by the Department of Energy, even when the same information was available to the community in the public domain. In the wake of Three Mile Island, Robert Ryan, director of the NRC's Office of State Programs, testified that siting the nuclear plants of Consolidated Edison near New York City was "insane." The example of insanity provided by the Con Ed plants was consistently cited by the Three Mile Island Commission, by congressional committees, by university scientists, and by the NRC's own officials. Former NRC officer Robert Pollard had been in charge of safety review for Indian Point #3; he characterized the Con Ed site as "Hiroshima on the Hudson." The Union of Concerned Scientists, formed in 1969 as a faculty group at M.I.T., concluded that the Indian Point plants were such immediate hazards that the UCS filed its first suit with the NRC to suspend a particular nuclear corporate license. In the opinion of UCS, representing 2,500 scientists, engineers and other professionals, Indian Point represented "a direct, immediate, and irreparable danger to the nation and its people."

The doubts expressed by the Union of Concerned Scientists about the operations of the plants were exacerbated by the proximity of Indian Point to the heavily populated New York City metropolitan area. Con Ed's operating record did not add to the community's confidence in Con Ed's management: twice the Con Ed grid had blacked out the city as a result, according to Con Ed statements, of an act of God. If God played tricks on Con Ed's management when the control panels of its Indian Point reactors began to blink warning lights, the reactors were only thirty-four miles from Central Park. Moreover, NRC regulations carefully spelled out that because of their inherent dangers, nuclear plants were not to be sited near high population densities. The careless placement of Indian Point plants by utility officers presented clear and present dangers to community continuances. The sites were justified by nothing more than the utility's evidence that it had been certified by the NRC— even if that certification contradicted the NRC's own regulations.

Consolidated Edison's attitudes were scored by the national commissions, but Con Ed's reliance upon the forbearance of God was no different from the attitude of many other nuclear utilities. Even after the reports from Three Mile Island were issued, Ira Freilicher, vice-president of the Long Island Lighting Company, remarked that if the "ultimate nuclear accident" occurred at LILCO's proposed Shoreham nuclear site, "it will not hurt anyone." Infuriated by Freilicher's hypocrisy, Karl Grossman, a reporter for the *East Hampton Star*, a weekly newspaper downwind from LILCO's Shoreham plant, dug out of the library a report of the NRC's Brookhaven Laboratory called "Theoretical Possibilities and Consequences of Major Accidents in Large Nuclear Power Plants." First issued

in the 1950s, the report was dubbed "WASH 740," and updated by the Brookhaven Laboratory in the 1960s as a result of the increase in the size of the nuclear plants being constructed. According to WASH 740, the estimable death count from a meltdown for the *average* nuclear plant ran to 45,000; the number of subsequent cancer casualties to 70,000; "damages could become an appreciable fraction of the gross national product," said WASH 740. A figure of $230 billion from a *single* accident was described as possible on a page stamped "For Official Use Only."

From reports such as WASH 740, informed members of the community derived the "technical information" that a meltdown might entomb "an area the size of Pennsylvania"—a line memorialized in the movie *China Syndrome*, but based upon the NRC's own data. Similarly, Karl Grossman was delivered two boxes of engineering reports from a town dump, indicating that Stone & Webster, in constructing the LILCO Shoreham plant, had checked off design changes which were potential safety hazards to the Shoreham plant's operations. Because the two boxes of engineering reports showed the checkoffs for only two months, Grossman queried the NRC inspector for Shoreham. Grossman discovered that no more than 2 percent of the proposed plant was inspected by the NRC anyway. Besides, the NRC inspector was located 200 miles away in Pennsylvania. When Grossman asked the NRC for the construction reports for other months, the NRC answered the inspection reports were secret. In a concession to outraged public opinion, the NRC appointed a full-time inspector for the Shoreham site, but only after the plant was 90 percent complete.

The combination of absent inspection, site location in contradiction to NRC's own regulations, inadequate management training, poor safety records, clandestine procedures, and outright lies, were sufficient beyond any reasonable doubt to require urgent and immediate change, just as six national commissions had recommended. As Dr. Henry Smyth had predicted in 1945, the questions posed by nuclear energy were never technical or scientific difficulties, but social and political choices. The irony of Dr. Teller's advocacy of nuclear power as a technology beneficial to all mankind, and Dr. Teller's opposition to censorship and secrecy, was that Dr. Teller might have been entirely right; but the procedures of the New Order, and the powers the New Order claimed over community continuances, worked to defeat Dr. Teller's hopes. The New Order demanded the use of all "technical information" without inspection, without limits of any kind upon its own transcendental authority to make ethical and political choices.

But when the secrets of "technical information" were cleared away from either the *Progressive* case, or the controversies over nuclear power plants, domestic and foreign, the urgent ethical and political choices were revealed to be far more terrifying than the arguments over the atom for peace or for war. The best summary of what was at issue was made by

Dr. Albert Speer as he pleaded guilty at Nuremberg for the collective crimes of the Nazi regime. Speer hoped that his own trial would contribute to laying down the ground rules for life to continue in human societies. He believed the consequences of Hitler's ambitions for the thousand-year Reich were not only an outgrowth of Hitler's personality, or the imposition of dictatorship in itself; he concluded that the extent of the Nazi's cultural crimes were multiplied by technology. "The nightmare shared by many people," said Albert Speer, was "that some day the nations of the world may be dominated by technology."

To the extent that the world worshipped technology, said Speer, the more essential would be the need for liberty, for the self-awareness of communities as a "counterpoise" to the new religion. "Now we know that we do not live in an earthquake-proof structure. The build-up of negative impulses, each reinforcing each other, can inexorably shake to pieces the complicated apparatus of the modern world. There is no halting this process by will alone. The danger is that the automatism of progress will depersonalize man further and withdraw more and more of his self-responsibility."

"Dazzled by the possibilities of technology," said Albert Speer, as he pleaded guilty to crimes against humanity, "I devoted crucial years of my life to serving it. But in the end my feelings about it are highly skeptical."

For a similar skepticism about an excess in the production of 30,000 hydrogen bombs, Howard Morland was prosecuted by Justice, and a gag order was issued to prevent publication of the *Progressive*. One year after the judge issued the order, his opinion and the arguments presented to the court were still secret. One year after Three Mile Island, not one change had been made in the procedures which the national commissions had concluded made the accident inevitable. During the year, officers of Met Ed had again attempted to censor by gag order from the local courts descriptions of Met Ed's ventings without NRC authorization or environmental notice. During the year, the Supreme Court decided, without hearing arguments, that CIA's seizure of the royalties from Frank Snepp's unauthorized history of CIA's failures in Vietnam was right and proper because Snepp was bound by the contract he had signed; but *obiter dicta*, the Court added that whether or not a government employee signed a contract, and whether or not a former employee's accounts of his government service actually contained national security matters, the government had an inherent right to seize the book or royalties anyway.

Assertions of such transcendental authority were radical departures from community continuities: censorship, blacklisting, secrecy, dossiers, informers, gag orders were the indelible stains of tyranny, instantly recognizable by every community as threats issued against the community's memories and the community's future. Beyond a shadow of reasonable doubt, the New Order was busy extending gargantuan authoritarian powers over every community social interest. In 1979, a farmer who shipped

the potatoes he grew on his own land, and shipped them from his own barn, was prosecuted as a criminal, subject to five years imprisonment because he had failed to get advance approval from the Department of Agriculture—although he'd tried for a month to get the local officers to leave their offices for the requisite inspection. Enemies of the People could be identified among small, but independent businessmen; among fishermen, whose catches 150 miles out to sea did not satisfy inspectors on the landing docks; among mayors of great cities who refused to swear loyalty to the Party's officers. Other Enemies of the People might include communities who refused to consent to nuclear plants or facilities to manufacture poison gas within their borders. Other communities were declared enemies for the values they embraced: intellectuals whose opinions were unapproved by authorized officers of the New Order; religious communities whose beliefs differed from the fundamentalisms of the New Order; artistic and critical communities who disdained the fashions endowed by the New Order's Ministry of Culture.

To prosecute variations from the New Order's orthodoxies, the New Order demanded and obtained from the courts: writs of assistance; the power to invade privacy without showing probable cause for crime in its warrants—or even showing any suspected crime whatever when invading the offices of newspapers or the homes of innocent third parties. To carry out obedience to its regulations, the New Order employed between 10,000 and 20,000 informers without warrants, although the actual number itself was secret, and the payments made from the public treasury to obtain unwarranted information were also secret. Some of these informants apparently had been accessories to murder on instructions from officers of Justice, but the material evidence to determine whether the New Order prosecuted dissent by murder was, of course, an ethical secret.

These secret political procedures against crimes real or imagined were employed as well against citizens who followed traditional and customary manners to advance ordinary opinions. Neither Jane Fonda nor her husband Tom Hayden could possibly be characterized as threats to national safety. They might appear foolish or wrongheaded, but they were not criminals or suspected of any crimes. They had never had access to any information that was to be kept secret in the interest of national defense or foreign policy, or that was properly classified pursuant to any executive order. The only information either ever possessed involved ethical and political questions commonly debated in the public domain. When asked how she qualified as a national political expert, Jane Fonda replied forcefully: "I am a citizen activist. I think it is in the highest tradition of our country for private citizens to speak out."

Tom Hayden spoke, wrote, and organized communities to effect change by the most ordinary means, both traditional and customary to

democratic politics. Hayden thought "citizens ought to have a say in the decisions that effect their lives." As a direct consequence of such traditional behavior, Jane Fonda and her husband, Tom Hayden, were spied upon by the same kind of satellites used to survey Castro's Cuba and Soviet Moscow. The satellites operated by the National Security Agency intercepted communications at the command of a computer named "Harvest." The interceptions were part of a highly technical surveillance program designated "Watch List," operated by an entire group of agencies.

Fonda and Hayden sued NSA to obtain copies of whatever documents had been collected on them. The documents, said the courts, were "top secret," not necessarily because information in the documents about Jane Fonda and Tom Hayden actually contained any secrets, but because if NSA revealed the nonsecret secrets, by doing so NSA would reveal how it conducted technological surveillance, which was, of course, secret. To justify domestic spying, NSA cited as one of its authorities CIA statutes in the United States Code, in spite of the express proscription against CIA to conduct domestic espionage. For the heresies Jane Fonda had expressed about the technologies of the New Order, she was, like Howard Morland, an Enemy of the People.

All tyrants were remembered as disgraceful because they feared the community interests over which they claimed transcendental authority. Everything tyranny did, it did by some law or regulation, certified as necessary and proper by lawyers and judges, but simultaneously, tyrants displayed by their manners their terror of community opinion. Tyrants always spoke well before large audiences, but then conducted the business of government from a walled garden or some heavily guarded mountain retreat—perhaps listening to the operas of Wagner or some such sentimental music. Above all, tyrants lied, and all their subordinates lied, again and again. To maintain power in a corporate technological state, three conditions were necessary: first, continuing crises—if not war, then the threat of war, because communities would accept the moral equivalents of war if these were claimed as necessary to community safety; second, no real political or social change could be initiated, because to do so threatened the entitlements of the officers designated to maintain order in the crises designated in the first condition; third, propaganda and lies, both technical and cultural, had to be issued ceaselessly, because otherwise the community of opinion might question whether the designated crises actually existed. It was always the questions, not the answers, that were dangerous to the New Order.

"Politics, as far as mobilizing support is concerned, represents the art of calculated cheating without *really* getting caught," James R. Schlesinger wrote in a 1967 paper for the Rand Corporation. "Slogans and catch phrases, even when unbacked by the commitment of resources, remain

effective instruments of political gain. One needs a steady flow of atten-
tion grabbing clues, and it is of lesser moment whether the indicated
castles in Spain ever materialize."

In a memorandum to President Carter dated June 28, 1979, Stuart Ei-
zenstat—the same White House aide who had drafted President Carter's
"Issues Definition Memorandum" on a national-cultural-policy-more-ef-
fective-than-weapons—summed up the "energy situation" in the sum-
mer of 1979. Eizenstat noted for the president's return from an energy
conference in Japan: that the White House efforts had "not yet broken
the back" of the truckers' strike; that gas lines were spreading throughout
the Northeast; that sporadic violence had continued to occur; that infla-
tion was soaring because of the increase in domestic energy costs. Eizen-
stat did not note in his memorandum to the president that the gas crisis
had been instigated deliberately by the President and Secretary Schlesin-
ger, in order to teach the American public a "painful lesson." Instead,
Eizenstat concluded that the president should take strong steps to "mo-
bilize the nation around a real crisis and with a clear enemy—OPEC."

Whether OPEC was actually an enemy of the nation was irrelevant to
the White House energy crisis. Within two weeks, President Carter ad-
dressed the nation by television: he issued a call to arms, telling his
audience that by winning a "war" against its energy problems, the United
States could regain confidence in itself. Among the proposals the presi-
dent advanced was an Energy Mobilization Board with powers "to cut red
tape." The EMB was approved by Congress as a "small elite group" that
could override *any* federal, state or local law that got in its way. The
authority to exercise such powers over community interests could not be
located in either the United States Constitution, or in the traditions of
any democracy.

To these extraordinary and radical claims for power by the New Order,
all the agencies of the White House Ministry of Culture remained silent.
Whether known as the agencies of the New Foundation, or the National
Foundation for the Arts and the Humanities, or whether they were under-
stood by an examination of their coordinated White House activities,
they maintained an absolute silence, because their policies could not
include contradicting the president of the United States under any cir-
cumstances. Yet such a silence, necessary for pragmatic political reasons,
carried with it a corollary: when Peace was declared to be War, Ignorance
said to be Strength, and Freedom no different from Slavery, and simulta-
neously the Ministries of art and history were required to keep silent,
those Ministries thereby condemned themselves to contemplation of the
banal, the futile, and the otherworldly.

Folk Arts Program Guidelines FY 1980 and Other Points for Discussion

The Folk Arts Program's first formal review by the National Council on the Arts seems an appropriate time to summarize the history of our program.

Although folk arts as a field was included in the Endowment's original enablinglegislation, no formalcommitmentoffunds to the discipline was made until 1973. Bess Lomax Hawes replaced Alan Jabbour as Director for Folk Arts within the Office of Special Projects in January of 1977. It turned out to be a significant year. Special projects budgeted $1,246,500 for folk arts, and activity increased tothepoint that anadministrativedecisionwasmade in February of 1978 to formally separate Folk Arts from Special Projects, complete with staff, independentbudget, reviewing panel and programstatus.

It began to seem clear that Folk Arts, with its rapid growth, frequent panel meetings and active staff, was cannibalizing the smaller Folk Music category, and that both programs would benefit by joiningforces. Another administrativeaction, supported by both Walter Anderson and Bess Lomax Hawes, detached the Folk Music Programfrom Music and transferred it to Folk Arts.

Folk Arts' budget for 1978 was $1,550,000. In 1979, with theadditionofthe Folk Music budget, we went up to $2,400,000. The period was a confusing one. The program had to deal with two conflicting and overlapping sets of deadlines, a fundingpolicysatisfactorytothe two reviewing panels (Folk Music and Folk Arts) had to be hammered out, and the two panels needed to be combined into asingleunit.

For these reasons, Folk Arts has only recently begun serious longrange planning. The results of our firstattempts at this process are contained in the tentativefive-yearsubmissiontothe Policy and Planning Committee oftheCouncil. Few substantive changes wouldbemade in 1980. In the distance, we see both newproblems and newopportunities. Untried forms for thepresentationof folk arts and folk music to the wider audience are beginningtoevolve. Almost daily, we hear from potential new constituencies, eachwithitsparticularneeds.

It seems wise to move deliberately, building onoursuccesses. We have not yet reached theprimarygoal of both Folk Music and Folk Arts: the recognitionand supportofthe master artists and artisans who embody the multiple aesthetic systems that make life intheUnitedStates both someaningful and sostimulating. We can afford atleast onemoreyearof experimentation, testing out newforms, newmethods, and newideas

embodying our oldgoals. Such proposals can be subsumed under our standardrequest for "innovative projects."

a. Support for thedirectpresentationof folk arts (a term which should hence forth be read as including folk music). Grants made inthiscategory cover festivals, concert series, exhibits, workshops, school residencies, apprenticeships and the like. Approximately 50% of our total budget has goneinto such. . . .

16

PROFILE / NEA: SCENES FROM A WINTER PALACE . . .

A totalitarian society which succeeded in perpetuating itself would probably set up a schizophrenic system of thought, in which the laws of common sense held good in everyday life and in certain exact sciences, but could be disregarded by the politician, the historian, and the sociologist.

— George Orwell
The Prevention of Literature

The fifty-eighth meeting of the National Council on the Arts was scheduled to begin at 8:30 A.M., Friday, February 9, 1979, in the conference room on the fourth floor of the East Wing of the National Gallery of Art, 4th Street and Constitution Avenue, on the Great Mall in Washington D.C. Eight inches of snow had fallen earlier in the week, then frozen to an icy glaze. On Friday, the skies were bright blue, and from time to time bitter northwest gusts raised small whirlwinds of powder. According to the agenda, the meeting would open with a report on "Folk Arts."

There were two entrances to the new East Wing designed by architect I. M. Pei. The public entrance to the galleries on the Constitution Avenue side of the building was still closed, and would only open later to admit the public; the second entrance to the museum was almost as grand, but was rarely seen by the public. The private doors were shielded from public view by a wall which divided the East Wing's ground plan into two overlapping triangles of separated work space. The more northerly of these triangles fronted Constitution and contained the National Gallery's four pink-marbled stories of exhibit space for art. On the building's southerly side, overlooking the Mall, the floor plans of the second triangle were devoted to administrative purposes—an odd four-story office building of the arts, containing marbled halls for the receptions and conferences called by the anointed officers of national culture. To reach the private

entrance of the East Wing on February 9, I had to climb snowbanks and thread a route through the Metro buses, parked nose to tail as a barricade to hem in the farmers of the American Agricultural Movement and the 1,000 tractors they had driven across the country to Washington.

The corral was the idea of Washington's Deputy Police Chief Robert W. Klotz. Confronted with 1,000 tractors blocking traffic in the streets, and with thousands of angry farmers and their families demonstrating day after day at various national farm agencies, Klotz recalled two glorious police-work operations: the day in 1972 during the Republican National Convention when he'd seen the convention center ringed with buses; and the day when his own special forces ringed the White House with buses during the Cambodian crisis in May, 1970. "There's nothing new under the sun," Chief Klotz said. "We grabbed anything, water trucks, snow plows, graders, buses, tow trucks, squad cars, anything that moved."

While the farmers were absorbed by fiery speeches upon the icy Mall, Klotz's cavalcade started at 14th Street, far from the Capitol, and had encircled the farmers before they could realize what had happened. It took a while before the farmers understood they'd been city-slickered. Chief Klotz had time to improve his makeshift cavalcade of hurriedly collected vehicles with an impenetrable wall of Metro buses. Even then —although their protests seemed futile—the farmers were determined to stay on until they could get someone to redress the grievances which were the cause of their peaceful assembly.

Just east of the National Gallery, at 3rd Street and Constitution Avenue, one Metro bus served as a sliding door to the steel hedge. In addition to imprisoning the farmers on the Mall, the buses also served to keep hundreds of riot police warm. Each man was armed, carried riot gas cannisters in canvas satchels, and gas masks, earned overtime as he passed day after day on twelve-hour shifts, suffering from boredom. While they waited in their buses, the policemen studied college courses, read *Penthouse* and *Playboy*, slept, rated passing women on a scale of one to ten, and played the newspaper obituary game. The cop who most inaccurately guessed the number of people who had died of cancer or heart failure that day was the loser and picked up the tab for the next coffee break. Chief Klotz supervised from a command trailer just west of the East Wing: in addition to the companies of foot soldiers he could command by radio from their Metro buses, he also had a troop of cavalry stabled on the Mall near the National Gallery of Art. When the cavalry exercised, the vapors from troopers and their mounts were exhaled as mist in the cold.

Within the barricade, the farmers lived in an assortment of trailers and campers: Chevy pickups with over-the-cab campers and a few Airstreams, but Winnebagos seemed to predominate. They had big new modern high-cab tractors with them, and a few small old-style Ford models. One little antique Ford was displayed near Constitution Avenue with a

hand-lettered sign that read: "HFA Cadillac." The farmers drove their tractors in pointless circles, lit bonfires to keep warm, quoted crop prices to each other, compared what they had learned about how their government actually worked, argued again their case against the national farm policies. The family farm was being deliberately ruined by Washington's politicians, but no one seemed to care. No one would listen while they lost equity year after year. They were falling into debt, and the inheritance taxes were ruinous. Land and machinery mortgages were running at ten, twelve, and even higher interest rates. Consider what will happen eventually, they said: corporate farms were being bought with foreign oil money; corporate farms would seem more efficient at first, but corporate farm workers would put in their eight-hour day with no stake in the farm's future. The cost of food would inevitably rise, they argued, from 16 percent of available income to 25 percent as in France, or 52 percent as it was in Russia. To get attention, they would burn their crops if they had to. They lobbied in congressional offices day after day; they were learning, they said, how to play the Washington game, but cynicism had set in. On Capitol Hill, hearings scheduled to receive their testimony were lightly attended. "The amazing thing to me," said J.D. Terral of Roosevelt County, New Mexico, "is when only three congressmen show up at a hearing. It beats the hell out of me. Only half a dozen of them even read the testimony we've prepared."

Early Friday morning, as I started up the icy sloping entrance to the administrative side of the East Wing of the National Gallery, a young farmer arrived with his family at the same moment at the East Wing's private doors. He had a two-year-old hoisted up on his shoulders. The child was so bundled against the cold that it was impossible to tell if it was a boy or a girl, and it was crying. The farmer's wife had a five-year-old girl by the hand. At the museum's entrance, the family had hesitated, unsure, because behind the glass doors they could see a captain in the blue uniform of the District Police with perhaps a dozen back-up men. The farmer explained that his family hoped to use the museum's bathrooms. Their camper was cold, but they didn't want any trouble. They had thought they could use the East Wing cafeteria to have breakfast, then they would hang around for a while and get warm. They might like to see the pictures, too. I explained that the farmer had arrived at the administrative entrance to the East Wing; that I supposed the squad of police was posted inside to keep out unauthorized visitors; that the public entrance was on the other side of the wall, directly behind them toward Constitution Avenue; that the museum itself would probably be open within an hour, but if the farmer wanted to, I would go through the administrative glass doors with him and his family. No, said the farmer, they didn't want any trouble. He and his family turned away.

Inside the private entrance to the East Wing, the police captain demanded I produce identification. I said I had none, and didn't need any

because I was on my way to a publicly announced meeting of the National Council on the Arts. The captain was determined, sure of his authority, until an NEA public information specialist offered an identification badge to the meeting if I would sign up at the registration desk. The NEA sticker would certify me as a representative of *Harper's* magazine. After certification as a member of the press, I hung my overcoat on the piperack downstairs and took the elevator to the fourth floor conference room where the National Council on the Arts was assembled, listening to a panel presentation: "Folk Arts Program Guidelines FY 1980 and Other Points of Discussion."

Near the floor-to-ceiling windows at the rear of a large conference room, it was possible to listen to the panel's report amplified by a sound system to an audience of perhaps 150, and at the same time enjoy a panoramic view of Capitol Hill. The golden dome shone majestically in the cold bright sun. According to the broadcast inside the room, the Folk Arts Program's first formal review by the National Council on the Arts was "an appropriate time to summarize briefly the history of our program." Although folk arts had been included in the endowment's original legislation, no funds were committed until 1973, according to the panel's history. In January, 1977, Bess Lomax Hawes replaced Alan Jabbour as director for Folk Arts within the Office of Special Projects, a significant change in the history of folk art, if the panel's reading was understood correctly. The Folk Arts budget for fiscal 1980 was about $2,400,000, and this sum was broken down for the National Council into official categories, one after another: festivals, dance music, apprenticeships, historical projects, documentation, archival documentation, films and recordings for the general public, folk arts coordinators, and consultancies—which were described as "our most important mechanisms for maintaining contact with our incredibly wide-spread constituencies."

Apparently storytellers, folk singers, and square dancers had become clients, like the farmers, of national rank. The fourth floor conference room was large enough so that those in attendance could leave their seats to circulate, working the aisles as delegates did at all national conventions. Buffet tables were laid out at the very rear of the room. Perhaps delegates could nibble pastries with consultants there. Along the side aisles, quilts were displayed as artwork, mounted and designated with captions beneath each example of patchwork design. These examples of history also convenienced those in attendance by shielding small conferences from the main body of the audience. Large plush modern chairs, couches, and smoking stands were arranged along the aisles formed between the displays of quiltwork and the windows looking out upon the Capitol and its golden dome. By the windows, the Folk Arts Panel could still be heard over the sound system: "So far, our most successful strategy in dealing with this situation has been to provide support for folk arts coordinators—professional folk arts experts who work full time out of a

state or local agency. We now have such persons in the arts agencies of eleven states."

Apparently constituents were being organized by full-time state commissioners. Looking down from the fourth floor windows of the National Gallery of Art, I could see the 3rd Street entrance to the Mall directly below. At the left of the view, I saw again the Metro bus which served as a sliding door through the wall of buses that had corraled the farmers. Near the only exit through the barricade, ragged groups of the Capitol's Special Police Forces stood about, identifiable in their bright orange slickers and black boots. In the center of this strange social landscape, a clump of about fifteen farmers gathered near a bonfire built on the snow. They wore tengallon hats. Their hands were stuffed down into the pockets of windbreakers. They stamped their feet from time to time. They stood in boots—work boots impervious to snow, to mud, or to cowshit, if that was where those boots had done their walking. They were the kind of laced boots advertised in the Sears catalogue—middle price range, ordered two pair at a time. A small, old-style, two-row tractor, flying the American flag upside down, circled the stamping boots, doing wheelies and skids on the ice to break the monotony. A far grander parade of big rigs slowly circled the entire breadth of the Mall, from one wall of buses at its south perimeter to the opposite wall at Constitution Avenue. The tractor parade advanced in an endless, pointless circle, each tractor displaying some hand-lettered sign: "100% Parity; Farmers Gone to DC/ USDA Gone to Hell; No Parity/No Grain/No Beer; Ravenna Nebraska demands/What is Rightfully Ours."

Inside the conference room delegates were seated on steel folding chairs. Their shoes were the shoes of teachers: rubber-soled or half-heeled brogans on the men: practical low-heeled walkers on the women. At the far end of the room, the National Council on the Arts was assembled around the head table: a peculiar arrangement of four tables pushed together to form a hollow square, so that instead of facing the audience of delegates, the council members faced in toward each other across the hollow square. From the back of the convention, I could not see the shoes of those at the head tables, because they were hidden beneath the folds of a green linen cover. Yet a good guess would be that there were no sturdy lace-ups from the Sears catalogue, nor any "easy walkers" from Tom McCann. Mr. Franklin J. Schaffner, director of the movie *Patton* and many others, would be sporting Gucci loafers with gold snaffle bits across the instep. Geraldine Stutz, a New York high fashion corporate executive, flashed gold from her wrists, and when she was bored, fidgeted by pressing a slim gold ballpoint pen to her lips. Gold also flashed from Mrs. Rosalind Wiener Wyman, a lawyer and the representative from Los Angeles and the Motion Picture Producer's Guild of America, Inc. As the history of folk arts continued, there were those seated around the hollow square who would check the time on square gold Piaget watches.

The arrangement of the squared council table was in itself curious. It appeared to be an adaptation from academic and bureaucratic manners, pragmatic to its purposes, yet with a peculiar style distant from the tea tables and samovars associated with salons of art. Because all four sides of the table faced in and the chairs of the participants were placed around the outside edges, all their remarks were exchanged across no more than twenty feet. The squared table seemed at first to be the result of stage directions to emphasize equalities, but the tableau was contradicted by microphones on all four sides. The "free and open discussion" so often praised for its virtue was being tape-recorded by a system of machines just to the left and behind the official appearances. Two young men stood guard over everything, adjusting dials. What was obviously an official drama was highlighted because everyone seated at the squared table inevitably had their backs to either the audience or, on the right-hand side of the table, council members had turned their backs to the windows and the magnificent panorama of the United States Capitol. In contrast to a town meeting in which the elected representatives faced their voters, the National Council on the Arts conducted its business as would a court of the czars: princes, grand dukes and great duchesses exchanged pleasantries across a table, while the bourgeoisie listened respectfully to their broadcast. At one point during the morning's proceedings, a succession of loud booms from the barricaded farmers rattled the fourth floor conference room windows. A staff member of the National Endowment for the Arts was dispatched to lower aluminum blinds, shutting the sun and whatever had caused the disturbance from view. What sounded like cannons continued for a while unexplained, until NEA Chairman Liv Biddle assured everyone that there was no danger, no reason for concern, according to the information he had just received; but the conference room remained shadowed and protected from the sun's bright reflections.

Livingston L. Biddle, Jr., occupied the center seat on one side of the squared table. His seat was placed so that his back was to the conference room's southern wall. Biddle faced the panelists, whose backs were to his audience, and he also faced the assembled audience, but over his panel's heads. To the extent that all seats around the council table were equal in the views they amplified to each other, Chairman Biddle was clearly first among these ordinaries of the arts. He put kindly, tentative, soft questions into his microphone, but his questions interrupted all other conversations—those of the council along opposite sides of the table to his right or left, or those of the panelists who had assembled before him. At Biddle's immediate left sat L. James Edgy, Jr., age forty-three, once a teacher, formerly executive director of the Ohio Arts Council, and deputy chairperson of NEA for "Intergovernmental Activities." At Biddle's immediate right was Ms. Mary Anne Tighe, age thirty-one, once a teacher, formerly arts advisor to Mrs. Joan Mondale, and deputy chairperson of NEA for "Programs." Perhaps because of the cold outside, the East Wing

conference room was overheated. Deputy Chairperson Jim Edgy had taken off his jacket to hear the panel presentations in his shirtsleeves. As Mary Anne Tighe listened, she often cocked her head to one side, shaking back her dark lustrous hair to reveal small round gold earrings which accented her shirtwaist dress.

Ms. Tighe checked her watch. Folk Arts was running long, and the *patois* of official concerns was difficult to follow. Any contradictions to what was being said could be explained, according to the Folk Arts panel presentation, by overlapping guidelines, processes, combined programs, and frequent reorganizations. There were both new problems and new opportunities, but there were also basic strategies. Although it now seemed wise to move deliberately in new directions, testing out new forms, new methods, the new ideas would embody Folk Arts' old goals. Funding capacity was so small, and Folk Arts' necessity for flexibility so great, that Folk Arts had not yet set up formal categories for project support. On the other hand, the pattern of funding by Folk Arts had been surprisingly stable, and was reflected under three headings: "(a) Support for the direct presentation of folk arts—a term which should hence forth (sic) be read as including Folk Music—Grants made in this category cover festivals, concert series, exhibits, workshops, school residencies, apprenticeships and the like."

"The like" might include a $26,000 grant to the Minnesota Historical Society for "continued support for a State Folklorist and further development of the folklife program in the State of Minnesota." Approximately 50 percent of Folk Arts' total budget went into projects for which, Folk Arts had just explained, no formal category had yet been set up. Another 30 percent of Folk Arts' budget went to category "(b) to document folk arts." NEA Folk Arts grants "supported" films, TV and radio shows, photographs, records, and audiotapes "to validate the traditional arts by presenting them back to their own communities through the media." NEA's Folk Arts director, Ms. Bess Lomax Hawes, had explained to Congress why folk arts were sometimes "an endangered species." Then she produced a scroll from 500 Turkish Americans from Chicago and presented it to the Honorable Sidney R. Yates, chairman of the House Subcommittee on Appropriations for NEA. Ms. Hawes testified that as a result of an NEA Folk Arts grant Chicago's Turkish Americans now felt they were "in the mainstream of American cultural life." Since Mr. Yates's home district was in Chicago, the scroll was accepted as evidence of how folk arts had validated traditional arts by presenting them back to their own community.

The third category of NEA's Folk Arts budget, amounting to 20 percent of its total, was spent annually on "(c) services to the field." These funds paid for conferences, surveys, support for state and privately based full-time Folk Arts "coordinators, evaluation, and the like." Although NEA made national NEA grants to political organizations, such as the Na-

tional Association of Counties, the Association of State Governors, the Mayors' Conference for the Arts, and, in addition, to organizations such as the Associated Councils of the Arts, National Assembly of State Arts Agencies, "and the like," all these grants were different from grants made by NEA's "Folk Arts Discipline" for "services to the field." The Folk Arts support for state or local organizations with respect to folk arts was an entirely different category from grants made for "Folk Arts Coordinators" by NEA to state or local governments for folk arts advisors who worked in state arts agencies. As the Folk Arts panel attempted to explain these categorical niceties to the National Council on the Arts, the panel spokesman said that the results of "our first attempts at long-range planning" were contained in "the tentative five-year submission to the Policy and Planning Committee of the National Council." Of the one hundred or so delegates still seated in their chairs, as many as seventy bent their heads to refer to the indicated pages in what was described as "your briefing books." An outline for five-year plans was of considerable interest to nearly everyone in the room for a number of reasons. Actually, what Folk Arts described as their "first attempts" at long range plans was only their first *admitted* attempt. Livingston Biddle's predecessor, Ms. Nancy Hanks, had prepared a "Blue Book" containing NEA's five-year statement of policies and plans, but then kept it secret, apparently because the political climate was not ripe for its reception. I immediately sought out an NEA Information Specialist to ask if I, too, could have a copy of the briefing book to which the Folk Arts panel referred.

NEA's answer was no, "the briefing book was not for public distribution."

There appeared to be at least sixty briefing books being consulted at that moment in the audience.

That made no difference. "The briefing book could not be made available to the press at this time."

When would it be available?

Public Information could not say. She would have to go through it first, deleting "any materials that could not be released."

How could anyone tell, after it was sanitized, whether the briefing book told the whole story?

"That just couldn't be helped."

Did it contain secrets?

"It wasn't secret, it just couldn't be made available."

There were members of the audience with briefing books who were identifiable as lobbyists for various associations. Was the NEA briefing book available to its own lobbyists and to commercial consultants as well, but not to the public?

Public information would get NEA's staff counsel to explain NEA's policy.

Waiting for NEA's staff counsel to arrive, I examined the patchwork quilts displayed near the rear of the conference room: "From the Roland L. Freeman Collection of Afro-American Quilts from the Mississippi *Folklife* Project." Down below on the snow-covered Mall, a pair of green John Deeres had engaged in a wheelie competition. In the parade of slowly circling rigs, a big diesel flew a Texas flag, but carried a sign that said: "Maine Potatoes." Near the bonfire, men worked together to get a giant, high, glass-cab machine up ramps laid at the rear of a ten-wheel flatbed trailer. The tractor probably had air-conditioning, CB radio, and cost somewhere near $60,000. Maybe its owner was giving up and heading home. He could probably pick up Johnny Cash and Dolly Parton on his FM radio to sing him all the way to Omaha. Meanwhile, "outreach" was being explained over the amplifiers in the conference room. "Outreach" was described as helping the public to understand what the Folk Arts programs were by "building support in the media and in the schools." To what seemed to be a desultory question from a member of the National Council, a Folk Arts panelist replied with surprising vehemence: "Any teacher who forces the student into the dominant culture cripples the child, and that teacher ought to be crippled."

Underneath all that goodwill for folk arts expressed in fundings for "outreach," there might be a broken leg for the teacher who taught a child its heritage. I wondered what could be the sources for such violence? And what were the radical perceptions that could tow an Endowment for Art into paranoia over a briefing book—a paranoia identical to the terrors perceived by the secretaries of Defense, Energy and State in connection with national security.

With which assistant general counsel "for the Arts," Ms. Susan Liberman, age thirty or so, arrived. She, too, wore a shirtwaist dress. She was polite, sure of herself—as only a lawyer can be when defending the client's privacy—and firm: no briefing books for the press. When the discussion rose above a whisper, Ms. Liberman suggested we move to the office hallways of the East Wing's fourth floor—so as not to disturb the conference.

By the stairwell I made my case. What was at issue should have been simple enough. The NEA was an agency registered under the "sunshine laws"; specifically, the National Council on the Arts was a "Federal Advisory Committee," and was required by both law and regulations to conduct its proceedings in accordance with the Federal Advisory Committee Act. Both law and regulations were explicit that copies of all "reports received, issued or approved" by any advisory committee were to be available. Certainly the National Council on the Arts was not conducting business subject to the exceptions provided for national security; certainly there could not be one whit of information in the council's briefing book that was secret. In any case, the book was already

widely distributed beyond members of the council itself; could not be identified as an "internal document"; and surely contained nothing that wouldn't eventually be published anyway.

Ms. Liberman was firm. The briefing book was not available. Any objection could be made in writing to NEA's general counsel, Mr. Robert Wade. If there were any further questions, Ms. Liberman would be happy to answer them. Her telephone number was 634–6588. NEA's public information specialist indicated, and Ms. Liberman obviously concurred, that it would be much better for me to occupy one of the seats assigned to the press, right next to the council's table where it would be much easier to hear everything clearly. Wandering around in the aisles, talking to delegates to the convention, was not entirely "appropriate."

Perhaps Public Information was upset because she had seen me in a conversation by the windows with a CPA who worked for NEA. Mr. CPA had been explaining why NEA was such a ripoff to the taxpayers, and ought to be abolished, or at least thoroughly audited by Congress. Mr. CPA wanted to remain anonymous, but he'd be coming up for retirement soon, then he could talk. He and his wife had worked hard all their lives and paid their taxes, but some of the stuff going on at NEA, in his opinion, ought to be brought out into the sunlight. I guessed that Public Information had no way of knowing what an NEA accountant had been saying; on the other hand, Public Information was clearly distressed by reporters "working the aisles." Whether the red briefing book contained secrets or not, there were assigned seats for the press, and that's where members of the press ought to be sitting.

Taking the designated seat immediately behind the squared conference table, I joined Miss Ruth Dean, arts and humanities reporter for the *Washington Star*, the only other member of the press in sight. Miss Dean had not been allowed a briefing book either. As it turned out, in addition to taking notes by hand, Ruth Dean fortunately operated a small Sony cassette tape recorder. During the eleven o'clock break between the panel on folk arts and an upcoming panel on "Federal-State Partnership Developments, including a survey of State Arts Agency support for music," I leaned forward to the council table to shake hands with William H. Eells, an executive of Ford Motor Company and chairman of the Budget Committee of NEA's National Council. I asked Eells whether he knew that the briefing book in his hands was "secret." Eells replied that was nonsense; it couldn't be. There wasn't anything secret in it. I summarized Ms. Liberman's recent opinion. Eells laughed: "That's ridiculous. Here, take mine. I can always get another."

After the break, Folk Arts' secret long-term plans were succeeded at the squared table of the National Council by the scheduled panel on "Federal-State Partnerships." Mr. Stephen Sell led off the presentation, reading into the microphones from materials also reproduced in the council's briefing book. Mr. Sell was general manager of the Atlanta Sym-

phony Orchestra, former chairman of the National Assembly of State Arts Agencies (NASAA), and currently chairman of NEA's Federal-State panel. He explained that his panel had met a month before to deliberate upon the current status of "the partnership." Unfortunately, the slides his panel had prepared to "update" the National Council on the Arts were not ready, but the charts and tables in "your briefing books" contained the same information. As the Federal-State presentation proceeded, Mr. Sell's panel indicated which chart would have been reflected upon the conference room's shadowed walls, if only the slides had been ready in time. Sell began by announcing that he had "a couple of statistics that might be of interest to you."

Sell told the council that the "total non-federal appropriations by State Arts Agencies for the arts in FY 1979 were $107.8 million." Both during his presentation and then subsequently in answers to questions put by members of the council, Sell made clear the significance of "the couple of statistics" he was announcing. He answered questions from William Eells about the ratios between federal and state totals in funding the arts. He heard comments from Ms. Rosalind Wiener Wyman upon the state ratios in connection with Proposition 13 in California. In Ms. Wyman's opinion the state of California would be increasing its funding of the arts by as much as 500 percent—as soon as Governor Jerry Brown began running for the presidency. Council member Theodore Bikel's comment echoed Thoreau: "One could say a milk cow and a farmer were a partnership." When Sell had concluded, we gathered around him for clarification and to check our notes. Again, he supplied his statistics, explaining that the figures on state funding of the arts had been collected by the National Assembly of State Arts Agencies. The next day Miss Dean's report in the *Washington Star* was headlined "State Funds Now Exceed Federal Aid to the Arts/Study Shows Local Agencies Are Providing a $107.8 Million Share."

The states, said Sell, were not just following the lead of NEA—that "guiding light of the Arts"—but they were, on their own initiatives, encouraging the nation's cultural progress—and certainly that was grand news, if true. Subsequent reports at the fifty-eighth meeting of the National Council on the Arts were equally upbeat: by the Task Force on Community Program Policy, by the panel on Long Range Planning for the Endowment, by panels on Opera-Musical Theater Guidelines, Music Program Guidelines, Dance Touring Program Guidelines, Literature Guidelines, and the Report of the Hispanic American Task Force. For two successive days the National Council on the Arts listened to dollar totals, discussions of "technical assistance," needs and trends and operating supports and marketing and advocacy and cooperation and coordination and "line items." Yet, it seemed to me, there were, after a while, peculiar rhythms, strange otherworldly cadences to the language of these reports. The new reality, we were told, was that "the arts were in a stage of

process." The chairman of the Literature panel explained to the council that NEA's literature program was looking for "projects outside the guidelines." Whatever these expressions of goodwill might have meant, they were sanctified by instances of demonstrable goodworks performed in the name of the arts; but very little was said about actual works of art or about working artists. Every discussion concentrated on the political organization and the budgets for institutions: the agenda of NEA's priorities was entirely filled with concerns of states, communities, cities, municipalities, education, labor, universities, regional consortia, challenge-grant programs with cooperating corporations, associations, foundations, and any political and social constituency, either real or imagined, old or new, that might be "reached" by means of some stage in the "process," either within or without the guidelines. When the National Council on the Arts assembled to advise NEA, it was a political establishment with ambitions for the arts that were unlimited as to political sovereignties, but silent on questions of aesthetics.

Understood as a state agency of political power, the sources of NEA's paranoia about their "briefing books" then became clear: not much of what NEA told its own conventions, or anyone else, was true in any everyday commonsense meaning. NEA's system of thought was schizophrenic: its perceptions were solely its own, entirely logical to continuing or expanding its own powers, but requiring NEA to disregard, insofar as possible, any details contradicting the transcendental authorities to which it laid claim. In the month following NEA's convention at the National Gallery conference room, the farmers used their tractors to plow out a Washington helpless under an unusual blizzard, and the Surveys and Investigations Staff of the House Appropriations Committee issued a report on NEA indicating just how many good reasons there were for NEA's paranoia about independent witnesses to NEA's Good News.

The House report was highly critical of NEA's performance and procedures. The House report found NEA so deficient in its management policies and practices that the NEA, said the report, was failing to meet its legislative mandates. The report recommended a General Accounting Office audit. The National Council on the Arts did not receive sufficient information from NEA to serve as informed advisors, said the House report, and cited the panel presentation on Federal-State partnerships by Stephen Sell as "inaccurate and misleading," and as an example of the council "being intentionally misled through inaccurate data that could significantly affect funding policy."

NEA was insulted, denied the report's findings, and argued that Stephen Sell had not said what the House report said he had said. NEA charged that the House investigative staff had relied, at least in part, on Ruth Dean's account of the meeting published the next day in the *Washington Star*. NEA said the investigative staff should have confirmed the

figures with NEA officials, instead of relying upon "this unconfirmed newspaper account of events for their data." What was remarkable about NEA's response was not so much whether Sell had actually said what he had said, nor NEA's gratuitous slander of Ruth Dean's accuracy, but that in NEA's opinion what Miss Dean reported and whether it was accurate depended upon NEA's confirmation instead of whether Ruth Dean, the House investigators—or anyone else for that matter—saw or heard what happened in the conference room at the time. The shadows dancing on the walls of NEA's conference room were cast as *unconfirmed* newspaper accounts unless NEA certified the miracles they exemplified; independent witnesses of any miracles required a blessing from NEA's officers before the realities could be affirmed.

The statistics announced by Sell were central to the dispute. He had told the National Council that the "total non-Federal appropriations by State Arts Agencies (SAA's) for the Arts in 1979 were $107.8 million," and that's what Ruth Dean's story in the *Star* reported. Unfortunately, what Sell had said was inaccurate. The miracles of state "participation" in the arts had not taken place exactly as Sell described them to the council. To begin with, Sell's total should have been $104.8 million, as NEA soon admitted. Sell had "inadvertently made the state appropriation figure $85 million instead of $82 million," said NEA, but whether Sell had been accurately quoted in the *Star*, including the error as Sell announced it, was of no concern to NEA. Six months later an NEA official cited to me Ruth Dean's "habitual inaccuracies in the *Star*." When the House investigators checked the NEA Federal-State program officer after the National Council had gone home, the Endowment official admitted that Sell's figures were misleading and "were presented for dramatic emphasis and not for accuracy." Yet NEA asserted that Ruth Dean had misinterpreted the dramatic emphasis of the events she had accurately recorded.

In reply to the House report, NEA pointed out that a member of the investigative staff "was given the proper figure by the head of the Federal-State program," and charged that the accurate figures had not been reflected in the House report. As a matter of fact, the House report carried the accurate figures, but that had nothing to do with the question of whether Sell had deliberately misled the National Council in the conference room while the farmers fired cannons, and was precisely the point the House report had made: NEA knew the statistics were false, and Ruth Dean had accurately incorporated the errors as announced. In response to this awkward evidence, NEA adopted a stance as if morally affronted: the assertions made of Sell's inaccuracies were "damaging not only to an individual who has achieved distinction in the arts, but implies serious derogation of Council procedures."

In NEA's opinion, inaccurate statistics were incidental. NEA asserted that "this accusation against Mr. Sell is apparently used in the report as

a principal means of suggesting that misinformation is regularly provided to the National Council on the Arts." The House report related how Sell had omitted to mention that a substantial share of total state appropriations for the arts was provided by the New York State legislature. Of the $82 million total appropriated by all state arts agencies, New York State provided $30 million. The dramatic emphasis of Sell's announcements about the partnership between NEA and the states had to be reduced by the $30 million provided by New York's unusual history. "Even those with a cursory knowledge of state giving to the arts are well-acquainted with the large amount provided by New York to its Arts Council," replied NEA. "What appears, then, to the investigators to be dissembling really reveals their own lack of knowledge and broad perspective about the very issue on which the Investigative Staff speaks with such authority."

Sell's analysis of the effects of New York's singular contribution of $30 million in his announcements to the Council—whatever the actual totals were—had no bearing on the validity of Sell's presentation, according to NEA officials, because the total amount of programming money available in the states exceeded the "regular" programming money in the Endowment's current budget, and because "the States were enthusiastic and important partners in supporting the Arts."

Ignoring the ambiguities inherent in the states' enthusiasms—whether they were enthusiastic partners to art or to a lucrative system of party patronage—it was peculiar that Sell had included in his total of $107 million NEA's own disbursements to the states. In their reply to the House report, NEA's choice of the word "regular" to qualify "total" programming monies was disingenuous at best. As to what the states actually contributed to national culture, Sell's totals had included as state funds the national funds distributed by NEA to the states, and then cited the aggregate total back to the council as a miracle of state growth. Sometimes two and two were three, sometimes five, sometimes all of them at once.

But that was not all the council would have to learn to become sane. It would be difficult: included in many state arts agency totals were funds for cultural activities that were not arts at all, but state support of libraries, historical commissions, state historical parks, state archives, and in some budgets, activities funded to promote tourism. Moreover, some state agencies were established as councils for arts *and* humanities, hence funds for humanities were included in state arts totals if the budgets were not itemized. To these structural complexities, NEA answered the House investigators by charging, gratuitously, that the report had claimed appropriations by states were *diverted* from arts to humanities —something the House report did not say at all.

NEA was impatient with details, because observable facts sometimes gave the lie to the miracles NEA worked in the name of the arts. Just as

CIA did, just as the Department of Energy did, and just as the Justice Department had done when confronted with Howard Morland's independent intuitions in the *Progressive* case, NEA found it necessary to assert "visible means of control" over descriptions by independent witnesses to NEA's miracles. The assertions by Ms. Liberman, assistant general counsel "for the Arts," that providing a copy of a briefing book would be "inappropriate" were not claims to protect actual secrets, but assertions of NEA's transcendental authority to lie if circumstances justified lies.

NEA had consistently claimed the authority to alter the past to its own convenience. In 1976, Ms. Nancy Hanks was chairperson of NEA. She was asked by Congress whether NEA had any long-range plans. Her answer was clear: "We have put together a study which was done presently by Anna Steele, director of our planning program, and called it the Blue Book because it is between blue covers and shocking blue paper, not blue in terms of spirit."

NEA mailed their Blue Book in 1977 to members of the National Council, then discussed its contents at two successive meetings. According to Ms. Hanks, the book revealed NEA's plans program by program, category by category, from 1976 through 1981. Each year NEA updated its five-year plans to project dollar totals five years ahead. During the appropriations hearings for fiscal 1978, Congressman Yates asked Ms. Hanks for a copy of the Blue Book. Ms. Hanks promised to deliver it. During the appropriations hearings for fiscal 1979, Mr. Yates asked again for a copy of the Blue Book. NEA's new chairman, Liv Biddle, promised to deliver it. Once again, Mr. Yates failed to receive a copy. In 1979, Mr. Yates's staff requested NEA to deliver a copy of the Blue Book, but was told, after a thorough search of NEA's offices, that the "Blue Book must have gone south"—it was "no longer available." Perhaps, NEA suggested, Ms. Hanks had taken it home with her when she left NEA. Although the Blue Book had disappeared, NEA officials later told me that I could examine the Blue Book in their library. Five-year plans traveled north and south, depending on the political climate.

Meanwhile, Liv Biddle had been suggesting to his arts "constituencies" that over a five-year period—perhaps by the mid-eighties—NEA's national budgets might rise to a level of $500–600 million. Biddle's estimate represented a whacking sum, for a number of reasons. To begin with, NEA's national budget represented about 15 percent of the total national dollars spent for the arts. NEA's programs served as an "imprimatur" for state, city, county, and municipal budgets, and also—under "matching grant," "challenge grant" and "treasury funds"—for dollars appropriated from tax-exempt institutions, particularly foundations and private and university corporations. When NEA hired Cultural Resources, Incorporated, as a "consultant" to raise these "matching monies" from "the private sector" for approved programs, Cultural Resources, Inc., estimated that NEA's $150 million budget actually represented

about $1 billion in "support" monies. By rule of thumb, NEA's ambitions for $500 million would represent a total of $3 billion to "support the Arts."

But NEA's sovereignties could only be estimated accurately by remembering that NEA was just one ministry of the many agencies coordinated by the Ministry of Culture, with crisscrossing activities and budgets within the Department of Education, with HHS programs for the aged and for youth, with GSA, CETA, HUD, PBS, ICA, the Smithsonian Institution, the National Park Service, Kennedy Center, National Science Foundation, the Departments of Defense, State, Energy, and the National Endowment for the Humanities. NEA and NEH were "the guiding lights" of the New Order's more than 300 programs and over $20 billion in annual expenditures for "a new national culture." If NEA declined to finance a program on "Understanding Congress," NEA could perhaps drop the scandal in NEH's lap; but in any event the program would eventually be broadcast over PBS thanks to a "matching grant" from Westinghouse.

NEA's budget for "challenge grants" might show program funds amounting to $28 million; however, these "total" funds were not "totals" at all, but were "marginal investments" by NEA which in turn were matched by funds appropriated either from other government entities, or from foundations or corporations. Moreover, each one of these activities was carefully coordinated with political constituencies. For example, NEA approved "challenge grants" under "Architecture + Environmental Arts" for $300,000 to Atlanta Landmarks, Inc.; but NEA's contribution was a small fraction of the intended effect upon Atlanta's skyline. NEA also made grants under an entirely different category, but it was also called "Architecture + Environmental Arts"; and this second category was without requirements for matching "challenge grant" funds. It was explained by NEA as assisting "projects that will broaden public design awareness and participation in resolving design issues." These small architectural grants went, for the most part, to architects or architectural partnerships, and to corporations, who in turn proposed schemes which would, if built, be funded by GSA, or state or city architectural commissions, provided the political authorities approved. Recipients under this second category included: "Administration and Management Research Association of New York City, Inc.—$12,220; Massachusetts Audubon Society—$10,000; The Minneapolis Society of Fine Arts—$5000; American Institute of Architects Foundation, Inc.—$11,400."

Yet architecture, qua architecture, was only one of NEA's designated categories in funding the social utilities of architecture. Still another NEA category was designated "City Spirit," and was described by NEA as: "A program to stimulate and encourage many community interests to come together and explore ways in which the arts can become an integral part of community life." Program funds distributed for these

social necessities went to institutions such as: Community Environments, New York—$15,000; University of California, Los Angeles—$25,000; American Dance Festival, Inc., New London, Conn.—$15,000; the Wolf Trap Foundation for the Performing Arts, Vienna, Virginia, located outside of Washington, D.C., and operated by the National Park Service—$8,170.

To understand why NEA, as one agency of the Ministry of Culture, would fund another agency such as the National Park Service, required inquiry into still other facets of NEA's architectural interest. "Works of Art in Public Places" elucidated the values advanced by the new national cultural policy in NEA's otherworldly language: "A program to give the public access to the best contemporary art in public situations outside museum walls. It is the Endowment's intention that the work of art will contribute to the public's enjoyment, education and enlightenment; that it will stimulate an effective partnership between cities, states, private institutions, the private sector and the federal government and that a distinguished heritage of public art will be passed on to future generations."

There was no better summary of the radical social and political theories of the Italian syndicalists—Mosca, Sorel, and Pareto. The New Order's ambitions were to create a state which was in itself a work of art. To carry forward the ideology of national cultural policy, first institutionalized by Mussolini, NEA made grants under the category "Public Places" to: the City of Baltimore—$50,000; Cedars-Sinai Medical Center, Los Angeles, California—$10,000; City Walls, Inc., New York—$5,000; City of Dallas—$40,000; Friends of the Park, Chicago, Illinois—$50,000; Governor's Special Commission on Art in State Buildings, Lansing, Michigan—$15,000; Hammarskjold Plaza Sculpture Garden, Inc., at the United Nations in New York—$5,000; City of Salinas, California—$50,000; State University of New York—$30,000; Port Authority of New York—$10,000; Private Arts Foundation of Washington, Washington, D.C.—$3,000.

These programs for art in public places included the ambitions of cities, states, private corporations connected with international organizations, hospitals, public authorities operated independently of any legislative control whatever—such as the Port Authority of New York—and private arts foundations which were not listed in the telephone directory either at the time the NEA grants were awarded or four years later. Although NEA said its program for "Works of Art in Public Places" provided "opportunities, challenges and employment for living American artists of exceptional talent and of regional or national significance," the list of grant recipients did not include the name of a single artist. Perhaps NEA's system of patronage worked to the benefit of artists by trickling down through incorporated institutions, but the "arts constituencies" NEA talked about were always exclusively arts *institutions*. If the categories

by which NEA proceeded were confusing, and if NEA shifted the names of its categories annually, drew up new guidelines or reframed its policy statements, NEA was absolutely consistent in its social and political design: regardless of any awkward details in NEA's language about what NEA said were its sovereignties, NEA was a glorious system of patronage entitled to support the New Order's ideology.

When the Carter administration took office, the *New York Times* and other leading journals of opinion expressed their anguish that the arts and humanities might be *politicized.* Hands were wrung and voices raised in a debate over "elitism" versus "populism," but what the wicked Democrats might do to the Republican procedures at NEH and NEA was soon resolved. The fears expressed had never been anything more than an argument over the division of spoils between two factions of the same orthodox establishment. As long as the "eastern seaboard illuminati" continued to get just about the same monies the Nixon administration had dealt out to Lincoln Center, the Metropolitan Opera, and the Boston Symphony, the oligarchs of the East had few objections to new "populist" fundings for "folk arts," or whatever it was those people did out there in Dubuque. If the directors of the Museum of Modern Art, or Yale's Repertory Theater were fearful of Mrs. Mondale's Minnesota tastes, she soon soothed their terrors. There would be plenty for everyone, because the arts and humanities had long since been politicized.

Upon the recommendation of Senator Claiborne Pell, sponsor of the original arts and humanities legislation, President Carter nominated Livingston L. Biddle, Jr., Pell's Princeton roommate, as chairman of NEA. The crocodile tears shed over Biddle's nomination by critics who feared politicization of the arts were schizophrenic by any standard, for Liv Biddle was no stranger to national cultural politics. His father had been instrumental in helping President Franklin D. Roosevelt set up the WPA arts program during the Great Depression. Following his family's traditions, Liv Biddle had served as a staff member of Pell's Senate Subcommittee on Education, Arts and the Humanities. As a special White House consultant on the arts for President Johnson, Biddle had drafted the 1965 legislation creating NEA, and it was for Biddle's bill that Senator Pell had collected a majority. Biddle had also served as deputy chairman of NEA and as director of NEA's congressional liaison staff. In 1976 he had worked to create the Museum Services Institute Bill, setting up still another arts agency separate from NEA under what was then the Department of Health, Education and Welfare. He had drafted the legislation creating the "challenge grant" programs which authorized the federal government to match $1 for every $3 contributed by foundations, corporations, states, municipalities, or private individuals for any approved arts project. In the sixties, as Deputy to NEA's first chairman, Roger Stevens, Biddle organized NEA under a Democratic administration. Thereafter, under a Republican administration, Biddle worked from Con-

gress with NEA's second chairperson, Nancy Hanks. When nominated by President Carter to serve as NEA's third chairman, Biddle said that he had a dream all along that he "would someday have a hand in guiding the programs" he had drafted. Biddle's dream was an example of his habitual modesty, because of course he'd "had a hand" in guiding the programs all along. To the insinuations that his appointment represented a "politicization" of the arts, Biddle said he was not that annoyed. "I just so disagree with the premise that the arts and the political process do not mix."

Liv Biddle's manners and style were Main Line Philadelphia. As a Philadelphia Biddle, he could claim inherited rights to his self-effacing modesty, his diffident speech, his half-amused gaze from behind thick glasses as politicians scrambled for national spoils. The Biddles of Philadelphia had proposed national banks in 1828, national railroads—from which the Main Line took its name—and national commissions of arts. Although Boston and Cambridge sometimes asserted they were the "Hub of the Universe," and New York built towers called the "World Trade Center," Philadelphia merely claimed that it was a city of brotherly love, traveled to Washington and asserted that the Pennsylvania Railroad *ought to* continue past Pittsburgh, at least as far as Cincinnati, as a "national commitment." Philadelphia had never hesitated to explain to senators what was the right thing to do—Manifest Destiny had always meant that there were never any contradictions between the political processes of democracy and the national hopes of Philadelphia. To suggestions that the arts might be subjected to "inappropriate governmental pressures," Biddle easily replied that NEA's processes were surrounded by "essential safeguards," and he cited the National Council on the Arts as one of these safeguards: "a group of private citizens, who pass on grant applications."

In addition to appointing Liv Biddle chairman of NEA, the president also nominated the members of the National Council on the Arts for six-year terms. Individual appointments were staggered so that council membership "revolved" to a certain extent, and over the years Republicans took the seats of Democrats or vice-versa. In practice, the seated chairman of NEA drew up a list of potential appointees, then the list was examined for its party regularities by members of the White House staff. Perhaps names were added from the White House pool of deserving—and, of course, qualified—contributors to the party's fortunes. Those empaneled as potential nominees to the National Council on the Arts then had to undergo security clearances through investigation by the FBI. Friends and neighbors of distinguished citizens were closely questioned, and their comments and judgments on the appointee's moral character, sexual habits, and loyalty to the government were conscientiously copied down on thick pads of yellow foolscap. The threat these distinguished citizens might represent, and for which they were investigated, had nothing much to do either with the national safety or with art, but concerned instead the party's domestic reputation. Any member of the president's

enemies list was an unlikely nominee in the first place; but among those in line for reward for party loyalty, there might be hidden embarrassments to the party's orthodoxy. Thereafter, each nominee for the twenty-six-member National Council on the Arts was again scrutinized, and confirmed only after Senate investigations.

To satisfy the Senate's continuing reputation for rectitude, and its traditional courtesies, each nominee for the National Council on the Arts had to supply a complete *dossier* of financial disclosure. The exact connection between *art* and security clearances, the gossip of neighbors, full financial disclosure, copies of tax returns, oaths of loyalty swearing to uphold the United States against its enemies both foreign and domestic was not immediately clear. All these procedures, however, were structurally necessary to a party of orthodoxy, and were effective against the appearance of heretics. Even in the arts, the New Order's suspicions about the reliability of its own officers continued down through the hierarchies of art to include members of state arts agencies. To accept a Democrat's seat on the New York State Council on the Arts, Shana Alexander, for ten years the liberal opponent of James Jackson Kilpatrick every week on CBS's "60 Minutes," was required to report to the local East Hampton, New York, Town Police Station to be fingerprinted. To make aesthetic judgments, fingerprints had to be on file.

Perhaps Shana Alexander constituted "a clear and present danger" to the New York State Council on the Arts; but, perhaps she did not, after all. Her term of office in New York would expire in 1980. The terms of Clint Eastwood, Billy Taylor, and Jamie Wyeth on the National Council on the Arts expired in 1978; the terms of Van Cliburn, Jerome Robbins, and Gunther Schuller expired in 1980; the terms of Theodore Bikel, Harold Prince, Martina Arroyo would not expire until 1984. To these well-known and accomplished artists, the New Order added names from its favorite constituencies—nominees who were faithful corporate executives, museum directors, university presidents—and these loyal officers always comprised a majority of each council.

No matter which way the lists were turned, when citizens served on the advisory council it would be hard to imagine in what sense they were "a group of private citizens," as Liv Biddle had described them. On the contrary, for the days they met they were sworn officers of the government. As the New Order censored Erica Jong, H. L. Mencken, Howard Morland, and Frank Snepp, members of the National Council on the Arts were serving the government that censored; but any private opinions the members might have held upon spectacular violations of the First Amendment never came to their own official attention. These nice distinctions between public and private perceptions required the National Council to adopt an official schizophrenia: the policy of NEA was to encourage literature, it said. In its capacity as an official advisor to NEA, the National Council always loved literature as much as anyone else, but

if other branches of the government were simultaneously censoring literature, those activities were beyond the council's official horizon. The matter of censorship had not come to NEA's attention, because it was not within NEA's "policy guidelines" to rely upon events reported in the public domain.

Unfortunately, there was some controversy over whether NEA had any policy at all; and, if there was any policy for NEA's activities, what that policy might be. The House report on NEA said NEA was charged, with the advice of the National Council on the Arts, to develop and promote a national policy for the Arts. The White House Ministry of Culture, in coordinating NEA's activities with every other agency, had said the same thing. Liv Biddle had stated that NEA would be more than a "catalyst," and had to be the "initiator" in making the arts "accessible to the public." The White House memorandum on national cultural policy, congressional testimony, minutes of council meetings, interviews in the press by NEA officers, and speeches to arts "constituencies" repeated how NEA was promoting a national policy for the arts. "It is not the icing on the cake," said Mrs. Mondale. "It is the very essence of our lives."

But NEA resented inferences made in the House report about NEA's policy: NEA said it was not making national policy. NEA was doing no such thing. The House report contained, said NEA, a misrepresentation of NEA's "mandate." The Endowment placed great reliance on the meaning of the written word, said NEA, and the Endowment's officers were extremely sensitive to language, "especially legislative language and that used in documents of the Congress which refer to our roles and responsibilities in relation to that statutory mandate." The House report's inferences on NEA's policy were "vastly misleading" because NEA's national policy was *support for* the arts, as opposed to *policy for* the arts. A policy for the arts would imply control of the arts, and that would be a misrepresentation of NEA's role, said Liv Biddle. "The role of the Endowment has always been as a catalyst, not as an arbiter of taste, not as a dominant or domineering entity. The Endowment is a partner in the development of the arts. Its funding encourages other support. The greatest fear of Congress, in the days when the enabling legislation was evolving, was that it might one day create a cultural czar."

Even if Liv Biddle contradicted himself in his Ministry's answer to the House report when he said he believed that NEA had to do more than be a "catalyst," he would never, never claim the powers of "cultural czar." Instead, NEA was only "a partner." When the partner issued a "Statement of Goals and Basic Policies," the National Council of NEA did not even dare to define art in its preamble: "It is not the intention of this statement to define 'art.' "

Because NEA refused to define art, refused responsibility for policy, and refused to publish plans for the future, the state arts agencies complained they lacked any way to interpret NEA's fifteen "artistic disci-

plines" to their legislatures, or to community organizations. NEA's programs appeared to be unplanned, capricious, arbitrary, and dependent above all upon political and party connections in Washington. The federal-state statistics on the "partnership" provided by Stephen Sell to the National Council could not be understood in any commonsense way— even if they had been accurate—because NEA not only funded state arts agencies, (SAAs), but also regional arts organizations (ROs), about 2,000 municipal arts councils, 4,000 community art programs, and, in addition, funded programs within each of these geographic jurisdictions by categories under entirely different "mandates" to finance efforts in architecture, painting, symphony, opera, dance, literature, theater, sculpture, crafts, design, folk arts ("henceforth to include Folk Music"), television, radio, museums, and "special projects." All these categories (which were not firmly defined as categories) for art disciplines (in which art was not defined) constantly changed their names and their "guidelines." Besides, NEA program officers had announced they were "looking for projects outside the guidelines," to the extent there were any guidelines.

Assessing these ambiguities, the House report concluded that NEA's national budget had grown beyond NEA's ability to administer its programs "in accordance with its own objectives." Although the National Council on the Arts had met quarterly for fifteen years to advise the chairman of NEA of his responsibility not to make national cultural policy, and the council reviewed the programs and procedures derived from the policy NEA was to avoid under any circumstance, the National Council was also *legally* required, as a board of directors would be, to review "recommendations" to NEA's chairman of 18,000 to 20,000 applications for grants each year, and to recommend 4,500 of these proposals annually for national funds. But as a practical matter, the "group of private citizens" who passed on these federal contracts could not possibly review 20,000 bids.

To begin with, although the National Council on the Arts was always described as a twenty-six-member board, not all members had been nominated by the president or confirmed by the Senate or were present at any particular "quarterly meeting." For the purpose of reviewing its recommendations to the chairman, a quorum of the National Council was fourteen members; but sometimes only seven were "available." And so before each quarterly meeting, the applications were screened by a complex system of staff reviews, paid consultants, task forces, subcommittees of task forces, peer-review panels divided into subsections for policy and grant reviews, contractors, subcontractors, and sub-subcontractors. But NEA also consistently funded what they described as "service organizations," which were actually lobbies for NEA's attention: horizontal associations, such as the National Assembly of State Arts Agencies, Associated Councils of the Arts, American Arts Alliance; and vertical associations, such as the American Symphony Orchestra League, National

Association of Regional Ballet, and the American Choral Directors Association. In addition to funding "service organizations," which were themselves competing for NEA's dollars, NEA also funded a wide variety of "regranting" organizations: entitlements created by NEA, and annually funded with grants from NEA, to distribute national dollars to applicants who applied to the NEA regranting organization rather than to NEA itself. Officials of these diverse entitlements—hundreds of "service organizations" and dozens of regranting establishments—met among themselves to discuss the topics of NEA's programs, procedures, plans, *and grants.* They met with NEA's national staff on the same topics. They were represented upon NEA's National Council on the Arts, as well as within NEA's complex system of consultants, contractors, subcontractors, task forces, subcommittees, and peer-review panels. Finally, they lobbied by means of meetings, literature, and testimony before Congress, including enlightening Congress upon such mysteries as "The Future and Politics of Creation."

Appraising these compositions, the House report on NEA's procedures characterized the system as a "closed circle." NEA's reply was that the National Endowment for the Arts did not claim perfection "or infallibility," but NEA contended "unequivocally" that the House report represented a "most serious disservice by consistently misrepresenting our mandate and operations." NEA was offended because the House report described one individual who was simultaneously chairman of a state arts agency, a member of an NEA program panel, a contract employee of NEA, and an advisor to Endowment functions. The House report also described an NEA panel chairman who was simultaneously a panel member in a different program, and under contract to NEA at the same time to perform still other functions. "We would argue," NEA condescended, "that these individuals have uncommon merit."

"No procedure is perfect," said NEA, but the Endowment was involved in "the very delicate business of judging artistic quality." Therefore, decisions on grants, which were "the fundamental business of the Endowment," were reached by careful consideration "of a variety of judgments, first by a panel and later by the National Council." As to whether the National Council actually reviewed bids for grants, NEA pointed out that it would be "absurd" to expect that the National Council, meeting for just two and a half days, "should be intimately familiar with the 18,000–20,000 applications which result in 4,500 grants." Because the council did not want to shirk its statutory requirements to make recommendations to the chairman, NEA had "streamlined" the procedure to review applications, insofar as possible, so that the council would have a "greater opportunity to advise the Chairman with respect to policies, programs and procedures."

The streamlined procedures worked to save the council's time. After the views of "regranting" and "service" organizations, and the "needs of

the field," and state arts agency priorities, and continuing programs, and consultants, subcontractors, task forces, policy-review panels, peer-review panels, and budgets had all been taken into account, NEA's staff prepared a briefing book for the National Council before each quarterly meeting, then mailed the briefing books to the council members. Lists of grants proposed for funding were annotated by one or two sentence abstracts suggesting their degree of "artistic excellence." If members of the National Council had doubts about a particular grant, the member's questions were to be submitted in writing to NEA's staff before the quarterly meeting. According to the House report, NEA staff would respond directly to the member's question, but neither questions nor answers were shared, circulated or discussed among council members. The House report described one National Council member who was astonished to learn how the NEA review system actually worked. It did not work as the council member had assumed: "I was sitting here listening with my mouth open."

Absurd or astounding, the National Council dutifully set aside two or three hours of each quarterly meeting to fulfill their statutory obligations. The grants to be approved passed by at an average of one every four minutes. There was no system at all to review the grants that were to be denied, except by appeal to political forces whose voices NEA's staff could not afford to ignore. Consequently, applicants for major funding soon hired "consultants" who not only knew the art of grantsmanship, but also "knew their way around." These facilitators, advisors, consultants, and collectors of appropriate research materials inevitably had worked at one time or another for NEA, state assemblies or attendant "service organizations." Their services were particularly valuable because the entire NEA system was characterized as "private." Although public meetings were conducted on "policy" topics, NEA argued that when it was engaged in making grants—the very heart of NEA's process, according to NEA—the entire procedure had to be sequestered from public inspection because, said NEA, not only did NEA have to protect the privacy of applicants, NEA also had to protect the confidentiality of how decisions were made for the "sensitive judgments" in national art. This curious formulation required NEA to continue practices which NEA itself agreed were "anomalies" to the relevant statutes for federal advisory committees, the sunshine laws of both state and federal governments, and the Freedom of Information Act. NEA's staff had informed some NEA panels that eventually NEA might be forced one day to comply with the law; meanwhile, secrecy was essential to the orderly conduct of procedures in the arts.

The logic that required national panels on art to be secret was equivalent to the pragmatic reasons cited by all the other institutions of the New Order—CIA, ICA, PBS, CPB, GSA, NRC, Defense, State, and Justice —except that in NEA's case, NEA's marvelous logic precisely defined the

New Order's schizophrenia. Certainly, no national security secrets were at issue, but as in other examples of the New Order's paranoia, there were fleeting truths in NEA's visions, and NEA was entirely logical about the consequences, and the alternatives, for which their paranoia was a symptom. NEA's impeccable reasoning ran: to make the "sensitive judgments so necessary to quality in the arts," peer-review panels had to be "free and open" in discussing an applicant's merits; if experts assembled as judges believed their "free and open" comments might be broadcast to their associates, then judges of artistic quality could not be found to serve on panels, because within each community of artists critical judgments were limited by strict aesthetic customs and manners; hence, if NEA's peer-review panels were required to make judgments on the record, NEA's procedures would be unworkable. In short, if NEA's panel meetings were "open," then NEA would be unable to enlist "secret" opinions from their judges—a conclusion which, after all, might very well be true. And, therefore, NEA's paranoia about revealing what actually occurred in their panel meetings was a logical conclusion to NEA's fears.

Indeed, by definition, a star chamber proceeding for any purpose would be secret; otherwise it would not be practical. NEA's logic required them to argue that for pragmatic reasons their procedures had to be "closed" or they wouldn't work; but simultaneously, NEA argued vociferously against any suggestion that they operated a "closed circle." Although apparently contradicting themselves by the laws of common sense which held good in everyday life, NEA had to be schizophrenic about the discussions they said were "free and open" to cloak why NEA's judgments were "free and open" to those appointed to them, but were not "free and open" to those excluded. NEA's hypocrisies illuminated the extent to which NEA was an establishment of the New Order, and the New Order feared public inspection for two substantial reasons: first, community review of ethical and political choices made by those entitled to the New Order's panels subjected the panelists to criticism; second, the criticism inevitably raised boisterous, and sometimes embarrassing, questions about the qualifications and the motives of those appointed to the entitlements which they served. The traditional solutions to these difficulties between communities and their national governments were the institutions and habits of democratic politics, but NEA's secret procedures, and the logical arguments NEA made for their necessity, demonstrated how completely NEA had abandoned the customs, manners and traditions of democracy, and adopted instead the New Order's "overriding national interests." NEA's manners were polite but firm: if NEA could not operate by secret devices, NEA believed that its authority to operate at all might be questioned, and any doubts raised by independent witnesses to NEA's goodworks summoned up NEA's terrors of community opinion.

When the House report questioned whether NEA's budget had grown

beyond NEA's ability to administer its programs, NEA rejected doubts about their management capabilities. To skepticism about NEA's performance, NEA claimed otherworldly sovereignties. "But, even if one assumes that the Endowment is stretched too thin administratively," NEA replied, "reversing the Federal Government's commitment to the arts is no solution." Whether or not the concrete realities of the House report were "almost without merit," according to NEA, the national commitment to the arts had to be continued. Behind such declarations of transcendental authority shrouded in secrecy, the House report disclosed NEA's national commitment included contracting procedures which "were seriously deficient." The NEA budgets for the federal-state "partnership"—the source of so much confusion in Stephen Sell's presentation to the council—totaled about $23 million. Of the state totals, approximately $15 million was designated as basic state operating grants (BSOGs). About $315,000 in BSOGs was distributed to each state arts agency willy-nilly; another $4 million was distributed to the states for what were described as "State and National Priorities." Still another category of national dollars was distributed as "basic regional operating grants," and these totaled about $2 million.

Since national revenues were footing the start-up dollars, Stephen Sell had reported to the National Council correctly, if inaccurately; some state arts agencies had spectacular growth patterns—some had 300 percent increases in a single year in local legislative appropriations to match and make use of the allotment of national NEA dollars. State arts agencies were finally being understood by local legislators as fabulous patronage devices, and especially attractive to those patrons of the arts—both Republican and Democrat—who were simultaneously the largest contributors to local party campaigns. State arts agency budgets revealed that local politicos were catching up with what national legislators had understood for a long time: patronage in the arts cut across old party lines.

Theoretically, NEA inspected and approved state arts agency budgets and plans, including five-year plans from the states to be coordinated with what was once NEA's secret five-year plan; but only a small minority of state arts agencies actually conducted audits or inspections of whatever it was their grantees did with federal-state dollars. Consequently, when the state of Delaware audited the Delaware Arts Council, NEA was considerably embarrassed. Delaware's auditors concluded: the Delaware State Arts Council should refund $62,000 to NEA for monies that either were not expended or were spent in an unauthorized manner; that fourteen groups funded in Delaware failed to provide any documentation at all for expenditures of $59,600; that unspent federal money was reported as spent; that federal funds were used to "match" federal funds, but entered as nonfederal to conform to NEA's grant-matching requirements. Delaware's chief auditor summarized his findings: "In plain terms, I

would characterize it as showing a complete lack of generally accepted bookkeeping and accounting practices."

NEA observed that Delaware represented a "truly exceptional" example. NEA said that the information in the House report on the Delaware audit was incomplete, misleading, and was based on "a media account rather than original sources." NEA alleged that the House report did not accurately or fairly represent the Delaware situation, and NEA would supply a summary of "our findings . . . on request." Nothing reported in the newspapers or quoted by auditors in Delaware could be certified until NEA's own blessings confirmed the meaning of the shadows on NEA's walls.

Whatever NEA's original data may have been, or whether Delaware was "truly exceptional" or not, NEA's senior federal-state staff reluctantly admitted to the House investigators that NEA had extremely limited information on how state arts agencies were spending federal money; that NEA had only recently initiated requests for information for SAAs about other federal monies, such as CETA grants, or grants from HUD or the Department of Education; and that many SAAs could not estimate the dollars currently spent, or which might be spent in the future for the arts in their own states. In many states, legislators had joined the arts bandwagon more enthusiastically than anyone had expected; if the local SAA would not grant funds for a legislator's pet project, the legislator would get appropriations passed for the project as a "line item" in the state's budget. SAAs not only had no control over "line item" arts appropriations, they had no way of estimating what their state totals actually were.

Some states, such as New Hampshire, New Mexico, North Dakota, and Idaho depended upon NEA for almost all of the state arts agency funds, either through BSOGs or through NEA's funding by artistic program categories. To confuse matters further, and despite NEA's gratuitous conclusion that funds for the humanities were being "diverted" from the arts, many states received BSOGs for "arts," and perhaps, but not necessarily, from the National Endowment for the Humanities for state councils established for the arts *and* humanities—Alabama, Arizona, Colorado, District of Columbia, Georgia, Maine, Massachusetts, North Dakota, Oklahoma, Texas, Virginia, and West Virginia. To compound the confusion, the budgets for municipal arts agencies within some states exceeded the budgets of the state arts agency. Houston's budget exceeded the budget for Texas. In San Francisco, what were labeled as "arts" upon national schedules appeared in the city's "publicity and advertising fund." In San Francisco, seventy nonprofit organizations, ranging from the Golden Gate Park Band to the Chinese Historical Society, were funded with city "arts" funds totaling nearly $2.5 million. Yet some or all of these advertisements for the streets of San Francisco might

also be funded by NEA, NEH, CETA, HUD, or Department of Education funds under different descriptions, and funded as well by state funds, PBS funds, or by challenge grants, treasury grants, local or national foundations, universities, and corporations. The San Francisco Opera and San Francisco Symphony collected about $200,000 each as "advertisements" for the city of San Francisco, in addition to all the money they could collect from every other source.

In NEA's home city of Washington, D.C., the District earned a BSOG as a "state" amounting to about $315,000; and the District of Columbia also collected about $500,000 from CETA for the "arts" from a total CETA budget for Washington, D.C., of about $17 million. But the District totals for the "arts" actually appeared to be around $7 million—by estimating federal monies distributed by the Park Service, the Smithsonian, Kennedy Center, NEA, and NEH under program categories. Even these amounts did not include either the funds distributed under arts budgets for education—amounting to another $3 million—or the amounts spent by the NEH for arts activities, either as "local projects" or as "national programs," which happened to occur in Washington.

For example, the Belgium American Educational Fund, Inc., sponsored a "cultural extravaganza" in Washington, San Francisco, and New York in April, 1980, to provide a royal welcome to Belgium's King Baudouin I and Queen Fabiola, with a musically choreographed fireworks display and other "cultural events." The cost to welcome the king and queen of Belgium carried a $4.5 million pricetag: the Belgian government donated $2,327,000; the National Endowment for the Arts, $212,000; and the National Endowment for the Humanities, $670,000. The balance, amounting to $1.3 million, was reported to have been raised from corporate donations, "and in kind support from participating United States institutions."

Estimating "in kind" funding would be treacherous; presumably the services or materials provided by participating institutions were dollar expenses in some budget somewhere, provided all the institutions or agencies or whatever they were could be identified. The Belgian extravaganza was the fourth such joint venture by NEA and NEH for "culturally enriching experiences" in Washington and other cities. NEA, NEH, and ICA as well, had previously sponsored "Canada Today," and "Salutes" to Mexico and Japan. Members of the NEA and NEH councils approved these expenditures, but as continuing artistic and educational experiences with programs covering three years, as opposed to the publicity announcements which suggested a three-city tour for a one month "cultural extravaganza." The White House objective of a well-coordinated-active-national-cultural-policy-more-effective-than-weapons provided no method to estimate from commingled national accounts how much money was spent by which institutions to accomplish what. Except for the assertions that the arts were goodworks, and all the agencies of the

arts were of goodwill, the dollars tithed were used to benefit the arts, humanities, trade, diplomacy, and to entertain royalty, without distinction and perhaps in kind. Except as decorations for the receptions attendant to such activities, artists, musicians, poets, dancers were incidental to the political and social objectives for which the activities were funded. When the National Council on the Arts assembled to deliberate on the national cultural policy which the White House Ministry of Culture claimed to coordinate in cooperation with NEA, the members of NEA's council not only did not know how much had been spent for what, they had no way to find out.

Whatever amounts were approved to accomplish whatever it was that was being coordinated, a small fraction of the totals were ever distributed to artists. Experienced officers of national cultural policy stated flatly that the national government "could not afford to deal directly with artists." Living artists were difficult, often unmanageable, created controversies unending. What was meant by "the arts," therefore, was slightly different from support of artists. At the national level, officers administering "programs in the arts" were sometimes ambiguous about whether cultural programs did, or did not, include works of art. Although much was said about the creative spirit, and how necessary the arts were to the enjoyment of life, the act of creation was fundamentally beyond the jurisdiction of bureaucratic programs no matter how they were administered or coordinated. Some state legislatures were more direct about the equivalencies between the utility of "the arts" and the dangers which might result from an artist's intuition. In the enabling legislation for arts and humanities, those few honest states forbade any distribution of any cultural dollars to any living artists.

The national cultural dollars were largely distributed to national and state agencies, and by arts agencies in cooperation with corporations and foundations to arts institutions, arts administration, arts management, and for the purposes of "education." In addition to basic state operating grants to state arts agencies, NEA funded an apparatus it created and designated as regional arts organizations, which were "mini" arts endowments of considerable administrative activity, but unrelated in any commonsense meaning to traditional political structures. Hence, they were without any constituencies, geographic or democratic, except for arts patronage constituencies which the regional arts organizations could create with the national monies supplied to them by NEA. The regional organizations included within their membership all but ten states, but three states belonged to two RO's simultaneously—Vermont, Maine, and New Hampshire. NEA's funding of ROs amounted to about $2 million annually in "basic regional operating grants," to which sums for NEA's national "priorities," approximating another $2 million, had to be added to estimate the regional activities.

Yet these sums would not include the national arts activities funded

directly by NEA within the region. In New Hampshire, for example, the trustees of the Swain School or the White Mountain Arts and Music Festival, Inc. might have received NEA grants under NEA's category for "Visual Arts"; but these NEA direct grants were separate and distinct from NEA's basic state operating grant to New Hampshire, by which NEA provided nearly all of New Hampshire's state BSOG, unmatched by New Hampshire's legislature. The BSOG, however, was separate again from New Hampshire's share from either or both of the two regional organizations to which New Hampshire belonged; and, of course, entirely different again from either national or state dollars distributed within New Hampshire for "the arts" or "education" from all the other "co-ordinated" agencies of the Ministry of Culture, such as CETA, PBS, GSA, National Park Service, and the Department of Education. During a panel presentation on federal-state partnerships at NEA, an executive director of an NEA-designated regional organization declared he thought it would be "presumptuous for NEA to attempt any standardized measures of accountability."

Questions about fiscal accountability cast no more than a dim, distant, and shaded light upon NEA's procedures. These were no more apropos than questions about whether the tithes collected by Rome were spent to worldly ends. After the Ford administration left Washington and during the transition, as Liv Biddle and Joe Duffey acceded to the chairmanships of NEA and NEH, neither Endowment could produce any annual report at all. All fiscal accountability was absent beyond the statutory deadlines for a period of fifteen months for NEA and nearly two years for NEH, but Congress was unfazed.

Understanding Congress required an admission that the absence of any financial reports at all was, politically, just one of those things. Political utility from arts appropriations meant understanding the principle that in the arts, the less fiscal accountability there was, in certain cases, the better. The apparatus of national culture easily survived suggestions of doubtful accounting practices; any challenges over how the money was spent were easily dispelled. Among the states, New York was the established leader in the magic benefits of arts patronage. The comptroller of the state of New York audited the New York State Council on the Arts expenditures of $27 million. During the audit a random sample of thirty-three approved grants showed: (a) seven of thirty-three applications were incomplete, but approved anyway; (b) twenty-eight of the thirty-three approved grants had no records to justify the amounts requested; (c) twelve of the thirty-three provided no records to indicate how New York's Council on the Arts arrived at its grant determinations; (d) in four instances grants were awarded to organizations which did not meet the council's own standards, but the organizations were awarded "sympathy grants" anyway. As did NEA, the New York Council used "independent" advisors and "panelists" to recommend grants for approval by subcom-

mittees established by New York's council. Prior to 1978 the panels kept no minutes of their meetings—a secret procedure clearly in violation of New York State's sunshine laws. The 130 advisors and panel members were supposed to have filed resumes testifying to their qualifications, but only sixty-three had done so. Of the sixty-three who had filed resumes, an examination of their qualifications indicated that thirty-six panelists were affiliated with the arts organizations submitting applications to the panels on which they served. A review of museum aid grants showed that "72 percent of the organizations who had panel member affiliations received Council approval for grants aggregating $1,068,999 of the $1,491,431 requested."

New York State's auditors noted: "At one subcommittee meeting, one council member out of four attended and his sole vote decided grants for 117 organizations." Yet the revelations of the New York State audit left the operations of New York's "commitment to the Arts" undisturbed. On one hand, the entirely separate budget of $26.4 million spent by New York City's Bureau of Cultural Affairs remained unexamined; so too did the direct NEA appropriations within the state, as well as the NEH funds, CETA funds, or other coordinated programs for education. When the story of the state audit was published by *New York* magazine, Ms. Kitty Carlisle Hart, Governor Carey's appointee as chairperson of New York State's Council on the Arts, was insulted. The article was inaccurate, she said, and had maligned the council's dedicated peer-advisory panels, accusing members of conflict of interest, "because most of them come from organizations that apply to the council."

Because most of the organizations in the state apply to the council every year, said Ms. Hart, "it would be impossible to find 145 'peers' to give of the extensive time and effort the council's panelists do who were not involved with one of its applicants." Ms. Hart scored Philip Nobile of *New York* for failing to contact the council before writing his article. Nobile had not been objective, she said, when he made it appear that the New York State Council on the Arts was plagued by mismanagement, conflict of interest, and staff abuse. "The Council can stand on its record," Ms. Hart concluded, "of providing nineteen years of positive, active support for the most vital, exciting cultural climate in the country."

Nobile replied that his story was about the audit, not the cultural climate, and he stood by the facts; but, of course, what the audit actually said was unrelated to the vital, exciting, cultural climate in New York, where New York's legislature had no intention of reversing New York's "commitment to the arts." Indeed, Ms. Hart's most difficult problems were not with standards of "accountability," but with enthusiastic legislators who were approving "line-item" appropriations for arts organizations they personally favored for their own districts—or similar proposals of fellow legislators—which Ms. Hart's authorized council had turned down for grants. Among many such examples, the New Muse

Community Museum in the Crown Heights section of Brooklyn had won for itself "line-item" appropriations from Albany totaling nearly $1 million in four years. The museum described itself as a multiservice African-American cultural organization. Although it had received small grants from Ms. Hart's council, it deemed these amounts insufficient, and so applied for more directly from the legislature. Andrew J. Gill, executive director, told John S. Friedman of the *New York Times* why the New Muse Community Museum would not be restricted by the art council's fiscal quotas: "It was a matter of survival. The council environment was hostile to us."

"It is hard for me to respond to Mr. Gill's feeling," Ms. Hart replied. "He has been a panelist. I don't see how he can say the Council is hostile. His perception is wrong."

Perhaps because he had been a panelist, Andrew Gill's perceptions about the cultural climate appeared to be acute. If the council's panel system did not work to the advantage of the New Muse Community Museum, there was plenty of money in the same Albany legislature in which Ms. Hart testified each year about art's needs. When he wanted to, the governor could put in a good word for his pet projects; the nabobs who ran the Metropolitan Museum of Art and Lincoln Center always got what they wanted; why shouldn't a museum in the Crown Heights section of Brooklyn, where the votes were, get its share of the cultural pie? What Andrew Gill's direct acquaintance with the vital, exciting, cultural climate had apparently taught him was that in the tax-exempt and state-funded secular service to the good of man, in the exquisite balance between the divine glories of art and neighborhood utilities, culture had substantial advantages over sewers, roads, rivers, and dams, or any of the old-style plums. The schemes blessed in the name of culture promised entertainments, audiences, publicity, and political connections for their sponsors, pictures in the newspapers and sometimes maybe a minute on the evening news—not to mention the rehabilitations and redemptions which the arts provided for transcendental verities unending—and for which nothing whatever would ever have to be delivered. In the heavenly politics of culture—in Mr. Gill's case, or for anyone else—there was no reason why the attendants in art's temples had to submit to the establishment's priests, or agree to some art council's peremptory judgments, until forced to do so.

That day might come. At some point the established arts councils would have to choose between those programs they favored and those they had to refuse. Until force was employed to back up the state's mandated programs, political swat was what counted. Anyone who wished to do so could organize, then lean on their legislators for the money. Auditors' revelations didn't matter at all. When compared to the exacting requirements and fearful expenses necessary in the sciences or engineering, the data by which culture was judged was far more flexible. If an

adequate sewer was promised to a city, not only was the expense exorbitant, and not only would it take years—maybe decades—to complete, every component of a sewer's operation had to flow downhill. The inestimable advantages to the politics of art were that the arts were relatively cheap; they were quick, immediate, visible, and who would ever complain about music that ran uphill? Whether the music was superb or only mediocre would be a matter of taste after all. Whether the state or NEA program director who funded music was a genius or couldn't find middle C didn't really matter. Whether the panel who considered applications for grants to music in secret meetings had actually ever heard the music they approved was unrelated to everyone's consent that music was "the very essence of our lives."

As long as music was "accessible," it *ought to be* approved: which meant that the size and social composition of music's audience, particularly its political and financial swat, was the aesthetic standard by which the New Order judged music. When a panel described "Music in America" to the National Council on the Arts, the panel wanted the council to know that "Music in the States had been developing for a long time." Presumably, what the panel meant had to do with organizing music in the states, because the music written, sung, or played in the states had been more or less continuous, and the sources of music were ancient, unrestricted by national boundaries, and unrelated to anything NEA, the states, or what any other political jurisdiction had ever done or would ever do. The panel on music in the states went on to clarify the matter for the National Council on the Arts, and nothing the panel said was connected in any way to music understood as song, melody, notes, or tone. The panel reported that a host of people were working on the program; that NEA was cooperating with the American Symphony Orchestra League; that a federal-state panel on Opera in America was established; that there may have been misunderstandings about what the thrust of the music program might be, but there was dialogue in process with the states; that music was engaged in long-range planning; that plans for audience development were underway, and for management planning too, and for fellowships in management; that the music program was providing the states with direct technical assistance and consultants; that music was engaged in marketing studies and programs for advocacy; that there were many developments in the field, and the program kept touch with the field, but "line-item" appropriations by states and municipalities for their local orchestras was leading to some confusion; yet the partnership dialogue "needed to be at the front end."

With respect to music, the National Council on the Arts heard no songs, but of course the council had no statutory responsibilities for melody. Instead, the music panel posed questions to the National Council on the Arts to be resolved as "policy decisions." The panel wondered if the Endowment should fund marketing; whether state budgets should

include marketing; whether NEA funds should be used to expand music programs to special constituencies, such as the handicapped, the aged, in hospitals or prisons in coordination with other national agencies. The panel thought that jazz was "a rapidly growing field that deserved recognition."

Apparently jazz was coming up NEA's Mississippi. Among the policy questions posed by the music panel to the National Council on the Arts was whether NEA and the states should attempt to pay musicians directly and support living composers or librettists. As a matter of fact, NEA had long since been doing so with grants made by a panel established for the purpose. Nearly $500,000 was distributed by NEA to composers and librettists as a portion of approximately $9 million in NEA appropriated funds divided among eight music "program" divisions. To these totals, about another $10 million dollars in "treasury funds" matched by "private" tax-deductible gifts had to be added to approximate a total of about $19 million distributed by NEA for music, but not counting regional, state, city, CETA, educational, or line-item appropriations.

In any practical sense, when NEA's grants to applicants provided an imprimatur, the approved musical organization could raise dollars from sources besides NEA; but without an NEA grant, fund-raising would be tough. To make NEA's judgments in music, eight peer-review panels were established, and their combined membership totaled some one hundred "experts" familiar with music's particulars. Their decisions were critical not only to funding, fund-raising, and music's administration, but inevitably to music's acceptance in music's community, as well as in political or social jurisdictions. Membership on a peer-review panel was in itself a useful career credential. Standards set by peer-review panels soon became national standards in dance, theater, museums, painting, and television programs for PBS, as well as in music.

The House report on NEA charged that all the more than one hundred peer-review panels established to each of NEA's fifteen "artistic disciplines" were "closed circles." NEA vociferously denied that any "closed" elite had been established, pointing out how membership on the panels rotated among many appointees. Although the members of each peer-review panel were appointed by NEA's program director for the program administered, NEA asserted that the panels for music, as well as each panel in every other art, were chosen from "as broad a spectrum as possible."

NEA's answer to the House report's charges of "closed circles" was as marvelous in its contradictions as NEA's schizophrenia about why the "free and open" panel discussions had to be secret. To begin with, any panel assembled to judge excellence or quality in music would be required, as a matter of common sense, to be composed of recognized and admired musicians. Those who were unknown to music, or ignorant of its topicalities, need not apply. Since the members of the panels were not

nominated or elected or proposed by anyone else except the NEA program director who distributed the funds his panel approved, differences between the program director and the distinguished members of his panel were unlikely to continue for long. On the other hand, the program director undoubtedly sought, "from as broad a spectrum as possible" the most distinguished volunteers he could enlist, but having established recognized authorities as judges, those magistrates of musical qualities would necessarily approve orthodox achievements. A panel of elites in music, or in any other art, did not assemble to dispute the value of their life's work. Whether described as "peer-review panels," or national academies of art, or any other characterization entitled by a state's powers to improve national culture, such elites were quite reasonably conservative. That's why they were there.

Although NEA officers claimed that they had no intention of acting as "cultural czars," or dictating national cultural policy, as soon as NEA appointed a panel to bestow imprimaturs in music, or any other art, a national cultural policy was in effect—operated and funded by national taxes to further the New Order's political ends.

In 1977 NEA's peer-review panel on "Music Planning" consisted of twenty-two members, including the chairman of the Baldwin Piano Company, the president of the Music Critic's Association, the president of Local #1, American Federation of Musicians, one dean from a school of music, six composer/musicians, eight managers, general managers, or general directors of opera companies or symphonies, and three chairmen, or former chairmen of state arts agencies—including a representative from Delaware's unfortunate example. Having established a national panel to plan for music, who else could make the necessary distinctions and choose between priorities except a panel composed of those with some experience of music's demands? To insist, as NEA officers did, that their panels were not "closed systems" was to defy the evidence of common sense.

The members of NEA's 1977 music panel not only represented NEA's judgments upon the intricacies of music planning, but also the opinions of the organizations they served as officers, delegates, trustees, or directors. The music planning panel was an elite appointed presumably to achieve NEA's ends, but also an elite representing horizontal and vertical social and political interests in the national establishment of music. As a matter of fact, the Music Planning panel included delegates from twenty-two music institutions, and the same delegates simultaneously represented seven "service organizations" which were founded by NEA and maintained annually by NEA grants: Association of American Dance Companies, Opera in America, National Assembly of State Arts Agencies, Association of Professional Vocal Assemblies, Chamber Music of America, Consortium of Jazz Organizations and Artists, Association of Independent Conservatories of Music. In sum, NEA appointed panels to

the topic of planning, created the lobbies to support the panel's plans, appointed representatives from those lobbies to review the plans, and then denied that either a "closed circle" existed, or that NEA set national cultural policies, lest NEA officers be described as "cultural czars."

NEA's contradictions revealed insights far more fascinating than simple questions of fiscal accountability: NEA officers did not believe for a moment that they had lied—any more than the schizophrenic lied about the fantastic, but entirely real, visions to which he was susceptible. What NEA consistently did was to insist, ipse dixit, upon perceptions that were not politically coherent, but separated from any present reality at all. Two and two were sometimes five, said NEA, with respect to state budgets, but there was more to it than that. NEA made its case for hegemony over the arts by composition, taking concurrently as its jurisdiction art and art administration, as if they were the same thing. NEA's defense of secret panels, fiscal lapses, and the appointment of elites—with or without rotation—proceeded by a logic composed of fallacies: since two and three were each less than four, but two and three were five, therefore five was less than four. Since peer-review panels were composed from "as broad a spectrum as possible," they were less than an established elite; but they made the "sensitive judgments" so necessary in the arts; therefore, the choices made by panels were less than an established national cultural policy. What would appear to be nonsense never troubled NEA, because as an agency of the New Order, NEA's radical comprehensions differed substantially from the orthodoxies of the past.

The old transcendental authorities guaranteed in whatever way they could that their believers would enter some promised land by redemption, by grace, by goodworks, or by faith; but the old revelations portrayed the promised land as another world—perhaps of milk and honey, perhaps with fountains flowing forever. The promises to be fulfilled in that happy place were to be made good only after death had come and gone, yet the radical vision of the New Order promised salvation—the promised land, the Great Society, the power and the glory everlasting, forever and ever —in the here and now. To maintain this illusion and to keep these promises, today's miracles had to be subject to reinterpretation tomorrow— not only as to what had happened, but whether anything had happened at all. In the way it interpreted realities and provided certainties, the New Order was an improbable theocracy. Its ruling priests in art and humanities and education and energy, discharging their duties on various advisory panels, had to be regarded as infallible. To maintain the New Order's ethical authorities, past events sometimes had to be rearranged to show that some trifling mistake had never been made, or to demonstrate that some miracle had actually happened. In politics, economics, and war, these small rearrangements often worked to everyone's advantage, but the most dangerous threat to the New Order's otherworldly claims to unlimited authority over every nuance of community life came from the

antics of artists. Since the New Order was insisting upon idealistic abstractions previously available only in the shadowed world of the dead, the New Order and all its coordinated agencies were in continuous conflict with the sunlit energies of art—which were erotic, loved intuition, change, and adventure. The New Order loved museums; art always labored to finish specific works now. The New Order promoted something called "the Arts," whereas Art worked to complete one vision at a time.

Art loved details, gloried in contradictions, abhorred secret processes, chafed at consensus, ignored demands for obedience, had never tolerated edicts or encyclicals, and shrugged at the claims of blessed institutions as the sole repositories of continuous or certified truths. Poets could laugh at popes, because popes had no jurisdiction over rhyme; painters finished the ceilings of chapels with the brush they held in their hand, and no curia had ever had the power to balance the colors. Even if the New Order collected to itself all the powers, thrones, and dominions of the world, to whistle its officers would have to carry some poor composer's tune. Art's songs had always been opposed to the bureaucratic procedures established by NEA; and the jurisdictional disputes between Art and Order had been irreconcilable from time's beginning. NEA dreaded admitting to the contradictions between Art and "the Arts"; NEA's schizophrenia was rooted in a fear that it was helpless to create; and NEA's hypocrisies weighed like a cloak of lead upon its procedures.

NEA carried its procedures to such otherworldly lengths that sometimes it didn't matter whether the particular art work proposed to a peer-review panel for approval was actually examined at all. After the "sensitive judgments so necessary to artistic excellence" had been made about an unknown proposal, grants were awarded anyway. In addition to the music panel on "plans"—which did not produce plans or policies—NEA also entitled a peer-review panel on music for "consultants," who of course did not advise NEA's music program on the national music policies NEA did not establish. In addition, there were NEA panels on folk music, choral music, jazz, opera, composers and librettists, and symphony orchestras. Needless to say, there were no panels appointed for disco, hard rock, punk rock, country and western, barbershop quartets, Cole Porter, Dietz and Schwartz, Milton Ager, Rodgers and Hart, George and Ira Gershwin, Barbra Streisand, or Muzak.

What NEA meant by "Music in America" was officially authorized music. Those who wanted to hear the top forty singles bought them without national grants. The most important officially designated NEA music program was the program for symphony orchestras. One NEA program specialist directed the orchestra program with the advice and consent of a peer-review panel consisting, at last count, of eleven experts —including one pianist and ten managers or directors from symphonies. NEA's orchestra program specialist selected the panel; the program specialist reviewed 150 applications received each year from symphonies

and solemnly awarded grants to 120 of them. Jazz also was supervised by one program specialist and also had a peer-review panel. Jazz received 600 applications, but could make only ninety grants because the budget for jazz was not one-tenth the amount allocated for symphonies. Besides, by far the largest grants for jazz went to academic studies of jazz, and to the Smithsonian Institution, which produced albums of jazz. The Smithsonian's jazz album series earned a tidy income for the Smithsonian's "private trust funds."

Symphony orchestras received 75 percent—or approximately $9.1 million—of all NEA dollars distributed to music. The totals were only approximate, because "treasury funds" and "private gifts" appeared to make up about half the total distributed directly by NEA. In their testimony at appropriations hearings, NEA officers could never quite agree on how many NEA dollars actually went to symphonies. Any figure that was adopted would deceive, because corporations loved to sponsor symphonies: AT&T spent a minimum of $10 million annually in "coordination" with NEA to sponsor tours by seven major orchestras, called "Bell System American Orchestras on Tour," a program which Liv Biddle said was a "pioneering step in corporate support of the musical arts in our country."

As tokens of AT&T's esteem for officially authorized music, Vice-President Edward M. Block presented silver batons to the conductors of the Los Angeles Philharmonic, the Pittsburgh Symphony, the New York Philharmonic, the Chicago Symphony, the Boston Symphony, and the Cleveland and Philadelphia Orchestras. As these orchestras toured, their printed programs would say they were playing for Ma Bell, because symphonies represented something more than the very best in music. They assembled audiences at each concert and associations in each city, which were simultaneously the same social and political constituencies from which sensible congressmen expected their support for primary campaigns and national elections. As soon as a national program was established to fund symphonies, any representative or senator who caviled at the distribution of national dollars, or Ma Bell's dollars, to his district's symphony was obviously somewhat less than sane, and did not appreciate the best in music. Any congressman who opposed the best in music in some other fellow's district did not yet understand how Congress worked. No one opposed symphonies; everyone agreed to a distribution of 80 percent of all music funds—if that's what the totals really were—to symphony orchestras. In contrast, and in all fairness, jazz lacked the same political clout, and so was not "truly great music," as defined in the political arts.

How NEA made "the critical judgments so necessary to excellence" in music was miraculous in itself. Until Liv Biddle appointed Ezra Laderman as director of NEA's music program, NEA had funded the great orchestras, in fact all orchestras, based on a percentage of each orchestra's

budget. The dedicated panelists who met in "free and open discussion" of symphonic qualities had not actually heard two-thirds of the symphonies their panel had funded during the previous three years. The panelists did the best they could by approving organizations or individuals they knew personally or, occasionally, by hearsay. Ezra Laderman explained to Mr. Yates's House Subcommittee on Appropriations that during 1980 the panel on orchestras hoped to make "on-site visits" to hear thirty-one of the 120 symphonies the panel funded. Laderman added, "I cannot imagine an orchestra in the United States that does not want to be as good as they possibly can be. And I think that their own review of their own capability is as exacting as we would be in trying to fund that orchestra, and trying to find the level proper for that orchestra."

Laderman's goodwill was surely well placed: every orchestra, every musician devoted to his art, would want to be as good as they possibly could be. Whether they were or not, and whether anyone from NEA ever actually saw the baton come down, or heard the strings bowed, was not connected by any immediate reality to what NEA claimed for its system of peer review. Two-thirds of NEA's orchestras might just as well have been judged on their quality by a panel composed of the deaf, dumb, and blind. Making judgments on the quality of NEA's program of "fellowships" for composer/librettists was far less glamorous than the potent political constituencies represented by symphony orchestras, and the budgets for composition reflected the differences: approximately 1,500 composers and librettists applied for fellowships to create new works or complete works in progress. The total of $500,000 for composition was incidentally less than the total awarded in music for "services to the field" and "program development"; that is, less than the amount for publicity and promotion. Those who succeeded in winning NEA fellowships for new music received amounts ranging from $1,000 to $5,000; amounts less than the dollars distributed to "consultants" who arranged parties to announce again how NEA supported the arts. The low priority assigned to the works of living composers in NEA's procedures for "Music in America" were further complicated because the works submitted had to be judged as present realities by an NEA composer/librettist peer-review panel—and actual works of music exposed NEA's other-worldliness to substantial hazards.

By "prescreening" the approximately 1,500 applications, NEA could reduce what NEA's officers explained was "the application load" to 650 —and then perhaps 450 finalists. Then the fifteen members of the composer/librettist panel divided into five groups to judge the merit of the applicant's samples—tapes or records were submitted along with scores. Unfortunately, NEA's rented audio equipment to hear music was inadequate or unusable, according to panel members quoted in the House report. NEA's staff assistants to the panel consumed the panel's time sorting through various samples, correlating the correct sample with the

corresponding scores and applications for grants, cueing the sample and attempting to answer the panel's questions at the same time. One peer-review session had to be terminated because the audio equipment wouldn't work at all; the works of living composers were sounds of silence. Asked by Mr. Yates's appropriations subcommittee why the music program lacked audio equipment of sufficient quality to make the fine distinctions music demanded, P. David Searles, NEA's deputy chairman for Policy and Planning, answered that program funds "cannot be used to provide this kind of equipment."

House committee member Norman D. Dicks, (D.-Wash.), said: "I think this is outrageous."

Whether NEA's peer-review panel system was outrageous, secret, a "closed circle" for an established elite, and despite doubts about its procedures, contracts, finances, and what-not, that made no difference to NEA's soaring accomplishments in the arts. NEA's 1981 budgets were increased to approximately $170 million, because the increases were good politics. NEA announced its new plans to expand its music programs to fund chamber music and choral groups. By expanding its "guidelines," NEA estimated that there were anywhere between 1,500 and 10,000 choral groups who might "qualify." Mr. Yates asked Ezra Laderman whether NEA's music program had enough staff and time to deal adequately with the applications NEA engendered. "The answer to that," said Laderman, "is no. Certainly with the new programs that have been established, we will not have the program specialists to deal adequately with the programs."

The House report quoted the opinion of an NEA panelist who concluded that both Endowments—Arts and Humanities—were "opening the floodgates of applications only to watch themselves drown," but Liv Biddle could afford to condescend. If the House reported that NEA's ambitions had grown beyond the level NEA could effectively manage, that was unfortunate, Biddle said. The House report had "chosen to take a negative approach rather than a positive one. The former can hurt the arts, the latter help the arts. The right choice seems clear to us."

PART III / The New
Order

17

FARCE / NEA: "A KIND OF REQUIEM HAS OCCURRED."

The farmers simply surrendered the land to the farm trust. There was nothing else for them to do. And having surrendered the land, the farmers next went to work for the farm trust, becoming managers, superintendents, foremen, and common laborers. They worked for wages. They became villeins, in short— serfs bound to the soil by a living wage.

—JACK LONDON
The Iron Heel

To avoid the sins of a negative approach, and to make the right political choices, required an interpretation of how Liv Biddle defined "positive approach." Thinking positively was something more than an ethical duty: apparently it was a particular moral obligation; even if it meant understanding Congress as a long-running political revue and appreciating the arts established by the New Foundation as a series of zany skits, but without laughing in the New Order's church—something like watching the Marx Brothers spend *A Night at the Opera,* beaming with goodwill at the arias sung by the soprano, but without giggling even once at Harpo's antics.

To answer congressional queries and the complaints of the states, the National Council on the Arts met once again around a squared, hollow table on Friday, May 11, 1979. By the time the council met in May, Wayne Peterson from Highmore, South Dakota, was the only farmer still camped on the Great Mall. Peterson was fifty years old in May, stood six feet three, weighed 220 pounds, owned over 4,400 acres of farmland, and owed the bank nearly half a million. If he sold out to the farm corporations, he'd be a rich man; when asked why he didn't sell, he said farms weren't for buying and selling, they were for farming. His talk was about home, going to church, the American flag, the family farm, and how if

things didn't change soon, it would all be gone. He admitted he was obsessed. He spent his days wandering through the labyrinth of national offices established on farm legislation and farm administrative regulations, but Donald P. Baker of the *Washington Post* reported that Wayne Peterson was barred from meeting with Vice-President Mondale, because Peterson's hands were too big. Eric Vaughn, from Mondale's "issues" staff, explained that when Peterson tried to get a hearing with Fritz Mondale of Minnesota for the American Agricultural Movement, Mondale's staff was advised that "the meeting wouldn't be a good idea." Peterson was considered one of the more militant AAM members, and he might be a "security risk" to the vice-president. Vaughn explained: "He's quite a large person. He puts people on edge. If he ever got angry—my God—what he could do. I can't get over the size of his hands." Vaughn admitted that Peterson was quite articulate. Vaughn wished he'd been able to get Peterson in to see Mondale, but the farmer's big hands had unfortunately made him a security risk.

Peterson said that he didn't want to stay in Washington, although he thought it was a pretty city, he was just trying to get someone to listen. While Peterson was making his daily rounds, the open session of the National Council on the Arts was called to order once again in the marbled halls of the Pan American Union Building. The first topic was NEA's elusive five-year plan, mapped out by NEA's staff policy planners in a draft for the National Council on the Arts Policy Planning Committee. Everyone had agreed again it would be a good idea to chart a course for the arts. Council member Theodore Bikel, actor and folk singer, played the bellman. He led off with a synopsis of how NEA could establish new priorities to include the individual artist, provide for midcareer training, support tours of live performances, and subsidize ticket sales for those too poor to pay scalper's prices. Theodore Bikel told them once, he told them twice, he told them thrice, and by then they should have known it must be true: at last the council would hunt the snark.

All day long the talk of artists surged with excitement around the squared table. Concert pianist Van Cliburn made a plea to support individual artists with operating funds for periods as long as one, two, maybe even three months, so that a musician could have time off to learn a new work. Music that was not performed, said Van Cliburn, ceased to exist. An endowment grant, he suggested, could pay the light, the gas, the water bill, while the musician absorbed the score into his system and thereby give the music he had studied a credible performance. Bikel agreed: "Why should an artist have to drive a cab for ten hours a day, then be expected to have something left over of his creative self to give?"

Bikel thought it was reprehensible that artists had to spend so much of their time fund-raising, "and making nice-nice to the rich community." Arts patron Dolores Wharton shot back: "They might give more if they didn't feel they were being treated nice-nice by condescending artists."

University president Willard L. Boyd thought his fellow councilors were getting into too much "specificity." In discussing the five-year plan for the arts everyone should keep in mind its long range parameters, its potential for review and change. "I think this is a benchmark document, and that we shouldn't be putting it into concrete."

J. C. Dickinson, Jr., museum director, and chairman of the Policy and Planning Committee of the National Council on the Arts, corrected President Boyd's use of the word "benchmark" as too fixed a description.

Bernard Blas Lopez, arts administrator, intervened. Everyone should be thinking in terms of "a road map pointing north, and there you have the whole hemisphere." There was no point to arguments within the "narrow bounds of specificity."

Van Cliburn recalled how Dag Hammarskjold had declined to say whether his compass pointed east or west, but said instead, "My compass points forward."

Chairman Liv Biddle thought the council "might be looking at the plan a year from now."

Mr. Dickinson redefined the council's position once again as "putting together a reasonable framework on which to base successive steps, deciding which way is forward, and in some cases whether we're pointing backwards."

The council adopted Mr. Dickinson's explanation as a resolution to approve drafts of the five-year plan on a year-to-year basis.

As for the House Appropriations Committee report on NEA, Liv Biddle once again explained the right choices. He told the council that the House report had misunderstood "the Endowment's basic mission to encourage support for the arts." The report contained "innocuous and misleading information," but had also accomplished some good. "It taught us to examine ourselves and take a thorough look at all our operations."

Council member Maureene Dees asked Biddle, "What happens to the report now?"

Biddle replied, "A kind of requiem has occurred."

At the congressional appropriations hearings for NEA, Committee Chairman Sidney R. Yates went over the House report item by item. Mr. Yates was worried that the National Council on the Arts spent only four minutes on each grant it approved. He wondered why the council spent so much time on policy and so little on deciding which grants were best. The council, said the NEA staffers, depended upon the recommendations of the endowment's peer-review panels, but they admitted the panels needed help. The panelists were overworked and underfunded. Not enough panelists were able to actually see or hear the applicants' performances. An extra million would be a good place to start. In answer to the House report's charges that the endowment's panels were involved in conflicts of interest, shielded by secret proceedings, Liv Biddle answered

that the regulations against conflicts of interest were rigorously followed by all panel members; and furthermore, all panelists were visible and well known in their fields. "They are not star-chamber performers in any sense of the word."

Yates brought up the charges in the House report that former program directors of the endowment went to work on endowment-financed projects. Yates read from the conflict of interest guidelines—which the National Council on the Arts had approved to be rigorously followed. The rules "also govern, where applicable, relations between the Endowment and former Council Members and former consultant experts for one year following termination" of their employment. Yates cited NEA program directors who were working on NEA-financed projects. He wondered why they were not comparable to former military officers who then went to work for defense contractors.

The delicate questions of conflict of interest were complicated. When Liv Biddle took over as chairman of NEA, he had promised to clean house. He would limit the tenure of NEA's fifteen powerful program directors to terms in office of no more than five years, and the National Council on the Arts had approved Biddle's new policy. Within a year, three of the six program directors affected by Biddle's new broom were working on NEA-funded projects, and one was kept on as a "special consultant" to Biddle. Walter Anderson, program director for music before Ezra Laderman was appointed to the post, worked in Biddle's office on special projects described as "international." Another former music program director, Ruth Mayleas, had been with NEA from the beginning, but then went to work for the Theater Development Fund in New York City on a specially created NEA project with a $100,000 contract—which included the same $45,792 government service salary Ruth Mayleas had earned at NEA. Vantile Whitfield, former program director for Expansion Arts, left NEA to work for the Arts Media Service, Inc. in New York, another "support organization" largely financed by an NEA $100,000 contract. Leonard Randolph, controversial director of NEA's literature program for nearly ten years, was given a fond going-away party in February, 1979, at NEA's offices. After red wine punch and cheese tidbits, Liv Biddle promised NEA's literature staff—and Randolph—that "old acquaintance would not be forgotten." After a month, Randolph reported to the Western States Arts Foundation, a project funded by a $59,750 contract as a "service organization" for NEA. In 1980, Randolph moved on to the Centrum Foundation, another NEA "service organization" for the art of literature.

Liv Biddle explained to Mr. Yates's subcommittee these anomalies to NEA's rigorous conflict of interest rules: what NEA had done represented a compassionate view, he said. With each of the program directors involved, Biddle had tried to work it out so that they would become "greater resources for the field of arts," and at the same time "extend

their own abilities." Biddle thought NEA's policy was fundamentally right: "The people have unique possibilities, and we're fully justified in keeping their services. It is a contract arrangement, and we gave careful, careful consideration, so that no one would be subject to hardships. We have new voices administering the programs, at the same time allowing those with experience to continue to give advice."

The many complexities of NEA's administration all required careful, careful consideration. For example, the dance touring program had three directors in three successive years, and two more new phases proposed to take place in 1980–81 and 1981–82; but the dance program had consistently been committed, NEA said, "to artistic excellence and integrity." The commitment was expressed by promoting and providing the artistic, administrative, and financial stability of the cultural institution, "and freedom of the creative individual."

By any measure, NEA's dance programs had been spectacular institutional successes. The programs started small—four dance companies in two states funded by $25,000 from NEA. By 1980, NEA distributed about $7 million to 110 dance companies with 278 "sponsors" in fifty states with "access to the program." But along the way, the success of dance created controversy. At the outset, the dance panel chose a "list" of touring companies "suitable" for local or national sponsors. Sponsors and "eligible" dance companies would then negotiate contracts. Then, NEA would approve the contracts in conjunction with State Arts Agencies or Regional Arts Organizations. As approved contracts arrived in Washington, NEA allocated funds for one-third of the minimum booking fee of the dance company for the "sponsored" performances. By the mid-seventies, the existence of the NEA dance program's "list" had created problems. First, an official list meant that any company not listed was shut off from raising funds on its own. Second, local dance companies which did not choose to tour did not qualify for the NEA "list." Hence, a local dance company could choose between conforming to NEA's requirement to tour, and thereby be added to the "list," or forgo community support for the expression of local creative individuals who wanted to stay home.

Despite repeated disclaimers to those who loved dance that NEA had no desire to establish a Ministry of Dance, the effects of NEA's administration were consistent. If national monies were distributed, there had to be some rules, or at least the appearance of rules. It would not do for the grand dukes and great duchesses of the empire to occupy loges at performances of the Official Ballet and express their approval by tossing gold coins down upon the stage. Although the guidelines for dance might change from year to year, some guidelines were better than no guidelines at all. By 1980, NEA's dance program director was Ms. Rhoda Grauer, who was a superb administrator, an articulate advocate of dance, and a shrewd judge of both present and potential excellence in dance compa-

nies and dancers. Rhoda Grauer described at the appropriations hearings, as she had previously described to the National Council on the Arts, that she and the panels on dance she appointed were met with unavoidable contradictions and frustration in the administration of national dance policy.

Ms. Grauer testified that her program received approximately 1,200 applications for grants in a year, and these varied considerably in their scale. NEA received applications from the New York City Ballet, which had an annual budget of $8 million and toured 110 dancers, and to which NEA's dance program might grant $100,000 or $200,000; and they also received applications from the Poughkeepsie Ballet Theater whose total budget was less than $20,000. Ms. Grauer explained that about 350 of her applications came from choreographers with dance companies or schools of dance, but NEA had no program for grants to dancers as dancers, only for dancers to the extent they were connected with dance companies. To manage the complexities of NEA's national dance policies, Ms. Grauer employed four different peer-review panels. Each of these panelists was run ragged—there was no way to judge dance except by seeing dancers or dance companies. Inevitably there were complaints about Ms. Grauer's panelists for conflicts of interest; others complained because panelists who attended performances might be afficionados of dance, but not dancers, choreographers, or even dance managers; instead they were often directors of dance companies, or trustees of dance "service organizations" such as the Association of American Dance Companies—funded by NEA —or merely enthusiastic lawyers.

Taken together, said Ms. Grauer, the combination of guidelines and "closed circles" of reviewers meeting in star chamber proceedings—a system of approvals and denials NEA said was absolutely necessary— meant that NEA had long since established a Ministry of Dance, despite disclaimers to the contrary, and whether or not the Ministry of Dance did or did not have any announced or revealed policy. Yet, Ms. Grauer stated, her difficulties did not end there. Concerned with a national policy for "the arts" in general, and delighted with the popularity of dance, members of the National Council on the Arts and members of Congress were confused about the sources of dance's success. Ms. Grauer attempted to explain, again and again: what was fondly called "the explosion" in dance was only remotely related to whatever it was the Ministries of Culture—NEA, NEH, ICA, CETA, Education—were funding, or for which their administrators were proposing guidelines.

By circumstance, American pleasures with dance began sometime in the 1930s, and were the result of genius. Histories of American dance differed as to who should be credited with what, and where. There were fierce disputes about Bennington's contributions, as opposed to those made by George Balanchine, Agnes de Mille, Jerome Robbins, Martha Graham, Roland Petit, the New York City Center Ballet, the Royal Dan-

ish, and the effects of the Broadway stage compared to the classical traditions maintained by Russia. There was no debate that substantial contributions to the exuberance and imagination of American dance were made by choreographers and dancers who escaped the obstinately conservative, structured Soviet system of a National Council of Dance which coordinated its efforts with local soviets who met in secret as peer-review panels to judge how best to continue Mother Russia's standards in dance.

Moreover, the audiences for American dance had "exploded" long before the National Endowment for Arts was created. Claims by NEA's "information specialists" that NEA was responsible for dance's popularity beggared the facts. In her attempt to direct NEA's dance program, Ms. Grauer was required to grab dance's tiger by the tail; and to a considerable extent NEA was responsible for imitative, unimaginative, untrained, unadministered, unadmired dance companies—whose loss would never have been missed except as residues of NEA guidelines.

Yet, still Ms. Grauer had not fully enumerated her difficulties. Devoted to a national policy for the arts in general, Congress and all those appointed to national and state committees were baffled by dance's particulars. Executives and administrators of governments, corporations, and universities spoke often of how they managed by objectives, but they also kept their policies subject to annual revision, and they avoided casting their plans, as they said, in concrete. Consequently they were astounded by the detail of artistic plans; they were confounded by how artists met deadlines set not by the month or week, but to the second, with no revisions at all—although the deadlines were agreed upon years in advance. A touring company that expected to play Phoenix not only entered the dance week upon its calendar years before the Congress that would vote the subsidy for Phoenix had even been elected, but the notation on the dance company's calendar indicated the curtain time, the sets, and what steps would be followed in Phoenix. Dance's span of concentration exceeded anything in the experience of Congress or in the habits of presidents of universities or corporations who sat upon dance's councils.

Ms. Grauer recounted one further and irreconcilable contradiction. Although vast national programs might fund dance institutions, Edward Villella continued to dance with the New York City Ballet for the same $100 per performance he was paid before all the national programs began because Villella loved to dance. Just as farmers believed that farms were not for buying and selling, but for farming, great dancers wanted to dance whether or not they were employed for the night as minor officials of the government. No matter what the patrons of dance told each other at intermission, the coins they showered on the stage for the performance had no effect upon a dancer's feet. In the magic fleeting instant when beauty appeared, the amount approved for national grants was irrelevant. Even more discomfiting to the patrons of art who expected the dancers to attend the reception and "talk nice-nice," talent often went off on its

own to form experimental dance companies, on the spur of the moment, without tapping the national capital for research and development funds, careless of what Corpos liked to call "marketing," indeed, foolish about whether there would be any audience at all, and indifferent at the *barre* to income projections, statements of profit and loss, or registration as 501(c)(3) nonprofit corporations. As director of NEA's dance program, Rhoda Grauer was required to maintain an impossible balance between the incompatibilities presented by dancers' ambitions and the NEA requirement for guidelines and judgments by peer-review panels: the ambitions held by dancers cut across the grain of everything the Corpos knew and were careless of all the goodwill expressed by dance's patrons. To dancers, dance had no utility; its *pas de deux* were irrational, impractical, and improvident. The consequence of these misunderstandings between national policy for dance and the community of dancers was inevitable: institutional dance approved by its patrons grew by "guidelines" which worked relentlessly to eliminate intuition, adventure, and change, no matter what NEA said about "the freedom of the creative individual."

Actually, the extent of NEA's "guidelines" for official dance and their concern for the "freedom of creative individuals" were only partially suggested by the $7 million listed under dance programs. NEA had other "guidelines" to include dance within their $6 million distribution for "Expansion Arts," a category NEA refused to define firmly, but which more or less included programs for instruction and training in the arts, exposure to the arts, special summer projects, pilot projects at state arts agencies, regional tours, community and neighborhood art services, and —if these categories were insufficient—general programs. Included under "Expansion Arts" were not only programs for dance as education, but also grants to worthy arts organizations such as: the Foundation for Multilingualism and Polyculturalism, Inc., and the Protestant Episcopal Cathedral Foundation, both in Washington, D.C.; the Haight Ashbury Community Development Company, San Francisco; and the Junior League of Shreveport, Louisiana.

Other dance programs could also be located under NEA's $5 million distribution for education; and in addition, within NEA's programs which disbursed $8 million to media arts—of which $3 million was spent for television programs which might eventually be aired on PBS and which might include "dance." Yet these amounts were not to be confused with the $500 million or so spent by public broadcasting, which might also include dance, or with the amounts appropriated to the National Endowment for the Humanities for "Public Programs" totaling about $20 million, which also sometimes included dance.

If all these guidelines confuse the reader, they confused NEA, too. When NEA's more than one hundred peer-review panels met, proposals were often shunted from panel to panel and from meeting to meeting

within NEA. Some proposals to NEA were deemed more appropriate to the "humanities," or perhaps to PBS, or the Departments of Interior, Parks, or Education—somebody else, somewhere. Unfortunately, proposals sometimes arrived as foundlings on a doorstep, without instructions on care and feeding, with the result that they were abandoned yet again—although the forwarding panel might have believed they were beauties, but sent to the wrong address. These perplexities dismayed, but not half so much as the simple fact that no matter what some panels decided, it didn't make any difference anyway.

Disco Beat Brings $4 Billion a Year to Dance Hall Industry . . .

(Combined News Services, Inc)—This week 150 exhibitors and 2,000 disco entrepreneurs met in New York for a forum sponsored by *Billboard:* "Disco Forum V." The explosion in Dance was estimated to generate $4 billion annually, making Dance as big as network Television in the entertainment market. As an urban amusement, disco may have already crested, according to trade sources, but the suburban market, with its vast second generation audience is a billion-dollar opportunity just starting to be tapped for Disco, Bump, and Boogie.

18

CASEBOOK / NEA: THE DAY A DOCUMENTARY FUND DISAPPEARED . . .

And don't forget that it is the press, the pulpit, and the university that mould public opinion, set the thought-pace of the nation.

—Jack London
The Iron Heel

NEA's panel for television operated according to "guidelines" even more confusing than those published for dance. In June, 1976, NEA announced that its Media Arts Program would accept bids to establish a fund to produce documentary films by independent filmmakers for public broadcasting. The announcement was put forth jointly by NEA and the Ford Foundation. The purpose, according to the fanfare, was to engage independent producers in programming, and to "reflect the diversity of our individuals and our regions in the United States." The announcement caused some excitement within the community of filmmakers, because until then, to a large extent they had been shut off from any access to PBS—partly by the BBC programs, and partly by public broadcasting's own internal procedures. The budget for independent productions was announced as an annual $1 million pool of funds, with $500,000 to be put up jointly by NEA and the Ford Foundation, but requiring the independent filmmaker to "match" the NEA/Ford $500,000 with another $500,000 raised from "outside sources" each year. The three-year total would be $3 million, but the key to a successful bid would be the independent producer's ability to raise $1.5 million. Gerald O'Grady, director of Media Study/Buffalo, thought he could raise the "matching" funds, so he put together a star-studded team and he bid.

O'Grady's proposal to NEA's peer-review panel was as thick as the

Washington telephone book. Between red plastic covers, the proposal explained that O'Grady was bidding on behalf of his own media study group and a consortium, which included John Reilly, who operated the Video Study Center facilities in New York City, and Donn Alan Pennebaker, who was the most distinguished of all the independent filmmakers. O'Grady's proposal detailed how the consortium would combine production facilities, production experience, a distinguished producer, and budgets. O'Grady described how he would raise the necessary $500,000 in matching funds each year for three years from the Vincent Astor Foundation, the William Benton Foundation, the Carnegie Corporation, the Lilly Endowment, the Henry Luce Foundation, the John and Mary Markle Foundation, the Public Welfare Foundation, the Alfred Sloan Foundation, and the Rockefeller Foundation. O'Grady's ability to match the NEA-Ford monies would be, he believed, the key to his bid's success. By the time the NEA panel considered O'Grady's bid, each of O'Grady's sources for "matching funds" had given at least a nod of approval to O'Grady's NEA proposal.

O'Grady's bid listed a distinguished panel of "consultants," including four presidents or general managers of educational television stations. In addition, O'Grady had assembled the mandatory "advisory group"; O'Grady's "board of directors" was a panel which could be fairly said to be as distinguished and as broadly representative as the membership of the National Council on the Arts itself. O'Grady's board included: Michael Ambrosino, executive producer, WGBH Science Program Group, and producer of PBS's "Nova" series; James Blue, director, the Media Center at Rice University; William F. Buckley, Jr., editor, *National Review*; Cesar Chavez, United Farmworkers; Frances T. "Sissy" Farenthold, pride of Texas and president, Wells College, Aurora, New York; Walter E. Fauntroy, delegate from the District of Columbia to the United States House of Representatives; Ms. Frances "Frankie" Fitzgerald, historian; Kenneth A. Gibson, mayor of Newark, New Jersey; Professor David Lang, Institute of Political Science and Public Affairs, Duke University; Norman Mailer, literature's good-bad boy; Margaret Mead, the world's most admired ethnologist; Ralph Nader, consumer advocate and gadfly of corporate law; Genevieve Oswald, curator, the Dance Collection, Lincoln Center, New York; Edward S. Perry, director of Film, Museum of Modern Art, New York; George A. Steiner, director, Center for Research and Dialogue on Business in Society, UCLA; Dr. Lewis Thomas, Sloan Kettering Memorial Center, New York; Judge Charles Longstreet Weltner, Atlanta, Georgia; Tom Wicker, *New York Times*; Odd Williams, president, Douglas County State Bank, Lawrence, Kansas; Andrew Young, at that time United States Representative from Georgia; and Edith Zornow, supervising producer, the Children's Television Workshop—"Sesame Street"—one of the only sure successes PBS could claim.

O'Grady's extraordinary board was gathered to support a proposal which was just as extraordinary. In the proposal, Donn Alan Pennebaker explained what was at issue. In granting national monopolies to three commercial television networks, and in maintaining those monopolies for the corporations that owned them, the federal government had consented to procedures that precluded any independent film producers, such as Pennebaker, from airing films on *news* subjects. Although the networks bought "entertainment" almost at random from independents, no outsider could display on the monopoly channels any independent insights into politics, social events, economics, or any combination of these. The network public affairs departments were the sole licensees of history. One network news director put it succinctly: "Goddamnit, don't you understand? What we've got to have is flaming noncontroversy!"

The public affairs departments were the guarantors of the networks' monopoly franchise, and dared not risk broadcasts by independents like Pennebaker who might air their own ideas. Pennebaker had made films for sixteen years, but seldom had those films been commissioned or acquired by either the commercial networks or by the university system's franchise, PBS. In 1960, Pennebaker made "Primary." It became a classic, but was considered unacceptable for network play because it was about politics; eventually, "Primary" appeared only on local stations, and even then in truncated, censored versions. In 1961, ABC asked Pennebaker and Drew Associates to make documentaries on South American unrest. The independents made thirteen films, and ABC turned down twelve of the thirteen films they had commissioned, airing only one, "Yanki No," which covered Castro in Cuba. Pennebaker guessed that ABC had commissioned the entire series because they had no access to Castro, as Pennebaker did, and ABC could afford to throw away the other twelve films. Later, when another independent film producer brought back interviews with Castro, CBS refused to broadcast the film until network news personalities were dubbed into the film so that it would appear that CBS had produced the film.

Pennebaker went to Hungary with Pablo Casals for a CBS special, because CBS's producer felt Pennebaker's crew could get closer to Casals than the CBS crew. When Pennebaker's crew filmed the confrontation between John Doar, assistant U.S. attorney, and Governor George Wallace at the door of the University of Alabama, all three networks refused to broadcast Pennebaker's scoop because, they said, independent productions conflicted with the productions of network public affairs directors. At the last minute, "Crisis" was broadcast to critical acclaim, because Xerox agreed to sponsor the show as a special.

"Monterey Pop," by Pennebaker's crew, became another classic. ABC financed "Monterey Pop," but refused to broadcast it, partly because Pennebaker's cameras had caught views of rock culture which were in-

delicate and therefore inappropriate to ABC's franchise for public affairs. Pennebaker's film of the original cast-recording session of *Company* was refused by all three networks: no outsiders. When Leacock and Pennebaker made a film for German television on "Stravinsky," they were forced to buy the United States rights to their own film before they could resell the rights at cost to a reluctant WNET, Channel 13, New York. When WNET—the Ford Foundation's flagship station in public broadcasting—proposed what seemed to be an enormous budget for Leacock and Pennebaker to do a film on old age, public broadcasting executives explained how the system worked: "We'll decide what you should do. You just make the film we tell you to."

Pennebaker would not agree to make films about old age, or any other subject, the way he was told to by the commercial networks or by public television either. Television censorship operated by two systems, but only one of the systems was ever discussed, and that one was essentially harmless. Every network—commercial and educational—maintained its own office of censor, usually called the "continuity" department. "Continuity" literally censored by excising naughty words, thereby making themselves the butt of jokes for "bleep-bleeps" in Johnny Carson's monologues. Censorship by "bleeps" was sometimes funny, perhaps defensible on the grounds of decorum or good manners, and always harmless.

The second system of censorship was quite different, had nothing to do with obscenity, never involved "bleeps," remained totally undebated, but relentlessly excluded from television any broadcasts except those approved for orthodox values. Censorship by procedure was a political censorship of social ideas: a system to prevent independent intuitions, to obscure the materials with which to debate social change, and to obstruct the beginnings of social and political adventures. The networks—both commercial and university—censored by excluding from "public affairs" any voices except their own: what was "public" was a political decision reserved to four public establishments. These four entitlements avoided controversy over political questions because the three commercial franchises were guaranteed by Congress and the university broadcasting system was a government agency. Both commercial and educational systems, therefore, were dependent upon the government's good will for their continuance. They avoided controversy, even skepticism, as assiduously as did bishops anointed by Rome. To no one's surprise, television broadcasting had justly earned a reputation as a "wasteland"; documentaries produced by network public affairs departments were determined in their banalities.

Pennebaker was an outspoken critic of banality, but for reasons that were essentially artistic. The political consequences of his ideas were byproducts of Pennebaker's aesthetic formulations; he threatened orthodoxy far more than words that could be bleeped. Pennebaker's documen-

taries were made by 16mm camera crews following the subject of the film's story. In the edited result, the subjects told their own stories in their own words and by their own actions—an entirely different kind of film from a network documentary in which the story was narrated and interpreted by baritone voices of public affairs department announcers. The network documentaries controlled the story; in Pennebaker's system, the story controlled the documentary—and reality was a dangerous subject. Worse, Pennebaker chose stories because of the potential for drama in the event or the personality in the film; but there was no reasonable way to guarantee in advance that the resulting film would "work." Pennebaker's stories were risky and sometimes failed; whereas the network stories always "worked" because they were safe. Network news producers worked for network corporations; their incomes—not to mention their summer houses in the Hamptons—depended upon their jobs. As an independent, Pennebaker had no job at all, and his work was not subject to either economic or social consents. The results of Pennebaker's independent intuitions were sometimes entertaining and news at the same time; because of Pennebaker's techniques, his productions needed little narration, no official interpretation, nothing except what the film itself said and showed.

In contrast, if network newscasters could not provide an "objective" interpretation of the events as they occurred, there was no basis to produce the broadcast. The networks' reasoning for their interpretations was entirely logical: if TV was entertaining, then it ought to be broadcast in prime time as entertainment; but if entertainment made news, then it came under the jurisdiction of network public affairs officials, an entirely different department where interpretations of the news always risked the continuance of the entire corporate franchise; therefore, news could only be what public affairs officials said it was, and nothing else. Independent producers could not be permitted because no contradictions could possibly exist; all producers had to be minor officials of the incorporated truths; each night's public confession ended by reminding America that's the way it was, according to the "insiders." When the O'Grady-Reilly-Pennebaker consortium proposed an alternative, they were also proposing a fundamental change, and there might have been no end to it. They proposed to package documentaries for public broadcasting so that "public TV could function more like a magazine or quarterly that welcomed outside contributors."

To consider the contribution outsiders might make to public broadcasting, NEA's peer-review panel for Media Arts met in Washington. The panel reviewed competing proposals to match the NEA-Ford Foundation Fund for Independent Documentaries. Everyone agreed a new approach should be tried. After various alternatives were discussed, the O'Grady-Reilly-Pennebaker bid was named the winning proposal. It happened that Gerald O'Grady, John Reilly, and Donn Alan Pennebaker were also mem-

bers of the NEA Media Arts panel at the time. Because they were bidders for the documentary fund, they did not attend the Washington panel meeting; but they heard immediately when their bid had won.

What happened next was not entirely clear. The winning bidders were summoned to attend a meeting in the office of Fred Friendly at the Ford Foundation Building in New York. Later, John Reilly would describe the meeting with Friendly as uncomfortable, sometimes rancorous, and strange. The attitudes of the independent filmmakers did not jibe with those of the Ford Foundation's mogul of documentaries for public television. Moreover, one of the losing bidders to administer the documentary fund was the Ford Foundation's favorite station in New York—WNET, Channel 13. The meeting between the representatives of the winning bid and Fred Friendly, *grise eminence* of a losing bidder, ended inconclusively. The Ford Foundation was ostensibly still putting up one quarter of the annual budget for the project NEA had awarded to O'Grady's consortium.

Within two months of the meeting in New York at the Ford Foundation, NEA official Brian O'Doherty announced from Washington that perhaps the original guidelines for the independent documentary fund had confused NEA's Media Arts panel as to what criteria were to be used in awarding the contract. So, despite NEA's prior notification to the O'Grady consortium that they had won the bid, O'Dougherty announced that new specifications had been drawn up and were being mailed to as "broad a spectrum" of potential bidders as possible. New bids for the documentary contract trickled in, but on the second round the O'Grady-Reilly-Pennebaker group refused to bid. Pennebaker believed it was hopeless. The Media Arts panel reconvened in Washington to consider which proposal best reflected NEA's revised criteria for "excellence in the arts." To no one's great surprise, WNET, Channel 13, won the second round of bids. Provided they agreed to make the films they were told to make, independent filmmakers would be supported by the National Endowment for the Arts "as evidence of the great variety of American culture." As Bill Moyers had said, PBS didn't censor, they just suffered from an "excess of pluralism."

In fulfilling its statutory obligations to NEA, the National Council on the Arts depended upon two-line summaries of projects to be approved. Consequently, members of the council had few clues, if any, to events surrounding the award of the Documentary Fund bid to WNET. Nor did the council's policy discussions raise the question of censorship—in the Documentary Fund case or any other case—because such matters did not come to the council's attention. The council depended upon the goodwill and goodwork of NEA's excellent staff; and, in turn, the staff appointed peer-review panels whose critical judgments could always be cited as "sensitive" to the question of "quality in the arts." Besides, in reviewing the suitability of each NEA grant, pragmatic choices had to be made

about budgets and funding, as well as matters of artistic merit. Members of the National Council on the Arts could not be expected to be familiar with every nuance in 20,000 applications; neither, in any practical way, could the honorable members of Congress.

The investigative staff of the House Appropriations Committee took nine months to complete their report, which had been requested of the whole appropriations committee by Sidney R. Yates, chairman of the House Subcommittee on Interior and Related Agencies—the subcommittee which heard NEA's annual requests for funding. When the House report was delivered in 1979, Mr. Yates said it was not what he had intended; it had not achieved the purposes he had desired. What he had really wanted, he explained, was to find out how the National Endowment for the Arts worked; what they did and how they did it; what their problems were; what faults there were, and what good points there were, too. Mr. Yates felt the House investigation team had ignored the good points: didn't the endowment "do anything to be commended?"

As the NEA staff sat before the subcommittee, preparing to testify, nodding their heads in agreement, Mr. Yates remarked to those assembled for the occasion: "I just can't believe that over the years of funding arts projects nothing was done that was constructive or beneficial. I cannot understand why our staff did not comment on the good work, if any, that the Endowment has done—and I use the words *if any* just to say that there isn't any in the report."

Mr. Yates feared that somebody on "the outside" who read the report would gain a one-sided impression, "perhaps a biased impression, certainly a misguided impression" of what NEA did. "Certainly," said Mr. Yates, "testimony before this Committee and other Congressional Committees are replete with examples of the benefits from NEA's work and its fundings."

Certainly anyone who doubted the goodwill or goodworks of NEA was misguided, indeed biased, if he or she was unable to understand testimony before congressional committees duly authorized for the purpose. What a shame the congressional investigating staff had so completely misunderstood the purposes for which their report had been requested. Their criticisms had not been constructive, and might give the wrong impression, particularly to "somebody on the outside."

Perhaps Mr. Yates's remarks about somebody "on the outside" were merely rhetorically awkward—a stumble of sorts, while marching along the railroad ties of progress in the arts. Yet his phrase lingered. Apparently there were "outsiders" and "insiders."

Nuclear Engineer

The Defense Intelligence Agency, a highly specialized organization working to meet diverse intelligence requirements of the Department of Defense, offers a challenging position for a Nuclear Engineer.

You will be responsible for evaluating or directing/managing the evaluation of nuclear reactor programs, worldwide. You will perform research, analysis, and interpretation of foreign nuclear reactors including research reactors capable of plutonium production, power reactors, both current and advanced designs and R & D activities related to their development.

The individual we seek should have an advanced degree in Nuclear Physics or Nuclear Engineering, 4-5 years of related experience, including familiarity with various types of nuclear reactors and with the complete nuclear fuel cycles.

Starting salary $34,713 (GS-14) including liberal fringe benefits associated with Federal employment. This position is located in Arlington (Rosslyn), VA. Civil Service status is not required. DIA hires direct. All applicants must be U.S. citizens and are subject to a thorough background inquiry. Applications will be accepted until June 13.

Please send completed Personal Qualifications Statement SF-171 or resume including salary history to:

DEFENSE INTELLIGENCE AGENCY
Civilian Personnel
Operations Division
Recruitment Branch (Dept. NE)
Washington, D.C. 20301

An Equal Opportunity Employer M/F

19

DEFINITIONS / NEA:
"SUBSIDIZING LINT"

The purpose of Newspeak was not only to provide a medium of expression for the world-view and mental habits proper to the devotees of Ingsoc, but to make all other modes of thought impossible.

—George Orwell
1984

Unfortunately for Mr. Yates and his congressional colleagues, and distressing to the National Endowments for the Arts and the Humanities as well, the sentiments and pieties of the New Order's national cultural policy were contradicted when the New Order attempted to fund literature. For one thing, the testimonies provided by literature were entirely unreliable, by definition always "on the outside," or written by "outsiders," and frequently literature established witnesses on its own authorities. Although the arts and techniques of dance, music, sculpture, and painting made statements, of course, and required feats of skill and imagination, their performances were played within the space of an abstract silence, and therefore always subject to interpretation. The motions of dance, the images of painting, the sounds of music raised aesthetic or critical questions, but like mathematics, no social or political difficulties. Literature, on the other hand, expressed what it had to say in a single voice. The independent intuitions of literature—if words were to mean anything at all—were judgments upon people and events, descriptions of the social and political landscape, and *therefore* clear and present dangers to the futile ideology advanced by the New Foundation.

Literature knew how to flatter, and gleemen appeared in the service of power, just as jugglers and magicians did; but literature could also sting, and bards might, on their own initiative, ignore the pompous advice of some official to adopt a "positive approach." When a writer recorded the

290

details of scandal, he included, among the tools he used to hammer the bits of evidence into a story, awkward bits of gossip and the stray documents. If the emperor had no clothes, some damn fool writer might take it into his head to say so. Writers liked ideas as much as the next person, but they copied down the materials of reality without bothering to check first whether their ideas coincided with the latest flatulent pronouncement of the anointed authorities. In fact, writers often took perverse pleasure in demonstrating how power lied. To pursue what caught their fancy, writers did not need an endorsement from some transcendental authority; instead, they went to work with whatever words were handy from the common stock stored in the public domain. To accomplish their ends, they did not need complex institutions of capital or labor; a pencil stub and a yellow pad would do. Writers accomplished nothing by coordination, cooperation, committees, service organizations, or consultants; they worked alone. Writers formed the shape of their stories in their own heads: when they expressed those intuitions in words, the completed work was the result of what had occurred in their imaginations. Proprietary claims by corporations or universities were preposterous when those establishments claimed title to the voices a writer heard while gazing out the window. Writers smiled when some dim-witted lawyer at the Department of Justice declared the writer's ideas could be "classified at birth." To avoid bureaucratic proscriptions, writers could change the form of whatever they knew whenever they chose: if the king's ministers denied the right to criticize, La Fontaine changed the minister into a fox who could not jump high enough.

When writers recorded events or told stories, they hoped to add to tomorrow's permanent storehouse of community memory; the bureaucrat worried about yesterday's memoranda. No writer needed permission to attempt comedy, tragedy, praise, gossip, dissent, satire, or verse. Language worked from authorities so ancient that the whole lot of popes, priests, kings, tyrants, despots, oligarchs, and dictators were powerless, and had always been powerless, to silence the causes or the effects of the word. When the National Endowment for the Arts made a grant of $5,000 to Erica Jong to compose poetry, and the Smithsonian subsequently refused to allow her to read it, all the endlessly repeated assurances of infinite goodwill by the Ministers of Culture were caught naked in the spotlight: they were liars.

Just what NEA, NEH, and all the other Ministries of Culture considered "literature" was in itself a marvelous exposition in *doublethink*. The ministers did not mean any printed matter, or writing taken as a whole, or the realm of letters in the community, or in the world, or in the present, or the great body of books kept as community memory in the public domain. No ordinary definitions of literature were ever embraced in the grandiloquent titles for programs on "literature." To the extent there were any guidelines at all for literature, NEA officers said

their grants were used to distribute funds for: (1) fellowships to creative writers; (2) residencies for writers; (3) assistance to small presses; (4) assistance to literary magazines; (5) distribution and promotion; (6) services to the field; (7) and finally, the ubiquitous "general programs." Although "general programs" might well cover any contingencies omitted in the first six categories, none of those preceding titles meant what they seemed to mean anyway.

At NEA a series of exclusionary regulations defined literature in such a way that writers whose interests were current social or political topics did not qualify. Factual analyses were not within NEA's purview. For example, Betty Friedan, author of *The Feminine Mystique* and other equally influential nonfiction works, did not qualify as an NEA writer—because her topics were not "creative." Similarly, even after she was fingerprinted to occupy a seat on the New York State Council on the Arts, Shana Alexander did not qualify as an "official" writer because her book on Patty Hearst, *Anyone's Daughter,* was not, by NEA's definition —or New York State's either—literature. All works of history, social commentary, or works including political analysis or consequence, fell through the cracks of NEA's literary administration. Theoretically, politics and history belonged under the aegis of the National Endowment for the Humanities. Yet, at NEH, contemporary authors were again eliminated by processes and procedures from NEH programs—unless the authors were approved members of the academic community. NEH Chairman Joe Duffey said he wished that NEH had been able to publish Garry Wills's study of Jefferson, but Wills would not have qualified for an NEH fellowship. In sum, the first set of exclusionary rules for the definition of official literature exempted NEA from any topic of current political or social interest, and NEH from any topic not academically approved.

The NEA guidelines for literature stated that the intent was to support "noncommercial" writing. The definition of "noncommercial" literature varied according to the whim of NEA program directors and the prevailing circumstances as each literature panel convened. Sometimes "noncommercial" meant that NEA awarded grants to nonprofit publishers and denied grants to "commercial" publishers. On the other hand, NEA literature panels were able to find a way to award fellowships to selected senior editors at Harper & Row, a giant publishing conglomerate whose owners at least attempted to make profits and did all they could to fend off lawsuits by authors who claimed Harper & Row's mergers were in restraint of trade. When NEA awarded a fellowship for $10,000 "to enable published writers of exceptional talent to set aside time for writing, research, or travel, and generally advance their careers," there were no strings attached. The writer could complete the work for which the grant was made, or forget it and take the money and spend a pleasant summer in Ireland. If the work was completed—or if some other work was com-

pleted instead—there was no reason why the writer could not sell the fiction or collection of poems, if that's what it was, to a commercial publisher. In fact, many NEA "noncommercial" fellowships resulted in commercial sales; and a likely buyer might be one of the "commercial" editors who sat on the peer-review panels that awarded the fellowship in the first place. In such cases, the publisher's advance to the writer for an acceptable work might be an aggregate of national funds combined with those of the commercial publisher. Finally, if a fellowship was awarded for poetry, but instead the writer decided fiction might be more useful "to generally advance his career," and the fiction then was sold to a commercial publisher, that would be quite all right, too. In Erica Jong's case, *Fear of Flying* derived from just such circumstances, enraging certain congressmen, who complained that national monies had been used to finance "dirty books."

NEA's official definition of "noncommercial" literature was further confused because NEA also funded small presses and literary magazines. With funds supplied by NEA, these "nonprofit" publishers paid for work which may have arrived on an editor's desk thanks to a fellowship for "creative writing," also funded by NEA. Of course, every nonprofit publisher made all the money he could for his publication; to do otherwise would be folly. Moreover, some "nonprofit" publishers were satraps of the tax-exempt university system, and so NEA funded presses already funded for education, both through the funding of "creative writers" and through the funding of the presses that published them. NEA distributed about $2,750,000 in fellowships to individuals, but another $2 million to publishers.

NEA applied no "means" test to determine whether the authors they favored needed the money; theoretically it was all-y-all-y-in-free, and the only test applied as qualification for grants was the "excellence of the work." Hence, *Paris Review,* owned by the Aga Khan, qualified as a "literary magazine," which indeed it was; and so did *Partisan Review,* owned by Rutgers University, the state of New Jersey's rival to Princeton. On the other hand, a poet such as Rod McKuen would not be invited to the White House receptions to celebrate national poetry, because McKuen's poetry sold millions of copies. McKuen's poetry was "commercial," and thereby disqualified from national support. But what was "commercial" and what was "noncommercial" did not actually depend so much on whether the work or its publication was excellent, but whether the work was futile and its authors would pose as *les artistes manqués,* supplicants for national dollars, and agree to follow the procedures established for literary mendicants.

The Ministry of Culture funded the *Smithsonian* magazine grandly, even if it did generate $55 million in "noncommercial" funds; but simultaneously NEA peer-review panels assiduously avoided any "coordination" with the Author's Guild or the Author's League of America,

because those organizations represented the published "commercial" writers. To avoid dealing with popular "commercial" writers, NEA created their own "service organizations" of authors and publishers, subsidized them, and nominated their officers. While volunteers from the Author's Guild, with a total annual budget of about $30,000, fought for years to assure royalties for authors' work, as guaranteed under Article I, Section 8, of the United States Constitution, the lobbies of the Ministry of Culture, with budgets in the billions, steadfastly opposed the commercial interests of authors, and argued that education had proprietary right and title to anything created for "commercial purposes." When the new Copyright Act of 1978 was finally approved by Congress, a compromise was reached by which "educators" could Xerox up to twenty copies of any work for classroom use. Whereupon universities, in conjunction with national contracts, financed publishing houses whose work consisted solely of Xeroxing the work of authors, binding it, and distributing it to educational organizations for sale to students—without paying a single author's royalty. English teachers used this sort of "noncommercial" publishing to create an anthology of current "creative" works.

Still, that was not all there was to the process of defining "commercial" and "noncommercial" under the sovereignties claimed by the Ministry of Culture. All these difficulties about what might be the literary property of an author and what uses the Ministry planned to make of the author's property were said to be "open to negotiation," a system of arbitration exactly similar to condemnation proceedings: with continuing assurances of goodwill, the railroad of "overriding national interests" was coming through town.

To make these delicate ethical and political choices "so necessary to the sensitive judgments required of the arts," the NEA literature panels met in secret. In instances in which NEA had plainly been involved in matters of censorship over an organization which NEA itself funded, NEA's legal counsel, Robert Wade, stated that the minutes of NEA's meeting with itself were secret minutes, and exempt from disclosure under the Privacy Act: that is, NEA's public business was a private matter. The secret procedures used to determine which categories of literature were favored by the Ministry of Culture were obscured by yet another category of "guidelines." NEA officers explained that their Literature program supported small presses and literary magazines, but what was small, or big, or perhaps just right, as Goldilocks had said, and what was literary as opposed to what was trash, were subjective and exclusionary judgments—and unavoidably so. All decisions upon questions of quality were logically reflections of the values of the peer-review panels appointed by NEA's director of Literature. Members of the NEA literature panels consistently expressed their goodwill toward the careers of young and talented writers, particularly because "an NEA grant often conferred in itself the recognition young talent so often needed for en-

couragement." But NEA's goodwill was unbounded. In due time, David Wilk, director of the NEA Literature program, announced that beginning in 1980 NEA would also be awarding fellowships to "older writers" in amounts of $15,000 to recognize the "contributions" these high-minded old noncommercial fellows had made to literature during their previously unrecognized careers in literature, however it was defined. For this new category of national prizes, NEA did not feel any peer-review panel would be necessary at all.

In the thick yellow fog of *doublethink,* the commonsense mind could still find its way; only the schizophrenic was terrified. Never mind the talk of "nice-nice" to patrons of the arts. Forget the procedures operated to veto independent film producers. Disregard all the categorical guidelines so necessary to "sensitive judgments." No pragmatic system of any program director at any agency of the Ministry of Culture would deliberately "recognize the contribution" made by any heretic of the New Order's ethical sovereignties: such an event would be as likely as a literature grant from President Jefferson Davis to Harriet Beecher Stowe to distribute *Uncle Tom's Cabin* for the moral edification of General Lee's Confederate Army. Charles Plymell, a distinguished poet and publisher of a small literary magazine, *Northeast Rising Sun*—which operated with grants from NEA—summed up his experience of fifteen years: "They subsidize lint."

Twigs For An Eagle's Nest . . .

"When the federal government operated on a fiscal year that ended June 30, late June in the Arts Endowment was a time made frantic by a last-minute rush to get grants signed and mailed.

"Nancy Hanks, the chairman, was ill in June 1974, and as acting chairman I signed hundreds of grants. Then, one morning, an immense batch arrived from our visual arts office. They were individual grants, mostly for $3000. Each grant folder contained a summary of the project proposed in the artist's own words. I began to read them and a few left me perplexed:

" 'My project is a series of paintings, 10 to 15 layers of paint deep, consisting entirely of extremely subtle gradations of gray.'

" 'The project I propose will temporarily manipulate the Chicago skyline for the period of one year.'

" 'My project is to introduce taxidermy as a sculpture media by using painted plywood construction, dirt, sand, gravel and animals to create different environmental situations.'

" 'My project, the Structure of Dry-Fly Fishing, is a complex video artwork on the order of a piece of sculpture.'

" 'I have in mind several pieces involving templates of the curvature of

the earth, and of monumental man-made structures. These in-scale tem-
plates would be transformed, rolled, folded or somehow distilled in order
to give insight to an otherwise vast visual or conceptual order.'

" 'The Porpoise Opera Project is an experimental project intended to
function in an oceanarium's porpoise stadium; to make use of existing
facilities; and to work with resident porpoises (Bottlenosed Dolphins) in
an effort to land and develop a full-length program or opera to be seen by
the public and documented on film.'

"On reflection, I signed these grants on the ground that the projects
had been endorsed by our professional advisers and that they probably
would not harm the Endowment."

> —Michael Straight, former deputy
> chairman of the National Endowment
> for the Arts in *Twigs for an Eagle's
> Nest*, published by Devon Press,
> New York/Berkeley, 1979.

20

BURLESQUE / NEA AND THE PREVENTION OF LITERATURE . . .

Magnificent roads will be built. There will be great achievements in science, and especially art. When the oligarchs have completely mastered the people, they will have time to spare for other things. They will become worshippers of beauty. They will become artlovers. And under their direction, and generously rewarded, will toil the artists. The result will be great art; for no longer, as up to yesterday, will the artists pander to the bourgeois taste of the middle class. It will be great art, I tell you, and wonder cities will arise that will make tawdry and cheap the cities of old time. And in these cities will the oligarchs dwell and worship beauty.

—Jack London
The Iron Heel

Writers could be embarrassing. They were nearly irrepressible. They were stubborn, self-contained, and on their own initiative they would compare the actualities of the present to the promises of the past. Writers refused to abstain from the facts. They were a great inconvenience to the just and beautiful society of love, peace, and understanding promised by the Ministry of Culture. When Congress established the National Foundation for the Arts and the Humanities in 1965, Congress specifically prohibited the new foundation from providing by grants more than 50 percent of the operating funds to any arts organization. In theory, if national monies did not control art's purse, art could maintain its freedoms. Congress was explicit in its fear of censorship. The authorization went on to specify prohibitions to the National Foundation's political activities: "No department, agency, officer or employee of the United States shall exercise any direction, supervision, or control over the policy determination, personnel, or curriculum, or the administration or operation of any school or other nonfederal agency, institution, organization or association."

Nevertheless, from the outset the National Foundation was engaged in continued violations of the proscriptions in its charter; the New Order was defiant of all the laws forbidding secret government or censorship; careless of all the laws prohibiting infringements upon the exclusive rights of authors to their writings; and to carry forward its ambitions, the New Order breached the First Amendment guarantees against the establishment of religion, the abridging of free speech or of the press, and the right of the people to peaceably assemble, and to petition the government for a redress of grievances.

In 1967, George Plimpton volunteered to help NEA "support" literature. Plimpton was the experienced editor of *Paris Review*, popular author, and centerpiece of a far-flung literary network; whereas no one at NEA knew much about literature, and they were unacquainted with many living authors. For NEA, Plimpton proposed to publish each year *The American Literary Anthology*, composed of the best in poetry, fiction, criticism, and articles. A distinguished jury would cull the winning selections from entries nominated by all the literary magazines. The resulting *American Anthology* would award a prize of $500 to each winning author, a prize of $250 to the editor of a winning selection, and a prize of $750 to the magazine which had published the winner—making a total of $1,500 for each winning "package." Plimpton would assemble the jury. The staff of *Paris Review* would then edit, design, and arrange the anthology. Each year a different major commercial publisher would distribute and promote the collection; NEA would put up $60,000 to cover the cost of the operation. Everybody gained, no one lost, and the winning authors earned recognition, a little money, and distribution through commercial outlets. *The American Literary Anthology/1* was published in 1968. Everyone agreed it was a great success.

In 1969, under the category of poetry, *American Literary Anthology/2* included as a winning selection an example of calligraphic poetry by Aram Saroyan. The title of Saroyan's poem—and the entire poem—consisted of seven letters: "LIGHGHT." Calligraphic poetry could be said to be new and experimental perhaps. Actually, the Dadaists had been fooling around with calligraphic impressions since 1919, but in the midsixties Dada was making a comeback in New York—both in art and in poetry. In any event, neither calligraphic poetry, Dada, nor art and poetry in general, had regulations against anyone who smiled. Unfortunately, the administrative assistant to the Hon. William Scherle, Republican, Iowa, spotted a copy of Plimpton's *American Literary Anthology/2* in the offices of NEA's deputy director, Michael Straight, and took the book away with him to Capitol Hill. Mr. Scherle read "LIGHGHT" and would not smile—not even a teensie weensie bit. From the floor of the House, Mr. Scherle's voice reached out to America: the government of the United-States-of-America had paid over $200 a letter for a p-o-e-m. In response to Mr. Scherle's outrage, sacks full of mail arrived in the base-

ment of President Nixon's White House: it was embarrassing—the way the National Endowment for the Arts was wasting the taxpayer's hard-earned dollar. Those people over at NEA would hear about this; and George Plimpton soon regretted he'd volunteered. He described the Honorable William Scherle as an "illiterate nitwit."

Plimpton had a curious constituency of his own. He was a celebrity author because he'd played football as a "Paper Lion" for Detroit. He'd sparred with Muhammad Ali. He'd played tennis at Forest Hills. He'd made the golf tour with the pros. He wasn't very good at any of these sports, but to write about them he experienced them. Besides, he was making a point, over and over—an argument he'd made all his life: he'd played the fool gladly in sports, in literature, and in love to explain, with all the charm he possessed, that there *were* standards of excellence. Adventure was still alive in the world, despite the exhausted imagination of his social equals educated at Exeter and Harvard. Plimpton was as patrician as they were. He was brought up in Cold Spring Harbor on Long Island's Gold Coast. He was cousin, or kissing cousin, to the heirs of empire who sat on the boards of great corporations, as trustees of the Metropolitan Opera and Lincoln Center, and were partners in Wall Street law firms, and he had something to tell them. He would explain the difference between what was ordinary and amateur, and what was superb and professional. "Superb" was his favorite word. The best boxer in the world was "superb," and an entirely different fellow from one of Plimpton's classmates who had sparred at Harvard. A professional golfer who could chip 100 "superb" shots in a row to within two feet of a pin was absolutely different from the Corpo executive who got off a lucky shot one afternoon at the club. Playing touch football was fun, but not the same as playing with the Detroit Lions, who were "superb."

Plimpton was also a gadfly of the ordinary in literature. In *Paris Review*, Plimpton published taped interviews with authors, asking them what was on their minds. What authors who were "superb" were thinking was not at all what pedagogues who taught "creative writing" at Mr. Scherle's Iowa University *thought* they were thinking. In *Paris Review* Plimpton published experiments in poetry and criticism. Much of it was precious; lots of it failed; and some of it was "superb." To promote *Paris Review*, Plimpton used lithographs adapted from the magazine's covers. He paid the artists next to nothing for their work, because at the time the artists needed the exposure and were unknown. Later, great museums would pay outrageous prices for the hundreds of *Paris Review* posters Plimpton had left over, and which he'd forgotten about. In all these activities, Plimpton was sometimes foolish, sometimes downright silly, but always of high good humor and considerable wit. Plimpton and *Paris Review* gave grand parties, supplied Fourth of July fireworks on the beach in Wainscott, Long Island, gathered the illuminati around a pool table in New York. There were pretty women, loud laughter, boisterous argu-

ments, and lots of fun. Having fun soon made Plimpton as much an enemy of the people as Erica Jong, H.L. Mencken, David Truong, Ronald Humphrey, Howard Morland, Frank Snepp, and Jane Fonda. "The Arts" were serious business, solemn, and certainly no occasion for laughter.

As the Honorable William Scherle roused America's consciousness to Plimpton's extravagance in publishing "LIGHGHT" the galley proofs for *The American Literary Anthology/3* were being made ready for its publisher. NEA's Deputy Director Michael Straight thought he'd better have a look, because NEA's reauthorization hearings were coming up before Congress. Straight read through the galleys with dismay. One of the winning contributing magazines described itself as "subversive as a Bolshie bomb." At the time, the Nixon administration was bombing Hanoi, invading Cambodia, collecting the names of 10,000 "enemies" on a list, and the names of writers were being added as enemies of the people nearly every day. Writers were leading marches to the steps of the Pentagon; others, on their own, were describing massacres in Viet villages. There was no sense in getting NEA's name associated with "Bolshie bombs." Straight saw another winning selection entitled "Fuck You." If NEA was having trouble over "LIGHGHT," imagine what Scherle could do with "Fuck You." And then there was a story by one Ed Sanders, titled "The Hairy Table," which was obviously obscene. Something had to be done, and quickly.

NEA Director Nancy Hanks called George Plimpton. "The Hairy Table" would be the end of NEA's budget appropriations from Congress: You've got to kill that story, Nancy Hanks said. Plimpton explained that a jury had picked Ed Sanders's story as a winner, and he really couldn't kill it. Besides, review copies of *Anthology/3* had already gone out to newspaper book reviewers, and to recall the collection would be to advertise it. Nancy Hanks suggested that Plimpton recall it anyway, for some reason he could make up. Perhaps he could pretend that "The Hairy Table" was being "postponed" to the fourth edition of the anthology— which could then be published after NEA's reauthorization hearings were over. Nancy Hanks was eloquent, but Plimpton still refused. Then, said Nancy Hanks, she had no alternative but to shut down *Anthology/3*. She was cancelling NEA's $60,000 grant for Plimpton's efforts. She would use as a pretext that Plimpton's jury had not followed the procedures exactly when they awarded the prize to Ed Sanders's story, "The Hairy Table." Procedures would be NEA's defense for breach of contract. Plimpton said he had an agreement with Harper & Row to distribute *Anthology/3*. The commercial publishers liked the idea of publishing the best from the nation's literary magazines, with or without NEA.

Nancy Hanks and Michael Straight were trapped between censoring Plimpton and continuing NEA's programs to develop national culture. If Plimpton published "The Hairy Table," millions of dollars for the arts would evaporate. The money was desperately needed by symphony or-

chestras, museums, opera companies, for theater and for dance. Besides, Nancy Hanks and Michael Straight had been creating small pilot projects for design in architecture, preservation of historic places, for the aged, for youth, for education, and then transferring the NEA pilot programs to other departments of the government where the budgets were huge; they didn't want to kill all these seedlings for one silly story. Michael Straight believed that government should be the determining factor in shaping every aspect of national life. To improve the quality of political life, Straight imagined a national culture similar to the "organic city" of the Italian renaissance. The arts would have the central role in giving coherence to a society that lacked any other reasons for its continuance. If the ideals of democracy had to be abandoned, then "beauty" could take their place. NEA was working to reward great art, and artists would be well paid. Even the cities themselves could be renewed and made beautiful— cities in the form of a palace; cities, that is, which were "conceived as a work of art." It would take time to reach a consensus in literature, yet it could be done; but not if Plimpton published "The Hairy Table."

Plimpton was always the gentleman. He let the arts be saved. *Anthology/3* disappeared. Ten years later there were minor differences between Plimpton's version and Michael Straight's text over what had been so objectionable in Ed Sanders's story. In both versions, the story was easily characterized as "dirty, dirty, dirty," but in his remembrances of eight years at NEA, Michael Straight reproduced a paragraph from Sanders as a demonstration of obscenity in a heterosexual encounter; whereas Plimpton recalled that Sanders's story was about a party at the Peace Eye bookstore where a jar of vaseline used by Allen Ginsberg in a homosexual adventure was on display on a "hairy table." Nancy Hanks and Michael Straight were absolutely right: Congress would have had a field day with either version. Literature was dangerous to the continuance of the arts. Whether Sanders' story was actually obscene, contained redeeming social values, or offended the community standards of literary magazine editors were issues beside the point: no court heard evidence presented; no jury decided the facts; no judge ruled on the law. To save the arts, NEA had acted as an arbiter of taste. In violation of its own charter, NEA had exercised control; but Nancy Hanks had no pragmatic alternatives—not if the arts were going to be the very essence of our lives.

"What this made them realize," said Plimpton, "was that literature was going to be very hard to manipulate. It was not like opera or ballet. It showed them they would have to create procedures that would act as a kind of buffer."

"Fuck the *Paris Review*," NEA's new director of the Literature program told George Plimpton; yet to manipulate literature, Leonard Randolph had no alternative except to institutionalize the procedures Plimpton had suggested. Literature was difficult to manipulate. Randolph needed procedures that would act as buffers. Consequently, a sovietiza-

tion of NEA's Literature program began. As Randolph proceeded, he caught the attention of Susan Wagner, former United Press correspondent, and columnist for publishing's trade magazine, *Publishers Weekly*. Because commercial publishers in New York were only vaguely interested in whatever it was NEA thought it was doing, *Publishers Weekly* would only run a few of Susan Wagner's stories on NEA, but she began collecting a considerable file anyway. What NEA was doing bothered her. Like George Plimpton, Susan Wagner knew a great deal about publishing, but from a completely different angle. She was an expert in copyright law. She had covered a ten-year battle to get the United States to conform to world copyright conventions. She believed that the educational establishment was determined to rob authors of their royalties. She began collecting her file on NEA almost accidentally, but when she left for Paris in 1978 to become UNESCO's expert on world copyright practice, she left behind a thick file on NEA's attempts to control writers.

Susan Wagner recorded that before taking over as director of the NEA literature program in 1970, Leonard Randolph had been a staff assistant to Roger Stevens when NEA was first starting up. Then Randolph spent two years campaigning for the arts in Pennsylvania. He returned to NEA in Washington as assistant director of federal-state relations. He told Susan Wagner he was particularly sensitive to the "importance of relations with the states." To accomplish NEA's objectives in literature, Randolph said, "we've done our best to let the states know about all our programs." NEA sent out lists of writers whose grants had been approved to state arts agencies. Randolph let the state organizations know about other writers whose work was "highly regarded," but who were not awarded NEA fellowships because of "budget restrictions." Randolph cited as examples of NEA's "support" a program called "Writers in Developing Colleges," which was handled through the state arts councils, who would take recommendations from Randolph on likely "fellows." Reading and residency programs were handled through state arts councils. Small press programs operated in New York, Idaho, and Alaska. Randolph pointed out how foundations also matched state funds to "support" writers, citing the "Western States Arts Foundation," which sponsored readings by poets, fiction writers, and playwrights.

The Artists in the Schools program spent $5 million each year, of which $800,000 went to poets. Local school districts and the state arts councils decided which poets they wanted, but if asked, Randolph could recommend good ones, of course. Besides existing organizations, and those created to meet NEA's objectives for "excellence in the arts," NEA funded "service organizations," including: Poets & Writers, Inc., which was simultaneously a service organization for the New York State Council on the Arts; the Committee of Small Magazine Editors and Publishers (COSMEP); and the Coordinating Council of Literary Magazines (CCLM).

NEA described Poets & Writers, Inc., COSMEP and CCLM as "independent, non-profit and private" literary organizations, but they were creatures of NEA's procedures, and acted as "regranting" organizations for NEA funds. They were also political buffers between Congress and NEA: if they squandered money for calligraphic p-o-e-m-s, printed dirty stories, or published obnoxious political opinions, NEA could tell Congress they were independent and the law forbade NEA to interfere. On the other hand, these "independent" service organizations were required to raise "matching" funds from foundations, corporations, and the states, but they could only do so if NEA approved of their projects. If NEA grants or approvals were withdrawn, the regranting organizations were helpless to continue on their own. Despite congressional prohibitions, NEA often supplied more than 50 percent of these regranting organizations' funds; whatever the amounts, they were captives of Leonard Randolph's system of patronage.

From 1970 to 1979, Leonard Randolph built, and then operated, a literary system with a structure radically different from the customs, manners, and traditions of literary practice in free countries. As NEA's Literature program expanded, Charles Plymell, editor of *Northeast Rising Sun* thought Randolph really meant to do his best for small presses, but said, "Randolph was just an old bureaucratic schoolmarm who was unpleasant when drunk and pleasant when sober."

Plymell saw Randolph at the continuing small conventions and meetings for literary presses, poets, and academic writers. He described Randolph as a dashing, handsome man, "almost chic, open shirt and necklace type, dashing off in foreign cars to meet planes, leaving us literati to squabble for small press grants." As Randolph went dashing off to meet another plane, it was always useful to remember that literature was defined, in NEA's lexicon, as whatever Randolph said it was today; tomorrow's "guidelines" for literature might be different; and with no contradictions at all, literature tomorrow might be different yet again from what it was yesterday. To understand how literature could be all things to all men at all times, it was essential to keep in mind that whatever the NEA Literature panel decided, Randolph could recommend more of the same in grants or fellowships from state arts councils, or from CCLM or COSMEP, or in "coordination" with "cooperating" foundations. Likewise, if the NEA Literature panel refused an applicant, Randolph could countermand their decision by recommending grants and fellowships from the "private" and "independent" organizations NEA funded and approved. Under NEA's system it made no difference what the word *literature* meant; and even when *literature* appeared to carry with it some significance on a particular day, whatever the Literature panel decided to further literature's hopes made no difference either. These absurdities were raised to the nth power because Randolph nomi-

nated the members of the Literature panel in the first place, and the resulting appointments by NEA to approve what Randolph proposed were colored by political, not literary, necessities.

In a memorandum to Michael Straight, Randolph reviewed the process by which he had selected the members of the Literature panel. Randolph reported that the Literature panel included three members from New England, three from California, one from the Plains states, one from the Midwest, one from the Rocky Mountains, two from New York State, and one from New York City. Randolph nominated Maxine Kumin to the panel because he had worked with Ms. Kumin on the Massachusetts State Arts Council and the Poetry-in-the-Schools program. Thereafter, Randolph nominated Ms. Kumin to serve as chairman of the panel after John Leonard stepped down. Randolph appointed Jack Shoemaker to the Literature panel because Shoemaker was a small-press publisher and had ideas about what NEA should do about small-press book distribution. Along with Shoemaker, Randolph added Shoemaker's friend Glenna Luschei, also from the West Coast and publisher of *Cafe Solo*, with "an excellent track record in publishing ethnic writers and women."

John Coe was chosen because of his state arts agency connections. Jose Ramon de la Torre was the only Spanish-speaking member of the NEA Literature panel, "and this is a resource we badly needed." Randolph explained that NEA received a small number of manuscript submissions each year in Spanish, and although NEA employed a reader fluent in Spanish to "screen" the applications, Senor de la Torre was recognized in Puerto Rico as a critic of some stature.

Randolph went on to explain that he had added Ernest Gaines to the Literature panel because Gaines's novel, *The Autobiography of Miss Jane Pittman*, had been the biggest "success story" that "a black writer has had these past few years." Gaines joined the panel because, according to Randolph, he thought he had volunteered for something important to *writers* in general, not just black writers. Randolph said he had chosen Albert Goldbarth to increase "the younger quotient on the panel." Goldbarth had been awarded an NEA fellowship, and could "represent" the Midwest area. Wayne S. Knutson was recommended to Randolph by the State Arts Agency of South Dakota, Randolph said, where Knutson also happened to be the agency's chairman. Knutson was simultaneously dean of the Fine Arts Department at the state university.

Randolph employed William Meredith as a "reader/screener" for the 1974–75 fellowship awards. Thereafter, Meredith was also recommended to the panel by Maxine Kumin. Speer Morgan came to Randolph's attention through work published in literary magazines Randolph funded. Reynolds Price represented North Carolina. As a commercial novelist of considerable success, Price was something of an oddity among the panel's membership. Price, in turn, recommended James Welch, described by Randolph as a "Native American poet/novelist." The euphemism "Na-

tive American" meant Indian in bureaucratic sign language. Frank Scioscia, according to Randolph, was the one person on the panel to represent the attitudes of "trade," that is, commercial publishing. Scioscia was sales manager at Harper & Row, the commercial conglomerate cited by the Author's Guild and P.E.N.—the traditional writers' associations—as one of the most offensive threats to the First Amendment by monopolization; Harper & Row had gobbled up one small publishing company after another. The few representatives of trade publishing to sit on the NEA Literature panel were always connected with Harper & Row: Panel Chairman Simon Michael Bessie, a Harper & Row editor, was succeeded by John Leonard, an editor of the *New York Times* whose publishing corporation promoted books which were distributed by Harper & Row; Scioscia, the Harper & Row sales manager who joined the panel as an expert on distribution, was succeeded by Frances McCullough—who was at the time a senior editor at Harper & Row and who subsequently became chairman of NEA's panel. Harper & Row editors and authors were awarded fellowships from the NEA Literature panel in support of "noncommercial" publishing.

In response to recommendations by the National Council on the Arts to recruit "more people from the media to serve on the panel," Randolph appointed Robert Kotlowitz, the program director at WNET, Channel 13, New York—the station which had won the second round of bidding for "independent" documentaries funded by NEA's Media Arts program. Kotlowitz's interests, said Randolph, "in expanding public television into the arts is well known." Kotlowitz bought NEA programs for Channel 13, distributed them to PBS, and simultaneously represented "media" to literature. Summing up his experience with NEA's Literature panel, Charles Plymell thought Randolph's policy was to help small presses, or at least let them scramble for grants, but the procedures followed for fellowships were more guarded. "Those who got them were usually boy friends of old queens on the panel and those who think of themselves as an elite, but whom I don't regard as an elite at all. In Randolph's years the pattern was mostly toward academic grad school types, especially in areas outside D.C. and New York City."

Those who thought of themselves as an elite were flattered by all the hugger-mugger of secret meetings to pass out national favors, but the most important secret of all was that the Literature panel itself had only the vaguest notion of what they were approving. To begin with, all applications for fellowships were read first by "screeners" hired by Randolph. The panel could approve or reject the work placed by Randolph in a member's hands, but not the work the panel never saw. Moreover, the panel judged the applications placed before it by meeting in subpanels. There was no way for any "outsider" to know which subpanels had recommended what work to the entire panel. The subpanels were established by Randolph and their composition was, according to NEA, secret.

Whatever secrets the subpanels kept, or the Literature panel as a whole kept, it didn't matter anyway: no matter what the panels decided, Randolph could do whatever he pleased. The Literature panel made grants to individuals for fellowships, but also approved lump sum budgets from NEA to NEA's regranting "service organizations." After those organizations, such as CCLM or COSMEP, had raised the matching funds NEA required—but whether, in fact, they raised the matching funds or not— the regranting organizations could in turn award fellowships to the same fellows NEA had already given fellowships; or, when Randolph recommended it, to fellows NEA had refused. To confuse matters further, NEA claimed that its policy prohibited any awards of fellowships on a repeat basis: no fellowships to the same fellows year after year. Yet, the regranting organizations could award the fellowships at their command while the NEA tap was turned off for two years. Thereafter, the fellowship cycle could be repeated. Nearly 20 percent of NEA's fellowships were, in fact, repeats.

NEA's burlesque of its entitlements was not yet complete. The "outsider" had to understand how NEA also made grants to small presses, grants for the publication of chapbooks, grants for the maintenance of six regional nonunion and wholly owned "print" centers, grants for the establishment of writers' centers, grants in cooperation with universities, schools, prisons, and state arts agencies with respect to literature, and funded these activities at the same time their own regranting organizations were simultaneously doing so. In practice this meant that NEA and all of its regranting organizations might "independently" award grants, if Randolph approved, to the same small press, the same literary magazine distributed by that press, to the same distributor, the same editor, the editor's contributors, and to the buyers as well. In this fantastic closed circle, grants could be disbursed by NEA's Literature panel, by CCLM, by COSMEP, by the Western States Arts Foundation, a state, and the state university *simultaneously*, but without any of the various institutions involved knowing what the others had granted or refused, unless Randolph chose to tell them.

Not only were there no financial audits, there were no literary accountings. When a small press consisted of no more than one or two people— sometimes husband and wife acting interchangeably as publisher and editor—and when perhaps a dozen friends served as the magazine's entire list of contributors, the distinctions were fine between grants made as fellowships to writers, or for publishing to editors, printers, designers, or distributors. These niceties were further compounded when COSMEP or CCLM also made grants to the same small crowd; but still further confused if, at the time the grants were made to the principal figure in promoting the fortunes of a particular press, that editor or publisher was simultaneously serving as a member of NEA's distinguished panel on Literature. NEA ruled that no conflict of interest had taken place as long

as the beneficiary member of the panel left the room while the vote was taken to approve fellowships to six of his eight contributors, as well as a grant to his press and a fellowship to his coauthor for a work to be published by still another press on still another NEA grant, while everyone involved was simultaneously getting grants from COSMEP and CCLM which were also approved for grants by the same NEA panel.

Such cases soon raised angry charges of favoritism, inside deals, and obvious conflicts of interest. NEA countered, replying that it was "monitoring" conflicts of interest closely, but admitted that a reading of NEA's published annual reports showing panelists and awards might give an "outsider" the impression that panelists were giving each other grants. NEA's counsel, Mr. Robert Wade, issued a special NEA directive to panelists, reminding them of their moral responsibilities; but NEA's ethical code, said Wade, had to allow for exceptions, because "the interests of the arts require a maximum contribution from the leaders in each field." As to various allegations that had cropped up about favoritism, about friends funding friends, Liv Biddle answered that he didn't know of a single case where a panelist was involved in his own award. "I don't know quite how to make a better system," Biddle declared. "The present one depends upon the experienced individual and the private citizen in the field. Otherwise you'd have a bureaucracy taking over. Then you'd have a chairman that would be an arbiter of taste, and that would be a disaster."

Such hypocrisies infuriated the literary community. Without authorization from Congress, absent any grants from the Ministry of Culture, writers began to collect their own evidence and to provide their own testimonies. Biddle explained to Congress that whatever NEA did, its actions were taken collectively—in decisions made by private individuals "in the field." Such outright characterizations of literature sovietized promptly created an opposition. Collectivization became the topic of samizdats. Felix Stefanile, editor of Sparrow Press and professor of English at Purdue University, enjoyed tweaking the noses of NEA Literature panelists. A.D. Winans, editor-publisher, Second Coming, Inc., San Francisco, corresponded with NEA officials, then published the answers to "the field's" laughter. Richard Kostelanetz published special issues of Precisely Two on NEA's tangle of grants. Geoffrey Cook described NEA's arrogance in Margins. Susan Wagner continued to follow the story for Publishers Weekly. Writers, poets, and editors swapped stories, Xeroxed lists of panelists' awards to each other, identified married couples picking up grants under different names. They knew who lived with whom. They watched who traded what grant to whom and when. If Liv Biddle did not know of a single case where a panelist was involved in his own award, they could name names, dates, and places. They simply ignored Robert Wade's legal mumbo jumbo about what NEA claimed was "secret" or "private," accumulating from the public record and community memory

whatever they pleased. As quickly as NEA put up barriers between NEA's political awards to literature through regranting organizations, the writers tore them down. They were slandered by NEA's officials as "a few disgruntled applicants for grants, whining about an unfair system;" but most of those who complained would have nothing whatever to do with NEA and they laughed at NEA's slander of their motives. Because they knew literature and operated their own presses, they were quicker and wittier on pennies than NEA could be with ponderous millions.

Among many historians of the NEA literary follies, Eric Baizer of Washington, D.C., was the most inventive. He had never applied for any NEA fellowships for his small White Murray Press, Box 14186, Washington, D.C. 20044. Baizer was never a disgruntled applicant, but an appalled outsider. His press was named for his cat, and under his cat's name Baizer began to publish by *samizdat* a running history of NEA he titled *Literaturgate*. His letterhead described the activities of White Murray Press as: "Poetry and Reviews/Trumpet, Flute and Sax Playing/Criticism of Federal Arts Funding/Impressions of Walter Brennan." Actually, Baizer did not need much practice for his imitations of Walter Brennan. Baizer was nearly six feet, about 165 pounds, and appeared to have been sent over from central casting to play the part of rumpled poet. He shambled into literary controversies, as if wandering into a funhouse by mistake. Then his intensity, the quickness of his speech, and his ideas tumbled out as he remembered details of NEA hypocrisy. Baizer believed NEA was steeped in frauds and giving literature a bad name; at the same time he thought NEA's pretenses funny. Revelations of fraud posed few dangers to NEA's sovereignties; but Baizer's ridicule might hurt.

Baizer published his own history of NEA, and it began to appear in *Literary Monitor*. He explained that he had originally had no interest in NEA, no idea of how it worked, and only began to be curious after an NEA Literature program specialist appeared on a radio talk show for which Baizer was cohost. The NEA official's answers to Baizer's questions were so vague, so contradictory, that Baizer decided to follow up. He asked for biographies of the members of the Literature panel. He was told all he had to do was phone NEA and the biographies would be sent over. Baizer phoned again and again, but the biographies never arrived. Finally, Baizer hired a lawyer, paying the fees from his own small salary at his regular job, and began filing formal Freedom of Information requests for the biographies and other matters pertinent to the funding of literature. For each of Baizer's requests, months passed. NEA was evasive. NEA claimed that biographical information on the panelists was exempt from public disclosure under the provisions of the Privacy Act. Although the Freedom of Information Act, the Federal Advisory Committee Act, and the Privacy Act itself actually contained no such exemptions, NEA's counsel, Robert Wade, piled up legal barriers to providing information, much of which Baizer already had, or could get, in the public domain.

NEA's insistence upon secrecy was exactly the same as the claims made by Justice and Energy against Howard Morland and the *Progressive:* what was secret became secret when NEA declared it to be secret. When NEA persisted in refusing biographical information on the panelists, Baizer filed a Freedom of Information administrative appeal. It took a month, but Livingston Biddle finally had to answer one of the questions Baizer had posed. Baizer had asked for the age of each panelist; Biddle's answer in its entirety read: "As of December 31, 1978, the ages of the Literature Advisory Panelists were 32, 34, 34, 35, 35, 36, 36, 37, 37, 38, 40, 40, 46, 46, 59, 63, 65."

Biddle claimed, however, that names which corresponded to the ages he had provided were secret without the consent of the panelists. Whereupon, Baizer filed Freedom of Information requests to determine which panelists had served on which subpanels in awarding literature fellowships. Wade replied that subpanel information was secret; in any event, the panel as a whole approved the grants. Wade included a list of the panel members who had voted on NEA's grants at a specific date and at a specific meeting. Baizer checked by telephone with panel members to discover whether those members NEA claimed had voted were actually present. Some said they were not. Baizer filed again with NEA to inquire how absent members could be recorded as having voted in favor of grants.

Baizer had originally intended to write a straightforward piece on how the Literature panel of NEA worked. He soon began to wonder why arts funding was so secretive: what did they have to hide? He was one of a handful of "outsiders" to attend the "open" meetings of the Literature panel. He noted that the National Council on the Arts did not include among its members one novelist, one short-story writer, poet, or playwright. He asked: "If I submitted a poetry book for NEA funding, would /council member/ Clint Eastwood read it?" Leonard Randolph replied that Clint Eastwood was one National Council member who loved poetry very much indeed. Baizer agreed, thereafter, with Merrill Leffler's opinion in the June, 1978, issue of *Crawdaddy:* "The word is that if Randolph is sympathetic to your proposal it will go; if he isn't, forget it. So Randolph can use muscle on things he doesn't like."

As Baizer continued his investigation of the inner workings of NEA, he assembled and continued to update the best bibliography available on NEA. He published it and sold it to anyone for $1.50 and a self-addressed stamped envelope. He was inventive enough to get himself added to NEA mailing lists of all kinds—including the NEA mailing list in which NEA advertised for congressional liaison specialists. Baizer, Winans, Stefanile each wrote NEA on the same topics, then swapped, and published the various NEA answers. As part of their underground *samizdat* war against the sovietization of American literature, they kept lists from year to year of which grants went to which gang of friends at NEA itself and at NEA's regranting organizations, CCLM and COSMEP. As part of his

continuing history of NEA's politics, Baizer interviewed, preserved on tape, and published leading poets, editors, and writers such as Allen Ginsberg and Charles Plymell. Baizer noted that Plymell was praised by critics as one of the outstanding poets of his generation; hundreds of Charles Plymell's poems had been published in the United States and Europe; Plymell's collections included *The Trashing of America* and *Are You a Kid?* and Plymell was also the author of a novel, *The Last of the Moccasins.* As a friend of Ginsberg, and as editor of *Northeast Rising Sun,* Plymell had been an eyewitness to NEA's war against independent intuitions, and Baizer recorded Plymell's history. It was the traditions of poetry itself that Plymell was moved to defend against NEA's *apparatchniks.*

Plymell thought the fellowship awards had something built into them which made them entirely manipulative. They were set up so as to bypass any criteria except the materials on the page in front of the panelist, which were minimal, but could be coupled with NEA words, such as "quality," "serious," "excellent," and thereafter argued as entirely defensible, excusing an appointed panelist for giving awards to his or her friends. The publishing grants were different in Plymell's opinion, with a little more credibility, because unlike the NEA fellowship grants, with a publishing grant someone had to publish something. When NEA first began funding small presses, Plymell supposed those involved in NEA's hierarchy believed they could rake it all off for themselves: "old grant barons like DeWitt Henry of *Ploughshares* . . . Phillips, the APR gang." But then the small-press industry started to make its claims. Still, Plymell said, "the stacking is obvious."

He cited CCLM as an example: the CCLM membership elected some members to its panels, but CCLM administrators, who were paid by NEA, kept a certain number of appointive seats on the panels. Although CCLM's unanimous votes on undisputed choices were "democratic," votes on debatable issues were cast by a carefully chosen group of panelists who were appointed by CCLM's administration. The appointed panelists could be used to create majorities with any splinter faction of the panel—a system of "democratic centralism" copied from the collective procedures of soviet, or "council" politics. As a result, Plymell said, CCLM favored mediocrity and academically oriented editors. Plymell cited the controversial *13th Moon,* edited by Ellen Marie Bissert, which was turned down for CCLM grants, while a safe mediocre magazine, *Calyx,* received a $30,000 NEA development grant. Plymell also described the outrage within the small-press community because Ron Padgett sat on an NEA Literature panel while fellowships of $10,000 each were awarded to six of his eight associates in the St. Mark's poetry group; further, that a CCLM editor's fellowship was awarded to Maureen Owen of the St. Mark's group, and she had also been awarded an NEA fellow-

ship—before Padgett joined the NEA panel, but while Maureen Owen was herself a member of the CCLM panel.

None of NEA's fevered literary activities were related in any common-sense way to literature; they were the political procedures typical to "insiders" of a politically motivated establishment; and political activities and favors were inextricably tangled with social adventures. During Leonard Randolph's years as head of NEA's Literature program, Plymell sat on a CCLM panel at a meeting in Albuquerque, New Mexico. The CCLM meeting included addresses by CCLM's officers and poets to "the little magazine community." Small-press people arranged themselves in power clusters amid the litter of cigarette butts and styrofoam cups stained with coffee, and clamored over the "serious" business of poetry and grants. Later, at a party held in a CCLM board member's house in Albuquerque, most of the CCLM board members were there to watch while an NEA Literature program official zeroed in on Charles Plymell.

Although Plymell was a married man, he said that in retrospect he had to suppose the NEA official was to some degree justified: the official probably associated Plymell with Plymell's friends—Ginsberg, Burroughs, and company, and their blatant homosexual activity. Plymell had a lot of gay friends, but he was confused and didn't know how to handle the NEA official's advances. Also, Plymell wanted very much *not* to start a ruckus in his host's home. The NEA official persevered, pouring Plymell stiff drinks and talking about the beauty of the O'Keeffe-like clouds floating over the New Mexico patio. NEA's heavily romantic gazes soon turned to overt advances. He lunged at Plymell's crotch and attempted to unzip Plymell's pants.

Plymell recalled that the NEA official hung on his every move and was very strong. Plymell could easily sympathize, he said, with women who had undergone the same kind of outrageous treatment. "It was like trying to get out of the embraces of a giant drunken Afghan dog who plops into your lap."

To the annoyance of the host, Plymell maneuvered a chair under NEA's man and announced, "This man's had too much to drink."

But nothing would deter the NEA official, and Plymell was soon entangled again in his embrace. Plymell danced around with him, "kind of holding him up as well as my zipper. I mused that *now* he puts the make on me *after* all the fellowships have been given out! There's no justice."

Plymell turned to Ishmael Reed, who was standing nearby, for some kind of help. "What's wrong with him?" asked Plymell.

Reed replied: "He just didn't have enough teddy bears when he was a kid."

What was damaging to literature was not that teddy bears were in short supply in Albuquerque, but that NEA pretended they operated a system in which no teddy bears were ever present, no passions ever expressed,

no eroticisms ever connected to NEA's sponsorship of poetry. Because the subject matter of poetry concentrated on the wonders, the loves and acts of birth, life, and death, a conclave of poets who ignored the nuances of sex would be a seminar of mutes. The rhythms of sex were a delight to literature; but NEA's claim of political sovereignty to call the tune was offensive to poetry's jurisdictions. At another NEA-sponsored meeting, this time a COSMEP convention in Massachusetts, the small-press people again brought their wares and displayed them on rickety tables. Some came from as far away as California and the Carolinas to have their work seen by the grand panjandrums of official literature. At the COSMEP conclave Charles Plymell saw Leonard Randolph's capacity for passionate outburst. As poets slipped away like a caucus of slugs, afraid they too might be included, Randolph told one poet-publisher, "You'll never get another grant."

Later no one could say exactly why NEA's director of Literature was blacklisting a COSMEP poet. Nor was it exactly clear what had aroused Randolph's passions in 1976 when he began a patronage war against NEA's own "regranting" apparatus, the Coordinating Council of Literary Magazines. A group of writers and editors founded CCLM in 1967 to lobby NEA for national dollars. From the moment of CCLM's establishment, NEA was CCLM's principal patron. After Nancy Hanks evaporated George Plimpton's *American Literary Anthology* for "procedural" faults, CCLM began to serve as one of NEA's buffers against congressional criticism and as a conduit for national funds to writers, editors, and magazine members—eventually numbering about 500. The CCLM conduit was entirely "independent" of NEA's Literature panel awards, and like a CIA "front," CCLM had "deniability"; but in 1976 Randolph was complaining that CCLM spent more than one third of the funds NEA provided on CCLM's administrative expenses and salaries.

CCLM argued the expenses and salaries were necessary because CCLM was providing the grant committees, advisory boards of consultants, and an "independent" board of directors which otherwise would be overhead costs of NEA's operations. Moreover, CCLM raised "matching funds" from corporations, foundations, and states—something NEA was forbidden to do. As Randolph began his CCLM patronage war in 1976, CCLM could show that its annual budget of about $350,000 had been "matched" recently by a Ford Foundation grant of $439,636 to develop a three-year program of distribution for "noncommercial literary publishing." Leonard Randolph pointed out that the Ford grant was the first such major fund-raising "matching grant" raised by CCLM; that the grant covered three years and was not a "match" of CCLM's annual budget; that CCLM was spending $150,000 each year for its headquarters costs out of the $400,000 provided by NEA; and that NEA was in reality CCLM's sole patron. Randolph apparently intended to eliminate CCLM as a middleman in distributing NEA's grants.

Randolph's Literature panel at NEA soon included representatives from COSMEP, the NEA-funded competitor to CCLM in distributing national grants. As COSMEP representatives were added to NEA's Literature panel, CCLM representatives were dropped. The Literature panel suddenly became generous to COSMEP's members and COSMEP projects, including a major grant for a book van that was such a wreck it had to be abandoned in a North Carolina parking lot. In December, 1975, Eleanor Shakin, executive director of CCLM, asked Randolph about CCLM's grant application for the following fiscal year. Randolph told her to submit an application for a grant of $400,000, budgeting the amount over fifteen months instead of the usual twelve in order to cover a transition period resulting from a change in the fiscal year of the national government—a year to end October 31 instead of July 31. The conference between Randolph and Eleanor Shakin was typical of NEA's grant procedures: favored grantees were told in advance how much to apply for, what period to cover, what activities to include, and which ones to omit. The resulting proposal submitted as "a grant application" for debate and review by the Literature panel, and thereafter by the National Council on the Arts, had the advantage of being reviewed in secret and approved in advance. In CCLM's case, the grant application also provided more than 50 percent of CCLM's total funds, and involved "direction" by an officer of the United States. All of these orderly procedures were in violation of NEA's statutes, but were justified by NEA's continuing goodwill to literature.

During the December, 1975, conversation with Randolph, Eleanor Shakin requested a meeting between the Literature panel and representatives from CCLM—following a practice previously established by Randolph. Under the "Privacy Act," meetings of the literature panel were secret, of course, from inspection by "outsiders," but not secret to favored grantees. In December, Randolph said that no meeting would be necessary and might, in fact, "be counterproductive."

Meanwhile, Ron Sukenick, chairman of CCLM, had requested a meeting with the Literature panel during its February 28, 1976, meeting in Washington. Randolph told Sukenick there would be no time available to hear CCLM officers this year. Instead, in March Randolph met with Eleanor Shakin and Ron Sukenick in the CCLM office in New York. Randolph said that CCLM's grant had been "conditionally" approved for the coming year, but the majority of members on the Literature panel had "grave reservations" against spending money from the Literature program budget on administrative expenses for an organization to give grants to literary magazines. The task of making grants to literary magazines—and the concomitant costs—was a work the Literature panel now felt it could carry forward itself.

What the Literature panel actually said during its meeting of February 28 was secret. Whether NEA's change in policy with respect to literature

was debated by the National Council on the Arts was also secret. The National Council was the sole body with statutory authority to make grants, of course, but whether its authority had been used to make a "conditional" grant was not entirely clear, because "conditional grants" were not listed among its authorities. Randolph directed CCLM to prepare documents explaining CCLM's administrative costs. Randolph's directive was a violation of NEA's charter, but CCLM forwarded its explanations to Randolph on April 8, 1976. Sukenick requested a meeting with the Literature panel again. Randolph assured Sukenick that he would set up the meeting in August.

In April, Randolph flew to New York to attend a combined meeting of CCLM's board of directors and its board of consultants. He explained again what he said were the Literature panel's "concerns" with CCLM's administrative costs. CCLM defended its costs again, pointing out that CCLM followed procedures in making the "sensitive judgments so necessary" to literature which were consistent with NEA's own procedures, and the attendant administrative costs were unavoidable. CCLM's officers asked Randolph about the current disposition of CCLM's grant application for the coming year 1976–77. Randolph explained that there were "administrative problems" in processing applications as a result of the change in the national fiscal year. The administrative delays were unavoidable. He said nothing about a review by the Literature panel of CCLM's application in Washington at the panel's May meeting.

Nine out of fifteen members of the Literature panel met in early May in Jackson, Mississippi: those present included Maxine Kumin, John Coe, Wayne S. Knutson, Robert Kotlowitz, Glenna Luschei, William Meredith, Speer Morgan, Reynolds Price and Frank Sciosca; those absent were Jack Shoemaker, Jose Ramon de la Torre, Ernest Gaines, Albert Goldbarth, John Leonard, James Welch. The minutes of the May meeting were secret, of course. Three years later NEA claimed the minutes of the 1976 May meeting were still secret.

In the course of two or three telephone conversations during late spring and early summer of 1976, Eleanor Shakin asked Randolph for information about the status of CCLM's application to NEA for its annual grant. Having heard nothing from Randolph to the contrary, CCLM assumed that Randolph's "conditional" approval of February was still in effect. The delay by NEA was the result of NEA's "administrative difficulties" with the new fiscal year, of course. Eleanor Shakin pointed out that CCLM's fiscal year ended June 30, as did its grant from the previous year, and that therefore CCLM was continuing its operations on faith. Randolph said the meeting in August between the NEA Literature panel and CCLM—the meeting Randolph had promised Sukenick in March— might not take place because NEA's operating budgets for literature were running short.

But in the middle of July, Randolph informed CCLM that a meeting

between CCLM and NEA could take place after all. Four representatives from CCLM were invited to travel to Washington. Although CCLM had passed its own fiscal year by six weeks, Ronald Sukenick, chairman of CCLM, Ishmael Reed, vice-chairman, Eleanor Shakin, executive director, and Suzanne Zavrian, director of the Ford Foundation-financed "distribution project," met Randolph at NEA's offices in Washington on August 7. At the meeting of the Literature panel in Jackson, Mississippi, in May, Randolph revealed, NEA's panel had voted unanimously to cut off all of CCLM's funds. Three years later, Randolph's successor as director of the Literature program, David Wilk, said that NEA had never cut off CCLM's funds. When Wilk was asked if minutes of the May meeting were made, he searched the records and answered that there were minutes. When asked if the minutes could be read by an "outsider," Wilk said he had consulted NEA's counsel, Robert Wade, and unfortunately the minutes "could not be made available." Those attending the meeting in Randolph's office on August 7 objected because Randolph tape-recorded the conference without permission from CCLM's representatives. When asked if the transcripts of the August meeting between Randolph and CCLM were available for inspection, David Wilk again consulted with NEA's counsel. Wilk regretted that the transcripts could not be made available.

Whatever the minutes of these secret meetings might have shown, Randolph explained that the National Council on the Arts had reversed the recommendation of the NEA Literature panel in May, and "in the interest of the orderly processing of funds to be granted to literary magazines in 1976–1977," the chairman of NEA, Nancy Hanks, had approved a grant to CCLM of between $250,000 and $400,000. Exactly why the National Council on the Arts decided to reverse the conclusions of its Literature panel was secret. The decisions on how the spread between $250,000 and $400,000 in grants would be made were decisions of Leonard Randolph. On August 7 he made it clear to CCLM that the Literature panel was bound by the decisions of the National Council; but the Literature panel, according to Randolph, wanted CCLM's grant-making functions ended. NEA could handle them directly.

The CCLM representatives returned to their offices and began to lobby for their survival. In August, Randolph telephoned to say that the grant amount would be $400,000 after all. In September, CCLM wrote its members to say the situation had been resolved for the moment: it would be another good year for magazines; CCLM members could apply to both NEA and CCLM for grants; but CCLM pointed out that the procedures followed by NEA were frightening: "Direct control by a government agency of all magazine grants is a much more effective control of the future of noncommercial literary expression than is direct censorship."

CCLM summarized the implications of NEA's procedures: "(1) it puts all power over federal money for literature into the hands of a small group

of people controlled by a government bureaucracy; (2) It puts this power into the hands of a group that is, for one reason or another, capable of acting in secrecy and in a duplicitous manner." In November, Leonard Randolph's serene and untroubled answer to CCLM's charges of censorship, secrecy and government control began: "There is no dispute between CCLM and the Literature panel. CCLM is, again this year, as it has been since 1966, a grantee receiving by far the major portion of its funds from the Literature Program of the National Endowment for the Arts."

Randolph continued, point by point, to allege that in a memorandum to CCLM members Chairman Ron Sukenick had been involved in "major distortions" in explaining a controversy that had never happened. After the 1976 squabble, Leonard Randolph continued to use CCLM and COSMEP as conduits for NEA's grants—in addition to the grants thereafter made by NEA itself directly and through Randolph's system of recommendations to state, foundation, and other government programs. By 1980 NEA funded over half of CCLM's adventures, more than half of COSMEP's ambitions, nearly half of P.E.N.'s budget, more than half of Poets & Writers, Inc. Despite prohibitions in NEA's charter to the contrary, NEA was in command of all "noncommercial" literature organizations. CCLM's fears in 1976 about censorship were eventually quieted by continuing NEA money. Many of NEA's most vocal critics were subsequently fortunate enough to be awarded "fellowships" despite their past criticisms, including CCLM's former chairman, Ron Sukenick.

As soon as Randolph had smoothed over the CCLM controversy, he was faced with another embarrassment. By political maneuvers a group of poets who described themselves as "New Populists" won control of CCLM's elective Literature panel. One of the victors expressed her pleasure at winning a seat at last upon CCLM's panel. She was quoted as saying: "I've been waiting ten years to get this revenge."

The new CCLM panel decided to fulfill their responsibilities as a conduit for NEA's literature grants without passing any judgments at all upon literary quality. To do so would not be "democratic," according to the manifestos of the New Populists. Therefore, an eight-page mimeographed newsletter founded yesterday had to be considered "equal" to a thick quarterly, even if the honored quarterly was over a hundred years old. Futhermore, since NEA claimed that no "means tests" were applicable in distributing national monies for literary excellence, it logically didn't matter one whit that a CCLM award to an eight-page mimeo newsletter constituted the newsletter's entire annual budget as opposed to an award which amounted to 1 percent of the quarterly's budget. The CCLM panelists divided the amount granted by NEA to CCLM by the number of applicants, and then distributed the quotient equally to all. The amount worked out to be exactly $930.23 for each press; the officers of CCLM solemnly mailed checks to all who had applied.

After the New Populists extracted their revenge from the elitists at NEA, Randolph was required to jiggle his patronage system once again. During the course of these political squabbles over the literary pie, David Wilk of *Truck Press*, and a sometime panel member of CCLM, wrote Randolph in support of CCLM's goodworks. Wilk complained about the secrecy at NEA: there was no way to find out what actually went on. He thought the questions about how NEA was funding literature should be "aired in public." He pointed out that rumors and misinformation were frequent. He cited NEA's procedures as faulty, lacking any indication of how grant applications were run through the NEA Literature panel, "which is both non-elective and self-perpetuating, semi-anonymous and hardly representative of the community it would be serving."

When David Wilk succeeded Leonard Randolph as director of NEA's Literature program in 1979, he was required to reverse his 1976 characterization of the Literature panel as self-perpetuating, semi-anonymous, and hardly representative. As soon as Wilk exercised NEA's powers, anyone who quoted Wilk's previous comments on NEA was "misguided." There were other embarrassments to Wilk's accession. In January, 1979, Miss Ruth Dean wrote a long summary in the *Washington Star* about "friends helping friends" at NEA's literature operation, while hiding behind the word "quality" as an excuse for selecting one grantee over another. Ruth Dean pointed out that Wilk's associate director for literature, Mary MacArthur, was the publisher of *Gallimaufry Press*; that the coeditor of *Gallimaufry Press* with Mary MacArthur was Jonis Agee, who was Wilk's wife; that *Gallimaufry*, quite sensibly, was distributed by Wilk's *Truck Press*; that Wilk had served on the board of COSMEP and MacArthur on the NEA Literature panel; and that while MacArthur was on the board of NEA's Literature panel, five "contributors" to *Gallimaufry* had coincidentally won "fellowships" from NEA.

There was more. Mary MacArthur had been a member of the NEA Literature panel since 1976. She was also a founder of the Writer's Center at Glen Echo, Maryland, just across the District of Columbia border. The Writer's Center got NEA grants while Mary MacArthur was on the NEA Literature panel: $5,000 to support "visiting editors in residence" in fiscal 1978; another $13,100 grant in 1978 for a phototypesetter, a grant, according to NEA, to be used for "institution and independent press publishing," and grants for a graphic production assistant and for administrative costs and resource materials, "serving as a resource to small press editors and to instruct in design, layout and printing." *Gallimaufry* was, oddly enough, typeset at Glen Echo, where coincidentally Mary MacArthur was head of the editors' workshop. One week after she was reelected to the Glen Echo board of directors, she resigned and stopped publication of *Gallimaufry*—but only after Ruth Dean's inquiries about conflicts of interest. Mary MacArthur told Ruth Dean she "couldn't

really understand" the connection that was made between her duties as literature panelist for NEA and head of the Glen Echo workshop "because I've really been so active in so many activities and with so many people."

The total monies for Glen Echo were on the order of $73,000, not counting fellowships, for 1977 and 1978. In a letter to Felix Stefanile, Mary MacArthur said, "I have no idea how you arrived at the figure of $37,300 in federal grant money awarded to me in 1977 and 1978. I have never received *any* Literature Program or other federal grants while I served on the panel (from August 1976 to December 1978). I did receive two grants from CCLM during the period you mention (1977 and 1978); however those were not federal grants, the Endowment has no say over the awarding of those grants, and the grand total scarcely came near the enormous sum you mention. All of the CCLM grant money was spent on the publication of *Gallimaufry Journal,* primarily for production costs and payments to authors."

Gallimaufry's income was also derived from book sales, Mary Mac-Arthur pointed out. These sales, however, were earned by distribution through David Wilk's *Truck Press.* Wilk had never accepted any NEA grants for himself either, but Wilk's Truck Distribution published *Truck Press* and *Truck Magazine* and Wilk's publications advertised *Gallimaufry's* publications. Wilk's Truck Distribution service was one of two literary truck distribution services. Wilk's service received NEA grants of $7,500 in fiscal 1977, $16,530 in fiscal 1978, as well as grants from CCLM, where Wilk had also served as a member of the panel.

Actually, Mary MacArthur had received publishing grants in 1976 during Randolph's patronage war with CCLM, just three months before she was appointed to NEA's Literature panel. Since she was not yet a member of the panel, no conflict of interest could be adduced. Similarly, the 1978 list of fellowships included Rita M. Brown, who was also listed as a member of the 1978—1979 Literature panel, but NEA's explanation cleared up any apparent conflict because the 1978 fellowship winners were decided in 1977, and therefore Rita Mae Brown only joined the panel *after* she had won her fellowship. The same held true for Lyn Hejinian, editor of *Tuumba Press,* whose grant in May, 1978, was made before she joined the Literature panel. As for Ann Pride, although she was treasurer of COSMEP at the same time she served on the Literature panel which awarded NEA grants to COSMEP, NEA had a policy of supporting "independent, private, non-profit efforts in the field."

Embarrassed by Ruth Dean's article in the *Washington Star,* Mr. Sidney Yates asked Liv Biddle at NEA's appropriations hearings if NEA had ever prepared an answer to Ruth Dean. Biddle said NEA's staff had prepared an answer. Yates also said that his committee had received a letter from Felix Stefanile, editor and publisher of *Sparrow Press,* with similar allegations, and NEA might want to reply to that too. The reason NEA might want to reply, said Yates, was obvious. The panel system was of

such consequence and such importance to the operation of NEA's system, "it is that layer in the bureaucracy, if I can call the seniors and the council members bureaucracy, it is that layer which is the key layer in the operation of the Endowment and I think it is essential that it be protected and as free of possible criticism as we can make it."

That was why, said Yates, he was raising these matters for reply. In response Liv Biddle's staff said they would enter their replies into Mr. Yates's hearing records.

But there was no reply from NEA at all to Ruth Dean's article. Nor did NEA indicate to Mr. Yates, or his House committee, that the sources of Miss Dean's article were to be found in NEA's own files. Instead, NEA put into the record a lengthy correspondence between NEA officers and Felix Stefanile. NEA omitted, however, the key letter from Mary MacArthur to Stefanile, dated April 30, 1979, in which Mary MacArthur explained which grants she got in 1976, 1977, 1978, and 1979 from CCLM or for Glen Echo press. With Mary MacArthur's key letter evaporated, a memorandum from David Wilk was entered in Mr. Yates's record. Wilk attacked Stefanile's letter as "inaccurate." Wilk asserted that "Mary MacArthur *never* received grants in 1977 and 1978; the figure of $37,000 ostensibly taken from Ruth Dean is entirely fictitous. Her 'federal grant record' (sic) consists solely of a single grant for publication of *Gallimaufry* in 1976." Wilk said that accusations of wrongdoing on Mary MacArthur's part were "most often received with incredulity, considering her reputation."

At the same appropriation hearings in 1979, Eric Baizer prepared testimony and appeared before Mr. Yates's House appropriations subcommittee as a public witness. Baizer reviewed the structural weaknesses in NEA's Literature program. Citing still other examples of conflicts of interest, Baizer was interrupted by Congressman Norman Dicks, sitting in the chair temporarily for the absent Mr. Yates, who had been called away to a memorial service for the victims of the Holocaust. As Baizer cited examples of friends helping friends, Dicks was incredulous: "You mean they make decisions on actual grants involving institutions on the board on which they sit?"

Baizer said that was what happened.

Mr. Dicks demanded names, specific examples—not just vague and outrageous allegations.

Baizer began to name names, dates.

Mr. Dicks cut him off. The subcommittee's staff would be getting back to the witness on that.

Months later, however, Baizer said the subcommittee staff had never contacted him to check the facts he had introduced. Despite its goodwill, Congress had wandered by mistake into the complexities of literature, a swamp in which it had neither authority nor experience. When Congress authorized its own investigations of the National Endowments, Congress

was at odds-ends when faced with its own conclusions. John Brademas, Democrat, Indiana, hearty supporter of the arts from the beginning of the New Foundation programs, was queried on the findings of the House investigation reports. He answered he was not impressed by them, "and from what I gather, Mr. Yates was not impressed either."

Brademas was asked what about the criticisms from "outsiders" that NEA and NEH were operated as "closed circles of friends," both as to acceptable philosophies and grant administration. Brademas adopted the line that there were bound to be disappointed applicants. "We want to be sure," he said, "that criticisms are not generated solely by disgruntled applicants who for good reason found their petitions rejected. I'm very familiar with that. People can always say, they didn't treat me fairly. The fact of the matter is they did not have a very impressive application."

When asked about existing cases of favoritism in grants awards at both endowments, Brademas was ready: "My own attitude on that is, as the old television series goes, I just want the facts ma'am. I want the evidence."

As Brademas was doing his "Dragnet" imitation, NEA was awarding the 1980 fellowships for literature, and a chorus of indignation swelled up in the literary community. *Samizdats* flew cross-country. Without authorization from Congress or grants from NEA, "outsiders" gathered testimony, computing lists of those favored by fellowships from overlapping "schools" and groups of poetry. Husbands and wives were identified receiving grants "independently" under different pen names. Baizer organized a group of independent writers from around the country who jointly signed a letter to NEA Chairman Liv Biddle protesting the "continuing instances of favoritism." The independent writers called upon Biddle to establish an "independent committee of experts" to evaluate NEA's program. As evidence, Baizer noted that Lyn Hejinian was on the panel while fellowships were awarded to three people she published: Clayton Eshleman, Ron Silliman, and Barrett Watten. "I think she was in the room when they were discussed," David Wilk admitted. "Our legal counsel said that was not a conflict of interest."

Wilk added that there were other times during the poetry panel discussion when Hejinian left the room during discussions of people who had published Hejinian's work, but the names of the members of the Literature subpanel for poetry were national secrets, of course; and the minutes of the meetings while 275 grants of $10,000 each were awarded were also secrets, according to the interpretation of NEA's counsel, Mr. Wade. Apparently not one instance of conflict of interest had yet come to the attention of Liv Biddle, Mr. Yates, or Mr. Brademas.

Writing in the *Home Planet News*, Zack Rogow charged that Wilk had met the indignation of literary "outsiders" with an attempt to silence dissent. To discover what had actually occurred during the Literature panel's secret meetings, Rogow had telephoned members of the panel

directly. He called Ann Pride, treasurer of COSMEP, who still sat upon NEA's parent panel while NEA awarded grants to COSMEP. In turn, Ann Pride apparently informed Wilk, who telephoned Rogow and directed Rogow to address all future questions to Wilk's office instead of "annoying" members of NEA's Literature panel. The day after Wilk's call to Rogow, Mary MacArthur, assistant director, circulated a memorandum to panelists urging them to pass all inquiries about Literature to NEA headquarters, and to decline inquiries from "the press" about NEA's procedures.

Rogow published what he described as a cover-up of a cover-up. Wilk wrote Rogow to claim "that I was not telling you not to call our panelists."

Whatever Wilk had meant to say, or whatever it was he meant when he said it, Rogow replied that Wilk's memory seemed to be playing tricks on him: Wilk's letter was a rephrasing of what Wilk had actually said— which was quite different from Wilk's call to not tell Rogow not to call. According to Rogow, Wilk had said he couldn't *force* Rogow not to telephone Literature panelists.

Although Wilk lacked the force to block questions about NEA's procedures, ambiguities continued over why Wilk and MacArthur were required to telephone "outsiders" and issue memoranda at all. Somehow, the program directors of the Ministry of Culture had maneuvered themselves into a position in which inquiries from the press they sponsored, or questions from small presses or great presses alike, had to be referred to headquarters where all the relevant documents were declared secret. When called, Frances McCullough, senior editor of Harper & Row and chairperson of NEA's Literature panel, referred queries to David Wilk. When asked whether she considered Harper & Row a press—in the sense that the First Amendment guaranteed a free press to all publishers as well as newspaper conglomerates, Fran McCullough said she'd never thought about it. When asked whether she believed the First Amendment covered the small presses funded by NEA and represented on NEA's Literature panel, Chairperson McCullough said she didn't know. When asked whether literature was covered by the principle of free press, she wouldn't comment; but as to the secret procedures, she offered that NEA's staff had instructed the panel that someday everything they discussed might be brought out into the open, because of the Freedom of Information laws. Eventually, the panel's secret procedures would have to be abandoned. When asked if she had received any memorandum from NEA suggesting that she not talk to the press, she said she didn't remember seeing any such memorandum.

When I asked him for it, David Wilk immediately mailed a copy of the MacArthur memorandum. When asked if NEA's Literature panel had been advised that its proceedings might eventually have to be open, Wilk replied he'd never heard that discussed. When asked why the panel was

required to meet in secret, Wilk answered that they were a panel of peers, and they would be open to criticism from the field and their peers for their private opinions. Commercial editors made their choices among their peers, and in the open, and I wondered why an NEA panel couldn't do the same? Wilk answered that the NEA panel was a panel of writers, not editors.

In fact, the NEA panel was headed by an editor and consisted of a majority of editors. All the secret memoranda, contradictions, examples of favoritism, scandals, and political maneuvers obscured how radical NEA's procedures were from how judgments were traditionally made in all the arts. Literature illustrated vividly what was true in every art, and illuminated NEA's unstated, but ultimate, objectives. To understand all the folderol about peer-review panels, it was only necessary to remember that no one but a conductor could choose who would bow his first violin. Until the advent of the National Foundation, no one had ever suggested that a panel meeting in secret and claiming the protections of the Privacy Act could decide whether a violinist should play, or could play, or could find C. In dance, George Balanchine would walk off the floor if he was directed to accept a prima ballerina because she had arrived with a matching grant from a patron—even if that patron was the New York State Council on the Arts. In literature, an editor read through manuscripts, poems, articles, serials, and short stories, as well as looked at the illustrations submitted, and then chose what he believed was the best he could get for his next issue. An editor acted in his own interest as an arbiter of taste. Every experienced editor would admit he had published work he thought was trash, but on the day he had to go to press he had no alternative except to print what he had at hand. Whatever he finally published, his rejections were signed in an open note. He might reject a piece because the issue at hand was already full, or had similar materials, or the cost of acquiring the piece exceeded his budget; a rejection might be encouraging and friendly, or rude and peremptory. Whatever an editor decided, his decisions were never anonymous, never made by a committee, never secret. Literature could not be secret, because it was published. The work an editor published as his choice in taste earned the editor his reputation. No editor could deliberately choose to publish trash consistently, because he would be ashamed to do so; no editor deliberately paid for futile, banal, or otherworldly material, because to do so would cut short his editorial career. No editor could afford to be an enemy of literature, any more than a ballet master could bring to center stage a klutz.

Although NEA complained to Congress of the heavy burdens placed upon their staff because the NEA staff was required to read 4,000 submissions for fellowship grants, NEA failed to explain that 4,000 submissions in a year were not really that many for an experienced editor, nor did the applications require complicated systems of screening. At the heart of the matter, NEA was promoting an astonishing fraud: an editor who read

submissions and paid money to encourage his contributors as NEA did, but never bothered to get completed work in return for the money advanced, was an editor engaged in some work other than literature; he was operating a system of cultural patronage.

The endowments of the Ministry of Culture were pursuing practices radically different from the traditions of literature or any of the arts. The first step in every art work required a collaboration and choices by the creator of the work and the producers, distributors, and promoters of the work to the community's attention. Choices about taste had to be made, not just openly, but obviously. Without exception, art dealers, conductors, ballet masters, and editors played favorites; but with visible responsibility and accountability for the aesthetic result. The procedures of the Ministry of Culture tossed all these customs and traditions overboard to convert artists—writers, poets, editors, dancers, folk singers, architects, painters, sculptors, playwrights, and all their promoters—into minor officials of the state propaganda machine. All the hugger-mugger about panels, secrecy, five-year plans, and the like were a smokescreen to disguise a political system which institutionalized futility and hoped for passive obedience.

The disobedient writers were angry about "conflicts of interest," about the sovietization of literature, about secrecy, but their principal objection to NEA's hypocrisies was that NEA's radical procedures were giving literature a bad name. The writers assumed that politics had no jurisdiction over poetry. Eric Baizer published a *manifesto* for poetry in the 1980s. Without assistance from any national grants, he job-printed and hand-numbered the pages of his declaration: "By the end of the '70's, the federal government & academia had drowned American poetry in a cess pool of grant corruption, sexual politics & obscurantism. Many ten year olds have more to say than the distinguished stars of academia. Universities turn poetry to dust. No great poet has ever been produced by a Washington backroom deal."

Despite slanders by politicians and officials of national culture, Baizer and the "outsiders" did not clamor for grants; they were not disappointed applicants. On the contrary, the effect of NEA's radical procedures had been to create an underground opposition. The poets were engaged in a literary guerrilla war against the fatuous slogans issued by the Ministry of Culture. In their campaign against the New Order, the poets collected and passed from hand to hand examples of atrocious poetry funded by the "insiders." Charles Plymell quoted with glee a p-o-e-m by panel member Ron Padgett: "Dawn breaks over the sprawling metropolis / You drink a glass of beer at three o'clock / Friends come and they go, the post office / Refuses a package, girls lie down / And they are fucked by huge turtles, a voice is heard."

Whether the officers of the New Order heard the voice of the turtle or not, Plymell objected to calling "these godawful lines" poetry. If Ron

Padgett wouldn't take his work seriously, Plymell asked, why should anyone else? An analysis of NEA's awards indicated to Plymell and to Baizer and to their partisans that nearly *one-third* of the total awards went to friends of friends. The dissidents pointed to repeated fundings to overlapping schools of poetry which were enemies of literature. While Padgett sat on the Literature panel in 1980, in addition to the six fellowships to the St. Mark's poetry group of which Padgett was a principal, over a dozen grants went to NAROPA, where Padgett was a favored reader. NAROPA, a secretive and sometimes violent Buddhist organization headquartered in Colorado, was a favored institution for NEA poetry grants. At NAROPA, Ron Padgett taught that poetry with meaning, structure, image, texture, was "too much work." Instead, Padgett explained how poetry could be constructed by writing questions on the top half of a page of paper, the answers on the bottom half, tearing the paper in two, collecting a stack of dismembered questions and answers, shuffling them, and then reading out the disjointed results: "Why do the archbishops gargle with rain water when balloons pop in the Park? Because it takes all your cabbage."

To the sensitive judgments so necessary in the arts, the NEA closed and secret system of official patronage found quality in Padgett's nonsense; that's why he served as a "peer" on the Literature panel while his friends at St. Mark's collected $60,000 and NAROPA $120,000. Although Liv Biddle could not think of a better system, others were proposed by those familiar with NEA's history. Following the lead of CCLM's New Populists, one proposal was to divide the 5,000 published authors listed by the *Author's Guild* into the aggregate totals distributed by NEA, its state councils, all university and foundation grants. Estimating the total of approximately $15 million, as a reward for being published once, each published author would get a check for $3,000 each year directly from the United States Treasury for the rest of his or her life. The advantage of the populist solution was that any publication was rewarded handsomely, but no politics or middlemen administrators would be needed. The populist solution would be an incentive for young writers. The elitists, however, countered with a proposal to rent the Houston Astrodome for an evening, fill the arena with a field of mud, and like the old country game of slippery pig, let all those who sought national literary fame wrestle for it. The elitists argued that no matter what was subsequently published, no one from Congress could possibly object. Moreover, all of NEA's bizarre guidelines on what was or was not commercial, profit or nonprofit, prose or poetry, could be eliminated. Hence, anyone could enter the contest, including previously excluded writers, such as William F. Buckley, Jr., Garry Wills, David Halberstam, Joan Didion, John Gregory Dunne, John Brooks and all of the *New Yorker* crowd, Frederick Forsyth, Lewis Lapham, and all the women who wrote prose, including Germaine Greer, Shana Alexander, Barbara Mahoney, Linda Francke, and Betty Frie-

dan. Even Rod McKuen, excluded from NEA's conduit system because he was too popular, could wrestle for it if he wanted to. The amounts contributed from the national purse could be "matched" by receipts from ticket sales to this star-studded event, as well as fantastic amounts earned from the sale of television rights. The entire program could be rigged so that at the moment Howard Cosell stopped the action, those still standing in the mud field would correctly match the budget calculated for prizes for the year—and the amounts could be truly grand.

By 1980, Charles Plymell was already at work on a more practical choice between these two extreme positions. Plymell believed that NEA had finally inadvertently created a way for Plymell's *Northeast Rising Sun* to make money. Plymell started a column in his magazine called "Litscam," which contained two kinds of material: examples of the godawful poetry funded by NEA's enemies of literature, as a demonstration that anyone could do it; secondly, an explanation to every *Northeast Rising Sun* subscriber on how to apply for NEA fellowships, and what to submit to NEA's Literature panel, depending upon the school of poetry established by its authority in the current year. If, for example, the Ron Padgett school of no-poetry was the best poetry, Plymell would instruct his subscribers how to tear up sheets of paper, sending to NEA's "screeners" the stuff that was "in," such as: "Why do monkeys throw crayons at stars? Because poets don't stand on their tongues." Plymell then bought ads in *Writer's Digest*, offering subscriptions to *Northeast Rising Sun* and describing the benefits of Plymell's new column "Litscam": "Here's how a couple made $20,000 in extra income from the federal government by just scribbling a few poems." In due time Plymell thought his promotion might get to be as big as the *Reader's Digest* sweepstakes: hundreds of thousands of graduates from creative writing courses all over America, scribbling away, entering NEA's literature contest every year. Very democratic; anyone could enter; surely NEA would pick the best from a million entries. Why not?

President Carter had called for an active, well-coordinated national culture; then surely everyone should be involved, not just the imperialists of academia, as Mrs. Mondale had called them. The White House had been leading the way. In January, 1980, Rosalynn Carter invited some 500 poets and "friends of poetry" to the White House—and who would be an enemy of poetry? The invitation billed the late afternoon event as a "Salute to Poetry and American Poets." Twenty-one simultaneous readings took place in corners on the White House ground floor, and as proportional representatives to America's diversities the readings included one Japanese-American poet, one Hispanic-American, an American Indian, an Israeli, and four blacks. Polish and Gaelic were not included, but might be next time. After the readings, the poets were greeted upstairs in the Red Room by the President and Mrs. Carter. An editor of the *New York Times Book Review*, James Atlas, was ecstatic:

"Here, in these disparate, independent voices, was an awareness of the collective possibilities of art, its capacity for expressing the experience of many classes and cultures. Art—to borrow an ideological term of the day —was no longer elitist, but the property of all."

A few artists might still wonder how their work had been put in the service of an ideology, but Mr. Atlas explained why the White House reception "offered the nation a glimpse of a literary revolution that has occurred over the last decade—a bewildering profusion of poetry in every form." He cited the *Directory of American Poets,* a reference work compiled by Poets & Writers, Inc. in New York. "It boasts," said the man from the *Times,* "nearly 2,000 entries, and many thousands more clamoring to be registered." He was substantially correct: a literary revolution was under way, directed and financed by the Ministry of Culture. The *Directory of American Poets* cited by Mr. Atlas was a fine example of the collective possibilities of art. Poets & Writers, Inc. published the directory with grants distributed by NEA and the New York State Council on the Arts. Although annual grants for the purpose had been made, the *Directory* was last published in 1975, with a supplement in 1977, but after that, Poets & Writers, Inc. had kept the names of poets "on file." Whether thousands more were clamoring to be registered, as Mr. Atlas claimed, there was no current directory. Yet the detail hardly mattered, as long as poets recognized that their work was now the property of all.

Writing in 1946 on *The Prevention of Literature,* George Orwell analyzed how the corporate state attacked intellectual liberty from two directions at once. The obvious assaults came from liberty's ideological enemies: the apologists of totalitarianism who censored outright—in the sense of "killing books"—excising passages or seizing the royalties due an author as a punishment for his intuitions. The totalitarians provided obvious examples: the Smithsonian bleeping out Erica Jong's passages on sex and politics; the National Park Service diminishing Mencken's colors; the Department of Energy attempting to hush Howard Morland and the *Progressive;* the seizure by CIA of Frank Snepp's royalties as if in imitation of Soviet seizure of the royalties due Solzhenitsyn.

These examples showed bullies demanding the right to tell lies, and their assaults were usually easy to repel because each time they censored they revealed some greater truth. In 1980, President Carter hosted poets at the White House and simultaneously sent to the Senate a bill demanding jail sentences for anyone who printed the name of a CIA employee, even if the employee's name could be obtained from a telephone book or from the book written by an approved CIA author. By demanding such peculiar legislation, President Carter demonstrated something that everyone more or less already knew, but found difficult to prove until the president cooperated by introducing bills of censorship: CIA was morally bankrupt and feared revelations about how they employed bullies and killers who had nothing whatever to do with gathering intelligence nec-

essary to the national safety. When CIA claimed secrecy exemptions from public scrutiny of its continued involvement in the international drug trade, CIA proved that their responsibilities for national security were entirely different from the assumptions held in the common opinion, or established by the laws that had authorized its operations, and contradictory to any reasonable expression of patriotism. Censoring opinions on radical CIA activities only served to advertise CIA's lawless conduct. When CIA asserted what Admiral Stansfield Turner described as "visible means of control" over books of fact and fiction as well, common sense instantly grasped how contemptuous CIA was of liberty, how ignorant Admiral Turner was of history, and why CIA's director was wholly unqualified to carry out the responsibilities with which he was entrusted. Assaults upon literature made by direct censorship were futile. Using nothing more than scraps of paper and a stub of a pencil, literature reported what ordinary men and women said, thought, and did, even inside *The Gulag Archipelago.* Short of murder, no force was adequate to silence literature, and even murder did not guarantee silence. When David Wilk said he could not *force* a writer not to call his Literature panel, he was spitting into the wind. No matter how much force NEA might command, no matter what CIA believed to be its inherent powers, no matter what the Supreme Court ruled, nothing would prevent writers from writing what they pleased. The most vicious tyrannies in history lacked the power to censor outright: consequently their crimes were fully recorded.

But the despotisms of the past used different procedures than the new totalitarian societies. Tyrants attempted to use force to silence dissent, if necessary by murdering their opponents; the New Order used its powers to erase reality. Instead of outright censorship, the officers of the New Order attempted to cage the whole imagination in the same cuckoo's nest with those who had given up their pasts, their futures, and everything else except the circumstances of a passive present. The New Order's assaults upon literature were directed by literature's ordinary, immediate, practical enemies, and George Orwell identified these as: the concentration of publishers; the monopolies in broadcasting and film; the encroachment of official bodies like the Ministry of Information and the British Council on the Arts which helped keep writers alive, but wasted their time and dictated their opinions. In 1980, the National Council on the Arts included among its members the representatives of power, monopoly, and bureaucracy, but no writers. As if following a program of mental hygiene, the policy discussions by the National Council on the Arts never touched upon the New Order's outright attempts at censorship, such as the *Progressive* case, or the Snepp case, or the procedural folderol to silence Erica Jong, H.L. Mencken, George Plimpton, CCLM, or congressional reports of the National Council's own inadequacies. It was as if none of these things had ever happened. A quiet requiem

had occurred. The National Council on the Arts knew nothing about American writers now exiled for their opinions, such as Philip Agee; or those who had adopted Ireland, exhausted by the assaults of the Treasury Department on the proceeds of literature. The National Council on the Arts never considered why CPB and PBS should be exempt from the worldwide copyright conventions; it knew nothing of the persistent conglomeration by publishers such as Harper & Row. It was ignorant of why lawyers now instructed writers to destroy all their notes. As a matter of policy, it never considered the writers serving jail terms for contempt of court; nor the lists of writers designated as "enemies." To the National Council on the Arts, it was as if these realities did not exist. The events never came to the attention of the National Council, even when reports of assaults upon literature appeared in the newspapers on the morning of the council's quarterly meeting. Meanwhile, the National Endowment expressed its continuing goodwill to literature by making grants to Poets & Writers, Inc.

By suggesting that writers accept tranquilizers in the form of grants, the Ministry of Culture hoped to diminish literature's power to engender heresies, but grants by themselves would not cage intuition, nor prevent its social and political consequences—doubt, disobedience, change, adventure. To prevent literature and to gain obedience to the unlimited powers of the New Order, a complex system of ideological institutions was necessary. All of these institutions simultaneously made claims of patriotism, goodwill, and secrecy. Each agency and department engendered to the limit of its abilities a continuous atmosphere of war, or diplomatic or technological crisis, because patriotic crises favored propaganda and suspended literature's independent intuitions of reality. Crises transferred moral authority from the lonely mind to the national officers appointed to ensure community survival. Hence, the director of Central Intelligence could silence one writer who revealed no secrets and had been, in the director's words, "circumspect," while capriciously allowing others to publish who had revealed secrets. Evidently no secrets were at issue, only power.

Officers of the New Order frequently excused their abuses by saying something to the effect that "it's a very real world out there," though no writer had ever imagined otherwise. The dispute between the New Order and literature centered on *who* had the authority to describe the real world. If even one writer could show why the crises of war or diplomacy or the technological moral equivalents of war were in reality frauds of community patience, the New Order's smiling goodwill would be unmasked. Behind the mask of an active-well-coordinated-national-policyfor-the-arts, "the very essence of our lives," literature might disclose the fevered eyes of power run rampant. In *The Prevention of Literature*, George Orwell sketched the necessary conditions to establish the bleak and terror-soaked world of *1984:* first, a continuous atmosphere of war;

as well, into a minor official, working on themes handed to him from above and never telling what seems to him the whole truth"; third, a corruption of language itself, so that whatever meaning words had once contained could be manipulated by ambiguous interpretations.

Humanities Report . . .

Robert Hollander, Jr., the departing vice chairman of the National Council on the Humanities who has earned a reputation as an inexorable watchdog of NEH during his tenure, exited with appropriate form at the mid-November meeting of the advisory council.

Hollander used his final hour as an NEH advisor to express his concern over NEH chairman Joseph D. Duffey's frequent use of "Chairman's grants"—funds which are approved at the chairman's pleasure for projects which are not required to go through the normal process of peer review. During the most recent grant cycle, Hollander noted, Duffey had given out 23 grants totalling $268,000—including a $15,000 grant to the Aspen Institute for Humanistic Studies which, in effect, overruled the Council's earlier decision to disapprove funding. Although the annual amount of almost $1.2 million is, Hollander acknowledged, well under the legal limit—10 percent of the Endowment's definite budget—he added that maybe the law itself was not well thought out. "I am questioning the wisdom of giving a chairman's grant when it could go through normal grant review procedures."

Chairman's grants, Duffey replied, are not exclusively emergency grants. Some, he said, go to projects that do not fit into any NEH program.

—Volume 1, Number 12,
American Association for the Advancement
of the Humanities

21

PROFILE / NEH: A JUST AND BEAUTIFUL SOCIETY...

When they want to do a thing in business, of course they must wait till there arises in their brains, somehow, a religious, or ethical, or scientific, or philosophic, concept that the thing is right. And then they go ahead and do it, unwitting that one of the weaknesses of the human mind is that the wish is parent to the thought.

—JACK LONDON
The Iron Heel

To distinguish the activities of the National Endowment for the Humanities from those of the National Endowment for the Arts, Joseph D. Duffey, chairman, frequently explained that NEH's responsibilities were "interpretative." Exactly what might be meant by "interpretative" in particular instances was subject to Duffey's interpretation.

Officers of the Humanities Endowment sometimes complained that NEH was not as well known as NEA; but if NEA was a guiding-light-for-the-arts-as-the-very-essence-of-our-lives, NEH was the central institution to an-active-well-coordinated-national-cultural-policy. Although Mrs. Mondale was well known as the honorary chairperson of the Federal Council on the Arts and the Humanities, Joseph D. Duffey was the *actual* chairman of the White House Ministry of Culture. When authorizations for NEA and NEH were approved in 1980, the expenditures for the twin endowments were projected through 1985. By then each agency would be spending about $300 million per year, but the amounts spent by either agency were meaningless unless their history was remembered: the deal struck at their founding during LBJ's administration was still being kept, and the "shotgun wedding" between arts and academia was a marriage that had ripened. Expenditures for the two endowments had continued to rise year by year, side by side, as they marched hand in hand toward a magic total of $600 million per year in national funds. To the extent that

330

projections made by the endowments themselves could be trusted at all, their national appropriation of $600 million was combined with "matching grants," "challenge grants," "treasury funds," regional and state appropriations, county, community and municipal appropriations; in turn, these sums represented only a fraction of still more millions spent by each of 300 other government programs to improve national culture under the aegis of HHS, Education, NSF, PBS, ICA, and so forth; and finally, all of these programs for culture were coordinated with university and private corporations, as well as with foundations established to make "ethical and political choices."

Although the combined dollar totals were extraordinary in themselves, the procedures used to make ethical choices were even more amazing. Without exception, all decisions on national cultural policy were made by councils and panels meeting in secret, which was peculiar enough in itself. Yet when secrecy surrounded the debates over the precise meaning of the word *humanist*, secret procedures were even more curious. Although the meaning of the word was constantly subject to revised interpretations, any secrecy to studies of humanistic interest corrupted the debate, contradicted claims of goodwill, vitiated the lessons to be learned from human nature, obscured the records of antiquity, diminished the shared joys of literature, weakened the analysis of philosophy, and restricted publication of *belles lettres* upon any of these topics. In the interpretation of learning, secret procedures clashed with learning's hopes, were anachronistic to learning's circulation, and illogical to learning's traditional modesties; as soon as secret procedures were adopted, they were evidence that those who employed them feared common opinion. The only kinds of secrets on the nature of man, or the study of man's fate, that had ever been justified as necessary in making ethical choices were *temple* secrets—the kinds of secrets kept by priests as mysteries from the uninitiated. When the officers of the National Endowment for the Humanities claimed secrecy was necessary to their procedures, their claims were identifiably the claims of priests.

The difficulty with assessing religious practices was that no true believer ever agreed how the particulars of faith were the identifiable sources of the believer's strange behavior. Calvinists promoted self-reliance, they said, and if "self-reliance" appeared to express itself as greed, the Calvinist was only doing the right thing. Popes were, from Rome's point of view, infallible because they were the vicars of Christ: consequently, all of the wars blessed by popes were in the natural order; and every heretic burned at the stake was justly sentenced. So too when cannibals boiled missionaries: the cannibals were engaged in ceremonies that were, without doubt, traditional customs. And when an eagle flew up at the death of Augustus, the vestal virgins who believed Caesar to be God had no difficulty thereafter rendering to Caesar all that the eagle had indicated Caesar was due.

Humanists who adopted temple procedures thus indicated by secret folderol the extent to which they were believers in humanism as the *religion of mankind.* Founded by Auguste Comte, usually identified as "positivism," but sometimes as "pragmatic humanism," the religion of Humanism favored a regulated system—a Great Society—with Love as its first principle, Order at its base, and Progress as its objective. As John Stuart Mill pointed out, Humanism was a strange religion because it appeared to be a faith without any god: yet humanism was a religion nonetheless. Its creed carried conviction, its sentimentalities were accepted by great multitudes of believers, and its priests claimed transcendental authorities to interpret the meaning of human life and to determine ethical and political choices. When humanists made promises for a world to come in which all nations could live in peace, they invoked powerful sentiments among their believers against the dismal anarchies and frightful disorders of a world in continuous war with itself. As evangelists for the General Welfare of all mankind, humanists preached that man was perfectible; demanded the services of every citizen to the great congregation of society; and easily demonstrated how the happiness of all depended upon the infinite duty to love one another, understand one another, and serve. To accomplish the collective objective of "everyone living for others," regulation of every nuance of social activity was obviously necessary. And so, in its practical aspect, Humanism undertook to coordinate every government operation by cooperating agreements with the great corporations and by consent of the Great Society's universities. Because universal altruism was the objective of a moral life, inculcation of that virtue—particularly by study of the social sciences—was the first principle of a humanist's educational system and a hundred great texts could be used to demonstrate the unity of all humanist thought. Thereafter, it should be obvious that the test of right conduct would always be conduct's motive: when acts were undertaken for the common good, they were by definition good; when acts were begun for independent reasons, they were "inappropriate." Cooperation and coordination were the keys: as long as approvals were obtained from the proper authorities. As long as progress was promised and goodwill asserted, there were no contradictions to any of the processes begun. If the catechism of the humanities seemed somewhat ridiculous, it was a creed promoted by giant budgets and with secret procedures by the National Endowment for the Humanities. Although the First Amendment prohibited the establishment of any religion which promised salvation in the afterlife, by logrolling Congress had approved without demur the propagation of a faith in the promised land here and now. As soon as NEH was understood as a religion, its absurdities were not foolish at all.

The offices of NEH did not look at all like those of a church. The endowment was housed in a commercial office building at 806 Fifteenth Street in downtown Washington. NEH was located about two blocks

from the White House, within two blocks of Washington's squalid zone of porno bookshops and skinflick theaters, and near the center of the main business activities of what amounted to a company town, where 30,000 lobbyists—about sixty for each elected representative—worked their trade. By the elevators in NEH's building the directory included the names of activities typical to Washington's devotions: the United States Parachute Association, Conrail Freight Sales Office, Population Association of America, Migrant Legal Action Program, Inc., and a local press program of Northwestern University, Inc. In the anteroom of Suite 1000, office of NEH's chairman, catalogues and "interpretative" explanations of the King Tut museum show graced the coffee tables. Some NEH officers were wistful that NEA and EXXON had seemed to get most of the credit for exhibiting the gold of ancient Egypt, whereas, it was actually NEH which had sponsored King Tut.

Chairman Joe Duffey agreed that NEH's public relations had often been inept. There had been, as Duffey said, "almost an air of secrecy" about NEH when he took over as chairman. That was why he had promoted NEH by a series of parties in Washington—and put up yellow and white striped tents on the Great Mall to advertise that humanities were "Civilization's Study of Itself." When I asked Duffey if *humanist* meant a man who believed in the religion of mankind, he looked surprised. A quotation from the *Oxford English Dictionary* defining the humanities as a religion apparently also surprised him. He said he'd never heard that definition. I read off the definition from the OED: "Any system of thought or action which is concerned with merely human interests, or with those of the human race in general, the religion of humanity; the devotion to those studies which promote human culture, literary culture, especially the system of the Humanists of Auguste Comte, or positivism."

The OED definitions, said Duffey, were not his interpretation. Not at all. Joe Duffey was self-evidently a man of goodwill: charming in the extreme; quick-witted, well read, thoughtful at the right moments; mindful of the difficulties, as he explained it, of coordinating demands of public policy with the contributions academic humanists could make. Duffey said it was possible to define the fields of "Humanities" and "Public Policy" with reasonable precision, though he agreed that definitions would naturally differ. He supposed, when it came to the humanities, he would be "something of what in Scotland they would call a 'broad church' man." On the other hand, he wouldn't want to say that any and all subjects belonged to the area of human inquiry defined as the humanities. He was satisfied with the list of disciplines that Congress wrote into the National Endowment for the Humanities legislation in 1965: "language, literature, history, philosophy, and so forth."

Any activity of declared goodwill not covered by interpretation of language, literature, history, or philosophy could be certified under the

guidelines provided by *so forth*, although the definitions applicable to *so forth* would naturally differ. If doubts remained about the Good News now enacted as a matter of law, Joe Duffey could explain. He hoped the humanities could house "our most creative efforts to make this a beautiful and just society." Although the definitions of what might constitute a "just society" were subject to many interpretations, Joe Duffey's explanations were rooted in a habitual goodwill to all men. He was a native of West Virginia, a graduate of Marshall University, and held graduate degrees from Andover Newton Theological School. He had started off as a Baptist minister, studied Lewis Mumford's social analyses of cities and power, taught at Hartford Seminary, and founded the Hartford Center for Urban Ethics. Then he gave up the ministry, took up politics, ran for the Senate in 1970 against Lowell Weicker, Jr., and lost.

After the campaign, Joe Duffey and Anne Wexler went to Paris. They stayed in the apartment of novelist James Jones while Duffey cleaned up a messy problem for the Ford Foundation and CIA. In Paris the Duffeys decided they'd try Washington, even during a Republican administration. They arrived from Paris at Dulles with five suitcases between them and ten letters of introduction. The letters were of little help. Politicians, it turned out, were fair-weather friends. As soon as Duffey's campaign had ended, all those who had urged him to run for the good of the party, the good of the country, to bring home the issues to the people, and so forth, could not find time to return his telephone calls when he needed a job. Duffey remembered it as a trying time. He said he really knew what it was like to stand outside the shop windows of power with his nose pressed against the glass.

Eventually he became chief executive officer and spokesman for the American Association of University Professors, one of the scores of lobbies for education located in Washington at One Dupont Circle. He served as chairman of the Democratic Committee's Task Force on Education. Early in the 1976 campaign, both Duffey and his wife, Anne Wexler, backed Jimmy Carter. In 1977, Anne Wexler became a trusted White House advisor to the new president and Joe Duffey was named assistant secretary of state for Educational and Cultural Affairs. When the White House reorganized Cultural Affairs out of existence by merging it into USIA to create the new ICA, Duffey was nominated, and eventually confirmed, as chairman of the Humanities Endowment. Simultaneously, he took over the chair of the Federal Council on the Arts and Humanities —the White House Ministry of Culture. Duffey effected the Ministry's various agreements to coordinate national culture between NEH, NEA, ICA, the Smithsonian, GSA, NSF, PBS, CPB, Education, CETA, and so forth. Although habitually modest, and casual, Joe Duffey was the statutory Minister of Culture, even if Joan Mondale got all the publicity.

Because Joe Duffey played a dual role as minister of the coordinating council and as chairman of NEH, what he had to say about national

cultural policy took on particular significance. The goals of NEH, Duffey said, were to promote public understanding and use of the humanities, and to relate the humanities to current conditions of human life. The transcendental values of the humanities were useful in the present, according to Duffey, to understand the ethical choices of human life. Relating the humanities to the American people was something more than "merely a process of disseminating a national culture." In Duffey's view, a "national culture" had begun to take hold in American life as early as mid-nineteenth century—a culture apparently different from the Western tradition that had preceded the New Revelation. To teach values, history, and promote among American citizens a sense of their human condition, the Humanities Endowment could not accomplish its ends directly, Duffey said, but relied instead upon the agency of hundreds of academic and cultural institutions, media groups, and community organizations. Yet Duffey hoped that carefully schooled thinkers and lay persons alike would work together "to build a culture." Duffey held that the humanities were not above everyday life, but inseparable from it; that the visions of the humanities were developed in a long tradition of thought "about what is moral and beautiful."

Defining what was moral and what was beautiful in the "humanities" and "public policy" required "interpretation," of course, and definitions would naturally differ, but NEH arrived at pragmatic conclusions through the processes administered by NEH. Because the motives of academic ethical choices were beyond criticism, and because NEH, NEA, and NSF and all the other agencies of the Ministry of Culture always expressed their goodwill to American society for all the programs their chairmen approved, there could be little doubt that whatever the agencies undertook was by definition "good." To explain the benefits of the "humanistic perspective" in achieving the aims of a moral, beautiful, and just society, Duffey said, the perspective of the humanities refined and sharpened present questions by placing those questions in history's context; as a result of the "complexity" of history's lessons, the humanities encouraged a habit of mind "which accepts contradiction and learns to anticipate objections."

"A slightly different way of saying the same thing," said Duffey, "is that the Humanistic tradition trains us to recognize that something of value is always lost in the advent of something new." In Duffey's opinion, the humanities were at work trying "to correct the errors of earlier misunderstandings."

The errors of the past could be corrected, Duffey explained, by viewing the benefits of science as "positive knowledge." The technical world, in Duffey's view, always sought to reduce, to set limits, and even to eliminate uncertainty; but the humanist cherished the element of mystery that remained. Duffey urged the acceptance of Baconian empiricism, what the Buddhists called "Vijn-Ana," the quality that evangelical Chris-

tians called "conviction," a fundamental attitude of mind—receptive to the world as it is, "humbly awaiting and welcoming its meanings for us."

One of the ways to experience the contribution of the humanities, according to Duffey, was to "stretch," to experience uncertainty by looking at the same phenomenon from several different vantage points: this was what was meant by "interdisciplinary inquiry." Our knowledge was part of a social construction and the sociology of knowledge, the contingencies of truth, were central to humanistic tradition. The humanistic insight, Duffey said, could become a path of intellectual liberation from the social world that surrounded us and locked us into limited ways of thinking that meshed with a limited definition of "reality."

When the perspectives of the humanities were adopted, "we are—at least for the moment of epiphany," according to Duffey, "released from the grip of the old limited realities." The humanities offered "a more positive view;" the critical issues of the nation could not be managed by "technical learning alone." Broad-church man that he was, Joe Duffey urged we set as goals for our educational system "broad social questions."

These broad social questions were to be "interpreted" by academic humanists—sometimes described as "professional" humanists—as a way to disengage from "parochial communities" and join a broader and more inclusive collective "built around concerns which are crucial to contemporary society." These concerns would be identified by dialogue between "professional humanists in the academic community and the lay public."

The catalogue of NEH's goodworks provided lists of grants to interpret —by dialogue—an unlimited list of topics. Humanists claimed moral authority over a range of ethical and political choices greater than the authority once claimed by bishops over intellectual, religious, scientific, social, political, economic, and military procedures. Although NEH's claims were in themselves odd, and radical departures from the traditional limits to democratic politics, humanistic authorities were advanced as a complete *system* of thought, not merely as the result of a radical but independent insight. Strangest of all, the broad social questions advocated by the system of academic humanism were announced as a method to do away with limited definitions of reality and—at the moment of epiphany—to replace the inheritance of "parochial" communities with a new radical vision of society. According to Duffey, "even the private and intimate issues, our sense of inner being and solitude, are expressed in humanistic tradition."

It would be extremely difficult to formulate a more exact definition than Joe Duffey's for the social ambitions of a religious sentiment. When the procedures of the Ministry of Culture were examined in detail, what NEA and NEH said and did often appeared to be contradictory to any commonsense analyses; but when the coordinated activities of the Ministry of Culture were examined as the goodworks of a systematized faith,

they were entirely consistent. Thereafter, there was nothing ridiculous about humanism at all—love, peace, and understanding one another would heal the human condition. In support of such vast goodwill, humanism was a theological idealism, absolutely perfect and infallible, and those "born again" by acceptance of humanism's moralities and beauties held an evangelical conviction, as Duffey explained it, and never needed to be troubled by any material realities. The dogma of humanism "accepted contradictions."

Humanism reveled in contradictions because even the most ordinary realities were subject to "interpretation" by none other than the humanists themselves. What had once been a school of philosophical speculation, steeped in ambiguities and largely discarded, had undergone a revival to become an operating system for making ethical and moral choices. After it was entitled by the establishment of NEH in 1965 and institutionalized by coordination through the White House Ministry of Culture in 1978, what humanists said and did could no longer be mocked —just as an atheist should restrain his laughter when granted an audience with the pope. The humanists were true believers, and if they were sometimes impatient with reality, it was only because they were required to abandon the whole truth to concentrate on their special version—they were anointed as responsible for the salvation of all mankind. Thereafter, humanists lived largely with their own thoughts. Just as the ordained ministers of established churches did, humanists had to arrive at conclusions from premises that dictated what the conclusions ought to be. Consequently, their intellectual difficulties were soon compounded by moral ones. Like ordinary ministers, the moral regeneration for which humanists labored always ennobled them to such an extent that no checks or balances remained upon the extravagance of their thoughts.

Because humanists declared as an absolute their love for all mankind, they believed that the promised land—when it was reached—would be a place of perfect unity and permanent peace. From this beautiful vision, humanists derived their golden rule: everyone should live for the good of others. The altruism of living for others, as interpreted by humanists, was a collective responsibility to such an extent that all facts had meaning insofar as they were interpreted by sociology—indeed, could not be understood without sociology. Humanists loved history, studied the contributions of the dead, demonstrated how the lessons supplied by the dead could be "interpreted" as applicable to current "broad social issues." To obtain peace, we must understand one another; therefore, unity of understanding as well as unity in action were not only political objectives, they were moral imperatives. The moral equivalencies of war invoked by the Carter administration over a trade deficit in oil appeared ridiculous if viewed as a mere political exhortation; a call for national unity over energy was, on the contrary, perfectly sensible when the president was understood to be proselytizing for moral unity. Every crisis—

energy, hostages, inflation, whatever—provided substantial theological reasons for moral unity regardless of any realities or congruencies between the causes or effects of the crisis. The Crusades were similar adventures: socially useful moral escapades regardless of the cities sacked along the way.

Absolution was granted in advance for all crimes in those instances where good motives were blessed in advance. In achieving the objectives of moral unities, the arts were useful; so were the humanities; and Education, Defense, Agriculture, PBS, and the activities of any other department or agency. Their hegemonies were all to be part of a well-coordinated-national-culture. To the extent that all participants in the "dialogue" of these collectivized activities agreed to every march taken toward the city of unity, all such believers participated in a permanent state of grace. Any objections to coordinated plans or operations, even if the objections were founded in obvious realities, were expressions of heresy, and treason. Hence, not one instance of censorship contradicted the goodwill, the collective altruism, of orthodox humanism. No citizen should believe that he lived merely for his own benefit; instead everyone should learn how he contributed to the general welfare.

Like art and thought, work had to be understood for its moral utilities. Hence wages were not a reward, or a right earned by the sweat of the worker's brow, or the result of intuition or adventure. Wages were provisions made by society for participation, in the same sense that pay was promised to soldiers. All the variations of wages, such as pensions, benefits for the sick or old, unemployment insurance, indexes of the cost of living were the rewards of successful economic campaigns. Wages were not something for which workers bargained alone, but collectively. Wages were so moral, in fact, that if the product of work became useless, or if the products remained unsold, the New Order would continue the corporation as an employer to continue the worker's moral contributions—particularly in California or Detroit where moral certitude about the New Order's goodwill was more important than the utility of Lockheed aircraft or Chrysler cars. Because the collective bargains struck between labor and capital were evidence of moral contributions to the general welfare, strikes by workers on their own initiative were logically *immoral* activities—a kind of brigandage—just as authors or artists were behaving shamefully when they worked for nothing more than their own delight and then insisted upon royalties.

To manage an advanced, complex, technological humanist society, to gain the goal of unity, an elite was necessary. The humanists frequently explained how government, corporations, and universities could work together; it didn't matter at all that there were no provisions in the Constitution for them to do so; nor any provisions in democratic tradition for these interests at all. Peace and progress were overriding national interests, therefore the members of the ruling class circulated freely be-

tween government, corporation, and university. All boards of directors, advisory councils, advisory committees, or commissions were constituted by members drawn from the three new institutional powers, and no one else need be included. All public functionaries who served these governing institutions were expected to name their successors—after appropriate discussion among themselves. Any election of elite officials by their social inferiors would be absurd to the new established order. Besides, the anarchy exemplified by legislative assemblies, local, state, or national, was sufficient to bar their opinions from serious consideration —as long as national unity was at issue.

The elite were the major officials of the New Order; all others were considered minor officials without standing to decide the great ethical choices—artists, writers, workers, aged, youth, minorities, students, soldiers. To understand how the theocratic, as opposed to the political, necessities of the New Order were decided, it was necessary to examine why humanists were opposed to personal indulgence of any kind. They were as earnest as puritans, and as suspicious of laughter, because the New Order's visions of love, peace, and understanding could not accommodate comedy or eroticism. Consequently, the ethical choices proposed by humanists prodigiously exaggerated the necessity for moral restraint. Because no citizen could believe he existed solely for his own benefit, every indulgence—no matter how it was expressed—was by nature an offense to the "overriding national interests." Humanists carried to extraordinary lengths their puritan righteousness in opposition to personal indulgence: wine, laughter, and sex were always excesses, never pleasures.

As a result, women were dangerous to the New Order, above all else. Women decided the ethics of sex without the advice of national councils, corporations, or academic senates, and sex was prima-facie self-indulgent. Although "woman" in the abstract was revered by humanists in a *role* as mother or wife, a specific woman might choose something besides collective love. Women rejected abstract roles, insofar as possible, to inhabit immediate reality. Women wanted erotic behavior for themselves, asked it of their lovers, and erotic behavior—as opposed to altruistic ethics—lacked utility: a breath of flowers on a spring day contributed absolutely nothing to national unity, and was a pleasure in itself without altruistic explanations. Humanists tolerated women as long as women would represent sentimentality, would appear at national ceremonies and commemorations with suitable moral effusions, and said nothing contradictory to the moral equivalents of war. Humanists accepted women as suitable decorations to decorum, but objected to Bella Abzug's outrageous hats. To the extent that a woman desired attentions for herself, she breached the sober manners of moral restraint. Besides, as everyone knew, a woman could be difficult to regulate—and national order depended upon ceaseless regulation. Some women bore children without

benefit of marriage. Others wanted abortion on demand. Nearly all claimed the right to determine by their own conscience matters of life and death. If the humanist system was to have unity, matters of life and death had to be decided collectively, by dialogue, and could not be left up to just anyone—particularly, serious abstract questions such as "population."

Women represented other difficulties to the grand design proposed by humanists. Although a man might argue that he was relating the humanities to all of human life, that his mind was fixed on his infinite love for all mankind, that he hoped to build a social structure that was moral and beautiful, and that he waited humbly to understand the meaning of life, the woman with whom he lived was liable to keep bringing up specifics —like whether they should go to dinner at John and Mary Smith's house on Saturday—despite the fact that the Smiths were hardly as loveable as all mankind. To such awkward present social realities, not so easily resolved by multiple interpretations, the passive quality of humanism's view of life—humbly waiting for meaning to be revealed by higher authorities—and the great esteem in which humanists viewed death were habits of mind upside down from woman's habitual views. Women greeted birth with joy, as a renewal, and as a specific promise to the future; whereas humanists studied birth rates in the abstract as a "problem" colored by Malthusian statistics. Women risked marriage with wondrous expectations, choosing adventure for its excitements and discoveries; whereas humanists "interpreted" anthropology and sociology as if there existed sailing instructions and maps somewhere to navigate uncharted voyages. Women grieved particular deaths as absolute and specific losses to the living community. They wept at the grave for someone's idiosyncrasies; humanists memorialized death as a supreme and impersonal regulation, universally applied, and therefore to be given inordinate respect.

To humanists, death represented the ultimate spiritual unification of all society, past and present. Death in the particular was thought of as a voyage from an objective existence in the living collective to a superior subjective existence in the collective unconscious of history. In one sense, death was recompense for devotion during life to the service of all mankind, and the National Endowment for the Humanities pointed with pride to its programs in which the aged recorded memories of their social history for "professional" humanists. NEH's grants for social history were similar to the programs advertised by Forest Lawn, except that NEH memorialized with tape recorders instead of granite stones. For the ordinary aged, NEH provided passages for common souls to university archives. Humanists viewed the contributions of the elite to collective unity somewhat differently. Important examples were solemnly recorded by public judgment, with obituaries in the New York Times, or by post-

humous circulation of the deceased's *curriculum vitae* to university libraries in publications such as *Who Was Who in America*. Even more significant examples of the elite were memorialized by "interpretative" biographies, undertaken by academic specialists funded by NEH grants for fellowships to study the dead, then funds to "research" and accumulate the appropriate criticisms, then grants to "subvent" the publication of the resulting academic book, and finally perhaps "media" grants to retranslate the historical commemoration to the laity's attention on television. In dollar amounts, NEH's contribution for a single biography of one nineteenth-century hero or heroine exceeded the amounts advanced by commercial publishers for the most successful distributions of paperback bestsellers. NEH, in contrast, *never* funded studies of present realities.

Along with all the other agencies of culture, NEH copiously funded "interpretations" of death in museums because humanists wanted to show how the accumulated weight of all the dead overshadowed the present insights of anyone living. In temples placed on the Great Mall of Washington, D.C., and in every other national city, traveling exhibits of the dead and of dead civilizations were offered to the laity for their edification. NEH was proud that so many stood in line to see the treasures of King Tut; pleased that the lessons of what was moral and beautiful had been made "accessible" to such a wide public; congratulated itself that NEH had provided tangible evidence of one of the greatest tyrannies ever founded upon slavery. NEH was equally proud of its exhibition and "interpretation" of the treasures of Dresden—although the very word *Dresden* apparently had an entirely different meaning to NEH than it had to Billy Pilgrim in *Slaughterhouse Five*.

To comprehend NEH's "interpretations" of history, and NEH's choices of *which* history was to be interpreted, an acceptance of the dogma of humanism easily resolved any apparent oddities: history was inhabited by the spirits of yesterday, who were to be consulted by the priests of humanism in temples of learning to interpret the broad social issues of the present. History—like literature and art—was judged first according to its utility in contributing to love, order, and progress. The guidelines for NEH grants made plain that those lessons of history, literature or art which failed to contribute to the perfectibility of man were disremembered as "inappropriate." *Slaughterhouse Five*, for example, remembered Dresden inappropriately. The book could be banned from school library shelves, but the banning of books did not come to the attention of NEH's National Council for "appropriate funding." In contrast, the Ministry of Culture devoted millions to providing exhibits for temples upon malls, for the maintenance of these museums and their guards, and for the construction of new temples to preserve the past. If the new temples displaced shade trees and quiet spaces where living men and women had

once lingered or enjoyed a picnic, or perhaps made love under the stars, the dispossession of the living by the dead was not a matter of public debate.

These ethical and political choices were the sole responsibility of academics who had taken the places once held by the clergy at the universities. The new clerics were endowed by the New Order; but like the clergy of the past, the new clerisy were the sole administrators of their own endowments—for the good of all mankind, of course. Yet the clerisy could sometimes be as disruptive to national unities as women sometimes were: therefore, as long as members of the clerisy inhabited academic institutions and enjoyed academic privileges they were to be excluded from either great riches or significant power. All their good-works were approved, with or without any showing of grace, as long as the clerisy would swear that each such activity was "nonprofit." In return, the clerisy were provided with generous—if not munificent—stipends, and in addition their incomes were guaranteed for their natural lives. The "tenure" promised to members of the clerisy was a contract of good behavior, an agreement to abide by certain rules of manners, and entirely similar to the protections offered to a young woman by marriage. The purpose of tenure was to concentrate the cleric's attention upon great general truths, the performance of narrow, specialized and repetitive duties, and soft speech. Like women, the clerisy were to mind their manners, sit up straight, speak clearly, act naturally, and see to their hemlines. Everything a cleric said was to be interpreted "objectively."

The clerisy, too, were to aid in the spiritual direction of society's ethical and moral agreements. They, too, were to be calculators of sociological necessities. They were to be venerated, as women were, and doors opened ahead of them for their passage. They were entitled to illuminate doctrinal questions on universal love. As anchorites once illuminated manuscripts in the gardens of monasteries, the modern clerisy labored in what were described as "think tanks," or "centers for advanced study," which invariably were landscaped with green lawns and flowing fountains to ease the modern mind in its calculations upon the subject of death. Yet the spirituality of the clerisy would be corrupted, obviously, if they took up any "outside" interest with vehement passion. Any independent, uncertified, unapproved passion pursued off-campus was a moral turpitude, and by definition, a personal indulgence. Tenure could then be terminated by a cleric's peers for "indiscretion," just as a woman's marriage contract was void upon public display of adultery. The annulments of tenure were theologically sound because, like women, the clerisy were also charged with reminding men of their moral duties to all mankind, past, present, and future. The transcendental sociology of humanism reported continuously on the broad social issues, as Joe Duffey called them, and "interpreted" how science, literature, art, history, politics, and law were to be incorporated into the collective vision deter-

mined to be necessary for the general welfare. Then each of these discoveries was to be made "accessible" to what Joe Duffey described as the "lay public."

Because the functions of the clerisy were social, complaints by the laity about education could be ignored. What the faithful of the New Order had to understand was how little difference it made whether academic learning sagged, illiteracy flourished, languages disappeared from the curriculum, students were ignorant, science stopped its discoveries, or whether teachers taught anything. Even the most private of private universities, such as Princeton, depended upon the New Order for half its funds; what had once been an institution of Presbyterian values now served a new system. The functions of the clerisy were to expiate the virtues of the new system, to operate business, law, and engineering schools to provide circulation for the elite, and to substantiate, by appropriate metaphysical speculations, how the Good News of love, order, and progress had been ordained.

To gain acceptance for these worthy transcendental values, humanists provided theocratic glosses for the New Order's mania for regulation. In Washington, fifty-five major rule-making agencies turned out 77,000 pages of new regulations each year. Between 1970 and 1980 the volume of regulations quadrupled, and twenty new regulatory agencies came into being. During the same decade, the number of lawyers practicing in Washington increased from 16,000 to 40,000. The expense of regulatory activity was tithed, voluntarily or by force, from the laity; but the lawyers practiced almost exclusively as representatives of great corporations or syndicates of corporate interest. The significance of all these attorneys, all the rules, regulations, interpretations, and agencies, was not what they actually declared or decreed. The vast majority of regulations contradicted other regulations. The tax code in itself required 60,000 pages of regulations and "interpretations," and the majority of IRS agents could not fill out the simplest citizen tax return without contradicting some rule. The social import of the New Order's frenzy to regulate derived from the requirement for a designated officer of the New Order to adjudicate the ambiguities in each particular instance. One regulatory agency took ten years to approve the label on a jar of peanut butter, but the agency's diligence was for the purpose of consumer protection, it was said, and not at all ludicrous, because officers of the New Order had to be judicious. When the New Order's regulations were examined for their internal consistencies, they were nonsense. Taken in their entirety, regulations were a perfectly sensible system to gain obedience.

Lawyers who studied the New Order's frenzy to regulate accurately described themselves as "power brokers." Their clients were those who had a stake in society's power; but these clients differed substantially from the rich of mythology and only faintly resembled the oligarchs of the past. Corpos could not squander their inheritance as they pleased.

Instead, they too were required to consent to the love of all mankind, the achievement of peace, the establishment of order, and the continuance of progress. Although historians had once characterized officers of national corporations as "robber barons," the chief executive officers of the New Order's corporations were to be viewed as something like knights: they were generous; they sponsored symphonies; they redressed wrongs; they cooperated in model-cities programs; they did what they could to protect the weak; they hired minorities and women; they no longer met in private clubs to watch naked girls jump up out of pies and dance all naked 'round the table. Instead they met in sylvan conference centers to listen to the clerisy. Corpos sponsored official art, because the arts were the very essence of our lives. They "matched" the grants of the National Endowment for the Humanities to "interpret" ethical choices.

To be efficient, the Corpos were required to concentrate capital. They were entrusted with the earnings of the past to administer the needs of the future. Their moral duty was to build better electrically for a better tomorrow. Consequently, they were unrestricted in their activities by any laws, they were virtually untaxed, and they could transfer the site of their jurisdictions from Delaware to the Bahamas as they pleased. They could meddle in foreign affairs, topple governments, foment revolution, indeed do anything at all, provided they could show how their motives were in the national interest, and provided no Corpo officer diverted his corporation's public profits to private indulgences. The misuse of a company limousine, for example, was a misdemeanor; whereas although a conspiracy to fix the price of fuel was a felony, the punishment consisted of a fine that had to be calculated as a minute decimal fraction of the profits the felony had earned. The logic behind the unlimited social behavior of Corpos was illuminating in itself, but also consistent with "humanist" theology. If the *motive* for price-fixing could be announced as consistent with overriding national interests, then the *act* of price-fixing was absolved. Hence, price-gouging admittedly increased profits; these earnings were multiplied by magic numbers—such as ten times earnings, or thirty times earnings, depending upon current perceptions about future social conditions; the multiple of earnings determined stock values; because capital was raised by creating debts, the higher the profits and the higher the earning ratios, the higher the value of the stock, and therefore the greater the capital available for progress. Ergo, prosecution for price-fixing hindered the progress necessary for the general welfare.

Such social formulations might seem quaint to an agnostic of the utility of greed; yet by 1980, exactly such "interpretations" were fully accepted. Moreover, because capital was funded by debts, private savings had little utility to Corpos. Except to sustain consumer expenditures—which were, after all, expressions of personal indulgence for material luxuries—the private savings aggregated by what once was described as the "middle class" were no longer needed. The perfect idealism of hu-

manism held that savings could be put to use for better purposes than those chosen by personal conscience. Therefore, savings could be taxed away by the New Order, or absorbed by inflation, while Corpo debts were guaranteed by the government. The middle class continued to vote, of course, which made "taxes" and "inflation" politically dangerous: but in due time the middle class were bound to disappear anyway—their self-indulgence made them parasites to progress. With the advice of the clerisy, the Corpos could determine how to make the best possible life for everyone. In each nation of the world, the international corporations—along with two or three circumspect bankers who guaranteed the government's loans—would decide how to finance the goodworks. Hence, Corpos were best qualified to determine the rates at which taxes should be levied and the extent to which inflation could be continued. Meanwhile, in each local society—depending on its history and geography—factions were to be organized in syndicates according to their wants and interests: the Chamber of Commerce, as well as the National Education Association; the Business Round Table, representing the top one hundred corporations, as well as the Teamsters Union; the National Association of Manufacturers, as well as the Cooperating Council of Literary Magazines. Each syndicate was then engaged in a continuing "dialogue" on its right conduct, its moral duties, and its share of income from the collective Great Society. Therefore, the ethical as well as the political choices were consistently the most significant decisions for progress.

Unfortunately, the deployment of some of the new technological mysteries raised ethical questions among the laity—such as hydrogen bombs, nuclear power plants, chemicals to increase crop yields, biological mutations, and so forth. If faith in the New Order's visions was to be maintained, science should be interpreted by education in the positive sense: all conclusions drawn from empirical evidence by properly constituted commissions would be made "accessible" to the laity, but not the evidence itself. Simultaneously, irrational questions founded in nothing but intuition were not to be encouraged. Flights of fancy disturbed the vast system of regulation necessary to the maintenance of social order. All truths, by whatever realization, had to be subordinate to collective utilities. The "interpretation" of which truths were to be encouraged and which insights were "inappropriate" could only be made by representatives of government, corporations, and the clerisy working together. By concatenations of the social order rightly understood, and by methods of social coordination among the members of the faith—techniques similar to those employed by temple priests in ancient societies—the ethical, moral, and political "interpretations" of humanism would then be disseminated—"made accessible," as Joe Duffey put it—as sacerdotal revelations.

If this brief summary of humanist theology appeared to be a catechism of poppycock—a kind of instant oatmeal ideology for which there was

not one whit of material reality except the lumpy porridge itself—nonetheless, it was the New Order's credo. By a recitation of its exhortations, the Ministry of Culture explained away any immediate instance of fraud, perjury, forgery, censorship, blacklisting, closed circles of awards, or any other criticisms. The report of the House Appropriations Committee investigative staff said that the chairman of the National Endowment for the Humanities, with the advice of the National Council, was to set "national policy for the humanities," to accomplish a "molded national policy," to establish a "national humanities policy."

Not at all, answered Joseph D. Duffey. He emphasized that he was to develop and encourage the pursuit of a national policy "for the promotion of progress and scholarship in the humanities." In Chairman Duffey's interpretation, the House report had made something more than a semantic mistake. If the chairman of NEH sought to mold a new national culture, as he had explained in his public speeches, his actions would not only be inappropriate, he told the Congress, they could be described as "authoritarian." If what Duffey said in answer to the House report seemed to contradict what Duffey said in testimony to the House Appropriations Committee, no contradictions existed because humanists interpreted reality from many points of view.

The policy decisions made by NEH, said Duffey, often affected what history books were written, what archives were preserved, what curricula were developed, and what studies were possible in the areas of the humanities. "It is for this very reason," Duffey explained, "that these decisions should be made in the public arena and in consultation with persons of experience and demonstrated achievement in various areas related to the Endowment's concerns." The chairman's explanation did not contradict NEH's practices at all, of course, because the actual secrecy of NEH's procedures was subject to NEH's "interpretations" as to who were the persons of experience and demonstrated achievement. The panels at NEH were so secret that even the names of the panel members were secret and the dates, times, and minutes of their meetings were secret to consider secret proposals and make decisions which, of course, were secret. To those who complained that secret meetings hardly met the chairman's own definitions of decisions made in the public arena, NEH replied that in many cases decisions were made without any panels at all, and therefore the panel's decisions were not necessarily secret. These apparent inconsistencies, however, were easily resolved as soon as the humanities were understood as an established religion. The mysteries interpreted to the initiates within the temple, gave the lay public no reason to doubt the revelations of the priests.

Under the direction of Chairman Duffey, the Ministry of Culture had signed cooperative agreements between NEH, NEA, the Office of Education, the Institute of Museum Services, the Smithsonian, the National Science Foundation, the International Communications Agency, GSA,

and so forth. What actually happened as a result of this active-well-coordinated-national-cultural policy was frequently declared to be in the interest of the general welfare. In each of these coordinations major corporations participated with both money and "services in kind." Whether or not the corporations were under indictment or had recently signed consent decrees for activities hostile to the public interest were considerations "inappropriate" to the Ministry of Culture's goodworks. In any event, all particulars about what was decided and by whom were secrets.

The House report charged that outside consultants hired by NEH made comments on applications for grants, but the comments were generally not made available to the panels that decided the grants. The House report was misleading, said NEH. The House report charged that unpaid reviewers and personnel participating in projects were not subject to conflict-of-interest checks, and thus helped to reinforce the "closed circle" of NEH's grant-making. NEH replied that in the future they would guard against even appearances of conflict of interest by extending their checks of conflict of interest. The House report charged that NEH panels apparently reached their judgments on proposals by basing their decisions upon the names of the grant's participating consultants, rather than the merits of the project itself; that furthermore there was no NEH check on the commitment of the consultants to serve as advisors to the proposal they apparently endorsed. NEH replied how unfortunate it was that the House report had quoted isolated comments about consultants.

The House report charged that NEH's panels were "ad hoc" assemblies. NEH replied that they maintained a pool of 7,000 names, that NEH was attempting, with the use of a computer, to expand the pool of names available for call for any of its panels to review whatever proposal was deemed appropriate. NEH pointed out that the expanded "pool" would include qualified women, persons from varied ethnic and minority backgrounds, "and representatives of a wide range of humanities institutions." Standing panels, NEH asserted, were not needed.

The House report charged that staff ran the panels, overruled panel decisions, hired consultants to develop project proposals for submission to the endowment. These NEH activities were contrary to legal proscriptions against the endowment engendering its own grants. NEH's response was that the House report was accurate as far as it went, "but misleading."

The realities of NEH's operations were subject to NEH's interpretations, but concealed from inspection by any "outsiders." To the uninitiated NEH followed procedures which bordered on the bizarre. In particular instances an NEH ad hoc panel had disapproved funding of a proposal, but the staff recommended the grant to the NEH Council anyway, without explaining why the panel had turned the proposal down, and presto, the National Council approved the grant. Another secret panel approved a grant which the National Council disapproved, but the

proposing institution was then awarded a chairman's grant anyway. If these "interpretations" appeared strange, many proposals were not considered by any panels at all. Meanwhile, the chairman of NEH testified to Congress that NEH's panel system was the very heart of its operation.

Yet there was more than that at the heart of NEH's operations. The projects funded by the endowment evaluated their own success. NEH had no procedures to verify whether matching funds were actually raised by challenge grant organizations. Or, variously, "challenge grant" and matching funds were back-dated to be interpreted as eligible, although "unofficial." Or, variously, NEH awarded "matching grant" funds to organizations not yet created, so that the organizations could be created to "match" the funds NEH awarded. The NEH funded an organization called "the Federation of Public Programs" to promote NEH activities in the states: an organization NEH created, funded, and maintained as its own lobby to carry out NEH's own policies in the states. Simultaneously NEH made lump sum grants in the millions to state humanities councils which were not public bodies at all, but self-designated, self-appointed, and self-perpetuating humanities organizations unrelated by legislation, customs, manners or traditions to any political jurisdiction. At the same time, officers of these same *private* agencies of self-determined goodwill and clandestine licenses of self-approved goodworks were members of the National Council on the Humanities: where they approved what they themselves proposed; and in addition served upon the National Council's state subcommittee, where they expressed their continuing determination to resist attempts by Congress, or anyone else, to call them to public account, or convert their private state humanities councils to public bodies subject to public law.

Such an otherworldly defiance of democratic custom could indeed be interpreted from the lessons of history, although NEH distributed no grants to do so. If the religion of humanism appeared ludicrous, even when mitigated by endless "interpretations," nevertheless it was a religion. As John Stuart Mill had pointed out, humanism was the regimen of a blockaded town. The customs proposed by humanists were ceremonies of power—power unchecked, power unlimited, power as the identifiable means to rule in this world by an anointed elite. Similar metaphysical ravings by a Hitler for a "Thousand Year Reich" were just as ridiculous and subject to meandering "interpretations," but just as profoundly sentimental about promoting world order. To forestall similar nonsense, the First Amendment prohibited the establishment of any religion: fundamental truths were the objective of every inquiring mind; but subjective revelations could not be combined with the powers of the state. As soon as any elite, any party of virtue anointed, took it upon themselves to define reality for the community, and then insisted upon obedience to revelation by regulation of ethical choices, violence followed fraud as surely as dark nights followed bright days. The commonsense test of

religious fraud was whether the acts proposed as moral guidelines in the public interest were open to public inspection; if an ethical conspiracy could only be conducted covertly in secret meetings, then presumably its pretense of goodwill collapsed. By refusing attempts by Congress to convert its activities from private state councils to public agencies, the humanities revealed how they were a private confession for the few. Despite the National Endowment for Humanities' pretense of goodwill to all mankind, the National Council for the Humanities absolutely refused to conduct its business in the sunshine.

Humanities

Published by the National Endowment for the Humanities
Chairman: Joseph D. Duffey

Recent NEH Grant Awards

Archeology & Anthropology
 ... David Prince; Ohio University Department of Film, Athens, OH:$65,833. Supports the production of a documentary film on recent anthropological discoveries in the story of human ancestry.PN

Archival
 ... Jack C. Thompson; Northwest Archivists, Inc., Portland, OR: $7,705. Supports a series of one-day workshops in Oregon, Washington, Idaho and Montana on disaster preparedness for archivists. RC

Arts—History & Criticism
 ... Dorothy H. Coons; Institute of Gerontology, The University of Michigan, Ann Arbor, MI: $9,976. Supports planning of a traveling exhibit of folk art which will highlight the contributions of older American folk artists to American arts and culture. PM

History—Non-U.S.
 ... Ray Hubbard; Unicorn Project, Inc., Potomac, MD: $108,558. Supports script and animation text for a film on life in and around a Welsh medieval castle. PN

History—U.S.
 ... Roger Fortin; Cincinnati Fire Museum Association, Cincinnati, OH:$9,910. Supports development of an overall interpretative program for the Fire Museum. PM
 ... J. Craig Jenkins; Center for Policy Research, New York, NY:$49,365. Supports a study of the role of "support organizations," such as churches, unions and corporations, in shaping the social movements of the 1960's. RS

. . . Ann J. Lane; Radcliffe College, Cambridge, MA: $80,000. Supports a biography of Charlotte Perkins Gilman (1860-1935). RO

. . . Joyce D. Miller; Amalgamated Clothing & Textile Workers Union, NY:$317,316. Supports continuation and expansion of a program of humanities seminars for ACTWU members. Seminars and accompanying discussion materials are designed to help members see their own life and work experiences in a broader historical and cultural context. AP

. . . Mary T. Murphy, age 25 & Helen Bresler, age 24; University of North Carolina, Chapel Hill, NC: $8,513. *Youthgrant* supports an oral and photographic history of Butte, Montana. AY

Intercultural Studies

. . . Jan Demarest; University of Colorado, Boulder, CO: $29,993. Supports an exhibit of French novelist George Sand's letters, manuscripts, drawings, photographs, paintings, and objects from Sand's puppet theater borrowed from France.PM

. . . Sarah Faunce; The Brooklyn Museum, NY: $149,620. Supports an exhibit which is part of the *Belgium Today* International Symposium on Belgian art between 1880–1914, focusing on Belgium's international role in the development of early modern art. PM

Interdisciplinary

. . . Clay Boland; Colorado Mountain College, Glenwood Springs, CO:$50,000. Supports the development of a two-year humanities program for community college students who expect to transfer to four-year institutions. EP

. . . Ellen M. Campbell; Marymount College, Tarrytown, NY: $11,000. Supports a project to open the Marymount College Library on three Sundays during the academic year to local residents for their private research projects.PL

. . . The following grants support humanities seminars for medical and health care teachers:

H. Tristram Engelhardt, Jr.; Kennedy Institute of Bioethics. Washington, DC: $35,893

Samuel Gorovitz; University of Maryland, College Park, MD:$30,348.FP

Karen A. Lebacqz; Pacific School of Religion, Berkeley, CA:$25,434. FP

. . . The following grants support academic year-long programs of fellowships for working journalists:

Lyle M. Nelson; Stanford University, Stanford, CA: $263,736. FP

Ben Yablonky; University of Michigan, Ann Arbor, MI:$382,500. FP

Jurisprudence

. . . The following grants support humanities seminars for teachers in law schools:

Derrick A Bell; Harvard University, Cambridge, MA: $49,675. FP

Leonard W. Levy; Claremont Graduate School, Claremont, CA: $59,864. Supports the preparation of a one-volume encyclopedia on American constitutional history and law. RT

Joel Sucher; Pacific Street Films, Brooklyn, NY: $20,000. Supports the planning of a film series entitled, "The Law, the Courts, and the People."

Language & Linguistics

. . . Germaine Bree; Wake Forest University, Winston-Salem, NC: $56,185. Supports a summer seminar in the field of French. FS

. . . William E. Coles, Jr.; University of Pittsburgh, Pittsburgh, PA:$48,171. Supports a summer seminar for college teachers in the fields of composition and rhetoric. FS

. . . James Gray; University of California—Berkeley, Berkeley, CA: $180,000. Supports the nationwide expansion of the Bay Area/National Writing Project. Through a series of institutes, publications, courses and inservice programs, the Project will develop a cadre of teachers informed about teaching composition from kindergarten through graduate school. ES

Literature

. . . Fred E. Carlisle; Michigan State University, East Lansing, MI:$48,970. Supports a summer seminar for college teachers in the field of English.

. . . Robert Geller; Learning in Focus, New York, NY: $50,000. Supports the development of scripts for a television adaptation of James Baldwin's *Go Tell It On The Mountain.* PN

. . . Robert Kotlowitz; Educational Broadcasting Corporation, New York, NY: $330,000. Supports the production of a 90-minute film on the life and work of American poet, Carl Sandburg. PN

. . . Yuri Rasovsky; National Radio Theater of Chicago, Chicago, IL:$299,960. Supports the production of twelve 60-minute radio programs dramatizing Homer's *Odyssey.* PN

Philosophy

. . . G. Fay Dickerson; American Theological Library Association, Philadelphia, PA: $97,922. Supports the development of an index of books in the field of religion published between 1970 and 1975. RT

. . . Albert R. Jonsen; University of California at San Francisco, San Francisco, CA: $78,000. Supports a study of the relationship between formal moral philosophy and the practices of common law. RO

Social Science

. . . Joel Kugelmass; Pacifica Foundation, Los Angeles, CA:$8,356. Supports planning a documentary radio series of national unity and social conflict in post-World War II America. PN

. . . Sheilah K. Mann; American Political Science Association, Washington, DC: $99,303. Supports a series of seminars for political science college faculties on the subject of citizenship and political education. EH

. . . Taketsugu Tsurutani; Washington State University, Pullman, WA: $59,824. Supports a research project on the relative roles of academics in the political affairs of the United States. RO

State Programs

. . . Alabama Committee for the Humanities and Public Policy, Birmingham-Southern College, AL: James Pate, Chairman, Jack Geren, Executive Director: up to $373,000 Outright, plus an offer of up to $15,000 Gifts and Matching

... Colorado Humanities Program, Boulder, CO; Pat Schlatter, Chairman, Katherine Lemmon, Executive Director: an offer of up to $40,000 Gifts and Matching (the grant supplements the previous G & M offer).

... New Jersey Committee for the Humanities, Rutgers, NJ: Leah Sloshberg, Chairman, Miriam L. Murphy, Executive Director: up to $461,500 Outright, plus an offer of up to $122,500 Gifts and Matching

... New York Council for the Humanities, New York, NY: Helene L. Kaplan, Chairman, Carol Groneman, Executive Director: up to $716,800 outright. . . .

The capital letters at the end of each grant description designate the division or office and the program through which the grant was made . . .

Special Programs

AD Special Projects
AP Program Development
AV Science, Technology and Human Values
AY Youthgrants
AZ Youth Projects

Education Programs
EC Consultants
ED Implementation
EH Higher Education
EP Pilot
ES Elementary and Secondary

Fellowship Programs

FA Independent Study
FB Young Humanists
FC Centers for Advanced Study
FF Special Fellowship Programs
FP Professions
FR Residential Fellowships
FS Summer Seminars
FT Summer Stipends

Planning & Policy Assessment

OP

Public Programs

PL Library Humanities Projects
PM Museums
PN Media

Research Programs

RO Research Resources
RD Conferences
RE Editions
RL Translations
RC Basic Research
RP Publications
RS State, Local and Regional History
RT Tools

State Programs

SA, SD, SO

Join the growing list of

scholars and teachers, students and critics
of history & philosophy & languages & literature & linguistics &
archeology & jurisprudence & art history and criticism & ethics &
women's studies & comparative religion & cultural anthropology &
folklore & sociology & ethnic studies & political theory &
international relations & other subjects concerned with questions
of value . . .

who already subscribe to *Humanities*

22

TEMPLE SECRETS / NEH: THE PROCEDURES OF PRIVILEGE . . .

Now I will tell you the answer to my question. It is this. The Party seeks power entirely for its own sake. We are not interested in the good of others; we are interested solely in power. Not wealth or luxury or long life or happiness; only power, pure power. . . . We are different from all the oligarchies of the past in that we know what we are doing. . . . The German Nazis and the Russian Communists came very close to us in their methods, but they never had the courage to recognize their own motives. . . . Power is not a means; it is an end.

—George Orwell
1984

Common sense easily grasped the essentials of government in the sunshine. Those who conducted their business in secret were claiming for themselves special privileges for their own peculiar visions. No matter what ministers said of their purposes, secret councils were evidence enough to contradict their goodwill. James Madison had summed up the essence of the matter: "A popular government without popular information or the means of acquiring it, is but a prologue to a farce or a tragedy or perhaps both."

Discussions of the absolute guarantees provided by the First Amendment usually centered on how free speech, a free press, the rights of assembly, and the prohibitions against the establishment of orthodoxy protected the individual against abuses of official powers; not much was ever said about how the First Amendment protected government from farce, tragedy, or both. Yet the origins of the amendment's prohibitions included immediate experience with visionaries who proposed variations of just, moral, or beautiful societies. In implementing the regulations necessary to achieving their purposes, those visionaries had soaked their communities in terror and violence. Although the prevalent assumptions

354

about government in the sunshine were that secrecy generally protected petty fraud and simple perjury, common sense would rarely admit that secrecy was being used to disguise an absolute truth—the kind of perfected orthodoxy prohibited by the First Amendment.

Every absolute truth was prohibited by the First Amendment; even the most negligible realizations. Every means to enforce acceptance of orthodoxy was prohibited. Congress was to make *no law* of any kind by which orthodoxy was to be established, because to enable orthodoxy would be a prologue to farce or tragedy or both. The tolerant patience of common opinion supposed that certain truths were self-evident, that all men were created equal, that they were endowed by the Creator with certain unalienable rights, that among these were life, liberty, and the pursuit of happiness. If wealth, luxury, long life, or happiness were the objects of community life, the commonsense mind found it difficult to accept that anyone would deliberately reject these tangible hopes to insist instead upon some vague, shadowed, fantastic vision, some ultimate heavenly order, separated from the material joys and sorrows of present life. The promised land, or whatever place there was to be, came later. Heaven could wait. The commonsense mind found it difficult to believe that anyone would meet in secret to furnish heaven's landscape now.

In the same sense, common opinion held that no one would voluntarily inhabit an insane asylum. When the common man did his duty and paid a Sunday visit to the asylum where his crazy cousin was committed, ordinary manners were to assure the patient that he'd be getting well and getting out soon. Common opinion refused to accept that it was the patient who insisted upon living behind barricades, shuffling along in private certitudes, wearing paper slippers, and reinterpreting ambiguities of the distant past to no one but fellow inmates. Common sense listened tolerantly for the voices only the mad could hear, but lacked the taste for a schizophrenic system of thought. Then, come Monday, common sense returned to the work-a-day world, perhaps with a saddened shrug, but living again in a landscape where two and two were unalterably four. To the commonsense mind, it was inexplicable that anyone would express pious affection for shadows dancing on the walls; it was baffling that anyone would genuflect to vast abstract forces who were said to control destiny; it was too crazy to accept that now all were to commit themselves to visionary interpretations of the meaning of life and death. As to the establishment of humanism as the national secular religion in the United States of America in 1980—or 1984—or at any other date—why, it was just as preposterous as whatever it was crazy cousin talked about all the time. Adopting humanism as the national cultural policy wouldn't just be a violation of the First Amendment, it would be a kind of institutionalized insanity, a treason of community memories. It would be impossible, a farce, a tragedy, or both. It could not happen here.

Yet the Ministry of Culture conducted its meetings in secret, and the

activities of the ministries of humanism appeared to be as unlimited as the visions of schizos. By law, the term "humanities" included, *but was not limited to*, the interpretation of the following: "language, both modern and classical, linguistics, literature, history, jurisprudence, philosophy, archeology, comparative religion, ethics, the history, criticism and theory of the arts, those aspects of the social sciences which have humanistic content and employ humanistic methods, and the study and application of the humanities to the human environment with particular attention to the relevance of the humanities to the current conditions of national life."

Not even Rome's Society for the Propagation of the Faith had claimed jurisdiction in this life for an orthodoxy so widely defined. To insist, in addition, that all decisions upon these catholic topics and all the procedures followed in promoting their acceptance were ethical and political choices which could only be made in secret, was an undisguised claim to power, not as a means, but as an end in itself.

To the credit of Senator Claiborne Pell, original author of the bills creating the National Foundation, by 1980 he was doing what he could to remind both National Councils of their public responsibilities. His committee directed that *all* meetings of the National Councils on the Arts and the Humanities were to be open to the general public. He suggested that council review of grant applications could be conducted in public meetings without jeopardizing the integrity of the review process. Information as to the time and place of each council meeting should be readily available to the public, and accommodation for members of the public should be anticipated at all such meetings. Pell's committee agreed there might be occasional exceptions to justify a secret session, such as instances when sensitive personnel matters were discussed, but exceptions to open processes—government in the sunshine—should be infrequent.

Pell's committee advised the National Endowment for the Humanities that the names of peer review panelists should be a matter of public record as soon as they were appointed to serve, as well as the specific panel on which each sat, and that these names be available to applicants or members of the public upon request. Summaries of panel comments should also be readily available. But NEH and the National Council on the Humanities defied each and every one of these congressional recommendations to discontinue secret procedures. By rejecting open procedures, NEH was in consistent and deliberate violation of an entire body of legislative and case law forbidding secret government. In 1974 William S. Morehead of Pennsylvania, chairman of the House Subcommittee on Government Information, had conducted ten years of hearings, review of court cases and legislation to prohibit exactly the kind of activity in which NEH was engaged. Mr. Morehead summarized what was at issue: "They forget they are servants of the people—the people are not their

servants. . . . Agency officials appeared and actually testified under oath that they had to balance the government's rights against the people's rights. The government, however, has no rights."

The "interpretation" of the law by the National Council on the Humanities was exactly opposite to Congressman Morehead's. On Monday, February 4, 1979, Stephen J. McCleary, designated as the Federal Advisory Committee "management officer" of NEH, placed a notice required by law in the Federal Register. The National Council on the Humanities would meet on February 22 and 23. McCleary's name and telephone number, as Federal Advisory Committee Management Officer, appeared on page 124 of the Sixth Annual Report of the President on Federal Advisory Committees. The report, signed by President Carter in March, 1978, to the Congress was required under Section 6 (c) of the Federal Advisory Committee Act, Public Law 92–463, and in accordance with Executive Order No. 12024.

The Federal Advisory Committee Act specified that each advisory committee established by each agency was to be listed by name, and each meeting was to be announced in the Federal Register thirty days before the committee met. On pages 103 and 104 of the sixth annual report, President Carter certified to Congress that the National Council on the Arts—and each of its panels, and the National Council on the Humanities—and each of its panels, were Federal Advisory Committees. On page 104 of the president's report, in addition to its council, NEH listed its committees: Advisory Committee on Science, Technology and Human Values; Education Panel, Fellowships Panel, Planning Office Panel, Public Programs Panel, and Research Panel. In sum, the Federal Advisory Committee Act specified that each designated panel was to be listed, its dates of meetings advertised, and in the Executive orders pursuant to the FACA legislation, the names and affiliations of those serving upon each panel were to be public. NEH did none of these things.

McCleary's notice was due thirty days before the National Council met and he was just a bit late. He was also required to publish an agenda of the scheduled meeting. He did so, but only in part. He advertised that the meeting would be held in the Shoreham Building, 806 15th Street, 1st Floor Conference Room, but gave notice that *all* of the proposed meeting throughout the day, Thursday, February 22, and most of the meeting on Friday, February 23, 1979, would consider financial information and personnel and similar files, according to McCleary, "the disclosure of which would constitute a clearly unwarranted invasion of privacy." McCleary had determined, he said, that the meeting would fall within exemptions (4) and (6) of 5 U.S.C. 552 b(c) and that it was essential "to close the meeting to protect the free exchange of internal views and to avoid interference with operation of the committee."

Although there were exemptions under the Freedom of Information Act, 5 U.S.C. 552(b) identifiable as "(4) trade secrets and commercial and

financial information obtained from a person and privileged or confidential," and "(6) personnel and medical files and similar files the disclosure of which would constitute a clearly unwarranted invasion of *personal* privacy," McCleary's determination included a slight rewording of the exemptions themselves. He also added a requirement for closing the council's meeting which had no existence at all in either legislative law or case law—"avoiding interference" with the National Council's operations. As to the agenda for those portions of the council's deliberations which McCleary had determined were to be closed, none was published —in itself a violation of the law.

According to McCleary's notice in the Federal Register, a portion of the morning session on Friday, February 23, 1979, would be open to the public. The agenda for the open portion was published to include reports on: new staff members; a summary of recent business; chairman's grants; application reports; evaluation; the arrangements for the Jefferson Lecture; the FY 1980 Appropriations Request; and a report on the Commission on the Humanities. The remainder of the day's meetings were to be closed, but no reasons were cited, and no agenda provided. All these omissions were violations of the Federal Advisory Committee Act. McCleary closed his notice by suggesting that those desiring more specific information should contact him, or call 724–0367.

Having obtained a Xeroxed copy from an independent source of the humanities council secret agenda for both days, I telephoned Mr. McCleary and asked if he would furnish a copy of the council's two-day agenda. He refused.

I asked what was the legal basis for refusing a copy of the council's agenda: what exemptions under the Federal Advisory Committee Act (FACA), or Freedom of Information Act (FOIA) could he cite to deny public access to the agenda itself? McCleary could not cite any. I asked if his determination of the law was his own or his agency's. He couldn't say.

I asked if the National Council had been provided with a briefing book in advance of the meeting. He couldn't say. What was the legal basis to refuse to answer whether there was a book or not? He couldn't say.

I asked if he would provide a copy of the agendas for the National Council subcommittees on Education, Fellowships, Planning and Special Programs, and Research Grants Programs, each of which was a registered Federal Advisory Committee in the sixth annual report of the president, and each of which was scheduled to meet in secret on Thursday. McCleary refused the agendas of each registered committee. I asked what exemptions under FACA or FOIA allowed him to refuse the agendas. He cited exemptions (4) "trade secrets," and (6) "privacy." I asked if he claimed that the agendas themselves were trade secrets and private?

McCleary wouldn't say. He offered that NEH was not a "Sunshine

agency." The FACA regulations, as reported by the president to Congress, required on page 178 that the names of each registered FACA committee member, his corporate, union, or other organizational affiliation, his office address, his home address, and other relevant affiliations be furnished on Standard Form 249. I asked if McCleary would provide me with the names of the National Council and the additional required information on Form 249. McCleary said he would have to call me back on that.

When he did, he refused to provide any more than the names of the members of the National Council as printed in NEH's annual report. He refused to mail a list. He would give me the names by telephone. He explained that as far as NEH was concerned, the only address he would provide for each council member was NEH's official address. For the days when the council met, members of the council were sworn employees of the government; therefore their address was their NEH address. When McCleary read the list of names over the telephone, without affiliations or identifications as required by the FACA, he included as members of the National Council those who had not yet been confirmed by the Senate for the duties McCleary suggested they were performing.

McCleary's determinations of what the law required were, it seemed to me, a farce. With a Xeroxed copy of NEH's secret two-day agenda in hand, I telephoned NEH's Chairman, Joe Duffey. I explained that I already had a copy of the agenda I had been refused; that the determinations by NEH's council to close every portion of NEH's meeting to the public except the Friday morning period between 8:30 A.M. and about ten—when the National Council would take up the nomination of a lecturer to memorialize Jefferson—was a grand joke on Jefferson's memory. Duffey was as charming as ever. He proposed that I join all the closed meetings, even those determined by NEH as "closed to the public."

Unless the public in general had the same privilege, and particularly unless Ruth Dean, reporter of the *Washington Star* was included in the meetings, I regretted that I could not accept.

Joe Duffey then offered a new bargain: he said that NEH's general counsel, Joseph Schurman, would draft a statement for me to sign that indemnified Joe Duffey for any violations of privacy for anything I learned in NEH's secret meetings.

Not only would I happily sign such an indemnification, I said, in addition I would promise to print it along with whatever I learned. The offer of my private participation behind the scenes at NEH was then withdrawn.

Over a period of two weeks, Joe Duffey and I exchanged telephone calls. I explained that I would test NEH's right to hold secret meetings and require the National Council to vote to close its meeting on Friday at the point the council was to nominate the Jefferson Lecturer. The logic was simple: the Council could not vote in secret to close its meetings; it

would have to vote in the open to continue in secret. There was no interpretation of law or provision in common sense for the council to vote secretly to be secret.

Then Joe Duffey offered to open the breakfast meeting on Thursday morning to "the public." Upon examination of the breakfast meeting agenda, and after consultation with Counsel Joe Schurman, Duffey had decided that no "trade secrets" or "privacy matters" would arise at the council's opening breakfast. Thereupon, he also invited Miss Ruth Dean of the *Washington Star* to attend. Duffey and I laughed together when I pointed out that when the time came to close the meeting to the public on Friday, I would be playing the part of John Doar at the school door, and he would be taking Governor George Wallace's part.

Meanwhile, Ms. Amanda G. Birrell, one of Washington's leading experts on FOIA law, had volunteered to help. Pro bonum publico, she studied the case and prepared a memorandum of law. She chose, as good lawyers always did, the narrowest grounds upon which to challenge NEH's policy of secret meetings: she cited NEH's notice in the Federal Register as insufficient under FACA, 86 Stat. 770, 5 U.S.C. App 1. Since the notice itself was technically insufficient under the law to close the meeting, the National Council on the Humanities could vote on the issue of whether or not to close portions of their meeting. I would provide NEH, its staff, and its National Council copies of Counselor Birrell's analysis. My purpose, as I explained to Joe Duffey, was not legal, but literary. When the members of the National Council were faced with the requirements of the law, what would they actually do about what was just and beautiful?

Ms. Birrell's contribution was to ensure that no member of the National Council could claim ignorance of the law. She analyzed the statutes. Her citations were complete. She briefly summarized the key cases. Under FACA, *all* advisory committee meetings were open to the public. Further, interested persons were invited to attend and appear before *all* FACA open meetings. Ms. Birrell traced the changes that had occurred under FACA, by law, by regulation, and as the result of cases. She cited the authorities to close an advisory committee meeting. Under 10 (d) of the FACA, the chairman of an agency to whom an advisory committee reported could close an advisory committee if the meeting met standards in the government in the Sunshine Act, 5 U.S.C. 552b (c). As originally enacted FACA incorporated FOIA's exemptions, under 5 U.S.C. 552 (b). However, Ms. Birrell noted, congressional displeasure with the D.C. circuit's incorporation of FOIA's exemption (5) on "internal communications within an agency" into the FACA in *Aviation Consumer Action* v. *Washburn*, 535 F. 2d 101 (D.C.Cir. 1976), led Congress both to redesign the exemptions for open meetings under the Sunshine Act and to conform the FACA to the newly designed exemptions. Ms. Birrell provided citations: Government in The Sunshine Act, P.L. 94-409, 90 Stat. 1241. 5

U.S.C. 552; H.R. No. 94-1441, 94th Congress, 2nd Sess. at 26 (1976) ("Conf. Report").

The congressional law and the cases both required the chairman to make a two-fold determination before an advisory committee could be closed. First, those portions of the meeting dealing with matters such as "trade secrets" or "privacy" could be closed under the applicable exemptions; but only if, secondly, the agency could show that the public interest was served by closing the meeting. The determinations made by NEH to close its meetings were insufficient as to either the legislation, the intent of the legislation, or the applicable case law under FOIA. Moreover, the burden of proof was upon NEH to show why secret meetings would be in the public interest. NEH had made no such showing. Nor had NEH even attempted the burden of proof.

NEH alleged that it was "essential" to close its meetings "to protect the free exchange of internal views and to avoid interference with the operation of the Committee." NEH's allegation was a recognizable claim before the FACA had been amended by Congress to put a stop to such claims, but not after the new amendments. Both the 1974 amendments to FOIA and FACA made clear that Congress had intended to overrule (b) (5) "inter-agency or intra-agency memoranda" as exemptions under FACA. In addition, case law made it clear that NEH could not pretend that exemptions which had been overruled by courts could continue as claims that public interest favored secrecy.

As to NEH's claims for exemption under "(4), financial information and trade secrets": those kinds of information were exempt only if the financial information had been submitted to the agency in confidence *and* would actually damage a competitive position. Case law claims under exemption (4) required the *agency* to prove not only the confidential nature of the information, but *also* the extent of the harm that would be caused by disclosure. NEH did no more than baldly state that its secret information was "financial." Not only did NEH hold secret meetings that were contrary to settled law, NEH was in the bizarre position of arguing that its nonprofit and public institutions, including states, were competitively harmed by disclosure of financial information that was not confidential at all, but required as a matter of public record anyway.

As to NEH's claims to "privacy," *all* legislation and *all* the cases, without exception, gave *no* privacy to the members of the advisory committee while they were sworn for the day to do the public business. To assert that public officers could only conduct public business protected in secret was nonsense. As to NEH's claims under exemption "(6) personnel files the disclosure of which would constitute a clearly unwarranted invasion of privacy," the exemption protected information of a *personal* nature—a word NEH omitted in its quotation of the law. Reinserted the law read: "invasion of *personal* privacy." The conference report on the Government in the Sunshine Act indicated that the "privacy" exemption

was to be interpreted in accordance with the Supreme Court's decision in *Department of Air Force* v. *Rose,* 425 U.S. 352 (1976). In that case, the Supreme Court balanced individual rights to privacy against the "public's right to know" how national institutions operated. The case law required NEH to show some particulars of clearly unwarranted *personal* privacy, not just privacy in general. When applicants for federal grants were being considered, perhaps their medical records or psychiatric reports or personal credit information was protected; but NEH could not claim "privacy" because their applications were being considered, or because their applications were either turned down or accepted. Finally, the panel reviewers and the National Council subcommittees on applications could not claim "privacy" for themselves as they chose one applicant over another in the public interest. In sum, NEH's claims for secret proceedings contradicted the existing legislation, contravened the pertinent case law, and defied the congressional committees who were NEH's own sponsors.

Yet NEH's defiance of accepted law for FACA meetings and NEH's concoction of FACA and FOIA exemptions disguised something more important about NEH's secret agendas. There was nothing listed on NEH's secret agenda that had anything whatever to do with the exemptions NEH claimed, no matter how they were interpreted. On Thursday morning, February 22, I accepted Joe Duffey's invitation to attend the breakfast meeting of the National Council on the Humanities. Duffey said I should explain to the council why I believed NEH was subject to the laws which required "Government in the Sunshine."

The Thursday breakfast meeting was held in the chairman's suite. Coffee, orange juice, and pastries were spread out on a buffet table. Miss Ruth Dean from the *Star* arrived to join me, and we stood together, sipping tepid coffee before Joe Duffey called his advisory council to order. The irresponsible press then found places on a couch.

Duffey explained to his council that an issue had been raised: whether a public arts agency could rightfully deliberate in secret—a practice NEH had followed without interruption for fourteen years; or whether the public's right to know about how its money was being spent "superseded" laws protecting the privacy of individuals and applications submitted for grant review. Duffey said he believed he could personally be penalized if he allowed "a clearly unwarranted invasion of privacy." To the council informally arranged around him on couches and chairs he explained that he favored as much openness as the law would allow. "After prodding," he said, "and consultation with NEH's legal counsel," he could find no legal reason why members of the press could not sit in on NEH's policy discussions. The morning breakfast council meeting would not cover any confidential matter. Therefore, he had invited members of the press.

His council was furious with him. They hated the idea of the press being present.

Robert Hollander, Jr., council member and associate professor in the Department of Romance Languages and Literature, Princeton University, announced that the intrusion by the press was, in his opinion, "rude." Miss Dean had to set the record straight for Professor Hollander. She told him she'd been invited to attend by the chairman.

Other members of the council sided with Hollander anyway, the presence of the press was an invasion of *their* privacy.

"I'm going to be even less polite," said Dr. Richard Wall Lyman, president of Stanford University. The tone of his voice was indeed considerably less polite than Hollander's: "When the chairman can't sit with his council without the press being present, then I wonder."

Mrs. Nancy Davies, member of the Oklahoma Humanities Committee, as well as member of the National Council, thought the solution to the problem was simple enough. National Council members would schedule secret meetings with the chairman in their hotel suites for breakfast, cocktails, or dinner. No one ever need know where or when the council met with its chairman and that would take care of that. Mrs. Concha Ortiz Y Pino De Kleven agreed. She was a member of the board of regents, University of Albuquerque, New Mexico, and a principal in New Mexico's privately operated Humanities Council. She said she'd play hostess for the first such off-the-record-meeting.

Dr. Joe B. Rushing, chancellor of the Tarrant County Texas Junior College District spoke up in the slow, canny accents of a good ol' boy. He warned the ladies of excess enthusiasm: "Down my way," said Dr. Rushing, "a little private meeting like that might get us a jail term."

Leon Stein, sitting as a council member, and editor emeritus of *Justice* magazine, International Ladies Garment Workers Union, wanted to know if any minutes were being taken. "Suppose I want to talk off the record," he asked Duffey. The chairman assured nominee Stein that no minutes were being taken. Leon Stein was still a member of the public himself, present only "by invitation" and would not be confirmed to his statutory duties as a member of the National Council until May 17.

Mrs. Blanchette Rockefeller, widow of John D. Rockefeller III, wondered how, if the press was present, the council could possibly discuss problems about the staff.

Duffey's council was at an impasse. They could not imagine doing business in public. Duffey declared the meeting would "go into executive session." The members of the press were excused.

Page 151 of the President's Report to Congress on Advisory Committees required "Detailed minutes shall be kept of each advisory committee meeting," but no minutes of any of NEH's Thursday meetings were available, because NEH kept no minutes of its subcommittees. The FACA

provisions on meetings, whether open or closed, included procedural requirements in the administration of the law. "The minutes shall include: the time and place of the meeting; a list of the advisory committee members and staff and agency employees present at the meeting; a complete summary of matters discussed and conclusions reached; copies of all reports received, issued, or approved by the advisory committee; a description of the extent to which the meeting was open to the public; and a description of public participation, including a list of members of the public who presented oral or written statements and an estimate of the number of members of the public who attended the meeting."

As chairman of an advisory committee, Joe Duffey was to certify the accuracy of the National Council minutes, and the minutes of each of NEH's designated subcommittees. Because there were no minutes for any NEH subcommittees, none were certified. As to the minutes of the council itself, those were taken in shorthand by Joe Schurman, and not necessarily accurate. When the minutes of the February meetings were eventually distributed to members of the National Council, Joe Schurman reported that members of the press "had insisted on attending the breakfast meeting held by the chairman and the Members of the Council on February 22." Meanwhile, Schurman had written me that when the issue was raised, "Mr. Duffey made arrangements for you and other members of the public to attend the breakfast. The Endowment regrets that the original notice did not list it as a public breakfast."

When asked if he would correct the discrepancies between the minutes as distributed to the council and his letter, Mr. Schurman promised to correct the minutes and mail a copy of his corrections to the council. He never did.

During the course of the heated discussions at the breakfast meeting Thursday morning, Duffey pointed out, with a smug smile, that if I sued NEH for noncompliance with the Sunshine laws, I would have to bear the considerable expense, in legal fees and costs, of going to court; whereas, NEH would be defended by government attorneys provided by the Justice Department from unlimited public funds. Duffey explained to the humanities council that NEH had been "in touch with the Justice Department" about the FACA and FOIA exemptions raised. When Chairman Duffey closed his breakfast meeting by announcing an "executive session," I telephoned Justice.

Contrary to what Joe Duffey had said to his council, when a citizen prevailed against an agency's defiance of the Sunshine laws, Congress had stipulated that the government pay the costs of the citizen's suit. After 1974, Congress had amended its legislation to discourage agencies from using the courts as an expensive device to slow compliance to what the agency was supposed to have done in the first place. As Duffey had suggested, the Justice Department was the government's attorney of record. Justice was required to defend agencies against citizen suits; but to

administer the Sunshine laws, Congress had established a special unit within the Justice Department to report upon agency compliance with the laws. The special unit would also save the government's money by refusing to defend arbitrary agency procedures, or prepare cases which were inherently futile. As the government's Sunshine specialists, the special unit in Justice would counsel agencies to obey the law rather than lose an expensive case in the district courts.

Because Justice would be the defense attorneys of NEH, I telephoned Mr. Douglas Wood to learn, if I could, whether NEH could provide any defensible arguments for NEH's secret meetings, and if Justice had concurred in NEH's use of exemptions for "trade secrets" and "privacy." I explained that I had been provided with a memorandum of law by Ms. Amanda G. Birrell, pro bonum; that Duffey had just told his council that NEH had been "in touch" with Justice on the legal interpretations.

Douglas Wood said he had never heard of NEH, did not know the agency, had never heard of Chairman Duffey, nor NEH's general counsel, Joe Schurman, and had never discussed any portion of any of the Sunshine laws with anyone at NEH. I supplied Mr. Wood with the NEH telephone extensions for Duffey and Schurman.

Wood asked if I was planning to sue.

I told him I was not going to sue; that I had carefully explained to Duffey again and again that it might appear as if I was raising legal questions, but I was pursuing a literary question: what would NEH do when asked to comply with the law?

Wood laughed. He said he would call NEH.

The "open" portion of NEH's quarterly council meeting was scheduled to start Friday morning before nine o'clock in the conference room on the first floor of NEH's offices in the Shoreham Building. It was a gloomy morning. Pouring rains and thunderstorms delayed Washington's rush hour traffic. A dingy moment of spring, with temperatures in the fifties, had suddenly appeared to wash away February snows.

The first floor NEH conference room was an even more dismal scene. Under fluorescent lights in an airtight inner chamber without windows, the National Council on the Humanities met in a sort of managerial bunker. The tabernacle of the humanities flickered with unearthly light, purples and blues at its General Electric sources, but sallow and waxen upon the cheeks of the women gathered for the love of all mankind to interpret broad social issues. Around the blank and sickly yellow walls, someone had fixed sad little posters—the kind of broadsheets sometimes taped up along the corridors of a high school by a desperate young teacher, but then left there long after she had given up. In imitation Remington style, a washed-out cowboy was riding a pastel bronco. The caption read: "The Town of Crested Butte Presents Humanities Forum 1975; Crested Butte—Pursuing Happiness or Facing Reality."

It was impossible not to wonder whether Crested Butte ever resolved

its difficulties with reality in the four years since NEH had provided a grant to inquire about happiness. Meanwhile, more recent reports of NEH's goodworks were being read off to its National Council—examples, it was said, "of how the humanities enriched the life of the mind." Listening to the catalogue of NEH's recent achievements and great plans —"Agenda item B., Ms. McFate"—the National Council members were seated around a hollowed square constructed from four long tables covered with green baize. Just as NEA's council faced inward at each other across the hollow's fifteen-foot open center, so also did NEH's council; except, at NEH's meeting, some of NEH's principal staff members occupied seats at the high table, side by side with council members confirmed by the Senate, and with council members nominated, but not yet duly certified for the statutory duties they were performing. Because the squared inward-looking conference table occupied much of the length and breadth of the room, there was barely enough space for three rows of folding chairs along one wall, two rows jammed against each other along the wall opposite the door, and one crowded row along the wall to the cave's only entrance. All the seats were filled by workers from NEH's staff, other invited and interested parties to NEH's operations, and lobbyists for NEH's funds. In addition to the members of the council and staff seated at the high table, an estimated eighty citizens occupied the room. Near the door, three chairs were designated by hastily stenciled sheets of paper left upon their seats: "Reserved for the Public."

Although fourteen members would constitute a quorum for the National Council's activities, only eight members were actually present: Nancy Davies, representing the privately operated Oklahoma Humanities Committee; Dr. John Hope Franklin, John Matthews Manly Professor of History at the University of Chicago, and soon to be named president of the American Historical Association; Jay Gordon Hall, former director of government relations, General Motors Corporation, Washington, D.C; Robert B. Hollander, Jr., Princeton University professor; Dr. Richard Wall Lyman, president of Stanford University, but soon to be president of the Rockefeller Foundation; Mrs. John D. Rockefeller III, listed as a trustee of New York's Museum of Modern Art; Dr. Joe B. Rushing; and Mrs. Concha Ortiz Y Pino De Kleven.

In addition to the eight sworn members of the council, six nominees of the president to the council were also present: Dr. Charles Hamilton, professor of Government, Columbia University; Carl Holman, president of the National Urban Coalition; Mary Beth Norton, assistant professor of history, Cornell University; Sister Joel Read, president, Alverno College, Milwaukee, Wisconsin; Leon Stein, representative of the International Ladies Garment Workers Union; and, Dr. Jacob Neusner, professor of religious studies and Ungerleider Distinguished Scholar of Judaic Studies at Brown University.

Almost without exception, each of these council members were repre-

sentatives of constituencies heavily funded by NEH programs that NEH's council approved. In one of the three seats reserved for the public, I sat beside Ruth Dean of the *Star*. Between our feet, Ruth Dean operated her tape recorder, upon which we both had come to depend to determine what was actually said at meetings of the Ministry of Culture. Our seats were immediately behind J. Gordon Hall, Professor Jack Neusner, and Mrs. De Kleven. As the officers of NEH continued their sing-song reports, Mrs. De Kleven reached back and handed me a booklet on New Mexico: "Here, why don't you do something useful—read this."

Mrs. De Kleven's booklet was handsomely illustrated with four-color plates on "The Land of Enchantment, filled with drama and mystery and magic." According to its publisher—The New Mexico Travel Division, Commerce and Industry Department—New Mexico's "colorful past flourished in the present." In the many-splendored land of New Mexico, "good overnight accommodations were available in Aztec, Farmington, Gallup, Grants, and Truth or Consequences."

Looking around the room, it seemed to me that the distinction between what was an open public meeting and a private secret meeting would soon become obvious. All eighty citizens present could remain within the tabernacle to hear secrets, if they were invited to do so. Secrets were not defined by what NEH alleged were secret or exempt, nor whether NEH's secrets were actually secret, but were determined by NEH—regardless of any laws to the contrary—according to who was allowed to hear what NEH said about itself; and the explanation for NEH's peculiar procedures at last began to come clear. By listening carefully as NEH explained its interpretations of national cultural policy—the sing-song reports of teachers talking down to their students at morning assembly —I finally realized why NEH insisted upon its own "interpretations" without testimony from independent witnesses: NEH hated reality in all its gorgeous detail, but loved its own illusions, its own mysteries, its own miracles as blessed by its own priesthood. The essential element of NEH's fervent secrecy was paranoia: but not a fear that petty frauds or minor perjuries might be revealed—although NEH provided enough examples of those—but a discovery that humanism was bankrupt of any transcendental authority for the political power NEH was exercising, as NEH put it, to determine "how the humanities could enrich the life of the mind."

Following his Friday morning agenda for February, 1979, Chairman Duffey announced that the 1979 Jefferson Lecture, sponsored by NEH, would be delivered by Professor Edward Shils, world-renowned analyst on the relations between intellectuals and power. After the Jefferson Lecture, the Smithsonian would host a reception for 1,300 distinguished representatives of government, corporations, universities, and friends of the arts and the humanities in the pendulum area of the National Museum of History and Technology. The Jefferson Lecture was NEH's big-

gest Washington affair. Invitations were by card and dress was black-tie. The nominations to choose the 1980 Jefferson lecturer were the next item on Chairman Duffey's agenda, and he announced those proceedings of NEH were "closed to the public."

For the second time in two days I objected: copies of Ms. Birrell's Memorandum of Law were in Mr. Duffey's hands and available to members of the council. I reviewed briefly what the law required of advisory committees and why government in the sunshine was to NEH's advantage. Certainly the work of scholars only gained by open procedures. If the council chose to close its meetings to the public, I asked the members present to vote in the open to declare themselves secret.

The reaction was immediate and hostile. In the confusion, Dr. Richard Wall Lyman spoke up: "Joe, I think one simple thing is quite clear. If we are going to consider a vote on this question, we need time to consider it. We need preparation. Clearly, Mr. Mooney has prepared . . . and it seems to me that the rest of us ought to have time to look at the law, maybe to hear opinions on the law from those qualified to give them, and not to rush us into voting at this point."

The president of Stanford continued, "None of us even knew this was going to be talked about this morning. I, for one, object to voting now, on that ground."

Apparently my explanations at the council breakfast meeting just twenty-four hours earlier had already been forgotten by Dr. Lyman.

"For that reason," Dr. Lyman continued, "for the reason just stated, I move to table the question. If indeed there is a motion before us."

Joe Duffey looked around his council table, then replied there was no motion before the council. "I have to ask whether you're suggesting we continue with an open meeting."

Dr. Lyman stood corrected, he said. There was no motion. If and when there was a motion, he would move to table it, for the reasons he had stated. Not because he didn't think the council should discuss it, he said, not because he didn't think the council should vote on it, at some point, but because this was not the moment. The council was not prepared. "Simply proceed," Lyman advised Duffey. "Why should anything change? This issue has not come before us."

Chairman Duffey announced that he intended to proceed by closing the meeting.

Professor Jack Neusner spoke up, the only council member to do so. He said he thought the council should take the question seriously, "and I think that it would be a shame to walk away, to lose the sense of urgency."

Chairman Duffey interjected that he'd consulted for months about this. On his counsel's advice, he now believed the law permitted the National Council to go into closed session to discuss applications. Duffey

thought there was some confusion with the National Council on the Arts which conducted its meetings quite differently.

Neusner tried again: "Could we have a special committee of the council to consult with the chairman and to compose a policy that would be in conformance with the law and public interest?"

Dr. John Hope Franklin interrupted. Earlier he had explained that he was resigning from the National Council to take up his duties as president of the American Historical Association. Now, he began by saying he was sorry he had but one opportunity to resign.

The council laughed in appreciation.

"There are some of us," Dr. Franklin continued, "who simply are not going to discuss individual applications and people in public. And if it does involve that solution, Mr. Chairman, you might see some other resignations from this council."

There were murmurs of assent. Somewhere in the room two or three people applauded—probably NEH staff.

"We're simply not going to lay before the public," Dr. Franklin said, "the careers, the passions, the weaknesses, the foibles, the problems, the whims and difficulties of candidates for funds from this council. And I stand by that very firmly."

Dr. Franklin had put the matter eloquently. As he concluded, there was more applause. Joe Schurman declared that in his opinion as general counsel, "The Sunshine law does not apply to this agency."

Chairman Duffey declared the meeting closed. The next day, Ruth Dean noted in the *Star* that portions of the "open" meeting had also been secret. At one juncture, Armen Tashdinian, director of NEH's Office of Planning and Policy Assessment, pointed out corrections in materials included in the briefing books provided to council members. The corrections dealt with the council's 1980 appropriations request to Congress. Duffey cautioned the council members to keep the information referred to by Tashdinian in TAB E "confidential," because Duffey declared NEH's appropriation requests were "privileged."

Apparently, NEH's own request for appropriation of public funds was a "trade secret." NEH apparently considered themselves to be in a state of siege, requiring barricades against any public scrutiny. After two days of wrangling, NEH imagined they could declare that their own secret procedures had never come to their own attention. And despite the exemptions NEH had cited in the FACA notice, it apparently made no difference at all to NEH that nothing involving either trade secrets or unwarranted invasion of personal privacy was actually discussed as NEH nominated historian Barbara Tuchman to be the 1980 Jefferson Lecturer. NEH had the sole authority to "interpret" the meaning of the shadows they cast upon their walls, even if there were no shadows at all in NEH's fluorescent cave.

On April 9, Professor Edward Shils delivered the 1979 Jefferson Lecture. He warned the academic community that there were limits to the claims of Caesar over academic interests; that God and Caesar were always in conflict; and that against Caesar's claims over every aspect of national life, universities were legitimate sources of opposition. After World War II, Dr. Shils explained, the national government had added "the use" of universities as an instrument of Caesar's policy, but then demanded that the university itself become obedient to Caesar's power. Dr. Edward Shils believed it was time for "a new declaration of rights and duties."

At the reception after the Jefferson Lecture, Chairman Duffey was asked his opinion of Dr. Shils's theme. Duffey said he admired the force of Dr. Shils's intellect, "but I do not think Professor Shils understands the social situation in this country."

Meanwhile, General Counsel Schurman forwarded a copy of a portion of what appeared to be either minutes or a memorandum headed, "1. Public Access to Council Meetings." The top and bottom of the document had been blanked out. Mr. Schurman's Xerox copy contained two significant admissions. First, in his opinion, the Thursday breakfast meeting of the National Council did appear to be what was often described in Sunshine law cases as a "brown bag" meeting. Advisory committees could not evade the law by conducting a private, informal meeting, with sandwiches brought along in "brown bags," deciding among themselves what they would decide in public, and then conducting a public meeting to announce conclusions already reached in secret. In the opinion of General Counsel Schurman, the informal meetings habitually conducted by the National Council could only be "closed to the public" if actual "applications or personnel matters were being discussed." Despite Counsel Schurman's opinion, beginning in May, 1979, NEH closed their informal meetings and conducted "brown bag" sessions. What topics were actually discussed was secret because NEH kept no minutes, although FACA regulations required NEH to do so.

In the blanked-out copy, Counsel Schurman provided his second significant admission by summarizing Dr. John Hope Franklin's eloquent position: "Mr. Franklin stated that he felt it was important that the Council refrain from laying before the public the weaknesses and foibles of applicants for Endowment support." Except for clearly unwarranted invasion of personal privacy, it was precisely the weaknesses and foibles of the endowment's applicants that the public had a right to know.

On March 21, 1979, General Counsel Schurman wrote a letter in answer to Ms. Amanda Birrell's Memorandum of Law. He sent copies of the letter to the members of the National Council on the Humanities and to Mr. Douglas Wood in the FOIA unit at the Department of Justice. Schurman's letter began by listing the cases cited by Ms. Birrell. He said it was difficult to reply to the citations, because not a single one of them involved the statute in question, the Federal Advisory Committee Act.

Schurman's assertion evaded Ms. Birrell's contention that the cases she had cited controlled the interpretation of FACA regulations.

Schurman then went on to cite cases which he believed provided "better guidance." He cited *Nader* v. *Dunlop,* 370 F. Supp. 177 (U.S. Dist. Ct., D.C., 1973), a case which came to the courts before FACA was amended. Yet Schurman's citation was a case in which the court held that blanket exemptions such as those claimed by NEH were, as Mr. Schurman himself noted in his letter, "clearly contrary to the Congressional intent and to the policy of the Advisory Act."

Next, Counsel Schurman cited *Aviation Consumer Action Project* v. *Washburn,* 535 F. 2d 101 (U.S. Ct. of Appeals, D.C., 1976). Mr. Schurman's citation was truly odd because he was citing the first case cited by Ms. Birrell in interpreting FACA regulations, and citing one of the key cases he had cited on the preceding page of his letter as a case which did *not* apply. Moreover, his own analysis of the FACA law continued to contradict, in his own words, the exemptions he claimed NEH was due. He closed by citing *Food Chemical News* v. *Davis,* 378 F. Supp. 1048 (U.S. Dist. Ct. D.C., 1974), which, in Schurman's own interpretation *prohibited* "informal meetings" exactly like those that NEH was conducting. In sum, by April, 1979, Chairman Duffey and the National Council on the Humanities had opinions from an outside pro bonum memorandum and in addition a letter opinion from their own general counsel that secret procedures by an advisory committee were "clearly contrary to the Congressional intent" of FACA legislation and contradictory to the case law as decided in the courts.

None of these findings made the slightest difference to NEH. Undaunted, Chairman Duffey cited two more cases, which he implied gave NEH the authority to hold secret meetings and keep secret records—the cases of Mr. *K.C. Wu* v. *the National Endowment for Humanities,* and *Wu* v. *Keeney.* Dr. Keeney was previously chairman of NEH. Upon hearing that Joe Duffey was citing the *Wu* cases, I telephoned him to ask if what I'd heard could be true: both cases were overruled after 1974, and were totally irrelevant.

Well, as a matter of fact, said Duffey, he had cited them, perhaps. I suggested he stop; he would make a fool of himself. He had been an officer of Americans for Democratic Action when Congress overrode President Ford's veto of the amended FOIA rules. As a once-upon-a-time interested party to the FOIA amendments, Duffey could not claim ignorance of the changes in the law.

It seemed to me that only one excuse remained to explain NEH's defiance of the applicable laws: Dr. Lyman's complaint that the National Council had not had sufficient time to consider the issues raised. And so, one year later, I returned to the conference room in the Shoreham Building for the council meeting on Friday, February 22, 1980. Once again, when Chairman Duffey moved to close the meeting of the National

Council, I objected and asked for the legal basis. Once again, General Counsel Joe Schurman cited "trade secrets" and "personnel matters." Once again, I asked the council to vote.

On February 22, 1980, the National Council on the Humanities voted unanimously to consider the nomination of the Jefferson lecturer in secret. Chairman Duffey ordered me to leave. During the byplay over how Jefferson's ideals could be declared secret, I asked Duffey whether a quorum of the council was present.

Although only twelve members were present—instead of the fourteen required for a quorum—Dr. Richard Lyman snapped back, "We'll decide that."

As vice-chairman of the National Council on the Humanities, Dr. Lyman believed his authorities included deciding whether six plus six equaled fourteen. His reply was a marvelous parody of O'Brien's lessons to his prisoner Winston in *1984:* sometimes a quorum was fourteen, sometimes twelve, sometimes all of these at once. It was very difficult to become sane: difficult to understand that events that happened before our very eyes had not necessarily come to the attention of those like Dr. Lyman who were themselves the principal actors in the events which had officially not occurred. A schizophrenic system of official thought was a necessity to the transcendental ethics of power.

But we must learn to understand one another. To achieve love, order, progress, truth was what the party said it was. The New Order was a collective solipsism, with powers over reality itself. Under the benevolent tutelage of the Ministry of Culture, all the dialogues and shifting interpretations had a single objective: to teach us that reality existed in the official findings, but nowhere else. When tyrants had seized power in the past, they justified their violence by making promises about a paradise that lay just around the corner in the future, where human beings would be free and equal; but the humanists of the New Order were different, they were pragmatists, and they had the audacity to admit that the object of their powers was power, and nothing else. There would be no future.

At first such claims were like those heard in a madhouse—visions not to be taken seriously: but transcendental powers to interpret the past with new meanings, willy-nilly, everyday, was a political derangement with dismal consequences. Without particular certainties from the past, the social conditions of the future were equally intangible. There would be no hopes, no reasons for change, no losses, nothing but love for one another, despair, and death. If these perceptions were taken literally, if those who advanced them in the public interest were to be believed, they were not only an ideology for power unlimited, they were a declaration of war—or the moral equivalent of war—by the corporate state against community opinion. They were an announcement of a state of siege.

During the coffee break at the February, 1980, meeting of the National Council on the Humanities, I stood at the squared council table with Chairman Duffey and General Counsel Schurman. Running down the printed agenda with my index finger, I asked which of the items listed could possibly include "trade secrets" or "clearly unwarranted invasions of personal privacy." The Ministers of Culture insisted every listed item was exempt—not only Tom Jefferson's lecture, but federal-state relations, long-term plans, budgets, everything.

Laughing, I said it appeared as if the endowment was claiming blanket exemptions from public inspection which exceeded those sought even by CIA.

"We do," said NEH's general counsel, "for humanists."

A random sample of Malfeasance: The Ministry directs . . .

The Council recommends that the following conditions apply to approved applications as follows:

H-36060 (Committee for the Humanities in Georgia)

that $102,300 will be released only if a second full-time professional staff member who is a fully qualified humanist begins an appointment with the Committee no later than July 1, 1979.

H-34750 (Nebraska Committee for the Humanities)

that (1) before announcing or funding the "special grants" category listed on pp. 19-20 of the proposal, the Committee must submit detailed guidelines to NEH for approval; and (2) that the Committee must submit to the Endowment, within 60 days, the criteria to be used to identify humanists who do not meet the Committee's definition of "professional scholars in the humanities" (p. 20 of the proposal). Inclusion of such humanists alone shall not be sufficient to guarantee humanist participation in projects until the Endowment approves these criteria.

The Council recommended that the following conditions apply to approved individual applications as follows:

PD-0037 (U.S. Conference of Mayors)

that USCM provide resumes for the project staff and consultants within 60 days

PD-0035 (Philadelphia Area Cultural Consortium)

that humanists with expertise in the city's black history be added to the project and their vitae submitted to the Endowment for approval.

PD-0011 (Pierce County Rural Library District)

that a full-time project coordinator with a background in the humanities be employed, subject to approval of the Endowment

PD-0005 (New York State Education Department)

that scholars specializing in minority and American studies be added to the advisory committee

PM-0019 (Scripps College on behalf of the Galleries of the Claremont Colleges)

that the project researcher and project consultant be identified and that their vitae be forwarded to the Endowment for approval prior to the release of funds.

23

SONGS FOR GOATS / THE NEW ORDER'S SECRETS . . .

Doremus discovered that neither he nor any other small citizen had been hearing one hundredth of what was going on in America. Windrip & Co. had, like Hitler and Mussolini, discovered that a modern state can, by the triple process of controlling every item in the press, breaking up at the start any association which might become dangerous, and keeping all machine guns, artillery, armored automobiles, and aeroplanes in the hands of the government, dominate the complex contemporary population better than had ever been done in medieval days, when rebellious peasantry were armed only with pitchforks and good-will, but the State was not armed much better.

—Sinclair Lewis
It Can't Happen Here

As a statement of national cultural policy for humanists, Joe Schurman's claims of exemptions were goofy—or so it appeared at first; but by 1980 all the coordinated agencies of the White House Ministry of Culture—and all the other agencies of government as well—claimed that secrecy was a necessity to the orderly conduct of government. By making continuous claims for secret government, the New Order demonstrated how little respect it had for the decent opinion of mankind.

Secrets at NEH or CIA—or at any other agency of the New Order—were but preludes to farce or tragedy or both, as James Madison knew. Secrets set in motion a long train of abuses and usurpations, as Thomas Jefferson had declared. Secrets invariably pursued the same object: a design to reduce the people under absolute despotism. Yet secrets were toxic not only to democratic governments, which derived their just powers from the consent of the governed; secrets were equally destructive to every form of political organization, no matter how constituted: republic, aristocracy, oligarchy, tyranny, and particularly the modern authoritarian

regimes managed by the best and the brightest of university and corporate idealists. Secrecy deceived first of all those entitled to secrecy's privileges —secrets were always songs for goats.

Secrecy corrupted the synaptic connections of all ordinary community associations. As a result, secrecy numbed the voluntary consents in the public domain; but the poisons of secrecy struck first at the ganglia of power, paralyzing the central nervous system of political community. Thereafter, neither democratic leaders nor dictators could locate any right choice for action. Every fact dusted up into whirlwinds of trivia, slogans, deceptions, and banalities. The secrets CIA kept from public inspection were legitimate to the extent they were necessary for the conduct of secret wars; but the wars themselves were not secrets from CIA's secret enemies; they were secret only from CIA's supporters. More-over, by concentrating on the hostile forces in mankind's vast geography, the result of CIA's certifiable paranoia was that other elements of the nation's interest wholly escaped CIA's attention—which was exactly why the agency established to collect intelligence kept making estimates that were wholly inaccurate.

Secrecy at CIA, at the National Endowments for the Arts and for the Humanities, and at every other agency of the New Order resulted in conclusions which were always tentative, subject to revision, qualified by circumstances unknown, and events unforeseeable. As a result, consistency in public policy was impossible: crises were permanent consequences of secrecy's incoherencies. By the nature of secret procedures— if the New Order happened to arrive at a definite conclusion—the result was a display of gigantic self-conceit, colossal self-confidence, and extravagant and silly claims of "overriding national interest" or "for humanists." Inevitably, within a month, perhaps no longer than a week, the New Order was required to pretend that some sleazy political fraud had somehow been beneficial to community interest when first announced, but was now being abandoned. The uncertainties engendered by secrecy were universal and applied equally to CIA, Energy, State, Defense, Justice, NEA, and NEH. When the National Council on the Humanities insisted on maintaining its secret proceedings, the council interpreted its goodwill for "humanists" by deliberate and persistent violation of the laws designed to promote respect for the workings of government. The effect of the council's decision was to make it appear as if "humanists" who were previously law-abiding citizens now had secrets to hide.

Thereafter, the honest staff at NEH was required to bleat like goats when they were confronted with still other violations of law. By secret procedures, the Humanities Council was enticed into approving grants which included explicit directions to the applicants as to who should be hired, what should be studied, and how the results were to be published or applied. All these instructions by NEH were persistent violations of NEH's authorization, and they steeped the members of NEH's council in

malfeasance; but because the council had declared its proceedings secret, its distinguished members would have to cite their ignorance as the sound reason for their approvals. They had betrayed themselves from any understanding of the "broad social issues" they took to be their responsibilities.

Of the members seated upon the National Council in 1979, Professor Jacob Neusner was the only one to call for a study of exactly what the council's legal responsibilities might be for open meetings, but the council refused to consider its policy. Later, in the *Chronicle of Higher Education*, Professor Neusner wrote that quality control was needed at the Humanities Endowment. The distinguished scholar asked what was it that the humanists thought they were doing? He wanted specific answers to where and how government should make its contributions. As a member of the National Council, as far as he could see, there was nothing akin to quality control, no way to know whether projects worked or did not.

Professor Neusner thought "youth programs" sponsored by NEH was surely an imaginative idea, but rich in kooky potentialities. He asked how NEH knew when youth programs succeeded. "Do we even know that the program has been carried out?"

"Sure we do," he was told, "because there is a report on the project."

"Who writes the report?"

"The person who does the project."

Neusner wanted to know, "Isn't that like having students grade their own papers?"

The answer, according to Neusner, was silence.

"How about having members of the state commissions of the humanities follow up the programs and tell us what they think of them?"

Deep silence.

Professor Neusner still believed in a definition of the humanities as a series of academic disciplines. He would not accept that the New Order "interpreted" humanities as a secular religion to justify power. Because he had asked questions that required answers detailed by reality, in the corridors of power Professor Neusner was soon being characterized as "flakey." He would later admit that he had considered resigning; that he was ashamed of himself for having accepted membership on the National Council as an honor; that never before had he ventured from his brilliant career in Judaic studies because he had been flattered. Only after encouragement from his many friends did he decide to remain on the Humanities Council. He would do what he could for the humanities as a field of study under the conditions imposed by humanism's state of siege.

"Cultural citizenship," according to NEH Chairman Duffey, "is integral to political citizenship in a democratic society." As NEH awarded its grants, NEH clarified their interpretation of "cultural citizenship": loyalty to the party's fleeting objectives—tentative, changeable at a mo-

ment's notice, trivial, secret, and banal. Without the consent of the National Council, for secret reasons and to effect secret objectives, the chairman of NEH was empowered to approve grants whose totals were not to exceed 10 percent of NEH's annual budget. The totals, however, were about the same as Governor John Connally spent for his abortive primary campaign—$10 to $12 million. Moreover, Chairman Duffey was not only entitled to considerable powers at NEH, he was also the chairman of the Federal Council on the Arts and Humanities—the Ministry of Culture coordinating more than 300 programs "more effective than weapons." Finally, every grant made by NEH was supposed to be matched by equal funds from university, foundation, or corporate sponsors. As Duffey defined the party's truths, he had at his command a fund which exceeded *all* the monies paid over by *all* the candidates for *all* the primary campaigns. None of Duffey's ethical and political choices were subject to inspection by the Federal Elections Commission.

Strangely, few opponents to the Party's interpretation of "cultural citizenship" were candidates for "cooperating" or "coordinated" grants. Instead, the chairman of NEH awarded $45,000 to the Foreign Policy Association for fifteen "town meetings" to discuss the reasons why the SALT II Treaty was in the best interest of the United States and appropriate for Senate ratification. Theoretically, NEH's funds were matched by funds raised from those who supported the Foreign Policy Association's activities—such as AT&T. Certification that "matching funds" had actually been raised for any NEH grant was provided by the grantee—just as students were expected to grade their own papers. After events in Afghanistan made SALT II less attractive, Duffey's grants for town meetings ceased for "cultural citizenship" with respect to SALT.

Meanwhile, to carry forward the benefits of scholarly discovery, Duffey awarded $175,000 to the United States Conference of Mayors "to bring human values to bear on public policy and to make better use of cultural facilities." Along with these highpurposes for the nation's cities, and as a specific condition of NEH's approval of the cultural citizenship of elected mayors, NEH demanded that copies of the resumés for the project's staff and its consultants be delivered to NEH within sixty days.

Without the approval or knowledge of NEH's established council, Chairman Duffey exercised his authority to make other grants in secret. Among the beneficiaries was the American Association of Community Colleges for "planning for community forums on energy use and the humanities." If there appeared to be incongruities in such definitions, the president had declared that the energy crisis was the moral equivalent of war. Without question the topic of war, and morals as well, were within the purview of the "cultural citizenship" of community colleges. Chairman Duffey also awarded a planning grant to the National Association of Neighborhoods for "planning for the Urban Partnership Project." The project itself was under the authority of other agencies of the New

Order's goodwill, but had coincidentally earned national attention after the president was seen on the evening news touring the rubble of the South Bronx. After other secret considerations, the Humanities Council made grant #0041 to the American Labor History Series, for "Made in U.S.A.," amounting to $2,376,825; and grant #0040 to the Southwest Center for ETV, Austin, Texas, for "Portraits of a People," amounting to $684,260. Without consulting the council Chairman Duffey made grants to the American Federation of Teachers, the National Council of La Raza, the National Italian-American Foundation, the National Coalition of Cuban-Americans, the National Consumers League, and the Oil, Chemical, and Atomic Workers International Union. After secret deliberations, and for reasons unknown, the National Council on the Humanities refused a grant to the Aspen Institute; whereupon, Chairman Duffey approved a grant anyway. To achieve the just and beautiful society, as Chairman Duffey had explained, some chairman's grants went to projects that did not fit into any of NEH's programs.

The ambiguities resulting from NEH's secret interpretations of "cultural citizenship" created an eerie banality to the sacerdotal discoveries announced as results of NEH's programs. NEH and the California Historical Society mutually funded a project titled "The American Farm." Writer Maisie Conrat and photographer Richard Conrat assembled nearly two hundred photographs depicting the farms of yesteryear and the farms of today. An exhibition of the photographs was mounted, then toured to Des Moines, Dallas, Seattle, Grand Forks, and San José. Simultaneously, Houghton-Mifflin Company published a handsome book to accompany the exhibit. According to NEH's announcements, the traditional American farm was disappearing, and the exhibition "The American Farm" "brought to public attention this reappraisal of our transformation from a rural to an urban society."

The photographs, the exhibition, the book were all excellent; but what did NEH mean by "public attention"? NEH's "reappraisal" consisted of conclusions, demonstrations, and illustrations from some other world— in which all things about farms were true at all times. NEH was proud the exhibit would tour in cooperation with the American Farm Bureau; yet, NEH's goodwill for the "disappearing American farm" trivialized the *actual* farmers who represented *actual* disappearing farms, and who were barricaded behind a wall of D.C. buses which held police armed with gas cannisters. Although they were within sight of NEH offices, the events on the Great Mall had not come to NEH's attention. Apparently, complaints that corporate conglomerates were taking over actual farms were matters NEH had not noticed. As part of NEH's "interpretation" of "cultural citizenship," NEH knew nothing about the farmer banned from meeting with Vice-President Mondale because the farmer's big hands constituted a security risk. Meanwhile, in cooperation with ICA, NEH funded "intercultural" studies for Latin America. Almost without excep-

tion, these studies urged land reform as the first step to effect social change; but those who attempted *actual* land reforms in Latin America were exiled, tortured, and murdered with funds provided by other New Order's agencies—a topic NEH assiduously avoided. Moreover, those who opposed similar incorporation of farms into conglomerates in South Dakota were equally uninteresting to NEH's "reappraisal of our transformation from a rural to an urban society."

Yet neither was there much about the *actual* conditions of urban society that interested NEH. In the agency's house organ, *Humanities*, the January, 1980, issue began with an essay by Robert Jay Lifton on "Nuclear Awareness." Dr. Lifton was justly famous as an interpreter of the impact of extreme historical circumstances on human behavior. At Yale University he held the professorship of the Foundation's Fund for Research in Psychiatry. On a research grant from NEH, he was working on a book titled *Doctors of the Holocaust*. For the first time in history, he believed, technology now threatened to annihilate the species. "Since the two great holocausts of World War II—Nazi genocide and the American bombings of Hiroshima and Nagasaki—this universal menace has affected us all psychologically." An omnipresent sense of universal danger haunted our era, in Dr. Lifton's opinion. The main response, he believed, was a denial, a numbness; "but that denial is uneasy; the death anxiety shows through underneath."

Dr. Lifton's analysis in *Humanities* of the psychological effects of terror—the state of siege in which every citizen, as he explained it, was hostage to political leaders, technicians, military and corporate planners—was gracefully written and psychiatrically accurate. As to whether Three Mile Island had been a threatened catastrophe or an actual catastrophe, Dr. Lifton said, "The point is we really don't know."

He knew that those opposed to established nuclear policies were engaged in political controversy, and he understood how people opposing nuclear projects could believe they were fighting not only for their own lives, but for those of their children. "One may question this interpretation, but it represents the conviction of increasing numbers of people."

The difficulties with Robert Jay Lifton's essay in *Humanities* were not in his insights, which were considerable, but in its banalities—the very evil Hannah Arendt had testified was at the heart of the Holocaust. According to six national commissions, Three Mile Island was an *actual* catastrophe, and the interpretations of a "clear and present danger" existed not only by conviction in the minds of people, but from evidence obtained at an actual site not far from Harrisburg, Pennsylvania. The events at TMI were not abstractions, but realities demanding immediate social action. It didn't matter how many people were convinced as an abstraction that they were hostages of political, technical, and corporate planners acting in secret; what mattered was whether the New Order was *actually* holding society hostage by secret meetings. To believe that

death camps were subject to interpretation in the light of cultural citizenship, depending upon one's point of view, was to exchange *actual* murders for a myth. When fraud and violence made their *actual* appearance, there was no earthly reason to accept their advent from many points of view; nor to humbly wait, as Duffey had suggested, welcoming meaning in the passive spirit of Buddhist Vijn-Ana.

But by 1980, few could object to the New Order's determined banalities. The New Order dominated all television production. After NEA refused the Donn Alan Pennebaker proposal, most independents gave up. The New Order funded nearly half of all literary organization operating budgets. After the Randolph years, only the poets could complain, and poets fortunately had always depended on some work other than poetry to maintain their lives. Through the maze of coordinated agencies directed by the White House Ministry of Culture, the New Order funded more than half of all university activities; moreover, the New Order "matched," by its own efforts, with cooperating corporations funding for every major program in art, music, literature, science, history, politics, and all the consequent questions of social and moral choice. As one former NEH contractee explained, he could not afford to speak out about the scams he knew. "You've got to remember that I have no choice. If I want to keep working I have to do business with these people day in and day out."

Although some chose to collaborate, there were others whose resistance was silent. They would "leak" to the press or to anyone who would listen. Like guerrillas in an occupied country, they Xeroxed secret documents, put them into envelopes with no return address, and dropped the evidence in the mail. Despite the self-congratulatory testimony by the officers of the New Order about a cultural-policy-more-effective-than-weapons, the actual procedures within the Ministry of Culture apparently disgusted some of its officers. The attitudes of most working artists, historians, and writers were somewhat different: to the extent they knew or cared about the Ministry of Culture, it seemed to be some sort of political establishment as corrupt and as foolish as most such political organizations generally were. There were no political rewards to be won from works of art; the only utility of art to politicians was as propaganda; and artists despised propaganda for its simpleminded deceits. Whatever the Ministry of Culture was doing, or claimed to be doing, had no effect on the immediate concentration necessary for an artist to complete the work upon his table.

Moreover, the manners of working artists were quite different from those who promoted art. When artists, historians, writers met socially they gossiped—just as neighbors would—and they talked shop, too, but never about abstract virtues of art, or about the specific work in which they were engaged. They talked instead about agents, dealers, prices, deals, productions. They talked about new combinations of lovers or sad

divorces. They exchanged horror stories about fraudulent accountings by publishers, about kamikaze movie producers, about dealers who had somehow lost their paintings. To the extent that "a well-coordinated active national cultural policy" would ever be mentioned at all, it could be dispatched in less than a minute by an anecdote illustrating bureaucratic stupidity.

A few—a very few—working artists took the trouble to review the New Order's abuses. The reaction by the Ministry of Culture and its congressional allies was to characterize any dissent as the complaint of a disappointed applicant. The slur of "sour grapes" was applied to whomever complained—whether poet, painter, sculptor, critic, editor, author, historian, folk singer, craftsman, research librarian—and whether the dissenter had ever been an applicant or not. If libel was insufficient to dispose of dissent, the New Order answered charges of malfeasance with silence, but suggested that the witness was, perhaps, "flakey," or "crazy."

In a strange way, the charge contained an element of truth. To Professor Neusner's reasonable questions about why grantees should be directed to evaluate their own projects, NEH had answered with silence. Then Chairman Duffey took Professor Neusner aside to suggest quietly that perhaps the professor's questions were evidence of instability. As a matter of fact, anyone who doubted orthodoxy's established truth, anyone who posed questions about the reality of miracles already certified, *was* crazy—from orthodoxy's point of view. The response to Neusner's doubts was exactly similar to Energy's reaction and Justice's prosecution of the questions put forward by Howard Morland in the *Progressive* case: inappropriate *questions*, requiring material answers, were threats to the New Order's divine revelations. As O'Brien patiently explained to his prisoner Winston in George Orwell's *1984*, "it was difficult to become sane."

According to those who heard the questions she raised about the film and television activities of NEA and NEH, Ms. Julie Motz was clearly "crazy." Her determination to expose what she said was nothing but a system of frauds was in itself proof of how crazy Julie Motz really was. To dispose of one series of her dissents, NEH also suggested that Ms. Motz wanted attention because she was a disappointed applicant. On April 19, 1979, General Counsel Joe Schurman wrote the members of the National Council on the Humanities to forestall any further testimony by Ms. Motz to members of the council individually, or collectively at the upcoming May meeting. Schurman suggested that all calls be referred to Dr. Richard Lyman at Stanford. According to Schurman's memorandum, Ms. Motz was "interested in a grant application, H-29640 (the Hudson River Film Project) which was twice recommended by the Council for rejection, once in August 1977 and again in May 1978."

Although it was true that NEH's council had twice rejected the Hudson River Film Project for NEH grants, Counsel Schurman omitted to tell

NEH's council a significant fact: the grant application Schurman said Ms. Motz was "interested" in discussing with council members was for a film that had long since been completed. The Hudson River Film Company raised its production money without NEH participation or approval, and with Sonja Gilligan as producer/director and Orson Welles as narrator the film had not only been completed, but had also been awarded prizes in New York State. *Hudson River* had qualified thereby for nomination in the documentary categories for an Oscar in the Motion Picture Association Academy awards. Mr. Schurman's memorandum was false about what Ms. Motz was interested in discussing.

Julie Motz had qualified as an enemy of the people and a disappointed applicant in the course of discovering by concrete example how the system operated by the Ministry of Culture *actually* worked—something members of the various national councils and various congressional committees apparently found distressing to learn. Proposals for independent films were examined first by "consultants." The commentary by the consultants on a specific proposal was then edited by endowment staff. Those comments or portions thereof which agreed with the staff's purposes might be attached to the proposal for a peer-review panel to consider. Those comments that disagreed with the staff's objectives were never seen by the panel. Thereafter, no matter what the panel voted in secret—to approve or disapprove—the staff again had an opportunity to edit the panel's views before sending the application to the National Council. In some cases, proposals to the endowments were accompanied by the applicant's previous work—because previous work provided the best example of an applicant's skills, endowment staff might report to the applicant that previous work—tapes or films—had been shown to the panel who would make the recommendations to the National Council. Not only were such statements false, Julie Motz could cite examples in which the endowment's staff had lost portions of previous works. In any event, members of panels chosen to judge works had never seen the works endowment officials claimed they showed.

Armed with evidence, Julie Motz testified at congressional hearings, traveling to Washington at her own expense, outraged by the hypocrisies she could demonstrate. She knew her testimony meant she had faint hope of ever again being funded by any of the agencies of the Ministry of Culture. She would be blacklisted. After one congressional hearing, funds were abruptly withdrawn that had previously been committed to her production company by the National Park Service. When NEH's Chairman Duffey characterized Julie Motz as attempting to extort grants by raising a fuss, her response was a shrug: "If that's what he thinks, let him say so. I don't care. The whole thing is so corrupt it has to be stopped."

The New Order's officers habitually assumed that everyone had no interest except private gain, but Julie Motz was a problem: there was no way to stop her from talking, she talked to anyone who would listen, and

she talked very fast. At congressional hearings, she made a terrible witness because she would not slowly labor through the banal, as was the custom. For their transcripts, congressional clerks had to ask Julie Motz to reconstruct her testimony after the hearings were over. She also presented the New Order with other problems. She arrived from New York in chic designer suits, size eight, with Madler bag and shoes to match, and sometimes wearing a hat in New York's latest fashion. Washington, she said, lacked style: it was a city of Mrs. Grundys and anxious club women, or ambitious office holders dressed in blue blazers and gray flannel skirts in frank imitation of their male counterparts. On one of her trips to Washington she complained that there wasn't a single place where a woman could get a decent hair cut. She said she'd stopped at the cosmetic shop a block from her hotel, "and they didn't even have purple eye shadow!"

"Imagine a city that restricted the height of its buildings," she remarked. "Instead of letting architects express the energies the buildings are supposed to contain, they've built these miles and miles of low, squat, ugly things. And that's how they think too. Each stupid department all shut up in a closed world of its own. Shut-ins. They see and hear no one, except the people in their own shop."

Julie Motz had the staff members of the Ministry of Culture at a disadvantage, and the honorable members of Congress baffled, because she knew what she was talking about, and they did not. She knew the practical details of film and television, tangible experiences beyond their competence. Besides, when the chairman of NEH awarded a secret grant, which NEH's staff or council had refused, to proceed with a film, Julie Motz knew about the deal the next day. Although Ministers of Culture might complain that charges about their extravagances were based upon gossip, the network of information in the arts operated on gossip and saw no reason to wait until some official certified the commonplace. Along with her partners, Julie Motz and the Gilligans had made *Christina's World*, a documentary produced for a total of $80,000, and *Christina's World* had won four Emmies. No one in the Ministry of Culture had ever won any Emmies, or anything comparable.

Julie Motz's hands were dirty in the *actual* work of art. She had been graduated in philosophy from Bryn Mawr, read aesthetics at the London School of Economics, studied film at Columbia University, and won her master's in film. She had also worked as a still photographer in museums, made vanity films, and worked on commercial Hollywood productions, including the 16mm location shots for George Plimpton's *Paper Lion*. Instead of sitting through academic seminars around long conference tables discussing "the art of film," Julie Motz's career included the kind of experience actual filmmakers usually had: she'd worked as a hatcheck girl at the Village Gate in order to eat and pay rent; she'd made educational films to show teachers how to teach; she'd threaded and spliced as

an editor; she'd raised money any way she could; she'd traipsed back and forth to the company's station wagon for still another piece of sound equipment; she'd waited through rainy days for available light. She'd even sat at the tables in Elaine's along with "CoCo" Brown, Stu and Grace Millar, Carol and Jack Gelber, Jack Richardson and Bob Brown, and other examples of talent, hope, skill, and the riffraff, too, who ate, talked, and drank films. Consequently, there were few in the official offices of the Ministry of Culture who had the slightest idea of what Julie Motz was talking about, and therefore she could be characterized as "crazy."

She recalled hearing in an academic exchange about the "creativity" process defined—by humanist interpretation—as the means by which an artist explored what form his visions might take. Her reaction was instantaneous: "Bullshit. Mozart knew exactly how he wanted his compositions to come out."

"The trouble is," said Julie Motz, "those people are threatened by anything that might turn out not to be boring." All those good intentions, she said, were to pave the road to banality. The panel system was a farce. The endowments were so unsure of themselves they gathered together experts to validate each other's work. "If they were sure they had a good script, or a good story to tell, why didn't they go ahead and make it?"

The real reason, she guessed, was they hated art. Except to the artist, art had no use. It had always been inefficient, just as the work of a really brilliant scientist was irresponsible and inefficient. As to statements such as Joan Mondale's, that it was the duty of the government to give the people what they really wanted, that was just so much political talk, and had nothing to do with how artists worked. Artists judged other artists by their works, not by some vague guess about who was going to use it, and certainly not according to what some put-together committee of academic bureaucrats thought about it. "The truth is," Julie Motz believed, "a national cultural policy would have to fear more than anything else the erotic thrust of brilliant art."

I asked her if she didn't feel silly, or get discouraged, playing the part of Joan of Arc against the dauphins of "culture."

"Yes," she admitted, "but I'll never give up. They're such liars." Then she paused for a moment—which in itself was unusual—and laughed at herself. "Yes, I know what happened to Joan of Arc. She died a virgin."

Of the many who were outraged at some of the Ministry's procedures, few had Julie Motz's stamina. For seventeen years Mary Ann Rosenfeld Liebert had worked at Marcel Dekker, Inc., a small commercial publishing house in New York. The main business at Marcel Dekker consisted of publishing research, reference and professional books, textbooks, and encyclopedias—largely technical materials. Along with these profitable technical materials, Mrs. Liebert nurtured a few books on the history and the glories of American dance. She admitted that the dance books were not profitable, but as many commercial publishers did, she thought they

were worth doing if Dekker could more or less break even. To continue her series she encouraged Sally Ann Kriegsman to attempt a history of the Bennington Dance Program. For the magnificent advance of $1,000, Mrs. Kriegsman began work.

Her effort included organizing the Bennington library files on the subject. After ten years, Mrs. Kriegsman's manuscript was ready for her editor, Mary Ann Liebert, at Marcel Dekker. At about the same time, an application arrived at NEH for a history of the Bennington Dance Program. In early 1978, the "Golodner" history, proposed by the Office of Grant Development of Bennington College, was sent around to consultants for their comments. Among the consultants was Allan M. ("Mike") Kriegsman, dance critic of the *Washington Post*, but also the husband of Sally Ann Kriegsman, author of the Dekker manuscript. Mike Kriegsman advised NEH that he would disqualify himself as a reviewer because of his conflict of interest; but he pointed out that a history of the Bennington Dance Program by his wife was ready for publication, and funding another history on the same subject for $20,000 perhaps did not make sense.

Mrs. Liebert immediately attempted to discover from NEH exactly what was going on, but NEH officers were evasive. By April, 1979, Mrs. Liebert had hired Blum & Nash, Washington attorneys, to force NEH to produce its documents about the Bennington grants. Although NEH cited, as usual, exemptions for "privacy," when faced with an actual suit, NEH delivered. With the evidence provided in the documents, Mrs. Liebert testified before Mr. Yates' subcommittee, explaining that if the Humanities Endowment intended to compete with commercial publishers, using secret procedures and unlimited funds, NEH would put commercial publishers out of business. If NEH pursued its Bennington proposal, Marcel Dekker, Inc. would have no alternative but to abandon its seventeen-year-old initiative in the history of dance. Neither Congress, nor the National Councils, nor any of the Ministries of Culture paid any more attention to Mary Ann Liebert than they had to Julie Motz. In 1980, Dekker gave up and abandoned its dance publication program. Pergammon Press, Dekker's competitor in dance publishing, came to the same conclusion. Pergammon also quit their dance publications.

After Dekker and Pergammon abandoned their dance publishing programs, NEH officials explained that the history of dance at Bennington, as first explained by NEH, had been modified from a textual history to an *oral* history—a series of remembrances on tape. In effect, by secret procedures and new "interpretations" NEH had evaporated not only two commercial publishing lines, but NEH's own approved history. During the course of the controversy over the competing Bennington histories, it turned out that NEH was doing something NEH officials described as "subventing" the publication of books by NEH scholars. That is, having granted fellowship or research funds for approved topics, NEH would

then pay commercial publishers, as well as "nonprofit" university presses, to publish what NEH approved. Because NEH operated by secret procedures, and because NEH's state councils were not only secret but determined by their own motion to be private as well, NEH "coordinated" its activities with foundations and corporations however it saw fit. There was no way to estimate accurately how deeply the Ministry of Culture was involved in commercial publishing, or with which publishers.

But "fellowships" awarded by NEH amounted to $20,000 each. An estimate of the totals awarded by NEH each year in fellowships exceeded *all* the monies that would approximate authors' royalties paid by *all* university presses to *all* authors for *all* "nonprofit" works. In addition, NEH made grants for "research," and these totals appeared to approximate *all* the royalties paid for author's works for *all* nonfiction commercial publishing. Moreover, some NEH grants for publication ranged as high as between three and four million dollars. In sum, NEH made no distinctions in its operations between commercial and noncommercial publishing. And, in the event that a commercial publisher chose to publish books in competition with NEH's favored choice, NEH's competition might be told in clear language to quit.

During the secret February council meeting in 1979, a proposal was considered by which NEH would sponsor a series of popular editions of nineteenth-century American authors—Mark Twain, Howells, Poe, Melville, and others. The subcommittee of the Humanities Council had a number of reservations about the proposal they were being asked to approve. Apparently NEH and the Ford Foundation would jointly sponsor the series of books: *Literary Classics of the United States.* The reason given for the series was that many of the works of nineteenth-century American authors were out of print and not readily available to scholars; but whether the proposal as discussed in the secret meetings in February, 1979, was a proposal to publish scholarly editions or popular editions was not entirely clear. There were no minutes of the discussion or the decision. The National Council left the final negotiations to Chairman Duffey for a revised proposal submitted jointly by the Ford Foundation, Jason Epstein of Random House, and Daniel Aaron of Harvard University. The amount approved for the tentative grant reportedly ranged between $250,000 and $350,000. In May, the council would approve or disapprove the final application.

In checking with Jason Epstein at Random House, however, it appeared that the actual appropriation by NEH would be more on the order of $1,000,000, "matched" by $800,000 from the Ford Foundation. And there were a number of other inconsistencies to the proposed *Literary Classics of the United States.* Before the February meeting, Roger Kennedy of the Ford Foundation had telephoned at least one university president to pass the word to a professor at that university, who also sat as a member of

the National Council, suggesting why that professor should cast his vote to approve the Ford Foundation proposal. After the May council meeting, the amount contributed by NEH to the total exceeded the statutory limitations in NEH's authorization. Finally, members of the National Council were not told that Harcourt Brace Jovanovich had announced in April a multimillion dollar, fifty-volume "America's Library"—a commercial project with specifications nearly identical to those proposed to NEH by Epstein of Random House, Aaron of Harvard University, and Kennedy of the Ford Foundation. Although the NEH approval at the February meeting of the council had been tentative, Roger Kennedy called upon William Jovanovich of HBJ, and Kennedy told the HBJ editors that the Epstein-Aaron-Ford Foundation editions had *already* been approved. Kennedy said that it was Harcourt Brace Jovanovich's "patriotic duty to withdraw."

After NEH's commercial competition agreed to withdraw, a nonprofit corporation was formed to receive the grants NEH had approved to republish popular editions that NEH had already published as scholarly editions in the early 1970s. In sum, the new popular publication of nineteenth-century American authors had nothing whatever to do with making out-of-print works available to scholars; on the contrary, NEH was funding commercial competition to commercial publishers' existing editions of the same works. And these evidences of NEH's goodwill for an active-well-coordinated-national-cultural-policy were accomplished by approving grants in secret for an application from a nonprofit organization which had not yet been created, but whose subsequent officers urged existing commercial publishers to withdraw. Every single element in this patchwork violated the original limitations Congress had set to NEH's activities; nor was any thought given to the consequences of the Ministry of Culture manipulating commercial publishers with promises of funds to be approved in the future along with disapprovals for any current expressions of dissent.

Secret procedures and corrupt procedures were substantial evidence of what the agencies of the Ministry of Culture actually meant by the arts-as-more-effective-than-weapons. Conclusive evidence of the New Order's powers was available day in and day out, and it was something anyone could see, as in the case of the purloined letter. Each and every agency of the Ministry of Culture coordinated its activities with corporate foundations, corporate political action committees, and corporations —seeking out "matching grants," "Treasury Funds," sponsorship for the activities Chairman Duffey interpreted as contributing to "the new national culture." EXXON sponsored the King Tut Museum show with NEH; Mobil Oil sponsored "The Art of Edward Munch" with NEA; Union Carbide sponsored studies of the social effects of nuclear or chemical policies with NSF. Every night on PBS, anyone could see how the goodwill expressed by the Ministry of Culture was made possible by a

grant from a list of legal fictions—but persons under the law, nevertheless—who almost without exception had been convicted of criminal conspiracies, of bribery, of subornation of public officials, of illegal campaign practices, and other similar activities to defraud the public interest. In many cases, Justice, Energy, SEC, FTC, or other agencies charged these Corpo partners of the Ministry of Culture with violations, then without admitting any guilt, the Corpos consented to discontinue the practice, and sponsored the arts. In contrast, imagine for a moment the uproar if in tuning to PBS the nation heard, "this program was made possible by grants from the National Endowment for the Arts and the Cocaine Dealers Association of Greater New York."

What was absurd about the favored partners for the activities of the Ministry of Culture was that no one doubted the New Order's partnership with Corpo criminals in the arts, or in any other activity. The new national cultural policy outlined by Chairman Duffey was to gain obedience to the New Order's ideology for the corporate state. The arts were more effective than weapons in numbing citizens to accept the transcendental ethical authorities the New Order claimed. The secrecies of agency procedures were not secrets from national enemies, but from democratic dissent. Once the elementary principles of the New Order's overwhelming powers were grasped, examples multiplied geometrically. The National Endowment for the Humanities was only one of the propaganda agencies for power unlimited—with no limits at all, and its examples were sometimes plainly silly, or cuckoo, but always consistent.

On January 25, 1980, NEH's general counsel, Joseph Schurman, wrote the indefatigable Julie Motz in reply to Ms. Motz's Freedom of Information request for a copy of what NEH called the "Fischetti report." In its entirety Shurman's answer read: "This is in reference to the report on this Endowment and its relations with outside foundations prepared by Pat Fischette (sic) in 1977. I am told that this report was prepared only in draft form. No final copy was prepared because it was misleading. In any event it has not been released and I will be unable to procure you a copy."

Hardly a word of General Counsel Schurman's letter was true. To begin with, NEH's acting chairman, Robert J. Kingston, directed Leonard Oliver, NEH officer, to accept Patrick R. Fischetti's final report in a memorandum dated September 16, 1977. Moreover, Counsel Schurman had a final copy—not a draft copy—of Fischetti's report when he wrote Ms. Motz. Fischetti's report covered the endowment's relations with corporations, not foundations. The study was financed by NEH and accepted by NEH to accomplish specific tasks as follows:

"1. To conduct a feasibility study on NEH relations with the Business Community with particular emphasis on the Challenge Grant Program, Gifts and Matching, and Corporate Humanities programs.

2. To provide a final report and plan for implementation of the findings and recommendations.

3. To examine NEH policy, processes, procedures, and publications as they reflect the business community's concerns."

To accomplish the objectives set for him by NEH, Fischetti interviewed dozens on NEH's staff and hundreds of corporate officers, sampled by region and by type of corporate business. Among Fischetti's many official conclusions in NEH's secret report was that NEH and its university allies would have to come around to corporate views on the "free enterprise system." Before NEH could improve its record of collecting corporate funds for NEH's projects, "free enterprise" would have to be accepted—as defined in the interpretations offered for a just and beautiful society by men like William Simon and David Packard. Both Simon and Packard were fully quoted by Fischetti to NEH.

Some of Fischetti's recommendations were subsequently adopted by NEH, but because of NEH's secret procedures there was no way of knowing whether NEH adopted new procedures as a result of Fischetti's report or for some other reason. In the name of NEH, consultant Fischetti had consulted with members of the Business Roundtable, the Council for Financial Aid to Education, Inc., the United States Chamber of Commerce, the National Executive Service Corps, and others. Thereafter, NEH initiated joint programs with many of the same groups.

Perhaps the most startling piece of correspondence addressed to Pat Fischetti, c/o Len Oliver at NEH, was the letter and plan proposed by E. B. Knauft, vice-president, Corporate Social Responsibility, Aetna Casualty, Hartford, Connecticut. In Fischetti's final report, Fischetti included Knauft's entire plan as an example of what NEH could accomplish by joint action with major corporations. Knauft titled his proposed project: "The Role of U.S. Corporations in the Society of the Future." Knauft thought Aetna Casualty would not be the right sponsor for what he proposed; instead, a "prestigious but 'neutral' sponsoring organization should be found," and funds raised through the "neutral" front.

Because, according to Knauft, "at no previous time has there been more broad, more challenging consideration of new limits and controls on the role of the corporation in American society," an identification of corporate contributions to society was urgent. Corpos were "the major employer of Americans, the major provider of food, of housing, of clothing, of transportation, of wealth in the United States."

Knauft's secret proposal to clarify the legitimacy of Corpo social and political ambitions included a series of conferences, somewhat like the White House Conference on the Arts. First there would be presentations of formal papers upon the role of the corporation "in the Society of the Future." Then, after several months to digest and react to the original materials, a second synod would be called to develop a statement of the role of the corporation "for the balance of this century and strategies to be adopted to fulfill that role." Thereafter, all papers and summaries and

conclusions would be published as encyclicals—to make the results "available to a wider audience."

The key topics for the conference included not only methods for corporate political operations, but considerations of the transcendental values corporations represented to society. The agenda included topics such as "changing worker attitudes," the accepted and dissenting philosophical and political thought about corporations, and "the political system and the corporation—ally and governor."

Of course, it should be understood that the secret views of Mr. Knauft in Fischetti's secret report for NEH's secret consideration were subject to many interpretations by humanists, as well as by those who pointed out correctly, as had Mrs. Mondale, that the arts were not just the icing on the cake.

Federal Trade Commission Complaints, Antitrust or Consumer*

Excerpted from *The Corporate Lobbies: Political Profiles of The Business Roundtable & The Chamber of Commerce*, by Mark Green, Director, Public Citizen's Congress Watch, and Andrew Buchsbaum, Public Information Director 'Big Business Day,' copyright Public Citizen, February, 1980, all rights reserved.

* *Key:* Docket numbers refer to computerized files of the Federal Trade Commission; CiB = Corruption in Business (New York: Facts on File, Inc., 1977); NA = Not Available.

Company	Date	Nature of Complaint	Docket #
Alcoa	6/15/73	Clayton, sec.8, interlocking directorates	C2415
	5/11/79	FTC Act, sec.5, deceptive practices, nondisclosure of material	
American Home Products	2/23/73	FTC Act, sec.5, unfair and deceptive advertising	D8918
Anaconda Co.	9/17/74	Clayton, sec.7. merger	8994
Armco Steel	6/15/73	Clayton, sec.8, interlocking directorates	2416
Atlantic Richfield Co.	7/18/73	FTC Act, sec.5, attempt to monopolize, horizontal restraints	D8934
	11/4/74	FTC Act, sec.5, consumer safety hazard, deceptive ads, nondisclosure of material facts	C2596
	10/13/76	Clayton, sec.7, mergers	7610044

Company	Date	Nature of Complaint	Docket #
Boise Cascade Corp.	4/15/74	FTC Act, sec.5, price fixing, predation, restraint of trade	D8958
Borg-Warner Corp.	8/20/75	Clayton, sec.7, merger	C2716
Bristol Myers	2/23/73	FTC Act, sec.5, false claims, restraint of trade	D8917
Champion Internat'l	4/15/74	FTC Act, sec.5, price fixing, predation, restraint of trade	D8958
Chrysler Corp.	1/9/74	Clayton, sec.8, interlocking directorates	C2484
	2/10/76	FTC Act, sec.5, unfair creditor remedies	7523170
	8/1/79	FTC Act, sec.5, deceptive and unfair practices	C2979
Coca-Cola Co.	9/10/74	Clayton sec.7, horizontal mergers	7410606
Corning Glass Works	11/27/78	FTC Act, sec.5, deceptive packaging	C2937
Dow Chemical Co.	11/4/74	FTC Act, sec.5, consumer safety hazard, deceptive ads, nondisclosure of material facts	C2596
E. I. duPont de Nemours	11/4/74	FTC Act, sec.5, consumer safety hazard, deceptive ads, nondisclosure of material facts	C2596
	4/27/76	FTC Act, sec.5, consumer safety hazard	D8870
Eastman Kodak Co.	3/22/76	FTC Act, sec.5	C2291
Exxon	7/18/73	FTC Act, sec.5, horizontal restraints, attempt to monopolize	D8934
	8/10/79	FTC Act, sec.5, conglomerate mergers	D9130
Federated Department Stores, Inc.	4/2/79	FTC Act, sec.5, practices/behavior	C2958
Firestone Tire and Rubber	9/9/75	FTC Act, sec.5, misc. deceptive advertising, consumer safety hazard	7623046
FMC Corporation	4/8/74	FTC Act, sec.5, nondisclosure/material facts, environmental safety, consumer safety hazard	D8961
Ford Motor Co.	12/10/74	FTC Act, sec.5, nondisclosure/material facts, misc. deceptive advertising	7523011
	2/10/76	FTC Act, sec.5, unfair creditor remedies	7523171

Company	Date	Nature of Complaint	Docket #
	3/22/76	FTC Act, sec.5, single company vertical restraints	7210053
	1/10/78	FTC Act, sec.5, deceptive practices, disparagement restraint of trade	D9105
General Electric	11/26/73	Clayton, sec.8, interlocking	C2477
	7/29/75	FTC Act, sec.5, unsubstantiated claim, deceptive advertising	D9049
General Foods Co.	7/14/76	FTC Act, sec.5, price discrimination, predation	7310030
General Motors Corp.	10/7/74	FTC Act, sec.5, deceptive advertising	C2564
	2/10/76	FTC Act, sec.5, unfair creditor remedies	7523172
	3/22/76	FTC Act, sec.5, vertical restraints, single company monopoly	7210053
General Tire and Rubber	11/4/74	FTC Act, sec.5, consumer safety hazard, deceptive ads, nondisclosure/material facts	C2596
Georgia-Pacific Corp.	3/12/73	Clayton, sec.2, brokerage	C2356
	5/25/73	FTC Act, sec.5, reciprocity	C2402
Gulf Oil Corp.	7/18/73	FTC Act, sec.5, attempt to monopolize, horizontal restraints	D8934
	7/15/75	FTC Act, credit advertising	7523095
	11/1/76	FTC Act, sec.5, unfair and deceptive practices	D4591
Ideal Basic Industries	6/24/75	FTC, sec.5, price fixing	9039
Int'l Harvester Co.	8/1/79	FTC Act, sec.5, deceptive and unfair practices	C2983
Int'l Paper Co.	4/15/74	FTC Act, sec.5, attempt to monopolize, price fixing, predation	C2518
Kennecott Copper Co.	6/15/73	Clayton, sec.8, restraint of trade	C2418
Koppers Co.	11/4/74	FTC Act, sec.5, consumer safety hazards, deceptive ads, nondisclosure/material facts	C2596
Kraftco Corp.	1/18/74	FTC Act, sec.5, horizontal mergers	D9035
	6/17/75	vertical licensing, horizontal mergers	7510028
Marcor Ind.	11/23/76	FTC Act, sec.5, unfair or deceptive acts	7723002

Company	Date	Nature of Complaint	Docket #
Mobil Oil Corp.	7/18/73	FTC Act, sec.5, attempt to monopolize, horizontal restraints	D8934
Monsanto Co.	11/4/74	FTC Act, sec.5, consumer safety hazard, deceptive ads, nondisclosure/material facts	C2596
Olin Corp.	11/4/74	FTC Act, sec.5, consumer safety hazard, deceptive ads, nondisclosure/material facts	C2596
Owens-Corning Fiberglass	11/4/74	FTC Act, sec.5, consumer safety hazard, nondisclosure/material facts	C2596
J. C. Penney Co.	2/2/73	FTC Act, sec.5, deceptive pricing	C2350
Phillips Petroleum	5/15/73	Clayton, sec.7, exclusive dealing	NA
PPG Industries	11/4/74	FTC Act, sec.5, consumer safety hazard, deceptive ads, nondisclosure/material facts	C2596
The Proctor and Gamble Company	11/1/76	FTC Act, sec.5, deceptive practices	D2148
Public Service, Colo.	9/12/78	FTC Act, sec.5, deceptive practices, false claims	C2907
RCA Corp.	6/12/75	conspiracy to monopolize	CiBp.193
Sears, Roebuck, and Co.	11/4/77	FTC Act, sec.5, nondisclosure/material facts, unsubstantiated claims deceptive ads	7523164
	9/17/74	FTC Act, sec.5, bait and switch	7123665
	4/20/77	FTC Act, sec.5, boycott	C2885
Shell Oil	7/18/73	FTC Act, sec.5, attempt to monopolize, horizontal restraints	D8934
Standard Oil Co. of Ind.	7/18/73	FTC Act, sec.5, attempt to monopolize, horizontal restraints	D8934
Tenneco Inc.	11/4/74	FTC Act, sec.5, consumer safety hazard, deceptive ads, nondisclosure/material facts	C2596
	10/29/76	price fixing	CiB
Texaco Inc.	7/18/73	FTC Act, sec.5, attempt to monopolize, horizontal restraints	D8934
Union Carbide Corp.	11/4/74	FTC Act, sec.5, consumer safety hazard, deceptive ads, nondisclosure/material facts	C2596

Company	Date	Nature of Complaint	Docket #
	10/4/74	FTC Act, sec.5, false advertising, misrepresentation, nondisclosure/material facts	C2557
Uniroyal Inc.	11/4/74	FTC Act, sec.5, consumer safety hazard, deceptive ads, nondisclosure/material facts	C2596
United States Steel	11/4/74	FTC Act, sec.5, consumer safety hazard, deceptive ads, nondisclosure/material facts	C2596
Weyerhaeuser Co.	4/15/74	FTC Act, sec.5, price fixing, predation, restraint of trade	D8958
Whirlpool	6/25/74	FTC Act, sec.5, deceptive practices, nondisclosure	C2515
Xerox Corp.	1/16/73	FTC Act, sec.5, single company monopoly	D8909

THE NEW ORDER / A CAULDRON OF
FIRE, FANNED BY THE WIND . . .

It was not that he was afraid of the authorities. He simply did not believe that this comic tyranny could endure. It can't happen here, *said even Doremus—even now.*

—SINCLAIR LEWIS
It Can't Happen Here

For the benefit of the Washington, D.C., Chamber of Commerce and other interested parties, and by the authority vested in it by the Congress, the National Park Service—censor of H. L. Mencken and one of the coordinated agencies of the White House Ministry of Culture—was responsible each year for declaring the week when the Japanese cherry trees were to blossom officially around the Great Mall. Despite the many powers the Park Service could summon up, the cherry trees always bloomed when they pleased, following some charming schedule of their own.

In 1979, the blossoms started just before Sunday, April 1. Despite what was a light gray drizzle or perhaps a sweaty fog, I drove down to the Mall with my wife and eighteen-month-old daughter. We would have a look at the cherry trees in early bloom and let Nell loose to stagger across the grass as she pleased. She walked by, staring down at her own feet, fascinated by the motion her shoes made across the landscape she traveled. Because it was Sunday morning and the day dismal, there were few passing cars and hardly a tourist to be seen anywhere.

The light morning drizzle floating down upon Constitution Avenue reminded me of the day a good many years earlier, when, as a young second lieutenant, I had paraded a sharp company of combat engineers down from Capitol Hill toward a reviewing stand set up on the south edge of the Ellipse. Despite the mists, the day had unexpectedly turned hot. Unfortunately, we were suited up in our wool Ike jackets and OD pants bloused into our engineer boots. Coming up to the reviewing stand

I turned back for a last look at my company before we passed in review. We were sweating plenty, but still looking good. Just before the guidon reached the north edge of the reviewing stand—where I was to give my company our eyes-right—the goddamn Marine Corps band struck up for us. In the blare of their trumpets, tubas, and drums, I had little hope the company behind me would ever hear eyes-right, no matter how I sang it out.

I let it fly anyway. And for luck, from under my salute I cursed the president of the United States and my commander-in-chief in 1952, Mr. Harry S. Truman, with as many foul words as I knew. Thanks to the Marine Corps band, he could not possibly have heard a single word. As I cursed him, I was grinning. He flipped back a salute above his own grin. Despite what I might have been saying, I was proud of myself, of my company, of my country, and of that cocky little sawed-off son-of-a-bitch from Missouri. On the same Constitution Avenue in April, 1979, I told the story for the umpteenth time to my wife. We circled the Ellipse to park the car by the National Park Service tourist information kiosk along the north side—at the back fence of the White House grounds.

The kiosk was closed. Once out of the car, we zig-zagged along after Nell. She was following her shoes more or less in the direction of Ground Zero—the national bench mark located at the north edge of the Ellipse and exactly south of the White House portico. As we meandered, a flight of three helicopters suddenly came whumping up over the trees along the edge of the Potomac. Two backup choppers peeled away toward Virginia. The president's camouflaged machine fluttered down to the White House south lawn. We crossed the Ellipse road to watch through the iron fence. We would wait and see the president's party board and lift off. But two mounted Capitol police wearing orange slickers against the drizzle appeared on either side of us to block off the northerly arc of Ellipse road. From both sides, two more men closed in on foot. We would have to move along, we were told by a young policeman of about thirty.

He was pleasant, a nice-looking fellow with a close-cropped blonde mustache, and obviously concerned.

I asked if the downdrafts from the chopper would be a danger to a small child: did the President's chopper really come out that low over the south fence?

Obviously, there was something I hadn't understood. The young policeman began to explain: downdrafts were not his concern. He was only following orders. He was instructed to clear the area directly below the president's flight path. It was a security measure. Those were the regulations. He seemed to be somewhat embarrassed at having to explain his duties.

His orders were all right with us. He needn't worry. We'd move along. Since Nell was not too sure a walker, and if we were about to carry her, in what direction and how far did the regulations require us to go before

the president was safe from any threats we might represent to his chopper?

The security police indicated that the shuttered National Park Service kiosk—over where our car was the only one parked, no more than fifty yards away—was considered to be in the "safe zone."

And so, a man and a woman and their child—the only security risks present that day—obediently removed themselves to the zone declared safe. We would wait anyway for the president to board, the chopper lift off, and pass. As it did, my guess was that if anyone intended to take a shot at a moving chopper, the kiosk we were using for cover provided a much better angle than the shot that would be required as an overhead from directly below the flight path. In fact, the kiosk set up a pretty fair field of fire, with perhaps two or three easy passing shots. Besides, the kiosk would cover any interference from the security men—as they were placed in their orange slickers. With a little imaginative planning, the kiosk could be used to mount something with some firepower. In sum, the security regulations to ensure the president's safety were effective against threats from eighteen-month-old toddlers, but otherwise unconnected to any reality of weather, terrain, or opportunity.

The same night we saw the president and his wife on the evening news. The chopper had flown them to Three Mile Island. They put pink plastic booties over their shoes and looked concerned as officials pointed to dials in the control room of the stricken nuclear plant. The President's spokesmen announced that no meltdown had occurred, and according to the information they had, there was no danger. No explanation was ever offered as to exactly what the pink plastic booties did to protect the president or his wife from the hydrogen bubble still uncontrolled inside the reactor.

Pink plastic booties combined with orange-slickered security men clearing imaginary fields of fire helped me to understand who the weapons of art were aimed at, and what the New Order meant by its declaration of the moral equivalent of war. The New Order consistently demonstrated, over and over, by what it said and what it did, that its powers were to be extended over all energies: not just the energies of energy; not just oil or money or the energies of science, fiction, history, and art; but the energies of reality in its entirety—the blooming of cherry trees on the Mall as well as the cauldron on fire in Harrisburg, fanned by the wind, tilted away from the north. Because the New Order actually claimed authority over the energies of love, order and progress, the New Order's officers pursued empty phantoms and they were themselves becoming empty. Soon they would keep evil fresh, and violence and outrage would echo in the streets. They were demanding obedience to false visions, consulting worthless auguries, deluding themselves by their own fancies. For powers so constituted, the New Order would not earn any salutes; not even deserve a decent curse.

Index